WORLD ART TREASURES

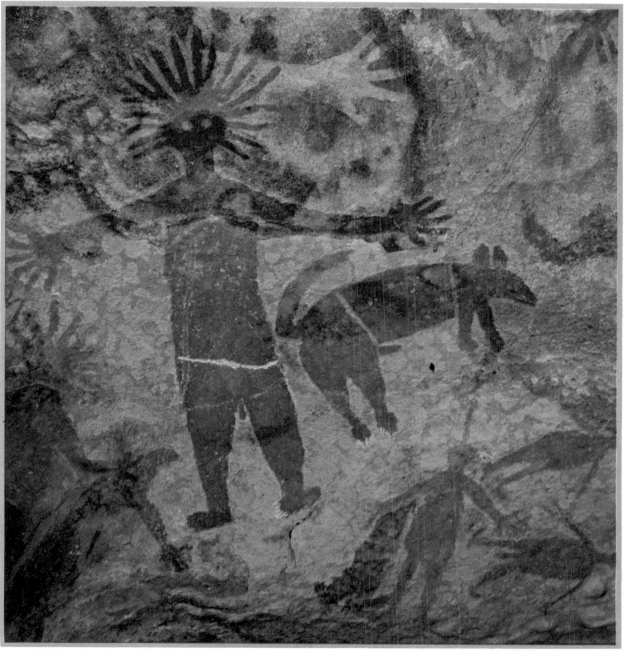

Rock painting, Queensland, Australia.

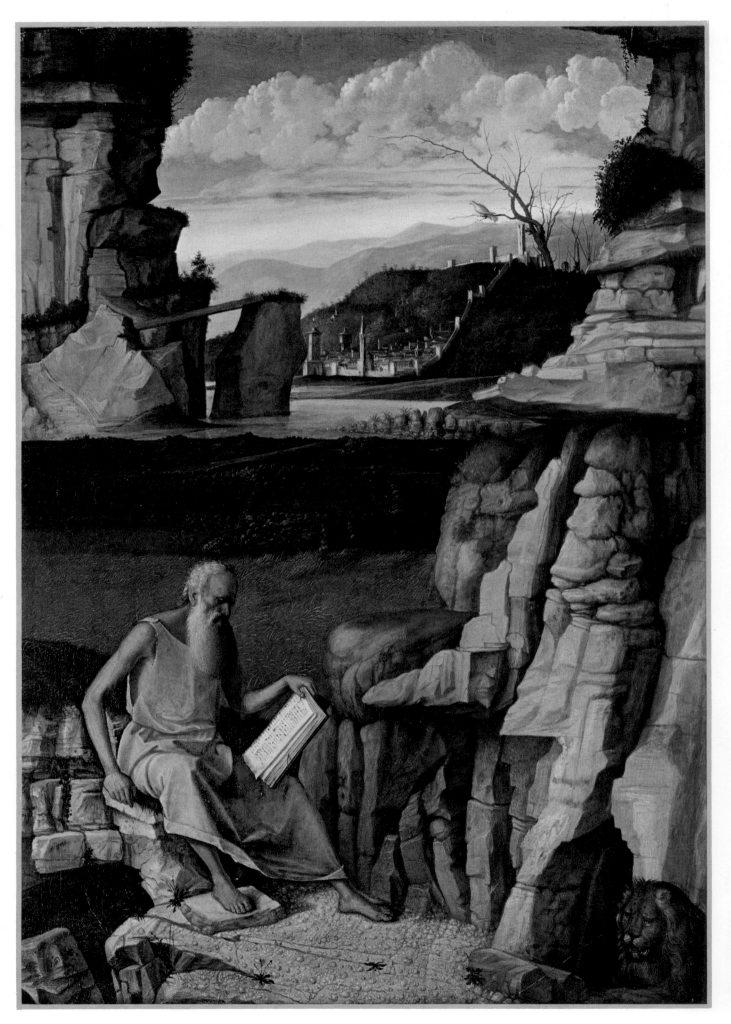

St. Jerome, Giovanni Bellini, National Gallery, London

WORLD ART TREASURES

General Editor
Geoffrey Hindley

Foreword by Dr. Frederick J. Cummings
Director, Detroit Institute of Arts

SPRING
BOOKS

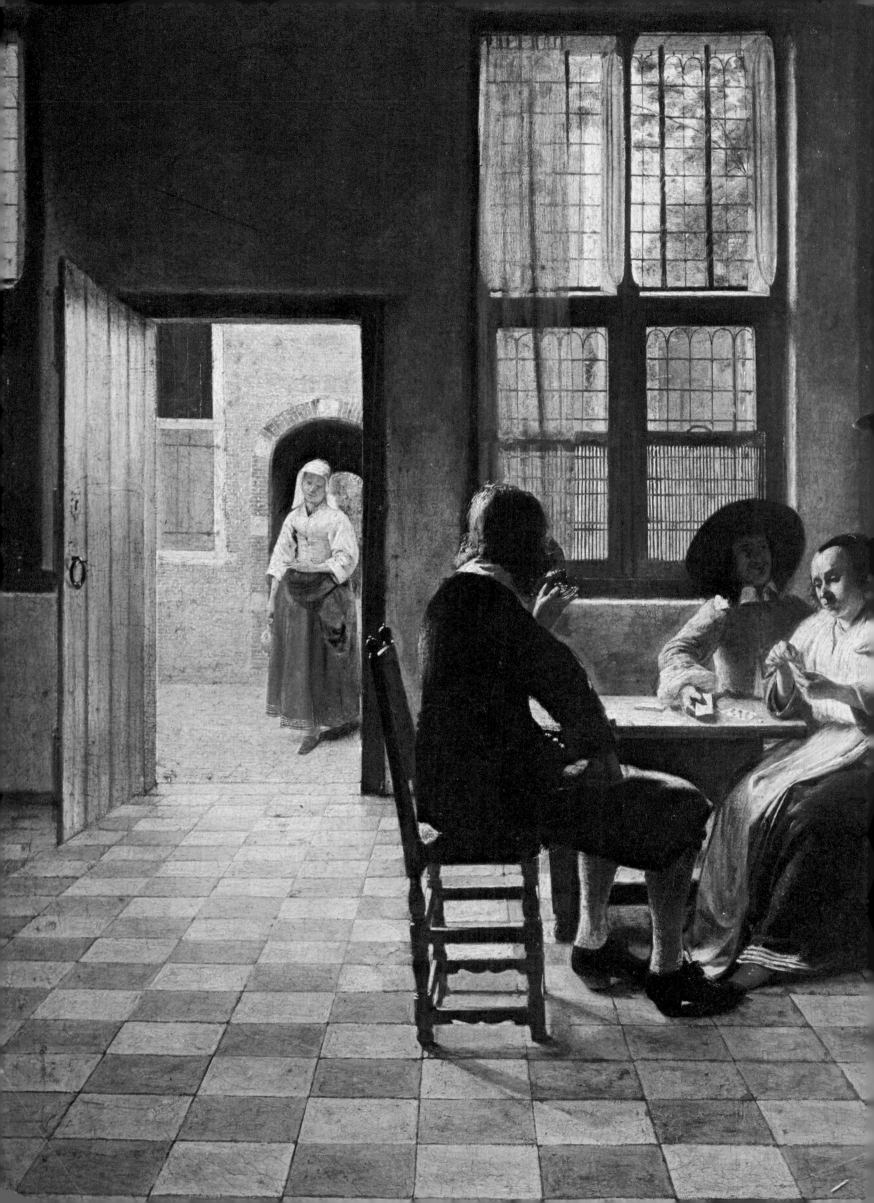

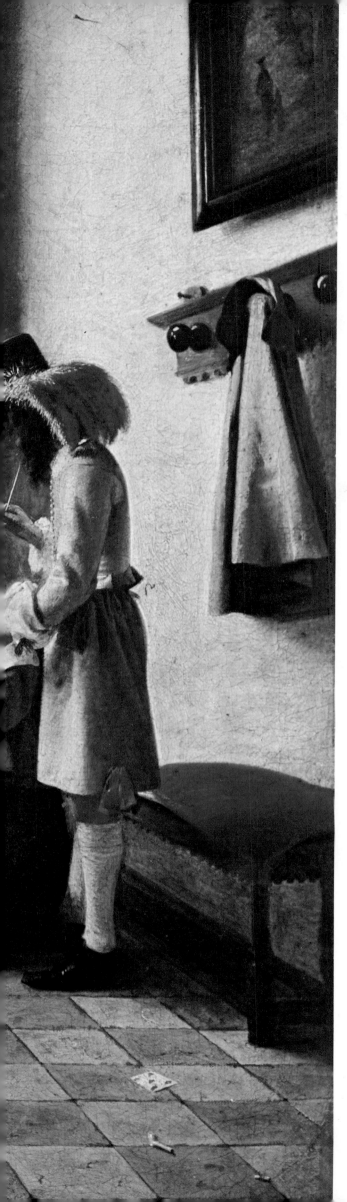

CONTENTS

First published in Great Britain by Octopus Books Limited in 1979

This edition published in 1989 by
Spring Books
Michelin House
81 Fulham Road
London SW3 6RB

© 1979 Octopus Books Limited

ISBN 0 600 56621 8

Printed in Yugoslavia

The Card Players (detail), Pieter de Hooch, National Gallery, London.

FOREWORD

Anyone who spends an hour or two in one of the great museums of the world—the British Museum in London or the Metropolitan in New York, for example, must be brash indeed if they are not at least a little awed by the variety of imaginative outpourings gathered in these treasure houses.

Such collections contain the surviving evidence of the life of the imagination of our predecessors throughout the world and the individual items speak in idioms as varied as language itself. As with language, study is repaid with increased understanding and art history is largely about when and where and by whom the objects were made. 'By whom' used not to be thought of much importance—no one knows who made the cave paintings or even for certain who carved the Parthenon sculptures, though so comparatively close to us in time. The label on an exquisite Egyptian limestone relief in the British Museum reads 'provenance uncertain, artist unknown', yet the sculpture speaks eloquently for itself and demonstrates that it has achieved an independent life of its own.

Art has performed many functions and served a bewildering variety of masters. It has often had a double purpose, the one determined by whoever paid the artist or controlled his life and the second the aim pursued by the artist in developing his personal ideas. When the interests of the artist were seriously at odds with the wishes of whoever ordered the work the view of the artist was liable to be rejected, as in the celebrated case of Rembrandt's *Night Watch*. Fortunately, if the work survives, it is reassessed by later generations in terms of the artistic contribution alone. To what extent does 'fashion' determine the esteem in which certain works of art are held? Victorian painting, sculpture, architecture are now enthusiastically studied and collected when only a few years ago few thought them worthy of serious consideration.

Discoveries from the remote past, like the cave paintings or sculptures recovered from the ground or the seabed, set the artist's mind off in new directions. Discoveries in other fields, especially, nowadays, in the sciences, can dominate, at least for a while, almost all the most significant artistic production. In this way the colour theories of Chevreuil led painters in the early 19th century to experiment with small touches of unmixed pigment placed side by side in order to achieve greater luminosity and brilliance—colours which the eye of the spectator combined. More recently the emergence of photography as a means of recording appearances with superlative accuracy, simple to use, requiring, apparently, little skill beyond a steady hand, has challenged the artist to justify his claim to be making a special contribution. Not surprisingly, the artists, or some of them, have taken over photography as an extension of the techniques available to them.

It is a formidable undertaking to try to bring together in one book the story of art from its beginnings until today—works which embrace a bewildering variety of aims and styles. Is there anything at all in common between, say, the cave paintings and the Sistine Chapel? Both certainly leave us with a sense of wonder, not because the task was difficult, although in each case it undoubtedly was so, but because with such comparatively simple means—some coloured pigment on a wall —a pictorial world has been created so vivid and real *in its own terms* that it moves us profoundly across many centuries.

7

One thing is certain: they were not made 'for their own sake' but with a practical intention. The intention of Michelangelo's ceiling is to tell the Christian version of the Creation and to demonstrate the splendour of the Catholic Church in the 16th century. The intention of the cave painters is less certain. As many of their paintings are deep in hillsides, without light, there must have been a special reason for the choice of such a difficult location. The cave paintings are often of animals and the hunt and it may be that they were believed to give the hunter power over his quarry (a belief which survives in black magic in the form of dolls stuck with pins).

It could be said that a certain magical quality is both in the cave paintings and in Michelangelo's work. Beyond that they are worlds apart in sophistication. The Sistine ceiling is constructed on an orderly architectural framework while the cave paintings display a casualness reminiscent of a child's scribbling pad in the way in which images are often haphazardly superimposed.

What is it that causes us to respond—more than that—to be profoundly moved by great art of all ages and all cultures? Is it simply that fundamentally we have not changed very much? That our responses to certain images, certain colours, are constant? That, for example, the colour blue is for ever associated with clear skies, calm seas—and so with tranquility, while red conjures up reminiscences of fire, blood, thus excitement, perhaps danger?

No matter how carefully the artist calculates the use of his materials —colour, shape, line—we re-interpret the work of past times with the knowledge and prejudices of our own time—Turner or Monet might be wryly amused to learn that their late paintings (many unfinished in Turner's case), are now acclaimed as the forerunners of the painterly abstraction of the 1950s.

From antiquity onwards painting has been considered a representational art by theoreticians. But painting has never been altogether a matter of pure imitation. Artists of all ages have respected natural appearances when it did not interfere with what they wanted to express. But all great art whether made by primitive man, by the Egyptians, Chinese or Byzantines, by Michelangelo, Poussin or Turner is often very remote from nature. A real peach or rose are beautiful things but the aspect lent to them by a Chardin or a Zurbaran is something utterly different from their imitation. The subject is simply the point of departure, important not in itself but in its consequences.

One of man's passions has been to disentangle apparent chaos, to create another and more orderly world and it is perhaps prompted by the mathematical perfection of plants, crystals and shells which lies beneath the surface of natural appearances. A desire, a longing for such order seems to be innate in human beings. The search by artists for this ideal and even dreamlike world is the story of art itself which this book sets out.

Norman Reid

August 1979
Sir Norman Reid
Director, The Tate Gallery, London

Configuration, Hans Arp, Kunstmuseum, Basel, Switzerland.
(previous page) Maple Trees, Tohaku, Chishaku-in Kyoto, Japan.

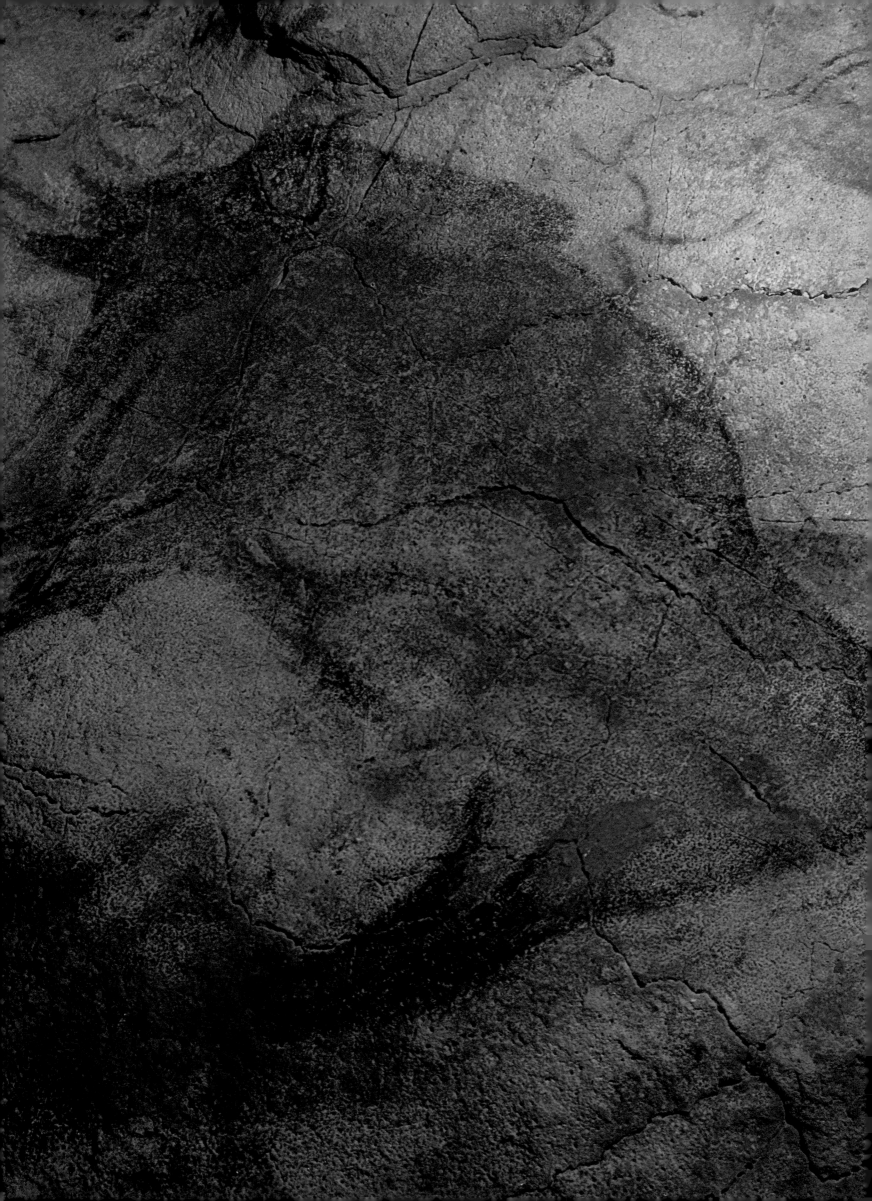

CAVE ART

Art as we understand it today appears fairly late in the story of the evolution of Man. The Stone Age is divided into the earlier Lower Palaeolithic and the later Upper Palaeolithic, and it is from the Upper Palaeolithic, starting about 30,000 years ago, that prehistoric art begins. Virtually all early art was motivated by some kind of religious requirement and wish fulfilment, often referred to as 'magico-religious' needs. Early man was unsure of those factors within his environment, such as wild animals, and those beyond which he could not fully understand, for example fire or the fertility of humans and animals. He therefore felt that he had to make some gesture of propitiation, or at least an attempt at sympathetic magic to achieve his desires.

The earliest sculptures are female figurines of the period known as Upper Aurignacian or Perigordian period in western Europe (named after French sites), or Gravettian in eastern Europe. In each case the period took its name from a type site. The figures are generally quite small, mostly less than 12 cm (4½in) high, and they all share the same basic characteristics: large breasts and buttocks with generally only a very schematic face, if one at all. The most famous example is the so-called 'Venus of Willendorf' from Lower Austria, but other similar 'venuses' are known from Gagarino (Ukraine), Malta (Siberia), Dolní Věstonice (Czechoslovakia), Mentone (Italy), Lespugne (France), etc., with one example from Laussel (France) carved as a facing figure on a block of limestone. Many of the figurines become excessively stylized down to just schematic lines representing the essential female characteristics. In the cultures of the period in eastern Europe some incredibly lifelike small baked clay modelled pieces representing the heads of various animals are found, some, such as the small head of a lioness from Dolní Věstonice, have damage which may have been done deliberately in a religico-magico attempt to influence the animal being hunted.

Cave art from western Europe, notably from France and Spain, in the Magdalenian period of about 20,000 years ago is finer and more widely known. When the first cave art was found late in the 19th century AD it was totally beyond anyone's comprehension that it could be so ancient. The famous bison painted on the ceiling of the cave at Altamira were discovered in 1878 by Marcelino de Sautuola, but it was not until the early years of the 20th century that any idea of the true age of Upper Palaeolithic cave painting began to be accepted. Other finds of now famous painted caves followed: La Mouthe, Font de Gaume, Niaux,

Polychrome bison, *c*.15,000–9,000 BC. Length about 198cm (78in). Altamira Cave, Santander, Spain. (*Previous page*)
At Altamira in northern Spain the roof of the cave is decorated with bison painted red and outlined in black—both colours being achieved from naturally occurring minerals. Most of the bison are shown standing in profile, but four are shown collapsed on to their legs in a heap. It has been suggested that these are dead, and so also might be the standing bison since their legs are stiff, and they could have been drawn from slain bison lying on their sides. Certainly the artists concerned were well aware of the bodily structure of the animals and were very accurate in their depiction of them.

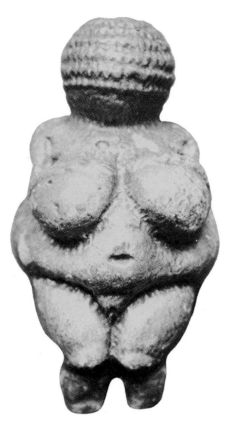

*Venus of Willendorf, c.*20,000–18,000 BC. Height 11cm (4¼in). Naturalhistoriches Museum, Vienna, Austria. (*Above*)
In the 'Venus of Willendorf', carved from carboniferous limestone, the prehistoric artist has achieved a great amount of detail using only the most primitive tools on the soft stone. The contours of the body are all grossly exaggerated except for the pathetically thin arms and hands which are folded across the top of the breasts. Another feature of this type of figurine is the almost complete absence of facial elements—the elaborate, tightly curled hairstyle is continued completely around the head and over the area of the face. All emphasis is on the symbolic sexual and fertility characteristics with no attempt at all to represent an individual.

·Painted frieze, *c*.15,000–9,000 BC. Lascaux Cave, Dordogne, France. (*Far right*)
The frieze of animals in the great hall of the cave at Lascaux at first sight seems to be a curious mixture of shapes and sizes. However, when individually examined it becomes apparent that the prehistoric artist was well aware of his subjects, especially the horses. He has shown with them in particular their different age groups and on one horse, known as the 'Chinese' horse, even its changing coat. Mixed with the horses are a group of frightened deer and two large aurochs (wild bulls), in strong black outline only. They dominate the scene and face each other across a small herd of deer.

Les Trois Frères, etc., and more recently Lascaux in 1940 and the controversial Roufignac in 1956. In the last 20 years cave art has also been discovered in eastern Europe at Kapova and the southern Urals.

The cave of Tuc d'Audoubert (France) is especially famous for its large clay sculptures of a pair of bison modelled lying on their sides on the cave floor deep underground. In some other caves the palaeolithic artist used his imagination to improve natural shapes on the rock face, as at El Castillo (Spain) where the bison's forequarters are painted and its hindquarters are in relief, utilizing the shape of the cave wall. He produced other highly artistic pieces featuring the animals he knew so well on everyday things, in ivory and bone at the end of spear-throwers and on the curious *batons de commandement*, variously described as having some ritual significance, or prosaically for the working of leather thongs through the hole pierced at their ends.

The palaeolithic artist used naturally occurring substances for his pigments, taking various ochres to achieve his reds, greens, yellows, etc., and lamp black or soot for the black. This is why so many of the colours have retained their brilliance and occasionally a painting has even been sealed beneath glistening stalactites that have dripped from the cave roof. Not all cave art, however, is painting; some caves are famous for their engravings of animals such as the rhinoceros head, bears and cave-lion at Les Combarelles, bison at La Grèze and horses at Hornos de la Peña. Sometimes both techniques are used together with great effect. Other forms of abstract art, 'spaghetti' drawings made by drawing fingers through the wet clay occur on the walls of several caves. Some evidence exists for a primitive 'pattern' book among the cave artists because engravings have been found on bone and pebbles which appear to be preparatory sketches for a subject in a cave painting, such as the bison engraved on a pebble from Laugerie Basse.

The depictions of animals obviously have some ritual and religious significance; some examples, such as the painted bison at Niaux or the cave-lion carved on a reindeer antler from Isturitz, are shown with arrows piercing them—a case of sympathetic magic. However, only one example of a 'composition' is known in Upper Palaeolithic cave painting, and that is in the Shaft of the Dead Man at Lascaux. Here it appears that the 'pin man' figure lying on the ground with his bird-topped staff beside him has been gored by the bison with lowered head that stands before him; the bison itself has been wounded. In contrast to this single composition scene in the Upper Palaeolithic, the rock-shelter art of the mesolithic hunters of eastern Spain of *c*. 10,000 BC is far more compositional. Lively incidents of archers hunting antelopes (at Remigia), or bringing down deer (at Los Caballos) are frequent.

Except for the rock-shelters, all the examples of cave art painting or sculpture *in situ*, are found deep underground in circumstances which evoke a suitable awe even in the modern beholder. No doubt there was someone, a kind of shamanistic figure, who was the leader in the ritual involved and the so-called 'sorcerer' engraved and painted on the cave wall at Les Trois Frères with his animal skin, mask and horns may be such a being. A pierced antler frontlet that could be worn in some ceremonial context was excavated from the mesolithic site of Star Carr in East Yorkshire, and it is a clue to the tradition of wearing such masks that travellers recorded in Siberia as late as the 18th century.

In the Upper Palaeolithic the painted caves must have been important areas with very deep religious and ritual meaning for Magdalenian man. It is one of the tragedies of modern life that many of the cave paintings are deteriorating because of 'over visiting' and an important site such as Lascaux, known for less than 40 years, is now closed to the public.

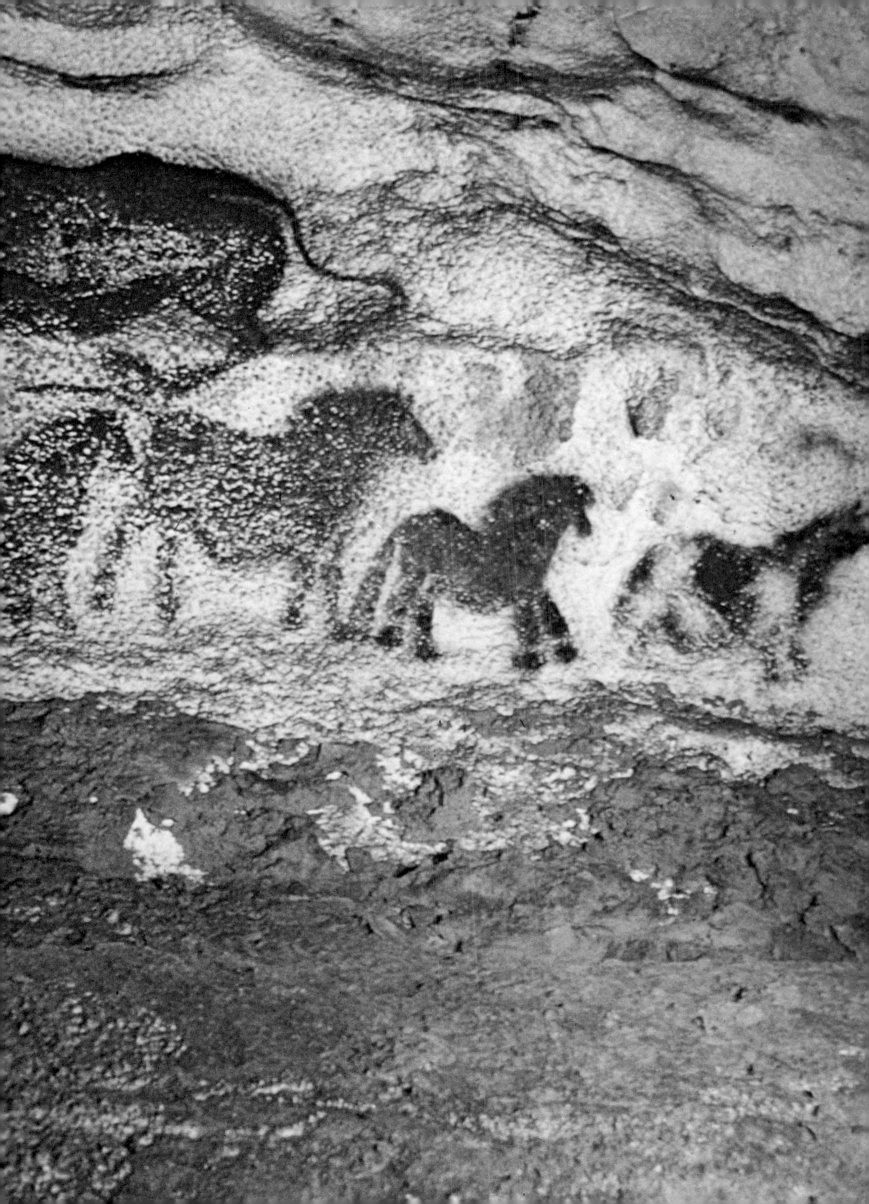

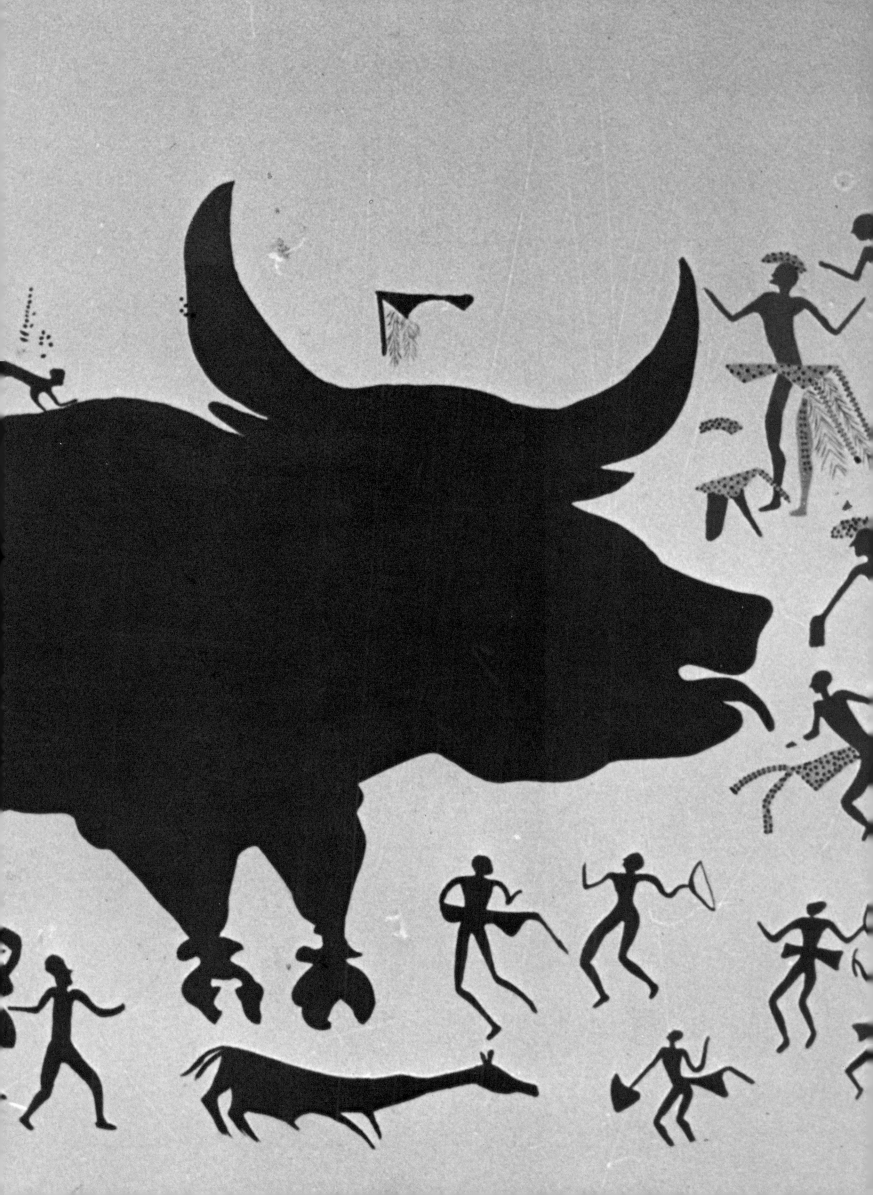

THE ART OF ANCIENT CIVILIZATIONS

It is only in very recent years that the full implications of the early origins of art in the Near East have been realized, and especially at the northern end of the so-called Fertile Crescent. This evidence comes not from the art historian but from the results of archeological excavation. Therefore, any conclusions that may be drawn from surviving painting, sculpture or other forms of art, must be tempered by remembering that what has survived is only by virtue of the vagaries of time and chance. Assessments of artistic influences and origins can at best be only speculative, at worst proved completely wrong by exciting new finds from totally unexpected areas. This is well exemplified by the excavations of James Mellaart on the Anatolian Plateau at the now famous sites of Hacilar and Çatal Hüyük which he discovered. Some 'cave art', engravings and mere scratchings by comparison with that of the Magdalenian culture in Europe, does exist along the sea coast of Anatolia (basically modern Turkey) at Beldibi, but art in a proper setting and context literally erupts on the Anatolian Plateau. At both Hacilar and Çatal Hüyük remarkable clay and pottery figurines were found, and also wall paintings at the latter site, for which carbon 14 dates in the seventh millennium BC have been obtained from tests on associated organic material.

As in prehistoric Europe the *raison d'être* of most early Near Eastern art lies in the need to provide for and to placate the religious requirements of the community. Some of the earliest sculpture in the Near East dates from the ninth millennium BC, with schematic faces carved on pebbles, carved animal heads on bone sickle handles, and a unique representation only a few centimetres high of an embracing couple from Ain Sakhri. These rare pieces come from the desert-based Natufian culture. On the Anatolian Plateau sites there have been found numerous examples of 'mother-goddess' figurines in clay, pottery and stone that reflect their earlier European sisters of the Upper Palaeolithic. In the early figurines the necessary fertility aspects are emphasized in the provision of large breasts and buttocks, and it is only much later that they become schematized down to the slim figurines with essential features accentuated by deeply engraved lines, akin to the 'Henry Moore' style figurines of the Greek Cycladic islands of *c.* 2500 BC. At Çatal Hüyük some of the mother-goddess figurines also represent an early concept of the 'Mistress of the Animals', better known again from later periods in Crete and Syria (where eventually in Classical times she becomes Cybele with her attendant lions). The goddess, with gross

Bull-teasing, *c.*6000 BC. Çatal Hüyük, Anatolia, Turkey. (*Previous page*)
The site of Çatal Hüyük covered more than 5.3 hectares (13 acres), an indication of its importance. It was occupied continuously from the mid-seventh to the mid-sixth millennium BC and 12 successive levels were excavated. The wall paintings found in the shrines were done in natural colours mixed with fat and painted on the white plaster that covered the walls. Replastering of the walls at fairly frequent intervals led to the superimposition of paintings, layer upon layer. This fine composition of a giant bull being teased by tiny 'match-stick men' is one of the liveliest from the series of paintings found.

*Narmer palette, c.*3100 BC. Height 61.5cm (25in). Cairo Museum, Egypt. (*Right*)
On one side of the slate palette of Narmer the king is shown wearing the tall White Crown (*hedjet*) of Upper Egypt and brandishing a mace above the head of an unfortunate captive. Before him the falcon god Horus has another victim ready, and behind the pharaoh his sandal-bearer, shown by convention at an appropriately much smaller scale, waits upon his master. The other side of the palette shows Narmer wearing the Red Crown (*deshret*) of Lower Egypt walking in a victory procession followed by standard bearers. The figures are executed in low relief and the surface of the slate is polished.

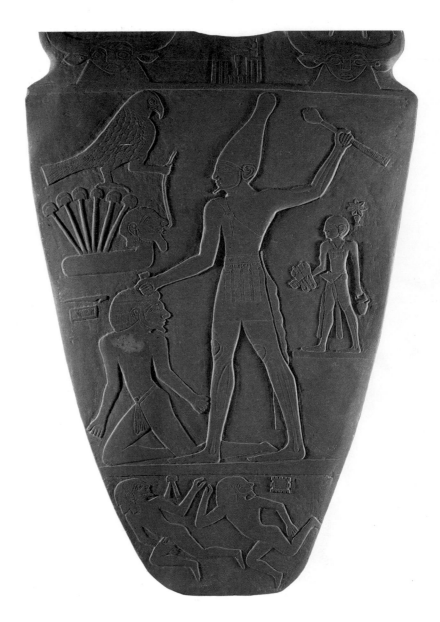

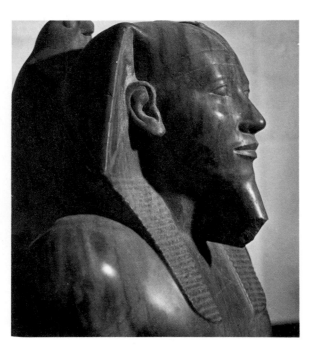

Chephren, *c.*2540 BC. Overall height 168cm (66in). Cairo Museum, Egypt. (*Above*)
The highly polished greenish-black diorite seated statue of the pharaoh Chephren is a masterpiece. Its finish was probably obtained by hours of rubbing with emery until the desired highly polished surface was achieved. This was then almost certainly covered in paint. Behind the pharaoh's headdress the falcon representing the god Horus enfolds the royal head with its wings, symbolizing the king's status as the god Horus upon earth, which the sculptor has also managed to convey in the god-like gaze of the face. This is the finest royal statue extant from the Old Kingdom in Egypt in both its execution and expressive symbolism.

characteristics, is represented giving birth on an animal-supported throne, and she dates from the mid-sixth millennium BC.

Most of the figurines from Hacilar and Çatal Hüyük are associated with rooms obviously specifically allocated for use as shrines. At Çatal Hüyük the houses and the shrines were entered by ladders through holes in the roof; thus the settlement presented a uniform blank wall to the world outside—obviously an effective security measure. In the shrines there was much evidence of art in the service of religion in addition to the goddess figurines. A particular feature was the series of bulls' heads modelled in the round in clay with real horns attached. The symbolism in art and sculpture of the bull and the ox as fertility emblems and the essence of strength go back to the earliest times, and are recurring figures in many of the early cultures. Bulls also feature prominently in the wall paintings that decorated the shrines. Huge specimens dominate the scenes and are surrounded by diminutive 'match-stick men' who taunt and tease the animal, even going so far as to pull its tail with impunity. How can this be viewed as anything other than some kind of ritual with heavy religious implications? Later parallels immediately come to mind in the ritual game of bull-leaping practised in Minoan Crete, and, not least, in the secular spectacles in the bull rings of modern day Spain. The ritual paintings on the shrine walls were renewed at fairly frequent intervals, as the excavator was able to show by the numerous superimposed levels of lime plaster on the walls.

One spectacular painting of a completely different nature from the ritual ones showed the eruption of a volcano which can be presumed

to be that of Hasan Dağ, not far from Çatal Hüyük. The area of the volcanic mountain was probably the source of the small artistic ornaments of obsidian, a volcanic glass, and the superbly worked arrowheads and polished circular mirrors of the material that were found in some of the graves. Obsidian, together with its products, was one of the widely traded materials in prehistoric times in the ancient Near East and Mediterranean. As well as appearing from sources on the Anatolian Plateau, it also occurs on several volcanic islands in the Mediterranean such as Melos and Lipari. Scientific analysis via the trace elements in obsidian objects can indicate the original source of the material. Gradually a picture is then built up of trading contacts in antiquity, which in turn can indicate those areas that could have been in touch with each other, exchanging not only goods but also artistic ideas and knowhow.

Remarkable 'sculpture' in the round was found by the late Dame Kathleen Kenyon in her excavations of the early levels at Jericho, to the north of the Dead Sea in Israel. Here, in a very early neolithic context of *c.* 7000 BC, she found evidence of the earliest fortified town with its huge bastion tower still standing more than eight metres (26ft) high. Buried beneath the floor of a house of the next phase was a group of ten human skulls which had been given a life-like appearance with modelled clay features and by using cowrie shells as eyes and the addition of red paint. The religious significance of this artistic enhancement of the skulls before their concealment is obvious, and the implications entailed of a possible ancestor cult are very interesting. Once again, art has come into being as a direct religious commitment.

The major civilizations of the ancient world grew up around the great river complexes, from west to east the Nile, the Tigris and Euphrates, the Indus, and in China on the Yellow River. Ample water, game and the fertility of the land adjacent to the water drew early man to such favourable habitats. In the prehistoric period in Egypt, usually referred to as predynastic (i.e. before the start of the dynastic period *c.* 3100 BC) several period or cultural divisions are recognized. Each is named after a type site where they were first recognized (a widespread archeological habit of nomenclature); there is the Amratian (from El Amra), the Gerzean (from El Gerza), etc. Although these cultures are mainly little known, each had distinctive pottery but they all shared the apparent need to provide figurines of the mother-goddess type. These are generally rather crude and often quite weird with long arms extended or crooked above their heads, and made of Nile mud baked red, ivory, or bone. Those in the last two materials tend to be very schematic with accentuated details marked on them. In the Gerzean culture (also called Naqada), a number of fantastic animals begin to be represented on slate palettes. The palettes were originally used for grinding up cosmetics such as green kohl for the eyes, and were quite small, often in the shape of animals, birds or fish. Then they began to be made larger and to have some special ritual use, as their original use was superceded in favour of their decoration. Curious intertwined beasts of apparently Mesopotamian origin occur on some palettes, and other links with the Tigris/Euphrates cultures can be seen on objects such as the Gebel Arak knife in the Louvre. This is a flint ripple-flaked blade with an ivory handle. On one side of the handle is carved a very Mesopotamian 'Gilgamesh-like' figure between two lions holding them physically apart—a sort of 'Master of the Animals'. The other side of the handle shows a battle in progress on water which features boats very close in style to those used by the marsh Arabs of the Tigris/Euphrates delta to this day, and which are called 'belims'. Other slate palettes show battle or hunting scenes cleverly executed in this difficult material.

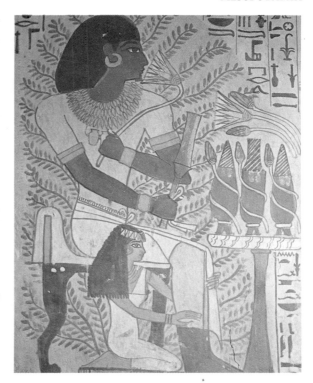

Sennofer sniffing a lotus flower, *c.*1430 BC. Tomb of Sennofer, No. 96B, Thebes, Egypt. (*Above*)
The use of natural materials as the base for colour used in Egyptian wall paintings has ensured that most of them have kept their original bright colours. The ochres were first crushed and then probably suspended in albumen (white of an egg) or fat before being painted on to the prepared wall. Draughtsmen would first sketch out the scene in black outline, and often corrections in red by a master hand can be seen on unfinished paintings. Here, artistic convention dictates that Sennofer must be shown larger than his 'sister-wife' Meryt who kneels beside him. Another convention in Egyptian art is the lack of true perspective, and hence both figures are shown in 'twisted' perspective with the torsos seen frontally but the heads and arms in profile.

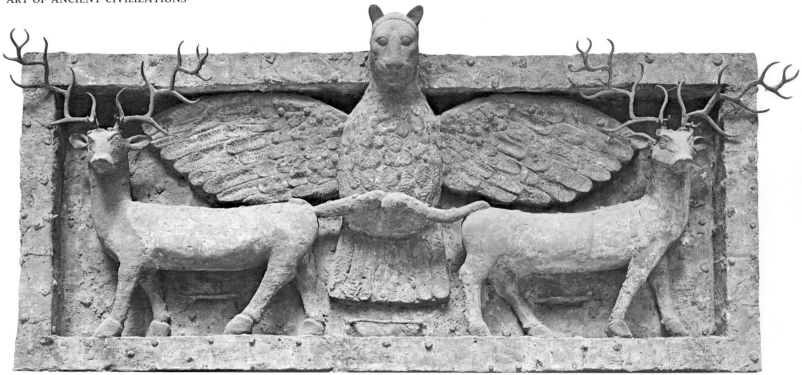

Copper panel of Imdugud, 3000–2340 BC. Height 107 × 238cm (42 × 94in). British Museum, London. (*Above*)
The copper relief of the lion-headed god Imdugud was originally placed above the entrance to the temple at Al'Ubaid in southern Mesopotamia (Iraq). It was reconstructed from thousands of fragments found in the excavations. Originally it had been built up by hammering and rivetting copper panels over bitumen laid on a wooden core to achieve the shape required. The curious elongation of the stags' bodies, whose tails the god holds in his claws, is probably incorrect. The type can be recognized as an Anatolian stag.

Gold mask of Tutankhamun, *c.*1352 BC. Height 52.5cm (21in). Cairo Museum, Egypt. (*Far right*)
Tutankhamun's gold death mask was raised from a single sheet of gold, probably at first rough hammered over a wooden core. It is inlaid with semi-precious stones and glass; the eyebrows are of lapis lazuli and the eyes of obsidian and white calcite. The whole weighs over 10kg (25lb). The back of the mask is heavily inscribed in small hieroglyphs. Although the portrait is idealized to a certain extent it is close to an accurate representation of the young king who died about 1,352 BC, probably aged 18 years. He wears the symbolic royal plaited beard and on his forehead are the sacred *uraeus* (cobra) and the vulture, emblems of kingship.

The first prime document, both historical and artistic, in Egypt is the Narmer palette found at Hierakonpolis with other ritual objects such as mace heads which were also decorated with scenes. It dates from the union of the two lands, Upper and Lower Egypt, in *c.* 3100 BC under the pharaoh Narmer (or Menes), and introduces several artistic conventions that were to become static or frozen throughout the next 3,500 years. There is little major sculpture in the early dynastic period although the art of stone working, especially vases in many different varieties of hard and soft stone reached a high degree of craftmanship. Fragments of fittings from furniture and other small ivory carvings such as gaming pieces show great skill and understanding of the material. The art of jewellery, in Egypt essentially based on a bead structure, exhibits fine workmanship, as in the set of four bracelets from the tomb of King Djer at Abydos, *c.* 3050 BC. Relief sculpture is best exemplified by the stele (tombstones) erected above the royal tombs at Abydos which are carved with the hieroglyphs or symbols of the king's name. The largest royal statue of this period is a limestone seated figure of the III Dynasty pharaoh Zoser, builder of the Step Pyramid at Saqqara, *c.* 2670 BC. He is life-size and sits closely wrapped in a long cloak and wearing the royal head-dress over a thick wig. The eyes of the statue were once inlaid to give it a very life-like appearance, but robbers have stolen them.

The Old Kingdom (Dynasties IV–VI, *c.* 2613–2181 BC) sees a blossoming of all aspects of the arts and architecture, the latter culminating in the Great Pyramid of Cheops at Giza, *c.* 2560 BC. Art in the service of the gods and religion is the keynote of all major artistic, as well as many minor, products in early Egypt. There is no private art as such for an individual's appreciation, it is all orientated towards provision for the next world. The ancient Egyptian essentially saw life on earth as merely a preparation for life after death. Immortality was the sole prerogative of the pharaoh at this period who was a god on earth and, by their close association with the godhead in death, the Egyptian nobles believed that they too could enjoy such benefits when their time came. The nobles did not accompany the pharaoh to the grave upon his death (as in Mesopotamia), only at the end of their natural terms were they buried in their own tombs called 'mastabas' set out in 'streets' close by the pharaoh's pyramid. The pyramids were not decorated or inscribed until the reign of Unas, last king of the V Dynasty, *c.* 2345 BC, when inscriptions known

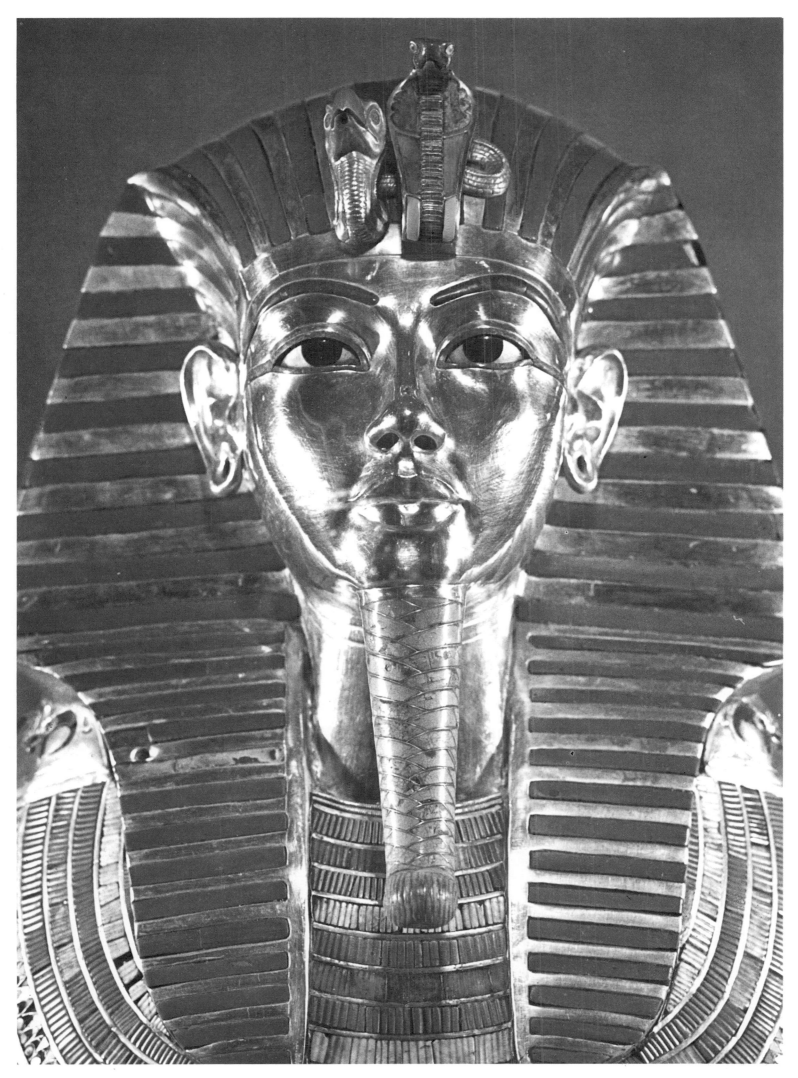

as the Pyramid Texts were carved upon the walls.

By contrast, the tombs of the nobles were heavily decorated with painted reliefs showing all aspects of everyday life about the dead man's estates. Often a statue of the deceased was provided showing him as a scribe, squatting cross-legged with his papyrus roll open on his lap and pen in hand ready to take down the dictates of his master the pharaoh. Also, large size, almost three-dimensional statues of the noble were provided in the act of walking through a 'false door' into their tomb chapel so that they could partake of the offerings left for them. These are called *ka* statues as they were the home of the *ka*, an aspect of the ancient Egyptian's soul. In other tombs a completely three-dimensional statue was often provided standing in a small, completely enclosed chamber called a *serdab*. A slit in the wall on a level with the eyes of the statue allowed it to look out into the offering chamber and spiritually partake of the offerings of food and wine left for the *ka*.

It is a curious fact that for all the size of the Great Pyramid the only sculpture known of its builder, Cheops, is a small 8 cm (3in) high ivory seated statuette inscribed with his name in the Cairo Museum. His successors Chephren and Mykerinus, builders of the second and third pyramids at Giza, were much better served. The slightly over life-size diorite seated figure of Chephren is a *tour de force* of ancient sculpture, and the several alabaster statues and slate plaques showing Mykerinus with gods and goddesses show mastery of subject and material.

In the V Dynasty the first large scale copper sculpture appears with the hollow statue of Pepi I and his son. Goldwork reaches its peak in the head of a hawk from Hierakonpolis crowned with tall plumes, and with the beady eyes of the bird cunningly suggested by the polished ends of an obsidian rod that passes through the head.

Sculpture in the round, reliefs and painting all conform to a set of rules known as the 'canon of proportion'. This was a theoretical grid plan of squares that could be imposed on anything, and it dictated the ratios of any aspect of representation of the body and its parts one to the other. A standardization of representation was thus available from early dynastic times that changed very little throughout the history of Egyptian art. The same stance of pharaoh smiting his enemies seen on the Narmer palette can be traced over 3,000 years and appears on the walls of a Roman temple, for example at Esna, where the Roman emperor appears in the guise of the Egyptian pharaoh, engaged in the identical

The Royal Standard of Ur, c.2750 BC. Height 20.3 × 48.3cm (8 × 19in). British Museum, London. (*Below*)
On either side are the two main scenes, of peace and war. The 'war' side here shows the Sumerian king, the large figure in the middle of the upper row, setting out with his army of pikemen and chariots to attack the enemy. In the bottom row several of the enemy have already been mown down by the Sumerian charioteers beneath their heavy, solid four-wheeled vehicles. The object itself was a hollow wooden box, probably the sounding board for a harp or lyre. Pieces of shell, lapis lazuli and red limestone were set into the black bitumen that covered the wooden sides to produce the lively mosaic scenes.

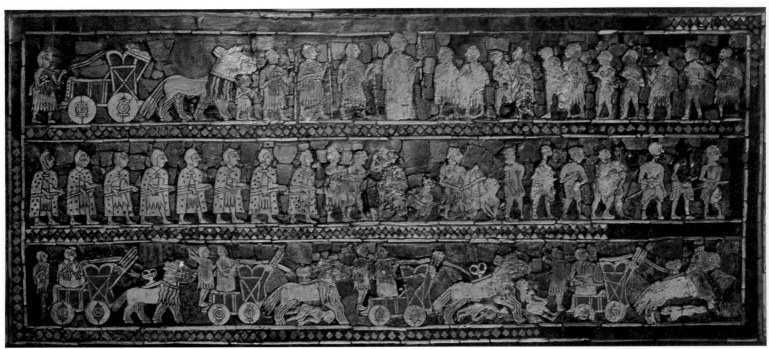

pursuit. Associated with the canon of proportion and very relevant to it was the Egyptian inability to understand or use perspective in reliefs or paintings, hence the curious 'twisted' aspect of seated and standing figures with their torsos seen full face and heads, legs and arms in profile. Only on very rare occasions is there a completely full face representation found on reliefs or in painting.

The Middle Kingdom in Egypt (XI and XII Dynasties, *c.* 2133–1786 BC) saw great advances in sculpture and metalwork, especially in jewellery from royal tombs such as that of the Princess Sit-Hathor-Yunet, buried near the pharaoh's pyramid at Lahun. The artistic techniques and craftsmanship exhibited in Middle Kingdom jewellery make it arguably the finest from ancient Egypt. Sculpture, especially royal but also of private persons, becomes very realistic. Whereas before the king was viewed as a god on earth, with the almost ethereal quality of the portrait statue of Chephren, here the portraits of the pharaohs with the names of Senusret and Amenemhet of the XII Dynasty are harsh, world-weary and are invariably given very large ears—'uneasy lies the head that wears the crown', and most obviously must of necessity hear all that goes on in the land. Relief sculpture has a classic clean simplicity of line that is not improved upon in later periods, where if anything it becomes too fussy. The period is contemporary with the height of the Minoan civilization of Crete and Cretan objects, especially fine painted pottery, are found in Egyptian tombs whilst Egyptian objects and inscribed statues have been found on Crete, notably at Knossos. Both civilizations at this period show a particular interest in and love of nature that is reflected especially in the jewellery with its flowers and rosettes of gold.

In about 1567 BC the princes of Thebes regained control of Egypt and founded the XVIII Dynasty and the New Kingdom that was to last for the next 500 years. It is from the XVIII Dynasty that the best known works of art survive, largely from the tombs of the kings and the nobles: wall paintings, sculpture, jewellery, etc. The Egyptian held to his belief that he needed to take all his finest material possessions with him via the tomb to the next world. So the walls of a noble's tomb must be decorated with scenes depicting his estate and the joys, pleasures, and workaday experiences of his life so that all might accompany him on the journey to the hereafter. Since natural ingredients were used in the pigments to obtain the colours used in the wall paintings many survive brilliantly to this day. Architecture is a feature of the period, with huge temples dedicated to the gods, especially the great god of Thebes, Amun. They were heavily endowed with the produce of the land and booty obtained from campaigns abroad under great warlike pharaohs such as Tuthmosis III. Large statues of the king, the gods, and of dedicatees of offering statues were placed in the temples. At times there were so many statues that room had to be made for more and the existing ones were removed and buried in great caches within the temple precincts—once dedicated such pieces were sacred and could not simply be thrown away. This is why in some instances, such as the Karnak cache, several thousand different statues were found in one place.

Whilst Egyptian art generally maintained its steady style of presentation at the outset of the New Kingdom, there was a break with tradition around the middle of the 14th century BC, referred to as the 'Amarna Age', when the pharaoh Akhenaten broke away from the old gods in favour of a single manifestation, the Aten. Although naturalism had been present in Egyptian art from the earliest times, especially when representing animals rather than humans, in official art a certain mannerism combined with naturalism comes to the fore at the direct instigation of the pharaoh. For some 15 to 20 years, around 1379–1361 BC, this

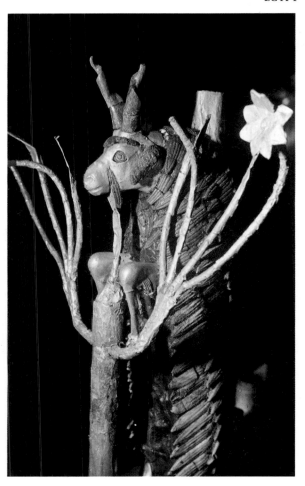

Ram caught in a thicket, c.2750 BC. Height 45.7cm (18in). British Museum, London. (*Above*)
The 'Ram' is rearing up to sniff at the flowers on the tree before it. It is one of a pair and the tube that rises behind its shoulders indicates that they both originally formed part of a piece of furniture. The animal was built up from a wooden core overlaid with bitumen; its body fleece is of white shell, its shoulder fleece, horns and eyes are of lapis lazuli, and its face and legs are covered with gold leaf. The tree is also gold leaf but the pedestal was of silver decorated with a mosaic pattern made up of pieces of shell, lapis lazuli and red limestone.

Hittite sculpture, *c*.720 BC. Height about 99cm (39in). Ankara Museum, Turkey. (*Right*)
The Neo-Hittite sculptures from Carchemish are very distinct from the fine clean-cut sculpture of the earlier Imperial period. Essentially the reason for this is the use of different stone for the carvings, the local coarse-grained black granite of north Syria. As it was difficult to work artistic standards soon declined; designs are badly balanced and human and animal representations are still and ungainly. On this block, from the so-called 'Royal Buttress' at Carchemish, Queen Luwarisas is shown carrying a child and leading an animal by a halter. Behind her is a panel of Hittite pictorial hieroglyphs, a script still not completely understood.

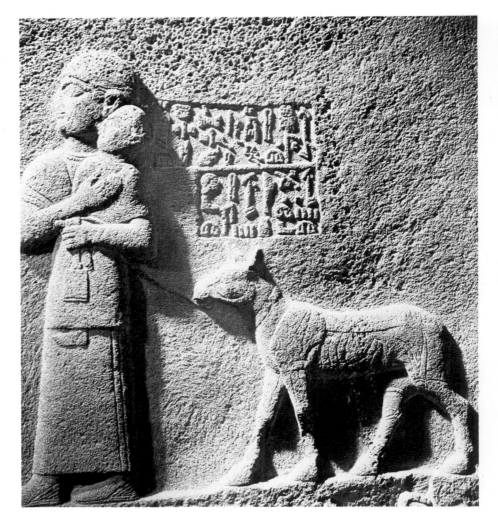

new-found 'freedom' is very evident by its contrast, at times verging on the grotesque, with most that had gone before. With Akhenaten's death and the return to the old gods of Thebes under Tutankhamun, *c.* 1361 BC, the priests of Amun regained their hold on the revenues of the country and thereby on artistic productions, although elements of 'Amarna' art can be identified for many years after, especially in sculpture and painting. Particularly pleasing from the Amarna period are the small sandstone blocks of reliefs (called *talatat*) which come from the Aten temples. These were all dismantled and their stone used elsewhere, generally as filling for later buildings, when the old gods returned. These blocks show animated scenes of people going about their daily business, in the palace, on the riverbank, feeding animals in the byre, etc. The very epitome of the period is the painted plaster head of Akhenaten's queen, Nefertiti (now in Berlin) which was found by German excavators along with other sculptured heads, many unfinished, of the queen and several princesses in the ruins of the workshop of the sculptor Thutmose at Amarna. Generally in the history of Egyptian art it is not possible to identify individual artists or sculptors, they were only seen as craftsmen along with the others, but occasionally the name of a sculptor or architect is known to us. The best known art objects from the XVIII Dynasty outside the Amarna period come from the virtually intact tomb of the pharaoh Tutankhamun found in the Valley of the Kings by Howard Carter in 1922. There, in the cramped space of only four small rooms, were jammed hundreds of treasures, as well as everyday things such as clothing, fans, and food. The best-known piece from the tomb is the solid gold mask that was fitted over the head of the king's mummy lying within its solid gold coffin. This was in its turn encased within two other coffins of wood inlaid with gold and semi-precious stones.

After Tutankhamun the XVIII Dynasty petered out within 30 years and a new dynasty was founded by Ramesses I, a dynasty that was to include great pharaohs such as Seti I and his even more famous son, Ramesses II, the great and long-lived conqueror. Relief sculpture and painting reached its highest point in the temple of Seti I at Abydos and in his tomb at Thebes, discovered by Belzoni in 1817. Ramesses II is better known for his innumerable buildings and reliefs showing him ever victorious in battle, and especially for his great temple at Abu Simbel in Nubia with its four 18-metre (60ft) high seated statues before the façade and the 9-metre (30ft) standing statues in the hypostyle hall inside. In a long reign he built many temples all highly decorated, even over-decorated, with reliefs and self laudatory inscriptions. Self glorification of the pharaoh is certainly the tenor of the reliefs on the temples, but this must be seen as representing the god on earth upon whom every aspect of the people and country depended. The priests were the 'middle men' in such dealing who dictated what was appropriate. The pharaoh had to honour the great gods and provide for them, despite being a god himself, and similarly the people had to offer to or placate the gods by their donations. The priests, with the ramifications of temple administration and estates, craftsmen to direct, and so on, were therefore at the centre and hence virtually all artistic productions were based upon or directly inspired by religious requirements.

Following the XIX Dynasty were another 11 dynasties whose artistic products were of varying quality. The gold mask and solid silver coffin found in the tomb of the Pharaoh Psusennes, c. 1000 BC, at Tanis, are very fine but pale by comparison with the splendour of earlier pieces. A 'renaissance' occurs in the XXVI or Saite Dynasty when sculptors especially look back to Middle and Old Kingdom models. The quality of works of art improves and, curiously, it is the Saite copying of Old Kingdom standing statues with their typical pose of left foot forward, arms straight down at the sides and fists clenched, that produces the prototype from which the classic Greek *kouros*, naked youth statues, derives. The influence of the world outside the Nile Valley becomes more important first with the invasion by the Assyrians, then the Persians under Cambysses in 525 BC, and ultimately the Greeks, Macedonians under Alexander the Great, in 332 BC. The last ruling house of Egypt was the Ptolemies, from Ptolemy I in 304 down to Cleopatra VII who committed suicide in 30 BC. A rather peculiar form of Egyptian art appears during this period, called Ptolemaic, heavily influenced by the

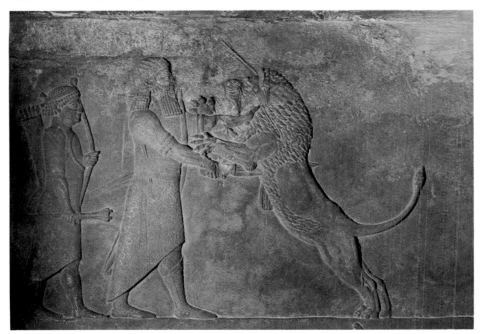

Lion Hunt, c.650 BC. Height 53cm (21in). British Museum, London. (*Left*)
The gypsum reliefs of the lion hunt of Ashurbanipal from Nineveh have all the zest of a modern comic strip. The sculptors who created these scenes had a good eye for detail, both in the clothing and accoutrements of the king and his attendants as well as for the animals involved, the horses and lions. Their sympathies seem to lie more with the animals, whether they are slain lions or frightened horses. The comic aspect is revealed elsewhere in this series of reliefs where it is seen that the lions are being released from cages for the king to hunt, and timid attendants are shown lifting the gates from within the protection of cages themselves.

23

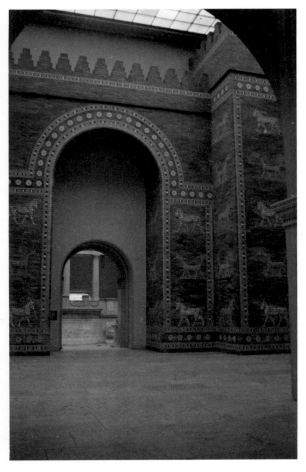

Ishtar Gate, c.580 B.C. Height about 12m (40ft). Staatliche Museen, Berlin, D.D.R.
The Ishtar Gate of Babylon must have been a fantastic sight in bright sunlight, the whole of its great height ablaze with polychrome decoration. The basic background bricks were bright glazed blue but the main feature of the decoration was the series of huge bulls, dragons and lions marching across the façade. These were obtained by each beast first being modelled in clay as a rectangular panel, then, whilst the clay was still soft it was cut up into bricks (probably using wire, like cutting through cheese). The bricks were next coated in glaze, fired in a kiln at a high temperature, and then reassembled in the gateway structure.

rounder, fuller styles of Greek art although retaining the manner and concepts essentially evolved 3,000 years earlier.

Sumer was the land of the two rivers, the Tigris and the Euphrates that join together just before flowing through the vast marsh at the head of the Persian Gulf. Between the two rivers, and to the west of the Euphrates, there grew up many early cities, and principal among them were Uruk, Eridu, Al'Ubaid, and Ur. They were ruled by kings whose duty it was as steward of the gods to govern the state for their benefit. The king was not seen as a god on earth as was the Egyptian pharaoh. This need to placate and serve the gods led to a script being evolved, at first pictographic then developing into the wedge-shaped cuneiform, so that records could be kept. Architecture in the service of the gods was exemplified by the stepped ziggurat (the original Tower of Babel) rising high above the flat landscape. Temples to the gods were placed upon the top, and many of them were extensively decorated, as at Uruk, with artistic patterns of mosaic wall cones and inlays of mother-of-pearl, pink limestone and black bitumen. These constituent elements were to feature large in many Mesopotamian works of art. Within the temple were dedicated statues of the suppliant, seated or standing dressed in sheepskin clothes and with hands invariably respectfully clasped in their laps or before their chests. One of the largest groups of such votive statues, some up to a metre (1 yard) high, was found in the Abu temple at Tell Asmar in central Iraq.

The finest example of large scale sculpture from the Mesopotamian area is the white marble head excavated at the temple of the goddess E-anna at Uruk. Dating from the end of the fourth millennium BC the head had been part of a composite statue (the body probably of wood), and provision had been made for the eyes and eyebrows to be supplied and inlaid separately. Uruk was a great centre of the arts where craftsmen were especially well versed in fashioning things from hard stones ranging from minute engraving on cylinder seals to reliefs of hunting scenes on huge boulders of basalt.

In the middle of the third millennium BC the temple at Al'Ubaid was decorated with copper sculptures of bulls laid over a wood and bitumen core, and by a huge sculpture of the god Imdugud shown as a lion-headed eagle holding two stags with his claws. Well-studied examples of animal sculpture in clay and limestone also occur. The preoccupation with representations of sheep, both wild and domestic, in the Uruk-Jemdet Nasr period stems from the idea of the divine flocks.

The Early Dynastic period in Mesopotamia is noted especially for the splendid finds from the royal graves of the First Dynasty at Ur, around the middle of the third millennium BC. The great death-pit with its servants buried alive to accompany their master in death was excavated by Sir Leonard Woolley in 1925. The royal burials were in a vaulted chamber and outside there lay ranged in rows the courtiers, animals, chariots and other goods necessary for the court to operate in the next world. This terrible waste of people had been discontinued earlier amongst the Egyptians where there had been some examples of the practice in the I Dynasty, c. 3000 BC. In Sumer it appears to coincide with a decline of the state. Fabulous objects discovered in the graves included a series of musical instruments, harps and lyres, all highly embellished with inlays and gold and silver bulls' heads, magnificent ladies' head-dresses of thin gold ribbon and flowers, superb gold cups, bowls, fluted beakers (even a gold feeding cup), gold helmets and weapons such as the solid gold dagger with a lapis lazuli handle and filigree gold sheath. Of particular interest is the so-called 'Ram caught in a thicket' of gold, shell and lapis lazuli set in bitumen. There were no

representations of daily life in the tombs as in Egypt except for the scenes on either side of an object known as the 'Standard of Ur'. On one side, carried out with inlays set in bitumen, is a scene of war in several registers and, balancing it on the other side, scenes of the court at peace. The object was probably the sounding box base for a harp or lyre.

Further up the Euphrates at the beginning of the third millennium the kingdom of Mari flourished. Sophisticated statues in limestone and gypsum have been found, and the library of cuneiform tablets from the site gives a marvellous insight into life at the time.

The cities, virtually city states, of the upper Tigris and Euphrates were permeated by Sumerian thought, religion and artistic concepts as each in turn had absorbed Sumer. At the end of the third millennium there came a Neo-Sumerian revival led by Gudea, king of Lagash, whose superb and confident looking diorite statues show him to be very complacent and their lengthy inscriptions in cuneiform record the new found prosperity. This is also the period of the Third Dynasty at Ur, when the great stepped ziggurat was built, and which still stands; the arts overall, sculpture, painting, and jewellery saw great improvements. The influence and authority of the dynasty at Ur extended over 800 km (500 miles) north into Assyria.

Under Hammurabi, the great lawgiver, in the 18th century BC the area of Mesopotamia was brought under the single rule of Babylon. Few works of art survive that can be definitely assigned to this period but the finest is undoubtedly the famous stele of Hammurabi in the Louvre. Inscribed with his Code of Laws it shows the king at the top standing before the seated sun god whom the inscription calls 'Lord of Justice and Law-giver'. The minute engraving on cylinder seals is the best artistic indicator of the period, and typical Mesopotamian motifs appear frequently on them. Wars with the neighbouring Kassites weakened the Babylonian state sufficiently for Assyria to take over about 1350 BC.

In central and south-west Anatolia the great empire of the Hittites flourished in the 14th and 13th centuries BC. The gold-hilted dagger with an iron blade found on the body of Tutankhamun was almost certainly a very valuable diplomatic gift from a Hittite king. They had their capital at Hattusas (Boghazköy) where the most splendid examples of their large scale sculpture are to be seen in the high relief animals carved on the city gates—the forerunners of the later Assyrian great winged, man-headed guardian *lamassu*. At the Hittite religious sanctuary of Yazili-kaya, near to the capital, there are long lines of gods, kings and soldiers cut in relief on the rock face. In the 12th century the Hittite empire broke up but five centuries later there was a 'Neo-Hittite' revival largely based in north Syria with Carchemish as its capital. The ruler in the late 8th century was King Araras and he greatly embellished the city with numerous reliefs. Generally about a metre (1 yard) high there were long sequences of slabs of black basalt with scenes of the king, gods and goddesses, soldiers and Hittite pictorial hieroglyphs. Most of the carvings were found in three areas dubbed by the excavators the 'Royal Buttress', the 'Long Wall of Sculptures', and the 'Herald's Wall'. The difficulty of working the hard basalt used for the reliefs explains why the standard of carving seems poor when compared to that of the earlier Hittite empire. The sculptors had to make use of the local stone as best they could, and its coarseness meant that they had to use strong simple lines to achieve any effect.

There is virtually no early Assyrian statuary extant, only seal engravings, and it is from the Late Assyrian period (1000–612 BC) that Assyrian art flourishes in great profusion. It is best exemplified by the relief sculpture that adorned the walls of the palaces in the late 9th and 8th

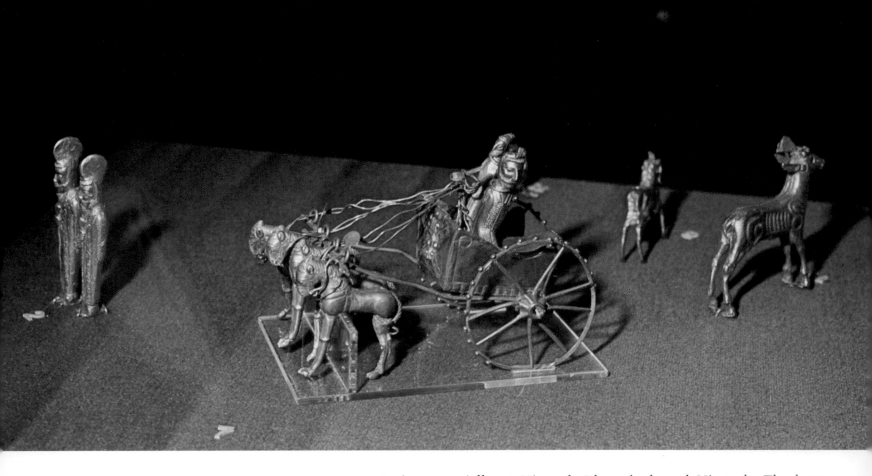

Gold chariot from the Oxus Treasure, *c.*5th century BC. Length 8.8cm (3½in). British Museum, London.
This miniature gold masterpiece drawn by four horses has a standing charioteer and a seated figure in the body of the chariot. Great care has been taken to indicate the features of the passengers, the details of their dress, and the harness of the horses, which is finely drawn gold wire. It is difficult to suggest what use would have been made of this tiny piece other than it may have been a votive offering in a temple, possibly for a chariot racing victory. A second tiny chariot from the Treasure also has two occupants, but has lost its horses.

centuries, especially at Nimrud, Khorsabad, and Nineveh. The best were produced in the reigns of Sennacherib and Ashurbanipal. Almost like a modern comic strip the friezes of sculpture ran around the walls of rooms and along corridors leading to audience chambers. The cuneiform inscriptions accompanying them left no doubt in the mind of the reader as to the supreme power of the king. The reliefs mostly feature the Assyrian king at war, ever victorious over a great number of nationalities in either running battle (when the defeated flee to drown in rivers), or in sieges (when the vanquished find themselves impaled on spikes outside their city gates). The zenith of Assyrian relief sculpture is the Lion Hunt of Ashurbanipal, a magnificent portrayal of the chase, of the king's fearlessness when shooting lions from his chariot or horseback, or even standing in hand to hand combat with the animals. Although the king and his attendants are shown in active pursuit of their prey there is a degree of coldness in the representation which is totally reversed in the approach to the hunted animals. One suspects that the sculptor had great sympathy for the hunted lions and wild asses so marvellous is his understanding and representation of the beasts at bay: a lion struck by an arrow in the forehead still roars defiance before he falls lifeless, and the dreadful pathos of the wounded lioness, her hind legs paralysed by arrows, dragging herself along on her forepaws.

Another feature of the palaces were the huge carved stone guardians of the entrances, *lamassu*. They were bearded human-headed figures wearing the horned head-dresses which indicated their divinity, with the bodies of lions or bulls. They are provided with five legs, divided with three seen from the side and two when viewed from the front. Thus from either angle the viewer was presented with the complete beast since the extraneous leg is only evident on walking round.

Artistic influences spreading from one country to another by way of trade are best seen in the Phoenician ivories of which hundreds of fine examples are known, especially from the excavations at Nimrud. The ivories were essentially intended as decorative fittings for furniture, often gilded and otherwise embellished. In their decoration and motifs

they make use of a number of styles from wide areas, and adapt many of them to local taste. Those found at Nimrud in over a hundred years of excavation have been classified into the Assyrian, Phoenician, and Syrian styles. The first has much in common with the Assyrian palace reliefs in the way it presents standing figures and decorative flower motifs. The Phoenician style is very distinctive being securely based on Egyptian art motifs but adapted from them with, at times, somewhat curious forms. The last group, Syrian, may well have come from that area but archeological evidence is lacking. Two of the ivories are justly famous. One, the head known as the 'Mona Lisa' of Nimrud, falls within the Syrian group, and is an enchanting yet enigmatic piece. The other, one of a pair of ivory plaques in the Phoenician style, shows a spirited scene of a young Negro being mauled by a lioness in a marshy thicket.

After the sack of Nineveh in 612 BC a new dynasty based itself and its empire on the city of Babylon. It had been an old capital of south Mesopotamia and Babylon's most famous king, Nebuchadnezzar, undertook an extensive rebuilding programme. Few works of art survive from this period, and even then these tend to be mediocre terracotta statuettes and indifferently carved cylinder seals. The art of the period is really embodied in its architecture which is artistically embellished as were the gates of Boghazköy. In Nebuchadnezzar's reign the 'speciality product' was a glazed brick modelled in high relief. These polychrome bricks were used with great effect on gateways and walls.

The last king of Babylon was Nabonidus who was defeated in the 6th century BC by Cyrus the Persian. Hitherto the Persians had been a semi-nomadic group but now Cyrus was king of a vast empire, and he settled his capital at Persepolis and founded the Achaemenid dynasty. It is from the palace at Persepolis that the best Persian sculptures come. Most of them were executed under Darius I, Xerxes, and Artaxerxes I. The carving is very fine and obviously owes much to contact with craftsmen outside the Persian world, especially the Greeks. This is particularly evident in the treatment of drapery. The great hall, the 'Hall of a Hundred Columns' or *apadana*, has a forest of columns on its high terrace but along the sides of the gently sloping stairways that lead up to the terrace are rows of relief sculpture showing tribute bearers and the like, beautifully observed studies carved with great care. So thoughtfully has the sculptor observed his subject that the effect is almost three dimensional, endeavouring even to suggest physical form under the draperies. The capitals of the columns in the hall are carved with adorsed (back-to-back) bulls in high relief, and the fluting of the columns has Greek overtones. Glazed brick following the Babylonian model was also used with great effect, especially in the life-size lines of brilliantly coloured archers of the royal guard from Susa.

Amongst the best elements of Persian Achaemenid art are the metalwork and jewellery. A large amount of both has survived; elegantly ribbed and fluted bowls in gold and silver, rhytons and drinking cups which have three-dimensional lions or fabulous beasts modelled at their foot, repoussé dishes, magnificently embellished weapons and walking staff heads. Persian objects travelled far afield into Europe and Asia—the oldest known Persian carpet is one of the 5th century BC found in the frozen tombs of the nomads of southern Siberia at Pazyryk, and silver vessels have been found in graves in southern Germany. Such exotic forms of art were often copied locally or further decorated to become assimilated into a different cultural and artistic environment. Amongst the mass of Persian jewellery that has survived the best known hoard is the Oxus Treasure, a large collection of dress ornaments, rings, two magnificent armlets with opposing griffin heads that were once

inlaid, several small bracelets, belt clasps, gold roundels, gold and silver statues, a miniature gold sculpture of two Persians in a chariot drawn by four horses and several pieces of fine plate. The treasure is an odd mixture of artistic influences which includes Scythian nomad art and Egyptian as well as one gold roundel which has a facing lion's head that is very Chinese in style.

When Alexander the Great marched against Darius the Great, King of Persia, his soldiers were astounded by the riches of the empire they were conquering, the buildings they saw and the races they overcame. When Alexander finally defeated Darius at the battle of Gaugamela in 331 BC he took the title of Great King himself. By the movement of people and ideas that he had brought about, he unleashed a 'Pandora's box' of artistic influences that were to fly throughout the then known world—influences of style and concept that spread as far as north-west India to introduce elements of Hellenistic art and culture into the local Ghandaran sculpture producing Greek-looking Indian art even in representations of the life of the Buddha.

The civilization of Minoan Crete, discovered by Sir Arthur Evans in 1900 and named after the legendary king Minos, is the first civilization of Europe. Crete was peopled by colonists coming from Asia Minor about 2800 BC. In the early phases Cretan art is best recognized in the jewellery from tombs at Mochlos, c. 2500 BC, especially in the diadems and hair ornaments that have much in common with the natural flower designs in gold on the head-dresses from the royal graves at Ur as well as in Old Kingdom Egypt. The stone vessels are very fine and beautifully worked, making the fullest use of any colouring or striations.

The great period of Minoan art is that of the palaces from about 2000 BC to around 1450 BC, with a break about 1700 BC due to earthquake destruction. Rule in Crete was based on individual palaces set in their own territories, the main ones being Knossos, Phaestos, Mallia, and Kato Zakro—all of which have produced artistic treasures. The high point of Minoan art can be narrowed to the Middle Minoan period from 1700 to 1550 BC when new influences, many of them stemming from Babylonia and passing via Syria were spreading throughout the Mediterranean, as were technological improvements. Notable among these ideas was metalworking and its techniques. The art was well understood, many metal shapes even being copied in pottery, and the Minoans also mastered the specialist techniques for jewellery including filigree and granulation, the latter learnt from Egypt and magnificently represented in the famous 'bee' pendant from Mallia. Jewellery from the period is rare but the quality is outstanding, as the hoard known as the Aegina Treasure shows with its gold pendants, pectorals, rings, beads of cornelian and lapis lazuli, together with a small gold cup. Sealstones, an offshoot of the jeweller's skill, are beautifully cut with lively scenes of goddesses, worshippers and animals. Other miniature work includes finely cut ivories (also used for seals), three-dimensional figures of acrobats and the like as well as two-dimensional plaques.

The major offering of Minoan art is the surviving frescos with their brilliant colours mainly from Knossos. They are proper frescos, the colours being painted on to wet plaster, not wall paintings as in the Egyptian tomb painting. Because of the need for speed in painting frescos, as the plaster dries very rapidly, there is a great naturalism and immediacy in Minoan art which is well coupled with the Minoan love of nature, animals and flowers. The scenes from nature in the frescos include flowers such as the lilies from the villa at Amnisos, dolphins sporting in the waves from the Queen's Megaron at Knossos, and the charming swallows in springtime that 'kiss' their beaks in mid-air above

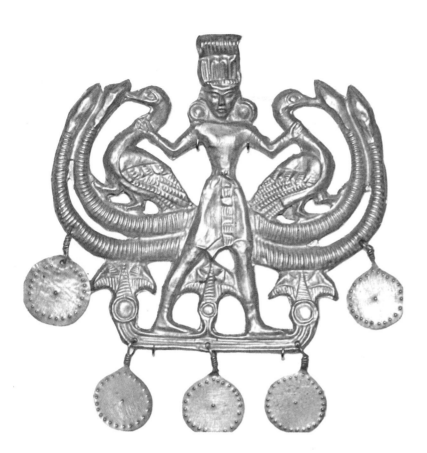

Gold pectoral, c. 1700–1550 BC. Height 6cm (2½in). British Museum, London.

The Aegina Treasure, of which this 'Master of Animals' pectoral is part, was bought by the British Museum in 1892, eight years before Sir Arthur Evans discovered and identified the Minoan civilization. The Treasure consists of pendants, pectorals, rings, beads and a small gold bowl found on the island of Aegina, off the Piraeus, but there is no question that it is of Minoan workmanship. This pectoral owes much of its inspiration to Near Eastern sources which go right back to early Sumer where the hero Gilgamesh similarly holds lions by their necks, instead of waterbirds. This piece is of thin gold, probably raised by hammering over a die of wood, and then chased and finished.

fields of flowers, recently found in the ruins of the Minoan town on the island of Thera, 110 km (70 miles) north of Crete. Other subjects are mainly concerned with life in the palace: the lines of courtiers carrying tall cups and vases (also seen as envoys painted on the walls of Egyptian tombs at the same period, such as that of the vizier Rekhmire at Thebes); the almost effeminate 'priest-king' with his tall waving head-dress; ladies watching a spectacle, and the famous 'Parisienne' with her carefully drawn features, alert eye, and red made-up lips. The bull-leaping spectacle represented on the frescos was an important part of palace life and ritual, and is also known from a small bronze statuette showing a male figure somersaulting over the charging bull's back. Fresco decoration is also used on the limestone sarcophagus found in the villa at Hagia Triadha, only a short walk from the palace at Phaistos. The two long sides show ritual scenes which include a trussed bull lying on a table while a piper with double-pipes plays and a priestess pours a libation at an altar. The other side has a scene of offerings being brought to a tomb while musicians play, and before the tomb stands a figure of the dead man. The two short ends of the sarcophagus are decorated with goddesses in chariots drawn by horses and griffins, the latter a Near Eastern motif that was to become very popular in Mycenaean art.

Numerous small objects were made in *faience*, a brightly coloured glazed frit, and they include representations in flat relief of Minoan two- and three-storeyed houses, flowers, animals, etc., but the finest pieces are the so-called 'Snake Goddesses', 30–35cm (11–13in) high. They come from a stone-lined pit in the palace at Knossos called the Temple Repositories, just outside the Shrine of the Double Axe. Two of the several figures found are substantially complete and show standing women dressed in the typical long Cretan skirt with an 'apron' over the front, and bodices that are wide open to reveal the breasts. Both hold snakes, either wriggling up their arms or one in each outstretched hand, and a snake entwines itself round the tall hat of one figure whilst the other appears to have a cat or other feline perched upon her head-dress. The group probably represents the goddess and her attendants, but which figure is which is debatable. A similar, smaller figure in ivory

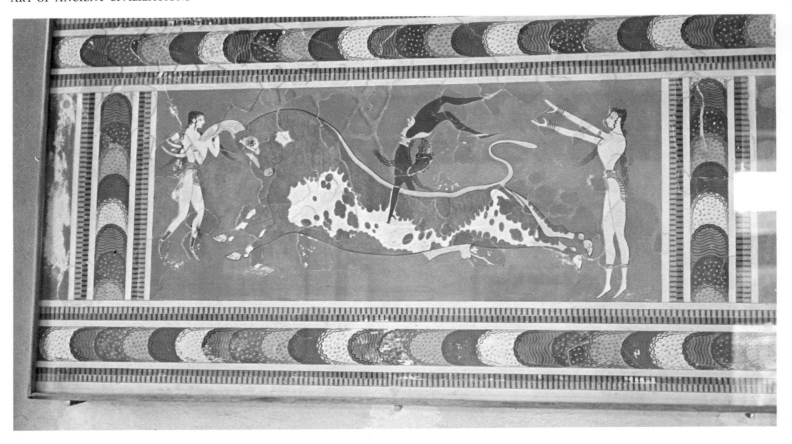

Bull-leaping sports, c.1550–1450 BC. Length about 244cm (96in). Archeological Museum, Herakleion, Crete. (*Above*) The brightly coloured wall paintings that adorned the walls of the Minoan palace at Knossos are all true frescoes, painted while the lime plaster base was still wet—hence the preservation of their colours. Their objects range across a variety of studies of nature and sea creatures such as dolphins and octopuses to the spectacle shown here—young male and female bull-leapers, the latter shown conventionally with lighter skin tones. Other frescoes show well dressed ladies with elaborate hairstyles watching a spectacle of some kind which could well be the bull-leaping sports that took place in the central courtyard of the palace.

Bull's head rhyton, c.1500–1450 BC. Height (without horns) 20.6cm (8in). Archeological Museum, Herakleion. (*Right*) Minoan craftsmen were not only skilled metalworkers but could also work the hardest stones. A particular speciality was the working of steatite in fine detail, especially for seal stones. Vases are known from several of the Minoan palaces that are carved with scenes of animated figures. This piece was found in the Little Palace at Knossos and represents a finely carved bull's head with its realistic inlaid eyes. It was used as a *rhyton*, a vessel for pouring libations. The head itself is hollow and there are two holes pierced through the bull's nostrils. Liquid was placed in the back of the head, held upside down, and it poured out through the nostrils on to the ground to appease the bull god worshipped in Crete—the 'Roarer'.

and gold is known. Despite their curious attributes the figures are very early representations of naturalism in the round before the Mycenaean 'take-over' of Crete. The Minoan civilization comes to an abrupt end around the middle of the 15th century BC, probably due to the eruption of the volcanic island of Thera (Santorini). When the devastated areas are reoccupied it is under Mycenaean overlords.

After the eruption of Thera only the palace of Knossos appears to have been restored and reoccupied to any large extent. The throne room was redecorated with frescos of guardian griffins amongst lilies, flanking a gypsum throne. Griffins appear frequently in Mycenaean art, on gold signets, ivory boxes, etc., as a favourite motif. The Late Bronze Age invaders from mainland Greece introduced other elements of their art, noticeably in the more formal representation of marine life and flowers in the decoration of the large 'Palace Style' vases. However, they learnt more from Cretan art than they gave to it. Apparently Minoan craftsmen went to the mainland because much of the artistic metalwork and jewellery of this period found there is certainly of Minoan inspiration, if not actually made by Cretan craftsmen. This is particularly evident in pieces such as the pair of gold drinking cups found secreted in a robbed tholos tomb at Vapheio near Sparta. The decoration in raised relief around each cup is a narrative relating to the catching of wild bulls, no doubt for the bull-leaping sports. One cup shows a slim-waisted and kilted Cretan youth endeavouring to catch a bull in some nets; disaster ensues with the Cretan being flung clear and the bull throwing up his hind legs and escaping. The second cup shows Cretan cunning as the wild bull is decoyed by a domesticated cow, and seems quite oblivious of the fact that his hind legs are being skilfully hobbled. Not only is the subject matter and technique Cretan, but so also is the background scenery and ground lines upon which the would-be captors and their prey move.

The greatest hoard of Mycenaean precious metalwork and jewellery was found by Heinrich Schliemann in the Shaft Graves at Mycenae in 1876. The jewellery consisted mostly of quite flimsy plaques, mainly for dress ornaments, beads and diadems (some of the latter being far too

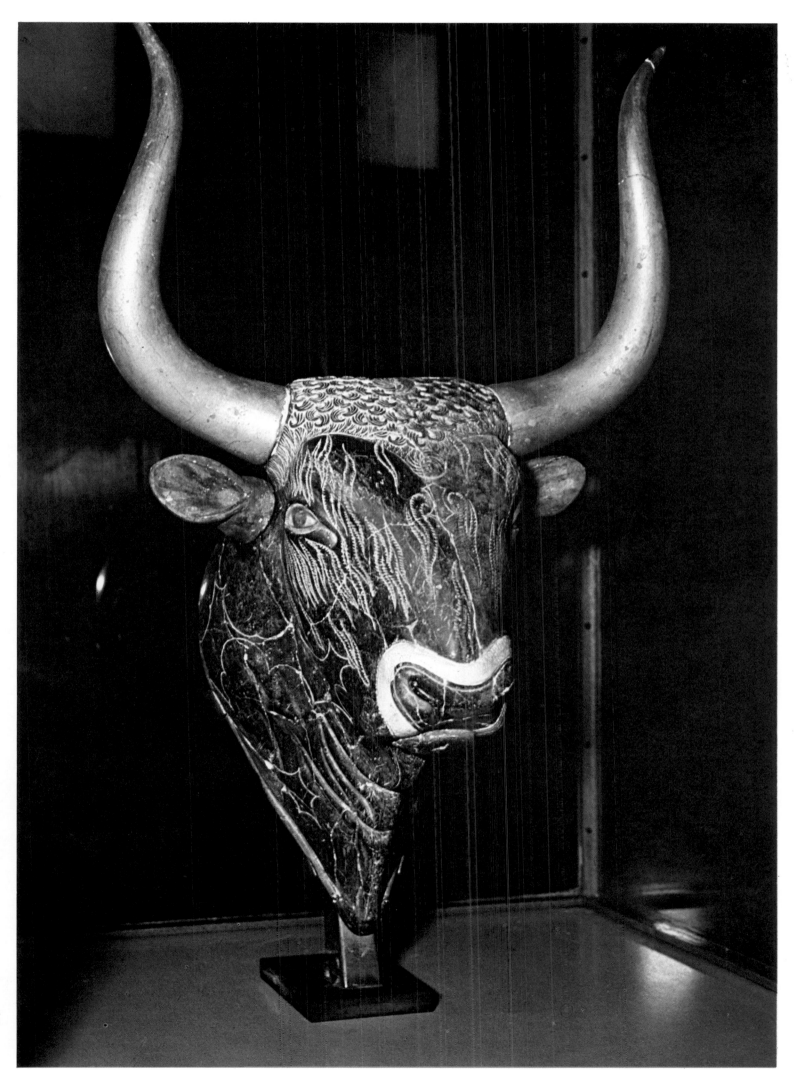

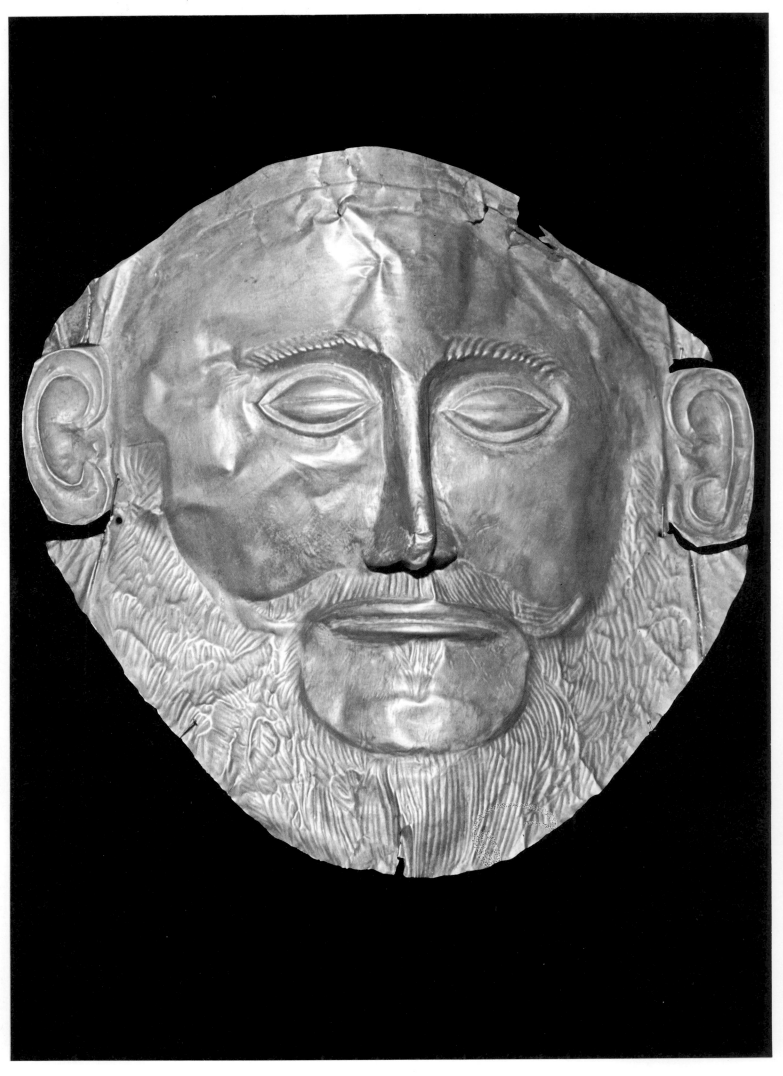

large actually to have been worn). The most striking finds were the gold death masks that covered the faces of several bodies, one of which Schliemann identified as that of the legendary Agamemnon, and the bronze daggers with inlaid blades. The Minoans had a tradition of making fine daggers for the mainland market and most have been found there rather than on Crete. The Shaft Grave specimens are superb examples of this craft with scenes inlaid into the blades in gold, silver and niello. On one dagger men bearing the typical Minoan figure-of-eight shaped shields hunt a lion—and the lion turns on one of the hunters. On another dagger cats hunt water birds in a marshy thicket. A blade from Thera has inlaid gold Cretan double axes (*labrys*) on it, one from Argos a dolphin playing, and another from Pylos, the only known example to retain its gold handle, shows hunting leopards. The hunted or fleeing animals are generally shown with their fore and hind legs outstretched, a typically Mycenaean motif which indicates speed and which is known as the 'flying gallop'. In the course of Mycenaean colonization overseas into the Near East via Cyprus, and into Syria at sites such as Ras Shamra (Ugarit), this motif becomes widely diffused. It appears quite early on in Egypt in the middle of the 16th century BC among the small gold animal plaques in the great Broad Collar of Queen Aahotep of the late XVII Dynasty.

Another popular and very typical Mycenaean motif was the running spiral. It occurs carved on the stone tomb stele from above Shaft Grave V at Mycenae beneath the scene of a charging charioteer; as architectural ornament on the door to the Treasury of Atreus (also at Mycenae); in metalwork, on gold plaques, inlaid into sword blades, and as the complete decoration running around a gold handled cup (also from Shaft Grave V).

Mycenaean sculpture is rare, the best known piece being the pair of heraldically opposed lions above the Lion Gate at Mycenae and they, together with the pillar which they flank, are of Cretan inspiration. Terracottas are common, especially the little figurines of household goddesses shaped like the Greek alphabet letters *phi* and *psi*, and from which they take their name (they are also often called 'Mycenaean dollies'). They appear to have been made by the potters who produced the distinctive and fine Mycenaean pottery, and an example of a large household goddess recently found on the island of Melos has a tubular body (probably built on a potter's wheel) which is topped by a rather curious, surprised-looking painted head. Snakes also featured in Mycenaean religious ritual and terracotta examples are new finds from Mycenae itself. There are a few examples of life-size terracotta sculptures, a goddess-head in clay from the island of Keos, and a painted plaster head of a 'sphinx' from Mycenae. Neither are very life-like. It is possible that large scale sculpture in wood existed, but it has not survived; this could have perhaps been larger versions of the typical small bronzes of worshippers, both men and women, represented standing with their clenched fists pressed against their foreheads.

The end of the Mycenaeans, and of the Late Bronze Age, comes with the invasions of peoples from outside, from northern Greece, around 1200 BC, a period which saw great upsets throughout the Mediterranean world. This is the beginning of the Dark Age in Greece when only the skill of fine pottery making, but decorated in a very schematic style, survives. It was to the Mycenaean Age, with the rich panoply of its warrior structured society, that Homer looked back in the *Iliad*, describing in detail the weapons, armour, boars' tusk helmets, funerary games and sacrifices, etc. Archeological discoveries are constantly revealing the accuracy of the poet's descriptions.

Mask of Agamemnon, c.1500 BC. Height 26cm (10½in). National Museum, Athens, Greece. (*Far left*)
This gold death mask found by Heinrich Schliemann at Mycenae in 1876 was only one of several (and others have been found in recent years in a grave circle just outside the gate of the citadel). This is undoubtedly the finest of the group with the quiet dignity of its lentoid eyes and carefully prepared beard and moustache. Although the gold is only a thin sheet the workmanship is competent but does not have the flair that characterizes the Minoan goldsmith. Other pieces from the same tomb (Shaft Grave V), such as the inlaid dagger blades, were certainly by Minoan craftsmen. The use of gold death masks was obviously copied from the Near East where it had been in vogue for centuries, and is best known from Tutankhamun's gold mask made 150 years later than this piece.

33

CLASSICAL ART

Augustus died in AD 14 after ruling the Roman empire for over 40 years. He was deified and his statue at his wife's villa at Prima Porta outside Rome represents him as a bare-footed Greek hero. The cupid on a dolphin by his right leg refers to the divine descent of his family from Venus. The sculptor made little attempt to tell us about his rather ordinary appearance described by Suetonius: 1.45m (5ft 7in) tall, but well proportioned, ears of normal size, yellowish curly hair, Roman nose, eyebrows which met over his nose, teeth small and decayed. Instead we are shown a youthful, dynamic figure in the pose of a famous Greek statue made 400 years earlier: Polykleitos's *Doryphoros (The Spear Bearer)*. Polykleitos's statue probably represented the Greek hero Achilles and was a model of human beauty which Polykleitos had created to illustrate his book on human proportion, the *Kanon*. The original has not survived (very little has from the 5th century BC), but we know of this statue through numerous Roman copies.

It is not surprising that this posthumous statue should have the form of a Greek hero, because Augustus was deeply in love with Greek culture and under him Greek ideas in art and architecture spread throughout the Roman empire. This Greek influence on Roman art had come about not only through the Greek cities in southern Italy, but also indirectly through the Etruscans, Rome's northern neighbours, and it had become increasingly strong after Rome's conquest of mainland Greece in 146 BC.

But the Romans did not admire contemporary Greek art. They despised the Hellenistic monarchs of Macedonia, Syria and Egypt as decadent and corrupt and considered their art to be over-luxurious, without moral value. What they admired was the art of democratic Greece, the art of the Greek city states who had resisted the Persian invasions of 490 and 480 BC and afterwards had built the temple of Zeus at Olympia and the Parthenon in Athens. These temples were decorated with sculpture which expressed the nobility of human beings and represented the gods as upholders of moral virtue. It was this art which the Romans admired and called the art of the highest class—classical art.

We use this term 'classical' with three different and sometimes contradictory meanings. Like the Romans we use it to describe art of enduring quality and to describe the style of Greek art in the 5th and 4th centuries BC. But we also use the term to describe a whole age from the rise of Greek civilization in the 8th century BC to the collapse of the

Kouros in a quarry at Naxos, mid-6th century. Marble, over life size. Naxos, Greece. (*Above*)
These early Greek statues were called 'Boys', in Greek *Kouroi*. They represented any ideal being, human or divine. Like the Egyptians, from whom they had learned most of their stone quarrying techniques, the Greeks blocked out the figures in the marble quarry before transporting them to the sculptor's workshop for finishing and painting.

A Sculptor's Workshop, the Foundry Painter, *c.*480 BC. Attic red-figure cup. Staatliche Museum, Berlin, Germany. (*Previous page*)
The new democratic constitution in Athens had withstood the impact of two Persian invasions, one in 490 and the other in 480 BC. It was during this period of crisis that a new style of art was created—classical art. The movement towards realism was first apparent in Athenian vase painting and it was taken further in sculpture. Sculptors preferred working in bronze because the figure was modelled first in clay and so they were no longer confined by the limitations of carving in marble. They used athletes in a gymnasium as their models of physical perfection.

western Roman empire in the 5th century AD. This was the classical age, but much of the art of this period was not classical in style.

The bronze age Mycenean empire had collapsed in the 12th century BC and there followed a dark age in Greece because the art of writing was lost and so we have no written records. But legends, which have been confirmed by archeology, show that this was a period of migration when a new wave of Greek speaking people, the Dorians, moved in from the north and settled mainly in the south, in the Peloponnese. At the same time there was a migration from the mainland to the Greek islands and the coast of Asia Minor. The Greek world gradually recovered, but it was no longer a kingdom in which the ruler of each city owed allegiance to one Great King. It was divided into separate city states which nevertheless recognized a common nationality through language and religion. The art of writing was reintroduced in the 8th century BC and we mark the beginning of classical civilization with the writings of Hesiod and Homer.

Their writings show that although little had survived materially from the Bronze Age, there was an important spiritual legacy. They worshipped the same gods in the same sanctuaries and many of their myths and legends were about heroes who had lived around the time that Agamemnon was king of Mycenae and had fought in the Trojan War which probably took place at the end of the 13th century BC.

The Sanctuary of Zeus at Olympia was said to have been laid out by Herakles, Prince of Tiryns, who belonged to the generation before the Trojan War. Daily offerings of food were burnt on the altar there and every four years, from 776 BC, there was a great athletic competition at which all Greek city states competed. Only Greeks were admitted to these games, and this was their test of nationality. It was not until the 7th century BC that a temple was built in the sanctuary to house the cult image of the god.

The earliest sacred images of Greek gods were carved out of the wood of the tree sacred to the divinity. Even in classical Athens, the most sacred relic was the old olive wood figure of Athena. But during the 7th century BC the new and larger temples demanded new and larger statues made out of more permanent materials. This was the period when trade was developing with Egypt, newly liberated with Greek help from Assyrian control. These first Greek merchants must have been overwhelmed by the splendour of the great Egyptian temples with their massive stone statues.

The first attempts by Greek sculptors to imitate Egyptian statues were very crude. They took as their model the Egyptian funeral image of a standing man which had been in use for over 2000 years with little change. It was used both as an image of their youthful god Apollo, and also for a monument to any heroic man, such as the brothers Kleobis and Biton whose statues were dedicated by the city of Argos at the sanctuary of Apollo at Delphi at the beginning of the 6th century BC.

These early stone statues, called *kouroi* or youths, were blocked out in the marble quarries following a system of proportion learned from the Egyptians by masons using an iron point held at right angles to the surface of the stone. It was only after most of the surplus stone had been cut away that the figure was shifted into the sculptor's workshop where finer modelling was achieved through the use of a flat chisel and a drill worked by a bow. The drill was also used to cut away the stone between the arms and the legs by drilling a series of holes close together. In the second quarter of the century the claw chisel was introduced, usually five toothed, which led to crisper handling of the marble and the tool marks were removed with a rasp. Because of the extensive use of the

point the crystalline structure of the marble was shattered, creating a velvety surface. To a large extent this was covered in paint because only women's flesh was left white while men's flesh was painted brown, hair and eyes were also coloured and clothing decorated with painted embroidery.

Although clearly inspired by Egyptian models, these early *kouros* figures were significantly different. The Egyptian figures still gave the impression of being part of the block of stone, and it was this stony quality which made them symbols of immortality. But the Greek artist, using iron tools unknown to the Egyptians, cut away the marble between the arms and legs and thus gave greater movement to the figure which now seemed to be actively walking instead of merely advancing one leg. They were also able to express greater interest in anatomy, seen especially in the structure of the knee, perhaps through Assyrian influence. Above all else the figures were naked and so clearly showed the inspiration of the naked athletes who competed in honour of the Olympian gods at the great Panhellenic games at Olympia.

By the middle of the century observation of the human figure was beginning to become more important than the Egyptian inspired concept. The sculptors still retained the rigid posture, but they were increasingly interested in the details of human anatomy and began to give the face a bright alert expression—the archaic smile. We can see these new features in the *Kouros* of Tenea, carved about 550 BC and found in a cemetery near Corinth.

Although these free-standing figures had been clearly inspired by Egyptian sculpture, the relief sculpture which decorated temples had developed with little foreign influence out of the decorations in painting and clay modelling. As a result the figures were not sunk into the surface of the stone, in the Egyptian manner, but the background was cut away. The earliest Doric temples built in the 7th century BC had been decorated with painted terracotta plaques and in the 6th century BC

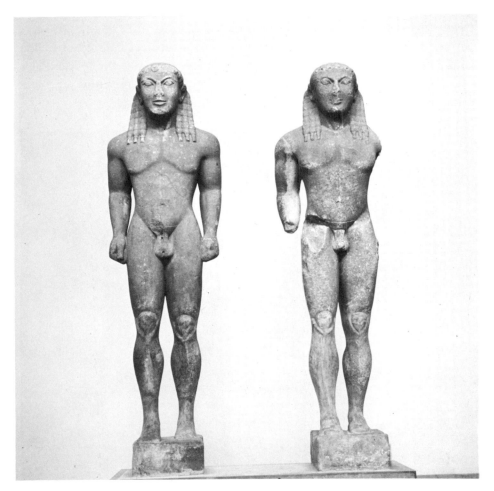

Kleobis and Biton, Medes of Argos, c.600 BC. Marble, 216 and 218cm (85 and 86in). Delphi Museum, Delphi, Greece. The historian Herodotus uses the story of Kleobis and Biton to illustrate the qualities in men which the Greeks most admired: enough to live on comfortably without vanity and physical strength in athletics. Their statues were dedicated by the city of Argos in the sanctuary of Apollo at Delphi because their mother was priestess of Hera and on the day of the festival the oxen were still in the fields so they hitched themselves to her ox cart and dragged it to the sanctuary, a distance of nearly six miles. After the ceremony was over the two boys fell asleep within the temple and never woke up—'heaven sent proof of how much better it is to be dead than alive'.

some temples in southern Italy were still covered with painted terracotta revetments and the triangular gable at the front and back of the temple was filled with a terracotta head of a Gorgon. But in 580 BC a stone temple was dedicated to Artemis by the city of Kerkyra (Corfu), a colony of Corinth where the Doric order had first evolved, and the front gable was filled with a relief carved out of limestone representing the Gorgon Medusa and other mythological subjects. During the 6th century BC artistic leadership passed to Athens and the temples on the Athenian acropolis had their gables decorated in high relief sculpture. About 520 BC the Old Temple of Athena was rebuilt and decorated with free-standing marble figures on the pediment of the gable representing the battle between gods and giants.

This battle scene in which the Olympian gods overcame the primitive earth forces was a popular theme for the decoration of religious buildings and was used for the friezes on both Doric and Ionic buildings. Doric friezes were divided up into square panels, *metopes*, whereas Ionic friezes were continuous. All Doric temples had friezes, but the Ionic frieze was only introduced towards the end of the 6th century BC. One of the most elaborate is found on the tiny but rich treasury dedicated by the wealthy island of Siphnos at the Sanctuary of Apollo at Delphi. The whole building is covered in sculpture—even the porch columns are replaced by statues of maidens and the pediment is filled with a relief scene showing the struggle between Herakles and Apollo for the tripod at Delphi. The upper part has been cut away so deeply that the figures appear carved in the round. A much shallower relief was used for the sides of the building and the artist has created an amazing illusion of form in space in a relief which is no more than 2.5cm (1in) deep. The north side shows the *Battle of Gods and Giants* and they are all represented in human form and with human emotions.

Oriental monarchs had frequently used battle scenes to decorate their palaces because they represented the king's triumph over his human enemies, and hunting scenes which represented his victory over the forces of nature. Even though the defeated enemy and the animals were allowed to express their emotions, the king's soldiers carried out their work without expression. The higher a soldier's rank, the less expressive and the more heiratic the image. The gods, and the king, who was of divine descent, were totally above all human feeling.

Young horsemen waiting to join the Panathenaic Procession, Ionic frieze from the cella of the Parthenon, *c.*440 BC. Marble. British Museum, London, England.

At the end of the war with Persia in 449 BC Perikles persuaded the Athenian National Assembly to rebuild the sanctuaries on the Acropolis which had been sacked by the Persians. His friend, the sculptor Pheidias, was appointed over-all designer of the whole project and he also carved the 9 metres (30 feet) cult image of Athena out of gold and ivory for the new temple, the Parthenon. The building was designed by Iktinos and at first sight it appears to be a typical Doric temple, but the cella is decorated with an Ionic frieze representing the procession held every four years to celebrate the union of Attica. This union of Doric and Ionic elements symbolized the Athenian ambition to create a union of the whole Greek world.

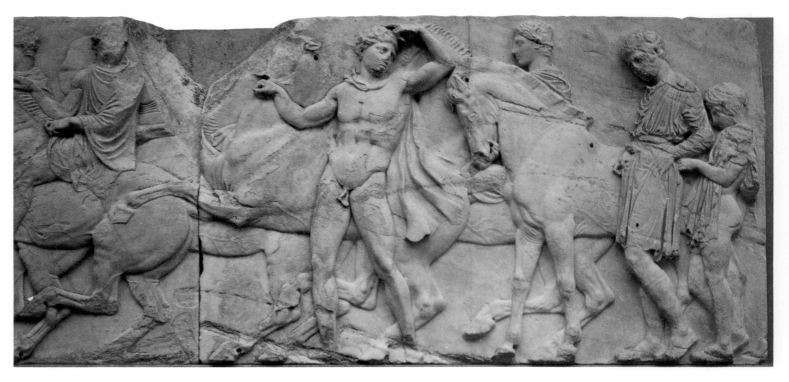

In contrast, the gods the Greeks worshipped were a group of immortals with totally human emotions. Not only were their affairs in heaven incestuous and chaotic, but in the *Iliad* and the *Odyssey*, Homer tells us how the Olympian gods interfered in human history, causing the disastrous Trojan war. The royal houses of the Mycenaean empire all claimed divine ancestors and this concept of the divine origins of the ruling family was revived in the Roman empire.

But in the 16th century BC Greek artists took a very detached view of their disreputable divinities and delighted in representing their human virtues and vices. This interest in the drama of Greek mythology found its fullest expression in the decoration of Athenian vases, which by the middle of the 6th century BC had become an important art form.

Pottery making was one of the few crafts to survive the dark ages following the fall of the Mycenaean empire. The vases were made out of the local clay, which in Athens had a high iron and silica content. The pot was thrown on a wheel and allowed to dry to leather hardness. It was then painted with a silica solution formed by mixing clay with water, encouraging the clay particles to coagulate and fall to the bottom by adding a peptising agent (probably urine) and then siphoning off the clear liquid. After painting, the pot was then fired in two stages: first at a high temperature but in a smoky reducing atmosphere which turned the whole pot black, reducing the red ferric oxide in the clay to the black ferrous compound. At the same time the high temperature fused the silica with the clay, turning it into a glass-like compound. The next stage was to open the kiln door and let in a blast of cold air which made the temperature of the kiln fall so that the silica 'glass' solidified and protected the surface of the vase, preventing the black ferrous oxide from reacting with the oxygen in the cold air. But the unprotected parts of the vase were fully exposed to the oxygen and as a result turned red again with the formation of ferric oxide.

During the 7th century BC Corinthian potters had considerably extended the palette of Greek vase painting by adding white clay and mixing it with manganese to produce various shades of purple and brown. They decorated their vases with bands of figures and mythical monsters, painted in colour against the background of their light local clay and with the detail incised in. It was this technique which was copied by the Athenians in the 6th century BC, but with a much smaller range of colours so that the male figures were reduced to a black silhouette against the red background of the clay. At first they had imitated Corinthian vases by arranging the decoration in bands, but by the middle of the century the vases were decorated with single groups of figures on each side.

One of the greatest of these black-figure painters was Exekias, who was working around 540 BC in Athens and decorated an amphora (a two-handled storage jar) now in the British Museum. On one side are the figures of the god of wine Dionysos and his son Oinopion, and on the other is a dramatic scene from the Trojan War when Achilles killed Penthesilea, the Queen of the Amazons. His face is covered by a helmet which gives him a look of grim determination. She has tried to escape and turns around to parry his blow but he forces her spear aside with his shield and sinks his own spear into her breast. Her legs give way and she looks up at him in dismay, and it was at this moment that he fell in love with her. The figures with their interlocking limbs form a sculptural group of great realism.

The vase is covered in inscriptions, naming the artist, the characters, and saying that Oneterides is beautiful. This is probably the Oneterides who became Archon of Athens (Chief Magistrate) in 527/6 so it is doubt-

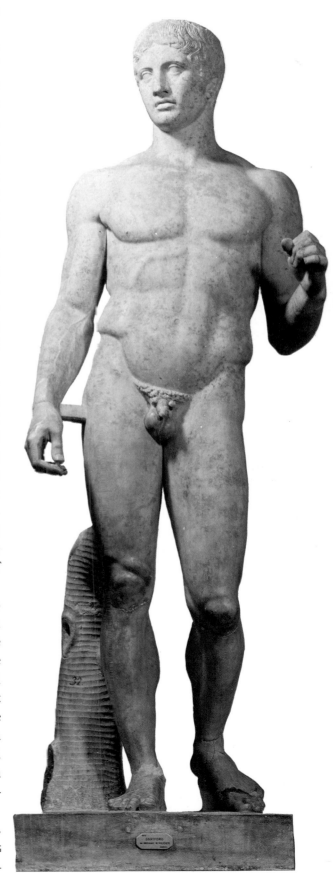

The Doryphoros, Roman copy in marble found in Pompeii of a bronze statue by Polykleitos c.440 BC. Museo Nazionale, Naples, Italy

Polykleitos was one of the most famous of classical sculptors, specializing in figures of heroic athletes, such as this spear-bearer who may represent Achilles. He created this figure to illustrate his book on human proportion, the *Kanon*. Although none of his original works in bronze have survived, he is known from the many accurate marble copies made for the Roman market in the first centuries BC and AD.

ful whether anyone would have dedicated a vase to his beauty after about 530 BC. The inscriptions about the beauty of Oneterides appear on another group of vases painted by an artist working for the potter Andokides. We do not know his name (it may have been the potter himself who decorated his own vases) but he introduced a completely new technique into vase decoration. He painted the vase black, leaving the figures as a red silhouette, so that instead of having to scratch in the detail, it could be painted in graded lines of wash. This created the illusion that the figures were carved in relief on the surface of the vase most effectively.

These vase paintings are very important because no monumental wall paintings have survived from this period in Greece. But they are also important as works of art in their own right. Although they were made for sale in the market place they were intended for a literate audience, as is shown by the number of inscriptions. They were one of the few forms of decoration which Athenians had in their very sparsely furnished homes.

Corinth had been the richest city and the artistic leader of the Greek world in the 7th century BC but this position was gradually taken over by Athens in the 6th century BC. As Athens evolved into a democratic city state where trade, culture and the arts flourished, we see a remarkable development in naturalism in the decorations of Athenian vases. Mythological subjects were still important, but we see an increasing number of scenes from everyday life, themes which would appeal to the ordinary working man proud of his achievements. One example is a cup by the Foundry Painter, an artist whose name we do not know but who had a very distinctive style and was working at the beginning of the 5th century BC. The interior shows Hephaistos, god of metal workers, giving a helmet to Thetis, mother of Achilles. The outside represents a sculptor's workshop and the processes of casting a statue.

This cup illustrates a major technical innovation which had taken place in sculpture during the 6th century BC, the re-introduction of lost-wax bronze casting (*cire-perdue*). Pliny attributed this 'discovery' to the Samian architects Rhoikos and Theodoros, but it was a very old technique dating back to the third millennium in Mesopotamia, but only recently reintroduced into Greece. The sculptor modelled his statue in clay around a metal armature, to give it support. It was then coated in wax and covered with a clay jacket. A bronze or iron rod was then driven through the whole to keep the jacket and inner core apart when the wax was melted out. Molten bronze was then poured in and on cooling formed a thin shell between the outer jacket and inner core, which could then be hacked away. The cup shows that Greek statues were cast in pieces that were finally soldered or riveted together and then the whole was laboriously polished. Detail was engraved in and the burnished surface was then protected by varnish or paint and the eyes inlaid with glass or semi-precious stones.

This new technique gave sculptors greater freedom to express the movement of the human figure, which had previously been limited by the size and shape of the marble block. Moreover, the tensile strength of bronze made poses possible which would have been impractical in marble which although strong under compression, snaps under the slightest tension. The artist was now completely liberated from the old Egyptian concepts of the human figure and could represent men as he saw them as moving, animated beings.

Few of these early bronze statues have survived, but we know of a famous group by Antenor of the *Tyrant Slayers* which was set up in the Market Place to celebrate the new constitution. This group was carried

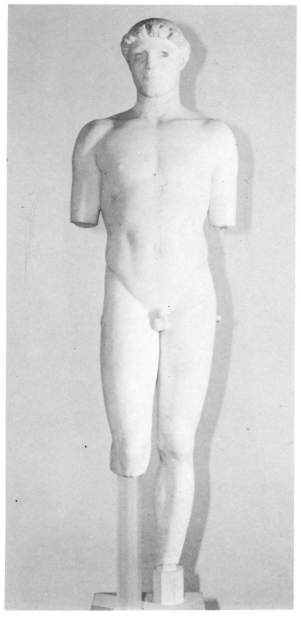

Youth, attributed to Kritios, just before 480 BC. Marble. Acropolis Museum, Athens, Greece.
Kritios was one of the leading Athenian sculptors at the present time of the Persian wars and creator of a bronze group set up in the Market Place of the Tyrant Slayers in celebration of the new democratic constitution in Athens. This young boy was found among the debris of the Persians' sack of the Acropolis in 480 BC. It introduces for the first time the typically classical *contrapposto* position, in which the figure is completely balanced in spite of the fact that its limbs are placed in contrasting positions.

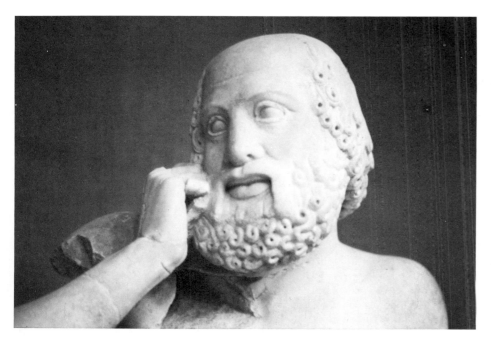

The Old Seer (detail), from the east pediment of the Temple of Zeus, Olympia, *c.*460 BC. Marble, 1.38cm (54½in). Olympia Museum, Olympia, Greece.

Olympia was the home of the Olympic Games and the first race run there was between Prince Pelops and King Oinomaos for the hand of his daughter. The front pediment represents the oath before the race and the Old Seer watches in horror because he knows that it will be broken and the race end in disaster. King Oinomaos was treacherously killed and Prince Pelops and his descendants were caught up in an endless round of murder and revenge, culminating in the killing of Agamemnon by his wife Klytemnestra. The realism of the pot-bellied bald old man who witnesses the oath is typical of severe style architecture. The severe style is the first phase of Classical Art which developed immediately after the Persian Wars. It was at this time that Aischylos had transformed Athenian drama, introducing a new moral concept of the Olympian gods as upholders of law and order.

away by the Persians when they sacked Athens in 480 BC but it was immediately replaced with a new group by Kritios and Nesiotes which we know through Roman copies. The head of Kritios's younger tyrant slayer looks remarkably like that of a marble figure excavated in the 19th century from the debris of the Persian Sack, so it must have been carved just before 480 BC. The *Kritian Boy* stands in a completely different pose from that of the old *kouros* figures. The weight is now on one leg and the other relaxed. There is no rigid order imposed upon the figure, but a harmony achieved through the balance of tension and relaxation. This is the *contrapposto* position—the essence of classical art.

The two Persian Wars in 490 and 480 BC had tested the new democratic government to the full and it had survived triumphantly. An Athenian navy and later a combined Greek army under Spartan control completely defeated the Persians. After this victory of the whole Greek world the new style in art spread all over Greece and is most perfectly expressed in the sculptural decorations of the Temple of Zeus at Olympia. This new temple, designed by a local architect, Libon of Elis, was constructed out of limestone and the sculpture was carved out of marble imported from the island of Paros.

The major expense in marble sculpture was transport and it has been estimated that a total of 130 tons of marble would have been required for all the figures on the two pediments at Olympia. It is very probable that the figures were roughed out in the quarries before shipment to Olympia. This could indicate that the sculptor was not a local man, as was the architect, but came from the island of Paros.

Whoever the sculptor was, he was thoroughly familiar with local legends. The sanctuary had originally been sacred to Pelops and contained his cenotaph, a grove surrounded by a stone wall and dating back to *c.*1100 BC. The front pediment of the temple represents the oath taken before Zeus at the start of the chariot race between Pelops and Oinomaos, King of Pisa, for the hand of his daughter Hippodamia. On the pediment an old seer looks up with foreboding at the four protagonists taking the oath to obey the rules of the competition, for he sees not only the coming death of Oinomaos, but also the doom awaiting Pelops' descendants.

At the time when the pediment was carved, a new concept of the role of the Olympian gods was developing; that of upholders of law and order. There was a new solemnity and seriousness in Greek art. In fact we call early classical art (from *c.*480–*c.*450 BC) the severe style. It is severe not only in its subject matter but also in its economy of expression and

Achilles and Penthesilea, Exekias, *c*.540 BC. Attic black-figure amphora. British Museum, London, England. (*Right*)
Exekias was the greatest of the Athenian vase-painters who decorated their works with figures in black silhouette. He chose tragic subjects, often derived from the saga of the Trojan war, in this instance the battle between Achilles and the Amazon queen. In spite of the limitations of the black-figure technique his figures create an expressive group. But artists of the next generation preferred to use and develop the much more naturalistic red-figure style.

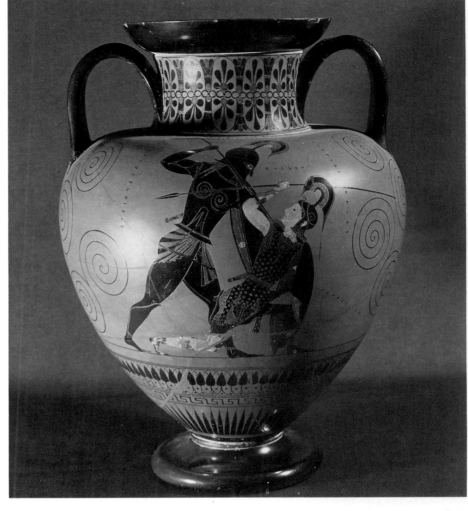

Apollo with a Lyre, *c*.460 BC. Painted cup. Delphi Museum, Delphi, Greece. (*Below*)
Polygnotos revolutionized painting in Athens by creating a much more expressive style through the development of pictorial space in his wall paintings which gave the illusion of looking through a window at figures set in a landscape. The vase painters attempted to imitate this new style, but it was not really appropriate for the decoration of curved surfaces. Nevertheless, this white ground cup gives us some idea of how he could create expressive forms through line alone, without the use of shading.

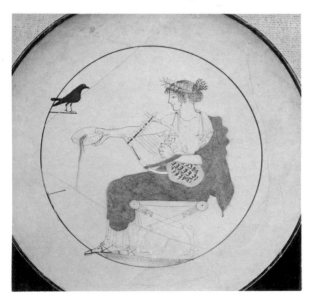

its realism. The drama of oath-taking at Olympia is witnessed by a bald-headed pot-bellied old man who raises his hand to his beard in a gesture of dismay. This very human witness reflected the current philosophy that seeing was believing. Justice in a democratic state was not achieved through the wisdom of an absolute ruler, but by the active participation of every citizen whose duty to the state included jury service. There he had to listen to conflicting evidence and try to discern the truth: and it was the evidence of the eye witness which was the most convincing. The ability to present evidence and assess its value required training and in the middle of the 5th century BC we see the rise of professional educators who systematized knowledge; the Sophists.

One of the most famous of the Sophist philosophers was Protagoras who charged 1,000 drachmae for a course which he claimed would make his students better men, but would accept a lower fee if, under oath, the student stated what he thought the course was worth. He believed that human experience was the only test of truth—'Man is the measure of all things'. He did not deny the existence of the gods, but one had no sure knowledge without experience.

It is this Greek insistence upon the problem of knowledge that led to the cult of the personality of the artist. They were not the first to record the names of their artists, but their artists were the first to become world famous. They achieved fame because they were saying something important and convinced their audience because of the reality of their evidence, presenting their ideas through realistically represented human beings.

The need for the concrete led to another revolution in the visual arts —the development of perspective. It is a matter of scholarly argument how far the Greeks understood the laws of optics and applied them to painting, but they certainly realized that our perception of the outside

world is governed by a very simple law of geometry: the size of the angle subtended by an object increases or decreases in inverse ratio according to the distance from the eye. If object A is 2m (2yd) away and object B 1m (1yd), A will appear to be half the size of B, if A and B are the same size. This means that on a flat surface an artist can record both the apparent and the real size of an object. He has a formula to record not only the appearance of the world around him, but also his knowledge of it.

This understanding of perspective had a great influence upon painting. Polygnotos of Thasos, who worked in Athens in the 460s, was famous for the realism of his figures—Pliny tells us that he was the first to represent them with the mouth open, showing the teeth, and varying the face from the rigidity which had existed previously. We can tell from Pausanius's description of his wall paintings of the *Sack of Troy* and the *Underworld* in the 'Clubhouse' of the people of Knidos at Delphi, that he was placing his figures in a landscape which could be seen to recede towards a horizon. This type of spatial composition is reflected in contemporary vase painting such as the vase by the Niobid Painter in the Louvre. On one side this is decorated with a complex composition including the figures of Herakles and Athena. This painting, although unsatisfactory as vase decoration, has a new realism because the picture space creates the illusion that we are looking through a window and the figures now have room to move, enhancing the drama of the scene. But it is not the actual moment of action which is represented, but the moment before or after. It is an art concerned with expressing the movements of the mind through the actions of the body.

A cup from Delphi, which was painted about the time of Polygnotos, gives us some idea of how he would have used colour. It represents *Apollo pouring a libation*. The figures are drawn in outline against the white ground and the rocky landscape of Mt Parnassos is also indicated by an irregular outline. The clothing is painted in washes of brown and black, the folds indicated by darker outlines. Although the figure appears solid this is achieved through the use of graded outlines, not through the use of shading.

This use of outline painting continued late into the classical period, but shading (*skiagraphia*) appears to have been introduced at the end of the 5th century BC by Apollodoros in Athens. Painting now began to rival sculpture as the most important form of art and the interiors of temples and public buildings were decorated with them. Alas, we know very little of this great period of classical painting because the originals have all disappeared and vase painting is too limited to give us any idea of its achievements.

Perikles, Athens' greatest statesman, dominated the age between the signing of the peace treaty with Persia in 449 BC and his death of plague in 429 BC. He persuaded the Assembly in 447 BC to use the money of the Delian League, formed for defence against the Persians, to rebuild the sanctuaries sacked by the Persians 30 years earlier. He commissioned his friend, the sculptor Pheidias, to be the over-all designer of the new Acropolis and to carve the cult image for the Parthenon—his new temple dedicated to Athena the Virgin.

The new temple, designed by Iktinos, was of unusual form. Like most of the temples in Athens it was in the Doric order, but instead of six columns front and back it had eight, more typical of Ionic temples, and around the outside of the inner building was a continuous Ionic frieze. This mixture of the orders symbolized the political ambitions of Athens because she saw herself as leader of the whole Greek world, both Dorian and Ionian.

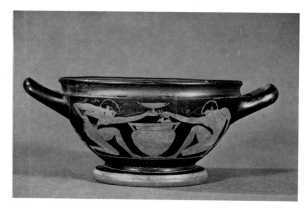

Boys serving wine, Epiktetos, c.520–490 BC. Attic red figure wine cup, 9.5cm (3¾in). Ashmolean Museum, Oxford, England.
Athenian vases were mainly produced for dinner parties, such as the one described by Plato in the *Symposium*. The serious drinking came after the meal was over, and a toast-master decreed how much water should be mixed with the wine depending on how sober or drunk he wanted to keep the company. The mixing bowl, jugs and cups were all painted and at the turn of the century the fashion was for scenes from everyday life.

Pheidias had been commissioned to carve the colossal gold and ivory figure of Athena for the interior of the temple, and he also probably designed its sculptural decoration. Its theme was the glory of Athena and Athens. The pediment at the front represented her birth on Mt Olympos, at the back her triumph over Poseidon in Athens, and the Ionic frieze was carved with the procession which was the culmination of the four yearly Panathenaic festival. The procession brought a new robe for the old olive wood image of the goddess kept in the back porch of the Old Temple. It was headed by the magistrates, the maidens who had woven the robe, libation bearers and the sacrificial animals and it was followed by representatives of the citizen army. But why did all the Olympian gods attend the ceremony and why do the young men lounge so unconcernedly against their horses as they wait for the summons to join the procession? And why so many horsemen in an army mainly made up out of foot-soldiers? Could it be that the frieze did not represent any ordinary Panathenaic ceremony but a procession in honour of the Athenian soldiers who had died to save their city at the Battle of Marathon 50 years earlier and so had saved the whole Greek world? Are the horsemen of the Parthenon the heroic image of these soldiers who had gained immortality through the heroism of their actions?

The young men are represented as ideally beautiful and totally indifferent to the cares of this world—the image of heroes of divine descent. This new heroic image of humanity was not just the creation of Pheidias: he owed much to Polykleitos of Argos who had worked out a perfect canon (or measuring rule) of symmetry for the human body in which every part could be related to the other. He created the *Doryphoros* to illustrate the theory that all artistic beauty, whether in the design of a temple or a vase or in the representation of a human being, has a geometric basis and expresses the divine order of the universe. This is a theory which goes back to the 6th century BC and the philosophy of Pythagoras, but it finds its fullest expression in the classical art of the 5th century.

Unlike Polykleitos, Pheidias's fame did not rest upon his ability to create ideally beautiful images of human beings, but in the superhuman beauty he gave to his images of the gods. His most famous statue was the gold and ivory image of Zeus for the Temple of Zeus at Olympia. According to Strabo when asked which model he was going to use he replied it was the model provided by Homer in the following lines from the Iliad:

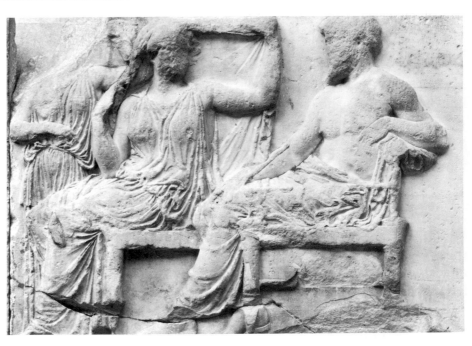

The Messenger Goddess Iris bringing the news of Athena's victory over Poseidon to the people of Athens. Parthenon frieze *c.*440 BC. Marble. British Museum, London, England. The Athenians were very proud of the fact that they had never been conquered by the Dorians and that Ion, the son of an Athenian princess, had led the migration to the islands and the coast of Asia Minor. This part of the Parthenon frieze depicts the aftermath of the clash between Athena, patron goddess of Athens, and Poseidon who had challenged her position as the city's goddess. Poseidon gave the people a spring of clear water, but Athena gave them the olive, and thus convinced the gods that she gave greater gifts to her people.

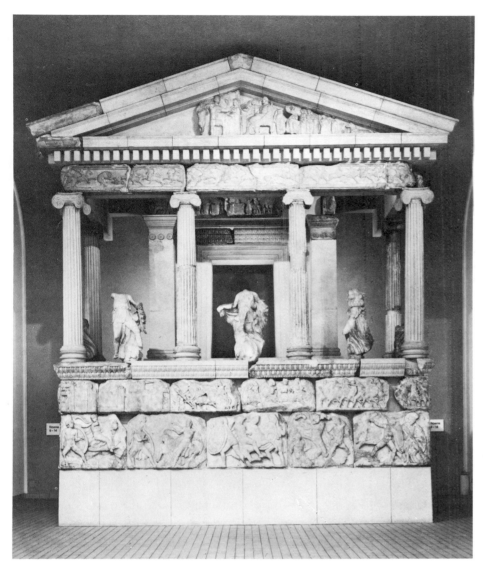

The Nereid Monument, a marble tomb from Xanthos, *c*.400 BC. British Museum, London, England.

The Peloponnesian war between Athens and Sparta which devastated the Greek world from 431–404 BC led to the migration of artists to kingdoms further east in search of work. Stylistically, it would appear that the artist who carved the enchanting Nereids—the sea nymphs, who dance between the columns waiting to take the soul of the dead man across the sea to the Land of the Blessed—must have worked under Pheidias on the Parthenon pediments.

> *Thus spoke the son of Kronos and nodded his dark brow and*
> *the ambrosial locks flowed down from the lord's immortal head,*
> *and he made great Olympos quake.* (Iliad I 527–30)

The beauty of this image was not only physical, but also moral, because it represented Zeus at the moment of taking an oath which could never be broken.

In some ways Pheidias had an invigorating influence upon Greek art because he created a subtle form of low relief which enabled the artist to create the impression of great depth and movement on a delicately modulated surface. He also created new ways of expressing movement, not so much from a study of anatomy, but from an understanding of the way in which movement affected drapery. He realized that drapery has a mass and volume of its own which is affected by movement independent of the body beneath, so that at times it clings to the body as if wet, but at others it swings clear in billowing forms through pressure of the air on its own substance.

This new, almost baroque style of expressing movement became very popular at the end of the 5th century BC. After the catastrophe of the Peloponnesian War which Athens finally lost to Sparta in 404 BC, many Athenian artists had to find work overseas, even in non-Greek countries such as Lycia in south-west Asia Minor, where the king commissioned an elaborate tomb in Xanthos. It takes the form of an Ionic temple on a high pedestal and between the columns are enchanting sea breezes dancing over the waves, taking the soul of the dead man to the Island of the Blessed. The artist has transformed the solid block of marble into a moving figure through this use of clinging and billowing drapery.

But in other ways the influence of Pheidias was disastrous for Greek

45

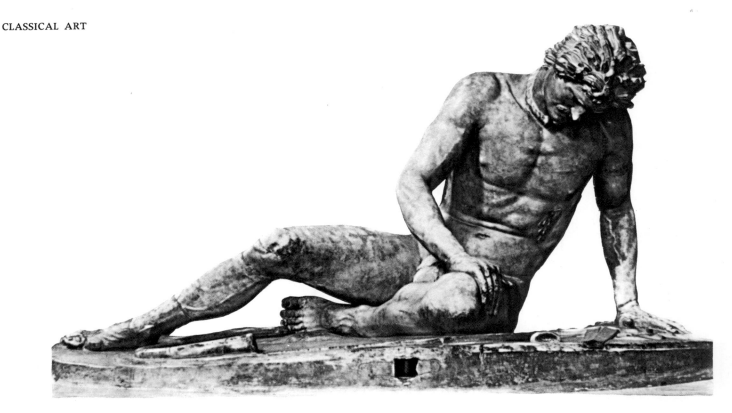

Dying Gaul, Roman copy in marble of a bronze figure from the monument Attalos I set up in Pergamon to celebrate his victory over the Gauls, 241 BC. Marble. Capitoline Museum, Rome, Italy.
Alexander's empire was carved up into separate kingdoms by his generals after his death in 323 BC. Pergamon did not become an independent state until the 3rd century BC when Attalos I, who took the title of king after his victory over the Gauls, had overrun much of Asia Minor. He encouraged a grimly realistic style in sculpture, much concerned with the depiction of suffering and death.

art because it led to increasing idealism and the rejection of realism, so that the later images of Greek gods, such as Praxiteles' *Hermes and the infant Dionysos* carved c.350 BC and dedicated in the Temple of Hera at Olympia, have an impossible sweetness. Hermes is represented as a beautiful young man holding his half-brother on one arm and teasing him by dangling a bunch of grapes just out of his reach. Instead of the classical balanced *contrapposto* position, the figure now has such exaggerated suppleness that it needs the support of a plinth, disguised by a fall of drapery. The figure is slender and subtly modelled and we are a long way from the heroic athletes who had dominated 5th century art. He is much closer to the type of beauty described by Plato in the *Symposium* written c.385:

> *When a man, starting from this sensible world and making his way upwards by a right use of his feelings of love for boys, begins to catch sight of that beauty, he is very near his goal. This is the right way of approaching or being initiated into the mysteries of love, to begin with examples of beauty in this world, and using them as steps to ascend continually with that absolute beauty as one's aim, from one instance of physical beauty to two and from two to all, then from physical beauty to beauty of knowledge, until from knowledge of various kinds one arrives at the supreme knowledge whose sole object is that absolute beauty and one knows at last what absolute beauty is.* (trans. W. Hamilton, Penguin 1951 p.94)

As a result of this influence from Pheidias we see a conflict between realism and idealism in Greek art in the 4th century BC. The images of gods became more idealized and quite distinct from the much more realistic representations of human beings. It was during the 4th century BC that we see the rise of portrait sculpture.

The term Hellenistic was invented to cover the period of history between the end of the classical city state and the rise of the Roman empire. Although Sparta had defeated Athens in the Peloponnesian War she had so exhausted her resources that she could never again play a decisive part in Greek history. Into this power vacuum came the Macedonians, led by Philip and later by his son Alexander the Great. They controlled the Greek city states until the break-up of Alexander's empire after his death. In an interlude when Athens very briefly regained her liberty in 280/279 BC a bronze statue by Polyeuktos of the

great orator and leader of the fight against the Macedonians, Demosthenes, was set up in the Market Place in Athens beside the Altar of the Twelve Gods. Although Demosthenes had been dead more than 40 years, Polyeuktos represented him very much as a living man. He expressed his rather dour, puritanical personality (his enemies accused him of being a 'water-drinker') through the whole attitude of the body with tightly clenched hands and downcast eyes, as if pausing in some great speech urging on Athens's resistance to Philip. This champion of democracy became a favourite subject of Roman art and we know him through numerous copies of the Imperial age.

The head of Demosthenes without the body is not particularly expressive. This is because Greek portraits were often posthumously commissioned for setting in public places. By contrast Roman portraits were usually commissioned by the man's family to be venerated with those of the other family ancestors in the family reception room. They were not looking for a public image but a souvenir of the man as they remembered him. This much more individual approach even influenced public portraits as we can see in the head of Pompey, which is also a copy of the original made during the imperial age, and now in the Ny Carlsberg Gly

The death of Alexander, who left no will, reduced the Greek world to chaos because rival generals were fighting for supremacy. It was only by 275 BC that order began to reappear with three supreme dynasties established by the rival generals: the Seleucids in Syria, the Ptolemies in Egypt and the Antigonids in Macedonia. During the 3rd century BC a fourth dynasty appeared, the Attalids in Pergamon, and they took over much of the Seleucid territory in Asia Minor.

The Attalids retained the old Macedonian concept of kingship through achievement in battle. Attalos claimed the title after defeating the Celts who had become a dangerous menace in Asia Minor in 241 BC. He celebrated this victory by setting up a great monument in the precinct of the Temple of Athena in Pergamon, which included a figure of a dying Celtic warrior. It is a careful study not only of a Celtic warrior who went into battle naked except for the golden torque around his neck, but also of the suffering of a dying man; because the man is so realistically depicted, his suffering is all the more poignant. We see here a return to the realism of early classical art.

In the 2nd century BC there was the development of a more baroque style. The *Winged Victory of Samothrace*, now in the Louvre was set in the Sanctuary of the Kabeiroi, gods of the sea and seamen, to celebrate some victory in the eternal struggle between the four dynasties The style looks back to that of Pheidias but whereas classical studies of movement always simplified the forms to express the structure of the figure, Hellenistic artists delighted in complexity. They never lost sight of the structure of the figure and emphasized the torsion to add to the drama, but they covered it with a complex pattern of drapery moving in counter currents to the general movement of the figure.

Although we can see a development in realism and in the expression of emotion and movement in Hellenistic art, it is nevertheless difficult to date individual works because there was a constant return to concepts which had been worked out in the 5th and 4th centuries BC. The *Winged Victory of Samothrace* cannot be dated on stylistic grounds—a coin issued by Demetrius Poliorketes (306–283 BC) to celebrate a naval victory has almost exactly the same composition. It has been dated by a study of the base which represents the prow of a ship overlooking a reflecting pool and must have been set up about 200 BC. Not only is it difficult to distinguish the art of one century from another in the Hellen-

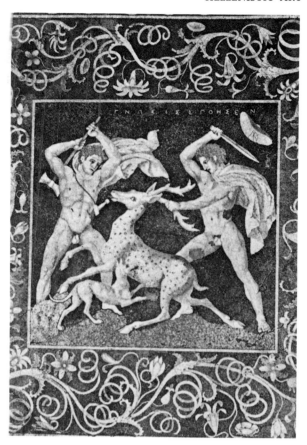

Achilles and Chiron, wall-painting c.50 BC, from Herculaneum, Italy. (*Above*)
The coast around Naples was one of the most civilized regions of the Mediterranean in the first century BC, and the luxurious houses and villas were decorated with wall paintings, often copying famous masterpieces of Classical Art. This painting of the education of the hero Achilles by the wise centaur Chiron is such a copy.
Combat with Animals, Gnosis, c.300 BC. Pebble mosaic from a house in Pella, Greece. (*Below*)
The Macedonian capital was transferred to Pella by King Archelous (413–399 BC) who made it an important artistic centre: the Athenian painter Zeuxis was attached to his court, and Euripedes died there in 406 BC.

Cult Statue of Antinous, after AD 130. Marble. Delphi Museum, Delphi, Greece. (*Above*)
The Emperor Hadrian deified his lover, Antinous, after he had drowned himself in the Nile, sacrificing his life to prevent the fulfilment of a prophecy. His cult was accepted at Delphi and this statue was inspired by Pheidias' *Omphalos Apollo*, created 500 years earlier. But the highly polished surface and the deeply drilled hair are typical of Roman sculpture of the 2nd century AD.

Winged Victory of Samothrace, c.200 BC. Marble. Musée du Louvre, Paris, France. (*Below*)
The Victory, her wings still spread in flight, alights on the prow of a ship. She commemorates some forgotten battle in the endless struggle between the different Hellenistic dynasties in which the island of Samothrace had played a part. The figure was probably carved in Rhodes and, in its expression of movement through drapery looks back to the art of Pheidias in the 5th century BC. But the dynamic twist of the torso and the intricate analysis of the counterplay of folds is a new baroque element in Hellenistic sculpture.

istic age, but be can see very little difference in style between the art of one country and another. Even though many were on non-Greek soil, they all shared the same artistic tradition and spoke the same language.

In spite of continuous warfare, it was a period of great culture and a high standard of living. Alexandria had become a centre for scientific research: medicine and engineering were to reach a point not to be achieved again until the 17th century. The cities were attractively and efficiently planned on a grid-iron system which allowed plenty of room for both private and public building. The standard of housing, even for ordinary people, could be luxurious.

The houses were built around a courtyard which was often elegantly colonnaded and the floors were covered in mosaic. A pebble mosaic floor of the late 4th or early 3rd century from a house at Pella, the new capital of Macedonia, represents two men clubbing a stag and is signed by the artist Gnosis. It reflects current developments in painting and the use of chiarascuro for the modelling of forms. But a new feature of Hellenistic painting seems to have been the development of an impressionist style, where the forms were modelled very loosely in broad strokes of paint and the emphasis was on colour, rather than tone. We see this new style of painting in a Macedonian tomb of the early 3rd century BC in Lefkadia. The façade has been modelled to imitate that of a palace with Ionic engaged columns superimposed upon Doric columns and between the columns of the lower storey are very freely painted figures of the rulers of the Underworld. This impressionistic style was further developed in the Roman period, and the architectural decorations of the tomb anticipate the decorations of Roman houses two centuries later.

Although much Roman art was not classical in style, nevertheless, it did owe a great debt to Greece. Italy had been colonized by the Greeks in the 8th century BC and at the same time the northern part of the country had seen the rise of Etruscan civilization. Etruscan culture was a strange mixture of elements, some like their alphabet clearly derived from their contact with the eastern Greek world. But their language was not related to Greek (we still cannot decipher it) and their art has a strange demonic quality and cannot be judged by the same standards as that of classical Greece.

During the 6th century BC Rome was little more than a small market town under Etruscan domination. But during the 5th and the 4th centuries with Greek help the Romans gained independence and survived a Celtic invasion. Through war with Carthage they not only gained control of the whole of the Italian peninsula but also of the western Mediterranean. In 146 BC Rome conquered Greece, Asia Minor was bequeathed to her in 133 BC and the last Hellenistic kingdom, Egypt, became a Roman province when Cleopatra committed suicide in 30 BC.

After the Roman conquest, Greek artists began to work for Roman patrons and many settled in Italy where, in the south, many Greek traditions were still alive. Rome was not a particularly attractive city, especially in the heat of the summer, and rich Romans preferred to move down to their elegant villas in the region around Naples. There the volcanic soil was fertile, the warm climate tempered by sea breezes and the beautiful landscape steeped in classical associations.

Naples, New Town, had only been founded in the 6th century BC, but at neighbouring Cumae was the cave of the Sibyl consulted by Aeneas the Trojan prince who had founded the Latin race. Augustus's family claimed descent from him and they owned land nearby at Baiae. His successor, Tiberius, built himself a luxurious villa on the island of Capri in the bay and he spent his last years there, rarely visiting Rome. These villas were designed to look out over the spectacular scenery of

the bay and their gleaming porticoes added to the beauty of the setting. They were as beautiful inside because they had been painted with architectural vistas to create a vision of a palace within a palace.

Some of these villas had rooms painted with figures clearly inspired by classical Greek art. The Villa of Mysteries in Pompeii contains a room set aside for religious functions and painted *c.*50 BC with scenes of the initiation of a bride into the mysteries of Dionysos. The quality of work produced for this sophisticated market is so high that it is difficult to tell whether we are looking at an original work of art or a copy of a masterpiece of the late 4th century BC. We face a similar problem in studying the sculpture. The *Mercury* from Herculaneum appears to be 4th century in style, and some regard it as a copy after a lost work by Lysippos, but it could be an original work by a classicizing sculptor of the 1st centuries BC/AD.

We call this revival of classical idealism which reached a peak in the reign of the Emperor Augustus neo-Atticism. We see it not only in his posthumous portrait from the villa at Prima Porta, but also in the sculptural decorations of the *Ara Pacis*. This altar was begun in 13 BC to celebrate the final pacification of Gaul and Spain and deliberately looked back to the idealism of Pheidias's sculpture for the Parthenon. Even the same themes were used: on the base of the altar is a frieze of civil and religious functionaries leading animals to sacrifice and this procession continues on two of the outside walls of the enclosure. It includes highly idealized portraits of all the imperial family, the main officials of state and some of the senators. The panels at the front and back of the enclosure represent *Aeneas making an offering to his Penates*, *Mars watching Romulus and Remus suckled by a wolf*, *Rome enthroned* and the *Bounty of the Land*. The seated figure in the centre may be the earth goddess Tellus, or a personification of Italy, flanked by salt water riding on a dolphin and fresh water on a swan, and probably symbolizes the prosperity of Italy under the peaceful rule of the emperor. Although the *Ara Pacis* looks back to the Parthenon it was not a copy but a recreation of Greek idealism in a Roman setting.

This neo-Attic style dominated Roman art until the fall of the Julio-Claudian dynasty (the dynasty founded by Agustus) with the suicide of Nero in AD 68. A much more realistic Roman style developed under the Flavian emperors Vespasian, Titus and Domitian, and this continued into the 2nd century AD under the Antonine emperors. But Greek idealism was not dead and it was vigorously revived under the emperor Hadrian (117–138 AD). He was nicknamed *Graeculus*, the little Greek, because of his love of Hellenic culture and at the end of his life he built himself a villa at Tivoli which recreated the most beautiful places in the Greek world. The sculpture he favoured was classicist in style, but contemporary in treatment. Whereas the portrait of Augustus from Prima Porta had been painted, the statues of Antinous, Hadrian's dead and deified lover, were all highly polished. Antinous drowned himself in the Nile during the emperor's visit to Egypt in AD 130 to prevent the fulfilment of a prophecy. Hadrian decreed him a god and his cult was accepted at both Olympia and Delphi. At Delphi the cult statue was derived from a statue of Apollo by Pheidias. But nobody would mistake this for an original work of the 5th century BC because the high polish subordinates the subtlety of modelling to purity of line and the hair, instead of framing the head in a delicately chiselled cape, is now drilled into separate strands which writhe like flames. Nevertheless, the whole concept of the statue that divinity can be expressed through the perfection of physical beauty proves the survival of the principles of classical art into the 2nd century AD.

Portrait of Demosthenes, Polyeuktos, *c.*280 BC. Roman copy in marble of the original. Ny Carlsberg Glyptothek, Copenhagen, Denmark.

The classical portrait only developed in the fourth century BC. In Greece it was always a full-length figure intended to be set up in a public place as an ideal image of citizenship. Demosthenes, a great Athenian statesman, had attempted to warn the Athenians of the dangers of the growing power of Macedonia which threatened the freedom of their city state. In the end he was forced to commit suicide by the conquering Macedonian forces, and he stands as a mourning figure to his own tragic end. The statue was set up in the Market Place in Athens 40 years after his death to celebrate a brief period of liberty from Macedonian control.

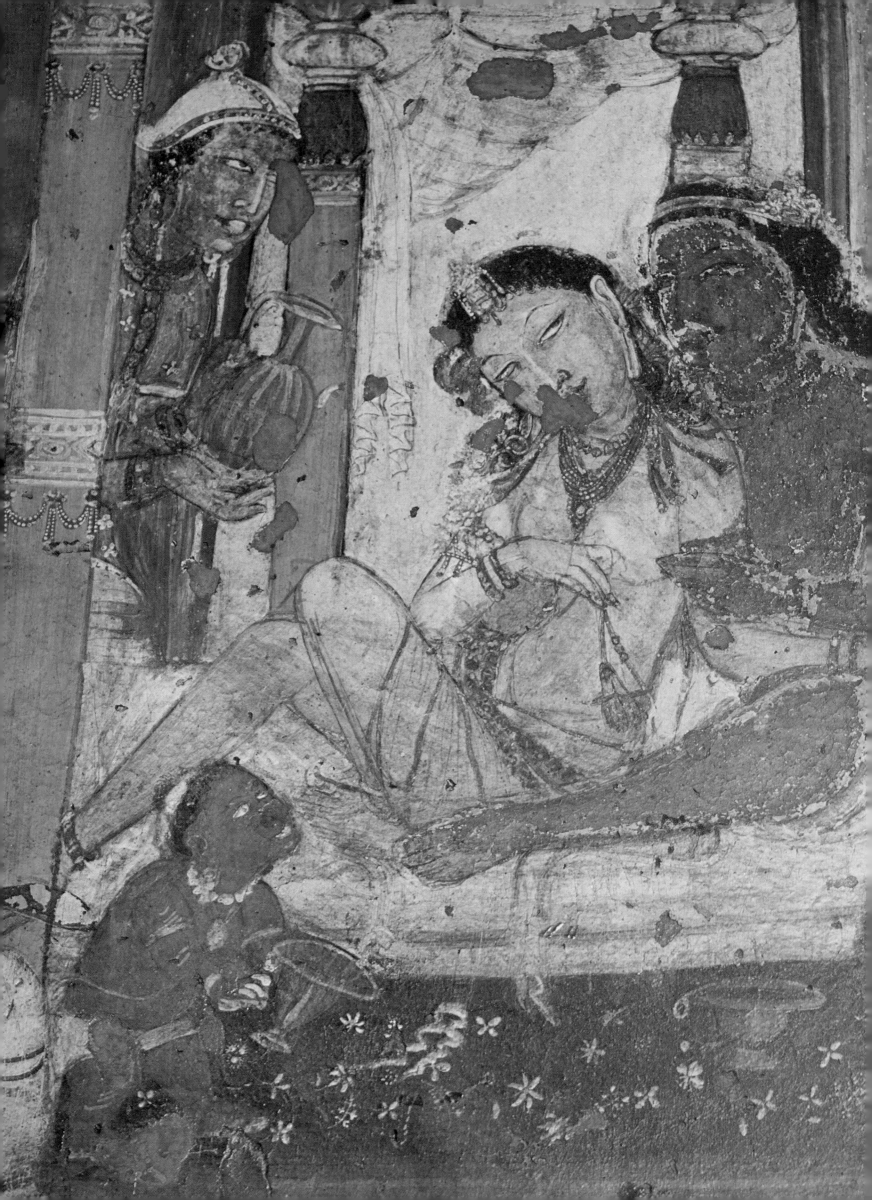

INDIAN ART

At the heart of Hinduism lies revelation. The divine word was revealed more than 3,000 years ago to inspired poet-seers (*rishis*) whose names are still honoured in India today. What remains of their utterances is a collection of 1,028 metrical hymns known as the *Rigveda*, which is still the ultimate scriptural authority in orthodox Hindu religion. The *Veda* was preserved through the ages by families of priests passing it on by word of mouth from father to son.

The deities of the *Veda*, being extensive poetic metaphors for natural and supernatural phenomena, were necessarily numerous and diverse. The high gods were not represented as icons within the original sacrificial cult. The words build up partially anthropomorphic images of elemental forces, and many components of these metaphors were to find concrete expression in later artistic representations of the gods.

It was a profound sensitivity to the diversity of existence which inspired much of the poetry of the *Veda*. The desire to crystallize all aspects of experience into individual groupings of symbols, coupled with evolving beliefs in a structure of immutable cosmic forces, was to ensure the perpetuation of the gods' hold over the Indian mind. It was inevitable that increasing mastery of stone, metalworking and painting should lead on to the concretization of the pantheon in visual form.

The elements which contributed to the classic portrayals of the gods of Hinduism came from two separate sources: the *Veda* and the non-vedic indigenous religious traditions. The *Shvetāshvatara Upanishad*, while expounding the typical upanishadic one-*brahman* concept, personalizes this usually neutral unified godhead as a masculine deity whom it calls Ishvara, Hara, Rudra and Shiva, which were all to be names of one of the primary gods of Hinduism. In parallel with this tendency within the vedic tradition, the indigenous god-cults were becoming integrated with established society. When Alexander the Great invaded India from 327 to 325 BC, his forces fought against Indian troops in the Panjab who worshipped a Herakles-like figure, and Indian inscriptions of the 2nd century BC describe sacred enclosures in which were housed images of similar legendary figures who were probably apotheosized local heroes or rulers. These minor deities were sometimes interrelated when the clans which worshipped them formed alliances. As the federations then merged with vedic society, their group-gods became assimilated to the now personalized gods of the *Veda*.

The Hindu cult-image derives its structural configuration from the

Vishnu, Indian: Hindu, 3rd century AD. Sandstone, height 21cm (8½in). Government Museum, Mathura, India. (*Right*) Early images of the god Vishnu, such as this, were partly based upon earlier heraldic representations of idealized emperors (see opposite, *Chakravartin*). The deity was largely an apotheosis of the temporal ruler, and both have the wheel of universal dominion as one of their symbols. The four-armed deity has additional emblems of a sacred fruit and an enormous war club; his front right hand is raised in the gesture of reassurance and protection.

Scene from the Vessantara Jātaka (fragment), Indian: Buddhist, 5th century. Gouache on treated rock. Cave 17, Ajantā, India. (*Previous page*)
A royal couple, probably Prince Vessantara and his wife, are seen making love upon a couch with servants in attendance. The prince is dark-hued, indicative of passion, while his wife has the cool, light complexion which represents both serenity of mood and aristocratic birth. Although this scene in the mural is erotic, the story told by the whole painting is intended to teach the Buddhist virtue of selfless generosity. Vessantara gave away his wealth, children and wife only to find that the recipients had been gods in disguise, who restored to him all that he had given.

Yaksha, Indian: folk-cult, 3rd–2nd centuries BC. Sandstone, height 260cm (104in). Government Museum, Mathura, India. (*Above*)
Colossal figures such as this were worshipped as manifestations of the spirit of sacred places in many parts of North India before Buddhist, Jaina or Hindu images were established. *Yakshas* were feared and their worship was largely ritual appeasement rather than adoration. The images were set up in the open air, frequently near a sacred tree. 'Primitives' in the art-historical sense, they are nevertheless powerful and accomplished sculptures.

same sources. Non-vedic cult statues standing up to 2.7m (9ft) in height survive from at least the 3rd century BC in north India. These represented *yakshas* or earth-spirits which were regarded as essentially benevolent to man, although awesome and capable of terrifying acts of destruction if neglected or ritually offended. These free-standing sculptures are endowed with a massive solidity and have an undeniably powerful, threatening presence. The heavy, primitive quality of the anatomical representation is belied by the intricacy with which the sashes, girdles and necklaces are sculpted.

Less overpowering versions of these sculptures were to be incorporated into Buddhist architecture of the Mauryan period, appearing in the role of attendants so as to magnify the central theme of the Buddhist doctrine. Succeeding dynasties up to the beginning of the Christian era saw the inclusion, for the first time, of detailed sculptural versions of the gods of the *Veda*. Deities such as Indra and Sūrya, although reduced by the Buddhist artists to a level of minor significance similar to that occupied by the earth-spirits, thus made their first appearance outside the realms of poetic metaphor in accomplished artistic interpretations

which displayed a remarkably close conformity to the salient features of the archaic vedic imagery. An antecedent 'vedic art' tradition using more perishable media, of which no material evidence remains, must be presumed in order to account for these sudden and mature portrayals.

Throughout the early Buddhist period the concept of royalty had also become increasingly more stereotyped. As early as the 2nd century BC, the proliferation of Buddhist art provided the Indian sculptor with the opportunity of recording the ideal-emperor image, the *chakravartin*, in stone. Such formulations, executed in relief, are virtual prototypes of the later Hindu cult-icons: the emperor is shown surrounded by inanimate attributes of power, such as the wheel of universal dominion, and flanked by human attendant figures in the persons of his queen, minister or priest and crown prince, while at his feet stand his war-horse and elephant. The existence of this cultural factor undoubtedly gave strong impetus and legitimacy to the desire on the part of the priests close to the throne (who were within the aristocratic vedic tradition) to represent the hieratic gods in anthropomorphic form but independent of the heretical Buddhist and Jaina artistic contexts. A tradition of worshipping life-sized cult statues of kings became especially popular during Kushāna rule in northwestern India. Under the patronage of this dynasty, during the first three centuries AD, a stiff hieratic style was evolved especially for the purpose, based upon the heraldic aspect of royal portraits on coins of the period.

Buddhist artistry had meanwhile developed icons of Bodhisattvas from the *yaksha* type of statuary, though on a smaller scale. These figures were portrayed holding a waterpot in the left hand and raising the right in the gesture of benevolence known as the *abhaya-mudra*. Cults centring around *Veda*-derived deities, no doubt led by Vedic priests

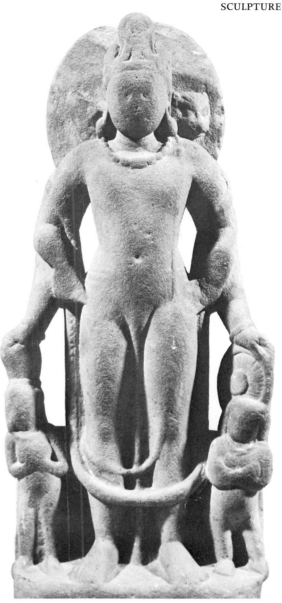

Syncretistic Vishnu image, Indian: Hindu, 5th century AD. Sandstone, height 27cm (11½in). Government Museum, Mathura, India. (*Above*)

A product of the classical phase of Indian art, during the rule of the Gupta dynasty, this image of Vishnu displays some important iconographic advances from the early version illustrated opposite. The wheel and war club, instead of being held aloft, are here personified and the hands of the god rest lightly upon them. The club is represented as a tutelary goddess, the wheel as a male figure. Vishnu himself is now backed by a large halo, upon which appear two animal faces. These represent the profiles of a boar and a lion, two of the mythologically most significant incarnations (*avatāras*) of the god.

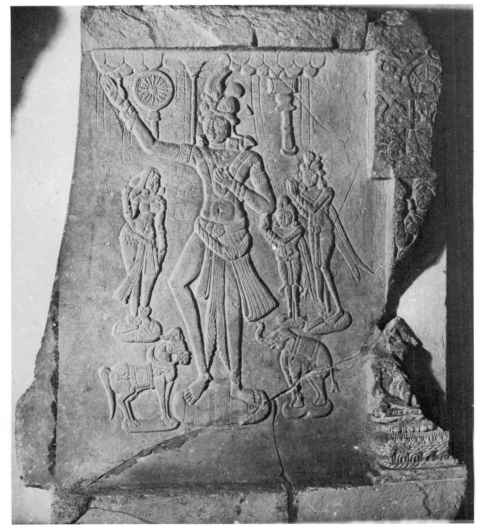

Chakravartin, Indian: Buddhist secular, 1st century BC. Limestone, height 130cm (51in). Government Museum, Madras, India. (*Left*)

This shallow relief slab, from a Buddhist monument at Jaggayyapeta, represents the ideal ruler, the Chakravartin or Universal Conqueror. The iconographic connection between such formal type-sculptures and later god-images can be seen by comparing this relief with the early Vishnu opposite. More developed Hindu images also include the consort, offspring and associated animal of the god, just as they appear in this depiction of a mortal king.

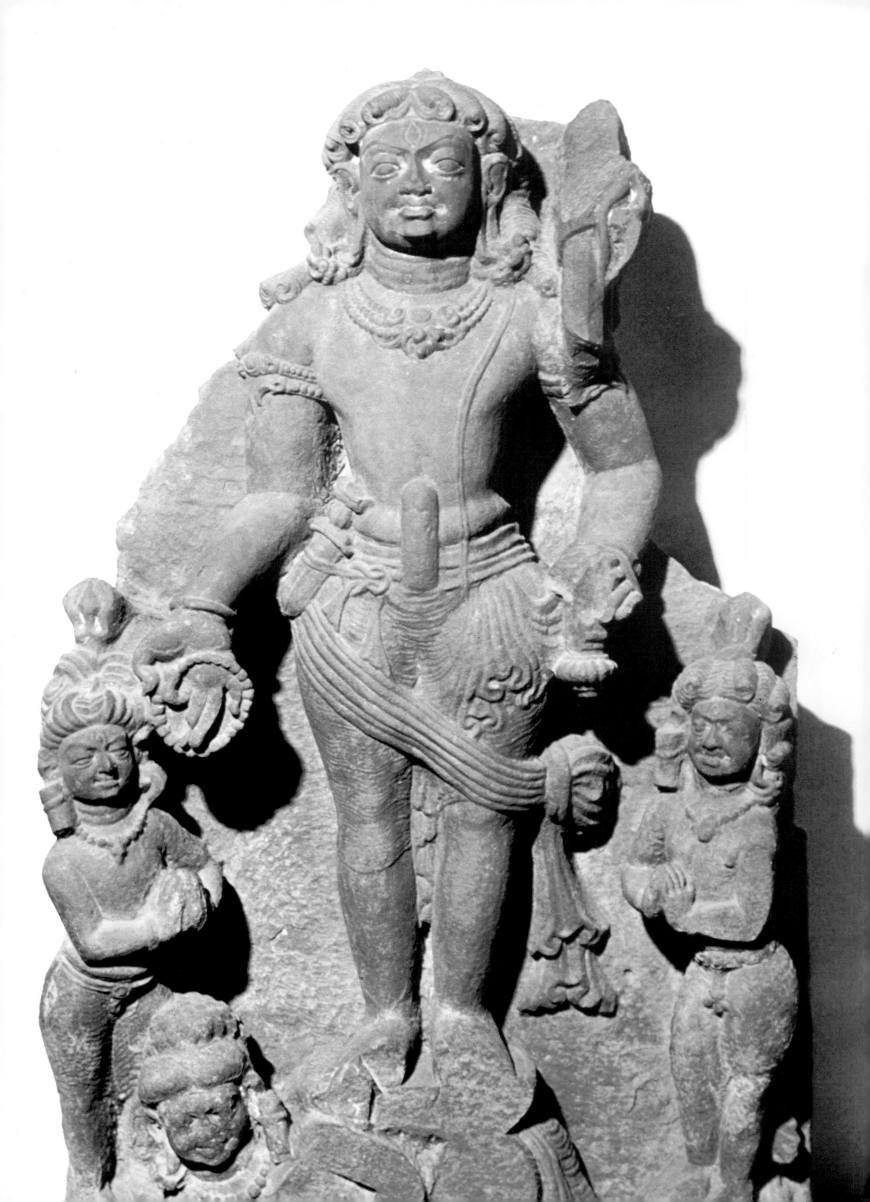

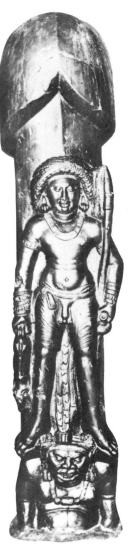

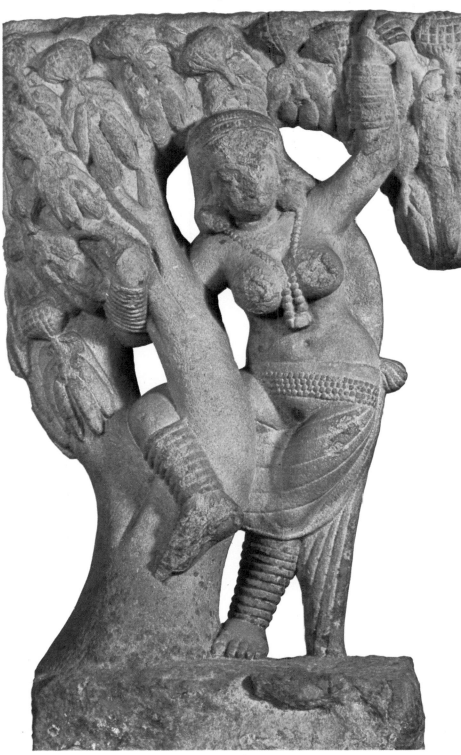

Rudra-Shiva and the Linga, Indian: Hindu, 2nd–1st centuries BC. Stone, height 150cm (60in). Parashurāmeshvara temple, Gudimallam, India. (*Above*)
One of the earliest Hindu images, it appears to have been worshipped continuously for 2,000 years. Standing with his back to a colossal phallus is the figure of a young man wearing a rich turban and jewels. He stands with feet astride, the penis prominently delineated through a close-fitting loincloth. He holds three objects: a waterpot, a dead ram and a tall axe. His feet are planted firmly upon the shoulders of an ugly *yaksha* figure.

anxious to emulate the successful integration of Buddhism with the indigenous religions, were quick to mobilize the same folk symbolism and to adapt Buddhist art-forms to their own idiom.

A remarkable image created by one such cult in the first or second century BC was discovered many years ago at Gudimallam in Andhra Pradesh, still being worshipped in a temple. In basic configuration it is clearly derived from the railing pillars carved with *yaksha* figures which surrounded Buddhist sacred spots. It is an early representation of Rudra-Shiva, the vedic god personalized in the *Shvetāshvatara Upanishad* and now associated with an indigenous phallic cult of the type mentioned with contempt in the *Rigveda*. His vedic background is clearly indicated by the sacrificial role in which he is evidently cast: the *linga* is also the stake (*yūpa*) to which the victim of the sacrifice, the dead ram, was tethered, and the woodsman's axe has been used to fell the tree from which the stake was hewn. The blood of the animal and the ritual water from the pot have fertilized the *yūpa*, making of it a symbol of fertility, just as his personal ornaments, often referred to in vedic

Yakshī. Indian: Buddhist folk-cult, 1st century AD. Sandstone. British Museum, London, England. (*Left*)
Tree-spirits on an architectural fragment from the famous Buddhist site at Sanchi. In ancient India it was believed that a kick from a young woman would cause a tree to blossom, an idea which contributed to the posture of these figures. The dryad entwines her limbs with those of the tree in such a way that her arms appear to form a branch sprouting from the trunk.

Shiva Bhairava, Indian: Hindu, c.700. Sandstone, height 88cm (35in). British Museum, London. (*Opposite*)
The god Shiva transforming himself from his terrifying (Bhairava) aspect into his supreme form. Condemned to roam the earth as a celibate ascetic for decapitating the archaic god Brahmā, the ugliness of sin is falling away and he stands as the axis of the universe, worshipped by mortal ascetics. His hair is still that of a wild man, his natural eyes bulge ferociously, but the third eye of wisdom opens upon his forehead. His phallus, by a Hindu paradox symbolic both of celibacy and of fertility, is worshipped by itself as the *Linga* (*above*).

Shiva as King of the Dance, Indian: Hindu, 12th century. Bronze, height 86cm (34¼in). St Louis Art Museum, St Louis, USA. (*Right*)

In medieval South India this form of Shiva as the Dance-King (*Nata-rāja*) was perfected during the rule of the Chola dynasty. The god dances within the endless cycle of the human condition, symbolized by the circle of fire and personified by the dwarf upon whom he stamps. The devotee, identifying himself with this seemingly inescapable round of unceasing existence, perceives his own route to salvation in the very force which drives it—the cosmic dance of Shiva. The front right hand of the god makes the sign of peace and his left points down at his left foot which, in continuation of the dance, is about to step out of the cyclical trap of time and desire. If the life-force is directed toward escape (*moksha*) from the endlessly self-consuming fire cycle of birth and death, instead of involvement in it, salvation is possible. This is the basic meaning of the dance.

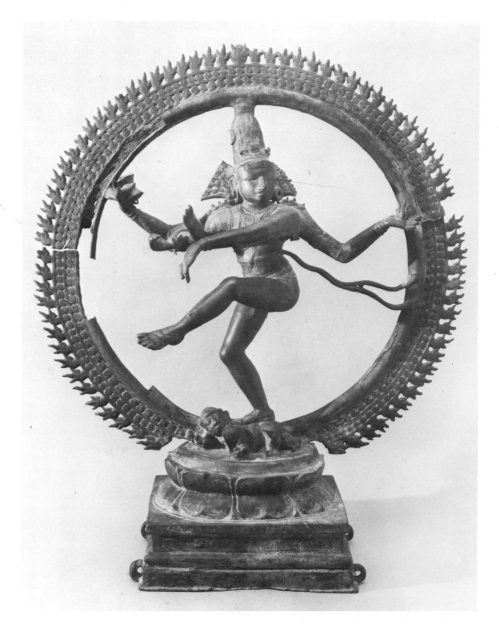

Head of the Man-Lion, Indian: Hindu, 14th–15th centuries. Red stone, total height 40cm (16in). Ashmolean Museum, Oxford, England. (*Below*)

The Man-Lion (*Nara-simha*) was one of the ten mythical incarnations of Vishnu. When a devotee of Vishnu was persecuted by a tyrannical king, the god assumed the terrifying form of a human warrior with the head of a lion who materialized from one of the pillars in the king's palace, threw the persecutor across his knees and disembowelled him. This particularly interesting figure is a cult-object in its own right; despite the frightening face, he is represented in peaceful mood, seated cross-legged in meditation.

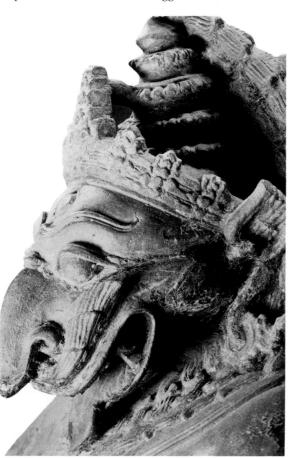

hymns to Rudra, represent riches for the worshipper. Taking up the theme of Buddhist devaluation of vedic deities, this cult figure treads underfoot an earth-spirit of the earlier indigenous religion.

The first images of the Hindu god Vishnu were clearly a continuation of this stylistic tradition, integrated with the features of the Kushāna royal cult statuary. But the iconography became more complex, Vishnu being possessed of four primary symbols which his image would have to display. The resolution of the structural problems involved led the sculptors to invent that characteristic of Hindu religious art which has caused so much puzzlement in the West, namely the multiplicity of arms. To the Bodhisattva image was added an extra pair of arms, positioned behind the original pair and wielding a mace and a disk, the two weapons of Vishnu. The Buddhist attributes were replaced by the other main symbols of the god, the lotus blossom and conch shell.

The multiplication of the number of arms was not, as early western observers in India believed, some monstrous aberration of the non-Christian mind, but merely the most natural and acceptable artistic solution to a very real problem in the evolution of religious symbolism. It had long been accepted that the form in which the gods most frequently appeared to men was anthropomorphic, a concept reinforced by the belief in the divinity of kings. The only naturalistic manner in which the image of a god could manifest its powers explicitly was to bear symbols of these powers in the form of clothing, jewellery, and objects held in the hands. But the acquisition on the part of the gods of

wider powers as their cults expanded necessitated the addition of more symbolical objects, and thus more arms.

Once the multi-armed image had been invented, it very rapidly became conventional and all god-images, whether in the round or in relief, displayed this characteristic. Images exist with up to 1,000 hands. The arms were always added in pairs, and each pair is usually strictly balanced in terms of symbolism: there is a logical connection to be sought between the objects held in any pair of hands. The total symbolical structure of an image in which the arms of one side have been damaged or lost can therefore normally be inferred from the remains.

The conventional Vishnu image of this period was four-armed, holding in the upper or rear hands the mace and disk, while the lower or front hands held the lotus and conch. At the time in question, two heads, those of a lion and of a boar, were added on either side of the central face of the god. Each of these animals was well known in current mythology and had been acquired by Vishnu as *avatāras* or incarnations of his divine nature from the more archaic myth-systems of the *Veda*. Although such three-headed images later became the foci of specific cults, the original reason for imposing the animal heads upon the standard Vishnu icon at this early date can only have been didactic, intended to explain the four attributes which the god held.

The boar was said to have been sent to rescue the Earth from the floor of the formless ocean—the raw material of creation—and establish it in

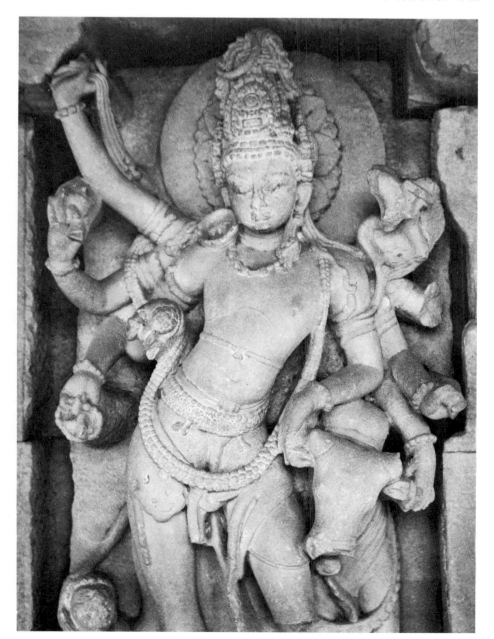

Shiva in Peaceful Mood, Indian: Hindu, 7th century. Stone sculpture. Durga temple, Aihole, India.
This image of Shiva stands in a niche let into the wall of the ambulatory passage surrounding a temple in the Deccan. It expresses perfectly the 'personality' of the god in his all-powerful, but peaceful mood. The bull, embodiment of sexual energy, nuzzles gently against his master who leans upon the hump on its back and strokes its ears. One of his lower right hands toys with a fruit, the seeds of which are the seeds of life itself, while in the hand below he counts the beads of a rosary, controlling the passage of cyclical time. His eyes are those of one lost in reverie, downcast and unfocused. The crescent moon, symbol of coolness and tranquility, hangs upon the long, piled strands of his hair. The mood of this sculpture is relaxed and yet threatening in its very informality.

Vishnu as the Form of the Universe, Indian: Hindu, 18th or 19th century. Painting, India. (*Right*)

If the energetic role of King of the Dance is the highest aspect of Shiva, the paramount form of Vishnu is that of the Universal Form (*Vishva-rūpa*). The earliest representations of the god in this form were sculptures executed in North India in the 5th century AD, based upon a visionary description in the *Bhagavad-Gītā*. The concept of a primeval Man (*Purusha*) from whom the universe was formed is at least 3,500 years old in India and is still part of living Hinduism today. The Hindu god in whom such concepts have crystallized is Vishnu. This modern painting perpetuates the same archaic belief, the form of the god expressing the anatomy of the cosmos.

Sūrya, Indian: Hindu, 13th century. Black chlorite. British Museum, London, England. (*Below*)

The sun-god, Sūrya, sits in happy and benevolent meditation, holding the two lotus blossoms which are his primary symbols. The performance of profound meditation is said in Hinduism to generate spiritual heat (*tapas*) and light (*tejas*) and so the whole body of the deity radiates life, prosperity and glory upon his worshippers. To all Hindus, the rising and the setting of the sun are moments of great significance when daily rituals are performed. Some sects worship the sun directly, without images.

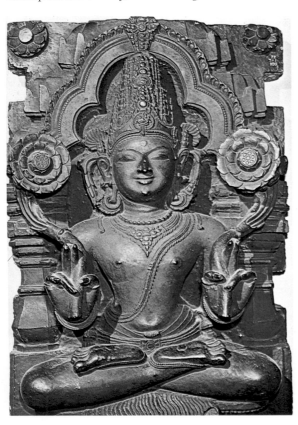

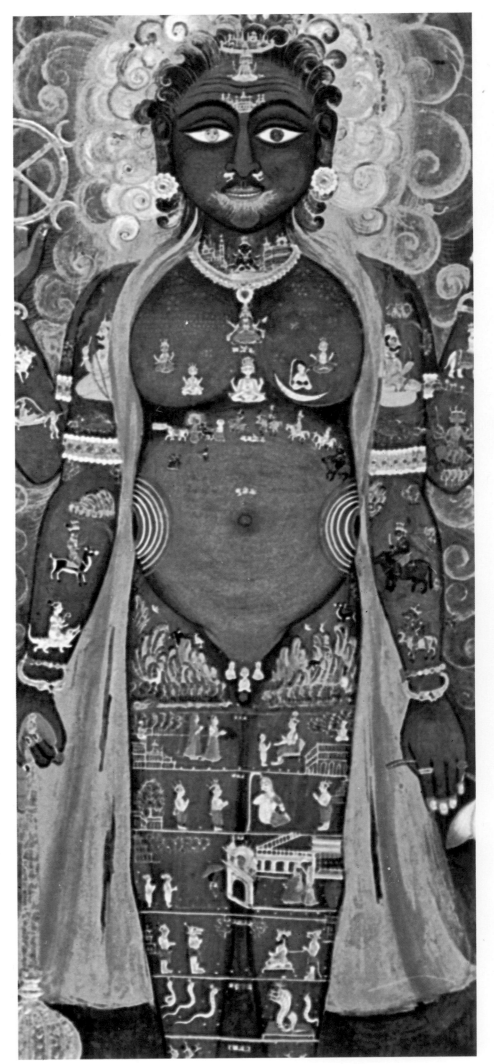

the light and air where it now stands firm. The head of this animal explains Vishnu's possession in his front hands of the watery emblems of conch-shell (sea) and lotus (rivers and lakes). A vedic metaphor for Indra, king of the gods, and a visual symbol of royal military power since Mauryan times, the lion represented the man-lion (*nara-simha*) incarnation which was a vengeful warrior sent to destroy a heretical king who persecuted the devotees of Vishnu. Its presence is clearly meant to contextualize the weapons, mace and disk, and so explain their relevance to the image. Vishnu thus is seen as demiurge and warrior, creator of the world and scourge of the unbelievers, a succinct and self-contained interpretation incorporated into the image itself.

It was the coalescence of social groups and religious idioms which created the art that we term Hindu. The exegetical employment of the lion and boar heads indicates that a point had been reached in the 5th century at which a wide-based mythological medium had been evolved to fuse all of these traditions into a single coherent religious system. The cult image itself, however, generally required little in the way of such additions because of the developments which were taking place in the evolution of the temple, with the extra scope which this provided for the depiction on wall surfaces of the contextualizing mythological episodes associated with the enshrined icon.

In generalized Hindu belief, every natural entity has an indwelling reality, of which the entity itself may or may not be aware. This intrinsic spirit is susceptible to invocation and address in ritual terms. Under certain circumstances it may become a phenomenon visible to man, and so be portrayed by an artist. It can also be subjugated by conjuration and forced to depart. Stone, for example, appears to the religious eye as male or female, living or dead. The material from which a Hindu cult image is to be made must therefore be found appropriate in these terms to the nature of the deity concerned before work may begin. At the quarry, the stonemason is required to speak to and placate with offerings the spirit of the living rock before cutting out and removing the block which he has selected for sculpting.

It is significant that the early Hindu gods were often portrayed standing upon a nature-spirit. This subjugated figure represented in extrinsic terms the folk religion which the new cult of the god superceded; intrinsically, however, it was an echo of the original genius of the rock still locked within its substance, but making way for the divine nature of the god which now dominated it. In later times, when cult icons were no longer required to depict the inner personality of the material from which they were made, the depressed figure remained an art motif of frequent occurrence, usually retaining its role of opposition to the deity. Muyalaka, the embodiment of human bondage beneath the feet of Shiva, and the antigod Mahisha trodden underfoot by a form of Durgā, are examples of it as a manifestation of evil, while in a beneficient role it became the Earth goddess Bhū supporting Vishnu.

The conception of a projected image first took form in the heart of the *shilpin* or sculptor, who entered into a state of deep contemplation to seek his vision of the god. A tenth century Sanskrit cult manual states: 'The form arises in the heart as the result of a religious yearning, which is animated by pious devotion' (*Kāshyapajnānakānda* 35). Because of this fundamental trust in revelation as the first step in the making of an icon, each image of a particular god is a unique creation in spite of the strict rules of iconography and iconometry to which the artist's vision was subject. The sculptor was aided in his *dhyāna*—meditation—by mnemonic verses reminding him of the general aspect and attributes of the god whom he was to symbolize in stone. The following literal trans-

Durgā, Indian: Hindu, 20th century.
This modern image of the goddess Durgā, the fierce consort of Shiva, illustrates the Hindu method of worship. Although the goddess, here portrayed in benign mood, has at least eight arms and is seated upon her symbolic animal, the tiger, these are hidden under a mass of sumptuous clothing and garlands. Hindu images were originally sculpted complete with clothing and body ornaments, but in modern ritual practice it is an essential part of the elaborate ceremonial of worship to heap the image with rich apparel and offerings of flowers, jewellery and cosmetic or symbolic finger-painting.

Vishvanātha temple, Khajuraho, Indian: Hindu, 1001–1002.
Stone 27m × 14m (89ft × 46ft) plan, India. (*Right*)
A Sanskrit inscription set into the wall states that this temple was dedicated to Shiva by King Dhanga of the Chandella dynasty. Around AD 1000, this ruling house was at the height of its power in central northern India and a vast amount of revenue was spent in the construction of grandiose temples like this. Basically, however, the design derives directly from the simplest and earliest of Hindu shrines. The tower (*shikhara*) surmounts the small shrine or 'womb-house' (*garbha-griha*) in which the Linga of Shiva was installed. In front of this is the hall called the *antarāla* or *sabhā*, and the entrance is through two porches or *mandapas*. The mountainous effect of the architecture seeks to imitate the fabulous Mount Meru, axis of the universe and abode of the gods.

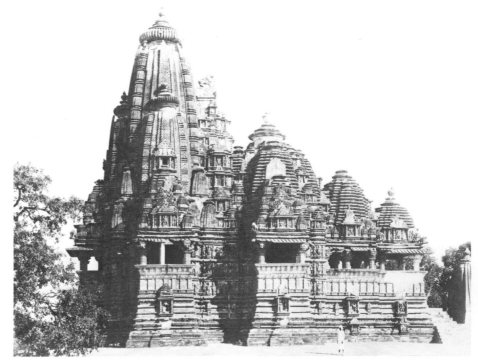

Ambikā, Indian: Jaina, 13th century. Marble. Jaina temple, Gujarat, India. (*Below*)
The Jaina religion was formed at the same time as Buddhism in North India. Instead of a succession of Buddhas, the Jainas believe in a series of saviours known as Tīrthankaras. Each of these is, in the iconography of the religion, attended by a male and a female figure. The Tīrthankara called Neminātha has as his female attendant this mother-goddess, Ambikā. Her symbolic animal is the lion, seen here in ferocious caricature. She is essentially a goddess of fertility and to symbolize this she holds bunches of ripe mangoes and supports an infant upon her lap.

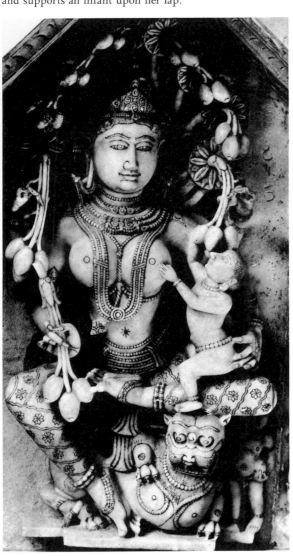

lation of one such description illustrates the extreme brevity of some of these passages, which were intended only as guidelines, leaving the artist's creative imagination free. 'Red-coloured perfect body and crown on head; in upper right hand conch and below it mightiest mace; in upper left there should be lotus and below it disk: thus Sankarshana's image should be, warrior caste's fulfiller of desires' (*Aparājita-pricchā* 217–6/7). Adherence to the canons of iconographical symbolism was considered vital, since it was imperative that the image faithfully reflect the abstract nature of the god, who would not enter it unless it adequately expressed his role in the interplay of cosmic forces. However, much dynastic temple sculpture does display extensive experimentation with iconographical form. Some so-called deviations were in fact dictated by the formation of new cults, but others appear to be creations based upon new visionary experiences.

A type of cult image which clearly presupposes such ancillary knowledge is the medieval south Indian conception of Shiva as Natarāja, Lord of the Dance. The icon is one result of the elevation of Shiva to the role of Great Teacher of all arts and rituals which are subservient to religion; as Natarāja he is the supreme exponent of the classical dance, itself an intense and highly disciplined form of ritual worship. The portrayal of Shiva in this role had therefore to conform strictly to the postures and gestures codified in the treaties on classical dancing which are collectively known as *nātya-shāstra*. Moreover, it was required of Natarāja bronzes, as of all cult images, that they transcend the human body itself in grace and beauty. In his upper right hand, Shiva in this form wields a double-ended drum of the type called *damaru* to provide his own rhythmic accompaniment to the dance.

It was through the sculptors' finely developed aesthetic sense which fused music and the dance with static visual form that the Natarāja image came to represent the highest form of Shiva. To his devotees, the Lord of the Dance symbolized not only the forces at work throughout the universe, but also the point at which all opposites were reconciled. The sound of the drum is the pulse of creation; the flame in his upper left hand is the fire of destruction. The eternal war between these two forces creates the dance, and paradoxically it is in the dance that the devotee discovers the stillness which is *moksha*, liberation from the wheel of time. But it is the modelling of the body of the god to echo the abstract symbolism of the drum and flame which evokes the intended emotional state in the worshipper. The hips of the god are twisted sharply to the

right, his right foot stamps upon the personification of a man's conditioned desires, his hair and sash whirl outward with the fury of the dance; at the same time, he makes the motionless gesture of reassurance and his face expresses a state of perfect serenity.

The icon first engages the mind of the devotee aesthetically by its form and intellectually by its symbolical attributes. When the worshipper then perceives both of Shiva's opposed moods—the *ugra* (violent) and the *shānta* (pacific)—united in the anatomy of the god, he becomes involved at the emotional level with its physical presence, which becomes the projected image of his own most basic internal conflicts. The ability of the artist to portray the god in a realistic dancing posture thus enabled him to convey the essentially restless nature of existence, to syncopate this restlessness in measured rhythms, and to carry the mind of the observer out of its self-defeating search for freedom in the cycles of time, into the nature of mind itself, where consciousness is unconditioned and universal.

The earliest surviving fragments of Indian painting—excluding a small amount of prehistoric tribal drawings on rock—are Buddhist, quite different in character from the early statuary of Hinduism. The maturity and fluency of style evident in these fragments presupposes a long anterior painting tradition. This is accounted for by the fact that Buddhist sculpture, most of which was certainly painted, had been developing for centuries before the archaic brahmanical religion based upon Vedic orthodoxy began systematically to create its own visible pantheon to serve the needs of its more popular cults which are known collectively as Hinduism. Early Buddhist relief sculpture had been

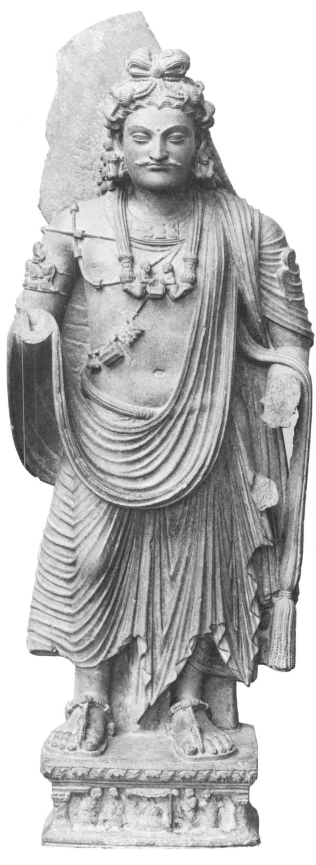

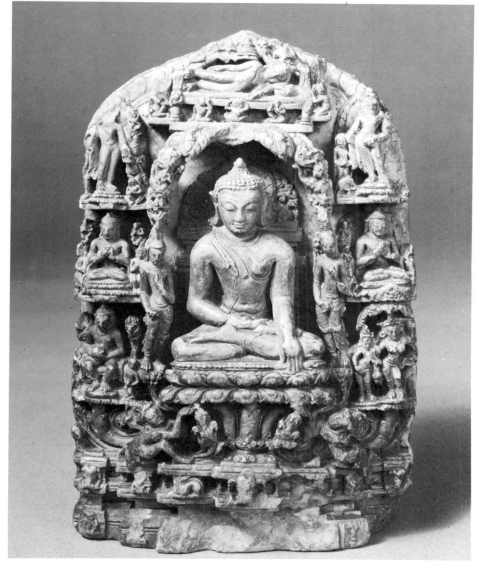

Bodhisattva, Indian: Buddhist, 2nd century AD. Stone, height 109cm (43in). Museum of Fine Arts, Boston. (*Above*)
A Bodhisattva achieves Nirvāna in his lifetime but remains in the world to help others toward the same spiritual goal. This statue is a creation of the admixture of Graeco-Roman, Persian and Indian styles which made up the art known as Gandhāran. He appears as a richly adorned aristocrat with only a massive halo to indicate his divinity.

The Buddha, Indian: Buddhist, 11th–12th centuries. Steatite, 12.7×8.57cm (5×3⅜in). Victoria & Albert Museum, London, England. (*Left*)
The Buddha is depicted seated in meditation immediately after his Enlightenment, with his right hand in the 'earth-touching gesture' (*bhūmi-sparsha-mudrā*). He is enthroned upon a symbolic double lotus rooted in the waters of eternity, to indicate that he is not one manifestation of the eternal Buddha-principle. He is surrounded by scenes from his earthly life, with his attainment of Nirvāna at the top.

Indra and entourage, Indian: Buddhist, 5th century. Wall painting. Cave 17, Ajaṇṭā, India.
This fragment of a severely damaged wall painting in the porch of one of the Ajaṇṭā caves represents the old Vedic god, Indra, flying through the cloud-stacked heavens. Accompanied by celestial nymphs and musicians, he is on his way to welcome and pay homage to the Buddha, who is said once to have ascended into the heaven-world of the archaic gods over which Indra ruled.

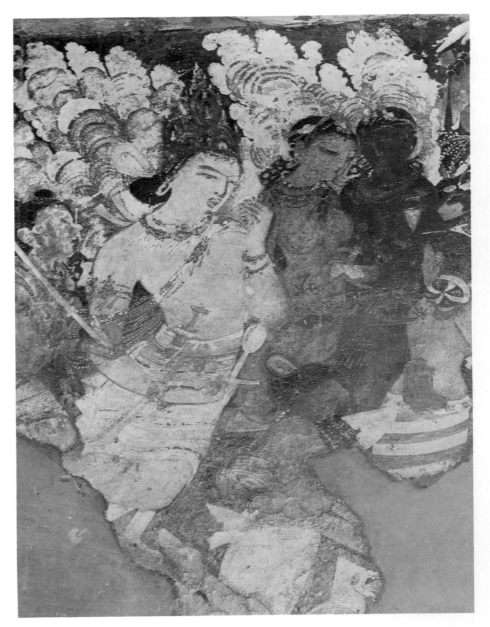

largely of a narrative didactic kind, and the first fragmentary paintings have a similar character.

These fragments are preserved, along with Buddhist painting of a later period, at Ajantā, inland from Bombay. The setting is impressive. There are 30 cave shrines which penetrate the long curved cliff face above the narrow Waghora River. The caves which archaeologists have numbered 9 and 10, near the middle of the curve, are Buddhist *chaitya*-halls, which means that they contain a cult object of cylindrical cross section culminating in a hemispherical top, imitative of the ancient burial mounds (*thūpa,* or *stūpa*) in which the divided remains of the Buddha are said to have been interred after his cremation. It is within these two ritual cave-shrines that the second century AD paintings are to be found. They were probably commissioned, supervised and quite possibly executed by the monks living in the adjacent caves 8, 12 and 13 which are *vihāras* or monasteries. The oldest works appear to be those in cave 9 and on the west wall of cave 10. They represent such themes as royal worship of sacred Buddhist symbols, a favourite Buddhist motif which expresses the subordination of temporal power to the sanctity of Buddhist doctrine. Some of the slightly later paintings —which are still part of the group of the most ancient Indian graphic work extant—depict certain of the *Jātakas,* stories of the Buddha's previous existences, arranged in horizontal narrative episodes which it was intended should be followed by the eye of the devotee for his edification as he performed his ritual circumambulation of the *stūpa* within the

cave. While the decorative aspect of these paintings and, to a degree, their secular content, cannot be denied, it is important to bear in mind their original religious purpose of teaching Buddhist doctrine. This, and not art for its own sake, was the primary motive force behind their creation. The paintings were in this sense complementary to the sculptural work inside the caves: the pictures explained, contextualized and elaborated upon the stone *stūpas* and images which were the true focus of the ritual devotion for which the cave interiors were designed.

The painting technique employed at Ajantā is similar to that found at ancient sites across Asia, but it is not found in the southern Deccan or south India. The basic surface upon which the artists had to work is the trap of the Western Ghats. This hard, unabsorbent rock was treated first with a dense layer of earth lightly held together by the intermixture of organic material; the rough ground so formed was then smoothed over with a thin surface of lime upon which the pictures were painted using a sticky pigmented tempera. The palette consisted of no more than the mineral pigments soot black, white of lime, red ochre, terra verde and yellow ochre mixed with gum.

Although a full colour symbology was not established in central India until about the 7th century AD, it is to be supposed that these early paintings used colour to a certain extent symbolically (ladies of green complexion, for example, are hardly indicative of a wholly naturalistic aesthetic) in accordance with a code already conventionalized in the painting of sculpture. The painting, particularly of the human form, is charged with confidence and verve, but dominated always by a sensitivity and respect for the subject which lends to the line (as sometimes distinct from the colouration) a convincing naturalism. Form is defined strongly in red ochre or black outlining and all elements are clearly conceived as contributory to the entire composition. Although perspective in the true western sense is unknown, a naive observation of elevation combined with overlapping techniques achieve quite striking three dimensional effects.

Buddhist wall painting continued here at Ajantā and at Bāgh to the north into the 6th and 7th centuries. By the 6th century, the constriction of scenes within horizontal, sequential registers had been abandoned for a more free covering of the whole wall surface, the separate incidents depicted running into each other without boundaries. The

Princess looking into a mirror, Indian: Buddhist, 5th century. Wall painting. Cave 17, Ajantā, India. (*Above*)
Paintings of this kind, although secular in content, have a basic solemnity to them, belied here only by the most delicate of details, such as the little fluttering streamers attached to the necklace of the princess and the awe of the child gazing at her. The seemingly casual composition of this group in fact parallels contemporary carvings of the gods in their fixed, hieratic postures. Thus the royal figure in the centre must be taller than the attendants and must, of course, utterly transcend them in beauty. The princess holds a lotus to her breast while regarding her image in a hand mirror: both gestures were repeated thousands of times in temple sculptures, Hindu and Buddhist alike, from this period into the modern age.

Preaching Buddhas. Indian. Sixth century AD. Gouache on treated rock. Approx. 100×120cm ($39\frac{1}{2} \times 47\frac{1}{2}$in). Cave 10, Ajantā, India. (*Left*)
Painting in the Ajantā caves was continued for many centuries, reflecting theological advances in Buddhism. This section of the ceiling of one of the Ajantā caves was repainted with the multiple Buddhas of Mahayanism some 800 years after the original mural work consisting of the narrative art of Theravada Buddhism. The repetition of these esoteric figures, their hands joined in the preaching gesture is a feature typical of the later Buddhist school, including those of Tibet. In this fragment, enshrined Buddhas with green halos (Amoghasiddi) alternate with identical figures whose symbolic colour is white (Vairochana).

Cosmographic temple ceiling, Indian: Jaina, 11th century. Marble. Vimala Shah temple interior, Mount Abu, India. (*Right*)
Built entirely of white marble in a style so delicate that any chisel proved too clumsy a tool—every minute detail having been finished by the patient and laborious rubbing away of the stone by hand—these domed ceilings epitomize the refinement and rarefied atmosphere of the upper world as conceived by Jaina tradition. Concentric circles rise inward upon the domed ceilings of the temple halls, meticulously carved with symbolic floral motifs and miniature celestial figures. There are nine significant concentric rings surrounding a central, pendant triple lotus. The outer circle contains the 64 Yoginīs, to be followed by a circle of 144 dancers and musicians, and a third circle of 48 figures upon animal mounts who probably represent the attendants of the 24 Tīrthankaras. Extending vertically across these first three bands are the 16 'wisdom-goddesses' (*vidyā-devīs*), headed by Sarasvatī. Above the goddesses, a fourth circle of 32 pendant lotuses surrounds a fifth circle containing 28 lotuses, all 60 blossoms having 16 petals. There follows a band of female dancers which is firmly separated by an upward step from a circle of geese, the *hamsas* of mythology whose flight paths define the boundary of the sky-world. The next circle, composed of 12 lotuses with miniature figures standing upon the stems, represents the 12 layers of the upper world, each with its resident gods. Within them, the innermost circle of male figures, standing in various postures and holding offerings or joining their hands in the gesture of reverence, surrounds the central pendant. This consists of 3 lotuses on a single stem, having 8, 6 and 16 petals respectively: an image of the highest strata and finial of the universe.

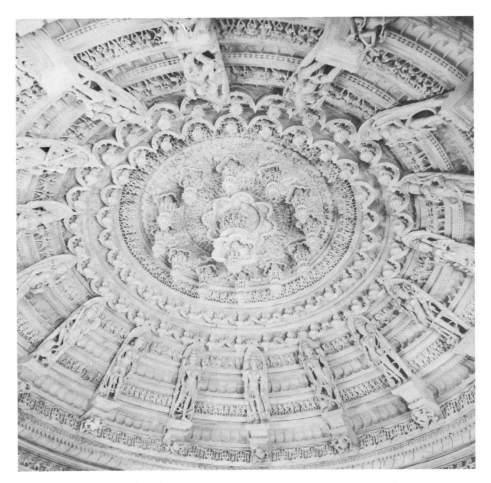

Cosmographic temple ceiling (detail), Indian: Jaina, 11th century. Marble. Vimala Shah temple interior, Mount Abu, India. (*Below*)
A detail from the series of sixteen 'wisdom-goddesses' around the temple dome.

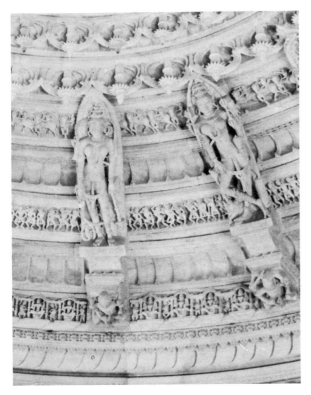

artistic conceptualization, however, was so strong that there was no sense of disorganization, but rather a graceful and logical transition from any particular scene into those around it. It will be noticed that the mystical vision has taken over from the strictly ritualistic: painting has turned a corner in technique, but the change is dictated as much by religious attitudes as by advances in artistic method.

The latest period of painting at Ajantā, that is during the first half of the 7th century, has been characterized as baroque, and it is the paintings of this phase which are best known. What is not always clear from these much published paintings is the fact that they represent the very best examples of a style which was successful only at the hands of a master artist, a member of a dying class, it would seem, for other works of this period are poorly composed and overblown.

The earliest surviving Hindu wall painting dates from the 6th century AD and is preserved in a cave temple dedicated to the god Vishnu at Bādāmī in the southern Deccan. Such fragments as survive are not sufficient to permit an accurate reconstruction of the scenes represented, although one analysis suggest that a principal ceiling panel depicted the Vedic god Indra surrounded by *apsarases* or celestial nymphs in his palace. The Bādāmī style is so different from that of Ajantā that a separate origin is certain; there are, however, no antecedent examples, and so the source remains a mystery. One of the reasons for the more rapid deterioration of these works than of the earlier paintings at Ajantā is probably the technique employed: whereas the base is the same rough earthen layer covered with a surface of lime plaster, the paint was applied *fresco secco*, rendering it far more liable to flaking. While the colour range and symbolic usage appears to be similar to that of Ajantā, the red ochre outline shapes the human form and feature in a unique—and evidently mature—style, at times with pronounced, yet not unnaturalistic elongation. At the same time there is a courtly, but not over-formalized gentleness to the portrayals which rivals the delicacy of expression at Ajantā. The most striking aspect of this style is the

subtle gradation of colour from darker to lighter in order to create an impression of roundness of form; and the manner of grouping figures, combined with these other techniques, lends intimacy and quietness.

More early Hindu painting, dating from the second half of the 8th century, survives in the great monolithic Kailāsa temple at Elurā. It is interesting to note that the architectural and the painting style both follow the pattern set by Bādāmi in the southern Deccan rather than that of Ajantā which lies a mere 100km (sixty miles) to the north. This style is continued in a 9th-century group of wall paintings in the Elurā cave shrine known as the Indra-sabhā, which are better preserved. Here the southern style is quite pronounced, placing the Bādāmi influence virtually beyond question.

In the Tamil south of India, the earliest decipherable fragments of painting—again, as at Ajantā and Bādāmī, clearly the products of a now lost preceding tradition—are found in the subsidiary shrines attached to the Tālagirīshvara temple at Panamalai, inland south of Madras. By far the best preserved fragment, dating from the early 8th century, represents a princess or perhaps an *apsaras* wearing a tall, intricately ornamented crown and several torques and necklaces. She is canopied by an enormous parasol—a sign of royalty—and stands upon one foot, her left knee raised, in a languid and provocative posture, her hips and face turned to the right while her nude torso is twisted to the left. The pose is charged with lithe and sinuous movement, but the painting is full of respect and admiration for the subject, who bears a certain resemblance, which should not be over-emphasized, to the famous wall paintings on the Sīgiriya rock in Sri Lanka. These south Indian paintings are done *fresco secco*, but upon a ground of lime mixed with sand (instead of earth) which imparts a slight gloss; this technique was not employed in Sri Lanka.

South Indian painting of Jaina inspiration, decidedly picturesque but somewhat lacking in force, survives in a cave shrine at Sittanavasal, between Tanjavur and Madurai. The fragments appear to be part of 9th-century renovation work carried out at the shrine. The largest and most impressive of the compositions here is painted upon the ceiling of the verandah and represents a pool choked with lotuses among which stand three nearly naked men engaged in plucking the blossoms; around them, fish inhabit the pool which is also visited by birds, elephants and some water-buffalo. The painting is unquestionably detailed and graceful, but appears to be secular in treatment, lacking the driving force of religious conviction.

By complete contrast, the magnificent murals in the Chola temple dedicated to Shiva under the name of Rājarājeshvara ('Lord of the King of Kings', an allusion to the ruler who sponsored the edifice) completed in or about AD 1010, are fired with religious zeal and imagination. They were overpainted in the 18th century in the modern temple style sometimes dignified with the description 'Late Medieval'. In places where this recent paintwork has already begun seriously peeling, it is being lifted off altogether to reveal the 11th-century work which includes splendid portrayals of Shiva Natarāja ('Lord of the Dance') and Shiva Tripurāntaka ('Destroyer of the Three Citadels').

From this period onward, with the arrival of the Muslims and the introduction of Persian techniques, the 'miniature' became very much the principal, and best known, type of representational painting. Restricted for the most part to folio illustrations of Islamic stories, Jaina miniatures illustrating palm-leaf scriptures and numerous Hindu styles influenced by Mughal court painting, the grand indigenous painting tradition was at an end.

Sarvatobhadrika, Indian: Jaina, 7th century. Bronze. Museum and Picture Gallery, Baroda, India.
These miniature Jaina shrines are often, inaccurately, referred to as 'chaumukh' shrines; they are properly termed *sarvatobhadrikas*, meaning 'auspicious in every direction'. A Tīrthankara with his symbolic animal and two attendants is seated upon each of the four sides. The contour of the finial conforms to the shape of the universe as described in the Jaina scriptures. Such shrines were intended for domestic worship.

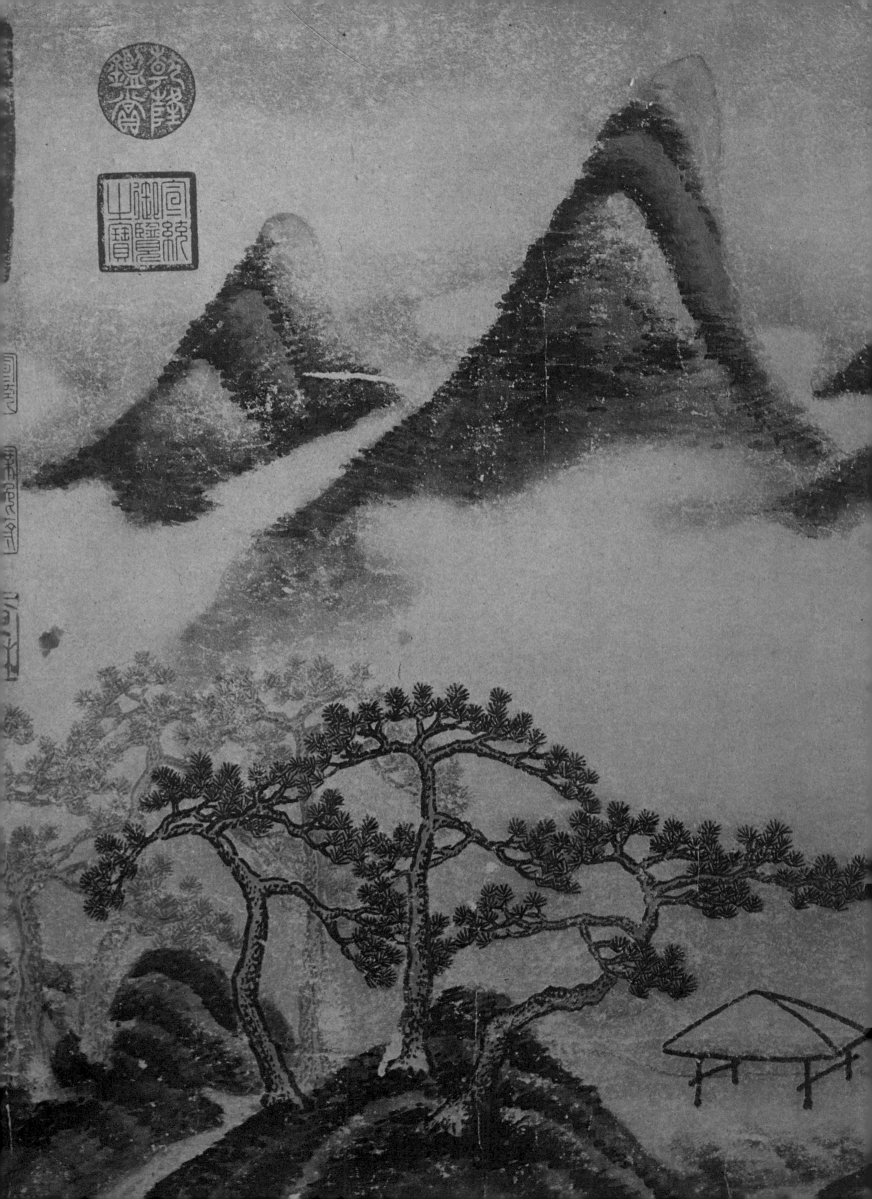

ORIENTAL ART
Chinese

A Chinese landscape painting appears light and insubstantial, faint and sketchy to those of us used to the rich oil paintings of solid figures or massed trees characteristic of Western art. In all respects, Chinese painting is different from Western painting and must be considered from the Chinese point of view.

Firstly, the materials used are different. A light hair brush, black ink and wash with rare colour and silk are all used both in painting and calligraphy and the connection between these two is crucial. The colophon (inscription, often a poem) on a painting is usually an integral part of the whole where the painter explains what he is trying to express in his picture. The connection with the written word is complex for it is often a poem that provides the inspiration for a painting. Painting, calligraphy and poetry are all products of the two main systems of thought in China, Confucianism and Taoism, which combine seemingly irreconcileable ideas to form the ideal scholar-official, the administrator who could paint and write poetry.

The use of an animal hair paintbrush dates back at least as far as the neolithic period in China. In the remains of a village settlement at Banpo (near Xian (Sian) in northwest China) which was inhabited about 5,000 years ago, fine red earthenware vessels were found which bear black painted decoration. Drawn with a brush, the designs are mainly geometric though sometimes represent, in a diagrammatic way, fish, deer or human faces. After these early examples of brushwork, it is difficult to find anything else that can provide an illustration of continuity in painting before the third century BC. The intervening period is most famous for its bronzes, not because they were all that the Chinese produced at the time but because bronze has survived better than silk and bamboo.

The earliest paintings on silk unearthed so far have been found near Changsha in south central China. Painted with a brush, possibly of bamboo with a rabbit-fur tip (one such has been found in a Han dynasty (202 BC–AD 220) tomb in Changsha), these paintings make use of colour in solid washes though there is much linear drawing over the colour. The subjects of these early paintings are mythological which is untypical of later painting but this may be because they were found in graves and are thus not characteristic examples of contemporary painting of which no other examples have yet been found.

By the end of the Han dynasty, the ideas that were to form the Chinese

Bird on a bough, anonymous, Song dynasty (960–1279). Coloured ink on silk, 25 × 22cm (10 × 8in). British Museum, London, England. (*Above*)
In contrast with the spare monochrome landscapes of the Song scholar-painters, bird and flower paintings were very popular during the Song.
Playing music under pine trees, Zhu Derun (Che Te-jun) (1294–1365). Hanging scroll, ink on paper. National Palace Museum, Taiwan. (*Below*)
Although considered one of the lesser landscape painters of the Yuan dynasty, Zhu Derun expresses the ideal of the scholar-painter in this painting.

aesthetic ideal were already established. It was at this time the beginnings of the imperial bureaucracy were seen, representing the triumph of ideas associated with Confucius (*c*.552–479 BC). These ideas were concerned with the world of men and with the good government of the people, not with the spiritual world. Though it seems unlikely that Confucius thought up all the ideas he has been credited with, his name has been given to the set of beliefs about man's place, correct rule and education that came to dominate traditional China. Accepting the feudal system as he found it, Confucius was concerned to improve it, not transform it. He believed that all had their place; that the ruler should rule, the subject obey and that in the home, the son should obey his father and the wife was subservient to her son, husband and husband's family. The most important aspect of the system in connection with painting and calligraphy was the belief in education. It was considered that a government official should be educated in the so-called Confucian classics and through learning these by rote would become fit for administration. The first imperial schools and exams to select officials were set up during the Han dynasty. In later dynasties, the educational system became increasingly biased towards the study of ancient literature and poetry. Not only should a candidate know classical works by heart, he should also be able to turn out a fair imitation of them himself.

In learning to write, every Chinese had to learn to use the brush. The Chinese language is not alphabetic but consists of over 13,000 separate 'characters'. Originally a picture writing, the language has developed into a very sophisticated system described as 'ideographic' since most characters now represent ideas rather than pictures. Each character may have from one to 30 strokes which must be written correctly and in the right order or they may be incomprehensible. For a child learning to write, copying is essential, both copying of the correct order of strokes and also of beautiful calligraphy since great store has always been set by fine writing. The need to copy is important in the study of painting and it does not have the same bad connotations as in the West; the Chinese feel that through copying a good model, the artist can improve his own technique and transcend mere repetition.

If the Confucian gentleman was one who had spent his childhood learning the classics by rote and his characters by copying, who passed exams in classical literature in order to go out and collect taxes and administer justice in a corner of the Chinese empire, he was also aware of other influences which formed the Chinese idea of nature and natural beauty. These other influences owed a great deal to Taoism. It would be wrong to assume that in traditional China, people described themselves as 'Confucianists' or 'Taoists', it was simply that these two important systems of thought influenced much of life; the Confucian particularly in the secular and political sphere, the Taoist in the philosophical, literary and scientific aspects. Taoism has two roots, one in mystic philosophy, one in magic. The two names connected with philosophical Taoism are Zhuangzi (Chuang-tzu) and Laozi (Lao-tzu) (both *c*.4th century BC). Both stressed the *Dao* (*Tao*) (usually translated as 'the Way') of nature, rather than that of man. Where Confucianism speaks of trying to improve and reform man, Taoism answers with non-action; any action was seen as a departure from the passive, natural forces. The language used in the book of Zhuangzi is witty, allusive and occasionally obscure but full of reference to the natural world. The Taoist ideal became the contemplation of nature rather than government service and even the committed scholar-official dreamt of retiring to a rustic hut in the mountains where he could watch the clouds and seasons change, seeing no-one but the occasional friend who came to exchange

paintings or verses over a jar of warm wine. The scholar recluse is a figure seen constantly in painting, sitting in his hut, gazing at the moon, and he is the dominant (usually first person) character in poetry.

Wang Wei (AD 699–761) is one of China's best-known poets and also a famous painter of great influence though no painting that can certainly be attributed to him has survived. We know about his painting from later works 'in the style of Wang Wei' and from literary records such as the *Lidai minghua ji* (Record of the famous painters of all the dynasties) by Zhang Yanyuan (Chang Yen-yuan) (AD 847) where Zhang states that he was a skilled landscape painter and quotes a poem of Wang Wei's:

In this present world I am wrongly called a poet;
In a former existence I must have been a painter!
That I cannot lay aside that extra occupation,
Is something recognised by my contemporaries . . .
and Zhang adds, 'How true those words are!'
(William Acker, *Some T'ang and pre-T'ang texts on Chinese painting*, vol. 2, Part 1, p. 265. Leiden, Brill, 1974.)

Elsewhere, Wang describes his reclusive life:
In calm loneliness I shut my door
Against the whole afterglowing sky
Cranes are nesting in the pines
No visitors at my wicket gate
Tender bamboos with the new bloom on them
Red lotuses shed of their old garments
A lamp shines at the ford
Water-chestnut pickers come home.
(G.W. Robinson, *Poems of Wang Wei*, Penguin, 1973)

The only other people envisaged in this scene are either friends or those who belong, wood-cutters, water-chestnut pickers and fishermen who do not remind the scholar of city life and his administrative obligations. Wang Wei was describing an idealized existence and perhaps Su Dongpo (Su Tung-p'o), 1037–1101, famous both as a poet and a painter of bamboo, describes the problem of the scholar-official more accurately:

Horses (detail), Zhao Mengfu (Chao Meng-fu) (1254–1322). Handscroll, 26×233cm ($10\frac{1}{4} \times 92$in). British Museum, London, England. (*Above*)
Zhao Mengfu is best-known for his horse paintings which he made for the Mongol rulers of China whom he served as court painter.

Spring mountains and pine trees, attributed to Mi Fei (1051–1107). Ink on paper, large album leaf. National Palace Museum, Peking, China. (*Pages 66–67*)
Mi Fei (sometimes known as Mi Fu) is another painter who presents problems of attribution; few paintings can be definitely ascribed to his hand. He was, however, one of the most influential of the Song dynasty masters. He was a great friend of the poet and bamboo painter Su Dongpo and they often met to drink wine and exchange poems. Mi Fei is best known for his 'dotted' mountains as seen in this painting. It is interesting to compare his wet spotted style with the dry brush of Ni Zan in the Rongxi studio (page 72).

Horse, anon, Tang dynasty (618–907 AD). Ink on paper. Bibliothèque Nationale, Paris, France. (*Below*)
In the Buddhist caves at Dunhuang in the far north-west of China, a vast number of printed sutras and Buddhist manuscripts were discovered, walled up in one of the caves of the painted and carved Buddhist site. While most of the artifacts relate to Buddhism, there are some, like this horse, which are not directly connected but may have been preliminary sketches for larger paintings.

Wild birds on the roof call insistently:
By the railing the frozen pond breaks into ripples . . .
In bed I heard the governor's drum and bugle,
Called the boy to fix my headband and hat.
Winding walks, hidden arbour—how cramped and dull!
Now a look at country meadows, the wide open spring!

(Burton Watson, Su Tung-p'o. *Selections from a Sung dynasty poet.*
Columbia University Press, 1965, p. 42)

Su Dongpo did not always complain about work, perhaps since he was lucky enough to be posted to Hangzhou (Hangchou), a town celebrated in popular rhyme as being like heaven since it is set amid mountains on the edge of a lotus-filled lake. One of the lake dykes is named after Su as he used to walk across it, one of the many painters and poets who have celebrated the beauty of Hangzhou over a thousand years. In a short poem written for a friend and colleague, he describes natural beauty in as few lines as the brush strokes on one of his bamboo paintings:

Lotuses have withered, they put up no umbrella to the rain;
One branch of chrysanthemum holds out against frost.
Good sights of all the year I'd have you remember,
But especially now, with citrons yellow and tangerines still green.

(Burton Watson, p. 112)

Thus painters and poets in China had a clear idea of what art meant to them; it was an integral part of the life of the scholar and reflected the spiritual side of a life spent in administration. Apart from this fundamental tenet, from the 6th century AD the principles of technique were clearly established. The first writings on art in China were concerned with calligraphy but in about AD 500 the painter Xie He (Hsieh Ho) described his Six Principles of Painting which have remained the fundamental rules mentioned in all discussion of technique in China. Like much early Chinese writing, his principles are open to various

On a mountain path in spring, Ma Yuan (*fl* 1190–1225). Album leaf, ink and colour on silk, height 27.4cm (10¾in). National Palace Museum, Taipei, Taiwan.

Ma Yuan is associated with Xia Gui (Hsia Kui) (*fl* 1200–30) as a man whose paintings represent the quintessence of Chinese landscape painting. Characteristic elements are the sense of space (and the isolation of the figure in the landscape), strong diagonals in composition, as in the willow branches in this album leaf, and claw-like roots to trees as also in this painting. Ma Yuan came from a painting family and became a member of the Academy of Painting at the end of the twelfth century. Nis influence on Japanese painting was enormous and he was particularly admired for his forceful brush-strokes.

interpretations and, particularly, to varied translation. Alexander Soper translates them thus: The first is 'animation through spirit consonance'. The second is 'structural method in the use of the brush'. The third is 'fidelity to the object in portraying forms'. The fourth is 'conformity to kind in applying colours'. The fifth is 'proper planning in placing (of the elements)'. The sixth is 'transmission (of the experiences of the past) in making copies'.

The third, fourth and fifth rules, applied to accurate portrayal of colour and form and good placing of parts, are all easy to understand The sixth rule is like the calligraphic training of a schoolchild. Just as in calligraphy, the painter would start by copying famous calligraphers' work and works by famous painters. First he might only copy elements of a painting, learning how to draw bare winter trees or bamboo after the style of Su Dongpo, later he would copy whole paintings. In the Ming dynasty (1368–1644) when colour printing became widespread, many books were produced which helped young painters since they reproduced, cheaply, famous paintings and copying material from well-known artists. Such books as the *Mustard Seed Garden* or the *Treatise on the paintings and writings of the Ten Bamboo Studio* were especially useful to provincial scholars who lived and worked far from the artistic centres of China. Whilst it is clear that a bad painter may never rise above his copying, a good Chinese painter had to be versatile enough to paint in the styles of past masters as well as his own. It is thanks to this habit of copying (which was also practised by apprentice painters in the West) that we have some idea of what paintings by early masters looked like since, as in the case of Wang Wei, no originals survive but there are many paintings 'in the style of' or 'after Wang Wei'.

The first two principles are more difficult. The second has sometimes been translated as 'bone-method in the use of the brush' and it describes brushwork that is firm, independent and energetic. Later Chinese writers on aesthetics devoted much space to consideration of the type of strokes used by different painters.

The first principle refers to the Chinese idea of *qi*; the breath (literally) or spirit that is in all living things, the fundamental animator of nature. The painter should be in harmony with the *qi* when painting and should express it in his work. William Acker recounts a meeting with an outstanding Chinese calligrapher whose hands were always stained with ink because of his habit of sticking his fingers into the inky end of the brush whilst painting. His explanation was that: 'in doing so the *qi* flowed down his arm and through his fingertips directly into the ink itself, and thence on to the paper where some of it would remain, animating the characters, even after the ink had dried'.

Both the first and second principles involve the artist as a person and his personal use of the brush. It may be said that through his individual brushwork and the expression of *qi* in his works, the painter rises above the mere copying of old masters and paints his own pictures.

The fourth principle of accuracy in the application of colour became almost obsolete in the characteristically monochrome paintings of scholars of the Song (Sung) dynasty (960–1279) and after. It was, however, relevant in earlier painting and to a separate group of later painters who are sometimes described as 'court' painters, 'academic' painters or painters of the 'Northern' (as opposed to 'Southern') school. The title 'Northern school' was first applied by the painter Dong Qichang (Tung Ch'i-ch'ang), 1555–1636. Looking back at Chinese painting he borrowed an idea from a split that had occurred in the Chan (better known by its later, Japanese, name of Zen) Buddhist School in the 7th century. He labelled those painters that he considered to be excessively con-

Li Bai (Li Po), Liang Kai, thirteenth century. Ink on paper, 78 × 33cm (31 × 13in). Cultural Properties Protection Commission, Tokyo, Japan.

Liang Kai was a successful painter and member of the Academy of Painting when he retired to a temple near Hangzhou and began to paint in the Chan (Zen) tradition. Chan painters wanted to express the sudden flash of inspiration that came to them and also to express the essence of an object rather than describe its surface. This portrait of one of the greatest of China's poets is minimal in brushwork yet complete in effect. Like many other of the greatest Chan paintings, it is now in Japan where the Chan painters had a lasting influence.

The Rongxi (Jung-hsi) studio, Ni Zan (Ni Tsan), 1301–74. Hanging scroll, ink on paper, length 73.3cm (28½in). National Palace Museum, Taipei, Taiwan.
Ni Zan is one of the great masters of Yuan dynasty landscape painting. Though he came from a wealthy family, he spent most of his later life on a houseboat among the lakes and rivers of south-eastern China. The austere simplicity of his life is reflected in his spare paintings and even sparer use of ink which he was said to treasure as if it were gold. He is admired for the deceptive force of his apparently faint and delicate brushwork and for his ability to 'distil' a landscape. In this example, many of the familiar and comforting elements are missing, there is no scholar sitting in the hut, no fishermen, not even a breeze to stir the stark trees or ripple the lake.

cerned with the outward appearance of things, with romantic realism and with decoration, as 'Northern' painters while those (he included himself) who looked at the inner nature of things and occupied themselves with higher ideals than mere decoration, he called painters of the 'Southern school'. He felt that it was Wang Wei, the painter-poet whose paintings are lost, who led the break away from the detailed, coloured style to become the founder of what Dong called the 'Southern school'.

Many of Dong's 'Northern' painters continued the traditions established by Gu Kaizhi (Ku K'ai-chih) (c.344–406) and the Tang dynasty (618–907), figure-painters who used colour which was often, though not always, eschewed by the scholar-painters. They painted warm, intimate scenes of children at play which were quite different from the cool landscapes of the 'Southern school'. They also excelled at bird and flower painting. The Huizong emperor of the Song dynasty who reigned from 1101–1125 was himself a skilled bird painter and it was he who set up the Imperial Painting Academy whose members specialized in the meticulous painting he enjoyed himself. Later Academy members who were admitted after taking an exam which might consist of illustrating a given line of verse (in spirit, an idea close to the heart of the scholar-poet-painters), followed Huizong's style, painting every feather on a bird, every stamen of a peony. This attention to detail was dismissed by the scholarly or 'Southern school' masters who considered, like Jing Hao (Ching Hao) in his *Notes on Brushwork*, (10th century) that detail was easy and faults in detail were the simplest to correct.

During the Ming (1368–1644) and the Qing (1644–1911) dynasties, the two styles, academy painting of birds, figures and flowers and the scholarly landscape style co-existed though they rarely touched. Apart from a number of individuals who painted in very personal styles, untouched by dominant trends since they had isolated themselves from the world in monasteries or retreats, these two styles of decorative or monochrome landscape have persisted until the present day. Though artists in contemporary China are concerned that their art should 'serve the people' and should be relevant to present-day concerns of ordinary people, they find much of their inspiration in this joint heritage. Art schools in China today train their students in oils, gouache and pencil but continue to teach traditional painting in the traditional way, by a long period of copying and learning from masters past and present.

In complete contrast with the defined and important place of painting in Chinese society, sculpture has no social position at all. This did not mean that the Chinese had no concept of space or form but, in general, these concepts were best exercised in the creation of the Chinese garden with its disappearing vistas and piled rocks, rather than in the creation of monumental stone sculpture. Though painters were often well-known and respected, all sculptures were anonymous and unsigned. Of all the arts only painting was respectable; sculpture fell into the category of applied art and was made by craftsmen who never achieved individual reputations. Even jade-carvers were regarded as artisans.

Apart from the dominance of painting which excluded sculpture, the Chinese did not have much of a monumental tradition either, which might have accorded an important position to sculpture. This lack of monumentality has existed in Chinese architecture since at least the 2nd century BC. By that time, though craftsmen were quite capable of building in brick or stone and producing permanent monuments, they preferred building in wood, perhaps because of its specific qualities like receptiveness to paint (as colour has always been important in Chinese architecture) and to carved decoration. Both in architecture and in sculpture, an important step was the introduction of Indian Buddhism

Landscape after Mi Fei, Cha Shibiao (Ch'a Shih-piao) (1615–98). Album leaf, ink on paper, 24 × 32cm (9½ × 12¾in). Cleveland Museum of Art, USA. (*Left*)
Cha Shibiao is often classed with Hongren (Hung-jen) (1610–63) as one of the 'Four Masters of Anhui', after the province in which he lived. In this album, Cha painted landscapes in the style of many of the great masters of the past, steeping himself in their styles and techniques in order to perfect his own. Painting in the style of Mi Fei implies following the very characteristic drawing of mountains without outline, their form suggested by soft, wet brush-strokes called 'Mi dots'.

Dragon, attributed to Muqi (Mu Ch'i), *fl.* mid-13th century. Hanging scroll, ink on silk. Height 123.8cm (48½in). Cleveland Museum of Art, USA. (*Below*)
Muqi, like Liang Kai, retired to a temple to paint Chan paintings in the hills around Hangzhou. This dragon scroll is infinitely less calm than his other paintings, filled with swirling clouds and the ferocious beast itself. The dragon is, in fact, a relatively benevolent symbol in Chinese art, associated with water, rain and clouds, often representing the spirit of a river which can be tamed with offerings. Again like Liang Kai, many of Muqi's greatest paintings are preserved in Japan where the range of subjects he treated can be seen in all its variety, from the grand Guanyin (Kuan-yin) Goddess of Mercy to a tiny study of six persimmons.

into China during the 1st century AD for the religion brought with it a concept of monumentality to glorify the pantheon and impress the faithful. Indian Buddhism brought the pagoda and pailou memorial arch (both forms that Chinese builders made very much their own) and the concept of iconography which affected painting styles as well as increasing the possibilities of sculpture in stone, lacquer and metal.

Before the introduction of Buddhism, stone sculpture existed in China but was perhaps confined to use in burial and architecture. Many of the solid stone animals which have been found in Shang dynasty (c.1550–c.1030 BC) tombs have holes in their backs, indicating that they may have served as supports for wooden structures. The animals are carved from square blocks of stone and retain the squareness of the uncarved block. They bear surface decoration which is close to that on contemporary bronzes. Later burial sculpture includes the massive horses of the Han dynasty (202 BC–AD 220), precursors of the impressive animals that stand along the avenues leading to royal tomb enclosures of the Tang (AD 618–907), Ming (1368–1644) and Qing (1644–1911). Towards the end of the Han, however, Buddhism greatly affected the rather small scope of Chinese sculpture in stone.

The indirect influence of Buddhism was great. Its direct impact was restricted in time and hardly felt after the 10th century AD. The Chinese of the 1st century AD had established a family system and concomitant social structure which made monastic Buddhism difficult to accept since leaving the family and entering a monastery meant that ancestral family spirits would not be fed at festivals, aged parents would not be cared for and the family would die out. Thus monastic Buddhism underwent a transformation in China which produced such schools as the Chan (or Zen) sect which stressed sudden enlightenment and did not imply withdrawal from society. Apart from such drawbacks, Buddhism did bring into China a pantheon which meant concrete representations of good and evil gods. In religious art this was important since earlier Chinese beliefs had been abstract but Buddhism with its statues and paintings illustrating the life of Buddha and hells for the wicked was more accessible to ordinary people and it influenced the growth of religious Taoism which took over the idea of a pantheon for the instruction of the illiterate.

The earliest great contributions of Buddhist art in China are still very

Landscape, Shao Mi (*fl.* 1620–40), dated 1638. Leaf from album of landscapes, ink and colour on paper. Seattle Art Museum, USA.
Shao Mi was often grouped with those of the Wu school like Wen Zhengming. He and his contemporaries, however, are noted for their innovative techniques and approach in which they disregarded much of the previous monochrome convention and laid more emphasis on colour and wash and on representation of actual places. Shao Mi was a noted poet and calligrapher, closely associated with other literati. In this album he made a pictorial record of the divine fairy land that he often saw in his dreams, though the places illustrated are not unfamiliar Chinese landscapes.

Indian in form and style. The huge rock-carvings at Yungang (Yunkang) in northern China, begun in 460, are solid and simple. It has been suggested that this is because the Chinese sculptors, working on an unfamiliar scale and on an unfamiliar icon, were not entirely in control of their work. This may be so but the figures gain, both from their site and their primitive simplicity. The great Buddha, in the attitude of meditation, sits 13.7m (45ft) high, against a yellow cliff and the blue sky, staring out across a dry river bed to the bald hills.

In contrast with the solid, simple figures of the earlier Yungang caves, the next great Buddhist project at Longmen (Lung-men) near Luoyang (Loyang) reveals a fine assertion of Chinese linear design. In the earliest caves, finished in 523, there are particularly beautiful relief panels with a light, almost painterly quality of line and lively grouping of slender, curving figures. The similarity of treatment between these panels and contemporary painting indicates a Chinese control of stone carving and of the Buddhist images.

If the earliest Longmen caves reveal such Chinese mastery of an imported art form and imported iconography, later figures at the same site show a further wave of imported influence. Indian images were brought back to China by pilgrims such as the monk Xuanzang who returned to China in 645 bearing sutras and carved figures. The massive Vairocana Buddha at Longmen (carved in 672) is more softly draped than the Yungang Buddha, rounder and more sensuous in form. The attendant figures, too, are livelier than at Yungang, with raised legs and scowls to protect the Buddha. This second period of influence from India caused some critics to accuse sculptors of carrying the sensuous style too far, making their figures look more like dancing girls than gods. During the Tang dynasty (618–907), opposition to the great wealth and power of Buddhist monasteries eventually caused a decline

in the faith, from which it never recovered. Such massive cave carvings were no longer commissioned by faithful Emperors and stone carving in China shrank both in scale and importance.

After the decline in Buddhist carving, it was necessary to look for other forms of sculpture. This was also true in the period before the arrival of Buddhism when, lacking a monumental tradition, artisans used bronze, lacquer and ceramics rather than stone. Though in all these materials utility was the main aim, food vessels bear surface decoration or were themselves formed into animals and may be considered as sculpture in so far as function is finally subservient to the overall, three-dimensional design.

Bronzes are the most important extant art form in China from c.1550–202 BC. The word 'extant' is important since we have to rely on what has survived in the tombs of the period and writings that relate to daily and spiritual life. There may have been other art forms of equivalent interest to the early Chinese but they have either not survived or not yet been unearthed. From literature we know that bronze vessels were used in daily life for sacrificial offerings to the supreme god to ask for blessings on wars, hunting expeditions and the safety of the dynastic rulers. It seems clear that after vessels of bronze had played such an important part in daily life, they were included in royal tombs for the same reasons since the Chinese believed that the spirit survived after death and was subject to good and bad influences from gods and other spirits. The vessels are almost all containers for food and wine or used for the preparation of such offerings. The tripod forms were used to heat food and wine for the Chinese preferred their wines heated, just as the Japanese drink warm *sake*.

The origin of bronze casting in China is, as yet, something of a mystery. It is common to assume that the introduction of new technology in the ancient world meant borrowing from neighbouring civilizations but Chinese metal technology was quite different from contemporary western Asiatic bronze working and thus implies a separate development. For example, the earliest bronzes in China seem to have been cast in ceramic moulds. In every other bronze age civilization, the progression is from beating or forging to, eventually, casting. Casting did not develop in Europe until many centuries after forging. It is not only in the technique of casting in complex piece-moulds that Chinese bronzes are separate from other local bronze industries, for the alloys used in China were also very different. Early western Asiatic bronzes were composed of a stable alloy of 90 per cent copper and 10 per cent tin while Chinese bronze contained a varying amount of tin, from 10 per cent to 20 per cent and lead was also added in varying quantities from 1 per cent to 18 per cent. The use of lead may have been consequent upon the casting since it reduces bubbles which would have prevented contact between alloy and mould.

The ceramic industry in early China must have helped the development of casting since control of high-temperature kilns could have provided the expertise needed to use high-temperature furnaces in alloy production. The moulds used were pottery and many parts have survived. It seems likely that a pottery model was made first, then a mould was formed around the model. The moulds were made in parts, with each part carefully dowelled together with the next. The core, forming the inside of the vessel, may also have been of clay but since none has so far been unearthed it is assumed that the core was broken to remove the vessel from the mould. In the earliest bronzes there was no decoration on the interior, only on the exterior of the vessels. By the late Zhou (Chou) (c.1030–256 BC), long inscriptions are found inside vessels

Vase of flowers, Chen Hongshou (Ch'en Hung-shou) (1598–1652). Hanging scroll, ink and colours on silk, 236.2 × 68.5cm (93 × 27⅝in). Metropolitan Museum, New York, USA.

Chen Hongshou was particularly famous for figure painting, a genre that had been almost ignored by the scholar-painters. He was also associated with illustrated books, producing among other things a set of designs for woodblock illustrations to the novel *The Water Margin*. His figure and flower paintings all show a fondness for the unusual, both in form and design, just as in this painting where, apart from the flowers, there is a miniature mountain, one of the fantastically weathered stones that were placed in gardens and even inside houses to recall the real landscape outside.

Head of a Bodhisattva, begun in the Northern Wei (AD 386–535). Cave 3, Yungang, Shanxi (Shansi) province, China. (*Above*)
The massive Buddhist cave carvings at Yungang were begun at the instigation of a monk called Tanyao in 460, taking their inspiration from Indian Buddhist rock carvings at Bamiyan. The full, fleshy face of this Bodhisattva also suggests a close following of an Indian model since the Chinese took some time to develop their own style of Buddhist sculpture. The Bodhisattva of cave 3 stands to the left of a Buddha figure and is much smaller since Bodhisattvas were those who had achieved nirvana but chose to remain in the world and help mankind.

which describe events in the life of the person the vessels were buried with. It seems that bronzes were quite often cast to commemorate events such as feudal enfiefments and when the feudal lord was buried, this record of his land and slave-holdings was buried with him.

Though the connections between the bronze and ceramic industries in early China are clear, the social importance of bronze workers was emphasized in the excavation of the Shang (1555–c.1030 BC), capital of Anyang where the better houses of the bronze artisans indicate that they may have represented an aristocracy amongst craftsmen. Yet, by the end of the Zhou period, bronzes had been replaced, first by lacquer in the Han period and then increasingly by ceramics. In burials, the Chinese had become increasingly concerned about the expense of burying precious metals and began to replace them with ceramics which were cheaper to produce in large quantities. In daily life, too, the beginnings of glazing, well-established by the early Han, and developments towards porcelain production meant that water-tight, relatively heat-proof vessels were in common use.

China is perhaps most famous for the invention of porcelain (perfected in the Tang, AD 618–907) some thousand years before Meissen managed to make it in the West, but all types of ceramics have provided scope for modelling. As ceramics began to dominate, all the funerary furniture that was provided in tombs—possessions, food, food vessels, even servants and horses (sacrificed in the royal Shang tombs)—was reproduced in pottery. Though the figures were mass-produced in piece-moulds, their character was not lost or reduced.

In decorative miniature sculpture, the Chinese made extensive use of jade, a hard-stone common in many stone-age cultures but which in China survived the neolithic to assume an elevated place in art. Jade is the name used for two hard-stones, nephrite and jadeite (the latter, imported from Burma, only appeared in China during the 18th century). They are extremely hard to work as their crystalline structure is

densely interlocked and it must have taken the early Chinese craftsmen months to work on a piece with only bronze tools and sand abrasive. The use of nephrite in the stone age in China is particularly interesting since the material is not found in China but across the Gobi desert near lake Baikal and Khotan. There must have been neolithic trade or exchange across northern Asia for the Chinese to obtain it. Later it came to signify the virtues of a Confucian gentleman: 'Charity is typified by its lustre, bright yet warm; rectitude by its translucency revealing the colour and markings inside; wisdom by its pure and penetrating note when struck; courage in that it may be broken but not bent; equity since it has sharp edges which harm no-one'. It is commonly used in

Magnolia, Wen Zhengming (Wen Cheng-ming) (1470–1559), dated 1549. Handscroll, colour on paper, 28 × 132cm (11 × 52¼in). John M. Crawford Collection, New York, USA. (*Above*)
Wen Zhengming was one of the amateur-scholar painters who came to be known as the Wu school, after Wuxian, in the Yangtze delta, where many of them lived. Wu school members were influenced by many of the past masters and yet are famous for their own free and expressive brushwork. The magnolia was painted for a friend, Hua Yun, who shared Wen's love of the flower. The colophon (in Wen Zhengming's hand) reads: "In the third month of 1549 of the Jiajing era, the magnolias in the courtyard were just hesitantly beginning to bloom; fragrant and lovely. So I painted this for the fun of it."

Crab and shrimp, Shen Zhou (Shen Chou), 1494. Album leaf, ink on paper. 34.7 × 55.4cm (13½ × 22in). National Palace Museum, Taipei, Taiwan. (*Opposite below*)
Shen Zhou (1427–1509) was the teacher of Wen Zhengming and a very important member of the 'Wu school'. He is most well-known as a follower of Ni Zan who he copied carefully and accurately, although he developed a style of his own which is far more intimate than the bare, frosty style of Ni Zan. In this album leaf, the crab and shrimp are painted in the 'boneless' style, without a hard ink outline. The colophon implies that he treated such studies as fun, but not as serious works. Later painters, such as Qi Baishi (Ch'i Pai-shih) (1863–1957), also painted such 'boneless' shrimps, so the careless approach of Shen Zhou has become part of the Chinese tradition.

Massive stone figures from the Ju xian si cave at Longmen. Tang dynasty, 618–906 AD. Near Luoyang, Henan (Honan) province, China. (*Left*)
The Buddhist carvings at Longmen were started in 494 at the order of an Emperor of the Northern Wei. The work was continued throughout succeeding dynasties, particularly under the Tang. These two figures, the favourite disciple of the Buddha, Ananda, and an attendant Bodhisattva (wearing a crown) stand to the right of the largest figure in the Longmen group, a Vairocana Buddha, 17 metres (56 feet) tall. This group of massive figures was started in 672 and was originally protected by a wooden structure. The central figures are quite upright and serene, revealing the sculptor's new mastery of carving in the round whilst the flame halo and low relief carvings demonstrate the native Chinese linear design.

Head and shoulders of a horse, Han dynasty, 202 BC–220 AD. Jade, 18.9cm (7½in) high. Victoria and Albert Museum, London, England. (*Right*)

By the Han, jade had lost its ritual significance and begun to assume the paramount position that it still holds in Chinese art. Throughout the ages it has been used in jewellery and decoration but for the scholar-painter it was attractive both because of its beauty and because of its association with high antiquity. Small animal carvings were made to be carried about and handled for jade remains cool and smooth to the touch at all times. The aristocratic horse, similar in modelling to the bronze 'Flying Horse' of Gansu, shows that with the introduction of iron tools and rotary cutting discs, the Han lapidary could sculpt the hard stone fully in the round.

Sākyamuni and Prabhūtaratna, Northern Wei, 518 AD. Gilt-bronze, 26cm (10¼in). Musée Guimet, Paris, France. (*Right*)

This small, gilded bronze image represents a meeting between the Buddha of the remote past and the historic Buddha (Sākyamuni) when Sākyamuni preached the Law. Such small figures were probably commissioned in large numbers as devotional acts by the faithful. The attenuated linear treatment of the figures and the flame mandalas, the sweeping folds of their clothing and elongated necks are all closer to contemporary painting than to the massive stone sculptures of the period. The slenderness of the figures, the swirl of the draperies and their position above the animals and plants of the base, emphasize the other-worldliness of the meeting depicted.

girls' names or in literature and poetry to describe female beauty or the beauty of a mountain pool. Amongst the Chinese in Hong Kong today it is also considered to be protective; if a woman breaks a jade bracelet, the bracelet has protected her from breaking her arm. This belief in its magical powers goes right back to the late Zhou period when it was believed that jade would prevent bodily decay after death.

From the bronze age onwards, most jade carvings have been small, perhaps because of the difficulties of carving and the expense of the material but also because many pieces were made for personal adornment or for carrying around in the pocket or placing on writing tables. This use of jade for personal decoration and household ornament stands in contrast to the way that paintings were used in China. Often the only paintings hanging permanently would be the ancestral portraits over the shrine in the central room of a house. The scholar-poet-painter pictures, especially handscrolls, were intended to be examined amongst friends, rolled out bit by bit across the study table or hung on a wall but not for long. This active appreciation of painting is very different from the attitude to sculpture. To the educated man, sculpture on the grand scale might be considered to be either part of popular religion and restricted to temples or royal tombs or else it was decorative, three-dimensional wall-paper. Whilst the jade-carvers excelled in their miniatures and the ceramic sculptors furnished beautiful and practical objects, sculpture in China was not considered art in itself.

Guanyin (Kuan-yin) with attendant. Bronze. (*Above*)
The figure standing on the lotus is that of Guanyin, the Chinese Buddhist version of Avalokitesvara, a Boddhisattva dedicated to relieving the suffering of mankind. In China, Guanyin assumed a definitely female form although the Indian Boddhisattvas and their representations were not particularly differentiated by gender. Because Guanyin's attributes of mercy and compassion were seen as particularly feminine, the Chinese represent her as female and in popular Buddhism she became the helper of barren women, of those in labour and more generally a female goddess. In one way, however, she did not wholly change sex since she is never shown with bound feet. After the Song, Chinese women's feet were invariably bound unless their economic status was so low that they were required to do heavy work that would have been impossible with 'lily feet'.

Goddess. Porcelain, height 24cm (9½in). British Museum, London, England. (*Left*)
This slender figure is made of white porcelain of a type usually known in the west as 'blanc de Chine'. The ware was produced at Dehua in Fujian (Fukien) province on the south China coast. Such white porcelains were produced in Dehua from the Song onwards but reached a peak of popularity in the 17th and 18th centuries. As Fujian was an area in which Buddhism persisted long after it had lost its influence elsewhere, many of the Dehua vessels are incense burners and the figures are usually of Buddhist deities. The Dehua kilns did not produce 'imperial wares' destined for court use, but nevertheless they reached a very high standard, particularly in figure moulding as this gently curved form demonstrates.

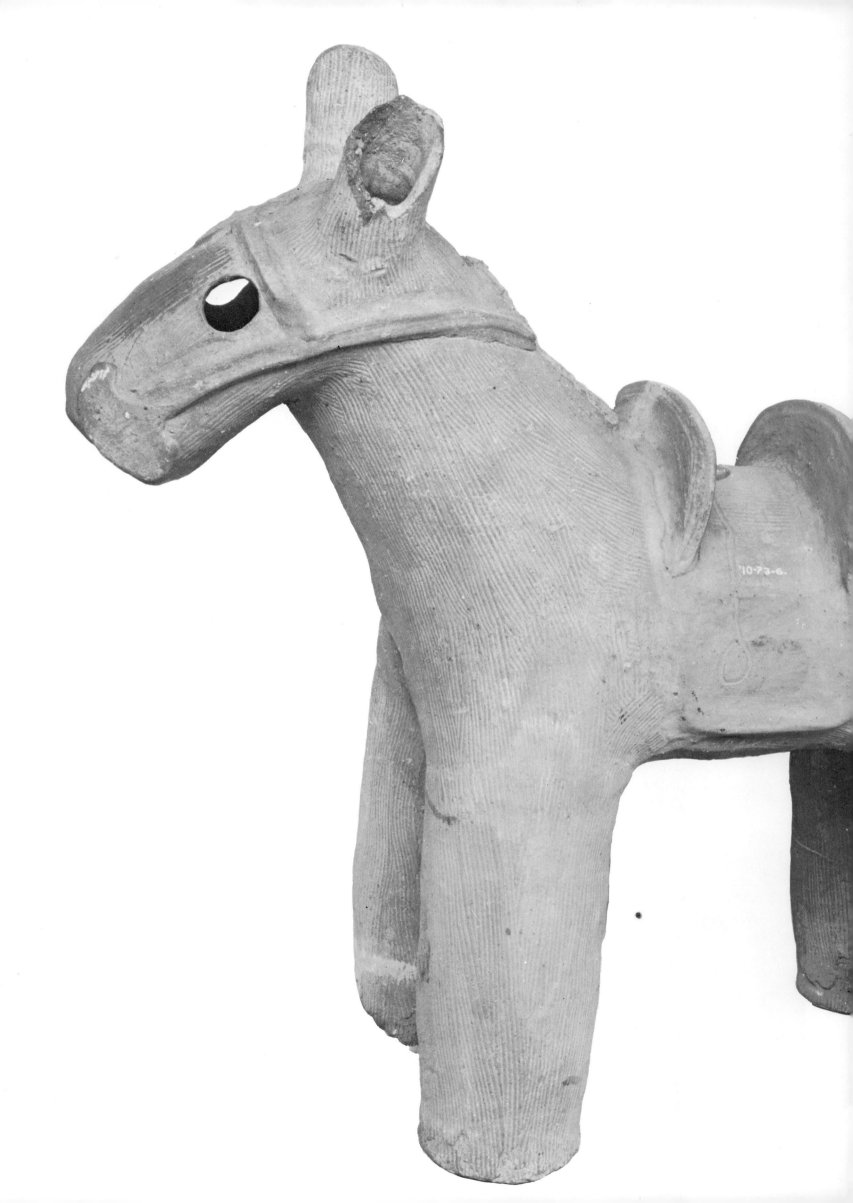

ORIENTAL ART
Japanese

Scholars are still arguing about when the early neolithic way of life in Japan gave way to a hunter-gathering, pottery making existence. It seems that as long ago as 7000 BC, simple pottery of a type which later evolved into the complex *Jomon* pottery was being made. *Jomon* means 'rope-impressed' and describes its primary decoration. Its makers, now known as the Jomon people, must have lived in a state of comparative stability and peace, for their pottery wares gradually developed, growing steadily more elaborate and fantastic, until the great change took place in the 3rd and 2nd centuries BC.

The succeeding Yayoi peoples may have come from Korea to Kyushu, the southern island of Japan, and then moved northward. They seem to have been related to the peoples of southern Asia, and they brought with them a truly agrarian culture (whereas the Jomon peoples had only just begun agriculture) based on wet-rice cultivation. The Yayoi people also brought with them the use of bronze and iron, and some knowledge of mainland technical achievements, mostly from Korea and the China of the Han dynasty. Many authorities consider the Yayoi as ancestors of the modern Japanese; it is not likely that the Ainu people, displaced to northern Japan, descend from the Jomon.

By the late 3rd or early 4th centuries AD the country had been more or less unified by a horse-riding nobility, organized by powerful chieftains who left great keyhole-shaped tumuli. These contained imported as well as native grave goods, of iron, bronze, jade, shell and stone, and were sometimes painted within. They were guarded by the modelled tube-construction pottery figures known as *Haniwa*.

The introduction of Buddhism from Korea in the 6th century AD started another radical change in Japanese history and art that was to have very far-reaching effects. At first the new religion existed side by side with the native Shinto (the way of the Gods), just as the culture of the Tumulus people (e.g. their *Sue* pottery) co-existed with the new centralizing Buddhist rulers of south eastern Japan. When Buddhism after some vicissitudes became the state religion, Shinto and Buddhism established a curious form of symbiosis that has continued until today.

In 592 the new centralized government at Nara, under the leadership of the Regent, Prince Shotoku, began to build a series of Buddhist temples, and to endow them with works of art. No temples from this early (Asuka) period survive, but some works of art of this period still exist in the earliest surviving temple, the Horyuji. The Horyuji was

Detail of the Choju Giga, a scroll of 'Frolicking animals'. Artist unknown, c.1130. Height 32cm (12½in). Kyoto National Museum, Japan. (*Right*)
The scrolls in this series may have been political satires of some sort. They demonstrate the love of caricature that runs through Japanese painting, as well as the deceptively simple-looking line drawing that is so important later. Drawing is done with a brush, using carbon ink ground up in water, and the pressure exerted on the brush controls the thickness of the line, which can vary in the course of its length. The density of the colour is controlled by the dilution of the ink.

Tomb-figure of a horse, Haniwa c.AD 400–500. Royal Scottish Museum, Edinburgh, Scotland. (*Previous page*)
Pottery figures such as this horse, based on a construction of tubes modelled into shapes, were used to decorate the outside of tumuli of important personages in the period c.200–500 AD: they were not grave-goods. Many such figures are known. This one tells us about horse-trappings, and others tell of armour, dress, houses, boats and implements used by the people of the day. Figures of animals are especially common and have great vigour and a sense of movement and life about them.

The Bodhisattva Fugen on an elephant, Heian period. Freer Gallery of Art, Washington, USA. (*Below*)
Still dependent on T'ang Chinese prototypes, this idealized 'portrait' is of the most formal type. Hanging scrolls were much in use in monasteries in the Heian period, but did not appear commonly in secular buildings until the 16th century. Buddhist paintings, especially of the Shingon sect, were objects of veneration. Fugen, riding on a six-fanged white elephant, personifies the teaching, meditation and spiritual practices of the Buddha and is the protector of devotees of the Lotus Sutra.

burned down in 670, but much of it was rebuilt before 700; it was finished in 711 and stands today, the oldest wooden building in the world. By this time, the influence on Japanese Buddhist art was more Chinese than Korean, and the Horyuji gives us a good idea of Chinese architecture of the 7th century.

But the earlier statues now within Horyuji depend on the Longmen style of north China as passed on via Korea. Two of these statues are the work of one master-craftsman, Tori, a member of the saddlers' guild. The Shaka Triad was commissioned in 623, and the Yakushi Buddha a little later. Both have a frontal concentration, and an emphasis on the linear, particularly in the pleated folds of dress, that had already been superseded in China. Both statues are of bronze which has been finely chiselled after casting, and gilded.

The Horyuji also contains much early painting. The wooden Tamamushi shrine, which may be a little earlier than the existing buildings, is a portable shrine, about 2m (7ft) tall, decorated with paintings from the Lotus Sutra, possibly in lacquer. Oil-based pigments were used on the dry plaster walls of the Kondo (Golden Hall), to create murals of paradise, in Chinese T'ang style. These beautiful paintings were destroyed by fire in 1949.

The 8th century, the Nara period, saw a great increase in Buddhist art, including the vast bronze Buddha in Todai-ji completed in 757 (though since almost completely re-made), and the increased use of other techniques of statuary—wood, either gilded or lacquered, painted clay, and *Kanshitsu* or dry lacquer, in which the outside of an image was built up of lacquer-soaked cloth, over a core which might or might not be removed. Nara period sculpture looked more directly to China for inspiration, and concentrated on the depiction of movement while retaining the pleasure in detail of the Asuka period. The eventual settling of the court at Nara resulted in the building of many monasteries that became politically powerful, rivalling the Fujiwara family who were now the leading aristocratic family more or less controlling the Emperor. Court etiquette and governmental methods were closely modelled on Tang China—even the city of Nara was laid out on the grid system, copying Ch'ang-an.

The Emperor Shomu's treasure, donated to Todaiji in 757, and still housed in the Shoso-in, included many paintings in T'ang style as well as applied arts, furniture, pottery, musical instruments, textiles and so on, some of which were of native origin (though usually imitating T'ang originals) and some imported—even glass from Sassanian Persia. Written works of the period include the *E-inga kyo*, a handscroll of the Causes and Effects sutra, which has continuous illustrations above the text.

In 794, the growing political power of the great Nara monasteries was so great, that the court moved to Heian-kyo, the modern Kyoto

which city was also laid out as a vast grid. In the following era, usually known as the Heian period (794–1185) the Fujiwara family dominated Japanese court life, and government. The Fujiwara were not only politically very astute, continuously marrying their daughters into the Imperial family, but were very considerable patrons of the arts, which flourished throughout the period. Court life was extremely formal and centralized: partly, of course, this was to avoid provincial rivals becoming too powerful. This inward-looking court life has been wonderfully described in the 10th century novel *Genji monogatari* (*The Tale of Genji*) by the court lady Murasaki Shikibu. Etiquette was of enormous importance, and led to a court art of great refinement that centred round poetry and calligraphy. Chinese calligraphy had arrived in illiterate Japan in the 6th century; it is perfectly unsuited to the Japanese language (which is of totally different origins from that of China) but was eagerly absorbed. Calligraphy, with its insistence on line as the major feature, became the basis of Japanese painting, just as it had in China. One exception to this, however, is an important style of painting which was much used in the Heian period for illustrating stories, on handscrolls (which are, in effect, books), such as the *Tale of Genji*. This style, the Yamato-e style, used straight lines for its basic formation: the viewpoint is usually downward, into buildings which lack roofs, and are constructed (as in real life) on a rectangular module. Within these angled rooms, the elegant court life is depicted in thick opaque pigments with minimal delineation of facial features. The earliest examples extant are 12th century. No secular painting other than handscrolls

The Golden Pavilion, Kinkakuji, Kyoto, Japan, first built in 1397.
This was originally partly a chapel for a monastery, built by the Shogun Yoshimitsu (1358–1408), as well as a waterside pavilion to be used for relaxation. Yoshimitsu was a collector of Chinese Sung dynasty paintings, in which such pavillions were often depicted, but the details of the architecture show a considerable variation from Chinese origins. A Japanese eclectic use of different styles results here in a most effective and beautiful building.

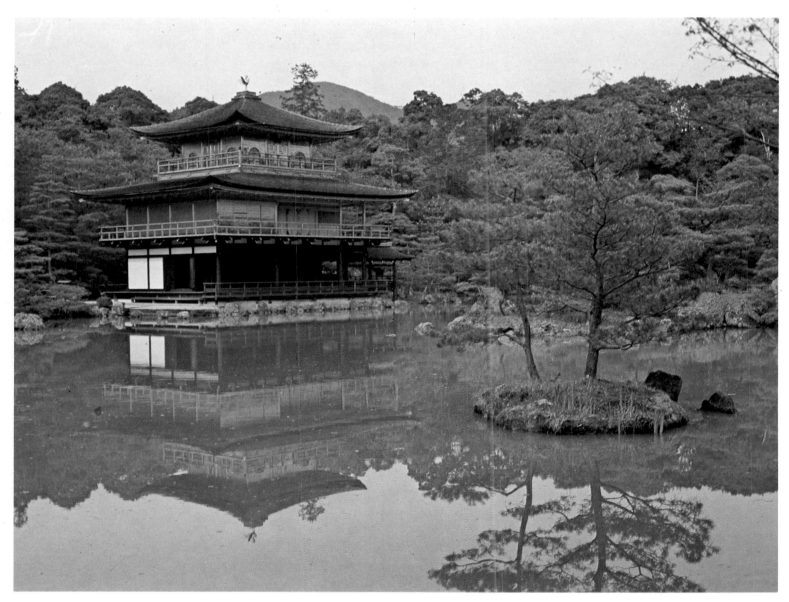

Genji playing Go, section from a handscroll of the Genji monogatari, 12th century. Height 22cm (8⅝in). Tokugawa Museum, Nagoya, Japan. (*Right*)
The conventions of the Yamato-e style are well shown in this scene where two ladies watch a game of Go; the downward view through open roofs; the diagonals powerfully indicated to break up the visual areas; the thick opaque pigments; the emphasis on decorative designs such as the dresses and the simple delineation of faces.

Mountain Landscape, attributed to Shubun, early 15th century. 88 × 33cm (35 × 13in). Seattle Art Museum, USA. (*Below*)
No paintings certainly by Shubun survive, but his style is represented in this beautiful landscape as the first offshoot of Chinese painting into a Japanese style, that paved the way for Sesshu. Ink painting depends on calligraphy for the components of its structure: this makes the emphasis on line stronger than that on colour, which is usually very muted. Perspective is vertical, not geometrical: basically, the higher up the picture, the further away. In subject, such pictures dwell upon the insignificance of man.

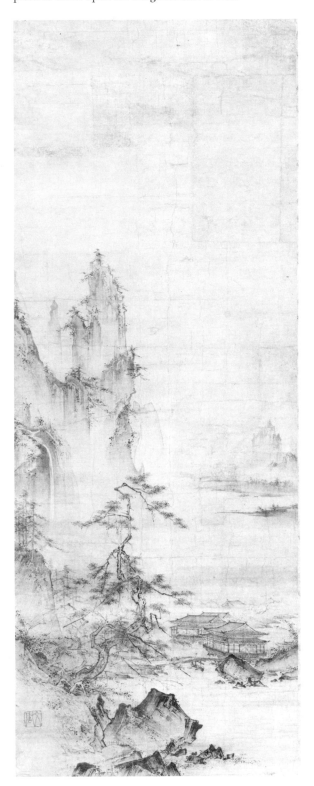

survives, but we know that screens and doors were painted with landscapes during the Heian period, for they are depicted in the Genji scrolls.

Buddhism was enriched by the introduction of new sects from China. The Shingon sect encouraged formal representation of the Buddhist personages, for it held that any figure of a deity must itself be that deity. Painters, therefore, had to be monks, and this was to be the normal thing for some centuries. The Tendai sect, believing that all creatures are held to be equal before the Buddha, encouraged paintings of nature and of animals, while the Pure Land sect tried to depict paradise.

At first Chinese in style, these Buddhistic paintings took on a Japanese flavour or character, that is first well seen in *The Death of the Buddha*, of 1086, in Kongobu-ji, where the animal mourners are as important as the human, and there is a decorative effect to it that is purely Japanese. This pattern becomes a standard one in Japanese art history. Elements of an art form are taken from outside (usually from China) and developed in a special way into something peculiarly Japanese. This is nearly always of a somewhat stylized and sophisticated elegance, and is avowedly decorative in effect, contrasting, perhaps, with the more austere approach of the Chinese.

The handscroll developed also as a method of telling Buddhist stories, which are often somewhat in caricature style, in contrast to the Yamato-e. The love of the depiction of genre scenes, so evident in such Buddhist tales as the story of the Flying Granary, and of satire such as the animal scrolls, the *Choju giga*, is recurrent throughout Japanese painting. In these handscrolls, read from right to left, the pictures may be separated by panels of text, or merely by some visual device within the painting, and the protagonists may reappear many times, even twice in the same scene.

Buddhist sculpture in the early Heian period was massive and formal, stationary and over-dignified in contrast to the more mobile effect of Nara period figures; only in the later Heian does a softening of this ponderous style appear in favour of a delicate and more detailed approach made possible by the use of jointed wood, instead of a single block.

The power exercised by the Fujiwara was waning, and by the end of the 11th century they were unable to control the power of the provincial clans. Civil war followed, with the Taira family seizing power only to lose it to the Minamoto after the battle of Dannoura (1185).

Minamoto Yoritomo moved the seat of his *de facto* government to Kamakura, leaving the Emperor and his court in Kyoto. This fact accentuates the split between the actual government and the puppet Emperors. In 1192 Yoritomo took the title of *Sei-i tai-Shogun*, 'Barbarian-

subduing great general', which title persisted, abbreviated to *Shogun* until the Meiji restoration of 1868. However, amid civil war, the Shoguns themselves became hereditary puppets of the Hōjō family, who acted as Regents. All attempts by either the Emperors' faction or that of any other family were firmly crushed, and the Kamakura period military government, the *Bakufu* lasted until 1333.

The legacy of the Fujiwara rule of the Heian period was a respect for the arts that was one of the tenets of the military class of Japan, the *samurai*. An educated man was equally at home with the writing-brush and the sword. This understanding of, and participation in the arts, usually through calligraphy, has remained a permanent feature of Japanese life, eventually spreading throughout all classes of society.

Formal Buddhist art in the Kamakura period was at a low ebb : images became static and formalized with no new stylistic approach. This is slightly surprising, as Chan Buddhism (Zen, in Japanese) had recently been imported from China. Zen was not to have a great effect on the arts until the Muromachi period. However, Buddhist handscrolls achieved a new openness of design and layout that was an important influence on later painting. This was partly due to the monk painters in the great monasteries. The Abbot of Kozan-ji in particular, Myoe-shonin, encouraged such painting and collected Chinese paintings as models. The Kamakura period handscrolls do not rely on opaque pigment, but use delicate wash techniques that allow the under-drawing to be seen. Myoe's portrait, by a pupil, sets the figure in a landscape—a new departure for the Buddhistic portrait that was to have far-reaching consequences.

Secular scrolls tell stories of wars (the *Heiji monogatari*) and of the lives of statesmen. Some of these statesmen are depicted in portraits either painted (for example Minamoto Yoritomo by Fujiwara Takanobu) or carved in wood (Uesugi Shigefusa).

Continual internal struggles to retain power, and the effects of two attempted invasions of Japan by the Mongol emperor Kublai Khan in 1274 and 1281 weakened the Hōjō rule. Although the second invasion was repelled after the Mongol fleet was destroyed by a typhoon (the original *Kamikaze* or divine wind) the Hōjō regents lost their power in

Ama-no-hashidate, Sesshu Toyo (1420–1506), painted between 1502–1506. 88 × 168cm (35½ × 66½in). Commission for the Protection of Cultural Properties, Tokyo, Japan.
Although Sesshu here depicts a real place, the beauty-spot 'The Bridge of Heaven', and even indicates the name of various temples etc, which almost never occurs in Chinese painting, this is very much a painting in Sesshu's own variant of Chinese styles. Only the mountains in profile in the foreground depart from this. This painting, late in Sesshu's life, is a synthesis of his own styles.

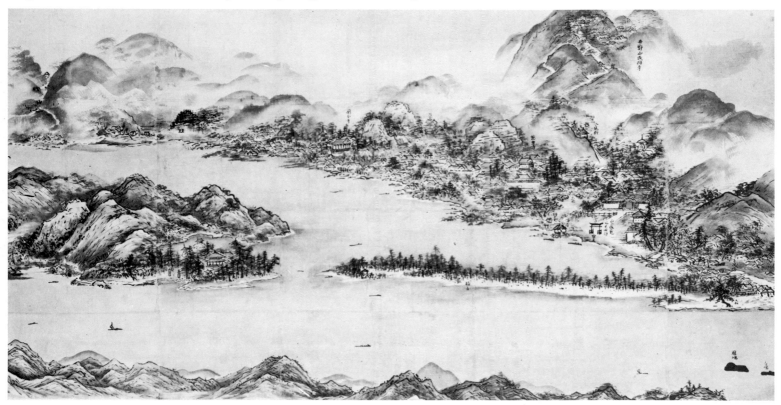

Part of the Maple Tree sliding doors, by Hasegawa Tohaku (1539-1610). Height 175cm (59¾in). Chishakuin, Kyoto, Japan.

The success of the Kano school decorative style caused a spate of rivals to appear, who painted decorative secular paintings. The styles of these artists were variants of Kano style but in degree: Tohaku was, like a Kano artist, equally at home in ink painting and in gold-leaf background decorative paintings. These sliding doors cover a whole wall of a room—they are the wall—and provide a very dominating decorative effect.

Lion dogs, six-fold screen attributed to Kano Eitoku (1543–1590). 225 × 459cm (7ft 5in × 15ft). Imperial Household Agency, Tokyo, Japan.

To Eitoku is attributed the invention of the gold leaf background to paintings which used both ink line and opaque colour. The wonderfully decorative effect suited the Kano school style, with its emphasis on decoration, and also the taste of the patrons of the school, the successive military dictators. In fact, the Kano retained the interest in its origins in Chinese styles, and all Kano artists were well trained in ink painting in the 'classical' manner.

1333 to an abdicated Emperor Go-daigo, who lost it in turn to the Ashikaga family. The Ashikaga family were Shoguns throughout the Muromachi (1392–1573) period, which was one of almost continual civil war.

The monk painters of Kyoto now started to look to China for a different sort of painting—ink painting. No longer narratives or portraits, these ink paintings are of the natural world, landscape, flowers and birds, or bamboo. Often man's diminutive place in the scale of nature is carefully depicted. This style largely derives from Chinese Sung painting, and relies on the brushstroke for depiction of line—there is little interest in colour. As in Chinese painting, there is no attempt at chiaroscuro, and perspective is vertical not geometric—that is, the higher up the picture, the further away from the viewer.

The earliest exponents of this style, Josetsu, Bunsei, Mincho and others were painting in a copied Chinese style. It was not until the return of Shubun from Korea in 1424, and, even more importantly, of Shubun's pupil Sesshu from three years in China in 1469, that this style began to become Japanese. Sesshu had been a member of the Chinese Che school, but was able when he returned to adapt to a new style, his innovative ink style that revolutionized Japanese painting and laid the foundations of the two secular schools, the Kano and the Ami schools.

The hanging painting, as an element of decoration rather than of worship, became the dominant format. This was helped by the creation in the 15th century of the *tokonoma* or alcove which was designed for the purpose of showing such paintings.

Both the Imperial court and the Shogunal court collected Chinese paintings and other works of art, and there was considerable trade with China. The later Ashikaga shoguns, in particular, were connoisseurs and collectors, and in order to escape temporarily from the cares of the world, they built retreats—pavilions or tea houses—into which they could invite a few chosen friends to discuss works of art and to drink tea. This is the origin of the Tea Ceremony which, with its philosophy of the appreciation of the beauty of simple objects, was to have such a profound influence on Japanese taste from the 16th century onwards. For such a setting, only ink paintings were sufficiently austere, while the chosen simplicity of the tea ceremony utensils was to change the

direction of some types of applied arts permanently.

Of course such buildings had to be set in suitable gardens, which are also based on Chinese prototypes; these are not usually gardens through which one walks, but gardens which create, in a small enclosed space, a microcosm of nature. Often this is a Chinese landscape where rocks are mountains and raked silver sand substitutes for water. Very rarely is there any view beyond the garden: it is entirely inward looking. In some larger gardens (Katsura, Shugakuin) one can walk around by certain paths only, and the very naturalness of the garden is created by the most stringent artificiality, by the blocking of some views and the opening of others, by the careful shaping of trees and selection of stones. In many ways this recalls the tenets of Chinese painting, where real scenery is rarely depicted: it is an ideal scene that is imagined.

Two secular schools of painting appeared in the Muromachi period, and both became hereditary. The Ami school under Noami specialized in a soft wash technique that is a variant of Sung style. Far more important is the Kano school. Kano Masanobu painted in a style derived from that of Sesshu, but his successors in the Momoyama and Edo periods developed the Kano style into a supremely decorative one while yet retaining the skill in ink painting that made them the 'classical' school of later Japan.

The Muromachi period was brought to a close by the rise to power of a new military overlord. Oda Nobunaga was not a great aristocrat, but virtually an upstart. By his own military genius, and by the careful exploitation of the newly-arrived Western weapon, the smooth-bore musket, he succeeded in almost totally unifying Japan under his control. The Portuguese had started trading with Japan at the beginning of the 16th century, and the most important of their assets was the use of the gun. The gun changed Japanese warfare radically, and one of its effects was the necessity for a new kind of castle, built on a rock-faced platform. Of course these castles had to be decorated within, and Nobunaga employed the Kano school painters Eitoku and his adopted son Sanraku. The surfaces for decoration were the sliding doors that divided the floor area into rooms that could be changed in size by the opening or removal of these partition doors, and six-fold screens that were important as the only decorative element that was not placed at right angles to its neighbour but could be placed, in pairs, anywhere in a room as a back-drop to an important personage.

Islands at Matsushima, six-fold screen by Tawaraya Sotatsu, early 17th century. 166 × 365cm ($\frac{3}{4}$ × 144$\frac{3}{4}$in). Freer Gallery of Art, Washington, USA. (*Above*)
Sotatsu had been a repairer and copyist of Yamato-e hand-scrolls. Here he has used the style to create a stylized impression of rugged pine-tree-clad islands. He has also made use of the Kano style cloud-band in gold leaf. The Rimpa style is another example of the Japanese genius for adapting various styles to produce an extremely decorative and beautiful result. Apart from paintings, the Rimpa artists also made designs for textiles, lacquer, metalwork and ceramics.

A scene from the Ise monogatari, fan painting by Ogata Korin (1658–1716). 35.6 × 22.7cm (14 × 9in). Freer Gallery of Art, Washington, USA. (*Below*)
In this fan, Korin uses a smaller format for the Rimpa style, clearly showing its Yamato-e ancestry. Fans, both the folding type and the rigid style (such as this), were often used as surfaces for painting, and even the greatest artists painted fans, considering the difficult shape as a challenge. Korin was even more eclectic in his tastes than the older Sotatsu; designs for Kimono attributed to him exist, and he used to decorate some of his brother Kenzan's ceramics.

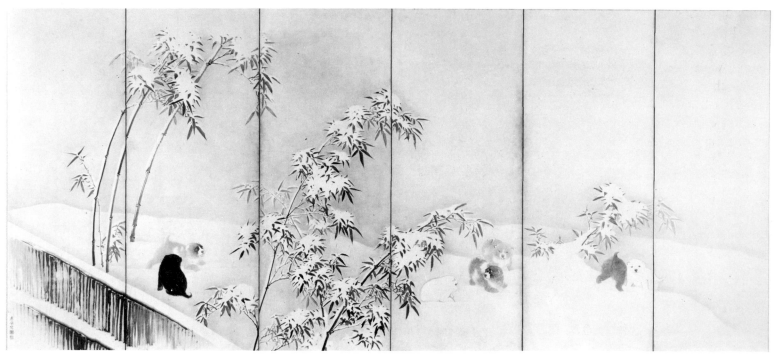

Puppies in the snow, six-fold screen by Maruyama Okyo (1733–95). 162 × 264cm (64 × 103in). Los Angeles County Museum, USA. (*Above*)

Okyo was interested in the depiction of real things: he reacted against the formalization of the Kano school and the abbreviation of the Rimpa. He was the leader of the 'return to nature' that had been started by Shiko. He actually made drawings from birds and animals, as a western artist might, in a sketch book. His finished paintings are never close to nature in the western sense, but were much more so than other Japanese painters: he could not, or did not try to get away entirely from his native traditions.

Landscape, Nakabayashi Chikuto (1776–1853). Album leaf. Cleveland Museum of Art, USA. (*Below*)

Chikuto was the theorist of the Nanga or Chinese revival school of the 18th and 19th centuries. His paintings therefore tend to be more in the formal Chinese style as practised in Ch'ing China, than following the path of individuality favoured by some of his contemporaries, and by the earlier generation of Nanga artists such as Taiga and Gyokudo.

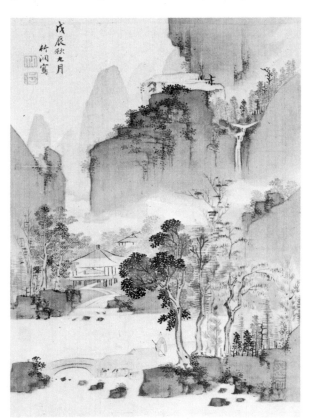

Kano Eitoku is credited with the invention of the gold leaf background to these screens and doors, though it seems likely that the idea came from imported Christian paintings. On the applied gold leaf, great masses of thick opaque colour built up bold paintings of trees, rocks and landscape with superbly decorative effect. This was, of course, a great contrast to the understated ink landscapes of former times and its revolutionary effect must have delighted the new dictator.

When Nobunaga was murdered in 1582, his successor, Hideyoshi, continued to employ Sanraku and his studio, under whom the style became less grandiose and more subtle, while retaining its decorative force. Rival schools using variations of the same techniques arose, the most effective being the school of Hasegawa Tohaku. Tohaku was equally skilled in the polychrome gold background style and in ink paintings of restraint and austerity. Ink painting was an important part of the training of an artist, and the Kano school supplied, thereafter, the teachers of most painters. Ink painting was also considered an accomplishment of the warrior. The paintings of Miyamoto Musashi (Niten) were regarded as particularly strong and bold on account of his skill as a swordsman: the two were held to be directly connected.

Hideyoshi was much influenced by the tea-master Sen-no-Rikyu, though his taste fluctuated between the love of the gorgeous, as exemplified by the Kano artists, and by the call of the simple as demanded by Rikyu. The tea-master's ideas of taste have had a profound influence on Japanese art ever since: in particular the concepts of *wabi*, the sort of simplicity to be found, say, in folk ceramics, changed the production of whole ceramic areas, and today, Momoyama-period tea utensils are the most highly prized of all Japanese-produced tea wares.

In the Imperial court in Kyoto the official painters were not the Kano, but the Tosa family, whose style derived from the Yamato-e style and was rather formal and stiff in execution.

Under Nobunaga and Hideyoshi, Christianity, as imported to Japan by the Jesuits, was tolerated and a considerable number of converts were made. Jesuit priests were allowed to travel in Japan, and Portuguese merchants were allowed to trade. This led to one other style of the Momoyama that deserves mention, and that is the Namban style, the style of the barbarians—the Portuguese. Delight in the new and curious led the Japanese to copy Western paintings and to experiment with Western styles. It also led to spirited caricatures of Westerners and their

ships as decorative designs, in particular on screens.

After Hideyoshi's death in 1598, one of his lieutenants, Tokugawa Ieyasu, fought his way to power. He became Shogun in 1603, and his family were Shoguns until the Meiji restoration in 1868. The period is called the Tokugawa period, or alternatively the Edo period after Edo (modern Tokyo) their new capital.

The Momoyama period had been one of great political and social change: a newly rich merchant class had arisen whose wealth was based on money, as opposed to rice, the former currency of the landowning class. These merchants demanded and themselves created the new forms and styles of art that were to appear in the Edo period.

The Tokugawa Shoguns ruled with considerable rigidity. For almost the first time, the country was unified and at peace. This peace was maintained throughout the period. Christianity was forbidden and contact with the outside world was strictly controlled. After 1639, the year of closure of the country, the only ships allowed into Japan were a few a year from Holland and China only, at special trading stations in Nagasaki harbour. Japanese people were not allowed back into the country if they left. This peace brought with it certain disadvantages, the greatest being the lack of employment for great numbers of the warrior class, formerly retainers of the great lords, who had no means of supporting themselves. Many of them moved to Edo where they lived a life of somewhat precarious dissolution.

The arts, however, flourished as never before, for new markets created new demands. The Kano school divided, one part remaining in Kyoto, the other moving with the Shogunal court to Edo. After the 17th century, however, the Kano school settled down into somewhat trite academicism, and Kano Tannyu was the last Kano painter of great ability. The school had, however, produced a subschool of genre painters who concentrated on paintings of the people: this was to be a formative influence on the *Ukiyo-e* school, the school of the woodblock-print makers.

A new school of decorative painting, later called the *Rimpa* school arose near Kyoto under the influence of Honami Koetsu, a celebrated calligrapher and sword appraiser, and Nonomura Sotatsu who seems to have been proprietor of a fan shop, and who had been employed as a repairer and copier of old Yamato-e handscrolls. Sotatsu based his style on an abbreviated form of Yamato-e, in which he borrowed elements and even figures from Yamato-e scrolls and used them as details and figures in a simplified, almost abstract, background of landscape and gold leaf. This produced a decorative scheme of painting of striking effect that was taken up and extended by Ogata Korin, a cloth merchant and kimono designer. This type of design, often of semi-realistic animals or plants against a plain gold leaf background, or of formalized waves and rocks is perhaps the most original of all Japanese styles, and certainly the most decorative. The style was influential, as was the Kano, on the Ukiyo-e style.

Other new styles that arose in the 18th century were the *Nanga*, the *Maruyama*, and the *Shijo* and its offshoots. The Nanga or Southern style was a Chinese revival, attempting to free itself from the Northern Sung style as transmitted in debased form by the Kano painters. The Nanga artists sought to emulate the style of the Southern Sung, following a visit to Nagasaki of some Chinese painters, notably Shen Nan-p'in (1731–3). The Southern Sung style was the style of the amateur scholars in China, while in Japan it was attempted by professional artists, notably Taiga, Buson, Chikuden and the potter Mokubei. The Japanese Nanga style was never very close to its Chinese origins, partly because

Woman dancing, anonymous, 17th century. Painting, 90.7 × 57.7cm (39 × 22½in). British Museum, London, England.

The origins of the Ukiyo-e style, the style of the woodblock print artists of Tokyo, lie in such paintings as this, which are themselves derived from a synthesis of other styles, notably the Kano. A new interest in paintings of the common people arose in the 17th century as a response to new markets created by the newly rich merchants of Sakai and Tokyo: this in turn led to a method of producing such paintings in quantity so as to reduce the price. Woodblock printing had been in use for Buddhistic subjects for centuries, but this was the first truly popular use.

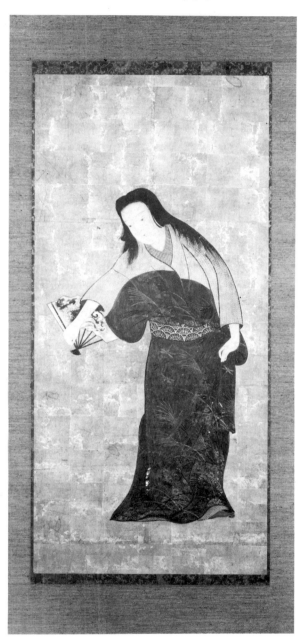

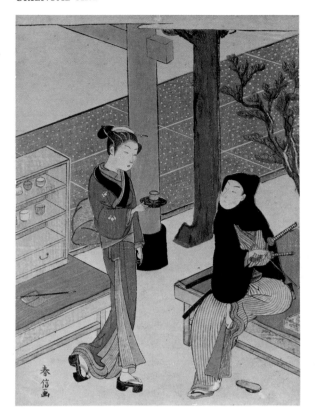

Beans, Suzuki Nanrei (1775–1844). Album-leaf painting, 27 × 38cm (10¾ × 15in). Ashmolean Museum, Oxford, England. (*Below*)
Nanrei (no relation to Harunobu) is perhaps the finest of the later Shijo artists, using the graded colour wash to perfection. The simplicity of line made possible by the big brush used to define an area in one stroke, with the gradation in colour due to the angle at which the brush is applied.

these very origins were confused in Japanese minds: the printed painting-manuals such as the *Mustard Seed Garden* were as influential as the Ch'ing derivatives of Southern Sung style that were available for study. The later painters of the Nanga school either took their own direction, as for example the wild landscapes of Gyokudo, or became prettier and less interesting, tending to fuse with the Shijo school.

Also as a reaction to formalized painting came the 'return to nature' of Maruyama Okyo, who attempted a form of realism in his painting that had not been much favoured in Japan before. He had many pupils, some of whom followed his style, but his two most famous pupils were more individual. Nagasawa Rosetsu turned Okyo's realism into his own personal interpretation of movement in particular, while Matsumura Goshun had been a pupil of the Nanga painter Buson before coming under Okyo's influence. Thereafter he founded the Shijo school, as a fusion of the 'realist' and Nanga styles. At its best, the Shijo style is supremely pretty, but it is a style that easily degenerates, in the hands of a less competent painter, into triviality.

Other individual painters were Ito Jakuchu, who painted in two styles that were almost diametrically opposed: a decorative highly colourful style that owes much to both Rimpa and Okyo, and a dashing ink style that is quite individual.

In the West the best known of the Edo period schools is the Ukiyo-e school—the school of the woodblock-print artists who, depicting the colourful and exotic world of the pleasure quarter of Edo, produced the first truly 'popular' Japanese art. The style started as book illustrations, often erotic, and developed as prints, either individual or in sets, that were a reflection of the lives of the people of the day, of the 'pop heroes' —actors, courtesans, tea-house girls and wrestlers. Often this type of

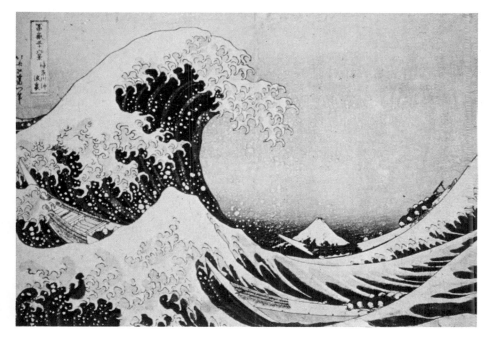

The hollow of the deep sea wave, Katsushika Hokusai (1760–1849). Woodblock print, 36 × 24.2cm (14¼ × 9½in). British Museum, London, England. (*Left*)
It was Hokusai who re-introduced landscape as a subject for prints: before that, landscape had been the most serious of subjects for more aristocratic forms of art than the plebeian prints. Hokusai, during his long life, experimented with many different styles of painting, and it was his simple brush-painted work, as much as prints of the startlingly original lay-out seen here, that so astounded the French artists of the mid-19th century. Works by Hokusai were greatly overpraised (marvellous though they are) and he is still perhaps the best known, in the West, of Japanese artists.

The Tea-stall of Osen, Suzuki Harunobu (1725–1770). Woodblock print, 26.75 × 21.5cm (10½ × 8½in). British Museum, London, England. (*Opposite top*)
The first Ukiyo-e prints had been in ink only, or with hand-colouring. Mostly they had been book-illustrations and broad-sheets, but by the beginning of the 18th century individual sub-schools were forming within the genre and large numbers of prints were produced. Printing in two colours began, and in 1764 the first truly polychrome print was made by Harunobu. Harunobu's figures are fragile dreams of the demi-monde: his favourite was Osen, the tea-house girl depicted here. Note the Yamato-e-like style of the face: in spite of this, it is possible to recognize individuals by their faces, so subtle is the drawing.

Courtesan, Kitagawa Utamaro (1753–1806). Woodblock print, 36 × 24.2cm (14¼ × 9½in). British Museum, London, England. (*Below*)
Utamaro's statuesque beauties, such a contrast to the fragile flowers of Harunobu, reflect a new strength in Ukiyo-e at the end of the 18th century. Bust portraits of 'pop heroes' appeared side by side with more conventional smaller figures, and caricature was taken to extreme lengths by Shunei and Sharaku. By now the print industry was very large and efficient, and a superb quality of printing was possible, in 10 colours. The engravers and painters' arts became almost as important as that of the designer.

print had literary overtones that might surprise one: the public for these prints was quite well educated in the Chinese and Japanese classics.

The style was at first one of line with occasional hand colouring. In the early 18th century there was some printing in two colours, but it was not until 1764 that the first real colour-prints, in 10 colours, were produced by Harunobu. This led the way to the actor-prints of Shunsho, to the statuesque beauties of Kiyonaga and Utamaro, to the startling portraits by Shunei and Sharaku. In the early 19th century Hokusai made landscape a subject for prints and this was taken up by Hiroshige but most later artists concentrated on bombastic historical or legendary scenes of lesser interest. The influence of these prints on the 19th century painters in France is well known.

Another great break in the Japanese tradition occurred in the middle of the 19th century. Following the arrival in Japan of Commodore Perry, trading concessions were forced out of the reluctant Japanese. This led, ultimately, to the fall of the Tokugawa Shoguns and the restoration to actual power of the Emperor—the Meiji Restoration—in 1868. The Meiji period was one in which Japan desperately tried to 'catch-up' with the industrialized Western world. Western things and clothes became the fashion—the court wore morning dress—and painters and sculptors looked to Europe.

Some Japanese artists went to Europe to study, while some European artists came to teach in Japan. Painting in oils in European styles almost eclipsed the water-based painting in Japanese styles of former times. Paintings were framed instead of rolled, and suited the new Westernized houses. The first realistic nude painting, by Baron Kuroda who had studied in Paris, caused a furore.

Comparatively few Japanese artists continued to work in their old styles—of these, the best known is Tomioka Tessai who worked in Nanga style. A new 'Japanese style' was formed by such men as Hishida Shunso and Takeuchi Seiho, which was really a Westernized extension or version of the Shijo style.

In this century there has been a gradual revival of Japanese styles, and at the same time a continued mastery of Western styles. Often the two are fused, but in both traditions, Japan has produced artists of international calibre. This is best shown, perhaps, in architecture, where Kenzo Tange is one of the most accomplished architects in the world, and in print-making, where Japan is almost unrivalled.

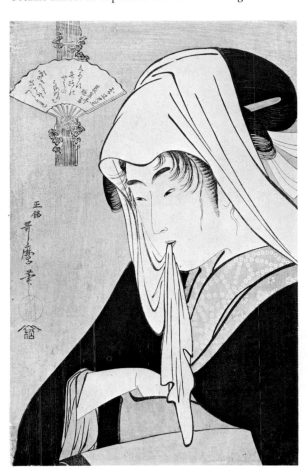

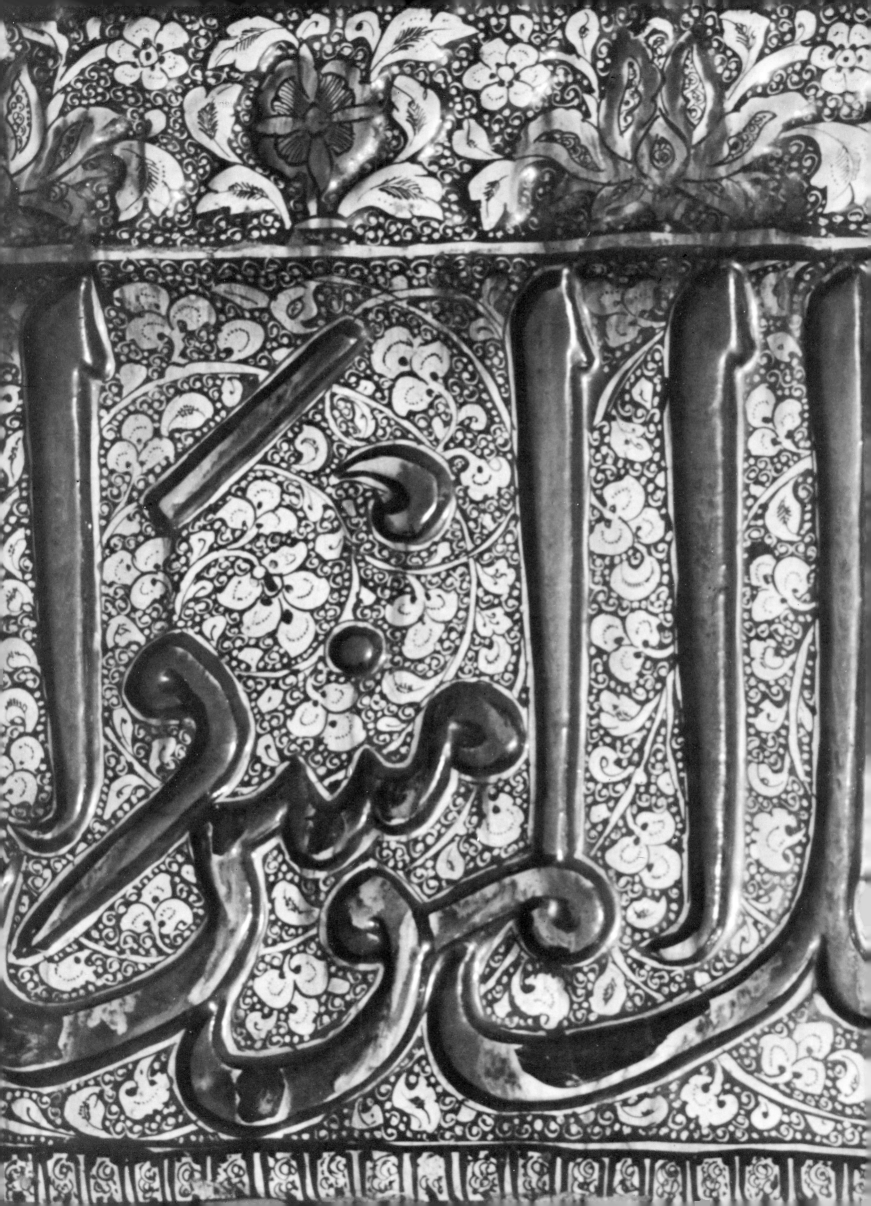

ISLAMIC ART

The overriding character of this art is determined in the word 'Islam', which means 'surrender to God'. It is essentially art in the service of religion, and even in its considerable secular achievements this aspect is never absent. In spite of regional differences, uniform qualities may be observed running through Islamic art from Morocco to Indonesia, and from Southern Russia to Nigeria.

The central belief of Islam is that God is literally manifested through every part of the real world. It is not possible for anything to be brought into existence independently of God's will. Nothing made by man must be claimed to have an independent existence; on the contrary it must always be related to the rest of God's work, and this relationship is often felt to be best stressed by pointing it out in words, by relating it to a passage from the Koran, the words of God as revealed to his prophet Muhammad. The work of creation by man can further be put into its setting as part of the ordered world of God by being given a regular geometrical form, which Moslems believe underlies all form in the visible world.

Another expression of the insignificance of the creative effort of man, and its subordination to God's will, is the comparative lack of any cult of the individual artist in Islam throughout most of history. Only a few names of artists are known to us, and these men never attained through their art the wealth and approval that was accorded to artists in the West. The individual personalities of the artists seldom appear in any form of direct expression in the work of art. Artists usually came from the craftsmen's class and were generally of low social standing.

The Umayyad caliphs inaugurated the first regular Islamic court in Damascus in the late 7th century. Syria had been one of the richest provinces of the empire of Alexander, then of the Roman and finally the Byzantine empires. It had a wealth of craftsmen skilled in Hellenistic and Byzantine traditions, and it was these who largely dominated Umayyad art. However, when the Abbasid caliphs took over in AD 750 the centre of Islamic art shifted to Baghdad in Iraq, and swiftly assumed a Persian colouration.

At the same time, the only surviving member of the Umayyad family escaped to the west and established a capital in Cordoba, from whence he ruled large territories in Spain and North Africa, thus splitting the Islamic world into two. The artistic significance of this division was reflected in the survival of a strong Syrian element in western Islamic

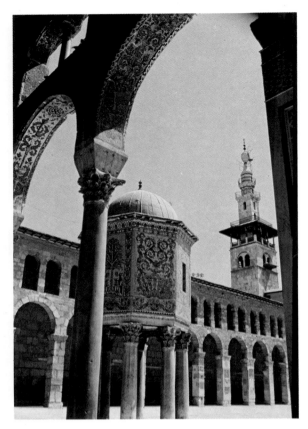

Umayyad Mosque, Damascus, Syria, 705–715. The courtyard.

This great early mosque has retained much of its original decoration in coloured marble veneers, designed in abstract geometrical patterns, and in polychrome mosaics on a gold background. The dependence of this style on later Roman decoration is enormous, although the theme of the mosaics is likely to be the world pacified by Islam; they portray rich, fantastic, palaces and landscapes, set among abstract decorations of grapevine scrolls. The small octagonal building, raised on columns, housed the mosque treasury.

Calligraphic Wall Tile, Mosque at Khonsar, Kashan, Iran, early 14th century. Earthenware glazed in lustre, blue and turquoise, 30cm (12in). Victoria and Albert Museum, London, England. (*Previous page*)

In the dusty towns of the semi-deserts, which made up much of the Islamic territory, the monotony of the vast, featureless landscape was cheerfully relieved by the use of pattern and colour on major monuments. This could be permanently done using the technique of glazed tile-work, which seems to have been continuously in use in Mesopotamia since Sumerian times. Into this brightly coloured, gleaming wall surface, the introduction of bands of quotation from the Koran lent a literally spiritual quality. The high regard in which handwritten scripts were held by the Arabs influenced their feeling for the shape of the letters and words, and was used throughout the history of Islamic art to intensify their meaning.

art until the 11th century.

In the east, a new quality was introduced into Islamic art by the infusion of Scytho-Turkish styles following the employment of large numbers of Turkish mercenaries by the court of the caliphs. This art, exemplified by the stucco decoration at Samarra, exerted a strong influence—although it was always in conflict with Persian influences.

In Egypt a mixture of ancient and Coptic elements were fused with imported Islamic tastes to produce the uniquely Egyptian Islamic style. It flourished under the Fatimid invaders, who made Cairo the leading cultural centre of the Islamic world in the 10th and 11th centuries, with an artistic influence which reached far to the east and west.

In the 13th and 14th centuries the Mongolian invasions added Chinese influences to Islamic art. The conquests of Timur (Tamberland) brought, after an initial period of destruction, new life into creative art, centring on Samarkand, which became the leading cultural centre of the east, rivalling Cairo, now ruled by the Mamelukes, and in the far west, Granada and Fez. The artistic renaissance inaugurated by Timur is known as Timurid art.

India had seen a steady infusion of Islamic people and ideas since the 10th century, but it was only after the invasion by the descendants of Timur, the Mughals, in the 16th century, that its independent achievements began to rival those of the great Islamic cultures further west. Under the Mughals, a synthesis of Persian and Indian elements gradually formed an original Indo-Islamic style.

The earliest representational art in Islam dates from the end of the 7th century and owes a debt to both Byzantine and Sassanian traditions. The mosaics of the Umayyad Mosque in Damascus include idyllic landscapes, urban scenes and fantastic palaces in various tones of gold, green and blue. In the Syrian desert, remote fortified palaces contain preserved early wall paintings which are already of two types, some with classical, modelled, three-dimensional effects and others with linear, non classical Sassanian styles of representation. The themes of the former often relate to classical mythology; in the latter different panels contain scenes of hunting, entertainment and dancing, or show the absolute ruler surrounded by his attendants.

Representational art in three dimensions has been found in plaster sculptures of this period, which were set in niches in the walls of palaces or incorporated into architectural decoration. Their style is a combination of the western classical and oriental hieratic influences mentioned above, with Arabian Nabataean and Egyptian Coptic qualities as well. The 'Abbasid empire, focused on Baghdad and Samarra, owed more to ancient Persian influence, with black outlines for the heavy, full-faced figures in its murals. Only fragments of these are known, painted in strong colours and conventionalized forms, with no indication of space or atmosphere.

From the first centuries of Muslim rule no book painting has survived. Among the earliest illustrated books that have come down to us is one on the *Constellations*, dated AD 1009 and based on a work of Ptolemy, which is in the Bodleian library, Oxford. The illustrations derive from engravings on a classical bronze globe, and are slightly conventionalized and fore-shortened linear drawings with strong influence from the ancient world, modified by the formal court style inherited from Sassanian art.

From Fatimid Egypt, four pages of a manuscript found in archaeological excavations give evidence of a style of painting which owes even more to convention, the poses stiff, the figures simplified and subservient to the decorations of the page. A single mural decoration, showing

the relaxed figure of a ruler with a beaker, has very similar features, although the forms are more flowing. These works have in common a head framed by a halo drawn with a double line, and the subservience of each figure to the overall decoration.

Many of the earliest surviving Islamic book paintings represent medicinal herbs or illustrate scientific texts. These are simple drawings usually without any background, retaining marked classical influence. Similar paintings illustrated books on animals. A popular romance, the *Maqāmāt* of al-Harīrī exists in a number of illustrated copies from different parts of the Islamic world. Two important copies, probably from Baghdad, date from *c.*1237. The illustrations are genre scenes with strong classical origins. There are often Byzantine style haloes, and it is clear that contemporary and late Roman paintings served as models for the illustrations. The finest of them, however, represent dynamic indoor and outdoor scenes with apparent ease; the naturalism is enhanced by interest in the psychological play of character. The natural colour of the paper forms the background—there is no frame.

From Mosul comes a group of manuscripts which indicate Persian-Turkish influence. Some are earlier than the manuscripts just referred to, and have paintings showing decorative preoccupation, the figures being fitted into a decorative framework, often incorporating calligraphy, with the faces arranged so that they form balanced patterns across the page. There is a strong courtly aspect, and the faces have a pronounced Mongol caste. They are round and squat with strands of the hair falling symmetrically in sinuous lines reminiscent of Chinese painting. The backgrounds are coloured, and the character throughout

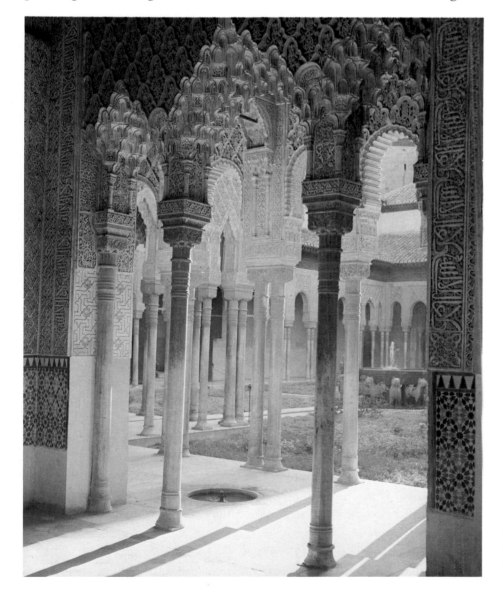

Alhambra, Granada, Spain. 13th and 14th centuries. An outstanding example of Moorish architecture in southern Spain. The fortified palace of Alhambra dominates the town of Granada. It was built by Yusuf I and Muhammed V, Nasrid rulers of Granada, and decorated with intricate stucco and tiles. The delicate facade conceals ornate reception rooms, graceful courtyards, pools and fountains.

Resting camels, al-Harīrī, 13th century, Iraq. Painting on vellum from the Maqāmāt, 28 × 37cm (11 × 14½in). Bibliothèque Nationale, Paris, France.
This painting reveals the heavy dependence of 'Abbasid painting on that of classical work, the traditions of which continued unabated in the neighbouring Byzantine empire. Undoubtedly book illustration must have been an art which existed during the earlier period in Islam; but these late examples are all that survive; they suggest that little change had taken place for some centuries.

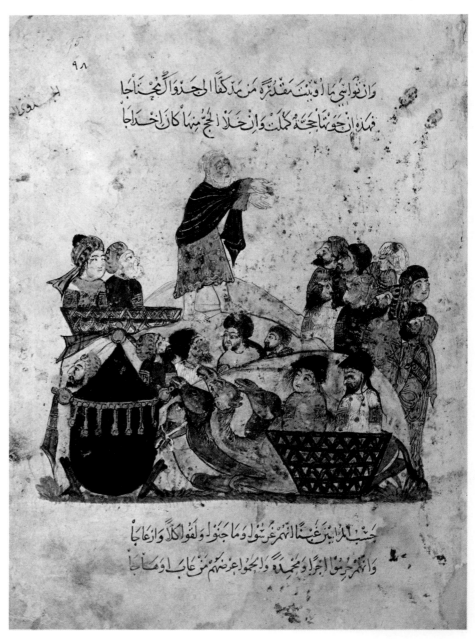

brilliant rather than subdued.

A single manuscript survives from the Seljuk areas to suggest that a style of painting existed in the 12th and 13th centuries in both Iran and Anatolia which paralleled the highly decorative style of painted pottery and metalwork at this time. Balanced groups of moving figures, often of men mounted on horseback with haloes encircling their heads, are arranged against a continuous scroll background executed in light and deep purples, incorporating birds and animals.

The great period of manuscript painting in Iraq ended with the Mongol conquest of Baghdad in 1258. Iraq and Persia became part of a large Far Eastern empire, which brought strong infusions of Chinese influence into Islamic art. Seljuk characteristics remained predominant, however, and the presence of the traditional Baghdad style is still evident. As Mongol painting evolved, some of the miniatures were set in Chinese types of landscape, with Turkish or Iraqi-styled figures in the foreground. A famous painting of a phoenix from the earliest surviving Mongol manuscript (late 13th century) has an aggressive graphic style and use of bright colour which are unprecedented in Islamic art. Other paintings are pure landscapes. In an endeavour to suggest an extension of the subject horizontally or vertically, the foliage or the landscape behind it sometimes overlaps the border to create and enhance the three dimensional effect. On other occasions rectangular sections of text, with the natural colour of the paper as a background,

are allowed to intrude into the compositions, following the manner of the calligraphic banner on a Chinese painting. Finally, by a combination of all these features, a new abstract compositional procedure of immense dynamic vitality was introduced into small miniature paintings.

In the early 14th century many manuscripts were prepared of the *Shāhnāmah*, a famous long poem recounting the adventures of the kings and soft blues. The paintings often seem like tinted drawings.

In the school of Tabriz a sophisticated urban style was developed, with exquisitely painted realistic detail; rather hieratic courtly figures are set against Chinese landscapes of gnarled trees, with, behind, hills piled one above the other and swirling clouds and streams. The colours of Persia; a number of these were illustrated with superb miniatures. In the school of Shiraz there was an emphasis on linear effects, and the use of thin subtle colouring with a limited palette of reds, browns, yellows are bright and strong, and the paintings appear confident and sophisticated.

At the end of the 14th century various regional schools developed styles of painting emphasizing a new sense of space. By raising the horizon line to create a landscape background for most of the action it was possible to arrange groups of horsemen or battle scenes one above the other so that they could be read as situated in a simplified form of perspective. This innovation permitted a new organization of the picture surface, for it freed the painter from the limiting, one level concept of traditional art. At first used simply, the new high horizon eventually allowed the creation of more complex compositions. In a single painting it was possible for the artist to move from an outdoor scene through a doorway into a palace, upstairs through different rooms and onto the roof. The field of action is clearly spread out before the viewer, who can take delight in the precise qualities of the line and association in the setting and its detail.

A new text became popular as the subject of illustration, the *Kham-sah*, a collection of five poems by Nizali. These illustrations of the Timurid period had superb compositions, fine detail, strong and brilliant colouring, and a unifying background of landscape. At Herat (now in Afghanistan) an important school of painting grew up in which the figures were reduced in number, the background was simplified, but the vertical arrangement of space and the strong colouring and compo-sition were retained. The figures are animated, with finely observed detail, and are convincingly related to each other and to the space in which they are placed; they are usually tall and slender, with slanting eyes, straight noses and pointed beards.

At Herat from 1420 onwards a great school of painting developed with the most exquisitely refined brushwork, well balanced composi-tions, and the subtlest of colour combinations. A copy of the *Shāhnāmah* made at this time contains the most brilliant series of paintings of this school, in which great play is made of the contrast between static land-scape and architectural settings and the dynamic, dramatic action of the figures. This manuscript appears to have had far reaching influence. The final flowering of the Herat school came with the work of the artist Bihzad (*c*.1475 to *c*.1525), who is generally acknowledged to be the greatest of all Persian painters. His lines and coloured surfaces have a continuity which is at once decorative and related to the quality of the calligraphy of the book within which the illustration is placed. The background is frequently left empty to emphasize the elongated figures, standardized and passive in face but expressive in their gestures. The essence of each character is captured more in form and movement than in feature. There is great subtlety in the variety of shades of colour, and

Bahram Gur Hunting, Sultan Muhammad, c.1540, Tabriz. Painting, 30.3 × 18.2cm (11¾ × 7¼in). British Library, London, England. (*Below left*)
Bahram Gur was an ancient Sassanian king celebrated by the poet Omar Khayyam as 'The Great Hunter'. The debt owed by Persian painting to Chinese painting is shown here. Depth is laid out across the surface of the page from bottom to top, and the figures are incorporated within it. But here the more precise calligraphic line of the Islamic artist has taken over from the bold brush strokes of the Chinese. The lines and coloured surfaces have a continuity which is at once decorative and related to the quality of the writing on the facing page; all great Islamic painters began their careers as calligraphers. There is considerable subtlety in the shades of colour, especially in matching those in the upper half to the gold background, and in placing discordant colours to throw forward the horses.

Suicide of Shirin on the corpse of the murdered Khusraw, possibly by Sultan Muhammad, c.1505, Tabriz. Painting, 28 × 20cm (11¾ × 8¾in). Keir Collection, London, England. (*Below right*)
This painting is the final scene in the manuscript, in which the young Shirin is shown killing herself on the corpse of her murdered husband, the last great king of the Sassanian, pre-Islamic, dynasty to rule Persia. Sultan Muhammad was trained at the Turkoman school, his style evolving further after he came to Tabriz. The use of a high horizon, at the level of the women looking down from the windows, allows the artist to indulge his taste for intricate decorative and spatial patterns.

especially in the use of harmonious relationships contrasted with discord, which led to pale pink landscapes, orange horses, and blue dragons. By extending the frame so that it is larger in the foreground, a sense of depth is sometimes introduced into the picture surface. The compositions have a diagrammatic coherence while retaining an abstract patterned quality.

The Herat style was carried far into the 16th century by the Bukhara school, which was founded when many of the Herat artists were taken to Bukhara and persuaded to work there. Eventually the style became mannered, employing bright colours, conventionalization and rich decoration. Sumptuousness and magnificence replaced the subtlety of colour and restraint of the Herat school.

To the west, early 16th century paintings of the Tabriz school continued the Turkoman tradition of realism and vitality, often markedly original but uneven in execution. To the south in Shiraz, illustrated manuscripts were produced on a commercial scale. For this purpose a fairly simple but effective style evolved from a combination of the court style of Tabriz painting with the linear, pale coloured style practised in the preceding century in Shiraz. After the rise of the Safavids, a royal school of painters was founded, including masters from both Tabriz and Herat, of whom the most distinguished was Shaykhzada, whose work was expressive and exquisitely fine—he had been a pupil of Bihzad. The Tabriz style was represented by Sultan Muhammad, whose work is full of imagination, fantasy and humour. Together these men

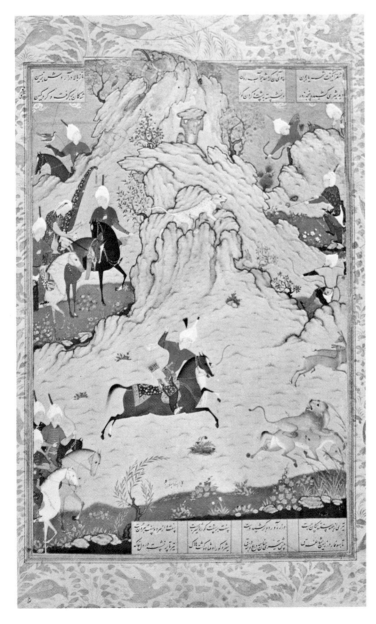

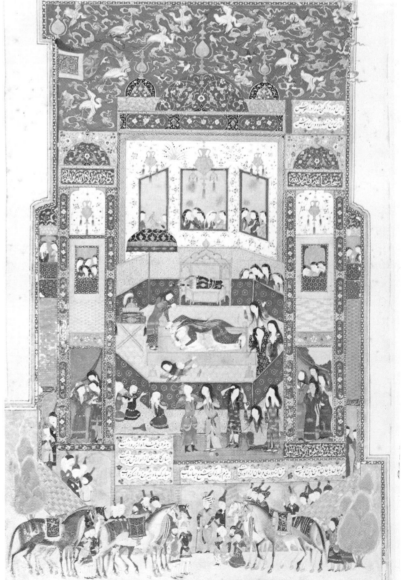

influenced each other so that by the late 1530s a synthesis had been achieved combining elegance, sensuousness and vitality.

Two other northern Persian cities, Qazwin and Meshed, developed the Royal Court style. Sadiqi Beg and Siyawush the Georgian painted mainly in the style of Muhammadi, depicting slim, elegant youths and girls arranged in exquisite compositions at picnics and hunting parties.

In 1598 Shah 'Abbas the Great established his capital at Isfahan, in central Persia, where a great painter soon emerged as the leader of the early 17th century Persian school. This was Riza-i 'Abbasi, who was probably the same artist as the man signing himself 'Aqa Riza' in the 1590s. His early style favoured slim, exquisite human figures, executed in fine calligraphic draughtsmanship with subtle pure colours; but about 1620 his style changed to represent plump youths and girls sketched with rapid calligraphic strokes and strongly coloured with yellows, browns and purples. The outstanding pupils of Riza-i 'Abbasi were Muhammed Qasam and Mu'im. The latter, who died only in 1707, evolved a style of great fluency combining many of the finest aspects of Persian painting in the two preceding centuries.

The early phases of Ottoman art are lost. In 1453, after the capture of Constantinople, its conqueror established a court school of painting there. As far as can be judged, its style derived either from the simple, conceptual illustrations of the old 'Abbasid court style or from similar qualities preserved in Mameluk painting. Paralleling it, however, was a more interesting type of linear decorative drawing showing dragons and other exotic or fantastic animals in battle or set in landscapes. These are accompanied by decorative studies of leaves and flowers. All have a pronouncedly calligraphic quality.

Later 16th and 17th century Turkish paintings are markedly different from those of contemporary Persia—which were mainly concerned with depicting a romantic, poetic ideal. Ottoman paintings were simple realistic illustrations of contemporary history, events in the lives of the Sultans and ordinary daily life in the cities and towns. Portraiture was also a common subject. There was a certain awareness of developments in western European art, especially in Venice, which led to a further emphasis on simple pure form and direct representation.

Mughal painting derives from a court school created when the Emperor Humayun invited the two leading masters of the Persian Tabriz school to Kabul. These were Abd al-Samad and Mir Sayyid Ali, who probably began the illustrations of the largest known Muslim manuscript, the *Dastin-i Amir Hamza*. Many aspects of these paintings are in the Persian style, especially the architectural settings and the decorative elements, but other aspects are unparalleled in Persian painting, and apparently derive from the strength of the pre-Mughal tradition in India. There was a much greater concern for realistic portrayal and for emotional reactions to the events portrayed and the experience of the participants. As in Turkey, this led ultimately to an interest in portraiture, and to a depiction of the daily life of the court in minute and loving detail. Historical narrative painting also grew up as a new form of artistic expression. At the same time, some of the greatest painters of the Mughal school, such as Basawan, were clearly trained in Hindu traditions, stemming particularly from Mughal contact with the world of the Rajput princes.

Eventually a reaction to realism began, and elements of ceremonial reasserted themselves, removing the image of the Emperor from his sphere of everyday life to an elevated level of symbolic representation. The Emperor's head was set in silhouette against a halo, and he was usually seen in profile, more as a strict abstraction than as a person in

Two Lovers, Riza-i 'Abbasi, 1629. Painting, 17 × 11cm (7 × 4½in). Metropolitan Museum of Art, New York, USA. Riza, the great master of the Safavid period of Isfahan, excelled in sensitive and convincing modelling of the human figure, and his rendering of faces approached true portraiture. His paintings concentrate on such subjects as this embracing couple, which is one of his most delicate and controlled paintings. The rapid calligraphic drawing is derived from Chinese influence in the Herat school, and the subtle, pure colours from Muhammadi.

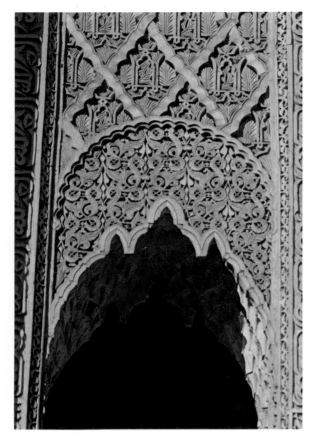

Ben Yusuf Madrasah, Marrakesh, Morocco, 16th century. Plant form arabesques executed in plasterwork. (*Above*)
Throughout its long history Islamic art had a tendency to adapt forms from other cultures, and this was certainly true of the debt it owed to the classical world of Greece and Rome. Foremost among these forms were the decorative plant forms of the acanthus leaf and the sinuous vine tendril. At the time Islam was being promulgated Byzantine and Islamic artists alike were experimenting with the development of the vine patterns to cover surfaces, and from these early designs evolved the true arabesque, an overall pattern of interlaced stems, tendrils, leaves, flowers and sometimes even birds and animals.

Almoravid Qubba, Marrakesh, Morocco, early 12th century. Star vaulting culminating in a dome, plaster on brick. (*Right*)
The inventive exuberance of this relatively early dome in Morocco illustrates the great rapidity with which Islamic art came to its full flowering. The vaulting is made up of advancing and receding planes, and is pierced to reveal a further dome of another dimension behind it. The design involved a considerable complexity of abstract geometrical calculation before it could be constructed. And, finally, it was embellished with a variety of small emblems or patterns executed in plaster.

contemporary reality. Elsewhere, however, the strength of realism continued to be one of the driving forces in Mughal painting.

Islamic artists were first brought into direct contact with European artists in the late 18th century. The results were disastrous. The idyllic conceptual, highly formalized art of the Islamic world could not be reconciled with the rational reality of the European world of perspective. Many attempts to combine the two were made, almost all of them unsuccessful. Islamic art fell into a decline from which it has only recovered, since the late 19th century, by the acceptance of a duality: on one hand a revival of the calligraphic, linear style of idyllic, poetic convention derived from Islamic tradition, and on the other hand an alignment with the intellectual and perceptual art of the west.

Decorative art has an importance in Islam which it hardly achieved in any other culture. From the ancient world the Arabs had adopted certain ornamental leaf motifs and developed them into intricate designs of vine leaf scrolls with intertwining patterns in branching stems and tendrils. From these and from the acanthus leaf and other plant form designs of antiquity, the so-called 'arabesque' was developed. In its naturalistic form this type of pattern celebrated the beauty of plant growth, and the formation of buds, flowers and fruit. Later, birds and animals were inserted among the leaves. It had a marked sense of rhythm perfectly matching that quality in Arabic poetry and music.

The geometrical arabesque derived from the classical Greek key pattern and its later variations, and the Roman floor and ceiling pattern of circles, squares and polygons. These two influences resulted in an intricate intertwined pattern of lines or narrow bands which followed straight paths or perfect arcs to create continuous spreading stellar patterns; these could be used to fill entire surfaces with ornamentation The various types of arabesque become the predominant unifying element of Islamic art at all times and in all places throughout the Islamic

Mustansirryyah Madrasah, Baghdad, Iraq, 13th century. Geometrical arabesques executed in brick.

The Arabs had a great interest in and talent for mathematics, and geometry played an important part in their art and architecture. The representation of living beings was frowned upon, especially in religious art, which meant that the entire interest of surface decoration had to be generated from within. The geometrical arabesque was one means of doing this. Straight and curved lines, circles, squares and polygons were intertwined and contrasted to produce complex patterns which often took the form of interlaced stars.

world. In backgrounds or borders to illuminations, in books, title pages, ornaments of household objects and furniture, carpets, glassware, ceramics and in buildings, these intricate rhythmic patterns cover almost every type of surface. Naturalistic arabesques were often contrasted with areas of geometrical arabesque and both might be contrasted with areas of a quite different character derived from cursive calligraphy. On the earliest Islamic buildings, the Dome of the Rock in Jerusalem, 691, and the Umayyad Mosque in Damascus, 705, the lower walls are panelled with slabs of marble and other stones arranged in abstract patterns of rectangles and squares, while the walls above are covered in superb mosaics of wholly Byzantine type, made of small pieces of coloured glass and stone set in plaster, representing fantastic landscapes and towns. In the houses of the 'Abbasid capital at Samarra elaborate stucco arabesques in moulded bas-relief flow across the walls in a version of abstract natural forms which is unlike that of any other period—although its influence survived for several centuries. The window openings of early Islamic buildings were usually filled with open geometrical arabesques. In the richer mosques and palaces these were carved from thin sheets of marble or alabaster, in other buildings made from fine white gypsum. Elaborate geometrical arabesques were also used in wall decorations in stone and gypsum in 8t1 and 9th century buildings in Egypt and Spain.

Glazed and brightly-coloured ceramic wall tiles had been extensively used in ancient Mesopotamia and by the Sassanids. The Islamic use of tiles began in earnest in 'Abbasid times, at Samarra, where the applica- tion of a metallic sheen to the tiles was developed. From there, it spread to Fatimid Egypt and Spain, and subsequently, in the 13th century, hexagonal and star-shaped lustre tiles were in widespread use in Persia. The monotony of the vast semi-desert landscape which made up much of Islamic territory could be cheerfully relieved by the use of

pattern and colour on major monuments. In the 12th and 13th centuries 'faience' mosaics were developed in Persia by cutting brilliantly coloured glazed tiles into a variety of shapes which were then assembled into complex patterns. Into this form of patterning the introduction of bands of decorative calligraphy lent a literal spiritual quality. The first complete covering of a building with this type of decoration in cut tiles was the Sircali Madrasa at Konya in Turkey in 1242. During his great building programme in Isfahan in Persia, in the early 17th century, Shah 'Abbas authorized the replacement of the mosaic patterns of cut tiles by square tiles on which parts of the overall pattern were painted in different colours. Although large scale patterns had been produced on square or rectangular tiles centuries before in bas-relief, this was the beginning of the use of square tiles painted with a number of different bright colours to simulate the earlier faience mosaic technique. A similar development took place about the same time in the great centre of tile manufacture at Iznik in Turkey. The 17th century saw the apogee of tile decoration in Persia and Turkey, but the technique declined steadily from the latter half of the 18th century.

Metalwork was one of the great Islamic crafts, used for a huge variety of objects in architecture and the home. Craftsmanship in metal reached levels of excellence approaching the highest achievements of the other fine arts. Usually, restrictions against luxury forebade the manufacture of articles in solid gold or solid silver, but some ruling princes appear to have ignored this prohibition and ways were evolved of avoiding these laws by means of various technical innovations. Hence articles might be made with non-precious metals such as bronze, brass, copper, or iron, and then inlaid with tiny amounts of gold and silver, producing a diverse and rich effect. This technique developed in Turkistan and in Eastern Persia, and was brought to perfection in the exquisite work of Mosul in Iraq during the 12th and 13th centuries. Subsequently the technique was skilfully used in many countries in the Islamic world. In ceramics the lustreware technique developed. This derived from

Masjid-i-Shah, Isfahan, Iran, early 17th century. Glazed tile decoration of various types. *(Below)*
During the erection of this building the type of tile decoration changed from cut faience to square tiles painted in the same bright colours to imitate the earlier techniques—a faster process to ensure the completion of the mosque within the lifetime of Shah 'Abbas. In its variety of styles, its quality of design and execution, and its brilliant colour, the decoration is among the most ambitious ever under-taken in Persia.

Seen from below it can be observed to be based on a perfect geometrical pattern, often of extraordinary ingenuity.

This fine façade exhibits considerable refinement, both in the restrained way in which the glazed tile surface is contained within borders of brickwork, and in the design of the stalactite vault over the portal. Such vaulting developed in the eleventh and twelfth centuries AD, and was at first restricted to the supporting corners under domes—indeed, it evolved from a careful, geometric arrangement of super-imposed 'squinch' arches. It developed into an intricate construction of small arches carrying cantilevered sections of vaults which could build up, by corbelling outwards, to cover almost any shape of arched or domed surface.

Nader-i-Shah Madrasah, Isfahan, Iran, early 18th century. Glazed brick and tilework decoration, with a stalactite vault within the portal. *(Right)*

ISLAMIC ART

practices used in late antiquity to provide a metallic sheen to black-glazed ware, but its possibilities were only fully discovered during the early Islamic period. By the end of the 8th century, plates and bowls were being decorated with low relief ornament which, when glazed with lustre appeared like chased goldwork or mother of pearl. An even more metallic effect was later developed, with undertones of yellow, brown, green, red, or purple. This new ceramic technique became popular and spread quickly throughout the Islamic world.

Other early pottery in the Islamic world involved a continuation of Roman techniques using green and yellow lead glazes over moulded ornaments, ranging from Hellenistic vine-scrolls, animals and birds to the more abstract patterns of the Sassanian world. Under the 'Abbasids at Samarra in Iraq, imitations of Chinese lead-glazed earthenware appeared, decorated with splashed patterns in the T'ang green-and-yellow style. The competition provided by Chinese porcelain also led to sustained efforts on the part of Iraqi and Persian potters to discover the secret of its manufacture. They were unsuccessful, but their attempts resulted in the development of an exceptionally hard and even trans-lucent pierced ware closely resembling pieces which were much prized from China and South East Asia. The opaque-white glaze which was invented for this pottery contained tin, which was a perfect surface for applying painting. The decoration was at first chiefly in blue, or in a combination of green and purple. Later it was joined to the various colours available in lustre pottery. The decoration favoured verses from the Koran in bold Kufic script, or animals, birds, single or grouped human figures, or a variety of formal patterns.

In the 12th century the Seljuk Turks also tried to produce Chinese porcelain. They failed to discover its secret, but succeeded in develop-ing a pure white, half-glassy material with which they could manufac-ture plates and bowls of extreme thinness. New alkaline glazes replaced the old lead ones and could be obtained in a wider variety of colours including turquoise, various shades of blue and purple, green and yel-low. These techniques made possible some of the most beautiful crea-tions in Islamic pottery. At the same time designs became more vital and naturalistic. Running beasts and humans were often shown in silhouette against coloured backgrounds.

Chinese influence in painted decorations in pottery became particu-larly pronounced during the Mongol period (13th to 14th centuries), when nervous, feathery, plant and landscape motifs or crane and lotus motifs were painted in black outlines on a white background, or in turquoise, purple and other subtle colours. By the 15th century Persian pottery was beginning to imitate the Ming blue and white porcelain styles. Imitations of blue or celadon-glazed wares were also being made from the 15th century onwards, which techniques became inventive in original ways in the 16th and 17th centuries. Polychrome painted dishes, representing women and groups of figures framed in flowers, were made in Kubachi, some of them among the most attractive pieces of pottery of this time.

Iznik pottery became famous in Asia Minor from the 13th century onwards, when tin-glazed painted wares of great originality were pro-duced. Designs involving blue tulips and other flowers arranged in leafy, curling arabesques on a brilliant white background, were devel-oped in the early 16th century. Other colours were added during that century, particularly sage green, pale purple and a bright red and the range of design possibilities increased still further. After the 17th century the standard of execution and design gradually declined in Turkey as elsewhere in the Islamic world.

Persian bowl, 13th century. Whitish earthenware painted in black and pale blue, covered with a clear glaze, height 11cm (4¼in), depth 19cm (7½in). Victoria and Albert Museum, London, England. (Below) Overglazed polychrome painted decoration, such as this, on pottery is regarded as producing the most beautiful and elegant ware of the period of Seljuk influence in Persia. In technique highly sophisticated, it combines influences from many countries, Fatimid Egypt, central Asia and China.

Syrian vase (Rakka type), late 12th century. White earthen-ware painted in black under a turquoise glaze, height 26cm (10¼in), depth 18cm (7⅛in). Victoria and Albert Museum, London, England. (Above) Black painting under a transparent blue or colourless glaze is a feature of pottery decoration developed by the Seljuks. At this time there was close contact between Syrian and Persian pottery, following the destruction of Rayy in Persia by the Mongols in 1220 when many potters fled from the city and found employment in Rakka. The quality of the design reveals close liaison between painters and potters.

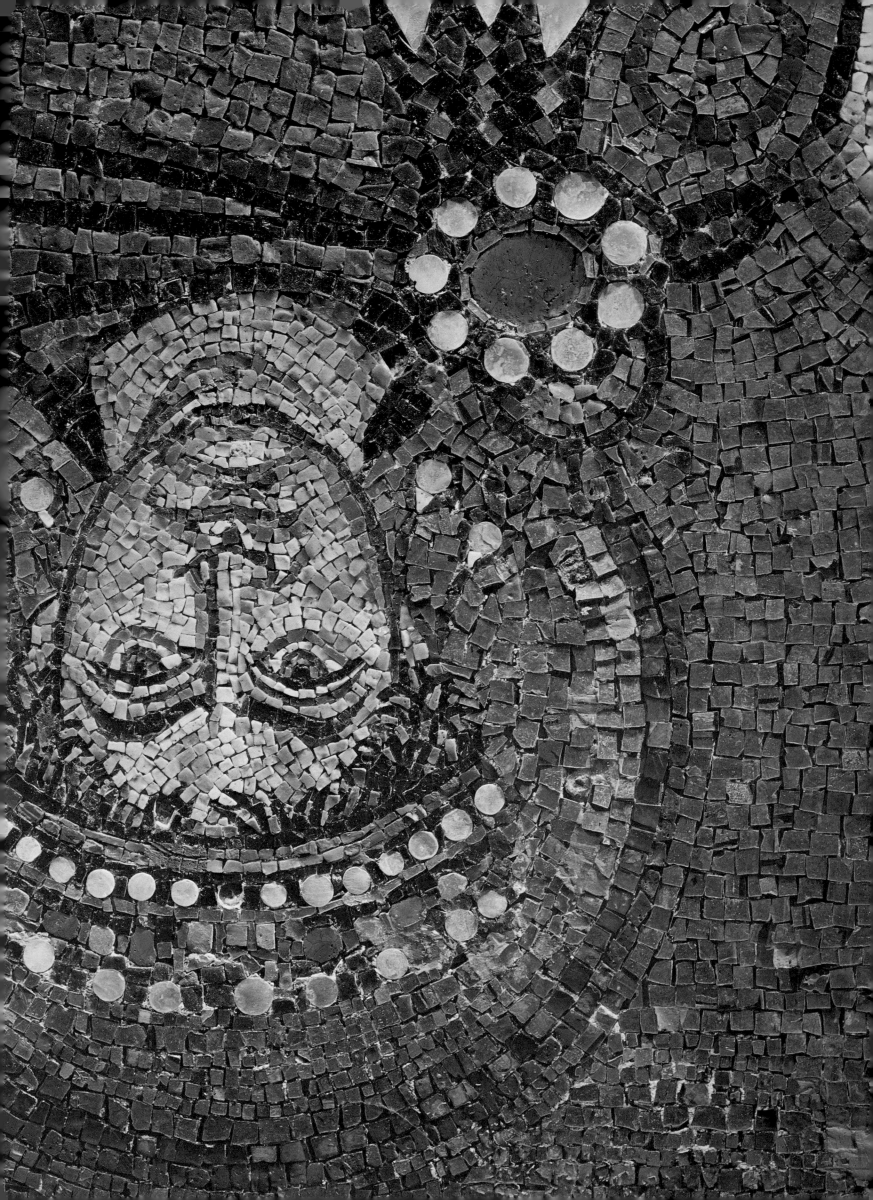

EARLY CHRISTIAN AND BYZANTINE ART

The art of the Hellenistic kingdoms and the first century of the Roman empire to a large extent looked back to the achievements of Greek art of the 5th and 4th centuries BC. But this influence began to wane in the 3rd century AD when the Roman empire was in crisis: there was no stable government, the frontiers were poorly defended because of civil war and all values were threatened by galloping inflation. Although Roman artists had often imitated classical art, they had never fully understood its formal principles and during the 3rd century AD they were almost completely rejected. Conditions on earth were so bad that thinking men began to hope for a better life after death and their hopes are reflected in the decorations of sarcophagi. The story of Prometheus, who had created man and endowed him with fire, was punished but eventually rescued, became a popular theme. Because of the extensive use of the drill the figures form a flat pattern on the surface of the stone and all clarity of construction has disappeared. One can barely distinguish the main subject of the relief, the brooding figure of Prometheus seated beside the reclining figure of his creation, Man.

The most influential philosopher was Plotinus, an Egyptian born c.AD 205, who developed the ideas of Plato, especially those expressed in the *Symposium*. He taught that there were many levels of the visible material world and the invisible spiritual world and that they were all connected to their source in the One God. This being could be sensed in the beauty of all visible things and could also be reached through thought. There was a connection between things visible and things invisible and a man had both a body and a soul. The body was a beautiful instrument through which the soul could express itself and a man should cherish and train his body in the same way that a musician should care for his musical instrument. We find this belief in the dominance of the soul over the material body expressed in the eyes of many 3rd and 4th century portraits, such as the gold engraved glass disk in the Vatican inscribed *Eusebius the Sweet Soul*.

Plotinus's philosophy appealed to the aristocrats, but around AD 260 there were major social changes in the Roman empire: the senatorial aristocracy were excluded from military command and from that date we see the rise of the new man, the professional soldier who was often of humble birth. The great reforming emperor Diocletian (284–305) was the son of a freedman from Dalmatia and his Caesar, Galerius, had herded cattle in the Carpathians. Diocletian divided the empire into two

Portrait of Justinian, after 540. Mosaic. S. Vitale, Ravenna, Italy, (*Previous page*)
Justinian united the eastern and western halves of the Roman empire by reconquering Italy. Its capital was no longer Rome but Constantinople, the old Byzantium. The church of S. Vitale had probably been begun by the Gothic king Theodoric, but the construction was completed by Justinian who placed his portrait within the sanctuary, as befitted God's representative on earth. The flat iconic image is both abstract and realistic at the same time. Although the glittering mosaic cubes destroy any illusion of pictorial space, we still can recognize the emperor's features.

administrative halves, creating a new eastern capital, and each half was ruled by an emperor and a caesar. We can see the type of harsh art his administration preferred in the portrait of the *Four Tetrarchs* now in St Marks, Venice.

Diocletian persecuted Christians because they refused to acknowledge his divinity and so he saw them as a threat to the safety of the state. The last persecution in 302 came as an appalling shock to Christians who saw no conflict in their loyalty to both Church and state. The Church, which was well-organized, provided for their material welfare: by AD 250 the Church in Rome was caring for over 1,500 poor people and widows. Moreover Christianity could be considered to be not only the heir to the best of Greek philosophy but also to Roman organization. Origen of Alexandria (c.185–254) who had been taught by the same master as Plotinus, showed that Christianity was the 'natural' or 'original' religion because Christ had created the best of Greek culture and had laid the foundations of the Christian Church when Augustus had brought peace to the Roman empire.

Perhaps about 10 per cent of the Roman empire had been converted to Christianity, probably more in the eastern provinces, when Diocletian's persecutions led to wide scale defection. But a miracle happened when the usurping emperor, Constantine, had a vision in 312 which he believed won him the crucial battle over his rival Maxentius for the control of Rome. In proclaiming himself a Christian emperor Constantine claimed himself to be a true successor of Augustus. By 324 he had reconquered the eastern provinces and in 330 he founded a new capital city on the site of Byzantium which he renamed Constantinople, the city of Constantine.

Christianity did not become the official religion of the Roman empire until the end of the 4th century, but it had official approval and new churches had to be provided for the vast numbers of converts. In Rome many of these churches were built on the sites of houses, or even private baths owned by prominent members of the Christian community, and the names of these original owners were often preserved in the *tituli*. For instance the church of S. Pudenziana is named after Pudens, the original owner of the land. Only the apse mosaic of this church survives and it represents Christ enthroned among the apostles. He is seated in the exedra of a great basilica built by Constantine on Golgotha and we can recognize other buildings built by Constantine in the background. The artist used a portrait of the new Christian city built by Constantine to symbolize the Heavenly Jerusalem.

Graven images were prohibited by the Ten Commandments, and so the Church used mosaic to create an image of its divinity. The mosaic of Christ was placed in the apse in exactly the same way that a statue of the emperor was placed in the apse of a legal basilica to show that his authority extended throughout his empire. Christ now took on the image and the authority of a Roman emperor and the emperor became His representative on earth.

In spite of the attempt by Constantine's nephew Julian to restore pagan religion, Christianity triumphed. It appealed to the poor because it offered them protection and it also appealed to the educated because of its respect for books. Its spread was associated with the development of a new type of publication, the codex. Older books had been written on rolls of papyrus paper, the writing divided into columns. These could be illustrated by inserting a diagram at the head of the column, but it did not encourage elaborate illustration because constant unrolling would flake off the paint. The change over to the codex, sheets of goat skin parchment, folded into pages and stitched into a book,

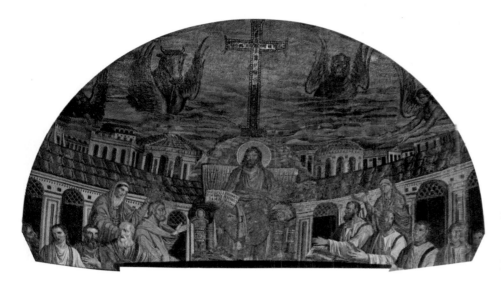

Christ enthroned with the Apostles in the Heavenly Jerusalem, early 5th century. Mosaic. Apse of S. Pudenziana, Rome, Italy.

After Christianity was accepted as the official religion of the Roman empire much church decoration was inspired by that of the Imperial Palace. Christ was represented like an emperor enthroned in the apse of His church. The background is a topographical view of the churches built by Constantine in Jerusalem.

offered far greater scope for the book illustrator because whole pages could be used and the pages protected the paint.

Homer and Virgil still remained the backbone of education, even in a Christian society, and de-luxe editions of their works were important sources of income for the different publishing houses. We are not certain where or when the Roman Virgil in the Vatican Library was produced, probably in the later 5th century. The illustration which represents Aeneas's visit to the Cumaean Sibyl still retains some of the illusionism and impressionistic technique of Roman art. But the temple (the Sibyl's cave) is treated as a purely diagrammatic pattern.

By the 6th century we begin to see distinct differences in style between the art of the eastern and western Mediterranean. Italy and the west had come under German rule in 476, though this made little difference to the art which still remained basically late Roman in style. But Constantinople, which had survived palace revolutions, began to regard itself not just as the new Rome but also the guardian of Hellenic culture. Greek again became the official language in the 5th century.

Greek always had been the language of civilized society throughout the eastern Mediterranean. But Latin had been the official language during the great days of the Roman empire and the whole structure of the Christian church reflected the supremacy of Latin civilization. But because of barbarian invasions, the church in Rome in the 5th and 6th the Christian Church reflected the supremacy of Latin civilization. But because of barbarian invasions, the Church in Rome in the 5th and 6th

Each city was a major art centre but again, as in the Hellenistic period, we have difficulty in distinguishing any local style. One of our major problems is in identifying where three purple manuscripts—the Rossano Gospels, the Sinope Fragment and the Vienna Genesis—were written and illustrated. The purple parchment indicates that they came from the scriptorium in the Imperial Palace at Constantinople and were intended as luxurious gifts to ease the course of diplomacy. But there are strangely conflicting features about them which suggest that either they had been produced in an eastern city, or that eastern artists were employed in Constantinople.

The Vienna Genesis is painted in a variety of styles. Some of the illustrations are set in an illusionistic landscape, others are narrative scenes on a bare ground line. In Picture 31 Potiphar's wife attempts to seduce Joseph in an opulent colonnaded bedroom. This takes up only one quarter of the illustration and the remaining space is devoted to the care of a little baby. This could perhaps be Potiphar's adopted daughter Osnath. She is not mentioned in the book of Genesis, but we know

The Baptism, c.1020. Hosias Loukas, near Delphi, Greece. Byzantine churches were designed as a microcosm of the universe and each part symbolized the relationship between man and God within the universe. Originally the apex of the dome contained a medallion of Christ Pantokrator, the All Mighty, but this was destroyed in an earthquake. The squinches, which act as bridges over the corners of the square central area of the church, were decorated with scenes of His incarnation, when God came down to earth and took human form. Although the style is austere, intended for monks who have renounced the world, the lavish materials, the polished marble panels on the walls and the gold mosaic within the vaults, reflect the riches of its imperial patron, Basil II.

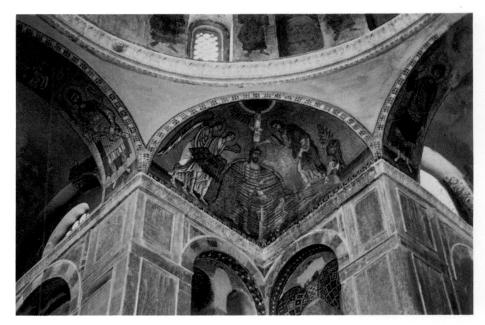

about her from Jewish legends and that Joseph later married her. Perhaps the manuscript could have been painted in Antioch or Jerusalem where Jewish traditions were very much alive, or by a Jewish artist working in Constantinople.

The most interesting feature of early Christian art is that fine art has almost completely disappeared and we see the growing importance of the applied arts, book illustration, mosaic decoration and ivory carving.

Byzantine art is the art of Constantinople. It is found in many other places in the eastern Mediterranean because artists from the capital worked there and their ideas spread, especially into Italy. But one must distinguish between the living and vital art of the capital and its weak and sterile imitation in the provinces.

It was not until the reign of Justinian (527–65) that Constantinople gained cultural supremacy over the other cities which had been devastated by religious faction. Justinian regarded himself as a new Constantine who once more united the Roman empire, liberating Italy from German occupation. This 'liberation' did more damage to Italy than was ever achieved by the Goths, who had been converted to Christianity and continued the policies of the Roman empire. The church of S. Vitale in Ravenna had been begun under the German king Theodoric perhaps as early as 522 but it was finally dedicated by Justinian to celebrate his reconquest of the western capital.

The dedication panel in the sanctuary represents Justinian with the bishop of Ravenna, Maximian (546–8), presenting a golden paten to the church. The artist took full advantage of the intense colours only possible with mosaic. The figures had been outlined on the bare wall and the section to be worked covered in plaster, which was roughly painted. The glass cubes were made from sheets of coloured glass which had been scratched with a diamond and then broken up. The cubes were quickly inserted into the wet plaster. The background was made from cubes cut from a sheet of golden glass made by sandwiching leaves of pure gold between sheets of plain glass and fusing the two in an oven. In earlier mosaics, for instance the floor at Pella or the apse of St Pudenziana, the artist had tried to imitate the subtle gradations of tone only possible in paint. But in Ravenna the artist exploited the medium to create new effects. In some ways these are very realistic portraits and we can recognize the complex personality of Justinian which contrasts so vividly with the austere personality of Bishop Maximian. However, the figures have no spatial form and overlap each other.

This loss of the sense of form is particularly evident in ivory carving,

even when the style appears to be classical. The *Archangel Michael* in the British Museum is the right wing of an imperial diptych, probably of Justinian's uncle, Justin. The left wing would have represented the emperor receiving the emblems of authority, the orb and the sceptre, from God's messenger, the Archangel Michael, on the right wing. The figure is obviously derived from a classical winged victory, but his spiritual nature is expressed by dissociating him from the architectural setting.

This iconic presentation of spiritual beings as images without physical substance led to the development of the painting of portraits of saints for veneration. One of the most important collections of portraits of saints has been found in the Monastery of St Catherine in Sinai. Monasteries had first developed in Egypt in the 3rd century AD as a form of rebellion against the corrupt authority of the Roman empire. How can you punish a man and force him to obey your will if he has no possessions, lives in conditions far worse than that of the worst prison and looks upon this life on earth as a painful prelude to the bliss of eternal life after death? Although Byzantine emperors were absolute rulers, nevertheless their power was always tempered by that of the monasteries. During the 8th and early 9th centuries emperors and monks were in open conflict, ostensibly over the subject of icons.

The 7th century had been a period of crisis because Justinian had overextended the resources of the empire by his reconquest of Italy and the frontiers had been weakened. The city was besieged first by the Persians and then by the Arabs and was only saved by a new ruler, Leo the Isaurian, who had been born in northern Syria and was very much in sympathy with the fundamentalism of Islam. He was proclaimed emperor in 717 and in 726 he issued the first edict against images. Under Constantine V the struggle became more bitter and there were fierce prosecutions. The Empress Irene, an Athenian by birth, restored religious art in 787 but blinded her own son, Constantine VI, in order to retain her power. It was during her reign that Charlemagne was crowned emperor of the west in Rome in 800. She was deposed and succeeded by three emperors of Asiatic origin who banned all forms of religious art once more, and it was not until the reign of Michael the Drunkard in 843 that it was once more permitted.

This controversy was partially caused by the fact that the veneration of religious images had come dangerously close to pagan image worship. It was based upon an aspect of Neo-Platonic philosophy which related the spiritual and the material world and showed that there was a connection between a holy being in heaven and his image on earth. In fact the real issue was the power of the monasteries which drained the empire of its resources because monks do not pay taxes nor can they be called up for military service.

In spite of saving the empire the Isaurian emperors were hated and the history of this period was rewritten so we have little idea of their achievements. The Amorians who came to power in 820 were too weak to control the empire and their dynasty ended with the murder of Michael the Drunkard by Basil the Macedonian in 867 and thus began a new golden age for the Byzantine empire, even though it was now reduced to its eastern provinces. This was the Macedonian Renaissance.

Basil began an ambitious programme of church building and decoration which set the pattern for future developments in Byzantine art. His New Church had a cross-in-square plan and was decorated with mosaics representing Christ Pantokrator amid concentric circles of angels in the dome, the Virgin in the apse and the walls decorated with saints. It was probably not until the 10th century that the idea evolved

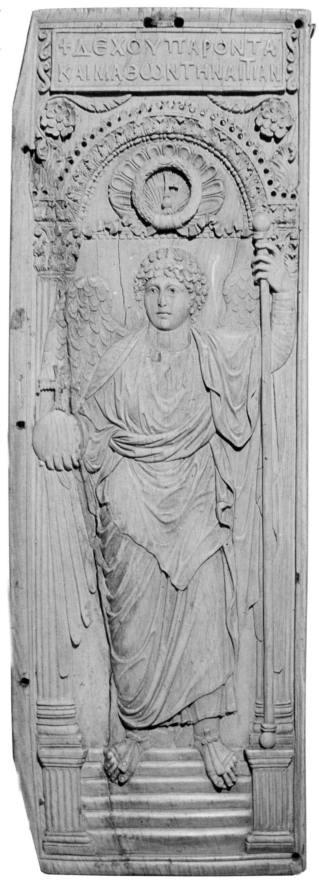

The Archangel Michael, c.519–527. Leaf of an ivory diptych, height 40cm (16in). British Museum, London, England. Diptyches were originally used as notebooks. Two leaves were hinged together and the inside surface covered in wax on which a message could be written with a pointed stylus. From the fifth century onwards elaborate ivory diptyches were carved to celebrate important events, such as the election of a new consul or emperor. The holes on the left hand side of this panel indicate that it was the right wing of a diptych and represents the Archangel Michael holding an orb and sceptre, emblems of Imperial rule, and above his head the inscription reads 'Receive these gifts and having learned the cause . . .'

of decorating a church with mosaics representing the twelve major festivals of the church year. These scenes from the life of the Virgin and of Christ were not presented in narrative order because although they had once taken place in time, they had happened for all time for the eternal salvation of mankind.

Hosias Loukas was a monastery church built over the tomb of a holy man living in a hermitage on the flanks of Mt Parnassos. He had prophesied in 942 that the Emperor Romanos II would recapture Crete, and this prophecy was fulfilled through the generalship of Nicephoras Phocas. Although begun under Romanos II the church was not completed until the Emperor Basil II visited Athens to give thanks to the Virgin of the Parthenon for his victory over the Bulgars. The church is decorated as if it were a microcosm symbolizing the union of heaven and earth. Originally in the apex of the dome was a mosaic of Christ Pantokrator but this was destroyed in an earthquake of 1593. In the minor dome over the sanctuary is the *Descent of the Holy Spirit*, and in the apse the mystery of the incarnation is presented by the majestic figures of the Virgin and Child. On the walls are the human beings who have entered heaven, the saints, and in the squinches, the bridges between the earthly walls and the dome of heaven, are the scenes of the incarnation when God came down to earth and took human form, the *Annunciation*, the *Nativity*, the *Presentation in the Temple* and the *Baptism*. The style is austere, for it was intended for monks who had renounced the material world to live a spiritual life, but it gave them a foretaste of the splendour awaiting them in heaven.

Mosaic decorations, especially in monastery churches, tended to be in a severe, abstract style, but ivory carving and manuscript illustrations were much more classical. To a large extent this revival of classicism was due to the copying of earlier models, but nevertheless we see a new movement in the paintings of the life of the Virgin and Christ which expresses an interest in their humanity and owes nothing to early Christian prototypes. This new style and iconography can be seen in illustrations of the Menologion of Basil II, a calendar of the feasts for the first half of the church year painted for Basil II in *c*.985. Each feast is illustrated by a half-page painting and the scribe recorded the names of the eight artists in the margin. They had obviously used a wide variety of sources but had adapted them to fit into the uniform style of this manuscript by setting the figures in a box-like space created by architecture and a landscape of hills set against a plain gold ground. The *Feast of the Immaculate Conception* is illustrated by the scene of Anna meeting Joachim at the Golden Gate of Jerusalem and they tenderly embrace each other having at last been reunited. It was in this chaste embrace, according to the book of James, that the Virgin was conceived.

There was a very marked change of style in the next two centuries, paralleled by developments in western art where Romanesque painting was extremely flat in style. In Byzantium the change of style can be partially explained by political events because in 1071 there was a disastrous defeat at the Battle of Manzikert which allowed the Turks to overrun Asia Minor. Ten years later Alexios Comnenos came to power (1081–1118) and the art of the Comnene era is extremely abstract, yet at the same time there was increasing interest in the expression of human emotions. The church of St Pantaleimon at Nerezi in Macedonia was dedicated in 1164, by Alexis, a member of the imperial family. The *Lamentation,* a new subject in art, is given great emotional intensity through the almost abstract use of outline in the tense curve of John's body, bent double with misery, and the anguish on the Virgin's face as she clutches her son's dead body, is emphasized by flashing highlights.

Lamentation, 1164. Wall painting, S. Pantaleimon, Nerezi, Yugoslavia.
Art during the Comnene era became increasingly austere as the Byzantine emperors struggled for survival after the Turkish invasion of Asia Minor. This church, on the northern frontiers of the Byzantine empire in Macedonia, was dedicated by Alexis Angelos, a member of the Imperial family. The flattened forms resemble the highly abstract contemporary Romanesque art in western Europe. But there is a new tragic power in the expression of the Virgin's grief at the death of her son.

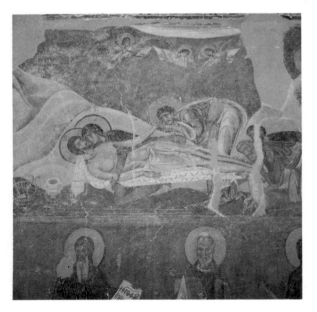

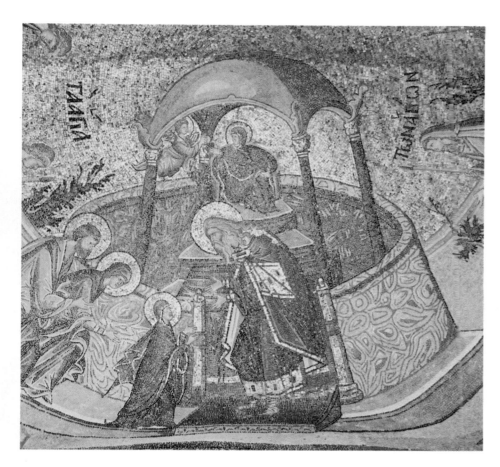

Presentation of the Virgin, 1315. Mosaic in the exo-narthex of the Church of the Chora (Kariye Camii), Istanbul, Turkey. In contrast to the abstraction of Comnene art, Palaeologue art has charm and naturalism. Michael Palaeologus, who regained Constantinople from the Crusaders in 1261, founded the last Byzantine dynasty. One of the patrons of this church was a Byzantine princess, Maria Palaelogina, whose betrothal to a Monghol Khan helped relieve, for a little while, the Ottoman Turks' threat to the city. This mosaic reflects the elegant and civilized way of life which would soon come to an end.

The centuries between the disastrous Battle of Manzikert and the fall of the Byzantine empire in 1453 saw perhaps the most beautiful flowering of Byzantine art. After the Latin conquest they had become increasingly aware of their Greek nationality and their heritage of classical culture. This influenced not just their minor arts, such as manuscript illustration and ivory carving, but also their church decoration. The Church of Christ on Chora was perhaps founded as early as the 4th century when the monastery stood outside the Constantinian walls before the Theodosian walls had been built, and so was dedicated to Christ in the Village. But to the 14th century mystical mind both Christ and the Virgin were the Village of the Living. The church building dates back to the 11th century but it was added to in 1120 by Isaac Comnencs, third son of the Emperor Alexios. In 1315 a double entrance hall was added with mosaic decorations. The scenes from the life of the Virgin and Christ were derived from similar sources to those used 300 years earlier by the painters working in the scriptorium of the Emperor Basil II. In the intervening centuries the scenes had been elaborated and artists delighted in intimate family scenes, such as the *First Steps of the Virgin*. Art had recovered from the flatness of the Comnene era and the figures are placed in a three-dimensional architectural setting. But there is an air of unreality about these mosaics: the colours are too enchanting, too much like jewels. The maiden who supports the Virgin is not a real life servant girl; she wears a floating scarf which reminds us of the goddesses who attend Mother Earth on Augustus's *Ara Pacis*. This elegant art of the Palaeologue era used beauty as an escape from the harsh reality of a dying empire.

These mosaics were begun about 10 years after Giotto had started work on a similar cycle of paintings illustrating the life of the Virgin and Christ in the Arena Chapel in Padua. Both obviously had a common source and both were equally concerned with the humanity of the Virgin and Christ. But Giotto's art had a new heroic quality which marked it not only as the beginning of the Italian Renaissance, but also of a new era in art.

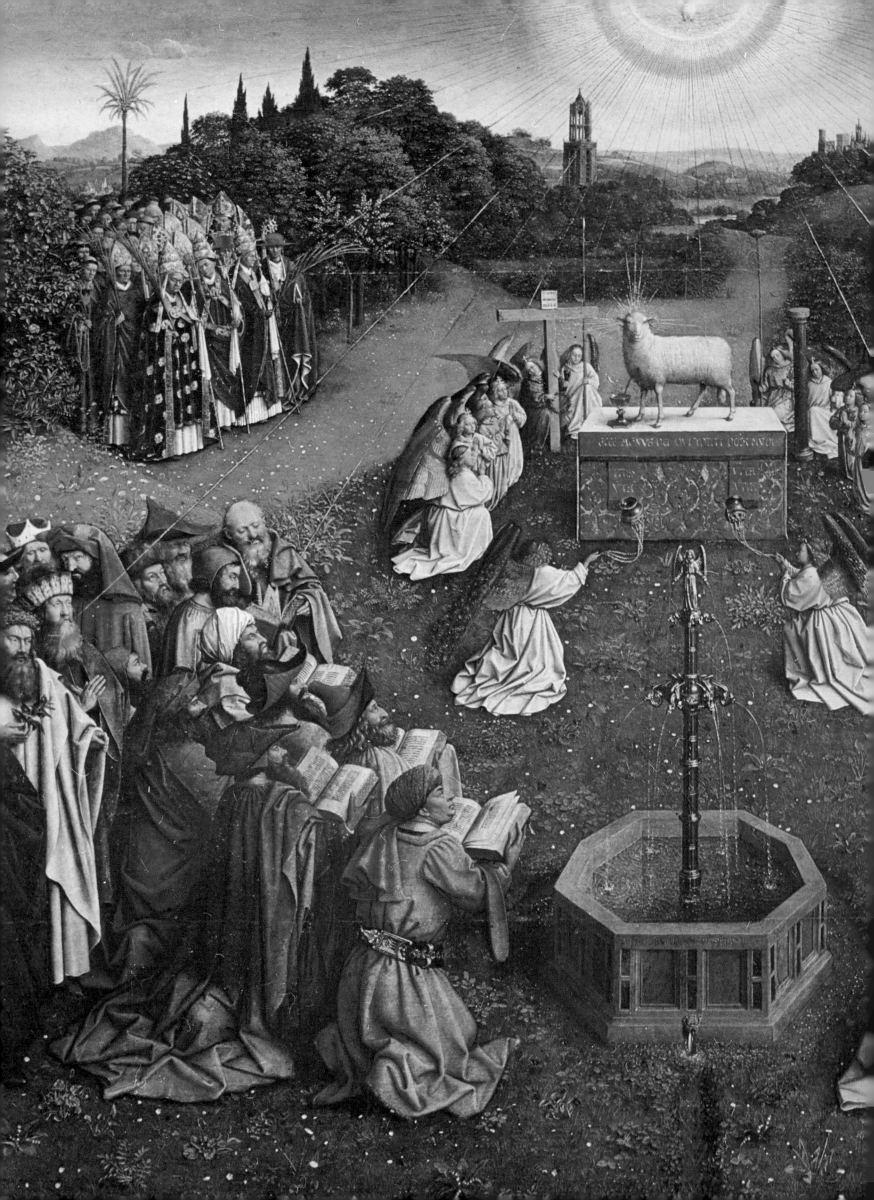

MEDIEVAL ART

'Medieval' is the adjective from 'middle ages'. The term is used to describe part or all of the 1,000 years of European history from roughly AD 500 to AD 1500. During this very long stretch of time the peoples of Europe shaped the culture which dominates the modern world. Institutions like the university and parliament; the systematic application of power to industrial processes; the application of gunpowder in war; the printing press; the characteristic European drive towards exploration and colonization; the concept of both national identity and the concept of European identity—these were just some of the elements in the chemistry of Europe with which subsequent centuries have been experimenting. They have been inspired by the most potent of all the habits of mind developed by Europe's intellectuals during the middle ages; this was the habit of what we might call progressive thinking.

Catholic Christendom believed that the divine mysteries were being progressively revealed. Unlike those of any other world religion, the 'philosophers' of Christianity, the theologians, could move on from one problem of the faith to another as each received its officially acceptable formulation in doctrine. This habit and technique of progressive, that is to say forward-moving and 'problem solving', thought held the seeds of revolution. When it turned from the mysteries of God to the mysteries of Nature, the stage was set for the most momentous revolution in the history of civilization. For it is this habit of thinking that inspires the whole process of science and technological development which has shaped the modern world.

This 1,000 years was the first age of Europe. How then did it get the name of 'middle' ages? The term springs from the kind of thinking made fashionable in Italy in the 15th century by a group of scholars now generally termed the humanists. Something of their ideas and the influence these had on artists is discussed in the next section of this book. Here we must note why they saw themselves to be different from their immediate predecessors and why they proclaimed that difference as a virtue.

The basis of their thought was an intense respect and study of ancient Greece and Rome. The ideas and art of classical antiquity had long provided a source of themes and inspiration. In the first age of Europe's development, Christendom gradually came to terms with the monumental achievements of its pagan precursor, the Roman empire. The law systems of continental Europe are still heavily indebted to generations of 'medieval' lawyers and commentators who integrated Roman

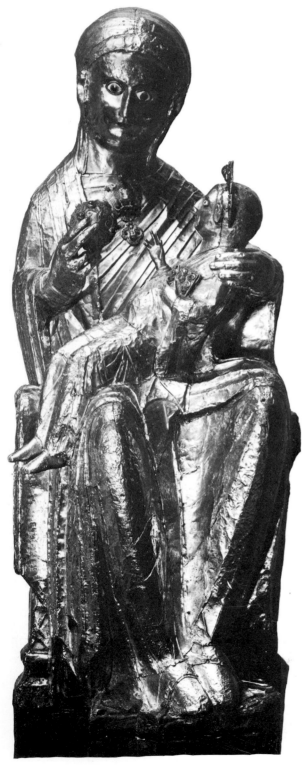

The Golden Madonna of Essen, German sculptor, possibly from Cologne, c.1000. Gold leaf on wooden core, eyes of enamel, child's halo embellished with jewels, height 74cm (29½in). Cathedral Treasury, Essen, Belgium.
The oldest known free-standing figure of the Madonna and Child, this statue was commissioned by the Abbess Mathilda, a member of the Ottonian imperial family. The art of the goldsmith was highly regarded in the middle ages. The costly medium was prized by wealthy patrons and conformed to the prevailing view that a great theme demanded precious materials. This figure, although comparatively small, reveals a master of monumental form.

law into a new European system. Devotees of chivalry considered it to be the perfection of ancient virtues—Julius Caesar and Alexander the Great were both seen as models of the knightly code. There were periods especially in the 8th, 9th and 12th centuries, when schools of art so consciously revived classical ideas that scholars sometimes call them 'renaissances'. Christendom might date its era from the birth of Christ, but it could not forget the ancient heritage. Of course it was selective about those aspects of the pagan past it admired, but it came to feel itself as part of a time continuum of which the classical world was merely the beginning. There are sculptures in the famous Gothic cathedral at Rheims which show their debt to classical models. They demonstrate the organic way European culture grew in its first 1,000 years from a soil fertilized by Christian and classical traditions.

The humanists broke in on this cumulative cycle of growth—many seemed to have hoped that they had felled the tree. They saw, quite rightly, that the piecemeal, selective and often frankly muddled absorption of classical ideas made it impossible to appreciate properly or even recognize at all the true genius of the Romano-Greek world. They set themselves to recover its true riches. They were contemptuous of what they considered the degenerate state of the Latin language. They believed that only with a faithful recovery of the classical thinking could civilization be reborn. They believed themselves the midwives of that rebirth and their own age a 'renaissance'. It followed that the millennium between the extinction of the Roman empire in the west and their own time was a largely unfortunate excursion in a backwater. Eventually someone coined the term 'middle ages'—and a teeming and inventive epoch of human genius was written off as a 1,000-year hiatus between a glorious classical past and a still more glorious, revived classical present. The assessment became part of received wisdom. In the 18th century, when thousands of 'medieval' treasures were cleared from French cathedrals to make way for more refined examples of what was then considered *le grand gout*, the 'high taste' of the Rococo style, a scholar dubbed the ancient style 'Gothic' after the barbarian tribes who had ravaged Europe more than 1,000 years before. Even today, so tenacious are catch phrases, this great millennium is still called the middle ages and its most dynamic and inspired architecture Gothic.

Perhaps art historians have clung to these outmoded terms because during the period painters and sculptors were classed with artisans and craftsmen in the social scale, they rarely signed their work and so most of them are now anonymous. These well-known facts have been the foundation for imposing theories about a revolution in the European attitude towards art itself. Scholars have even compared the exalted respect which artists claimed and often received from the Renaissance onwards with the frequent anonymity of their predecessors in order to argue that artistic genius only received the respect due to it with the Renaissance. It is generally supposed that during these 'middle ages' people rated the human individual and his personal achievements less highly than we do today.

It depends on one's point of view. There is no absolute scale of values that establishes the skill and insight of the visual artist above those of the philosopher, theologian or mystic. The centuries between Scotus Erigena and William of Ockham (from the 900s to the 1300s) produced minds of startling originality, inventiveness and intellectual power. Their names are well-known to us and they were renowned among their contemporaries. Students travelled from all over Europe to hear them lecture. Their controversies rocked the intellectual world. Unfortunately, of course, it was they, the churchmen, who wrote most of

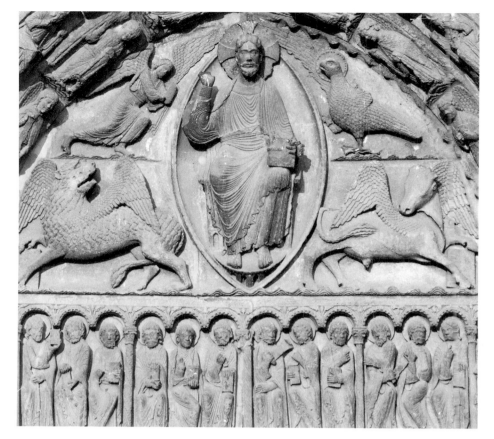

Christ in majesty with apostles (detail). Chartres Cathedral, France (*Left*)
Chartres cathedral is a key building in the history of Gothic art. Begun in 1195 and completed some 40 years later, it is not only a miracle of architecture but also retains all its mid-13th century stained glass and is adorned with a profusion of sculpture. This belongs to two periods. The West Front work, surviving from the previous cathedral, dates from the mid-12th century but already shows a move towards the freedom and naturalism of the best Gothic work. The sculptures on the porches of the North and South Transepts, almost a century later, are mature Gothic.

The Adoration of the Lamb, central lower panel of *The Ghent Altarpiece*, Hubert (d.1426) and Jan van Eyck (c.1390–1441). Painting on panel, 136·5 × 242cm (53¾ × 95½in). St Bavon Cathedral, Ghent, Belgium. (*Pages 112–113*)
A Latin inscription eulogizes Hubert and indicates the work was completed in 1432. Hubert's contribution is difficult to assess. Four wing panels show courtiers and pilgrims. Upper panels depict Adam, Angels, Mary, God, John the Baptist, St Cecilia, and Eve; when closed the backs of the wings show The Annunciation, Saints and Donors. The whole altarpiece is almost 3m high and more than 4m long (135 × 168in).

the material on which historians of ideas base their theories. But the testimony of the art itself at once dispels the notion that the period was not interested in artists and their products.

It is certainly true that artists were organized in guilds, just like butchers, bakers and grocers. It is also true that in the view of the establishment an artist was not anyone special, and therefore should not consider himself endowed with a unique personal gift, but rather that he was developing a human inheritance, there for anyone to take. This anti-élitist stance, surprisingly in tune with today's fashionable attitudes, was summed up in the 12th century: *Whoever will contribute both care and concern is able to attain capacity for all arts and skills. What God has given man as an inheritance, let man strive . . . to attain. When it is attained let none glorify himself as if it came from himself*. Since most of the records that survive come from establishment sources it is easy to suppose that the artists themselves thought like this. Fortunately a few real voices do survive in the documents. A scribe working in Christchurch monastery, Canterbury, in the middle of that same century, left this inscription round a picture of himself: 'Fame proclaims you in your writing for ever, Eadwine, . . . The worthiness of this book demonstrates your excellence.' A sculptor working in Modena, Italy, chiselled an inscription on a piece of his work. 'Among sculptors, your work shines forth, O Wiligelmo. How greatly you are worthy of honours.' Such healthy self approval is not often found in these early centuries, but there is no reason to let ourselves be persuaded by the patchiness of our sources that talented men and women of the period were any less self aware than today.

Cover of the Codex Aureus ('Golden Book') of St Emmeram, Court School of the Emperor Charles the Bald (Rheims or St Denis), c.870. Gold, pearls and precious stones. Staatsbibliothek, Munich, F.D.R. (*Below*)
The jewels are each set in filigree gold mounts. The gold reliefs depict scenes from the life of Christ, the Four Apostles and Christ in Glory. This masterpiece of the jeweller's art demonstrates the reverence for books and above all the Holy Scriptures. The ms itself is illuminated with paintings of great power whose style, like that of the cover reliefs, harks back to late classical art.

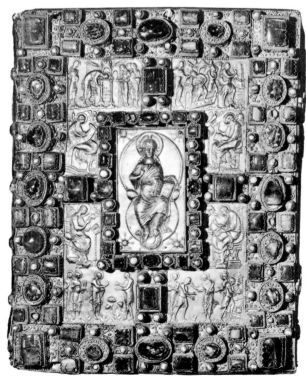

As to their guild membership, artists, like other professional men of the period, valued it as giving them standing in society. And that, in an age when status, or what the English called 'worship' (i.e. 'worthship'), gave one self respect and a recognized position in the human family, was a thing to value. It is not surprising that the painters' guild of Siena had strict rules to ensure that all its members and apprentices attended the festival of St Luke—the patron saint of artists—because, it was believed he had painted the first portrait of Mary, Mother of Christ. In any case

the guild offered advantages. It protected its members from unreasonable competition and generally had charitable provisions to help members in time of illness or hardship. It also acted like a modern professional body, enforcing standards of workmanship and quality to protect patrons but, more importantly, to safeguard the reputation of the profession. Rather disconcertingly, perhaps, we read in the statutes of Parisian painters of 1391 that members doing wall paintings should be sure to clean the wall thoroughly of any existing decorative scheme before starting the new work. Conservation was of little concern to medieval artists and craftsmen.

Artists were not unduly proud by modern standards as to the type of work they would undertake. For a long time the London painters' guild was considered an offshoot of the saddlers' guild; painters in Paris and elsewhere accepted many commissions for saddle painting. Even so distinguished an artist as Melchior Broederlam, who produced one of the finest altarpieces of the late 14th century for Philip the Bold, Duke of Burgundy, decorated jousting equipment and did other such decorative work for the Duke. This may seem rather humble work. However, since the Duke was one of the greatest men in Europe and since the cult of chivalry was the most brilliant activity of high society we can suppose that Broederlam was no more insulted than a modern sculptor might be by a commission for a statue outside a civic centre.

The skills acquired by an artist during his long and arduous apprenticeship included those of a skilled craftsman. Among them was the preparation of his colours. Each pigment had to be processed from its raw materials; each required special treatment, for example the colour effect of any one pigment could vary according to the size of the granules but in every case four basic processes were necessary—purification, drying, grinding and tempering.

Impurities were removed by washing. For example: a soil bearing the oxides of iron which the painter could use as 'coloured earths', or 'red ochres', also contained sandy particles and humus, mould or peat. The soil was mixed with water and the sand quickly settled to the bottom, the humus floating to the top as scum. When this had been lifted off the watery mixture was drained from the sand and left until all the ochre

Virgin and Child, French, 1339. Silver-gilt and enamel base panels, 69cm (27in). Musée du Louvre, Paris. (*Above*)
Presented to the Abbey of St Denis by the widowed queen of Charles IV of France, this graceful figure in its supple S-curve pose, speaks of the sophistication and elegance expected by royal patrons of the early International Gothic style. The luxury of the medium was, for contemporaries, an integral quality of such devotional objects. The pearl-crowned fleur de lys is a reliquary designed to hold a lock of Our Lady's Hair. Around the base 14 enamel panels depict the history of Christ's Passion.

Reliquary in the form of a coffer, French (Limoges). Second half 13th century. Champlevé enamel on copper gilt. Victoria and Albert Museum, London, England. (*Right*)
This small reliquary is a fine example of the skill of the metalworker and enameller. Perhaps made to contain a fragment of the True Cross or the bones of a saint, it is decorated with religious scenes and angels.

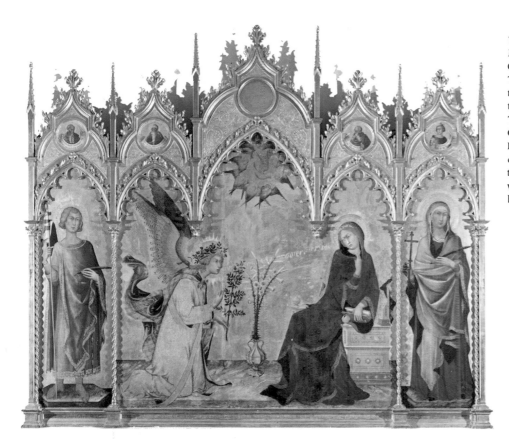

The Annunciation, Simone Martini (*c*.1284–1344) and Lippo Memmi (*fl*.1317–47). Painted 1333 for an altar in Siena Cathedral. Paint on prepared panel. Uffizi, Florence, Italy. The signatures of the two artists, brothers in law, appear on the altarpiece; it is generally thought that Memmi painted the saints on each side of the central panel shown above. The touching scene depicts the moment when the archangel Gabriel hails the Virgin Mary as mother-to-be of Christ. Between the figures stands a vase of lilies, symbol of chastity, and in the pointed arch above is a Dove, symbol of the Holy Ghost. The preparation of the relief panel on which the painting was done, was an arduous and lengthy business.

particles had settled. The clear water could then be poured off and the pigment particles dried. The final settling process might be interrupted and the watery suspension decanted two or three times leaving ever finer sediments. These pigments dried as pigment granules of graded sizes and hence different colour properties.

The red ochres, the yellow ochres and the somewhat dull and variable green earths were natural pigments. Surviving textbooks also describe the manufacture of numerous 'artificial' pigments. One interesting process produced a lovely and vivid green from verdigris, caused by acids attacking copper. One method was to hang copper over hot, fuming vinegar in sealed pots; another to immerse the copper in fermenting *marc*—poor man's brandy; in England apple vinegar was often used. But verdigris green was liable to react with moisture or impurities in the air and darken to an almost brown colour. Flemish painters seem to have had some secret of tempering it so as to preserve the colour—Italians were less successful. The green was lavishly employed by manuscript illuminators—sometimes the whole page would be stained with it—and, perhaps because in a closed book the air had less opportunity to attack it, it has survived better here than on panel paintings.

A most important family of artificial pigments were the 'lakes'— compounds of aluminium hydroxide (i.e. alumina) and an organic dye-stuff. The manufacturing process required alum, an essential raw material not only in colour making but also in leather tanning and glass making.

Alum was worked at Ischia in the kingdom of Naples but the finest quality came from mines in Anatolia in the Byzantine empire. In the early 1300s Anatolia was conquered by the Turks who imposed export duties on the trade. Thus indirectly every exquisite book of Gospels, every dazzling altarpiece, even the robes of the cardinals of the Church, now paid its little levy to the infidels. This scandal of the faith was cheerfully tolerated until, in 1460, large deposits of good quality alum were discovered near Cittavecchia in the Papal States. The popes leased the rights to the great merchant house of the Medici, pronounced excommunication for anybody who continued trading with Turkey, and, despite the canon law prohibition of monopolies, eliminated

'The artist Xeuxis painting a portrait of Helen of 'Troy,' Flemish, late 15th century. Miniature from a manuscript of Cicero's *Rhetoric*. Bibliotheek der Universiteit, Ghent, Belgium. (*Below*)

The picture illustrates Cicero's account of how the famous Greek artist, commissioned to paint a picture of the legendary Helen, supposedly chose five beautiful women as models, to combine their best points in an image of ideal beauty. Despite his classical theme, the artist depicts a contemporary studio. Notice the high easel, the apprentice grinding the colours, the binding round the hairs on the brush and the bowls of mixed paints.

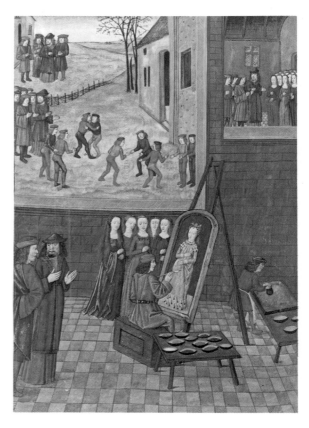

'God creates the heavens, the earth, the sun and moon . . . French, mid-15th century. Miniature from an Old Testament. Osterreichische Nationalbibliothek, Vienna, Austria. (*Above*)
The artist follows the Genesis creation myth. At the centre is the Earth 'without form and void'; the wavy ring represents 'the waters above the firmament'; the sun, moon and stars are shown in a black firmament. The creator wields a master mason's compasses. This large instrument was used to transfer a design for an architectural feature into a full-size working outline in a wet plaster bed.

Presumed 'Self Portrait', Adam Krafft (1455/60–1508). Stone, life-size. Church of St Lorentz, Nuremberg. (*Below*)
Recognized as Nuremberg's chief sculptor during his life, Krafft occupied a distinguished place in a book on the *Eminent Artists* of the city, published in the 1540s. It tells us that beneath 'the Tabernacle in the church of St Lorentz he portrayed himself as though he were alive'.

Neapolitan competition with a cartel agreement. The alum profits were 'set aside' for a crusade against the Turks. The crusade never happened.

Alum is a compound of aluminium sulphate and sodium or potassium. Mixed in solution with potassium carbonate, it throws a precipitate of virtually colourless alumina which absorbs any organic dye stuff introduced to make a stable, strong colour compound called a lake.

The costliest and most admired pigments were vermilion and ultramarine. Vermilion, a brilliant sealing-wax red, demanded a brilliant setting with equally vigorous colours. It was manufactured from red sulphide of mercury which occurs naturally as cinnabar or can be produced chemically by heating sulphur and mercury. When it first forms it is black, but when ground into powder it develops a red colour, which deepens the more finely it is ground. It was tempered with egg yolk.

Ultramarine is ground from the blue rock, lapis lazuli, found in Persia. Even the best lapis contains impurities, such as white calcite and sparkling, gold-glinting iron pyrites. Separating these out was a laborious and extremely costly business—the finest ultramarine was reckoned at eight ducats an ounce. The ability to commission its use marked out the patron as a man of immense wealth. The bishop of Arezzo commissioning an altarpiece in 1320 specified that only genuine azure ultramarine made from lapis lazuli should be used. He also specified that the artist should use gold leaf of 100 leaves to the florin, a very high quality.

The pigment granules, prepared by processes like those described above, could only be applied to the painting surface in a fluid medium. Various types of medium were used to 'temper' or bind the pigment. Rarely, as in the case of vermilion, the binding 'tempera' might be the emulsified yolks of eggs, but this was heavy and greasy and for the fine work of the book illuminator the best type of tempera was thought to be that of egg whites, which was called 'glair'. Whipped egg-white turns first into a firm, tacky froth and then into a thin, watery liquid which flows smoothly from brush and pen. Perfectionists preferred the use of a special whip-shaped stick for beating the glair and insisted on the absolute cleanliness of all implements. However, even with the best precautions it quickly went off without the addition of a preserving agent—usually red sulphide of arsenic.

Glair was a free-running medium, excellent for the delicate art of illumination. Fresh and clear, it bound the pigment particles in a clear matrix and so preserved their individual quality. Nevertheless, the effect was considered to lack depth and richness and from the 14th century the finished painting was generally varnished either with a thicker glair mixture or a solution of wood gum. Gum, dissolved in water with honey also came to be used as a medium, though artists debated its relative merits with those of glair. During the 15th century, through a historical development difficult to disentangle, the use of an oil-based medium to temper the pigments became general.

Most of the paintings in this period were done on parchment or wood panels, canvas being little used before the 1400s. One of the grandest commissions an artist and his workshop could receive was for a large altarpiece with several panels and wings, a 'polyptych'. The panels and the often highly decorated frame which held them required lengthy preparation. First the large surfaces required glueing up with an immensely strong cement-glue made from lime and cheese. Next the skeleton of the frame was made with its foliage trimmings, crockets and so forth, roughly carved in place or separately, to be attached later. Now the artists and their assistants assembled the whole thing with nails or wooden dowels. If nails were used, slivers of tin foil had to be glued over their heads to prevent rust stains coming through.

Reliquary Bust of Charlemagne, c.1350. Cathedral Treasury, Aachen, France.
The name of Charlemagne, in German *'Karl der Grosse'*, towered over the legend and theory of medieval empire. In 1166 he was canonized by the pope at the prompting of the Emperor Frederick I Barbarossa. This idealized portrait bust was made to hold parts of his skull, relics of religious veneration in his saintly cult. Heavily jewelled, adorned with imperial eagles, its crown embellished with classical cameos and topped with a cross, it is a compelling image of the theoretical prestige of the Holy Roman Emperor.

Next the structure was painted with hot size or glue, followed by two or three thicker coats, each being allowed a day or two to dry. Strips of linen or parchment might be glued over the surface in case of cracks in the wood. Now came the first layer of heavy *gesso* (Italian for gypsum) a thick white 'paint' of plaster and glue. The whole structure received several layers which set very hard. The carved decorations were now finished in fine detail. Next came coat after coat of fine *gesso* (*gesso sottile*) to yield a fine silky surface.

Large areas of such a prestigious commission would be decorated in gold leaf—the frame, the background, the halos of the saints. These parts had to be coated with reddish clay or 'bole', laid down layer by layer and polished. Now the fine gold leaf, hardly thicker than a cobweb could be applied. Since the pressure of the burnishing tool left marks, the artist carefully directed the burnisher's strokes according to the lighting where the work was to stand. (This was usually from below). Gilding which overlapped into the painting areas was either trimmed off or painted over with a size mixture; paint applied direct to the gold was liable to peel off.

Only the grandest work would be prepared with such protracted care, but for any panel painting an artist would have to go through the basic operations. The monk illuminating a holy text or the professional scribe working in a public scriptorium worked on a surface which he had only to finish, but before it reached his desk it had gone through a long production process. Parchment was made from skins. For ease of binding the pages were stitched in double folios and goat or sheep skins were large enough for most purposes. However some volumes, such as the massive choir books, might have pages as much as a metre long. These demanded large parchments which were made from calves' skins, parchments *vitulinum* which gives us the word, 'vellum'.

The pelt was soaked in a solution of water and lime to loosen the fur or hair and leech out fat and oils. After a few days it was scraped clean of hairs and stretched on a frame, being scraped again while still wet with a curved, moon-shaped knife or *lunellarium*, to produce an even thinness. The hide was wetted again and the skin side was polished with pumice, after which it was left to dry ready for the scriptorium. There even the finest parchments might receive further polishing and 'pouncing' with pumice, chalk or resin to remove roughness and oiliness and to reduce absorbency. However, all this care would be wasted if the skin had been stored for any length of time before the process of manufacture started. In the 11th century, Flemish and Norman parchment was particularly prized because it was 'all white and smooth and handsome' whereas the Burgundian workshops were reckoned to produce rough and mottled fabric.

During the 5th and 6th centuries the German invaders of Britain, known collectively as the Anglo-Saxons, established rival kingdoms, warring among themselves and pressing against the Celtic peoples to north and west who had once occupied the whole island. Celtic Christianity made its stronghold in Ireland, from where missionaries were later to establish important monasteries in continental Europe.

The barbarian invasions had broken church authority throughout Europe. When the German peoples converted to Christianity local variants of ritual and belief appeared. The Visigothic rite of Spain, for example, endured for generations. The great pope, St Gregory, envisaged a day when the diverse traditions would practise one orthodox Catholic faith under the leadership of Rome. In 597 he dispatched St Augustine to convert the English. After a faltering start the mission converted some of the Anglo-Saxon royal houses and by the mid-7th century its chief battle was with the Celtic Irish church, which warred tenaciously with Rome and, for a time, seemed likely to win the allegiance of the powerful northern English kingdoms of Northumbria. At the historic Synod of Whitby in 664 the issue was decided in favour of Rome.

For the next century and a half the English church was the principal agent for Catholic Christian force in northern Europe. Irish monks and English missionaries revitalized the church in France and converted pagan tribes in parts of Germany. Northumbria enjoyed a brilliant cultural epoch which produced the great historian Bede and such artistic masterpieces as the Book of Kells and the Lindisfarne Gospels.

The Northumbrian of Hiberno-Saxon style drew on three at first sight irreconcilable sources of inspiration: the ancient Celtic tradition of abstract whorl and spiral designs, the Germanic and Scandinavian style of abstract animal forms and the early Christian art of the Mediterranean world with its roots in classical antiquity. Italian manuscripts were circulating in Northumbria in the 7th century and necessarily affected the work of scribes, since the copying of religious works was their principal job.

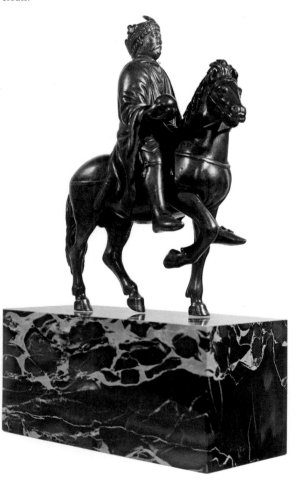

Equestrian figure, probably Charlemagne, Metz, 9th century. Bronze, 24cm (9½in). Musée du Louvre, Paris, France.
The small figure of the king, according to some scholars Charlemagne's grandson, Charles the Bald, sits astride a horse made in the 16th century, presumably to replace a lost or damaged original. Charlemagne's biographer, Einhard, describes him as wearing traditional Frankish dress—shoes on his feet, cross gartered hose, a close fitting coat on his shoulders and chest and, overall, a loose blue cloak.

'Carpet' page from the Lindisfarne Gospels, attributed to Eadfrith, Bishop of Lindisfarne 698–721. Manuscript illumination. British Museum, London, England. (Below)

Settled by Columban monks from Iona in 635, the island of Lindisfarne off the northeast coast of England became a chief artistic centre of the Christian Anglo-Saxon kingdom of Northumbria. These Gospels, written to honour St Cuthbert and other saints whose relics were on Lindisfarne, drew artistic inspiration from the interwoven animal forms of earlier pagan Anglo-Saxon ornaments and weapons. In the 8th century, the Golden Age of Northumbrian culture produced the saintly historian Bede and the scholar Alcuin, through him influencing the Carolingian renaissance in Europe.

The Lindisfarne Gospels (c. 700) a memorial of love to the great northern saint, Cuthbert, show the inventive genius at work on tradition. Each Gospel is introduced by a portrait, supposedly of the evangelist, derived ultimately from some Mediterranean model, a page of decorative pattern, and a page devoted to an intricately elaborated initial letter of the first word of the text. In the words of the modern scholar George Henderson: *The glorious richness, cohesion, and vitality of the decorative language of the Book of Lindisfarne renders it one of the greatest monuments of abstract art in European history.* Abstract patterns gripped the imagination of these northern masters. In the Book of Kells it takes over the whole work in a miracle of controlled fantasy.

The northern schools of England, Scotland and Ireland created a sculptural art to match the achievements of the manuscript illuminators in a series of stone crosses which developed from the later 7th century. The cross-slab from Nigg in Ross, a pattern of sinuous curves, perforated bosses and interlinking key patterns, suggests the example of metalwork. The 8th-century Ruthwell cross shows in the figures of Christ and Mary Magdalene a feeling for monumental form matching that of late Roman sculpture and which may have been inspired by a sarcophagus of late Roman date. During the time of the empire such stone burial caskets were exported all over the Roman world.

Madonna and Child enthroned between Zacharias and St John the Baptist, book cover of the 'Lorsch' Gospels, Palace School of Aachen, early 9th century. Ivory, 38.5 × 27cm (15 × 10⅝in), Victoria and Albert Museum, London, England. (Left)

Placed among arches and pillars, the figures are clearly inspired by an attempt to imitate late classical models. But the Carolingian carver is not interested in anatomical fidelity or the presentation of a weighty physical presence. Instead, the drapery folds make a lively swirling pattern and there is little sense of the bodies beneath. The bottom panel depicts scenes from the Nativity Story.

As Northumbrian culture reached its flowering, important events were shaping a new order in the realm of the Franks across the Channel. The first great Frankish kingdom had been founded by Clovis, converted to Christianity and crowned king in Rheims cathedral in 496. The kingdom had broken up in the rivalries of his descendants and was not reunited until the late 7th century. By this time, the Merovingian kings as they were called after a legendary ancestor of Clovis, were the puppets of their chief ministers. In 752 the last Merovingian was confined to a monastery and his chief minister Pepin the Short was proclaimed king with the blessing of the pope.

At the time Rome was under attack from the Lombard kingdom of north Italy. Pepin defeated the Lombards and gave part of their territory to the popes. In 768 he was succeeded by his son Charles, known to history as Charlemagne. He extended the Frankish territories into an empire which covered most of Europe, including the Lombard kingdom. On Christmas Day 800 he was formally crowned emperor in Rome by Pope Leo III. Thus Charlemagne's dynasty owed both its kingly crown and its imperial title to the popes. More important at the dawn of the 9th century was the fact that the papacy depended on the might of the Frankish ruler.

Rome was still part of a united Christian world whose true power centre was Constantinople. The Byzantine emperors who ruled there claimed direct descent from Ancient Rome and were the senior partners of the patriarchs of Constantinople in church as well as state. In the East, Rome's claim to be head of the church was not acknowledged, though it was accorded a special honour as the see of St Peter. Viewed from the great imperial city in the East neither Pope Leo nor his 'emperor' carried the authority that they claimed for themselves.

But the Lombards had broken Byzantine power in Italy. Charlemagne's coronation as king of the Lombards in their capital at Pavia in 774 confirmed the supremacy of the new Frankish state in the west. During the next 30 years, by warfare, massacre and resettlement he 'converted' the Saxons to Christianity. The once-pagan barbarian Germanic tribes had erected a new Christian state of imperial dimensions in the ruins of the old Roman empire.

Charlemagne and his advisers, embarrassed by the illiteracy into which the Frankish church had sunk, began its renovation. Scholars were recruited from Irish, Lombard and above all Anglo-Saxon schools and monasteries; at their head was the Northumbrian scholar Alcuin of York. Hand in hand with the revival of learning went the revival of the arts. The minster at Aachen, one of the few surviving pieces of Caroling-ian architecture, is heavily indebted to Byzantine influences, but with the Byzantine empire in the throes of the iconoclastic controversy, up-to-date contemporary models for a Christian imperial art were lacking.

The Carolingian court artists aimed to revive the golden age of early Christian Rome. The modern scholar Peter Kidson has written, *nearly every important change that occurred in the history of medieval art took place under the catalytic auspices of some aspect of what had been handed down from the ancient world.* For the Carolingian age Rome was not the city of the Caesars but of the Christian basilicas and monuments built since the 4th century; for them the art of the classical world had been transmuted by earlier Christian artists. In the process fundamental qualities of the classical style were lost. In the carving of the period, mostly represented by exquisite ivories, the classical sense of space and form is weakened by the characteristic Germanic fascination with orna-ment and pattern—draperies are used not so as to reveal the solid physical presence beneath but to enliven the surface with decoration.

Christ and Mary Magdalene, detail from the Ruthwell cross, Northumbrian, late 7th century. Stone, height of cross 4.5m (15ft).

The northern Anglo-Saxon artist was clearly a master of remarkable talent. Despite the damaged state of the carving it is clear that he had seen examples of classical Roman work. The simplicity of the composition and power of the forms reveal understanding of sophisticated exemplars and deep inner inspiration.

Wall paintings seem to have embellished most of the larger churches but the very few examples we know are fragmentary and unimpressive. Carolingian painting survives almost exclusively in the pages of illuminated manuscripts. One of the chief tasks in the re-education of the clergy was the multiplication of manuscripts. Alcuin justified the study of pagan classical authors because it could help 'the better understanding of the mysteries of the divine scriptures'. (In passing we should remember that most classical literature that has survived has done so thanks to the labours of medieval copyists.) But of course their principal work was to produce religious texts. The models were mostly late Roman and Early Christian books called *codices* (singular *codex*). These followed the ancient practice of prefacing a book with a portrayal of the author. The copyists also decorated the pages and illustrated the main points of the narrative, as homage to the holy text and also to remind the user, perhaps a poor reader, of the message of the text. Classical manuscripts were seldom illustrated. The school of Alcuin at Tours, where Charlemagne had appointed him archbishop in 796, adopted a sturdy and beautifully legible script known as Carolingian minuscule (i.e. 'small letters') which is the basis of ordinary modern type.

It seems that some Byzantine artists came to work at the palace school in Aachen. The physical power and presence of the figures in some of

St Matthew, Palace School, Aachen, painted before 800. Illuminated page from the Coronation Gospels of the Holy Roman Empire. Kunsthistorischesmuseum, Vienna, Austria. (*Below*)

According to legend the book was placed in the tomb of Charlemagne at the time of his death and was ceremoniously removed from it by the Emperor Otto III during the celebrations of the safe coming of the millennium during the year AD 1000. The confident handling of form, perspective and composition and the superlative craftsmanship, convince art historians that the book is one of a small number created by Byzantine artists brought to work for Charlemagne at Aachen.

Dragon's head prow post, anonymous, 9th century. Carved wood. Universitets Oldsaksamling, Oslo, Norway.

The prow posts of the Vikings' long ships must have inspired terror in the English and Irish victims of their plundering raids. Some Viking communities had laws requiring returning captains to unship the posts before entering home waters 'so as not to frighten the spirits of the land'. The animal tracery that adorns the prow represents one of the main traditions of Norse art.

...the manuscript copies there are too fully in the tradition of late Roman realism to be the work of a northern artist. But perhaps the most remarkable and certainly the most influential Carolingian book is the Psalter now at Utrecht, made about 820. Utrecht had been established as the archiepiscopal see of St Willibrord, the 7th-century Northumbrian evangelist of the Friesians whose work was continued among the pagan Germanic tribes outside the Frankish kingdom by the great English saint, Boniface. The Utrecht Psalter became known in England in the 10th century and was a source of inspiration for English artists for another two centuries. Every psalm and canticle is illustrated with a profusion of line drawings done in red-brown ink, in a style heavily indebted to the illusionistic realism of late classical painting. The vigorous, sometimes congested, pages are packed with visual metaphors and numerous allusions to antique themes.

Carolingian art flourished for a generation after the emperor's death in 814. The period saw the production of large, single-volume Bibles which remained standard models for copyists for the next two centuries. The pattern for most of these Carolingian Bibles may have been a fine 5th-century volume made in Rome for Pope Leo the Great. One at least, however, that copied for Count Vivian, lay abbot of Tours, seems to have had a still earlier, more classical, model. By the mid 9th century the impulse of Europe's first classical 'renovation', to use the word of the Carolingian scholars themselves, was petering out.

Charlemagne died in 814 and was succeeded as emperor by his son

Psalm 88, detail of a page from the Utrecht Psalter, School of Rheims, c.820. Ink on paper, 33×25cm (13×10in). University Library, Utrecht, Netherlands. (Below)

The remarkable drawings that adorn the Utrecht Psalter provide illustrations of the literal meanings of the psalms, and sometimes of theological commentaries on them. Some of these commentaries are much earlier in date than this Bible and the 9th-century artists have employed a style which is clearly influenced by mss done in late classical antiquity. The Psalter's style of outline drawing was particularly influential in Anglo-Saxon England.

Led by their lay-abbot, Count Vivian, monks from the Abbey of St Martin at Tours present the Bible to the Frankish ruler, Charles the Bald. School of Tours (843–51). Illuminated page from Count Vivian's Bible, 49.5×37.5cm (19½×14¾in). Bibliothèque Nationale, Paris, France. (Right)

This book was probably presented to Charles when he visited Tours in 851. The Bible being presented is, of course, the very book in which the illumination appears. The subject of a book being presented to a patron became fairly common in later centuries, but this picture is one of the first of the type and one of the very earliest representations of a contemporary event in medieval art.

Louis I. He struggled to hold the empire together but at his death in 843 it was divided between his three sons by the momentous Treaty of Verdun. The imperial title went to the eldest, who also received a weak and almost indefensible strip of territory lying between the two power blocks which in later ages were to become the states of France and Germany. The last ruler to wield the imperial power established by Charlemagne died in 899, but the idea which the great emperor bequeathed, the idea of a united European imperium, did not die. It was revived in 962 when the German king, Otto I, was crowned emperor by the pope at Rome. The title, later 'Holy Roman Emperor', continued until 1806; the coronation at Rome until the 15th century.

Otto's power extended through northern Italy as well as Germany and for a century he and his successors ruled the most powerful state in medieval Europe. They claimed to be the heirs of Rome and even to be the political deputies of God on earth. These grandiose assertions were promoted in the official art of the Ottonian period. They reached their highest point in the brief reign of the youthful Otto III. His mother was a Byzantine princess and his exalted notions of his own status reflect Byzantine ideas, notably that of the emperor as *christomimetes*, that is as the actor or personator of Christ. A Gospel Book presented to the emperor about the year 1000 gave this mystical concept a literal interpretation that would have astonished Byzantine theorists. It shows Otto born up on the shoulders of a figure representing earth, in the act of being crowned by the hand of God. He is enthroned in a vertical pointed oval border, called a *mandorla*, which, by tradition, was the setting for representations of Christ.

Soon after the year 1000 changes took place that were to lead to a new style in art and architecture. The actual number of the year may have played some part in the sudden surge of creativity in the 11th century. As it approached there was fevered speculation in some quarters as to what the coming of the millennium, the thousandth year of the Christian era, might portend. During it the emperor, Otto III, attended special celebrations to mark the event. When it passed peacefully, many must have reflected thankfully that the time of the Apocalypse had not yet arrived.

Moves towards the new style began in the lands of the empire. Archbishop Bernward of Hildesheim (993–1022) commissioned a monumental bronze candlestick, made about the year 1020 and bearing, on a spiral band rising the height of the shaft, scenes of the life of Christ. The subject is to be expected from an archbishop, but the form is quite obviously copied from the Columns of Trajan and Marcus Aurelius at Rome. Bernward's enthusiasm for the ancient glories of Rome was no doubt inspired by the numerous journeys he had made there, and reinforced by his appointment as tutor to the young emperor Otto III. It led to another artistic commission, a pair of bronze doors for his church of St Michael. They are technically remarkable as being the first such decorated doors cast in one piece since Roman times. In architecture, too, the ruined monuments from the German 11th century indicate that the style, known to art historians as Romanesque, was prefigured by the artists of the empire, Europe's leading power.

The Ottonian theory of empire-church relations approached the caesaro-papism of the eastern, Byzantine empire. It rested on actual political power in Germany and northern Italy. This was, moreover, a time when the papacy was weak. The papal office had become submerged in the political rivalries of the Roman aristocratic families and, in common with most church appointments of the time, was bought and sold. The church in Germany was powerful and respected and its

Ezra, Northumbrian, early 8th century. Illuminated page from the Codex Amiatinus, 35 × 25cm (13¾ × 9¾in). Biblioteca Laurenziana, Florence, Italy.

This is a copy of an early Christian illustration. The pose of the scribe is reminiscent, for example, of the figure of St Matthew (page 123), but notice the ill-contrived placing of the legs compared with the earlier work and the inaccurate perspective of the cupboard and table. The prophet is shown surrounded by the tools of the medieval illuminator's craft. On the floor are a scraper for smoothing rough parchment and the dividers for marking out the spacing and main elements of the design.

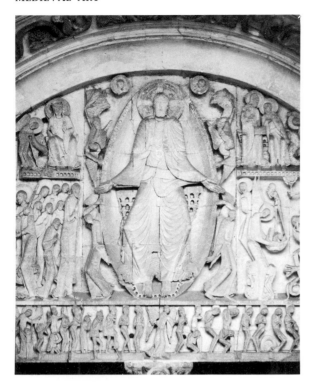

The Last Judgement, Gislebertus (active 1125–1135). Tympanum, Autun cathedral, France.
One of the few medieval sculptors we know by name, Gislebertus must have enjoyed immense renown since the cathedral authorities allowed him to 'sign' this masterpiece with the words 'Gislebertus hoc fecit', 'Gislebertus made this', along the central band just below the feet of Christ. The tympanum together with the capitals inside the cathedral, also attributed to Gislebertus, constitute what is perhaps the greatest single achievement of Romanesque sculpture.

senior members were employed as chief ministers in the imperial government. The scandal of the popes was thrown in to high relief by the reform of monasticism, begun in the year 910 with the foundation of the Abbey of Cluny in Burgundy. This initiated a slow movement of reform but only the emperors had the prestige to reform the head of the church.

In the 1040s Emperor Henry III went to Rome where he deposed one pope and supervised the 'election' and installation of four others. He built better than he perhaps intended for his last nominee, Leo IX, initiated a programme of general church reform that was soon questioning the existing arrangements for German ecclesiastical appointments and particularly the way in which the bishops were 'invested' with their lands by a layman. With Pope Gregory VII the reform shifted into overdrive. This small ugly dynamo of a man reversed the traditional relationship of empire and papacy. He claimed that only the pope was God's vicar on earth and as the spiritual was higher than the material, so was the pope higher than the emperor. He shattered the stately image of the emperors as protectors of God's church and began a struggle between the secular and spiritual power that was to rumble on for centuries.

In art the chief surviving glories of the Romanesque are found in central and southern France and northern Italy. The period marked the start of a new epoch for it saw the birth of European monumental sculpture. Whereas the painters were working in a well-established tradition, the sculptors were still to discover how the medium in which they were working could be handled. As a result, numerous local schools sprang up, each with characteristic stylistic traits and possibly each with their own pattern books. Their demanding brief was to fit their compositions into areas often awkward in shape and placed at difficult angles. To

The Emperor Otto III enthroned among his councillors, Reichenau or Court School, late 990s. Illuminated page from the Gospel Book of Otto III, 33 × 24cm (13 × 9⅜in). Staatsbibliothek, Munich, F.D.R. (*Right*)
This picture is obviously indebted to classical influence. Equally obvious are the medieval traits—the exaggerated scale of the emperor to show his importance, and the grotesque little faces in the capitals. On the facing page, allegorical figures representing classical regions of the empire, Slavonia, Germania, Gallia and Roma, approach the demi-god like figure of the emperor.

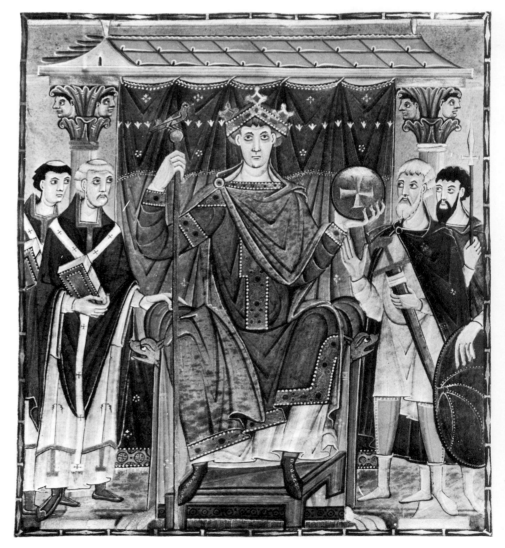

Adam and Eve clothe their nakedness before God, detail from the doors of the Church of St Michael, Hildesheim, 1015. Bronze, 58 × 109cm (23 × 43in). Hildesheim, F.D.R. (*Left*)
Even in miniature, the anger of God and the guilt of Adam and Eve are apparent. Adam gestures from God's finger of accusation to Eve who, in turn, points to the serpent. Over them looms the fateful Tree of Knowledge. The other scenes on the doors depict the chief incidents in the Bible, from the creation myth to the time of Christ.

make the rounded capital of a pillar, the recessed jamb of a doorway or the rounded or pointed surface (*tympanum*) between the door lintel and the arch over it appear the natural home of the carvings demanded considerable ingenuity. Nor was the job made easier by the fact that the artist was rarely free to choose the *dramatis personae* of his compositions.

The sculpture we admire for its form and aesthetic qualities was actually commissioned as much to teach a largely illiterate public as to embellish the house of God. The carvings that covered the facades of the great churches that now began to rise throughout Europe were scriptural commentaries in stone. Today the churches themselves bulk large in their townscapes—when they were built they rose among the surrounding houses like mountains. Their sheer size must sometimes have been oppressive, but the brightly painted statuary soaring above the open square at the great west end provided a vivid backdrop for the bustle of town life below. We can still admire the ingenuity with which the artists accommodated the clustering imagery into awkward spaces, but in most cases the overall scheme would have been designed according to a detailed theological brief worked out in discussion between the sculptor and members of the cathedral clergy who were, after all, commissioning the work.

In southern Europe, Italy, Provence and Spain, sculptors had a wealth of ancient Roman monuments to study; the work of Wilgelmo at Modena cathedral shows how one man re-interpreted the tradition. In the north, where the remains of the classical past were far more unusual, sculptors seem to have taken their themes from work of contemporary painters, usually the manuscript illuminators. Indeed it has been suggested that the earliest function of the sculptor-masons of Romanesque churches was to carve in relief patterns already painted on the stone. It may be so. But the way towards a true, monumental three-dimensional art was being already pioneered by the metalworkers and goldsmiths and it is one of these, Rainier of Huy who achieved one of the most advanced masterpieces of Romanesque modelling. The brass font he worked in the 1110s, now in the Church of Saint-Barthelemy, Liège, is supported by oxen and embellished with figures which show an understanding of anatomy, posture and movement quite startlingly in advance of anything we might reasonably have expected from artists working in this period.

Christ in Majesty, French, late 11th century. Marble, life-size. Church of St Sernin, Toulouse, France. (*Below*)
St Sernin was one of the pilgrim churches on the route to Santiago de Compostela in Spain, designed for the display of relics. In previous ages these had been kept hidden, but during the Romanesque period the Church became more open to the secular world. Sculptural 'sermons in stone' adorned the buildings. Here Christ, surrounded by the emblems of his Apostles, raises his hand in blessing while the book proclaims the message "Peace be unto you".

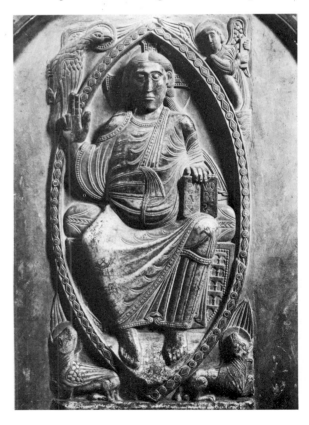

Apostles, Rheims Cathedral, France.
Begun in 1211, Rheims is a coherent masterpiece of the Gothic style yet some of the sculptures display a treatment of drapery that seems to betray a knowledge of classical models. In general however, the work of the sculptors marks a high point in the combination of drama and naturalism which characterizes high Gothic while the artists have triumphantly solved the problem of creating figures apparently free of the verticality of the shafts and columns but remaining organically a part of the total design.

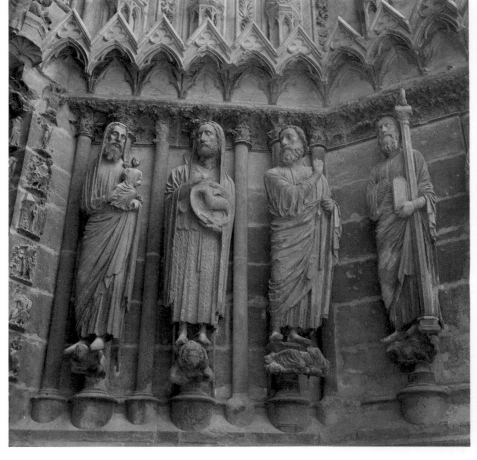

St Paul and the Viper (detail), English (?), late 12th century. Wall painting, 137cm square (54in). Chapel of St Anselm, Canterbury Cathedral, Canterbury, England. (*Below*)
This incident, during Paul's shipwreck on Malta, is recorded in the Acts of the Apostles. 'And when Paul had gathered a bundle of sticks, and put them on the fire, there came a viper out of the heat and fastened on his hand . . . And he shook the beast into the fire and felt no harm.' The sinuous lines of the drapery, suggesting the curves of the body beneath, derive from the 12th-century English 'damp-fold' style'.

The emergence of this new sculpture has justly been called 'the first step in the direction of a truly representational art'. At the same time, the Romanesque artists showed themselves masters of pattern and ornamentation in semi-abstract designs that hark back to the two-dimensional preoccupations of an earlier period. Yet it is the figure carvings that seize our imagination. Often, as in the tympanum over the south doorway of the Abbey church of Saint-Pierre, Moissac, they are carved in high relief; in the same church the figure of Jeremiah which helps support the tympanum shows the beginning of the break from the stone of the architecture into free movement. The mood varies with the 'violence of divine inspiration', as in the figure of Isaiah from a doorway in the Abbey church of Souillac.

Much of the finest Romanesque painting employs firm, smooth lines and flat strong colours. The vivid, unsubtle tones and clearly defined areas suggest that painters were seeking to emulate the effect of enamel and stained glass, arts that were reaching their maturity during the 12th century. Two majestic Bibles from England exemplify the new manner. The new style must, in fact, have made an especially strong impact in England where, for close on two centuries, the prevailing style had been a development of the lively, almost calligraphic style of the Utrecht Psalter, tinted with light washes of colour. These great English works in the new style were the Bury Bible and the Winchester Bible. The latter was commissioned by the great bishop of Winchester, Henry of Blois. Brother of King Stephen and the richest churchman in the country, he was also a prominent figure in the troubled politics of the reign. It is interesting to reflect that both these masterpieces were produced at a time when England was torn by cruel civil war during which, in the famous words of one chronicler, it seemed as though 'God and his angels slept'.

The Romanesque style in sculpture persisted into the late 12th century as architecture moved into a new phase known to art history as Gothic. Its hallmarks are the pointed arch, instead of the rounded

arch of Romanesque, ribbed vaulting for the barrel arched vaults of the earlier style and great areas of glass. These new features are all found in the abbey church of St Denis outside Paris, begun in 1135 for Abbot Suger, the chief minister of King Louis VI of France. By the second half of the 12th century, northern France was in the full flood of an architectural revolution which produced at Chartres a marvel of Gothic engineering in stone. Contemporaries recognized the glory of the enterprise and people of all social ranks worked with the labourers in dragging the stone to the site.

The building is the vehicle for two great iconographic programmes in stained glass and sculpture. These represent the summation of the doctrine of the contemporary Christian church and its view of history. The by-now classic theological parallels between the figures of the Old Testament and the New are all there; yet with new majesty and compelling power. Even so the elongated figures standing in the vertical postures dictated by the architecture are occasionally somewhat stiff

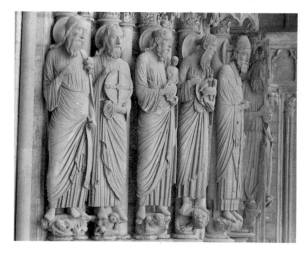

Prophets and saints. Central bay, North porch, Chartres Cathedral, France. (*Above*)
These carvings of the prophets Isaiah and Jeremiah and saints Simeon, John the Baptist and Peter once again demonstrate the power and skill of the 13th century craftsmen.

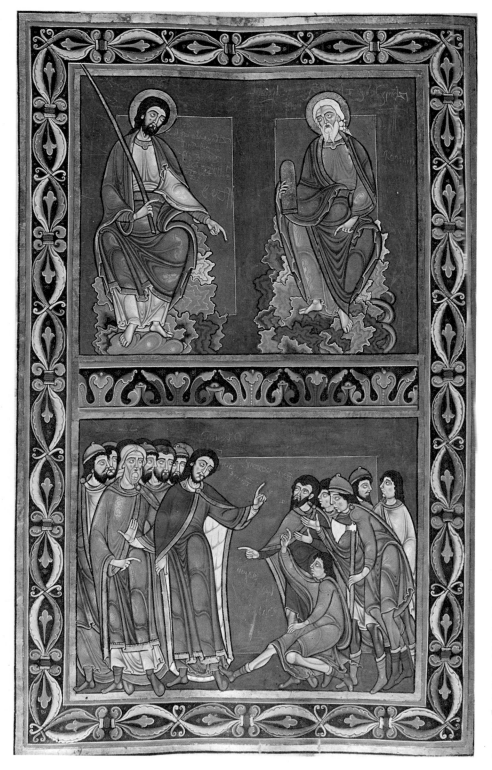

Moses and Aaron, Master Hugo of Bury St Edmunds, painted 1130–40. Illuminated page from the Bury Bible, 51 × 36cm (20½ × 14in). Corpus Christi College, Cambridge, England. (*Left*)
The artist seems to have drawn on diverse sources, from the earlier English St Albans style, to Flemish idioms and even the inspiration of Byzantine models. The abbot of Bury at the time was an Italian who had been in contact with Greek monasteries in the south of Italy. But the master who created this great Bible has combined these various influences to produce what has been called "one of the greatest glories of English Romanesque art".

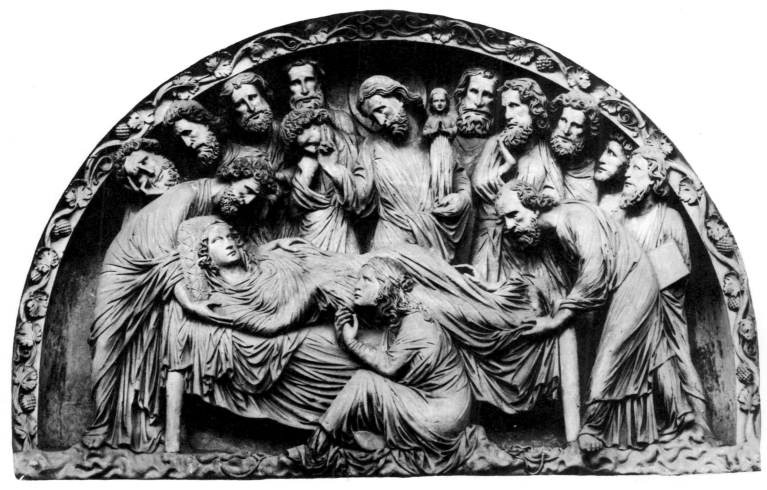

The Death of the Virgin, German, mid-11th century. Tympanum, portal, south transept, Strasbourg Cathedral, Strasbourg, France. (*Above*)
The treatment of the drapery shows French influence and the iconography of Christ carrying his mother's soul to heaven derives from Byzantine sources. But the drama of the treatment is typically German while the sculptor's mastery of technique enables him to achieve precisely the portrayal of grief he wants, even though sentimental.

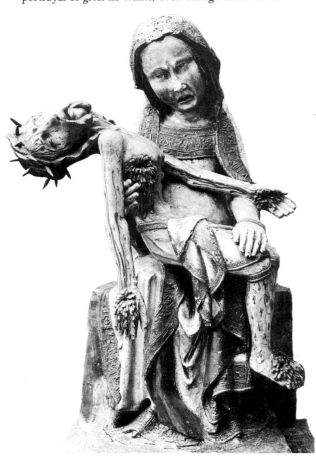

and are essentially Romanesque in mood. It was at Rheims, where a similar great scheme was in progress, that the problems of carving free standing figures in the round began to be more fully solved. The sculptors there seem to have made use of actual Roman statues as their models.

As Gothic sculpture developed, gesture, facial expression and movement were all brought into play to express human personality and emotions. Such a use of sculpture was new and the sculptors had to experiment. The 13th century witnessed a profusion of diverse and often brilliant solutions to the portrayals of human beauty, wisdom, nobility, grief and pain and, in addition, some fine portrait sculptures.

Some of the most violently expressive work was done in Germany. During the middle three decades of the 13th century full scale sculpture programmes were in progress at the cathedrals of Bamberg, Strasbourg and Naumburg. There is little trace of Gothic influence in the architecture but the sculpture is clearly affected by the new expressive spirit abroad.

The *Last Judgment* in the round-arched tympanum at Bamberg shows the souls of the saved divided from those of the damned by the figure of Judgment according to the standard iconographic formula. But instead of suffering the usual disgustingly physical torments, the damned seem at first sight to be convulsed with merriment. In fact the artist has endeavoured to depict the hysterical laughter of the damned in contrast to the beatific smiles of the blessed ones standing opposite. To the modern eye the attempt fails somewhat absurdly, but the concept is a bold one and fully in keeping with the aims of the new sculpture. By contrast, the figures surrounding the deathbed scene of the Virgin Mary at Strasbourg, admirably express the sculptor's intention of sensitive, possibly a little sentimental, grief and suffering.

The Master of Naumburg presents us with a yet more realistic drama of the emotions. The choir of the cathedral is divided from the nave by a screen; commonly such screens were surmounted by a presentation of

the crucified Christ between the mourning figures of St John and the Virgin. The Naumburg sculptor breaks with convention by placing this scene at floor level so that the doors leading to the choir are on either side of the upright of the cross and the worshipper entering the choir does so under the outstretched arms of Christ. Thus the mystical world of the image is brought right into the real world of the congregation. Nor is the Christ, here presented, the victor over death that Romanesque artists loved to portray; instead the sculptor shows the pain and suffering of the slow death by crucifixion. This approach was to become so general that it is difficult to realize the impact it must have made in the 1250s. However, even this innovator baulked at the full logic of his decision. For the Madonna and Evangelist, in expressive postures of grief, stand not at the foot of the cross, as normally presented, but on plinths which raise them above the level of passing worshippers. Their heads are at the level of the suffering Christ and to have had them mingling, as it were, with common humanity, seems to have been too breathtakingly democratic.

A surprise of quite another kind awaits us when we do go through the doors of this sculptured calvary. The choir beyond is in fact a sort of memorial church to earlier benefactors of the cathedral and is adorned with statues of secular figures carved with almost waxwork

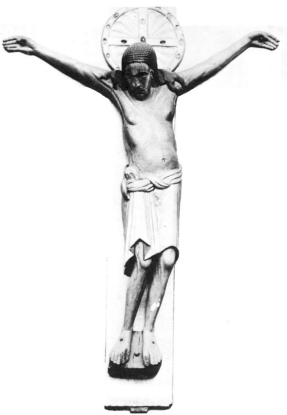

The Gero Crucifix, German, 970s. Wood, with traces of colour, height 188cm (74in). Cologne Cathedral. (*Above*)
Before the 11th century comparatively few large-scale sculptures survive and those are mostly of wood. The face expresses exhaustion and dour resignation. The almost pendulous effect of the breast shows the artist's endeavour to portray the anatomical consequences of death by crucifixion as the tortured muscles and tendons drag on the flesh of the torso.

Ekkehard and Uta, Master of Naumburg, mid-13th century. Stone, life-size. West choir, Naumburg Cathedral. (*Left*)
These life-like figures are 'portraits' of the 11th-century Margrave of Meissen (a co-founder of the cathedral) and his wife. From the vivid realism of the sculptures, we can deduce that the master worked from living models; but his aim is apparently to create images which embody contemporary ideals of the chivalrous knight and lady.

The Roettgen Pietá, German, *c*.1300. Wood, height 88.5cm (35in). Rheinisches Landesmuseum, Bonn, FDR. (*Opposite below*)
The figure of the Virgin mourning her dead son, his body on her knees in tragic echo of her nursing him as a baby, was generally treated with compassion, hence the term 'pietá'. This German statue depicts the haggard despair of Mary and the vicious lacerations of the corpse with an almost hysterical expressionism.

Carved capitals, Chapter House, Southwell Minster, 1290–5. Southwell, Nottinghamshire, England. (*Below*)
The master carver is anonymous, but his technical skill is breathtaking.

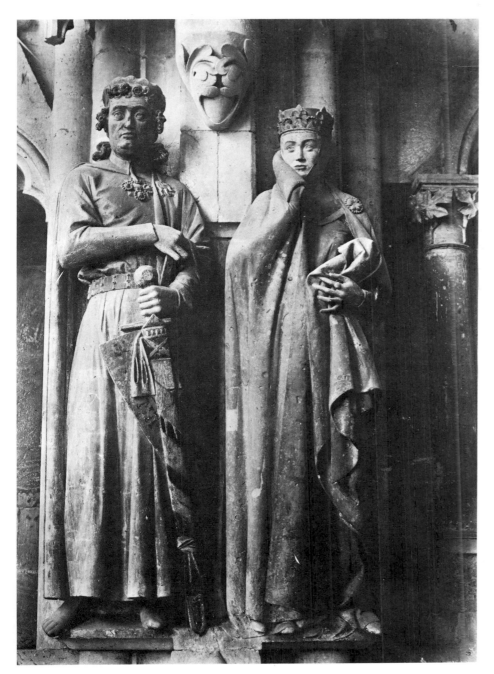

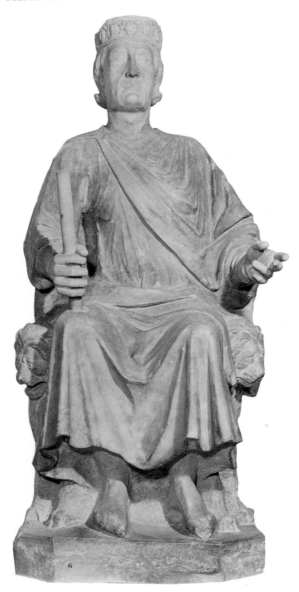

Charles of Anjou as Senator of Rome, Arnolfo di Cambio
(*c.*1232–1302), carved *c.*1277. Marble, over life-size. Capito-
line Museum, Rome, Italy. (*Above*)
A Frenchman, Charles was crowned King of Naples and
Sicily by the pope in 1266, after defeating the pope's
enemies. Charles's power was shattered by the Sicilian
Vespers revolt of 1282. In this statue, the first monumental
portrait by a known sculptor, the king-senator's ruthless-
ness is betrayed by his uneasy posture on the edge of his
lion throne. Stylistically influenced by classical models,
Arnolfo also reveals acute insight into the insecurity of
a tyrant.

*Duke Philip the Good of Burgundy receives the MS of the
'Chronicles of Hainault'*, Flemish, 1448. Miniature from the
Chroniques de Hainault, 18 × 24cm (7 × 9½in). Bibliothèque
Royale de Belgique, Brussels, Belgium. (*Right*)
Philip, who acquired Hainault in the 1420s, is flanked by
his son, Charles, and his great Chancellor, Rolin (see page
136). The Duke wears the chain of the order of the Golden
Fleece, which he founded to emulate the Order of the
Garter, and hat, tunic and hose of black, his favourite colour.

The Wilton Diptych, anonymous, England, *c.*1395. Tempera
on oak panel, painted surface 45.7 × 29.2cm (18 × 11½in).
National Gallery, London, England. (*Opposite, top*)
This unique work is a triumph both of the International
Gothic style and royal iconography. Richard II of England
kneels in intercession to the Madonna and Child. He is
sponsored by St John the Baptist and the Anglo-Saxon
kings, St Edward the Confessor and St Edmund the Martyr.
Heaven's favour seems assured since even the angels wear
the king's White Hart badge and one raises the cross of St
George, patron of England's Order of the Garter.

realism. However these are not portraits from the life. The figure of the
11th-century knight Ekkehard, for example, is rather, an idealized
notion of the 13th-century idea of German chivalry. His is a far remove
from the harsh tyrant face of Charles of Anjou, King of Sicily and Naples
done about 1277 by Arnolfino di Cambio.

Charles, the youngest brother of St Louis, King Louis IX of France,
had come to Italy at the invitation of the popes to extirpate the power
of the Hohenstauffen in Sicily. Their rule had been established by the
Emperor Frederick II. This astonishing person, emperor of Germany and,
through his mother, king of Sicily, had spent most of his reign (1197–
1250) in his southern kingdom. He shocked Christendom by his patron-
age of its Arab scholars and intrigued artists by commissioning
propaganda works which must mimic the style of pagan imperial Rome.
He terrified the popes. His successor, his illegitimate son, Manfred, a
paragon of that knightly chivalry epitomized by the sculptor of Naum-
burg, was no match for the hard-faced unscrupulous Charles. By 1268
the Frenchman had defeated and killed the last of the Hohenstauffen
and received their Italian kingdom at the hands of the pope.

Charles, who did not see lavish artistic patronage as the best way to
further his political objectives, did not advance the influence of French
Gothic art in Italy. But it was already felt. Arnolfo di Cambio had worked
as assistant to Giovanni Pisano on the pulpit in Siena Cathedral (1265)
and Giovanni's work shows familiarity with French and German models,
possibly the carvings at Bamberg. Even Giovanni's father, the great
Nicola Pisano, who may have worked for Frederick II and was inspired
by classical models, deployed the expressive techniques of northern
Gothic.

Siena was an interchange point in the flow of ideas between north
and south. Its painters who, like the master Duccio, infused new life
into the conventions of Byzantine art once so strong in Italy, took easily
to the flowing, sinuous lines of the northern style. Among the most
important successors of Duccio were his pupil Simone Martini and the
brothers Lorenzetti. Simone's beautiful and evocative painting of the
Annunciation makes an almost exaggeratedly medieval use of gold leaf
in the background, clearly inspired by the example of Byzantine icons,
and the Gothic arches hint strongly at his interest in northern Gothic as
do the lissom lines of the figures. But the placing and painting of the

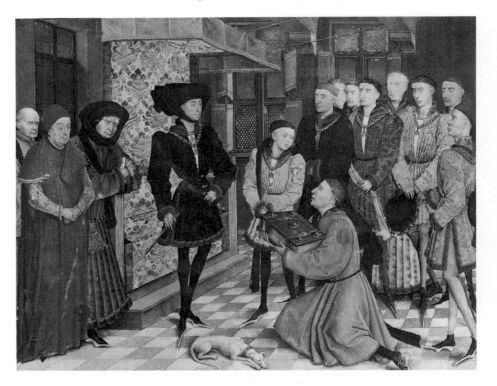

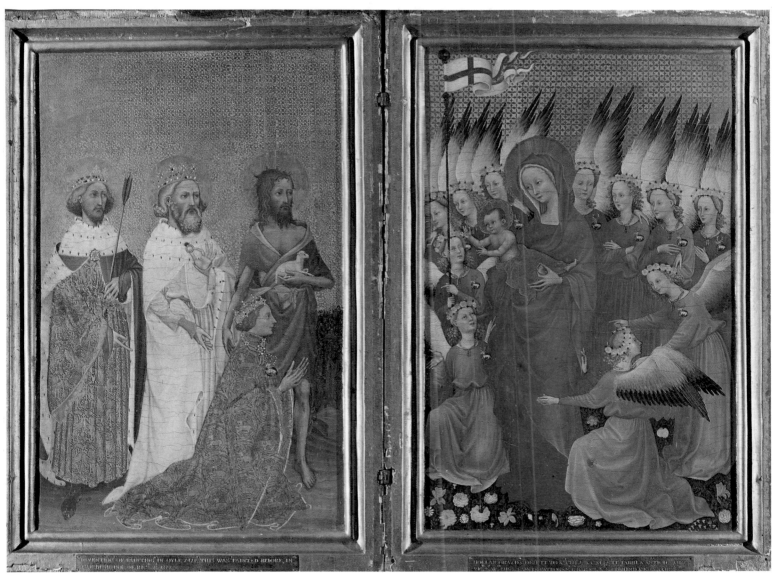

vase has a concrete and weighty realism which belongs to the monumental world that Giotto was bringing to painting. The famous series of frescos done by Ambrogio Lorenzetti for the Palazzo Pubblico, Siena, in the late 1330s brings to the allegorical exposition of the civic virtues of *Good Government* a sense of space and depth which foreshadows the commonplaces of Renaissance perspective.

Until about 1300, one of the chief functions of painters had been to colour the work of sculptors. The now bare walls of statues in medieval churches were originally embellished with life-like, perhaps sometimes garish, colours. Where the manuscript illuminators sought to enhance their books with precious pigments and gold inks, because their patrons prized art objects for their intrinsic worth as much as their artistic merit, wall painters were often employed, at least in the early part of our period, because mosaics were too expensive. For centuries, painting was something of a secondary art, with its main brief to colour two dimensional surfaces. Where attempts were made to simulate the effect of carving in the round, it was usually because the patron could not afford the more expensive services of the sculptor or goldsmith. However, during the later 13th century and the beginning of the 14th, the move towards realistic, illusionistic, representational art, initiated by the Romanesque sculptors, shifted to the field of painting. It was the Italians who led the field.

The new turn taken by Italian art, and also its rapid rise to prominence, can be partly explained by the increasing wealth of the merchant classes there and their inexorable rise into the ranks of the aristocracy. Lorenzetti's commission for the town hall of Siena was by no means

January, from the *Très Riches Heures du Duc de Berri,* c.1415, Pol Limb(o)urg and his brothers. Manuscript illumination, 29×21cm ($11\frac{1}{2} \times 8\frac{1}{2}$in). Musée Condé, Chantilly, France. (*Below*)
A scene from the greatest of all Books of Hours.

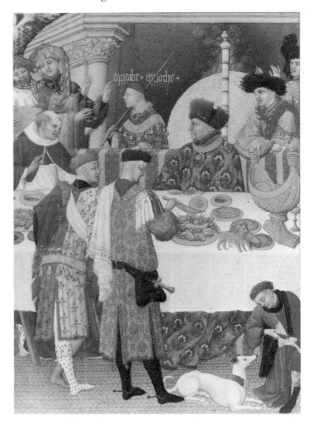

Ex-voto of Bishop Očko Vlasim, attributed to Master Theodoric of Prague, painted *c.*1370. Paint on panel, detail. Narodnie Galerie, Prague, Czechoslovakia.
In the imperial records Theodoric is described as 'beloved master'. His patron, the Emperor Charles IV shown here kneeling, commissioned the greatest buildings of medieval Prague, chief among them the Cathedral, which beautify the city to this day. The 'soft manner' of Theodoric's courtly style contrasts with the mainstream of the International Gothic style as represented by the Limburg Brothers.

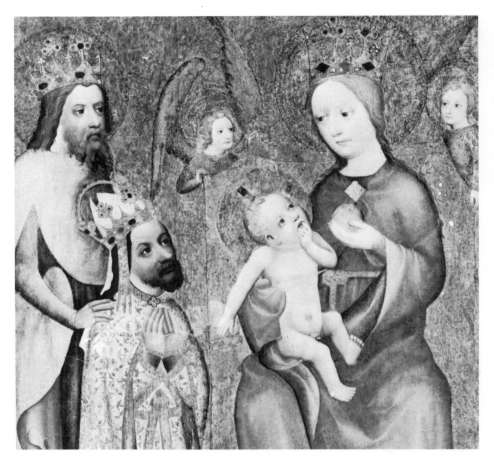

unique—in the next century the great Florentine banking house of the Medici was to begin its career as one of the most lavish families in the history of artistic patronage. One might perhaps hazard the suggestion that the dogged pursuit of unmysterious realism, defined not as the insight into the true nature of things which had been the objective of the Gothic artist but as the exact representation of mere physical appearances, was well calculated to win the approval of the 'no nonsense' common sense for which businessmen, whether Yorkshiremen or Florentines, are famed.

However, while it might be tempting to see the culture of the Renaissance as the first instance of bankers' art, the trend towards increasing lay patronage of the arts had begun more than a century before. One of the great cultural enterprises of 13th-century England, the re-building of Westminster Abbey was long carried out under the enthusiastic, expert and sometimes impatient patronage of King Henry III. It was his cult of his saintly predecessor, the old English king Edward the Confessor, which informed his enthusiasm for the site—since Edward had built the original abbey; but it was Henry's love of architecture, painting and sculpture that inspired his enthusiasm for the work of his master builders and craftsmen.

In the following century lay interest in devotional art opened a new market for artworks and a new interest in artists and craftsmen. A taste for greater privacy was reflected in and encouraged by trends in domestic architecture. The rich came to conduct their personal devotions in private chapels—and the demand for devotional objects increased. Artists, and even musicians who were rated very low indeed on the social scale, were increasingly favoured with the friendship of kings. The association between Richard the Lionheart and his minstrel Blondel has become legendary. King Edward II of England earned the contempt of his barons by rowing for sport, having metalwork as a hobby and having artists as friends—Jack of St Albans, a painter, in 1326 entertained the royal party one evening after supper with a dance on the table.

Tours, he travelled in Italy during the 1440s and the results are to be found in the Italianate influence in his work. There were also some Italian artists in France at this time. In 1477, the death of Charles the Rash at the battle of Nancy put an end to the great Burgundian state. The growing political strength and confidence of France proper is reflected in the fact that the court art of such centres as the Loire takes on a new vigour. In the 1490s King Charles VIII invaded Italy; thereafter the French kings looked more and more to the south for their artists. By the end of the century Italian masters had developed something of a school at Amboise and in the next century the school of Fontainebleau was to be still more influential in spreading Italian ideas. The great example of the Flemish school of Burgundy was left to one side.

Philip the Bold had three astute and ambitious successors: John the Fearless (d. 1419), Philip the Good (d. 1469) and Charles the Rash (killed at the Battle of Nancy in 1477). Eventually they aimed to raise their growing territories to the status of a kingdom and enlisted all the considerable artistic talents among their subjects to this policy. A Carthusian monastery at Champmol outside Dijon was planned as a stately mausoleum for the dynasty, just as St Denis was for the kings of France. It was laid out on spacious lines by the architect Drouet de Dammartin. The principal feature was a colonnaded cloister in the centre of which rose an immense and majestic Calvary. It stood over a sacred well, a centre of pilgrimage, and was mounted on a high base supported by the prophets Moses, Zacchariah, Daniel and Isaiah, who, it was believed, had prophesied Christ's passion.

These four monumental figures and the head of the Crucified Christ are about all that survives of the work which the sculptor Claus Sluter from Harlem did for the Chartreuse of Champmol. It is enough to proclaim him a sculptor of genius anticipating the power of Michelangelo. A majestic catafalque for Duke Philip was begun in the 1380s under Sluter's direction but was not completed until 1411, some years after his death. He was also commissioned for the sculptures in the monastery chapel.

The great winged altarpiece there was carved by a Flemish sculptor

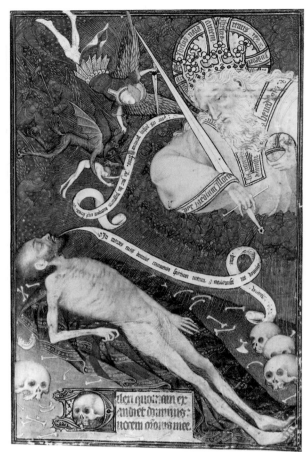

The Dead Man Before God, French, early 15th century. Miniature from the Rohan Book of Hours. Bibliothèque Nationale, Paris, France. (*Above*)
'Into thy hands, Oh Lord, I commit my spirit.' 'Do Penance for thy sins and thou shalt be with me at the Last Day.' In this majestic dialogue of death, the anonymous French artist sums up the haunting preoccupation of a society which believed in an afterlife and divine judgement. The Devil has already seized the naked soul, but St Michael, God's champion, flies with drawn sword, to deliver it.

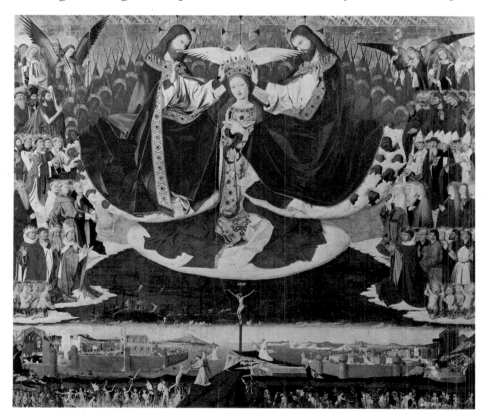

The Coronation of the Virgin, Enguerrand Quarton (c.1410–d.1462). Hospice Civil, Villeneuve-les-Avignon, France. (*Left*)
This majestic altarpiece is one of the few medieval paintings for which the original contract survives. Drawn up on 25 April. 1453, between the painter and a priest, Jean de Montignac, it stipulates a fee of 120 florins and delivery within 12 months. Moreover it specifies every detail of the unusual iconographic scheme which, among other things, demanded that there should be no difference between the Father and the Son in the Trinity which crowns the Virgin.

137

Pietà, attributed to Jean Malouel (*died* 1415), painted *c*.1400. Painting on panel, diameter 64cm (25¼in). Musée du Louvre, Paris, France. (*Above*)

'Malouel' (possibly a French version of the Flemish *maelweel*, 'paint-well'), from Limbricht in Guelders, was probably the uncle of the Limbourg brothers. *Valet de chambre* of Philip the Bold of Burgundy, he painted altarpieces for the Chartreuse of Champmol from 1397 and coloured Sluter's sculpture *The Well of Moses*.

The Well of Moses, Claus Sluter (died *c*.1405), 1395–1405. Champmol, near Dijon, France. (*Below*)

One of the few works surviving from the hand of the Netherlands-born sculptor, it reveals him as a master anticipating Michelangelo both in technique and feeling for his medium and in his understanding of human psychology. The figures represent Moses, with the horns attributed to him by medieval tradition, and five other prophets whose books were thought to prophesy the coming of Christ.

the duke admired and the backs of the closed wings painted by Melchior Broederlam of Ypres, his favourite painter. The painter filled an extremely difficult shape with an ingenious and elegant masterpiece in the International style. The work was done at Broederlam's studio in Ypres and then transported to Champmol to be installed.

The chief ducal painter there was Jean Malouel. It seems likely that Malouel was the uncle of the Limbourg brothers but his work has considerably more psychological realism. Five altarpieces were commissioned from him but the work was not all finished at his death and Henri Bellechose took over. The monastery was one of the marvels of Europe until it was destroyed and its treasures dispersed during the French Revolution. In the 15th century it served its function as a monument to the piety and prestige of the dukes.

However, even as the monastery of Champmol was being completed, their economic and political power was shifting north. Philip the Bold was count of Flanders by marriage and his successors won control of Hainault, Zeeland and Holland. The great commercial and industrial wealth of the Low Countries came to feed their coffers and a constellation of creative talent became their subjects. Guillaume de Machaut, chaplain to Duke Philip the Good, was the most renowned of a brilliant circle of composer-musicians who served the Burgundian court. Today the artists are still better known for a series of masterpieces of inspiring spirituality and power. Their patrons also expected more practical services.

Aristocratic Europe was absorbed in the public relations of power. Opulent display and expertise in the code and practice of chivalry were diplomatic and political tools. Philip the Good was an acknowledged arbiter of contests on the tournament field and courtly behaviour off it. The ceremony of his court earned respect in an age when ceremonial was considered important. The dukes of Burgundy presided over the most brilliant and prestigious court of the period and the artists who received their patronage were required to maintain its trappings.

In 1435 Hue de Boulogne, artist and *valet de chambre* of Duke Philip the Good, was commissioned to provide painted decorations for a banquet at Lille. On each of the two principal tables stood an artificial hawthorn tree with flowers of gold and silver and the arms of France and the principal guests in its branches. Hundreds of wooden plates had to be painted with the duke's badges. Nineteen years later, Philip threw the biggest party of the century. The Feast of the Pheasant, held in 1454, was staged as an act of dedication when the duke and his court pledged themselves to go on crusade against the Turks who had captured Christian Constantinople the year before. In fact their vows were hedged with so many qualifications that there was no danger of anyone having to fulfil them. Days of court ceremonial preceded the feast which was really a massive demonstration of the duke's wealth and prestige. The banquet, which went on till three in the morning, was punctuated with tableaux and dramatic interludes. A plumber, six joiners, a sculptor, a locksmith and no fewer than 35 artists worked to prepare the costumes, décor and stage machinery of the entertainment.

Even the greatest northern artist of the century found himself occasionally involved in work which, today, would not generally be considered the province of an artist. Jan van Eyck, born about 1390, started his career in the service of the courts of Holland. The territory became part of Burgundy in the 1420s and van Eyck a member of the household of Philip the Good. He was made a *valet de chambre*, 'in order that he shall be obliged to work at painting for him as often as it shall please the duke'. But the painter was also employed on two secret

missions for the duke and, in 1428, travelled to Lisbon with a Burgundian embassy negotiating Philip's marriage to Isabel of Portugal. Van Eyck was to paint the lady's portrait. Thereafter he lived mostly in Bruges, buying a house there in 1432. On his death nine years later his wife received a handsome pension from the court.

His largest and probably most famous work is the great altarpiece in the cathedral of St Bavon in Ghent, called the *Adoration of the Lamb*. It is a vast allegory set in a landscape. The great work was begun with his elder brother Hubert who died in 1426 and of whom little else is known. At the centre, on a verdant lawn amidst trees, stands an altar on which we see the sacrificial Lamb of God. Groups of saints, clerics and nobles converge on it while others, amongst them fashionably clad esquires and knights, troop towards the field of worship through rocky landscapes. The wide panorama is portrayed with a jewel like precision of detail which is the hallmark of van Eyck's style and was the despair of imitators. A gentle sunlight glows over the scene uniting the scores of diverse and devout pilgrims in one mystical and eternal moment.

The same magic pervades *The Virgin of the Chancellor Rolin*. In this remarkable picture the hard-faced chief minister of Duke Philip's government kneels before a modest girl Mother of God with the Christ child on her knee and a hovering angel holding a crown above her head. Through the colonnaded wall behind we see a distant view of a flourishing port, reminding us of the trading wealth on which Burgundy's prosperity rested. The Infant Prince of Heaven and his Mother sit in the workaday world of trade, politics and power and nothing seems sentimental, nothing seems incongruous.

The paintings of van Eyck tell us that he was a man of rare quality, who saw everywhere in the mundane world about him signs of the spiritual constituent in our common humanity. The mysterious little painting in London's National Gallery, known variously as the *Arnolfini Marriage Group* or the *Betrothal of the Arnolfini* sums up his insight into the human condition. As we would expect of him every last detail of dress and furniture is meticulously recorded and yet the young man and woman are poised in a moment of contemplation which invests their really commonplace relationship of bride and groom with a strange, transcendental aura.

Giovanni Arnolfini of Lucca was a member of the large Italian

The Avignon Pietà, French, *c*.1470. Oil on panel, 154 × 207cm (64 × 86in). Musée du Louvre, Paris, France. (*Above*) One of the most marvellous achievements of European art, this masterpiece was discovered at Avignon. The unknown southern French master has achieved a monumental simplicity more characteristic of Italian artists and an intensity of expression first achieved in the works of Rogier van der Weyden. The iconography of a *pietà*, in which the mourning Virgin (here flanked by a kneeling donor and St John, with Mary Magdalene on her left) supports the dead Christ, reminds us of the happy days when she dandled the Christ Child on her knee.

The Descent from the Cross, Rogier van der Weyden (*c*.1399–1464), painted *c*.1435. Oil on panel, 200 × 265cm (78¾ × 104¼in). Prado, Madrid, Spain. (*Left*)
Commissioned for the Chapel of the Archers' Guild of Louvain, Belgium, this painting is one of a number of versions of the subject from Rogier's workshop. He was official painter to the city of Brussels from 1436 and later visited Italy where his work was much admired. The sculptural quality of the figures, the stage-like setting and, above all, the expressive faces and gestures involve the spectator in the tragedy of grief.

merchant community in the cities of the Low Countries. One of the most distinguished of their number was Tommaso Portinari, the chief factor for the Medici bank at Bruges. He plunged into the opulent life-style of the Burgundian court with enthusiasm. The generous terms on which he lent his firm's money to the dukes and the lavish expenditures he made, naturally to maintain the prestige of the company, brought his branch to bankruptcy. It took the head office in Florence years to sort out the mess but we at least have reason to be grateful for his extravagance. In 1475 he commissioned from Hugo van der Goes the great altarpiece which still bears his name.

This majestic work was duly taken to Florence where it was to exert a considerable influence on Florentine painters such as Ghirlandaio. Van der Goes himself became a member of the painters' guild at Ghent in 1467 and its dean seven years later. In his mid thirties and in the full flood of a brilliant career, he was nevertheless subject to attacks of depression. Shortly after his election as dean of the guild, he entered a monastery near Brussels; he gave up painting altogether in 1481 and died the following year.

At this time Flanders and the north of Italy were the twin economic power houses of Europe. The commercial links between them were almost inevitable and it is not surprising that these generated artistic interchange. A contemporary of Hugo's, Joos van Gent, settled at the court of Urbino while the work of their younger colleague from Hainault, Jan Gossaert called Mabuse, was to be strongly affected by a visit to Rome in the early 1500s. But by this time he had already completed his most impressive masterpiece, the *Adoration of the Kings*. Its jewelled perfection is the culmination of a natural progression begun by the miniaturists of the Low Countries, initiated by the Limbourg brothers and continued by the Bruges school.

The strength of the miniaturist tradition in the north is apparent in the sparkling detail of van Eyck's work but in one crucial respect the Netherlands school broke with the centuries' old development of European painting. At some time probably in the second quarter of the century and possibly in the workshop of van Eyck himself an important advance was made in the tempering of pigments, by the use of oil based medium. The technical details of this major development are given in the next section of this book; here we need only note that what was soon to become the almost universal medium of painting was evolved in the Low Countries and that its secrets may have been transmitted to

The Adoration of the Shepherds, commonly called 'The Portinari Altarpiece', Hugo van der Goes (c.1440–82). Oil on panel. Uffizi, Florence, Italy. (*Below*)
One of the most important paintings of the 15th century this work was commissioned from the Ghent-born van der Goes by the Florentine merchant Tommaso Portinari while serving in the branch of the Medici Bank at Bruges. Its arrival in Florence caused a sensation among the artists there. Among those whose work suggests a close study of the Flemish masterpiece is Domenico Ghirlandaio.

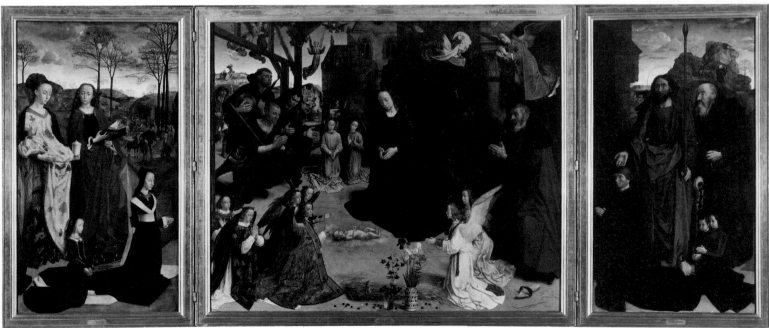

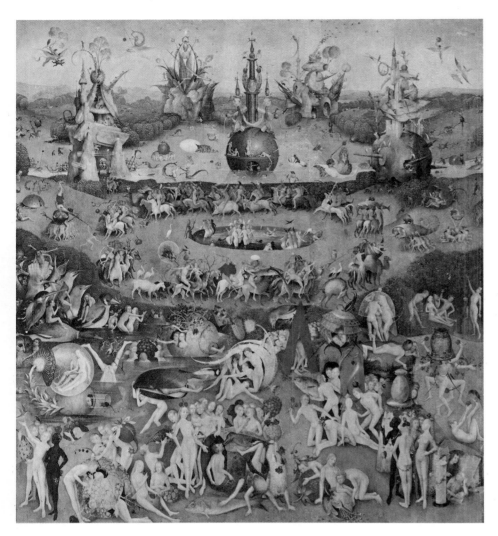

The Garden of Earthly Delights, central panel of a triptych, Hieronymous Bosch (*c*.1450–1516). Oil on prepared panel, 220 × 195cm (86½ × 76½in). Prado, Madrid, Spain. (*Left*)
Although we know little about his life, Bosch was one of the most renowned painters of his time. The profuse, and now often obscure, symbolism of his works derived, it is thought, from folklore, literary metaphors and proverbs familiar enough to educated contemporaries, who could thus interpret his moral allegories. Even for us, the fact that this central panel is flanked on the left by the Garden of Eden and, on the right, by Hell, make it obvious what the moralizing artist thought about the pleasures of sex and sensuality here portrayed.

the artists of the Italian schools by Petrus Christus, who probably visited Italy and seems to have been a pupil or assistant of van Eyck.

At one time many of his paintings were attributed to the hand of van Eyck, so little is known of his life. It is an all too common pattern with these early Flemish masters. Rogier van der Weyden, the most important artist in the Netherlands after the death of van Eyck, was justly admired by his contemporaries and was formally appointed 'painter to the city' in Brussels in the late 1440s. The title, something of a rarity, was probably in imitation of the titles and honorifics increasingly bestowed on painters by dukes and kings. In fact Rogier did much work for the Burgundian court, painting outstanding portraits of courtiers and of the Duke's son Charles the Rash, also a fine *Last Judgment* to the commission of Chancellor Rolin. It is likely that he visited Italy and some of his work certainly suggests Italianate influences. The *Descent from the Cross*, stylistically a most important work, has a monumental and sculptural quality unusual in the work of his Flemish contemporaries. Another painting, the *Madonna with Four Saints* now in Frankfurt, carries the arms of the Medici family and their patron saints. Whether the commission was placed while the artist was in Italy or by a Medici agent in the Low Countries is not clear but the work itself is one more instance of the close ties between the great industrial and artistic centres of northern and southern Europe.

The Italians regarded their work in the light of a 'renaissance' and artist historians sometimes refer to the superb art of the Flemish school as the Northern Renaissance. We have seen that the north undoubtedly learnt from the south just as it had lessons to teach, but it is equally clear that the Flemish art of the 15th century developed from its own powerful tradition to produce its own unique glories in the story of Europe's artistic heritage.

The Adoration of the Kings, Jan Gossaert called 'Mabuse' (*c*.1472–1536). Oil on canvas, 177 × 161cm (69¾ × 63½in). National Gallery, London, England.
The rich detail and careful technique make this picture a fascinating and beautiful example of the late Netherlandish style. However, Gossaert, who visited Italy in 1508, soon turned to an Italianate manner, aiming to emulate the themes and style of the classical Renaissance. He was the first of the Netherlands 'Romanists' and produced a number of fine portraits.

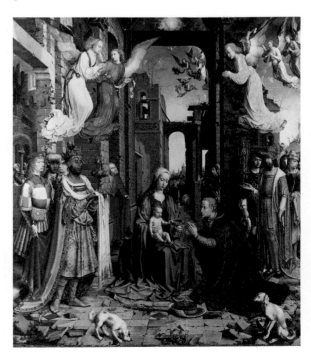

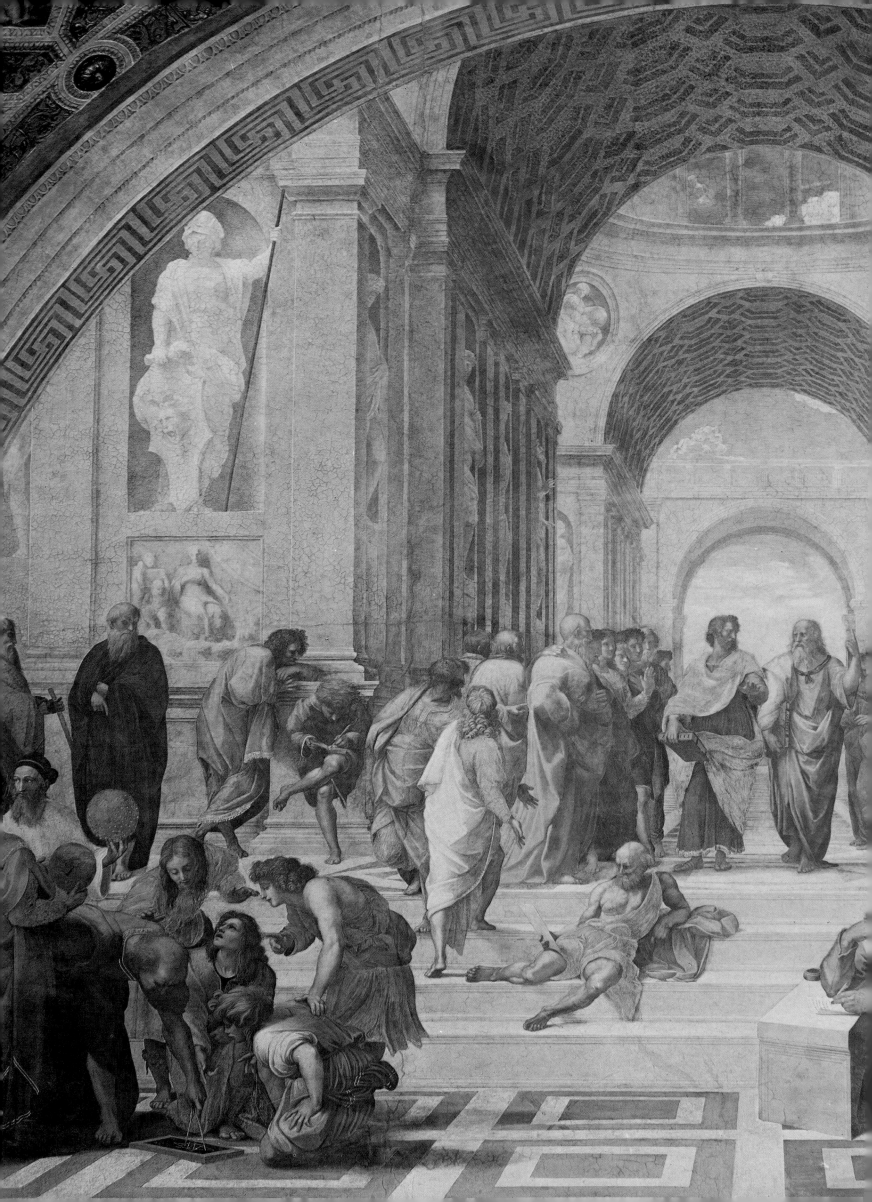

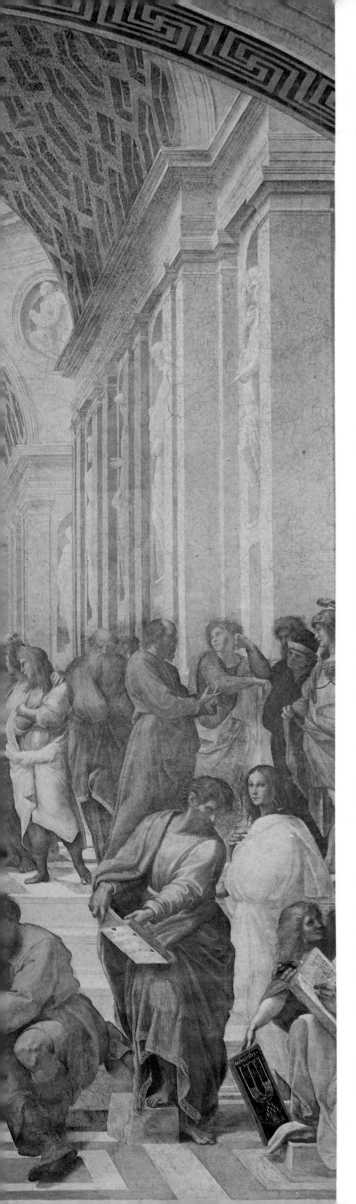

THE GRAND TRADITION

To paint you need colours, a medium and a support. Colours are made from soft rocks which are ground to powder; a medium is a fluid or sticky stuff to mix the colours into a paste so that they can be worked with a brush; a support is something to paint on.

In fresco the support is a wall. The wall must be prepared by spreading it with plaster; colours are mixed with water and paint is applied on to the wet plaster. When the plaster dries the water has gone, and the paint and plaster have become one crystalline surface which will last for centuries unchanged—except by dirt which can be cleaned off. Because they are unmixed (except with the plaster) colours are matt, pure and clear.

Fresco was revived in Giotto's time and decayed in Michelangelo's, but during that period it was dominant in Italy. It was a difficult technique. First the wall was rough plastered, and on the rough plaster the design was sketched. On top of the rough plaster was laid a finer plaster —the *intonaco*; but only so much *intonaco* as could be painted in one day, because it had to be painted wet. The next day a new ration of *intonaco* was laid and painted, and so on. So the painter had to work quickly, while the plaster dried, and accurately, because he could not rub out. Above all he had to know where he was going, because he worked not from the important parts to the unimportant, but from the top down, lest paint drip on painted plaster below.

As each patch of *intonaco* covered up a patch of sketch the painter had to repeat it on the wet plaster freehand. This was alright in Giotto's day when forms were generalized, but when in the 15th century they became individualized (e.g. portrait heads) it would not do. So the cartoon developed. The cartoon was a full-sized sketch on paper which was cut up into work patches to match the *intonaco*. A patch of the cartoon was put on a patch of wet *intonaco* and transferred to the plaster by pouncing charcoal through pinholes or tracing with a stylus.

Colours in fresco were pure and clear, but in this period they were few. It was a technique suited to bold decorative effects, giving painting an attractive surface which harmonized easily with architecture because it preserved the feel of the wall or vault. Paintings which drew you into the picture so that you forgot the wall, which were realistic in forms and textures and lighting, needed different techniques: frescos should be stylized.

Blues were the difficulty. Only two were known—the expensive

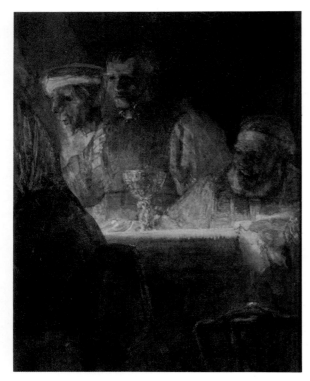

Conspiracy of Julius Civilis (detail), Rembrandt (1606–69), 1661. Oil on canvas, existing fragment 196 × 309cm (77 × 120in). Nationalmuseum, Stockholm, Sweden. (*Above*)
Compared with this Rembrandt even Titian's *Madonna* (*opposite*) looks smooth and Hals' brushwork monotonously regular (page 146). For Rembrandt has attacked his paint with thumb, knife, scraper, even the end of his marl-stick, anything that came to hand and produced the desired effect.
Madonna and Child with infant Baptist and Angels, ascribed to Michelangelo (1475–1564), *c*.1495. Tempera on panel, 105 × 76cm (41 × 30in). National Gallery, London, England. (*Below*)
This unfinished panel reveals the stages such paintings went through. On the left a charcoal outline has been blocked in with an even layer of green earth. The Madonna's robe and flesh have reached the next stage, that of modelling in three tones of green; but the flesh of the children and and of the youths to the right has passed both these stages and received its warm browns.

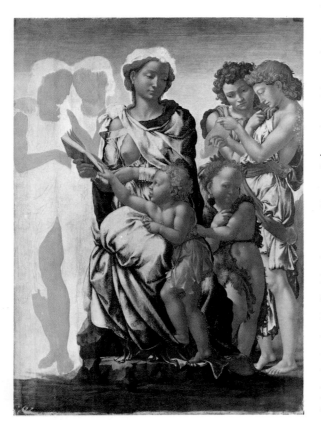

lapis lazuli (ultramarine) was not soluble in water and the cheaper azurite turned green if mixed with plaster. So blues had to be put on after the plaster had dried using a sticky medium, normally a glue. But as time elapsed the glue lost its elasticity, and hence its grip on the wall, and then it fell off. Early frescos tend to have lost their blues. In murals which are not true frescos—like most of those before Giotto—all the colours tended to fall off, and few have survived.

Michelangelo worked in true fresco, but his fellow artists wanted something quicker and more flexible and developed half-fresco. In this they painted on plaster which was nearly dry so they could make the work patches much larger, and they partially solved the falling-off problem by roughing its surface to give the paint grip—an unacceptable solution earlier when patrons wanted smooth surfaces and fine finish. Now a broader finish was permitted when the work would be seen at a distance. Half-fresco underlay many of the great decorative schemes of the Baroque and Rococo. Thus Pozzo and Tiepolo combined the gay decorative colour, light tones and high stylization the technique needs with illusion; a whole ceiling opens through soaring palaces to a sky alive with a mass of angels.

Altarpieces were smaller than murals and could be studied more closely. They needed a more portable support, that is wood, and a richer and more precise medium, that is tempera. The panel was prepared like a wall, only more finely, with *gesso*, a specially fine plaster in a succession of thin layers. The medium was egg-yolk diluted with water or a milky juice from the fig. Colours were richer, deeper and more luminous than in fresco, but still limited in number and range. Combined with varnish they dried hard as stone and were very durable.

The colours were also opaque but thin. They did not blend easily with each other and dried in a few minutes, when they were difficult to re-work. Tempera painting was slow, patient work, suited to meticulousness not spontaneity; and here too the artist had to know very precisely where he was going.

When the panel was prepared he drew his design on it, followed by the underpainting in shades of green earth. Only then was the top painting slowly applied in thin layers. Finally it was varnished. Procedure was formal: first gilding (if any), then architecture and drapery, last of all flesh. Everywhere the artist worked in three tones; a basic tone deepened for shadows and whitened for lights. Like fresco, tempera suited formalized art, with a bright decorative surface and not too much realism.

But in the Netherlands realism was wanted, so—it used to be said—the van Eycks invented oil painting. They did not. We do not know just what they did, but undoubtedly they improved what use of oil existed and combined it with tempera.

Oil paint dried slowly, colours would mix, there was greater range, more colours and deeper tones. It was also more versatile, for oil could be more opaque or more transparent. Something was lost of course: a certain joyousness of surface. Probably the van Eycks underpainted in tempera, for quick drying and the precision of brushstroke they needed for detail. Colours in tempera glowed through oil glazes, giving depth and translucency to shadows; while modelling was fuller, textures more accurate, light and atmosphere subtle beyond what was imaginable before.

This mixed technique passed to Venice where it was changed into true oils. A new support, canvas, proved more convenient for the easel pictures now coming into vogue; but it was also used for altarpieces and even murals, which could thus be painted in the artist's studio.

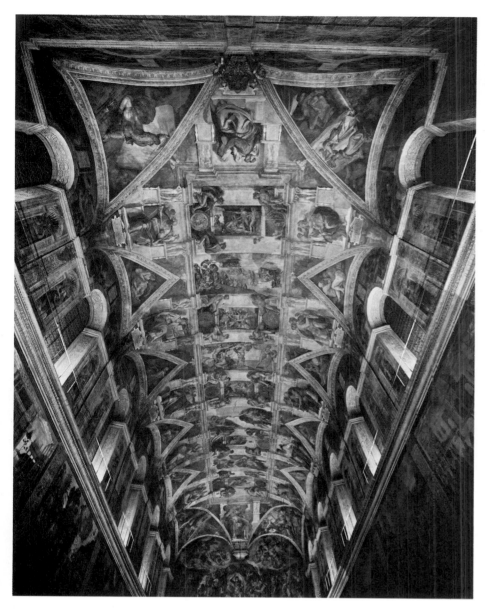

Sistine Chapel Ceiling, Michelangelo (1475–1564), painted 1510. Fresco on plaster, 375 × 380cm (147 × 149in). Vatican, Rome, Italy. (*Left*)
Detailed naturalism is out of place in fresco which calls for a bold stylization which relates it to the building it adorns. Here Michelangelo used contours, strong modelling and simple colours to achieve clarity; while flesh, cloth and marble are given the same neutral texture lest differentiation should disrupt the surface. So, while the figures stand proud of the architecture both blend in one decorative whole.

School of Athens, Raphael (1483–1520), painted 1509–10. Fresco on plaster, base 770cm (303in). Vatican, Rome, Italy. (*Pages 142–3*)
In fresco the artist paints on wet plaster so that paint and wall dry into one tough surface. He prepares only as much plaster as he can paint in a day, and the next day does the same until the work is complete. The joins between days' work can be discovered and in this work show that Raphael painted architecture and drapery very quickly, covering a large area in a single day; yet, occasionally, took a whole day to paint one head.

Madonna and Child, Titian (*c*.1485–1576), *c*.1570. Oil on canvas, 75 × 63cm (30 × 25in). National Gallery, London, England. (*Below*)
Like Michelangelo, Titian painted in layers, but, because of the versatility of oil, the stages are not clearly defined. By using oil he did not have to paint the picture part by part, but could at all times preserve the compositional unity of the whole. His colours are not simple greens and reds kept within firm boundaries, but so mixed that every part of his canvas seems to contain all of them, though in differing proportions. Nor did Titian smoothe down his paint surface, but left the brush strokes and dabs visible to create an expressive texture.

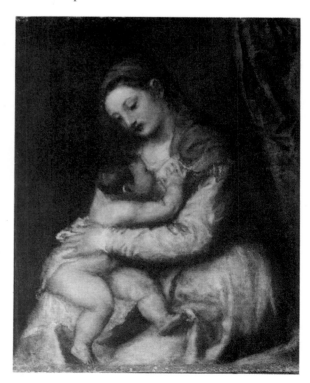

Van Eyckian oils were applied thinly, but now with a new diluent—spirits of turpentine—thicker paint could be handled. Paint began to be part of the picture; not merely the means of executing it but a thing enjoyable in itself. It could be built up into a paste (*impasto*) for the highlights; or scratched (*scumbled*) across the shadows so that the colours below would gleam through. It could be smooth, or be rough, transparent or opaque, polished to enamel or left to reveal brushwork which could be rhythmical, excited, tender, sensuous or passionate; in a word, paint could express a mood.

Preparation was simplified; now not a full cartoon but a free sketch would suffice, made on the canvas itself, nor need under-paintings be detailed or meticulously contoured. Titian especially, for he was the pioneer of this art, refused to pinion his imagination early; since the versatility of oils allowed second thoughts he could develop his ideas as he went along. He would lay glaze upon glaze, and through them would glow the underpaintings, and through those too the warm ground. Shadows became rich in colour and mystery, and the highlights striking in *impasto*.

There was a new unity in a picture; for the artist worked on it, not from the top down or from drapery to flesh, but all at once. So the old gay colours, set side by side, gave place to a general colour tone, which modulated, complicated and drew together, all the colours. Titian discovered optical finish, that is, instead of his painting within precise contours and enamelling every surface, he asked the spectator to stand back, whereupon the splodges, blobs and whirls of paint fell into place

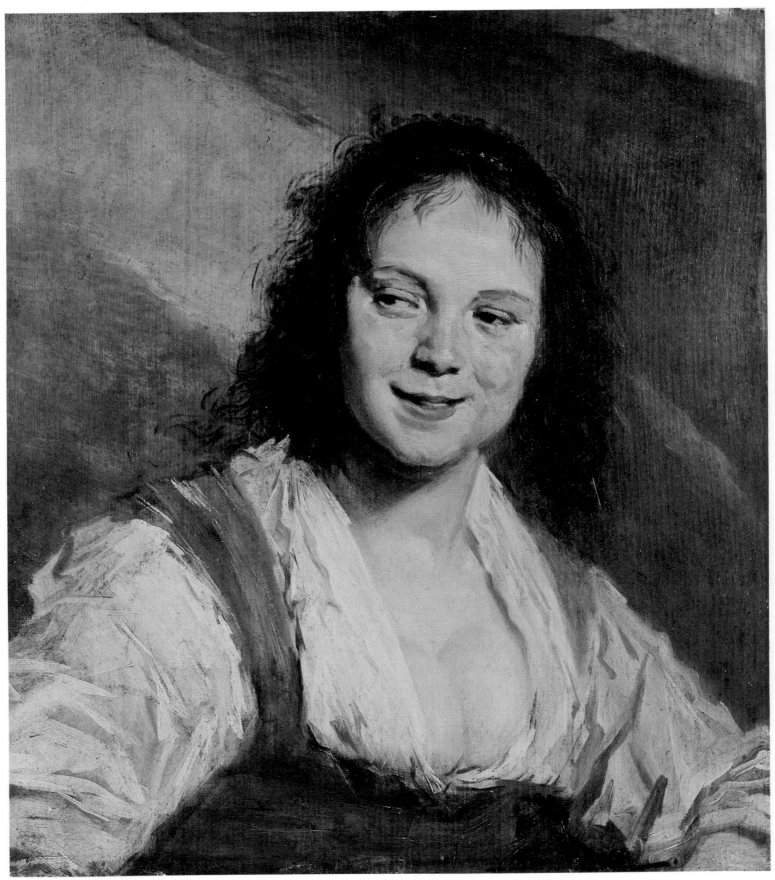

The Gypsy, Franz Hals (c.1580–1666), painted c.1630. Oil on canvas, 58 × 52cm (22¾ × 20½in). Musée du Louvre, Paris, France.

Unlike tempera oil paint can be put on as a thick paste, and Hals does so here, especially in the high lights. It can also preserve the brush strokes; and Hals makes long dashes of them running violently against each other. Oil thus allows painting to have an air of spontaneity like rapid hand-writing. It can also suggest life and movement: Hals is not simply representing the head and shoulders of a buxom gypsy girl, but someone who knows her effect on spectators and is slyly watching for it.

and the whole became alive and real. Of course not all artists painted like this, for oils could be laid fine and caressed smooth, and most patrons preferred it that way. So schools of drawing and schools of colour were distinguishable right through to the split between Ingres and Delacroix.

New colours were gradually invented, some of them dangerous, like Prussian blue, which darkened, or bitumen, which cracked, but many were valuable discoveries, such as a strong yellow and a stable green. Great colourists like Titian and Rubens actually had few colours but they made a little go a long way.

In the 1830s came the collapsible tin tube, and artists began to buy their colours mixed instead of grinding and tempering them daily. Poppy oil was preferred by the makers for ease of packing, and the buttery consistency preserved brushstrokes more perfectly than ever. Here were the technical foundations of Impressionism. With tubes enough colours could be carried for painting in the open air. The increased variety meant pictures could be built of colours; and with buttery paint one could luxuriate in textured surfaces, or express in rough, high ridges or fierce strokes, the passionate emotions of a Van Gogh.

Sculpture is a dual art; it may be carved or it may be modelled; one reaches its end by cutting away, the other by building up; one is natural to wood or stone, the other to bronze. Wood and stone are particular materials with particular qualities—grain for instance—which the sculptor may respect or override: bronze is, in many ways, less limiting.

Carving is slow, laborious work; most of Michelangelo's sculptures remain unfinished and many were never begun. Other sculptors, therefore, when they had made their models in clay or wax, hired masons to do the carving; a procedure most fully exploited by Bernini. This produced quantitative results, but quality depended on how closely the master supervised execution; how far he modified his idea (as sketched in the model) to realization in a harder material and on a larger scale; and whether or not he gave final life to its surface.

Pointing machines—instruments which measured points on the model and could transfer them enlarged to the copy—helped the masons. In the 16th century these were rudimentary but in the time of Canova (c.1800) they were nearly perfect. But mechanical reproduction produced mechanical results; artistically dead.

Stone limits a sculptor, for it is weighty and brittle in tension. A large standing statue needs something like a tree trunk for support if its ankles are not to snap; a monumental cavalier requires a fallen enemy beneath the belly if his horse is to prance. Sculptors were fertile in such expedients, particularly Bernini, yet the need for them remained, which was not the case with bronze. Bronze is for sculptors what oil is for painters, the most versatile of media. It can be given any shape: tall and thin or broad and short; it can be given any finish: burnished, gilded, patinated or textured as required. It is durable, although it goes green when unprotected and exposed. Limbs, necks and noses in bronze are less vulnerable to accidents or war, though statues may be looted for metal or melted into cannon.

Bronzes are modelled, though not directly. First comes the sketch, the small sculpture, perhaps in wax. This is copied full size in a soft material like clay; and from the clay a plaster which forms the 'core' is cast. Over the core a skin of wax is spread and the sculptor may work on this to enliven its forms, before a plaster mould is built around it. Pins are stuck in the mould to hold the core, and vents made through which the melted wax runs away when the mould is heated at the next stage. Molten bronze is then poured through the vents, until it fills the gap between core and mould which the wax has left. When it has cooled, the mould is broken, and the bronze revealed.

Much remains to be done. The core must be removed; rods of bronze fill the air-holes, bars of bronze the vents, and must be sawn off. Then the still rough statue must be worked over lengthily and skilfully, filed, chased and polished until the desired finish is achieved. In the Renaissance casting large works was chancy, and even Michelangelo failed in his first attempt to cast a huge image of Julius II. But as experience increased, techniques improved.

The Awakening Slave (unfinished), Michelangelo (1475–1564), c.1527. Carved marble, height 270cm (106in). Accademia, Florence, Italy.
Michelangelo first embodied his idea in a wax or clay statuette, then his assistants roughed out the block with a sculptor's pick. Next the artist himself attacked the stone with a pointed chisel, knocking off large irregular lumps at each bang of the mallet. Closer to the slave's skin he worked with a claw, a serrated chisel which scratched parallel grooves like hatching. He worked always from the front, struggling to release the figure which he imagined as imprisoned within the marble.

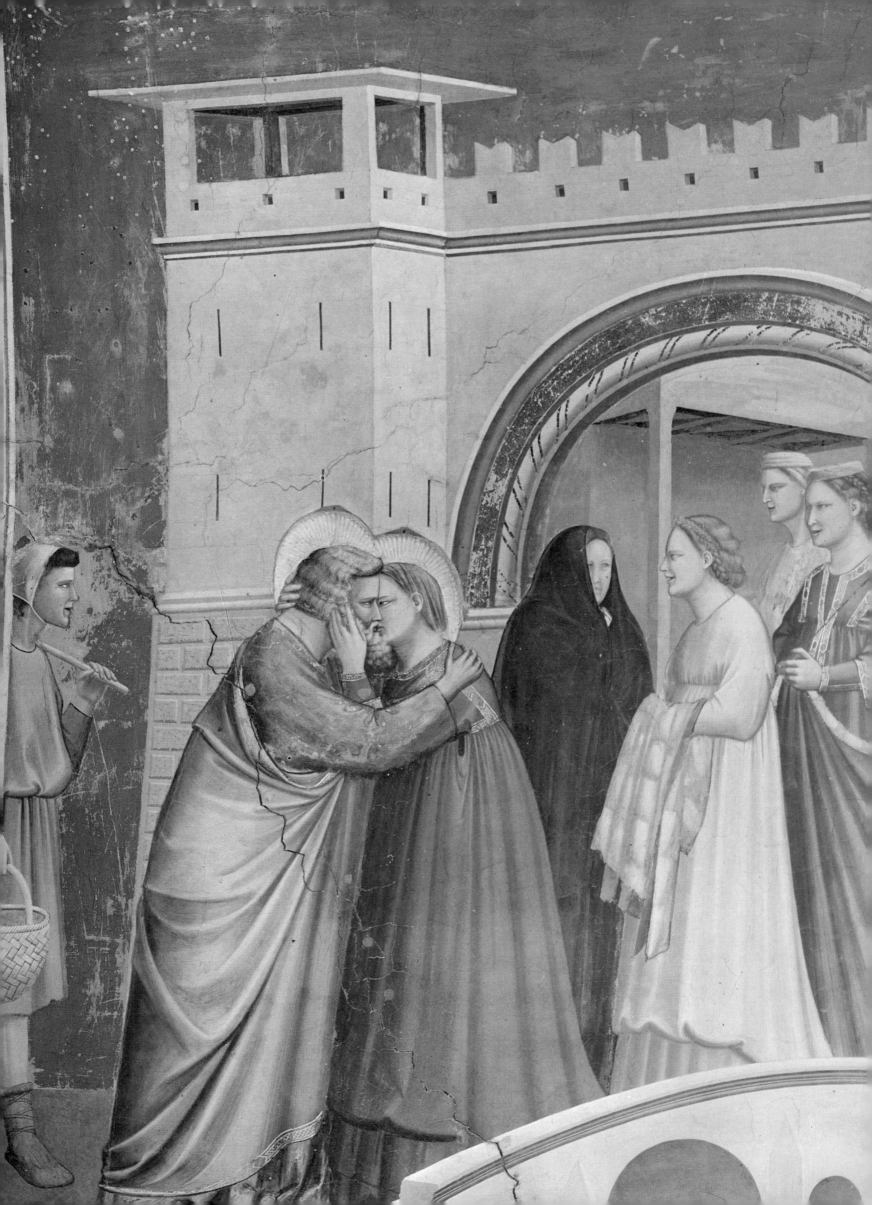

THE GRAND TRADITION
The Renaissance

It used to be said that Renaissance art began with Giotto and rose to a climax in Michelangelo and thereafter degenerated. This was traditional wisdom. Nowadays, however, scholars stress the element of continuity with the Middle Ages and warn us against seeing the Renaissance as a sharp break with the past.

But the idea of Renaissance, that is of a re-birth of civilization involving a repudiation of the past, is not Victorian but dominates the Renaissance itself. About the time of the battle of Agincourt (1415) scholars in Florence developed an intense admiration for ancient Rome. Everywhere they looked the Romans seemed to have surpassed them—in buildings, in literature and in art; so they came to regard the long ages which separated them from Roman civilization as barbarous or 'Gothic' —the Goths had sacked Rome. Later as they developed confidence in themselves they began to think they could equal and even surpass Rome—hence 'Renaissance', the re-birth of civilization after the barbarous 'middle age'.

They took a new view of the artist. He was no longer to be a superior cobbler, a craftsman who did the humble job his employer paid him for; he was to be the genius who contributed to the 'progress' of civilization by his scientific discoveries. Thus Brunelleschi discovered 'true' perspective and Masaccio discovered how to apply it to pictures so that they seemed much more lifelike. This idea of a civilization which progressed was new, though it was not our idea of progress. Our progress is based on the machine whose possibilities are limitless, theirs on the organism which matures from childhood, then ages and dies; after which there must be a re-birth. Giotto was their archetype.

Giotto painted his great picture cycles around the year 1300, when Edward I of England was building his very medieval castles in Wales. Like his contemporary Dante Giotto was a Florentine, though Dante was noble while Giotto was the son of a peasant. In 1302 Dante was exiled in consequence of some very medieval faction fighting, and in the year when Giotto was bringing about his 're-birth' of art, Dante was composing the greatest of medieval poems. In these same years Arnulfo di Cambio began Florence's cathedral which Brunelleschi was later to cap with his tremendous dome. Yet the cathedral is a Gothic building, and hence medieval; why therefore did Vasari, the first art-historian, writing in the lifetime of Michelangelo, regard Giotto as the founder of Renaissance art?

It was because of his revolutionary naturalism. The painter of the

149

The Crib of Grecchio, Giotto (1276–1336), painted about 1300. Fresco 274 × 244cm (108 × 96in). San Francesco, Assisi. (*Above*)
St Francis is shown making the first Christmas Crib, and miraculously the infant Christ appears in his arms. The figures are solid, wear contemporary dress and are only slightly too large. The perspective is inaccurate, but it makes the church furnishings three-dimensional and creates some sense of space. The mouths of the singing friars are carefully observed while the crucifix seen from behind is truly remarkable.

The Meeting at the Golden Gate, Giotto (1276–1336), painted about 1305. Fresco 213 × 183cm (84 × 72in). Arena Chapel, Padua. (*Previous page*)
Joachim and Anna are old but without children, and Joachim has just been expelled from the Temple because he has not fulfilled his duty to the law. While the couple are separated an angel has appeared to each, telling them that Anna shall bear a daughter who shall be the mother of the Redeemer. They meet at the Golden Gate of Jerusalem and embrace tenderly. Anna's relatives smile, welcoming only a joyful family event, but they themselves are solemn, aware of their awful responsibility. Between the two groups an ominous figure foreshadows the Passion.

Crib of Grecchio had begun to re-discover the science of representing natural appearances, most strikingly in the crucifix seen from the back. He painted it from the back because he imagined us to be standing within the choir and that is how we should see it from there. For an older painter the back of a crucifix would have had no meaning, since the meaning of a crucifix lay in the sacred image and that was not altered by where one was standing. This was a huge change of outlook, but was it a specially Renaissance change; was it for instance inspired by Roman art? Perhaps a little, but its true source lay in a change in the outlook of society itself. Religion in the 13th century wore a more human face than in the 12th largely because the new preaching orders, the Franciscans and Dominicans, illustrated their highly popular sermons with homely parables, which required a more human and naturalistic art. The fact that most non-Italian scholars think the St Francis cycle was not painted by Giotto does not affect the argument; the revolution is there all the same whoever was the artist.

However, it does affect our idea of Giotto, for at Padua Giotto uses a simplified stage set which suggests a scene rather than attempts an illusion of reality, and he did this because his purpose was drama and not description. In the *Meeting* the gentle curve of the bridge leads the women out from the city, while the powerful swing of the arch of the Golden Gate and the inward step of Joachim's servant force us to concentrate on the embracing couple. In the *Crib* one must read the text to be aware that a miracle has occurred; naturalism is strong, drama weak; but in the *Meeting* Giotto uses naturalism to enhance the sacred drama by showing us human feelings.

A new sculpture was created by Nicola Pisano (*c*.1220–*c*.1280) and his son Giovanni (*c*.1245–*c*.1315). Though as early as 1260 Nicola's stone relief of the *Adoration of the Magi* is based on the study of Roman sarcophagus reliefs, and was therefore more truly Renaissance than Giovanni's panel of *c*.1300. Giovanni exemplified another influence on Italian art at this time, that of French Gothic sculpture. Unlike Giotto, who observed the classic unities of action, time and place, Giovanni Pisano, Gothic fashion, tells several incidents, involving the same characters at different times, in his story within the same frame. There are other Gothic characteristics, for where Giotto's art is one of classic restraint, Giovanni Pisano's is both gracious and emotional.

Italy was at this time divided into states, many of which had their own schools of painting. A Sienese school, more conservative and less

Adoration of the Magi, Giovanni Pisano (*c*.1245–1315), dated about 1310. Marble, about 84 × 107cm (33 × 42in). From the pulpit in San Andrea, Pistoia. (*Right*) ·
The eldest king kneels to kiss the toe of the infant Christ, who clutches his gift. The two other kings wait their turn to offer homage, but also relate an earlier part of the story—how the angel came to them and pointed out the star which would lead them to Bethlehem. Behind them are their horses. Below and right the sleeping Joseph is warned by the angel of Herod's plans and advised to flee into Egypt, while on the opposite side the angel also warns the sleeping kings who return by another way.

The Temptation of Christ, Duccio (*c*.1255–1318), painted about 1310. Tempera on panel, about 43 × 46cm (17 × 18in). From the Maesta in Siena Cathedral, Frick Collection, New York. (*Left*)
'Again, the devil taketh him up into an exceeding high mountain, and sheweth him all the kingdoms of the world.' Duccio's mountain, and indeed his whole landscape, consists of the traditional stylized rocks, his cities are wooden models of uncertain perspective; but all are three-dimensional and the further hills really do look further away. But this semi-realism is subordinated to religious purpose by the scale of the figures. This is Gothic realism, where each part of the picture is real, but the whole is unreal because it is a pictorial sermon.

adventurous than the Florentine, was founded by Duccio (*c*.1255–1318). He seemed reluctant to break with the Byzantine tradition, but infused it with new humanity and a new naturalism of detail adapting it to the change in outlook produced by the preaching friars. His figures are not massive and monumental like Giotto's, but slender.

Ambrogio Lorenzetti, another Sienese artist, developed the more realistic aspects of Duccio's work. After Duccio's barren rocks Ambrogio's landscape looks very friendly and convincing. but closer examination reveals that it is more like a relief map dotted with tiny models than the real thing. Nonetheless an immense new vision was there.

In the second half of the 14th century Italian art was charming but unadventurous. Perhaps patrons lost confidence, for Florence was hit by financial disasters in the 1340s, and in 1348 came the appalling catastrophe of the Black Death. But with the new century confidence revived and a bevy of geniuses appeared comparable to those of 1300.

Gentile da Fabriano was not among them. He was a very fashionable artist, and very expensive, but he rather summed up the old art than began a new. He worked in the style we now call 'International Gothic', then practised all over Europe. The subject of the *Adoration* suited him admirably, for it allowed him to present a courtly procession ending in royal homage. He revelled in gold and in gold embroidered clothes; he loved the elegant figures and refined behaviour of aristocrats; and so his picture is an enjoyable one, full of gay colours and lively movements of men and animals. It is not deeply spiritual and is untouched by a Renaissance interest either in space or in the antique. It is about late medieval chivalry, painted as a fairy tale; yet there is much closely observed detail—the animals for instance are based on careful drawings made from life.

So it was not Gentile but Masaccio who in his brief life changed the face of art. Four or five years only separate his *Tribute* from Gentile's *Adoration*, yet we are in a different world. Gone are the gold and the embroideries, the charm, the playing-card flatness and impossible

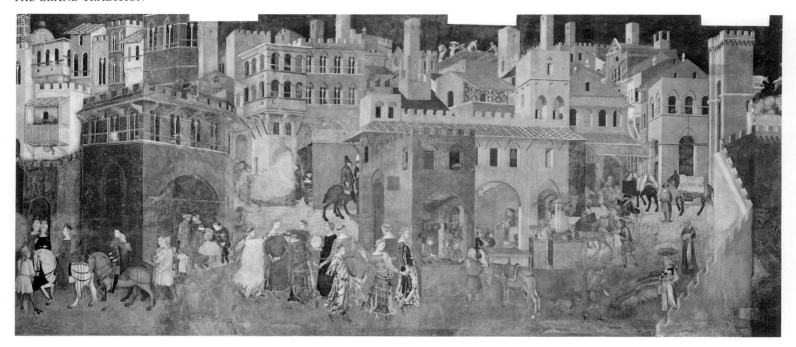

Good Government (Detail), Ambrogio Lorenzetti (c.1290–c.1348). Painted c.1338. Fresco. Town Hall, Siena. (*Above*) Nobles ride out of Siena with their hawks while peasants drive pigs and laden mules into the city. Further off others are at work with flails or harvesting, and further still are rolling hills and lakes dotted with farms and forts. This is the first landscape since Roman times and reveals a new enthusiasm for nature; yet its purpose is medieval for it is a moral allegory.

space. The high seriousness of Giotto has come again, with a new roundness of solids in which figures are heavy and stand on their own feet; and there is a new sense of space, in which the buildings are in proportion to the men and the mountains are distant and climbable. The lighting too is unified, coming from its actual source, the window above the altar. The solidity derived from a study of antique sculpture; the space from the new perspective invented by the architect Brunelleschi (1377–1446) and which Masaccio was the first to use in paintings; and the light, probably from a study of clay models set inside a little model stage with a window like that of the chapel. Masaccio's picture is not captivating like Gentile's; his apostles are not nicely born and delicately bred as they have so often been depicted, but tough fishermen and craftsmen.

In the *Tribute* Masaccio is grand, but its subject, taxation, though it exasperates, hardly touches our deepest feelings; so it is first in his *Expulsion* that we find his power to render tragedy; and here, at the age of 24, he showed himself a master. Technical faults are obvious; in the 1420s anatomy had not yet been studied, so the figures are ill-proportioned, stiff-jointed and clumsy. However, this is not important. Vasari wrote in 1568 '. . . the chapel has always been frequented by an infinite number of masters and designers up to the present time.' Those masters then included Michelangelo, and would now include Henry Moore; who on his scholarship stay in Florence went every morning, first to the Masaccios. By a reversal of the true order, it is of early Moores that they now remind us. They are tremendously sculptural, and express bitterness of spirit through the sheer tangibility of Adam's shoulder and Eve's thigh. Why this should be so I cannot say, but that it is so

The Tribute Money, Masaccio (1401–1428), dated about 1427. Fresco, 255 × 598cm (100 × 235in). Brancacci Chapel, Church of the Carmine, Florence. (*Right*)
The man with his back to us holds out his hand demanding tribute. Christ directs Peter, 'go thou to the sea and cast an hook'. Peter repeats Christ's gesture; then (far left) he is squatting by the sea taking the coin from the fish's mouth; finally (far right) he pays the tribute. Peter appears three times in the same picture, an old-fashioned, Gothic method of narration. Yet this is the first great Renaissance picture, for the figures have the grandeur of antique statues, are set in a space created by scientific perspective, and lit by natural light accurately observed.

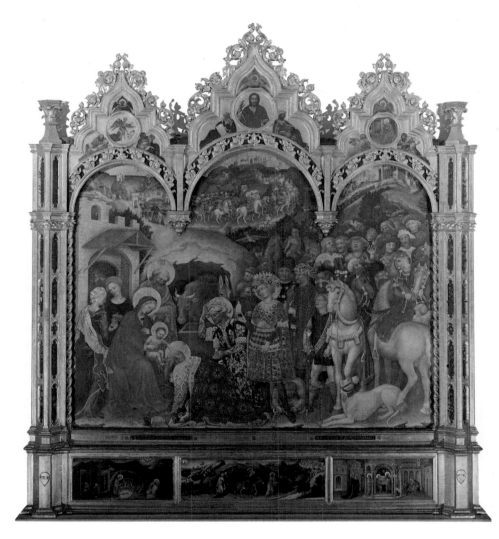

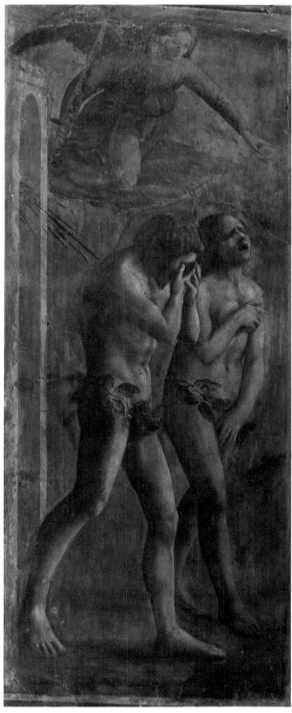

The Adoration of the Magi, Gentile da Fabriano (c.1370–1427), painted in 1423. Tempera on panel, about 113 × 220cm (45 × 87in). Uffizi, Florence. (*Left*)
An elegant Mary sits before a ruined building which stands for the now obsolete Old Testament, while her ladies examine the gift in a jewelled casket. Behind Joseph is the Cave of the Nativity, now a stable. Gorgeously attired, the three kings lay down crowns and spurs in turn to pay homage to the child king. Their courtiers, dressed in high fashion and jostled by their horses, have brought monkeys and leopards which symbolize the sins which Christ will redeem.

The Expulsion, Masaccio (1401–1428), painted c.1424–5. Fresco, 208 × 88cm (82 × 35in). Brancacci Chapel, Church of the Carmine, Florence. (*Below*)
A fiery red angel drives Adam and Eve through the gate of Paradise. Limp with grief, Adam stumbles forward shutting the future from his eyes; Eve throws back her head and howls. Instinctively she covers herself in the manner of an antique Venus, not with merely natural modesty but a consciousness of sin and shame.

Michelangelo and Moore stand guarantors. Paradoxically, though they are so sculptural they are also most painterly; for their massive limbs are shaped less by contour than by light, rendered with an impassioned rather than a careful brush.

Less revolutionary than Masaccio, since he was a generation older, the sculptor Ghiberti kept a goldsmith's shop in which he made such precious jewellery as papal mitres. He was a perfectionist who worked very slowly, taking 27 years to bring his second Baptistery doors to completion in spite of much help from assistants. At first he took an old-fashioned view of himself as an expert craftsman; later, under the influence of the Florentine scholars, he began to read classical books, and to see himself as a creative genius, thereby helping to develop the new Renaissance idea of the artist. In this panel he is in some ways still medieval, for he does not yet employ perspective; but he nonetheless creates a sense of space by progressively reducing the depth of relief as figures and objects are more distant. This makes paler shadows and suggests the softening effects of atmosphere; compare this with Giovanni Pisano's *Adoration,* where the depth of relief is even and there is no such sense of space. But Ghiberti shared with Giovanni the love of graceful Gothic curves which produce a lyrical quality. He was not naturally monumental, so his *Jehovah,* though dignified, lacks power. He delighted in flights of angels, who joyfully bear up in Eve in the Creation, shudder at the Fall, and swoop rustling behind God in the Expulsion. But it was in his Eves, (though not free from Gothic characteristics), that he revealed his study of antique sculptures, and he went more than half way to re-creating the classical sense of female beauty. Unexpectedly for a sculptor he had a real feeling for landscape, for if his foreground is rocky there is a springlike freshness about the wood.

While Masaccio was at work in the Brancacci applying the new per-

Herod's Feast, Donatello (c.1386–1466), dated 1427. Gilt bronze relief, 60 × 61cm (23½ × 24in). Baptistery, Siena.
A kneeling soldier presents John the Baptist's head on a charger. Herod recoils, spreading his hands to repel the horrid dish. A diner remonstrates, banging the table with the back of his open hand; another starts away covering half his face, disgusted yet fascinated. Salome herself, caught in mid-dance, is shocked. Even the palace has the air of a gaol; its servants thugs.

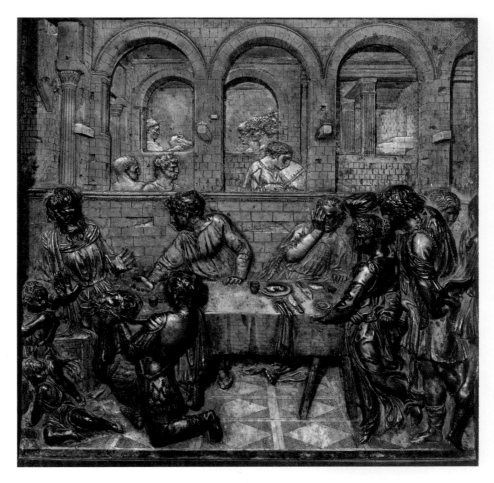

spective to painting, Donatello in *Herod's Feast* was doing the same for sculpture, though he had made some experiments some 10 years earlier. In this panel his fascination in it shows; for he was not content with receding lines on the floor and bits of wall visible through the arches, but pulled stones out of the wall, and stuck posts into the wall, and pointed them at us, all without any clear purpose other than to demonstrate perspective. The obvious use of perspective—the one for which Brunelleschi invented it—is to create the illusion of space; and Donatello did use it for that, but he saw that it could also heighten emotion. The lines of the floor and of those curious posts rush inwards and together all the faster because we are made to observe the scene from rather high up and very close to, while the figure groups, Herod and the children and the diner covering his face, jump sideways and apart; an inextricable tangle of heads and legs and arms and frocks tells us that 'chaos is come again'. Here is none of the classic understatement of Giotto and Masaccio; Donatello like a Jacobean dramatist drenches his stage with blood.

Donatello was the pupil of Ghiberti, but how different! Ghiberti could be as delicate and as finicky as a watchmaker; Donatello seemed to jab with his chisel like Van Gogh with his palette knife. He was a master of the figure too, for his creatures could leap and twist, smile and grimace, shout and exclaim, as no painter made them do before Leonardo. But there was another Donatello, the creator of *David*, the first free-standing statue (not in a niche) that we know of the Renaissance. Here is no blood, passion is over, and David contemplates the severed head as quietly as an antique god. Yet this is paradoxical, for his body is not a classic nude but 'so natural that it seems incredible to artists that it was not moulded upon the living body'. The statue with its odd hat and armoured legs obviously had a meaning, but we do not know what it was. Donatello was a homosexual, and this could have affected him subconsciously as he modelled the form, but it could not have been its public meaning. Was it the triumph of the republic as Michelangelo's *David* was to be or did it prefigure Christ's victory over Satan? What-

ever its meaning and un-Greek naturalism, this statue was a big step towards the recovery of the antique.

In Vasari's eyes Uccello wasted himself on oddities of perspective so that his figures became dry and his horses wooden. Yet for the early Renaissance perspective was science linking art and reality, and this interest should have made Uccello one of its leaders; but his pictures look quite unreal. Thus in his *St George and the Dragon* the real depth given by the movements of the horse and the real animal parts from which the dragon is made, only underline the fantasy of the whole. In his most famous work—the three battle pictures which once adorned the bedroom of Lorenzo the Magnificent—we find the same mixture of chivalric romance. Thus in the scene now in London there is a perspective floor on which the action takes place but which does not pass into the landscape, the horses are rocking horses, the armour engineer's drawings are neither modified by shadows nor casting shadows, while the tiny distant figures are as luminous as glow-worms. But Uccello recognized that one-point perspective was artificial (since our eyes create new vanishing points whenever they move) so he provided his pictures with more than one such point. Connoisseurs of contemporary art delight in his paintings; for he turns horses and armoured knights, damask caps and cloaks, orchards and hills, into hard-edged geometrical shapes; and he reconciles perspectival movements into irrational depth with decorative surface patterns, appearing as a precursor of Cubism.

Piero della Francesca was as devoted to the study of perspective as Uccello, indeed he finally abandoned art for mathematics. If we cannot be sure about the subject of the *Flagellation*, we are certain that it is one of the most elaborate demonstrations of mathematical perspective ever painted. One might think that this would make the picture as dry as a theorem: but not at all. For perspective and proportion so precisely position every figure that they are held in a kind of enchantment by the columns and tiled floors; out of the very clarity of his thought Piero

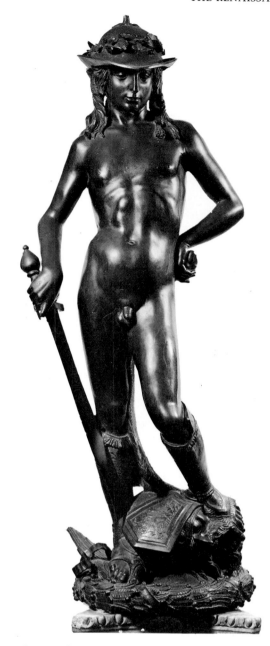

David, Donatello (*c.*1386–1466), probably made about 1440. Bronze, 160cm (63in). Bargello, Florence. (*Above*)
'In the courtyard of the palace of the Signoria there is a nude David of life-size, who has cut off Goliath's head and places his raised foot upon it, while his right hand holds a sword. This figure is so natural and possesses such beauty that it seems incredible to artists that it was not moulded upon a living body. This statue formerly stood in the courtyard of the Medici palace.' Vasari 1568.

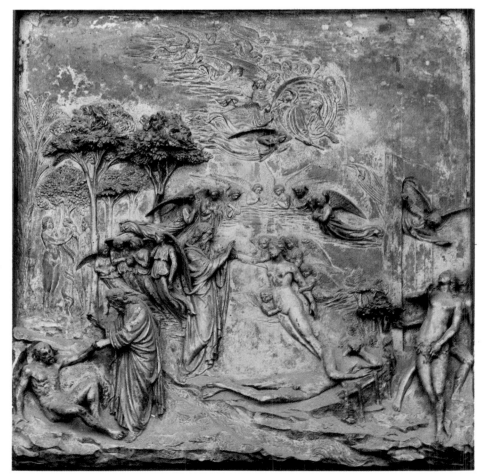

The Creation and Fall of Man, Ghiberti (1378–1455), from *The Gate of Paradise*, 1425–52. Gilt bronze relief, 79 × 79cm (31 × 31in). Baptistery, Florence. (*Left*)
At the bottom left God creates Adam and in the centre, Eve. Behind the creation of Adam we see the Fall, and (carrying our eyes up and across) God and his angels driving the guilty pair from Paradise. Where Masaccio's painting is sculptural, Ghiberti's sculpture is painterly, full of a sense of atmospheric space; and where Masaccio is tragic Ghiberti is lyrical. Much here is Gothic, yet his Eves might be called the first Venuses of the Renaissance.

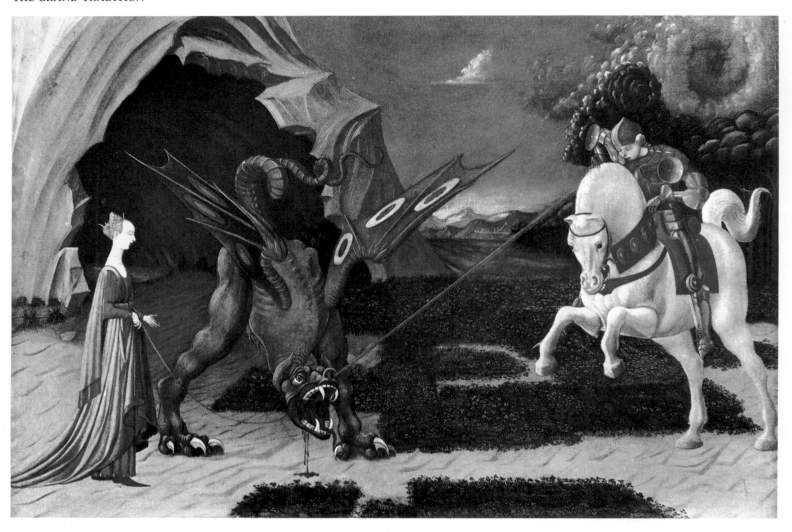

St George and the Dragon, Paolo Uccello (c.1397–1475), painted c.1460. Tempera on canvas, 56 × 74cm (22 × 29in). National Gallery, London. (*Above*)
'And the saint said to the damsel "Fear not, my child, and throw thy girdle about the dragon's neck!" This she did, and the dragon . . . followed her like a little dog on a leash.' (Jacobus da Voragine, *Golden Legend*). Uccello is a Renaissance scientist when he creates deep space through perspective and when he makes the horse charge like a slow motion film. He is characteristically Renaissance when he compounds his fantastic dragon from the bodies of real species, and wholly medieval in his drawing of the cave and the two innocents straight from a fairy tale.

The Flagellation of Christ, Piero della Francesca (c.1415–1492), probably dated about 1455. Tempera and possibly oil on wood, 59 × 81cm (23 × 32in). National Gallery of the Marches, Urbino. (*Right below*)
Three grave figures discuss an event symbolized by the flagellation of Christ. One of them—a portrait and, by his embroidered robe, a prince—listens to the arguments of another who may be a learned Greek; while a barefooted youth with the courageous stance and golden hair of Piero's young martyrs, seems to call for heroic action. The painting is an allegory, and probably refers to the flagellation of Christendom when the Turks took Constantinople in 1453.
Both this picture and the *Baptism* (*opposite top*) show the formal, geometrical sense of proportion which characterizes so much of Piero's work.

created mystery. For if Donatello was the apostle of movement and Uccello of pageantry, Piero was the apostle of stillness. There is no rush into the depths of this painting; we are made aware of the measured space of the loggia and of the measured recession of the courtyard, and of everything fitting together into a complex yet entirely unified surface pattern, with all the surprising suddenness of completing a jigsaw.

In his *Resurrection* Piero acted differently. As was quite commonly done in this century of experiment—Uccello did it in his *Rout* and Masaccio in his *Trinity*—he used more than one perspective in the same picture. We see the guards from below, which makes them twist and toss in unrestful slumber; but we are level with Christ, which with his centrality and frontality invests him with an archaic majesty, so that he seems to rise with a slow but irresistible force. It has been argued that in the 15th century men did not think of fertility gods, and no doubt in their conscious minds they did not, yet it is difficult to avoid the conviction that here Piero intuitively saw the Christian resurrection in archetypal terms.

Piero was not only a painter-mathematician, he was also a student of light. The landscape in which Christ rises conveys the feeling of his native Umbria, and he has evoked his scene through the particular light of early dawn, thereby anticipating for his quiet hills some of the poetry that Giorgione later developed in Venice. Yet this is a symbolic landscape for the trees, bare and dead on the left are, on the right, resurrected into full leaf. Nature itself shares in the revival of the buried God.

Where the *Resurrection* uses two perspectives the *Flagellation* employs two light sources, both as elaborately worked out. The main light comes from the sun, which must be high on the left. Its beams pour down the staircase behind the enthroned Pilate, creating strong modelling and short shadows for the three large figures and alternate areas of

light and shade for the paved court. But that bay of the loggia in which the flagellation occurs is lit, as one can see from its bright ceiling, from low on the right. This cannot be reflected light, because that part of the courtyard from which it must reflect is itself in shadow from the building; it must therefore be a miraculous light to indicate that the flagellation is not reality but a vision.

Finally we must note Piero's architecture. Though the buildings on the right are Italian vernacular, those of Pilate's residence are in the most Roman style we have seen yet. Their inspiration comes from Alberti, the first of the Renaissance universal men. Alberti as architect replaced the graceful arcades of Brunelleschi by buildings with a renewed Roman gravitas, though he enriched them with Venetian mosaics, as we see here in the version which Piero gives us.

Piero could be Roman when occasion demanded but Mantegna was passionately Roman, and with a true archeologist's desire to get his detail right. Sebastian was the saint one invoked against the plague, but Mantegna made him an excuse for proclaiming his admiration for Rome, modelling his body on Roman statues and surrounding him with Roman remains. In the *Bridal Chamber*, however, he is occupied with the perspective ideas of Donatello. He opened the walls on to wide landscapes; but his crowning achievement was to pierce the vault to reveal the sky, with a group of sharply foreshortened figures close at hand and peering down. Yet even here he was competing with Rome, for the Roman architect Vitruvius had written a treatise for Augustus, describing how the interiors of Roman mansions were often frescoed with landscapes, both actual and mythological. In his *Oculus of the Camera degli Sposi,* the so called *Bridal Chamber*—itself no doubt a playful

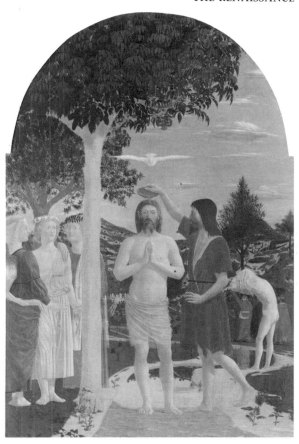

The Baptism of Christ, Piero della Francesca (before 1420–92), painted *c*.1448–50. Panel, 167 × 114cm (66 × 45in). National Gallery, London, England. (*Above*)

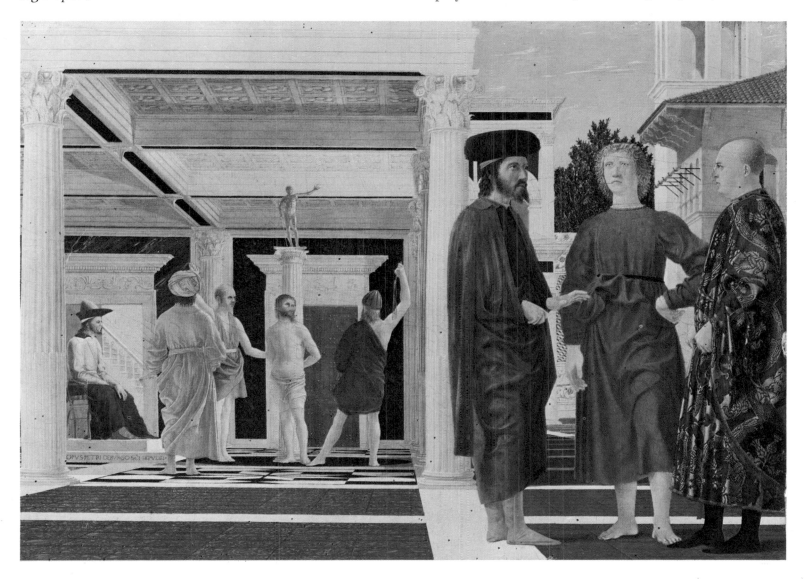

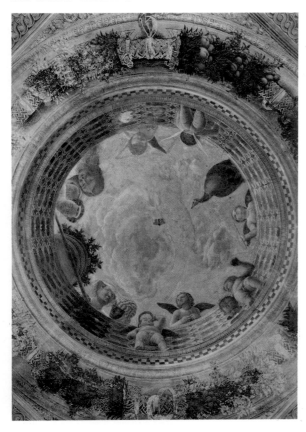

Oculus of the Camera degli Sposi, Andrea Mantegna (c.1431–1506), painted about 1473. Fresco, diameter 270cm (106in). Ducal Palace, Mantua. (*Above*)
The so-called Bridal Chamber is a vaulted cube with a side of 805cm (317in), painted to simulate an openwork summer-house in a landscape. Above the fireplace sits the ruler of Mantua amidst his family and court; on another wall he meets his younger son now a cardinal, while horses, grooms and dogs stand ready for the chase. The ceiling is decorated with medallions of the Caesars, and in the centre is an oculus apparently open to the sky.

Adoration of the Magi, Sandro Botticelli (c.1445–1510), painted about 1476. Tempera on panel, 112 × 134cm (44 × 53in). Uffizi, Florence. (*Right*)
The king about to kiss the child's toe is Cosimo the Elder, the first Medici to rule Florence. Piero the Gouty, his son and successor, is the king in red and his son and successor, Lorenzo the Magnificent, is to his right, in profile with black hair and black clothing. In the foreground, on the extreme left is Lorenzo's unfortunate younger brother Giuliano, murdered in the anti-Medici plot of 1478. The massive fair haired young man wearing a yellow cloak opposite him, is Botticelli himself. All these identifications however are contested.

Birth of Venus, Sandro Botticelli (c.1445–1510), painted about 1486. Tempera on linen, 172 × 278cm (68 × 110in). Florence, Uffizi. (*Far right above*)
'Propelled by soft zephyrs, a maiden of almost unearthly beauty, comes gliding over the sea; holding her hair together with her right hand and with her left covering her delicate breast, she steps from a shell on to the beach that covers itself with fragrant flowers beneath her footsteps. Here the three Hours receive her and array her in a pearl embroidered cloak.' Poliziano, poet to Lorenzo the Magnificent; from his poem *The Joust* of 1475, which provided the immediate inspiration for Botticelli's picture.

reference to the huge real oculus of Hadrian's Pantheon (*c.* AD 120)—Mantegna must have considered that he had surpassed his masters.

The brothers Pollaiuolo ran a goldsmith's workshop like Ghiberti, which turned out not only jewellery and sculpture but paintings. If their *Sebastian* is not a lovable picture it is a marvellous document, telling us the state of pictorial science in the 1470s. Mantegna's Sebastian was drawn from classical statues, but the Pollaiuoli drew theirs from a living model: we even know his name—Gino di Capponi. The result looks feeble beside Mantegna's, yet anatomy was a discipline to be mastered if the new art was to be no mere pastiche of the old; and this is demonstrated in the magnificent archers for theý show the nude in action. Vasari understood this when he wrote *Antonio . . . dissected many bodies to examine their anatomy, being the first to show how the muscles must be looked for to take their proper place in figures.* The landscape too, though it was supposed to be around Rome and a Roman ruin was duly included, was really a study of Florence's own valley; another application of scientific naturalism. But panoramas go awkwardly into mathematical perspective; so here, while the distances stir our imagination, the passage from the archers to the first horsemen leaves us with a feeling of some unease.

As a young man Botticelli also took an interest in perspective, so in his Uffizi *Adoration* the action takes place not across but into the picture; though he gives Rome no more than a sideways glance in the loose classicality of the arcade. Later in life he became religious, but not yet; and the fragile Madonna and tiny child fail to keep our eyes from wandering. They wander of course to the portraits, which, even if the identifications are challenged, remain vivid and memorable images. Some, like the self-portrait and the head of the youngest king, are wonderfully beautiful, others vigorously and economically characterized; all are intensely alive. We are fascinated too by the crowds; full of that restless, noisy movement the Impressionists enjoyed so much; but here achieved by quite opposite means, using a hard and precise contour and sharp oppositions of colour. This line and this liveliness were Florentine and had their source in Donatello, being in complete contrast to the stately and silent Umbrian, Piero della Francesca.

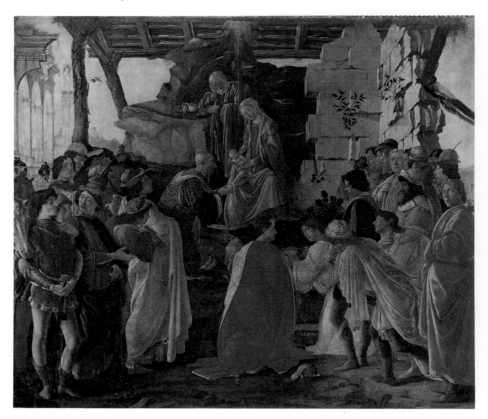

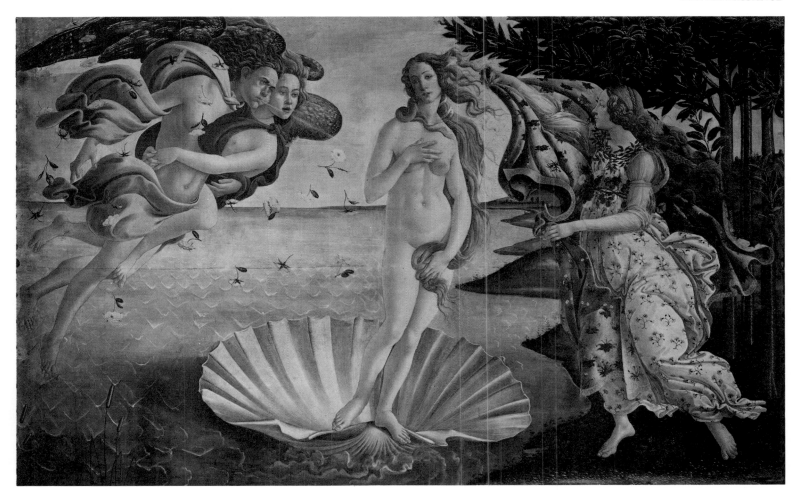

Both *Primavera* (Spring) and *The Birth of Venus* were painted for the same young Medici whose tutor was a philosopher; so this re-birth of what, to the medieval mind, must have seemed the most dangerous of the pagan goddesses, is a moral allegory imaging the birth of beauty and truth. But *Venus* of course is also an exquisite lyric, conceived and perhaps hung like a tapestry for it is on cloth. So the picture has a two-fold nature: Venus recalls antique statues in her nudity and her pose, yet with her sloping shoulders, round breasts and long, sinuous figure, she is very Gothic. Her central position, the water, the Hour reaching forward over her like St John, and the wind gods like angels on her other side, suggest the baptism of Christ; and there is indeed a chaste purity about this Venus as she floats dreamily towards the shore, un-ruffled by the fierce activities around her. Choosing a cool and abstract light, indifferent to texture, perspective and anatomy, Botticelli did not try like the Pollaiuoli brothers to imitate the real world, but painted the equivalent of a song. Everywhere his line sings; determinedly in the Hour, excitedly in the wind gods, and with a gentle melancholy in Venus herself.

Something of 15th century lyricism still hangs about the Louvre *Virgin of the Rocks*, for though Leonardo, as yet only 31, developed here the pyramidal composition so beloved of the High Renaissance, the criss-cross of hands and glances and the youthful charm of the adults preserve the freshness of the earlier phase. In the London version a quarter of a century later the pyramid is heavier, the space deeper, the grotto darker, the adults older and more aware, and the whole more solemn and silent. In both versions but more so in the later, Leonardo, by his careful study of light achieved a rounder modelling than hitherto, though by his own invented technique of *sfumato* or smokiness he sweetened the transitions from light to dark: and as his oblique per-spective sucks us through aqueous depths, we are given intimations of a geological time when the rocks were conceived in the earth's womb.

The Martyrdom of St Sebastian, Antonio Pollaiuolo (c.1432–98) and Piero Pollaiuolo (c.1441–c.1496), painted 1475. Tempera on panel, 291 × 202cm (115 × 80in). National Gallery, London. (*Below*)
'This work was the most admired of all that Antonio did. He always copied nature as closely as possible, and has here represented an archer drawing the bowstring to his breast and bending down to charge it, putting all the force of his body into the action, for we may see the swelling of his veins and muscles and the manner in which he is holding his breath.' Vasari 1568.

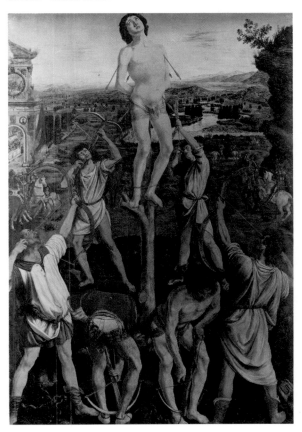

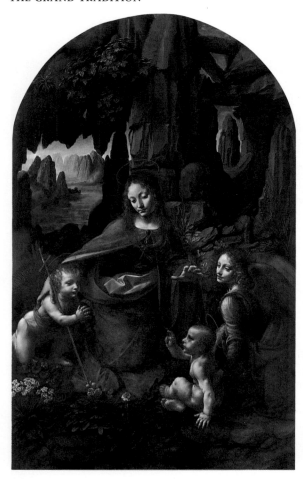

The Virgin of the Rocks, Leonardo da Vinci (1452–1519), painted 1503–06. Oil on panel, 189 × 120cm (74½ × 47in). National Gallery, London. (*Above*)
This, the second version of the *Virgin of the Rocks* is less charming than the painting in the Louvre and more solemn. The angel's meditation tenderly foresees the Passion; the Madonna stretching out her hand as though to protect her son, does not touch him, resigned to his allotted role. Instead she steadies the infant Baptist who kneels to adore the Saviour; and he, grave as a sage, gives benediction like a pope. The dark pool and the primeval caverns deepen our sense of mystery.

This evolutionary and Freudian analysis may be an anachronism; but who knows with Leonardo, for what could be more anachronistic than his design for a bicycle?

If the *Virgin of the Rocks* looked forward to the High Renaissance, with the *Last Supper* it began. The subject was a common one for the end wall of a monastic refectory. About 1480 Ghirlandaio had painted one in Florence, where the Disciples are strung out easily behind the table, a handful of cherries on each plate and pleasant fruit trees visible in the gardens beyond. Leonardo composed the Disciples into excited groups, balanced yet subtly varied on either side; he gave his scene the illusion of reality by using the actual light from the refectory windows high on the left. Then he condensed them around too small a table, while an accelerated perspective further concentrates the action as it rushes to a vanishing point behind Christ's head. Here all the accumulated researches of the century—into light, perspective, physical anatomy and the psychology of gesture and expression—were harnessed to the service of pictorial narrative, so that every device multiplies the complexity while it clarifies the meaning, at once variegating, unifying, and heightening the intensity of the depicted drama.

Leonardo painted few portraits, and none of the kings and princes who desired one was ever painted, because the individual was for him only a starting point. *Mona Lisa* convinces us that she is a real person. We need not doubt that the smile is the reason behind the picture, as it is the reason for its fame; yet there is more in the picture than the smile. When Raphael saw some early and now lost study for it, what he saw was not a smile (which may not have been there) but a magnificent pose, an arrangement of volumes in defined space, an essay in pictorial construction which inspired several of his own portraits: and this pictorial architecture is still there (and would be much more visible if the picture were cleaned). Then there is the light—its strong modelling and soft shadows would be less murky but no less mysterious after a cleaning; and there is the subtle painting of layer upon layer of translucent veils. Yet we do return to the smile, which certainly was what fascinated Leonardo for he used variations of it elsewhere. In his *Madonna and St Anne*, the Virgin's smile is motherly and the grandmother's spiritual, the one telling of Christ's human the other of his divine nature; in his *St John*, the Baptist's smile concerns the 'Word become Flesh'; in the lost *Leda*, it is about the sexual attraction which ensures the propagation

The Last Supper, Leonardo da Vinci (1452–1519), painted during the late 1490s. Fresco, 460 × 880cm (181 × 346in). Refectory of Santa Maria delle Grazie, Milan. (*Right*)
Christ has spoken the words 'One of you will betray me', and the Disciples react, each in character. Some argue, some protest, some point to themselves and say 'Lord, is it I?'. Judas, startled, recoils sharply across the table, upsetting the salt; the headstrong Peter pushes his way to Christ, clapping John's shoulder; the sensitive John faints. Christ, with his arms opened as the willing sacrifice, is calm, the stable centre within the tumult.

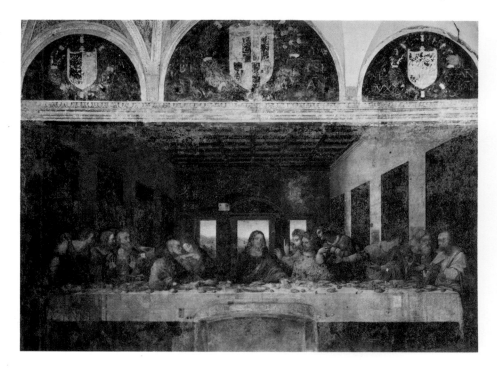

of the species. In the *Mona Lisa*, if the smile is more particular it is also more general; beyond that one cannot go.

Michelangelo's antipathy to the portrait was absolute and his *David* is not an individual but an ideal; nor is he a child like Donatello's and Verrocchio's but a huge gangling youth with hands and feet and head too big for his body. 'There is no excellent beauty' says Bacon, 'which hath not some strangeness in the proportion', and perhaps it is his very ungainliness which gives this David his appeal. For behind his idealized form we sense a knotty reality that removes him from the remoter world of myth and endows him with present power to summon up the hero in every man.

Michelangelo was also a great painter and a great architect; but he was greatest as a sculptor and this fact conditions all his work. Where a painter combines figures to express a scene, a sculptor compresses a scene into a figure. So in the Sistine Chapel figures do not decorate the ceiling so much as the ceiling supports and displays its figures. It provides plinths and pedestals and backings for an enormous number of painted statues. This is true of the picture scenes also; for even in those first painted, where the figures are smallest and least effective, it is still the individual sculptural group which catches our eye. The accessories are cut ruthlessly; the Garden of Eden is reduced to a tree, Noah's shrine to a block and a wall. All the vast illusion of marble vaulting framing the pictures and enthroning the prophets is no more than a harmonious accompaniment which sustains these statues but never competes. This is no fault in Michelangelo—it is never a fault in an artist to understand the nature of his genius—for it freed him to develop on his ceiling, figure by figure, in complex posture after complex posture, that vocabulary of the human body, especially of the male nude which was to become one of the twin pillars supporting all subsequent art. The other pillar, the combining of many figures into elaborate and harmonious groups, was primarily the work of Raphael.

As he painted Michelangelo grew in power. In his first bay nude had repeated nude, in a symmetrical series of image and mirror image; but in his final bay where God separates the light, diversity is deliberate and extreme. While one heroic youth, at his ease in the sun, radiates a latent energy and a sublime confidence in his powers, his opposite heaves and strains at what, viewed literally, is the trivial task of lifting a bag of nuts. The same scene viewed symbolically, is an emblem of human struggle; a struggle which, at 36, Michelangelo still believed that humanity could and, in fact, would win.

When summoned to Rome by Pope Julius Raphael's first task was to paint four allegories on the walls of the Camera della Segnatura or Signet Chamber. They were to represent Justice, Theology, Philosophy and Poetry, and were to surround the Pope with a summary of humanist culture. Here Raphael first showed his genius as the inventor of the pictorial symphony. Beside these resplendent creations the decorations of his old master Perugino and of the Borgia's painter, Pinturicchio, looked feeble and stilted. In the finest of them—*Philosophy* or *School of Athens*—all the most famous Greek philosophers, astronomers and mathematicians engage in keen debate and the instruction of youth. The figures are set in an enormous Roman hall inspired by Bramante's plans for the new St Peter's, the building with which the Pope intended to challenge the grandest monuments of the Caesars. In each of the frescos, numerous beautiful, heroic or imposing figures are arranged in complex but harmonious groups; the eye is led gently from one to another on to the climax of each picture—the Host, Aristotle and Plato, or Apollo. Each group takes its proportioned place in the airy scene, of which the

Mona Lisa, Leonardo da Vinci (1452–1519), painted about 1506–10. Probably oil on panel, 77 × 53cm (30 × 21in). Louvre, Paris. (*Below*)

Mona Lisa was the wife of Francesco del Gioconda, an obscure Florentine citizen, but we cannot be sure that this is her portrait. As we know little about her this does not matter; what matters is whether this is a portrait at all. Vasari says that Leonardo was attracted by curious heads, and would follow such people about until he got a clear idea of them. Somewhere, on someone, he had seen something like this smile, and been fascinated and puzzled and set himself to explore. Was it not that which set him painting, and not a contract to portray somebody's wife?

The Expulsion of Heliodorus, Raphael (1483–1520), painted 1511–12. Fresco, base 750cm (295in). Vatican. (*Above*)
Sent by the king of Syria to rob the Temple, Heliodorus is leaving with his booty amid the screams of the people, when the prayers of the high priest are suddenly answered. Out of the sky appears a terrible rider clad in golden armour and followed by two noble youths, who together fall upon Heliodorus and drive him out.

God Separating Light from Darkness, Michelangelo (1475–1564), painted 1511. Fresco, 180 × 260cm (71 × 102in). Sistine Chapel, Vatican. (*Above*)
This is the first day of Creation, and within a frame of white marble God the Father twists in creative fury, thrusting away the darkness. Around him on marble plinths sit four youths, at once statues and alive; whose presence is excused rather than explained by their holding swags to support medallions. The medallions illustrate the ascent of Elijah in the fiery chariot and the sacrifice of Isaac. Though earliest in the story this bay was the last to be painted, and reveals Michelangelo at his most powerful.

diffused and genial light smoothes the tranquil colours and fills the room with a transcendent optimism, energetic yet balanced, rational and serene.

As one steps into the next room everything changes. All seems darker, and each wall bears scenes of violence; for Raphael's new commission was to paint four miraculous salvations of the church. Partly to suit the commission, partly as a result of his own development, and partly because Bramante (who had the key of the chapel) had shown him Michelangelo's unfinished ceiling, Raphael's style changed. His colours became stronger, his shadows darker, the twists and turns of figures more extreme, and his designs move more forcefully to their conclusion. In the *Heliodorus* we enter with the Pope, (the contemporary dress of his litter bearers revealing that he and they observe from outside time) and we are at once caught up among scared mothers and terrified children. We climb to a vantage with the bolder spirits, see the praying priest, then, following with our gaze the pointing arms, are drawn across and outwards to where the golden horseman tramples the robber and his band. Instead of gliding leisurely from group to group as in the *School of Athens*, the action here moves swiftly into and out of depth. Even the architecture is no longer spacious, but ponderous and claustrophobic; and the light, no longer tranquil, bounces angrily from dome to dome. What was begun in Leonardo's *Last Supper* here finds its fulfilment; for in his Vatican frescos Raphael developed the art of painting into a supple instrument, capable of rendering all the nuances and emotions of epic drama.

With the completion of the Sistine Ceiling and the Vatican frescos the High Renaissance had reached its climax, and, apart from in Venice, largely run its course. The Renaissance had created classic art: but what was that art? To begin with it was art in the grand manner, art whose subjects were great men, sacred events or the gods and heroes of antiquity. It was also idealizing and saints and apostles, gods and heroes looked and behaved as great figures should. It was rational, with figures and setting, style and treatment appropriate to the subject, and everything in the picture capable of explanation. While they were still

in the making such rules were fresh and flexible, and led to the near perfection of the Ceiling and the Vatican frescos. However, perfection is a dead end, and Raphael, continuing to experiment and finding the rules constricting, strained and broke them. Thus, in his *Fire in the Borgo*, he pushed the main incident far back and made it small, filling the foreground with brilliant figures who seemed to be there only to be admired. Michelangelo had a personality too tremendous to be long contained within any rules, even his own.

Moreover the High Renaissance, as we have seen, viewed the artist no longer as a craftsman but as a creative mind, and therefore demanded originality. A true genius like Leonardo was original because he saw more deeply into reality, but there followed artists who pursued originality as an end. Such artists, trained in classic rules, broke them to produce original effects, so that instead of determining the style the subject became a pretext for exhibiting the style, and complicated postures were used to display virtuosity. This art needed and found a race of sophisticated patrons, who, knowing the rules, savoured their witty or skilful disruption. Such were the origins of 'Mannerism', a style which later generations would call degenerate, but which we today, having contemporary art to stretch our responses, can look at with less prejudiced eyes.

Always temperamental, after the completion of the Ceiling Michelangelo suffered increasingly from frustration and despair. Politically the sanguine hopes which inspired the Renaissance had collapsed. Italy was invaded and fought over by French and Spaniards, by 1525 it had lost real independence. These same years witnessed that revolt against the church which quickly carried half Europe into the Protestant camp. In 1527 Rome was sacked and the unpaid mercenaries of the Emperor created such havoc that the city never recovered as a centre of Renaissance art. On a narrower stage the Medici had subverted the republican government of Florence and established a despotism. After the sack of Rome, they were thrown out and there followed a siege by papal and imperial troops at which Michelangelo was in charge of the defence of the city. It fell and despotism returned, and only by hiding did Michelangelo escape the assassins of the new duke. Yet he continued to work on the Medici tombs for several years, until, in 1534, he accepted a voluntary but permanent exile.

In retrospect Michelangelo's achievements seem enormous, but he himself was obsessed by his failures. He had not completed the Medici Chapel; leaving hurriedly he had not even seen it assembled in its present truncated form. Most disastrous was the Julius tomb, the project by which he set most store. As conceived in 1505 it was to comprise a monument with four walls and 40 statues; as erected in 1545 it had one wall and only one statue, the *Moses*, by the master himself. True there were the unfinished *Slaves* (now in the Louvre and Accademia, Florence) and to us they are among the most moving of his works. In their Herculean but doomed efforts to writhe free of the imprisoning marble, they express, as never before or since, Man's hopeless struggle to rise above the limits of his flesh.

Painting was swifter; and although he was 60, Michelangelo completed the vast *Last Judgement* between 1534 and 1541. It was not however a monument to the High Renaissance but to the counter-reformation, the stern and inhibiting reaction of the Catholic church to Protestant rebellion. Its innumerable massive nudes are no longer beautiful, no longer confident, and for all their powerful muscles they are not capable of any achievement by their unaided strength and will: all are now helpless puppets in the hands of one Almighty God.

David, Michelangelo (1475–1564), carved 1501–04. Marble, 411cm (162in). Accademia, Florence. (*Above*)
Michelangelo has carved David on the scale of a Goliath whom he does not show—Goliath's head should be at David's feet, as it is in the *David* of Donatello. Nor does this David load his sling, but throws it lightly across his shoulder, making it a sign of his identity rather than a weapon for action. Michelangelo dissociates David from his particular moment, even from his particular story; so that he becomes an emblem of the Florentine republic's will to resist, or more generally still, an emblem of ambitious youth's will to achievement.

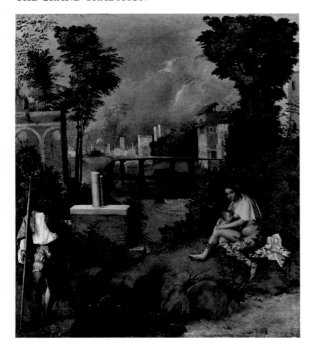

The Tempest, Giorgione (1477–1510), painted about 1505. Probably oil on canvas, 82 × 73cm (32 × 29in). Accademia, Venice. (*Above*)
Argument has raged over the meaning of this picture, but should now rest. As Edgar Wind has demonstrated, it is an allegory; of Fortitude (the man) and Charity (the woman) who abide the inconstancy of Fortune (the storm). Giorgione also took up the challenge from antiquity, for Pliny wrote that Apelles painted the unpaintable, a storm. Yet as early as 1525 a Venetian called the painting 'a landscape with a storm and a soldier and a gypsy', landscape and storm placed first. It is perhaps the first landscape of mood.

The Venetian school stood apart from this development, and to understand it we must go back to the 15th century and Giovanni Bellini. His genius moulded it until it became the rival of Florence and Rome, and enabled it to continue the ideals of the High Renaissance long after they had collapsed elsewhere. Venetian art was to be an art of colour rather than of line, of painting rather than of drawing, of harmonies rather than intellectual excitement. All this began with Bellini. Bellini's figures were no less sculptural than those of the Florentines, but it was a sensuous sculpture of static mass caressed by a soft light rather than a sculpture of nervous line, muscular form and postures expressive of movement. Nor do we expect the same anatomical research from Bellini as from Pollaiuolo and Leonardo; and we should be surprised if, like Piero, he had ended as a mathematician, though he studied perspective as a painter. For Venetian painters were painters, not universal men; they produced no sculpture, designed no buildings, invented no bicycles. But they do give a new importance to landscape. The *Sacred Allegory* was not typical of Bellini's work which consisted mostly of Madonnas, but he seized the chance to make his figures so small that the landscape is revealed. Moreover this subdues them, and they seem to have absorbed the placidity of the lake and to bask in the sun which warms the hills. Bellini's picture is more than a puzzle; he prepares us for Giorgione and such works as *The Tempest* often described as the first landscape of mood.

Giorgione brought us the easel picture, the moveable framed painting not painted on a particular wall or for a particular altar. He placed a new emphasis on paintings as a source of pleasure, whereas hitherto they were devotional, commemorative or moral. For the exhortation in the *Tempest* was surely never more than an excuse for painting a 'poesie', a new form of Giorgione's invention, which was an invitation to daydream in a lazy Arcadia rather than a summons to effort and endurance. The poesie was immediately popular and was so swiftly imitated, that it is a real problem to separate Giorgione's own work from that of his disciples. In the *Tempest* he makes us savour first the intense hush, then the flash which throws a bizarre light on the houses, and the trembling of the leaves in the lifting wind preceding the storm. But the young man is not King Lear nor the woman a Bedlam beggar, and we do not believe they will suffer over much.

Titian, whose 60-year reign shaped the mature phase of Venetian Renaissance, was a pupil of Giorgione's, and became so imbued with his spirit, that in his early years it is a problem to tell the two apart—

Sacred Allegory, Giovanni Bellini (c.1430–1516), painted about 1495. Oil on wood, 73 × 119cm (29 × 47in). Uffizi, Florence. (*Right*)
This is not a surrealist fantasy but a Christian allegory. The seated child is Christ, played with by cherubim (one of whom plants the tree of life) and adored by the saints Jerome and Sebastian and by the prophet Isaiah. Mary, enthroned as the Church, presides over a salvation debate between Mercy and Justice, while a Paynim walks away. The enclosure is the New Testament and the shore the Old Testament. Across the lake cave dweller and centaur indicate the primitive world before Moses.

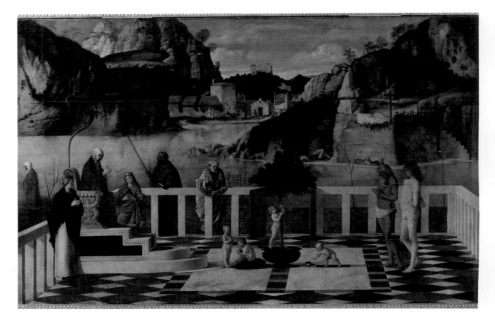

Night and Day, Michelangelo (1475–1564), 1526–34. Marble Tomb of Giuliano di Medici, Sacristy of San Lorenzo, Florence, Italy. (*Left*)
These two figures epitomize Michelangelo's power as a sculptor. Night, with relaxed shoulders and bowed head, is turned inwards, uncaring of the outside world. Day, in contrast, with powerful muscles flexed, twists round to stare outward at the viewer. The head, just blocked out of the marble, adds immeasurably to the power of this figure.

for example in the Paris *Fête Champêtre*. But when he painted *Bacchus and Ariadne* he was fully himself, readier than Giorgione to take literary and visual inspiration from antiquity. He worked from Catullus' description of Bacchus' train, including 'some girding themselves with serpents'; and the form of Titian's serpent figure was adapted from the recently excavated Laocöon. But Titian was no more cramped by his sources than Shakespeare, and he re-created his scene in grandly Venetian terms. There is a strong sense of flesh in his nudes—flesh and bone and weight and firm substance, the very opposite of the stylish abstractions of the Mannerists. This fleshiness lends a vigorous reality to his Bacchanal, for although we have to do with a god and a heroine and an episode from an epic poem, we never quite lose the feeling of a glorious romp in the sun.

Titian's Venuses share this quality of flesh, and in his *Venus Anadyomene* it appears with so little classical disguise that a bather rather than a goddess comes to mind. Yet his *Venus of Urbino* 20 years later was more characteristic. She is a new version of Giorgione's Venus from the beginning of the century; but where Giorgione set his Venus in a landscape, and wrapped her in a cocoon of sleep from which only a fairy prince might wake her, Titian laid his upon a bed in a palace room. Though she has the same body and almost the same pose as Giorgione's, she is awake, and, if indolent, aware. She is stretched across the front of his picture so that she seems very close to us, and we could touch one protruding corner of her pillow. Titian liked asymmetrical composition, and screened off one half of the bed with a green curtain leaving the other open to the room. The room itself, and again this is characteristic, is opened through a columned porch to a glimpse of landscape and sky.

A decade later he created a new type, a Venus of the very ample proportions so beloved by the Venetians, turned more fully towards us. She reclines as before, sometimes with a Cupid, sometimes also with a male admirer who amuses her with songs and music. One bewitched musician is the young Philip of Spain himself. The young Philip is rather a conceit than a portrait, but Titian was a portrait painter and one of the greatest. Most of us judge portraits by their likeness—not easily done when the subject is long dead, but it can generally be sensed. Not all Titian's portraits pass this test, for occasionally he chose to make an ideal image (as Michelangelo always did) but most do, for he used no set pose but adapted his style to his sitter. This produced an extraordinary variety: for instance, although Renaissance portraits are generally formal (it was an age of hierarchy and titles) that known as *Dr Parma* is quite spontaneous. Sometimes the portraits are so pene-

Moses defends the daughters of Jethro, Rosso (1495–1540), painted about 1525. Oil on canvas, 160 × 117cm (63 × 46in). Uffizi, Florence. (*Below*)
Moses drives away the shepherds so that Jethro's daughters can water their flocks. The nudes on the Sistine Ceiling fascinated Rosso and he treats his subject as an excuse for painting nudes in violent action. This exemplifies the style of Mannerism; a wilful art, consciously virtuoso, consciously original, intended to startle or impress a sophisticated aristocracy. For three centuries Mannerism was considered degenerate, but today we can appreciate its anticipations of certain aspects of 20th century art, in this instance, Cubism.

Bacchus and Ariadne, Titian (*c*.1485–1576), painted 1523. Oil on canvas, 175 × 190cm (69 × 75in). National Gallery, London. (*Right*)

After helping Theseus out of the labyrinth Ariadne has been left weeping on Naxos. Suddenly Bacchus arrives with his rowdy train, but she is frightened and tries to flee. From the right we are hurried by the two brown bodies past Silenus and the tambourine girl, and pause with the cymbals. Then we are carried forward by Bacchus' leap, and, as he hangs in the air, we see their eyes meet and Ariadne spell-bound; the leopards and smiling coast indifferent to their drama.

Charles V on Horseback, Titian (*c*.1485–1576), painted 1548. Oil on canvas, 332 × 279cm (131 × 110in). Prado, Madrid. (*Far right*)

The portrait celebrates Charles' victory at Muhlberg, and therefore shows the Emperor mounted on a rearing horse as knight protector of the Church. Titian has played down the protruding lip and jaw and given him great presence. The gilded armour forms a climax to the reds of the rosettes and the horse's trappings and the red-golds of the sunset which suffuse the fields. Again Titian closes off one side (with the rider and trees) to carry the eye into the distances on the other.

St George and the Dragon, Tintoretto (1518–94), painted about 1560. Oil on canvas, 157 × 100cm (62 × 39in). National Gallery, London. (*Below*)

St George and the Dragon was a popular subject but this one is exceptional in that Tintoretto has pushed the combatants back into the picture and 'starred' the princess, who indeed seems about to tumble forward on top of us. He has also shown a corpse in a position suggesting the crucified Christ, and God the Father appearing in a spiral cloud above, both of which are without precedent. The design is like a spring of which the tilted axle is the princess, and which unwinds anti-clockwise in ever widening arcs.

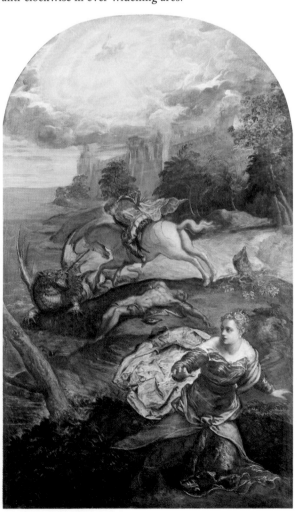

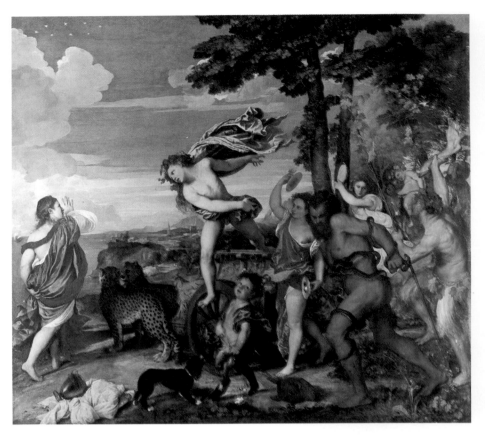

trating that one is tempted to weave a story round the subject—like that *Young Man with a Glove* in the Louvre who might be Romeo; or the real life story of treachery and suspicion which Titian exposed in his group of Pope Paul III and his nephews. Portraits too could have a special purpose; thus *Charles V on Horseback* shows the Emperor as champion of the Faith; elsewhere Titian painted him as a darkly clad statesman, seated, shrewdly listening and coldly weighing his interlocutor. Finally a portrait should be a picture, and a life-size picture of a horseman must be decorative. Titian's was magnificently so and established the form for two centuries.

'The design of Michelangelo and the colour of Titian' is what Tintoretto is said to have aimed at, and he may well have done so for it was the ideal of the moment—not a very sensible ideal—like putting meat and pudding on the same plate. Tintoretto's work contains many recollections of both artists but there is much more besides. Tintoretto used rich and glowing colours so that no one could think of him except as Venetian, yet he put a new emphasis on drawing. Unlike Titian's his nudes are shape before they are substance and without sensuousness. But they are summary and not realistic shapes for Tintoretto was a Mannerist; and though Venetian Mannerism differed from Florentine they shared many characteristics, among them the cult of originality. Tintoretto is full of surprises; for instance we look at St George's princess as Degas would have looked at her—from an opera box sharply above and to her right. It was Tintoretto who broke the stranglehold that Leonardo's classic solution had had on the theme of the Last Supper; choosing again a 'Degas' angle he plunged the table into depth and picked out the arguing disciples with floods and spots of light. For it was above all with light that he experimented, building a little model theatre to try out unusual effects; so that everywhere sudden lights strike his fingers and pick out parts of his rooms in unexpected and exciting ways. But if theatrical he could also be spiritual, for with El Greco he was a leading exponent of the counter-reformation.

The last of the great Venetians, Veronese, was hardly interested in the counter-reformation but is best described as the poet of gracious

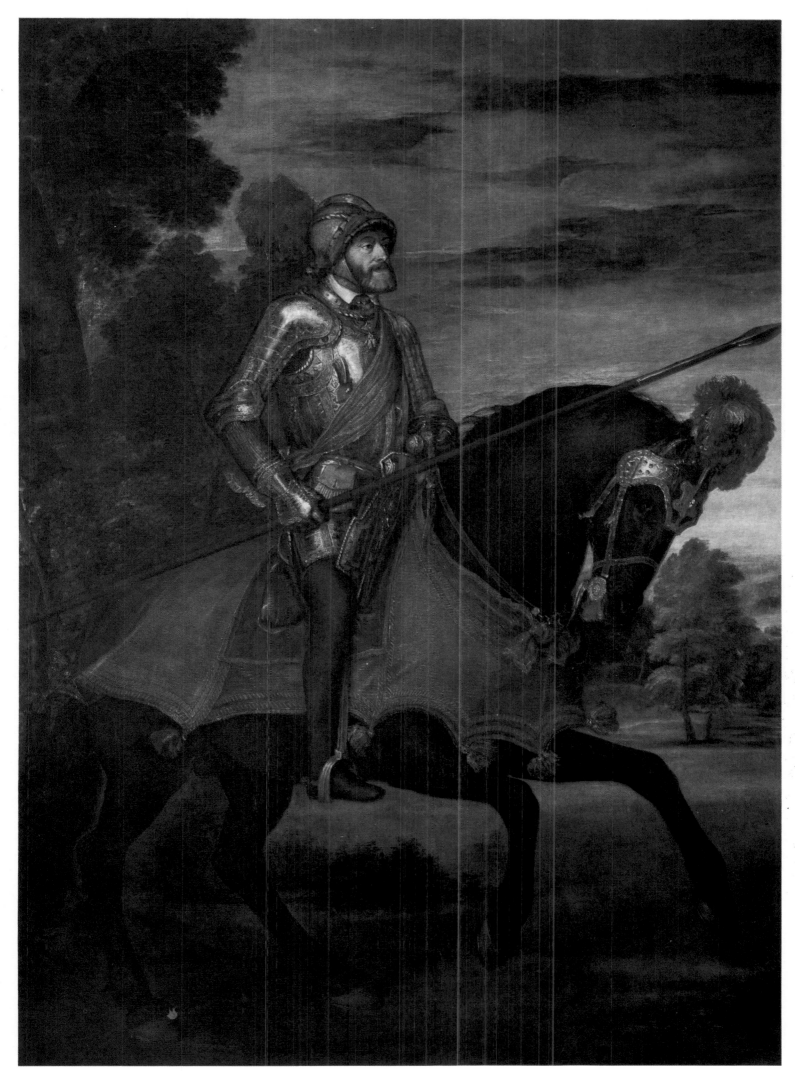

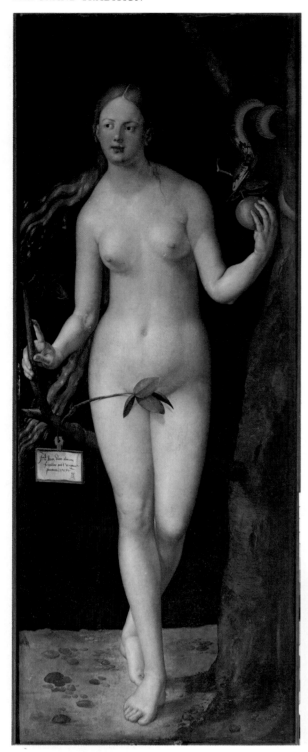

Eve, Dürer (1471–1528), painted 1507. Oil on panel, 209 × 81cm (82 × 32in). Prado, Madrid. (*Above*)
Dürer's Adam and Eve are a curious pair, half Classic, half Gothic and this mixture epitomizes Dürer, a German drawn by the south. Yet the message is as pure as the forms are hybrid, since Dürer has not painted love but sin. The blank spaces—the black negative shapes—are alive with a force which turns them towards each other, and is felt in a breathless delicacy, in tensions in limbs, in a slight rising on the toes and sliding glances of allure and possession.

Venus and Adonis, Veronese (1528–1588), painted about 1580. Oil on canvas, 212 × 191cm (83 × 75in). Prado, Madrid. (*Right*)
Venus' ample form and Adonis' maturity may be unappealing to an age which prefers the slim, but the Venetians loved them, for they suggested opulence and rich Alexandrian feasts. We can respond more easily to the harmony of pastel blue and subdued orange; to the cool flesh and late afternoon sky, and to the lush greenery of a magnifico's splendid park. The group is shaped like a rough circle which gently revolves with its centre at Adonis' elbow.

living in the Venetian style. One would think he had ransacked the Bible for every banquet he could find, and painted each with an appetite whetted by Roman writers. He painted these gargantuan feasts for monastic refectories, where they could hardly have encouraged too strict a régime. Though choice dishes and rare wines are taken for granted, what we see are gorgeous costumes, patrician hosts, and crowds of pages, servants, soldiers, monkeys and buffoons. His tables are set in courtyards or beneath arcades, from which one's eye ranges to the splendid palaces which Palladio was designing and which magnates ruined themselves building. Once Veronese was called before the Inquisition, and charged with including profane irrelevancies in a huge *Last Supper*. Boldly he claimed artist's licence, and since the Venetian Inquisition was not the Spanish, merely had to change the picture's name. Veronese was not only a painter of feasts; what he truly celebrates in his work was the glory of Venice. By his genius as a decorator and his unshakeable optimism he kept both the classic style and the spirit of Renaissance alive almost to the end of the century.

During the 15th century northern Europe created its own new art without reference to Greece and Rome. In its paintings space was atmospheric but not truly geometrical, figures were solid but not sculpturally so, bodies were accurately observed but not scientifically studied, there was the fact of nakedness but no ideal of the nude. It was Dürer who introduced Italian ideas into Germany.

But Dürer's mind was split which produced tensions and odd results. Brought up in the Gothic, he had educated himself in the Renaissance, and his whole life became a struggle to reconcile the two. At one moment he seems another van Eyck (as when he draws a patch of turf blade by blade and leaf by leaf); at the next another Leonardo writing a treatise on perspective and the art of measurement. Dürer combined

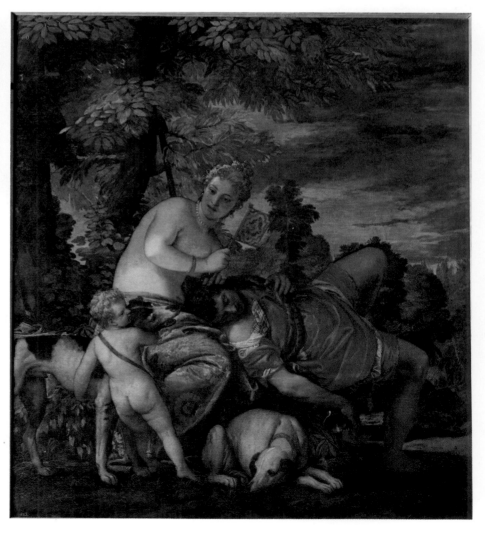

the capacity for minute and loving observation with a questioning and theorizing intelligence.

He was primarily an engraver; master of a hard precise line, who learned from the engravings of Pollaiuolo and Mantegna how to represent the unclothed body in vigorous movement, and who taught himself the Italian perspective which gave his *Adoration of the Magi* (Uffizi 1504) a linear unity new in the north. He was at once attracted and repelled by the ideals of beauty and the nude, and plunged into a study of Vitruvius to discover the secret canon of proportions. He tried out the results in an engraving of Adam and Eve, where the figures are not only inspired by the antique but are geometrically constructed. They did not satisfy him. Vitruvius was wrong; there was not one canon of beauty but many and what mattered was that the parts should harmonize within the whole. So in his painted *Adam and Eve* sculptural ideas from antiquity have been absorbed and digested so completely that he could use them to express a purely Gothic spirit. For, though he continued to learn from Italy, Dürer's deepest instincts were Gothic. His final masterpiece, the *Four Apostles* (Munich 1526) is of figures fully clothed, whose facial types and knotted rhythms are German but whose forms are as sculptural and monumental as those of Masaccio.

Cranach was the same age as Dürer, but the Venuses for which he is best known are a generation later. They are not the outcome of a struggle to reconcile classical and Gothic proportions, but of a delighted acceptance by the reformed court of Saxony of the idea that the nude was permissible, and of its encouragement of a painter who could translate it into purely Gothic terms. Morally reprehensible perhaps, but it did produce a genuine alternative to the Mediterranean ideal.

Dürer, taken up with other aims, had not developed the art of landscape which his early water colours proved to be within his power. It was the youthful Cranach, then working in Austria, who first created a late Gothic land of gnarled trunks and shaggy firs, twisted branches and precipitous heights as frightening backgrounds to a crucifixion or a flight into Egypt; and it was Altdorfer who made the forest the main subject of a picture, thereby creating (contemporaneously with Giorgione) a German version of the landscape of mood.

The French invaded Italy and so the Renaissance came to France, for François I brought back not only pictures but artists. Greatest of these was Leonardo through whom the king was to acquire the *Mona Lisa*, but he was then more scientist than painter and exerted no influence. Rosso and Primaticcio however, who were employed to decorate the vast new chateau at Fontainebleau, were very important. Its walls and ceilings were swathed in pictured nymphs, and these were framed by sculptured nymphs, and both were surrounded by stuccoed garlands and swags of fruit. Primaticcio had been trained by Giulio Romano and Giulio by Raphael, so the high style of Rome travelled to France, modified on its journey to a modish elegance—for the omnipresent nymphs have the slenderest proportions and an air of sophisticated refinement that is already Parisian. French painters were led to imitate, but none could rival the Italians, though with Jean Goujon (c.1510–64) a school of decorative sculpture was founded. Fontainebleau also became a centre of cultural diffusion, for where François led, Henry VIII of England and other rulers were quick to follow.

A generation younger than Dürer, Holbein could take Renaissance ideas in his stride; what he lacked was enlightened patronage. In his home city of Basel the reformation had stopped the demand for religious pictures, and the English court (apart from ephemeral decorations) wanted only portraits, so that an artist of huge and varied abilities was

View of Trent, Dürer (1471–1528). Water colour on paper, 24 × 26cm (9 × 10in). Formerly Bremen Kunstalle. (*Above*)
We can identify the spot from which Dürer sketched, probably on his return from Venice via the Brenner; for the town has retained its profile although the Adige has moved. It is a view that Turner would have loved and everyone must photograph, yet Dürer would not have framed it nor anyone have bought it. It was a side of his nature Dürer did not develop, confining landscape to the backgrounds of his figure pieces and leaving it to Altdorfer to pioneer an art of landscape.

Venus in a Landscape, Lucas Cranach the Elder (1472–1553), painted 1529. Oil on panel, 380 × 255cm (150 × 100in). Louvre, Paris. (*Below*)
If Venus is one ancestor of Dürer's Eve, Eve is the sole ancestor of Cranach's Venus, who owes nothing to Italian art save the right to be painted. Her slim figure and delicate walk, her tantalizing accoutrements and sinuous contour make her far more provocative than the Latin goddess. She was instantly popular with German humanists who had learned from classical texts that the nude was respectable, but not from classical art what it should look like. She is a siren who minces through a landscape no less picturesque and dangerous than herself.

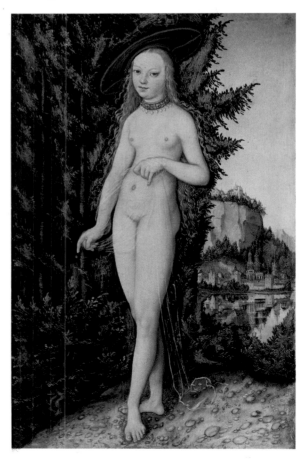

Children's Games, Pieter Bruegel the Elder (c.1525–69), painted 1559–60. Oil on panel 118 × 161cm (46 × 63in). Kunsthistorisches Museum, Vienna. (*Right*)
Bruegel depicts 84 children's games, many recognizable because they are still played. This is not a scene but a dictionary of typical activities; the buildings and spaces not a town but an arrangement of proper scenery. Bruegel describes men's behaviour like an entomologist describing bees. He is no naïve peasant but a sophisticated artist, who draws in perspective and catches a characteristic movement as quickly and unerringly as Degas; and if he scatters his mannequins they cohere in a lively pattern.

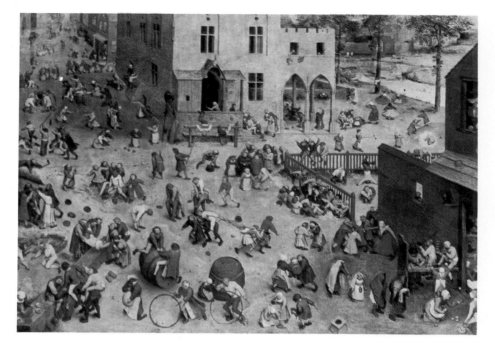

confined to a single theme. He showed his skills in the *Ambassadors*; the foreshortened skull, the still life, the faces and the furs demonstrate his confident mastery over all technical problems. It is for his skill in minute detail that Holbein is most frequently admired—as in the jewelled costume of Henry VIII, which was perhaps not by his own hand—but his real power lay elsewhere. He had a genius for cool analytical observation which coupled with an unsurpassable precision of line, enabled him to give his portraits a definitive air; we feel that the last word has been said, for there is no arguing with such clarity.

Bruegel was the great eccentric, who, admired in his own day, became for 200 years 'Peasant Bruegel', a sort of rustic clown who painted his own kind. The real Bruegel knew Italy and Italian art, his friends were intellectuals, his patrons highly cultivated men like Cardinal Granvella, viceroy of the Netherlands. We may also think of him as a painter-scientist; not indeed a geometrician or geologist like Leonardo, but an anthropologist. He was no political reformer; he did not romanticize his peasants whom he showed as ignorant, narrow, even grotesque. If he had an axe to grind it was that of the traditional moralist, though a broad minded and sympathetic one. Dürer had concluded there were many canons of beauty, including a rustic canon; and it was such a rustic canon that Bruegel adopted as suitable for his homely subjects. He was also a pioneer of landscape; and though in paintings like *Hunters in the Snow* he followed the old form of illustrating the months, he caught the poetry of the passing seasons in an entirely original way.

What then was the result of this diffusion of Renaissance ideas? Its immediate effects were limited but ultimately it changed the basis of all subsequent art. Only in Germany where there was a strong visual tradition and several painters of genius, did the blending of Gothic and Renaissance styles produce a vigorous though short-lived school. In France there was the charm of Fontainebleau, which had a French accent but was not indigenous; in England Holbein died without influence, and neither Berruguete nor Greco created a significant Spanish school; even in the Netherlands there was more imaginative extravagance than creation. But the diffusion slowly destroyed an old art which had exhausted its possibilities, gradually spread new attitudes and techniques and thereby laid the foundations on which, at least in the Low Countries, Spain and France, the next century was to build.

Catherine Howard, Hans Holbein the Younger (1497–1543), painted 1540–41. Oil and tempera on oak, 74 × 51cm (29 × 20in). Museum of Art, Toledo, Ohio. (*Far right*)
Henry VIII's fifth wife was queen at 21 and a year later beheaded. Holbein notes little deviations from the norm which characterize the individual. Devoid of emotion, utterly objective, he tells us the exact truth. The blue-green dress on a blue-green board tends to flatten, as do the inscription and the contours of the head; yet the light on the sleeves gives them a marvellous fullness, and the curving braid sets the figure back. Holbein perfectly reconciles pattern of surface with illusion of depth.

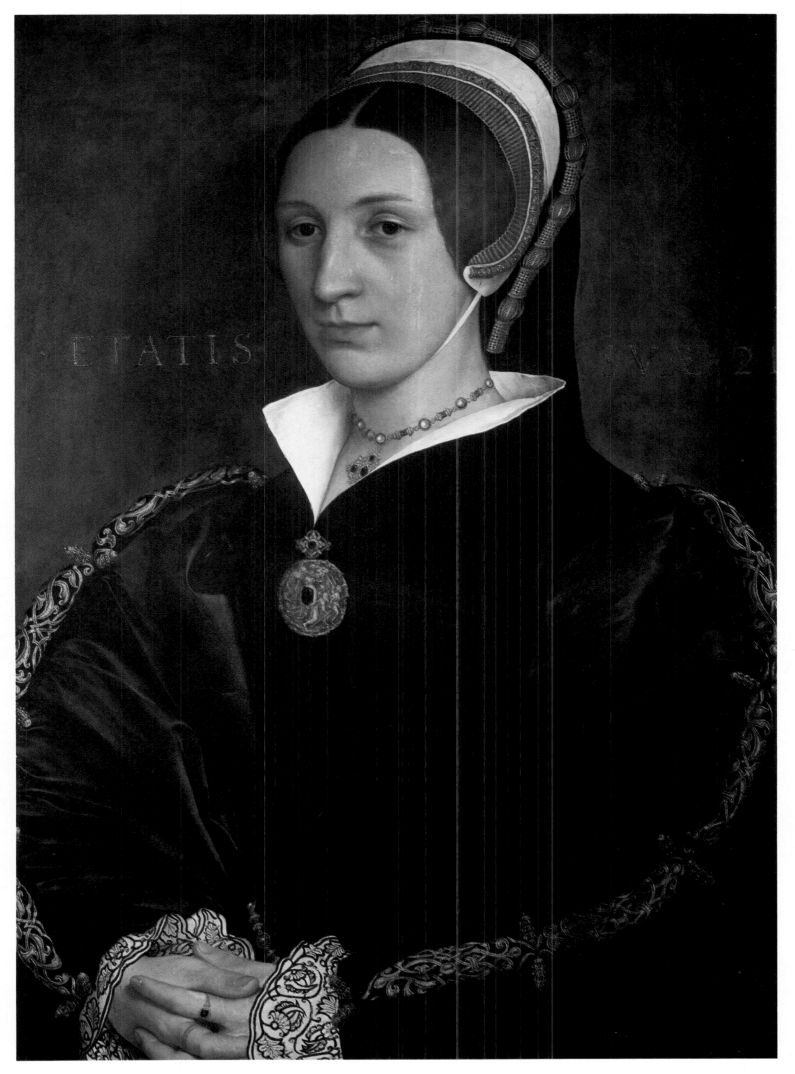

THE GRAND TRADITION
17th Century Art

Many historians have pointed out that the 17th century marks the beginning of modern Europe. The political boundaries become recognizable for the first time to present-day eyes. Spain, Portugal (after 1640), the Dutch Republic, the Spanish Netherlands (modern Holland and Belgium) and France all had boundaries which remain approximately the same today. Italy, however, was still subdivided into dozens of small states and Germany was composed of more than 300 sovereign states. These divisions did not change radically until the early 19th century.

Artistic development in each country was very closely linked to the religious, political and economic order. In Spain the all-powerful Catholic church and the monarchy supported a few painters of genius in portraiture and religious art but discouraged other forms of artistic expression. In the Dutch Republic the absence of the two great influences of church and state allowed a much greater freedom of subject matter and to a certain extent of style. From an artistic point of view the Italian states and France lay between these two extremes. Germany on the other hand played little part at this time and the one German painter of originality, Adam Elsheimer, spent most of his short career in Rome.

The 17th century saw great advances with the philosophy of Descartes, the scientific enquiry of Isaac Newton and medicine in the Dutch Republic. The influence of these new ideas on painting is difficult to define but it is true that a number of artists quite deliberately departed from the Renaissance tradition of grand decoration. They became more intellectual, like Poussin, or depicted current events as Rembrandt did in his famous *Anatomy Lesson of Dr Tulp*. Nevertheless the need to decorate the larger surfaces of churches and palaces remained dominant —state patronage very rarely encouraged painters of small easel pictures.

Contrary to what is often thought the 17th century cannot be described as a consistent movement towards an ideal. There were some general conventions, especially in Italy, but even these contradicted themselves and were subject to the attacks of such anti-establishment painters as Caravaggio.

The most important single institution for the patronage of art in the 17th century was the Papacy. This was no new development, as in the previous century it was a Papal commission which had brought into being Michelangelo's Sistine Ceiling. Only the Pope had the financial

resources to commission works of art which would always remain significant on account of their size. St Peter's in Rome was nearing completion in the early years of the century and each successive Pope tried to contribute some monument or decoration as a memorial to the splendour of his reign.

By curious paradox Rome did not produce a tradition of native painters as had Florence, Siena or Venice in the previous three centuries. Perugino, Botticelli, Raphael, Michelangelo had all been imported to work in the city. In the last years of the 16th century this tradition was continued by a family of painters from Bologna, the Carracci. Two brothers and a cousin they all had immense energy and talent and evolved a fresco technique largely derived from the study of Michelangelo.

The most important contribution made by the Carracci family was the decoration of a ceiling in the Farnese Palace in Rome, the top storey of which had been designed by Michelangelo. The chief innovation in this complicated design was the painting of *trompe l'oeil* giants, borders and frames in grisaille. This gave the flat ceiling a three-dimensional appearance. Thus the Carracci had taken Michelangelo's division of the Sistine Ceiling into compartments one stage further by unifying the whole into one complete illusionistic design. This modest achievement on a small scale was to be developed by succeeding generations of ceiling painters in Rome, culminating in Pietro da Cortona's vast ceiling in the Palazzo Barberini, executed in the 1630s.

By 1600 it was obvious that the Carracci had established themselves successfully, and that their style of easel painting, much closer to Correggio, was to become the norm for official commissions. They were equally adept at painting complicated altarpieces in oil paint with much use of the precious ultramarine blue. Correggio was their ideal and they adopted his soft edges, sharply contrasted lighting and rich colour with skill and enthusiasm.

It seemed as if the art of painting had arrived at a kind of plateau, inspired by the great masters of the Renaissance. Rome was full of the masterpieces of Raphael and Michelangelo. The Papacy was strong and prosperous and the new century dawned with a group of young painters already being trained in the ways of the Carracci. It is therefore difficult

The Ecstasy of St Francis (detail), Caravaggio (1573–1610), probably painted in the early 1590s. Canvas 91.5 × 127cm (36 × 50in). Wadsworth Athenaeum, Hartford, Connecticut, USA. (*Previous page*)
This picture is a good example of Caravaggio's early more sentimental manner which earned notoriety when he was only in his twenties. Already his habit of reducing a supposedly sublime religious theme to its bare and very human essentials is obvious in this picture. The very earth-bound looking Angel is supporting St Francis who has collapsed on the ground in religious ecstasy. It was this almost irreverent quality that allowed pictures of this type to appear to a small circle of cardinals with highly sophisticated tastes. Later Caravaggio's art was to become very much more severe.

Polyphemus and Galatea, Annibale Carracci (1560–1609), painted in the period 1597–1600. Fresco. Detail of the ceiling in the Galleria Farnese in the Palazzo Farnese, Rome. (*Left*)
In isolation this detail from the Farnese ceiling shows how great was the artist's debt to Michelangelo's nearby Sistine ceiling. The same muscular figures and broad gestures appear. However when seen as a whole Carracci's work was very much more illusionistic in its intent. There is never any doubt, in front of Michelangelo's ceiling, that it is a flat surface. There seems hardly the possibility that the Farnese ceiling is a flat surface at all so many are the tricks of illusion employed by the artist, especially with the painting of the frame of each picture.

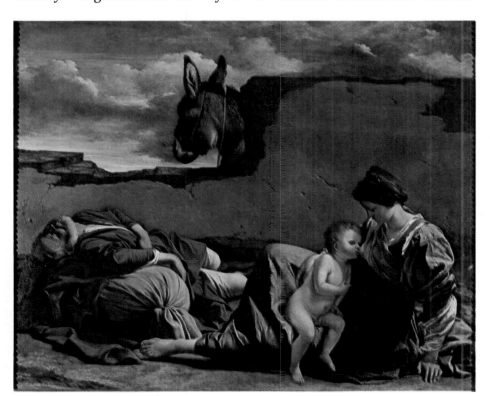

The rest on the Flight into Egypt, Orazio Gentileschi (1563–c.1639), probably painted about 1620. Canvas 172.5 × 215cm (68 × 85in). City Museum and Art Gallery, Birmingham, England. (*Left*)
Gentileschi was one of the most able and individual of Caravaggio's followers. He interpreted his style in his own way and produced a series of original compositions. In this instance the general tonality is light and has not been influenced by Caravaggio's later work. However the drama and emotion is very strongly felt. Joseph has fallen back exhausted from the long ride on an uncomfortable ass and this acts as a strong contrast to the gentle scene in the foreground of the Virgin and Child. The painting of the rocks is both original and dramatic and the large size of this picture means that its effect is overwhelming in a way not usually associated with this particular subject.

175

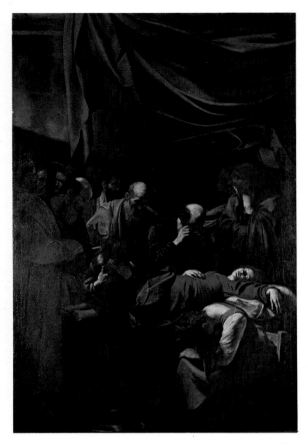

The Death of the Virgin, Caravaggio (1571–1610), probably painted *c*.1605–1606. Canvas 369 × 245cm (145 × 96in). Musée du Louvre, Paris, France.

It is difficult for modern eyes to see why this picture caused such a furore when it was painted. Not only was the model the figure of a well-known Rome prostitute—her body had been fished out of the Tiber—but the picture exhibited a complete lack of decorum for so sacred a subject. By removing all the trappings of a conventional religious scene Caravaggio shows immense powers of drama. When only in his thirties he completely abandoned his earlier style and concentrated on dramatic intensity—note for instance the different expressions of the observers of the scene. The scene was all the more shocking to religious purists as it was believed that the Virgin did not die at all but was translated to heaven while sleeping (The Dormition).

for the modern observer, familiar with the development of painting over the next three centuries, to realize the impact the young Caravaggio had on the establishment traditions as represented by the Carracci. Caravaggio's art appealed in its time to a very few people, but as they were the influential minority, his secular pictures found their way into the private collections of certain cardinals. He also received a few important religious commissions through the influence of his powerful patrons. By contrast, in terms of the sheer numbers of pictures produced and their effect on three successive generations of painters in Rome, the Carracci were far more influential.

Caravaggio's art was totally dramatic in content and it is easier to see the influence it had in the decade after his death in 1610. His pictures annoyed his contemporaries more for their apparently irreverent approach to the subject matter than their style. His *Death of the Virgin* caused an outrage when it was discovered that the model for the Virgin had been the corpse of a well-known prostitute fished out of the river Tiber. Writing two centuries later Ruskin described Caravaggio as 'the blackguard'—more a comment on the painter's moral state than his art. Contrary to the frequently held view Caravaggio did not 'liberate' painting from existing conventions. He altered the emphasis of the subject matter. Instead of trying to depict an ideal situation of a perfect Virgin ascending to a perfect heaven he sought to depict the event as it may well have happened. Thus his paintings which include the disciples show them with their bare feet dirty as would have been the case. All his models appear to be taken from real life.

Paradoxically Nicolas Poussin who was some 20 years younger than Caravaggio was also obsessed with truth and in his religious pictures he took great pains to follow the Bible story in every detail. But Poussin preferred to place his Biblical figures in classical Roman dress because he believed that as the Holy Land was under Roman domination Roman costume was likely to have been worn. Thus Caravaggio's and Poussin's search for truth as they saw it led them to create totally different types of pictures—Caravaggio with life-size figures in dramatic situations, Poussin with small static figures frozen as if taken from an antique frieze.

The effect of Caravaggio's art on a limited number of his contemporaries and successors was far reaching. He visited Naples twice during his period in Rome in the first years of the 17th century. Then he went to Malta and from there to Sicily, dying on his return to Italy in 1610 at the early age of 39. In Naples a whole generation of painters was to grow up, influenced largely by the few altarpieces by Caravaggio which they could see in the local churches. In Malta and Sicily his direct influence was minimal, but in Rome, where only the pictures from the first half of his career were available, the influence of his art was dramatic. It was especially effective on young painters who had come from other countries.

Most of the other Italian city states had painters attached to their courts but it was not a period when great inventiveness was encouraged. Carlo Dolci was the most important court painter in Florence. There was little activity at all in Venice and Bologna had provided Rome with a whole new generation of painters after the Carracci, notably Domenichino, and Guido Reni. Only Genoa retained some sense of independence with solid painters like Bernardo Strozzi.

In view of the relative decline of the other centres in Italy it is hardly surprising that almost all the young painters for whom Italy was a mecca, where they could learn their art, chose to go to Rome. The fashion for almost all these youngsters between *c*.1610 and *c*.1630 was to imitate

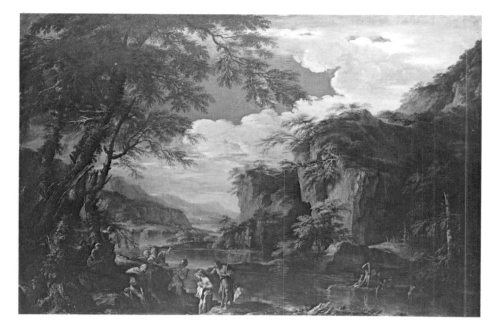

The Baptism of Christ in the Jordan, Salvator Rosa (1615–73), signed, probably painted in the 1640s. Canvas 173 × 258.7cm (68 × 101½in). Art Gallery, Glasgow, Scotland.
The subject matter plays an insignificant part in this elaborate picture—the artist's intention was to create a dramatic landscape. All his life Salvator was fascinated with wild scenery and the coarseness of untamed nature. Writing at the end of the 17th century the English poet Pope summed it up perfectly by the couplet 'Whate'er Claude did limn with soft'ning hue, or savage Rosa dashed or learned Poussin drew'. In his own time Salvator stood on the very edges of convention and only in the 18th century did his landscapes become the accepted norm for aspiring young artists to imitate when they were required to represent the sublime in nature.

Caravaggio. The resultant style was remarkably uniform and even today experts disagree over the exact authorship of many of these pictures which may have been painted by Manfredi, Renieri, Honthorst, Terbrugghen, Baburen, Tournier or Vouet. It was only when these painters, with the exception of Manfredi who was Italian and Valentin who died young, left Rome that their styles showed signs of modification. Indeed one of the most astonishing effects of Caravaggio's influence is the anonymity of his following. It was as if each painter sought to immerse his style in the adored ideal. This type of art was practised, quite literally in back street studios, as it must be remembered that official commissions were still going to the progeny of the Carracci.

Lying somewhere between the two extremes of official patronage and almost clandestine activity was a third trend. This was the completely new category of landscape painting. Landscape had formed an important part in the backgrounds of Renaissance paintings and by Leonardo's time, at the end of the 15th century, aerial perspective had already been mastered. But the pervasive system of patronage could not allow a painter to produce a picture without a subject. Credit for the invention of the art of pure landscape must go, surprisingly enough, to the Carracci family, who, with the assistance of Domenichino painted a series of lunettes for the Aldobrandini family. These are all now in the Galleria Doria in Rome. They appear tame to modern eyes composed as they are of neatly balanced trees with a distant view in between. With the exception of the fiery Salvator Rosa this innovation was not followed up by Italian artists. Instead many foreign painters took over where the Carracci had begun and one of them, Claude, went on to create a style of landscape painting whose effects were to be felt for the next two centuries.

The exception to this foreign preserve is the figure of Salvator Rosa. A rebel by temperament he spent the early part of his career in Naples and then moved to Rome. Most of his pictures are savage landscapes peopled by witches, devils or hermits. Crags, broken trees and torrents abound and it was this gloomy style that was to make its mark on 18th century sensibility which used Salvator as the perfect example of how a painter could inspire the emotion of terror in a painting.

The evolution of landscape as an acceptable subject also had roots in Rome with Adam Elsheimer. Working in the first decade of the 17th century, alongside the Carracci, most of his pictures are small subject pieces. He did, however, paint a few pure landscapes like the *Aurora* at Brunswick. The effect was immense all over northern Europe, because

The Adoration of the Shepherds, Guido Reni (1575–1642), probably painted about 1640. Canvas 189 × 126cm (74 × 50in). National Gallery, London, England.
Although this picture appears quite conventional in 17th century terms it is in fact very backward looking combining many elements from the 16th century. The light emanating from the Christ Child goes back to Correggio's celebrated *La Notte* (Dresden, Gemäldegalerie). The lack of intensity and drama is especially obvious when this picture is compared to Caravaggio's *Death of the Virgin* of 30 years before. Instead there is an emphasis on sentiment almost to the point of anecdote. All the figures are slightly idealized or improved in order to increase the charm of the scene. This was a general trend in Italy during the middle years of the 17th century.

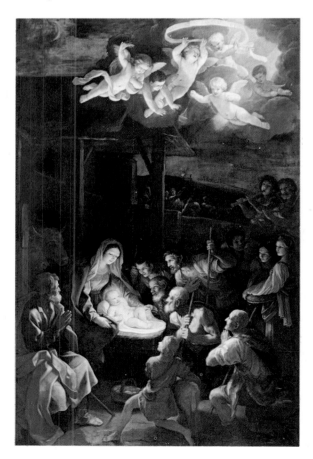

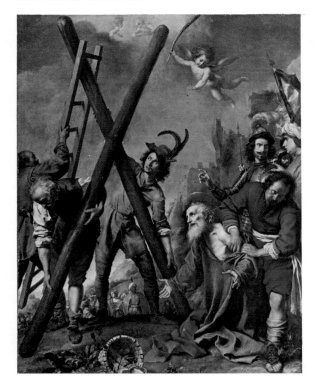

St Andrew praying before his martyrdom, Carlo Dolci (1616–86), signed and dated: *Carolus Dolcius Florentinus Fact. 1643*. Canvas 115.5 × 91.5cm (45 × 36in). City Museum and Art Gallery, Birmingham, England.

Carlo Dolci became in his maturity a totally eclectic artist. His patrons obviously despised the type of art stemming from the style of Caravaggio and his school. Instead they wanted references to the great painters of the 16th century. Carlo Dolci provided them with plenty of references. In the centre background for instance is a figure copied directly from Titian. In order to be up to date Dolci added his own peculiar form of sweetness. Guido Reni did the same thing in a slightly different way. Dolci preferred scenes of cruelty and unpleasantness and then painted them with an exquisite refinement which made him one of the most successful painters of his generation.

his pictures were engraved. Elsheimer died young but his small copper panels set the tone for a new generation of painters coming from the north in the 1620s.

The most important names were Breenbergh and Poelenburgh from the Dutch Republic and Paul Bril from Antwerp. Bril was older and specialized in seaport scenes which became very popular. Poelenburgh and Breenbergh both took back to the north with them a highly polished style of small idyllic landscapes often bathed in golden light. This new vision of Italy, based both on the observation of nature, and of what Elsheimer could teach them, had far reaching effects on the evolution of landscape painting in the north.

By far the greatest painter of landscape who had arrived in Rome in the 1620s was Claude Gellée, called Le Lorrain after his native duchy. He had already completed numerous examples of landscape painting and his early work is a careful pastiche of Elsheimer's light and Bril's seaports. But he rapidly evolved, quite alone, a type of landscape painting which later generations came to regard as perfect. His massing of trees was influenced by the Carracci and Domenichino models but his real originality lay in his treatment of light. He was fascinated by morning and evening effects, and over 1,000 of his drawings still survive, most of them executed in the open air. Claude was the very first painter to depict convincingly the rising and the setting sun. He avoided the full light of the midday, preferring to define his compositions by using exquisite gradations of tone which create an illusion of atmosphere.

Claude was an individualist and he is often contrasted and compared with his illustrious contemporary Nicolas Poussin. Poussin was from Normandy, several hundred miles from Lorraine, and his obsession with intellectual and moral seriousness led him down a very different path. In his early years in Rome in the 1620s and 1630s he was fascinated by Venetian art of the previous century and did not evolve a distinct style. The famous *Bacchanales* by Titian were at that time in Rome in the collection of the Aldobrandini family. But suddenly, about 1640, Poussin rejected much of what he had learned from the old masters and started to paint small pictures with figures arranged horizontally like a classical frieze. He took to theorizing about his own art, denying the role of intuition, and demanding of himself that every part of a picture should be thought out rather than felt. In doing this he evolved a formula which those who lacked imagination found easy to follow. Thus Poussin became at the end of his life the model for the newly-formed French Academy in Paris. It is true of both Claude and Poussin that they made far less of a stir in their own lives than their work was to make in academies for the next two centuries. They were worshipped by academic and avant-garde artists alike and even in the 19th century certain aspects of the work of both Ingres and Turner were inescapably tied to Poussin and Claude respectively.

Even though the ceiling decorations of Pietro da Cortona were the largest and most obvious artistic commission in Rome in the middle years of the century it must not be forgotten that the city was also visited by painters who had achieved distinction already. Rubens had been to Rome as a young man and had secured an important commission in the Chiesa Nuova. Subsequently he never forgot his Italian experiences and they had the effect of loosening and broadening his style. Velazquez was to react very differently. He admired the huge collection of Titian's best work collected by the Spanish royal family and when on a visit to Rome he painted the portrait of a Borghese Pope (Rome, Galleria Doria) it seems as if he tightened his style and made it slightly less personal and more like Titian.

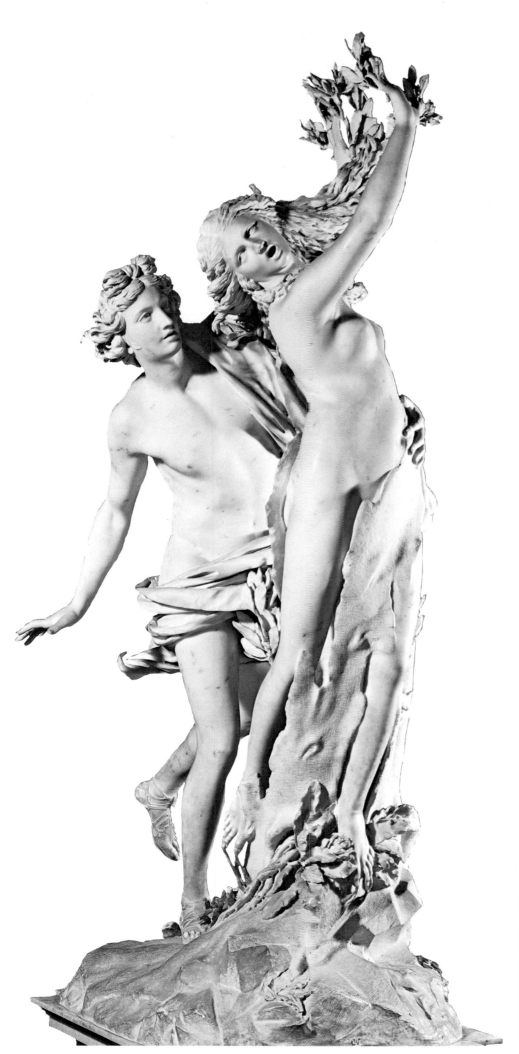

Apollo and Daphne, Gian Lorenzo Bernini (1598–1680), sculpted in 1624. Marble. Galleria Borghese, Rome. (*Left*) Of all the artistic figures of the 17th century in Italy, Bernini was the most versatile and made the most impact on his times, and this is still visible today in Rome. Sculpture formed a very important part of this output and he continued the tradition established by Michelangelo that, in the hands of a genius, marble could be made to react in a way quite unlike the surface properties normally associated with it. It was quite typical of the 17th century to experiment with illusionism in an unsuitable medium. Bernini succeeded and in this brilliant sculpture the terrible moment when Daphne turns into a tree at the instant of being caught by Apollo is captured with perfect accuracy. Hair, flesh and draperies are all given an illusion of texture even though the marble is really smooth and white.

The Stoning of Stephen, Adam Elsheimer (1578–1610), probably painted 1602–5. Copper, 34.7 × 28.7cm (13⅜ × 11¼in). National Gallery of Scotland, Edinburgh, Scotland. (*Below*)
Although this is a recent addition to the small number of pictures, known to be by Elsheimer, art historians have long been aware of its existence because Rubens had made a drawing of many of the main figures. Even though Elsheimer worked on such a small scale, his pictures were extremely influential from the point of view of the originality of their composition through the newly popular medium of engraving. In this picture the extreme complexity of the composition makes it appear as if it were very much larger. It has certainly the type of elaborate drama favoured by many painters of the next generation, especially Rubens and Rembrandt in his early phase.

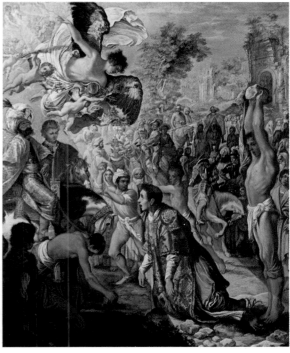

The forge of Vulcan, Diego Velazquez (1599–1660), probably painted about 1630. Canvas 223 × 290cm (88 × 114in). Prado, Madrid, Spain.

Pictures of this type are very unusual in Spanish painting as a whole but Velazquez was extremely versatile. Most of his surviving pictures are portraits commissioned for the court—his mythologies and landscapes are few but they break totally new ground. The workers in Vulcan's forge have some references to Caravaggio, probably by way of Caravaggio's Neapolitan period but the composition and mood are unique to Velazquez. His skill with detail is also obvious, note for instance all the tools in the forge. The appearance of Venus on the left transforms the scene into a mythology in a slightly uneasy way thus illustrating the artist's unfamiliarity with this type of picture.

The Maids of Honour (Las Meninas), Diego Velazquez (1599–1660), probably painted in 1656. Canvas 318 × 276cm (124 × 112in). Prado, Madrid, Spain.

One of the most celebrated pictures in the whole of 17th-century art this painting, as is often the case with great pictures, exists on several different levels. The technique of illusionism has been perfected. It is as if the portraiture of Titian had been combined with the Dutch ability to place figures convincingly in an interior. The subject matter is much more complex than appears at first sight as the King and Queen can just be seen dimly reflected in the mirror at the back of the room. They are therefore standing in the position of the spectator *being painted* by the artist, watched by their maids of honour, who of course do not appear on the canvas the artist is painting. The picture also forms the only reliable self portrait of Velazquez, who depicts himself quite formally dressed. 'Artistic' costume was a 19th-century innovation. Before that period painters did not set themselves apart from society by their manner of dressing.

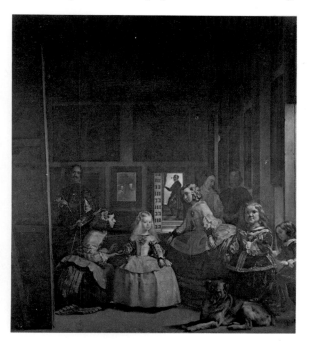

To modern eyes painting in Italy in the 17th century appears over-complex. Florid decorations and passionate religious sentiments about saints in martyrdom, or ecstasy, or both, were more highly esteemed than the careful observation of a few simple facts of human existence. Still life for instance is very rare in Italian painting of the period. It cannot be repeated too often that Caravaggio was an exception in his time—most other painters were concerned with similar themes but treated them in a very different way. Martyrdom and suffering were important aspects of the theology of the day. Painters never tired of showing female saints with their eyes torn out and placed on a platter or the suffering St Sebastian pierced with arrows. All was to be rewarded by a place in Heaven, the saint being carried there by ample cherubim. Thus painters were used by the church as an effective means of illustrating a theological programme for which the present century has neither understanding nor sympathy. This tight system of control left very little room for what might be termed a universal man of the type associated with the Renaissance.

The great exception was Gianlorenzo Bernini who dominates the whole of the first half of the century in Rome. His most obvious achievement was the Piazza in front of St Peter's. Acknowledged as the greatest sculptor of his day, he was also an architect of genius and his few surviving paintings have often been confused with those of Velazquez as their portrait styles were very similar. Bernini was too strong and too flamboyant a character to succumb to the precise programming required of lesser men. Thus he was able to execute each commission, in whatever medium required, with equal confidence. Rome's fountains are largely his. Late in life he visited France to execute the bust of the young Louis XIV which gave rise to the celebrated anecdote that when he was chiselling the bust in public, in front of the whole court, he was jeered at for making a mistake in the king's forehead, which then turned miraculously into a curl.

If Bernini represented the outward-looking side of Italian art at the time Carlo Dolci represented the opposite extreme. His figures have a tearful softness. He was the darling of the declining Florentine court and was appreciated for his faultless technique. His saucer-eyed saints are used to this day for a certain type of religious propaganda and Dolci's success, both in his own time and for the next three centuries, gives

some indication of the relative decline of Italian painters in this period. Nevertheless Italy remained the centre for artists to visit even though the centres of innovation had shifted, quite unexpectedly, to the far north of the European mainland.

The Alps effectively isolated Italy from northern Europe and Italian influence had its strongest effects in Spain. From a political point of view Spain had always had connections, and indeed ambitions, in Italy. A number of the north Italian duchies, like Parma and Piacenza were under Spanish domination, as was the Kingdom of the Two Sicilies (Naples). In the previous century the Spanish court had looked to Italy for its chief painter, Titian, and it was the court in Madrid which virtually controlled almost all patronage. In practical terms this court domination is difficult to explain as Spain was a rich country by European standards, but even so, the provincial cities, with the marginal exception of Seville, did not become active centres of painting, as did those of the Netherlands, and to some extent of France.

By far the most important painter was Velazquez. His early training took place in his native Seville but he soon gravitated to Madrid where he served the court for 30 years. It is not often realized how many of the most original painters of the 17th century worked outside court patronage, Caravaggio, Vermeer, Georges de La Tour. The great exceptions were Velazquez in Spain and Rubens in the Spanish Netherlands. Velazquez had a very narrow range. As a young man he had executed a few dark pictures of peasant genre called *bodegones* but he concentrated on portraits almost exclusively. He was unique in his time for being able to produce an individual and personal style which also suited his patrons. It is almost as if Philip IV of Spain, whom Velazquez recorded from youth to old age, in a memorable series of portraits, did not understand that his court painter had taken over where Titian had left off. Because Velazquez was so influential in the 19th century, particularly on Manet and Whistler, his real innovations are easy to overlook in terms of the very strict conventions of his own time.

In his last years Titian had experimented with oil paint, using a very much more broken texture than had previously been known. The dry paint was dragged over the surface giving the edges a softness which increased the illusion of movement and life. Titian's broad brushwork was based on an immaculate sense of drawing, therefore in a seemingly hurriedly executed picture the drawing was always accurate. Velazquez perfected this technique. He was able to paint a strictly formal portrait of a member of the royal family, using a very few colours—black was commonly worn—and yet with a few brief touches of colour and brisk use of the brush he was able to make the whole spring to life.

Even though Velazquez relied too heavily on Titian he was forward looking in the sense that his freedom with oil paint was not surpassed until the 18th century. Almost all the other painters in Spain at the time were totally bound by the conventions of the previous century and drew their inspiration from contemporary events in Italy. Odd painters like Zurbarán had an individuality of character that allowed them to transcend the conventional compositions with which they had to satisfy their patrons. Zurbarán was able to paint genuinely moving pictures of saints in suffering because of his temperament. He had a certain severity giving his saints great power especially when seen in mystical conversation. Another talented painter was Ribera who went to Naples when young and stayed there. His pictures are vaguely Caravaggesque, he preferred elderly saints and scenes of suffering. His pictures are robust, careful in tone, and have suffered undue neglect in the 20th century as their subject matter is too severe and lacks the eccentricity and excite-

Vanitas, Juan de Valdés Leal (1622–90), monogrammed and dated 1660. Canvas 131 × 99cm (52 × 39in). Wadsworth Athenaeum, Hartford, Connecticut, USA. (*Above*)
This picture reflects perfectly the religious mood of Spain in the middle years of the 17th century. The work of art was used to remind people of religious truths and not as an object of pleasant decoration as had become the habit in the Dutch Republic. Each object in the picture had a specific meaning among the more obvious being wordly wealth in the foreground. Less obvious is the extinguished candle on the right showing how brief is man's life. The bubble being blown by the angel on the left makes the same point. The angel on the right lifts a curtain to reveal a picture of *The Last Judgement*. Interestingly enough this picture has a pendant, now separated and in the York City Art Gallery, depicting a *Jesuit Conversation*. Thus the two pictures, when together, would have acted as a kind of positive and negative approach to life as seen by the stern religious doctrines of the period.

The Christic Child contemplating the Crown of Thorns, Francisco de Zurbarán (1598–1664), probably painted about 1630. Canvas 165×230cm (65×90½in). Museum of Art, Cleveland, Ohio, USA.

It is typical of the religious intensity found in Spain in the 17th century to construct a hypothetical event not recorded in the Bible story. Here the youthful Christ contemplates the Crown of Thorns to come as the Virgin Mary looks on. Zurbarán avoided the excessive sentimentality of Murillo and painted in a sharp clear style that was specifically his own. The dramatic use of lighting could well have been derived from some knowledge of the art of Caravaggio but the moods expressed in Zurbarán's pictures are often intensely spiritual rather than down to earth, as in Caravaggio.

ment of Caravaggio. Indeed Ribera became a typical Neapolitan painter, using the same deep shadows, intensity and lack of colour, as were favoured by the many Neapolitan painters of the first half of the century.

Outside court portraiture almost all the painting in 17th century Spain was of a religious nature. Its epitome is seen in the art of Murillo. He had the capacity to combine a faultless technique with a powerful sentiment producing a convention which continues to this day in the world of religious devotions. His ascending Virgins are pretty, but they are recognizable as human beings. Nevertheless they radiate a sense of sweet divinity. For modern taste Murillo is a disaster, but he represented the true achievements of the Spanish painters of the time. He was also adept at *genre* painting producing small groups of peasant boys eating melons and simpering peasants and flower girls. Although well known, these were only a very small proportion of his total output. Murillo perfectly fulfilled the expected role of providing acceptable religious propaganda for the all-powerful church.

The political as well as religious power of the Papacy was immense all over Italy and in Spain; in France however this was very much less obvious. In terms of style French painters often betrayed Italian influences, even though a number of them never went there, but church control over subject matter was much less pervasive. By 17th century standards France was an immense country, and it was the only one, especially in the second half of the century, to have a really effective central government.

Louis XIV had gone down in history as the monarch who controlled the arts with the result that he was able to supervise the creation of Versailles, the largest and the most lavishly decorated palace that had so far been seen in Europe. The official control of all the arts did not become totally effective until the 1670s and the painters active all over France in the first half of the century showed much more originality than was possible under the domination of Louis XIV. Indeed over the last 100 years the provincial centres of France have yielded a number of rediscoveries of painters who worked quietly in their local centres, without even national recognition but whose abilities were far above the average. Reappraisal of this type of art has become fashionable and the name of Georges de La Tour is now well-known although even 20 years ago he was not included in text books.

In the early years of the century the influence of Caravaggio appeared

spasmodically in southern France. This is apparent in the work of such minor painters as Nicolas Tournier of Toulouse who was able to produce quite competent altarpieces in the new style which was already out of date in distant Rome. By about 1630 the direct influence of Caravaggio in Rome was over and painters sought different models to imitate. But in France it was only just becoming fashionable to produce intense, dramatically lit altarpieces with down-to-earth subject matter. Even La Tour can be seen to have followed conventions ultimately derived from Caravaggio in his choice of subject matter, but it is for his originality that he is justly esteemed.

Tantalisingly little is known of his life. He worked for 30 years in the small town of Lunéville in the duchy of Lorraine not far from where Claude was born seven years after him. A few local commissions were forthcoming, curiously enough from the town of Lunéville itself for presentation to the occupying French governor in the capital, Nancy. No contemporary record gives the slightest inkling of the exceptional nature of his art. Basically in only about a dozen pictures, La Tour explored the visual effects of candlelight, with the same passion which Vermeer of Delft reserved for a bare plaster wall affected by the light from a window.

Almost all of La Tour's best pictures consist of a very few figures, usually two or three. His technique of lighting them is unique in the whole history of painting. They are almost always seen in reflected candlelight and sometimes the candle flame itself is shielded by a hand, which produces an eerie effect. Much has been written about a religious revival in Lorraine at the time within the confines of the Roman Catholic Church, where there is a return to a certain simplicity. It is not known whether La Tour had anything directly to do with this movement, but all his pictures are devoid of conventional religious symbols. There are no angels present at his Nativities, his interest lay in depicting each scene exactly as it may have happened.

Many other provincial centres had talented local painters. Their work is often still locked in small museums, Jacques de L'Estin at Troyes; Jean Tassel at Langres; Guy François at Le Puy. All these painters have had local exhibitions in recent years but their talents are still underestimated. None of them looked to the capital, Paris, as an artistic centre. Painting activity in the city had been limited to a large amount of decorative work in the churches, almost none of which has survived. The reign of Henri IV, who was assassinated in 1610, was a barren period as far as painting was concerned. The new reign of Louis XIII ushered in a very different attitude personified by the Queen Mother, Marie de Medici. She employed the competent painter from Antwerp, Frans Pourbus the Younger, as court portraitist. He set the style for French portraiture for the first 40 years of the century and the few native painters who received commissions tended to imitate his model.

The most important artistic event was the commission by Marie de Medici of a colossal cycle of pictures from Rubens, with the glories of the reign of Henri IV as their theme. Rubens' sketches for the whole series survive in the Alte Pinakothek, Munich, and it is possible here to appreciate his inventiveness in composition, and his ability to imbue grandeur and splendour into people who quite obviously lacked it in life. The complete cycle is still visible today in the Louvre. For such a vast undertaking Rubens employed studio assistants and he could never have known that this immense team work was to have such a profound influence on the course of French painting for the next two centuries. The cycle was to serve as a model for aspiring young painters who had no opportunity to visit Italy.

Landscape with figures (detail), The Le Nain brothers, Antoine (c.1588–1648), Louis (c.1593–1648), Mathieu (c.1607–77), painted in the 1640s. Canvas 54.6 × 67.3cm (21½ × 27in). Victoria and Albert Museum, London, England. Apart from the work of the Le Nain brothers, peasant painting was rare in 17th century France. Such pictures are therefore especially interesting from the point of view of social history as they give the impression that French peasants were probably less well off than their Dutch counterparts who were so often painted. The Le Nain brothers however, differed from all the Dutch painters in having a curious detachment from their subject. The peasants are painted just staring into space rather than taking part in specific events such as brawling or drinking, as they do in Dutch art. Note also the beautiful broad landscape in the background capturing perfectly the low and bare hills of northern France.

Landscape with Jacob and Laban and his daughters, Claude Gelée, called Claude Lorrain (1600–82), signed and dated lower left: CLAVDIO I.V.F. ROMAE 1676. Canvas 73.5 × 95cm (29 × 37½in). Dulwich College Picture Gallery, London, England.

Towards the end of his long life Claude seemed to sum up all he had learned in the art of landscape painting. The picture's subject played an increasingly minor role and the artist's interests became ever more concerned with atmosphere rather than composition. Some of the most exquisite passages in this picture are in the areas to the left and right of the central tree, where the artist has been concerned with the effect of distance and the change which the intervening atmosphere brings about on the colour of the objects. Many writers have noted that Claude used rather unconvincing and elongated figures in his pictures but he always made sure that they harmonized perfectly with their setting.

The return of Vouet to Paris in the 1620s turned out to be a significant event but not for the expected reason. Instead of importing his competent but uninspired 'Caravaggism' to the French court he changed his style completely and introduced a much blander and more decorative art which had its roots in the lighter palettes of Guido Reni and Guercino in their mature years. He was thus able to satisfy his court patrons, Louis XIII and the Queen Mother by a much more modern approach than was possible anywhere else in the country. He immediately set up a studio in the Italian manner and began to train pupils in his style of painting.

The logical outcome of Vouet's powerful presence would have been the perpetuation of a second-hand Italian inspired style pandering to the rather provincial court. But events took a dramatic turn when in 1640 Louis XIII personally invited Poussin to Paris in order to decorate one of the largest existing interiors—the *grande galerie* of the Louvre. Poussin was temperamentally unsuited to such a project but his prestige in distant Rome was already becoming known. The lasting effect of Poussin's visit, which lasted two unhappy years, was a complete reversal of style for Vouet's pupils and for the new generation of painters. Louis XIII's famous comment on the arrival of Poussin '*Voilà Vouet bien attrapé*', was more apt than he probably realized. From that point onwards almost all French painters used Poussin's motifs in one way or another. Even when they went to Rome, like the young Charles Le Brun, it was to Poussin they looked and when they returned to Paris they used Rubens' *Medici Cycle* as a model of how to execute a large decoration.

The middle years of the century in Paris saw a small number of highly individual painters none of them natives of the city, come to maturity. The long minority of Louis XIV during this period meant that there was a lack of centralized direction in the arts. The dominant painter was Philippe de Champaigne. A native of Brussels, he had arrived in Paris as a young man and had come under the influence of both Rubens and Poussin. Then in his middle years he evolved a totally personal style. It is said that his unique painting style was caused by the miraculous cure of his daughter from paralysis when in the Jansenist convent of Port Royal, but this miracle did not take place until the 1660s. A more likely explanation is that in the middle years of the century a sudden change came over certain parts of French society. The parallel is in the early

part of the century in Rome, where Caravaggio's unconventional art could suddenly become sought after by a small but informed circle.

This change in French cultivated society took a very different form— the elevation of classical austerity. In literature the plays of Racine are taken as the purest embodiment of this spirit. Like Poussin, Racine used a classical form and like Poussin was consistently austere. But Champaigne did not on the whole follow classical precepts but introduced a new sobriety and austerity into his art. The northern parallel is the endless portraiture, most of it still locked up in almshouses and town halls of the devout Dutch burghers.

The same restraint is found in the work of the brothers Le Nain. Almost all their pictures are genre pieces, and in contrast to the Flemish and Dutch treatments of the same subject matter, the peasants of the Le Nain brothers rarely seem to be doing anything. They are just observed, carefully, without emotion, and without moral. Although relatively obscure in their time, the approach taken by the Le Nain brothers makes them significant as influences in the 19th century, especially on the art of Courbet.

It is dangerous to see cultural history as one neatly defined pattern. The writings of the Jansenist Pascal rarely touch upon art and when it is mentioned he deplored the fact that painters depicted objects (peasants, vegetables, etc.) which we do not seem to admire in life. Thus in the circles of the intelligentsia it was thought that art should be spiritually or morally uplifting. Both of these concepts mystify modern attempts to understand the art of the past. This period of intellectual and artistic experiment was all too brief. When Louis XIV assumed personal power in 1661, taking over from Mazarin, the whole position changed and all artists who received patronage were programmed into the decoration of palaces displaying royal power and luxury.

Louis XIV was served, in the person of Le Brun, by a painter of competence. He could organize exactly the right type of decoration to fit the right type of space. But he lacked imagination to modern eyes and his art appears dead. Yet he was an excellent portraitist but these are rare in his art.

Taken as a whole French painting in the 17th century has a certain consistency. The great individualists, La Tour and the Le Nain brothers, were little known in their time. The tastes of the two monarchs Louis XIII and Louis XIV are easily defined. This lack of real variety has led to

The Exposition of Moses, Nicolas Poussin (1593–1665), painted in 1654. Canvas, 150 × 204cm (59 × 80½in). Ashmolean Museum, Oxford, England.
This picture was painted by Poussin in 1654, at the height of his maturity, for his friend the painter Jacques Stella. It embodies all Poussin's ideals about art and it is one of the rare pictures where the balance between Poussin's intellectual approach and his intuitive ability with paint is not uneasy. One of Poussin's preoccupations was with faithfulness to the story. Thus he attempted a depiction of ancient Egypt, although at that time in Rome there was very little information available to him. Poussin was also concerned with the compositional balance of his pictures, hence the symmetry of the trees and the careful delineation of each object. In his pictures nothing is left to chance or the imagination of the beholder.

The Adoration of the Shepherds, Georges de La Tour (1593–1652), probably painted in the 1640s. Canvas 107 × 137cm (42 × 54in). Musée du Louvre, Paris.

Because La Tour was so isolated in Luneville his pictures have an individualism unusual in the whole of 17th century art. In this picture the Nativity is depicted with hieratic simplicity, as if that was the proper way to depict the event. Quite the reverse was of course true, as in the 17th century artists were constantly experimenting with different ways of depicting the Nativity. La Tour's inherent skill is also apparent here as he has achieved the incredible feat of painting the main figures in reflected candlelight.

neglect by historians, as French painting was to change out of all recognition in the 18th century and in the 19th century France was to become the centre of Europe in the field of artistic experiment.

Immediately to the north-east of France lay the Netherlands. Divided in the middle ages into 17 provinces, their political history in the 17th century was one of considerable instability, especially in the southern part bordering on France. In the 16th century the whole area had come under Spanish control although from an artistic point of view this had had little visible effect. In practical terms it had meant that the Spanish court had collected southern Netherlandish pictures, a phenomenon which explains the many works of Hieronymus Bosch in Madrid and of Brueghel in Vienna—the acquisition of the southern Netherlands by the Austrian branch of the Hapsburg dynasty meant that many works of art were transferred from Brussels to Vienna.

The seven northernmost provinces had succeeded, after a great struggle in breaking away from Spanish domination and establishing the Dutch Republic. The remaining 10 provinces were in a sorry position indeed. Their northernmost boundary was under constant threat from the Dutch and the provinces of Brabant and Limburg were partly under the control of the Dutch States General. The southern boundary with France was constantly embattled and in the middle years of the century several major Flemish cities came under what turned out to be permanent French control. Thus Arras, Douai, Valenciennes, Lille and many smaller towns came finally under the control of Louis XIV. To make matters worse the Brussels government was usually in the hands of a junior member of the Spanish royal family acting as regent and they were thus unable to take rapid decisive action. Antwerp, which had been the richest city in the whole of northern Europe in the 16th century, was effectively strangled economically by the fact that the enterprising Dutch closed the mouth of the river Scheldt. With Antwerp closed Amsterdam prospered correspondingly as its more northerly substitute.

It is therefore a question of considerable importance as to how such an intense period of artistic activity could have taken place in such a politically unstable territory—it was hardly a country even in the 17th century sense of the term. It was basically a piece of property used by

the Spanish crown as a convenient source of tax revenue. The answer to the problem is twofold. Firstly the citizens were the heirs of a great tradition of painting which had flourished in the previous two centuries. The merchants were therefore accustomed to buying pictures to ornament their homes. Secondly the government in Brussels supplied a considerable source of patronage, as did the church. The Roman Catholic church was particularly active in Antwerp as this still rich city was dangerously near the boundary of the Protestant area. The political power of the church was matched, in reverse, by the fact that the Dutch had established a Protestant-oriented republic.

In the first 40 years of the 17th century Antwerp remained a great artistic centre. The Dutch were only a dozen miles to the north but culturally their proximity was not obvious. Even today there is still confusion between what is often termed Dutch and Flemish art. Comparison between the museums of Antwerp and Amsterdam makes the point clearly enough. Art in Antwerp was still based on the domination of church and state. Pictures bought by merchants took a secondary place and it is only in this field that there is any possibility of confusion.

The two most important heirs to the 16th century tradition were the brothers Jan and Pieter Brueghel. Sons of the great Pieter Brueghel they continued painting his compositions for 50 years after his death. The brothers had immense skill with minute detail and placed a different emphasis on the type of pictures they painted. Jan Brueghel produced a small number of exquisitely wrought still life pictures which were to be highly influential. It was a characteristic of this transitional period for painting to run in families. There was the Francken dynasty who also specialized in small religious pictures executed with much fine detail. In the early years of the century Antwerp was full of artists' studios producing work for a variety of patrons. The newly established Jesuits were very powerful and gave many commissions for altarpieces in their spacious churches which were built in a very Italianate style.

This variety of art tends to be overshadowed by the appearance of the most energetic painter of the whole 17th century in Europe, Peter Paul Rubens. He was the most truly international painter of his time working in some capacity for all the major European courts the significant exception being the nearby Dutch Republic. In his spare time he was used as a diplomat by the Spanish regent in Brussels for missions to Spain where he was also employed by the court. His Italian sojourn and work for the French court have already been mentioned and yet the greater part of his activity centred round his studio in Antwerp. His working methods are difficult to understand because he was so successful in producing a truly colossal number of pictures most of which are of a very high standard. One example of his prodigious abilities as a decorator can be seen in the ceiling he painted for Charles I of England for the king's Banqueting House in his newly begun palace of Whitehall. After making the sketches each large canvas was produced in the studio in Antwerp and then shipped over to London for assembly *in situ*. It is worth adding that the recipients of this grand decoration were so unaccustomed to the idea of a cycle of pictures representing a particular theme, (in this case the good government of King James I) that they placed the pictures on the ceiling in the wrong order—this was only corrected in recent years.

Many of the artists in Rubens' studio made reputations in their own right even though their success was partly reliant on the demand for Rubens-type pictures. The greatest individualist to come from the Rubens studio was van Dyck. His early work was heavily reliant on that of his master but he soon evolved a very personal style of portrait

Still life of flowers, Jan Brueghel the Elder, also known as 'Velvet' Brueghel, (1568–1625), probably painted about 1600. Panel 26.5 × 17.5cm (10½ × 7in). M.H. de Young Memorial Museum, San Francisco, California, USA.
Jan Brueghel was one of the earliest painters to take up flower painting as one of the genres in which he specialized. Relatively few survive although pictures of this type were to be immensely influential throughout the 17th century both in the Spanish Netherlands and the Dutch Republic. The scale of this picture is tiny and it is likely that each flower was prepared for inclusion in the finished picture by being drawn very carefully. Once a proper repertoire was complete then bouquets, large and small, could be constructed to order. Even here it is obvious that the flowers did not bloom at once as the hot early summer sun, encouraging the rose to bloom causes the delicate narcissus to fade. In this period flowers had specific meanings many of which have now been lost to us.

painting. In this he was successful all over Europe, especially amongst certain Genoese merchant and banking families and in England. He became court painter to Charles I and epitomized that monarch in a memorable series of portraits.

Van Dyck had little influence in Europe but in England his position became unique. Most of the native talent in painting had concentrated on the art of miniature painting. This was a direct descendant of manuscript illumination, and used a similar technique of watercolour or gouache on vellum or ivory. Charles I had also a few other Netherlandish painters at his court but no native ones. So pervasive did van Dyck's influence become that most formal portraiture, whether it was by Englishmen or foreigners followed his model for the next two centuries. Painting did not languish in the British Isles in the first part of the century through lack of patronage—Charles I was one of the most lavish monarchs in Europe. Yet nobody has been able to explain why the country which had both the wealth and the patron to produce great native artists failed to do so.

The contrast could hardly be greater than with the nearby Dutch Republic. Diplomatically relations between all the countries in northern Europe were especially complex. This was dictated both by dynastic ambition and by the fact that Protestant rulers had to seek alliances and marriages with countries of similar religion. When this did not happen, for example, when Charles I married a French Catholic, an already difficult situation was worsened. Looked at in a broad European context the position of the Dutch Republic was precarious. The territory it covered was very small indeed. There were a number of enemies apart from Spain with whom the country remained at war until the Peace of Munster in 1648. Most of the national effort was spent in defence or in the expansion of commercial interest all over the world—the Dutch founded New Amsterdam (New York); colonized South Africa, and developed the East Indies (Batavia). Hence their immense productivity in painting becomes all the more difficult to explain. Protestantism was not the reason for the production of so many paintings as there was still a large Catholic minority in the southern provinces of the Republic, especially in Utrecht and that part of Brabant under Dutch control.

Dutch painters worked in a very different way from most artists in other centres so far discussed. Over much of the rest of Europe painters had to maintain a formal studio where they could train pupils and use assistants for the preparation of canvases and panels. They could entertain prospective clients and show them sketches for proposed work and also a selection of finished canvases. The Dutch on the whole do not seem to have followed this practice. They preferred what must be termed an amateur approach. Many painters worked on small oak panels, which were often not even primed, and it is known that a good number of them had other means of income, probably out of necessity rather than desire. Thus van Goyen speculated in tulip bulbs, Jan Steen owned a brewery, Vermeer was an art expert and dealer, Hobbema was a wine gauger, van der Capelle an art collector and so on.

Dutch painters also chose very different places to work. Provincial centres, with the exception of France, have not featured in this survey as painters generally were so closely associated with government. In the Dutch Republic the government assiduously avoided having anything to do with painting. The Stadholder gave a few commissions for the decoration of his modest palace near The Hague and commissioned the *Passion Series* (Alte Pinakothek, Munich) from Rembrandt, but this was an exception.

Each town was able to support an active group of painters each

Charles I on horseback, Anthony van Dyck (1599–1641), probably painted in the 1630s. Canvas 367 × 292cm (144½ × 155in). National Gallery, London, England
It is curious that most people's impressions of the tragic figure of Charles I are derived from van Dyck's portraits of him rather than, for instance, looking at the type of art he collected. At an early age van Dyck mastered the art of dignifying his sitters even if he did not specifically flatter them. More than any other painter of the entire 17th century he set the tone for an accepted norm for portrait painting which was to prevail throughout the 18th century too.

specializing in a different genre. In Haarlem for instance there would be the formal portraitist who would be used by the burghers for portraits to be placed in the town hall as a reminder of their period of office. There was in the case of Haarlem a painter—Cornelis van Haarlem—of the previous generation, living into old age and continuing to paint in the Mannerist style derived from Italian 16th century models. Then there were the specialists in landscape, genre, still life and religious and mythological painting. Each town, especially Haarlem, Leiden, Utrecht and Amsterdam repeated this pattern with a few local variations. This explains the enormous variety of Dutch painting of the period and also serves as a partial explanation of why so many still life painters could exist—each town would support several—rather than their congregating in one place.

The Dutch also made several important contributions to painting in the choice of subject matter and its emphasis. A certain minority followed the traditions of Italy especially in Utrecht, where for a short period in the 1620s a group of painters Honthorst, Terbrugghen and Baburen imported a Caravaggesque style. Italian-type landscapes proliferated especially in Haarlem and Utrecht and to a certain extent in Amsterdam. They appealed to collectors because, bathed in golden light, they gave an idyllic cast to a foreign landscape.

The real innovators in the art of landscape were less successful in their lifetimes. The first experiments were made in Haarlem with tentative records of sand dunes and open sky. This soon developed into a whole school of what might be called realist landscape painting. Artists like Jan van Goyen, Salomon van Ruysdael and later Jacob van Ruisdael

The Judgement of Paris, Peter Paul Rubens (1577–1640), probably painted in the early 1630s. Panel 144.8 × 193.7cm (57 × 76in). National Gallery, London.
Rubens was preoccupied with the painting of human flesh. For later generations this has sometimes proved to be his downfall because ideas of beauty have changed. In this once celebrated picture, three perfect ideals of female beauty are depicted. It is only in front of the original that Rubens' ability with texture and paint is obvious and he was one of the few painters to achieve the illusion of the transparent nature of flesh. The composition is very carefully worked out and the poses of the female figures were clearly designed to be erotic. The landscape background is beautifully painted and late in life Rubens produced, for his own pleasure, a short series of great panoramic vistas like the *Chateau de Steen* also in the London National Gallery.

The Union of England and Scotland with Hercules and Envy and Minerva and Ignorance, The Apotheosis of James I, The benefits of the Government of James I with Abundance and Avarice and Reason and Intemperate Discord, Peter Paul Rubens (1577–1640) and his studio, painted in the 1620s. Canvas stretched on the ceiling. Banqueting Hall, Whitehall, London, England.

This is the only important example of grand Baroque decoration to survive from the first part of the 17th century in Britain and it gives some idea of the pretensions of the monarchy of Charles I to form part of the European artistic tradition. The model was of course Marie de Medici's programme for the Luxembourg palace in Paris, glorifying the reign of her late husband Henri IV. The actual painting of these panels is of relatively low quality but seen at the correct distance and in the setting for which they were intended the result is indeed impressive. Artists of this period, especially Rubens, were not preoccupied with the autograph status of their work, instead they concentrated on its decorative effect and ability to satisfy the customer.

and Hobbema sought to record their local landscape as they saw it. Often there is a heavy sky, and a sense of impending storms. With hindsight it is possible to see that this was a great contribution to the subsequent development of art and Dutch landscape painting of this type had far reaching effects in the 18th century both in England and France.

Genre painting too proliferated. The stylistic source for this goes back to the Brueghel family in the southern Netherlands and more specifically to such influential but obscure figures as Adriaen Brouwer, who had travelled north from Antwerp to Haarlem, where his peasant interiors were to set the fashion for a whole generation of painters.

Seascape painting became a Dutch speciality. This area has been left too long in the realm of the marine historian. It is not generally known that in order to make a ship look convincing on the water it has to be perfectly accurate. Thus such pictures are of inestimable value to the marine historian. Their qualities as works of art have been neglected in recent years. Dramatic storms and perfect calm were both favoured extremes.

The general character of Dutch painting in the period is its incredible richness and variety. Exquisitely painted interiors with ladies in silk were the preserve of Terborch and yet he had a rival in the same genre, Metsu. There was rarely one pre-eminent painter for each genre. The three most famous names, however, Hals, Vermeer and Rembrandt are all quite untypical of their times. Hals spent his entire career in Haarlem painting portraits almost exclusively. His style was unique in his time— he developed a freedom of brushwork in his faces and draperies not seen again until Manet in the 1860s. His exceptional abilities were the cause of his relative lack of esteem among his contemporaries. He gave his sitters too much character. The formal portraits of his more successful contemporary Verspronck were much more carefully polished—it was not just a matter of skill, (Hals had plenty of that) but one of approach. By rapid flicks of the brush Hals discovered the secret of a sudden smile or frown. He could record the surface of his sitters' faces brilliantly and still reveal much of their character.

By contrast Vermeer appears to have been a very different character. The town of Delft in which he spent his relatively short active life was less inhabited by painters than Haarlem, and Vermeer only painted very few pictures because of his other activities. The only written record in his lifetime concerning the quality of his art is a complaint that the local baker, who had taken pictures in lieu of money, had paid too much for a picture because it only contained a single figure. Today his *View of Delft* in the Mauritshuis, The Hague, counts as one of the great pictures of all time not only of the 17th century. It is as if Vermeer saw differently from any other painter before or since. He laid his paint on the canvas in a unique way achieving a transparency which is very rare with the oil paint. Each minute detail is recorded but the breadth of the whole is never lost. But it was not until the middle years of the 19th century that Vermeer was rediscovered—by a French writer—and for the last one hundred years he has been generally regarded to be one of the greatest of all painters.

For many people Rembrandt is the epitome of Dutch art. Yet like all geniuses he was utterly untypical of his time. His vast *Night Watch* in the Rijksmuseum, Amsterdam, is unlike any other Dutch picture painted in the period. It is bigger, broader and owes more to the great Venetian painters of the 16th century than to any piece of contemporary art. But it also shows many of the characteristics for which Rembrandt has almost always been esteemed. He was able to mould oil paint on the surface of the canvas, using thick and thin layers sometimes one over

the other as well as juxtaposed, in order to achieve an illusion of three dimensions. He also contrived to make his figures emerge from those brown shadows in an uncannily realistic way.

Rembrandt's career began in his native Leiden and as a young man he moved to Amsterdam where he spent the rest of his career. Information about his life is patchy, but a large amount of detail survives about the contents of his house because they were listed at the time of his insolvency in mid-career. Piecing the scrappy information together it seems as if the financial difficulties under which Rembrandt laboured for most of his life were caused by mis-management and personal extravagance rather than by a lack of commissions. But these characteristics, despised by writers defending bourgeois standards, contributed to Rembrandt's greatness. His expenditure on gold helmets, Eastern carpets, gold and silver of every sort, Persian miniatures, engravings, coins, medals, rich costumes, furs, and countless other things meant that he employed them as accessories in his pictures. All through the second part of his career many of his greatest pictures glow with the trappings of his personal extravagance.

Much has also been written about his obsession with self portraiture. He showed himself in many different moods although the sad ones are those most often reproduced. In his art Rembrandt showed many of the qualities of the extrovert, but he combined these with introspection and self-analysis. Thus the greatest genius of the age defies generalization. Painter, draughtsman and etcher—in each field he touched his art transcends that of his contemporaries. His painted landscapes are

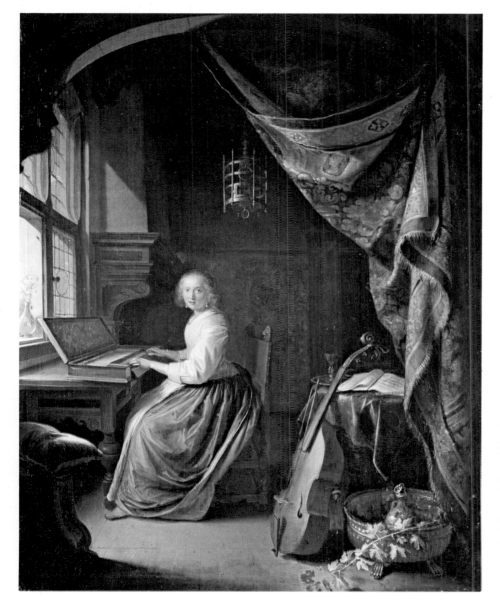

A lady at the clavichord, Gerrit Dou (1613–75), probably painted in the 1660s. Panel 32.5 × 28.2cm (13 × 11in). Dulwich College Picture Gallery, London, England.
Dou had been a pupil of Rembrandt during the early years in Leiden in the 1620s but he soon lost what the greater painter had to teach him and went his own way producing incredibly detailed interior scenes. Dou's reputation was indeed greater than Rembrandt's in the 17th century although of course the position has been reversed for the last two centuries. In spite of the almost painful meticulousness Dou was in full control of his composition and it is even thought by some scholars that pictures of this type by Dou could have influenced the young Vermeer in nearby Delft.

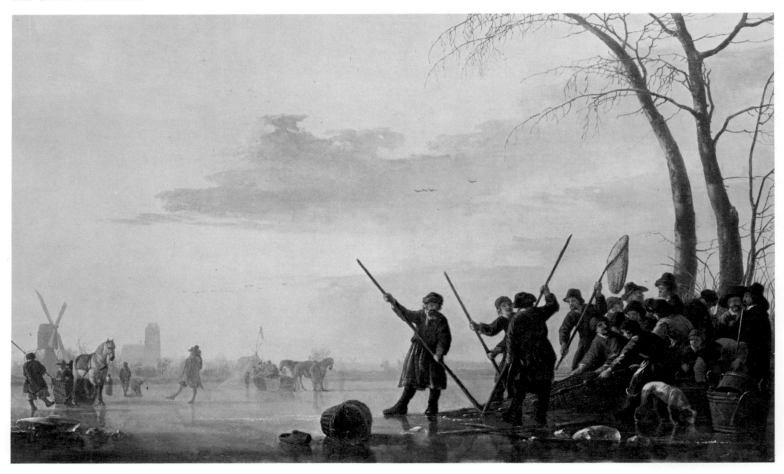

Fishing under the ice on the Maas, Aelbert Cuyp (1620–1691), probably painted in the 1650s. Oil on canvas. 53 × 87cm (21 × 34½in). M.H. de Young Memorial Museum, San Francisco, California, USA. (*Above*)
Although Cuyp remained relatively isolated in his time in his native Dordrecht, seen here in the background, his pictures epitomize many aspects of Dutch life and landscape. Dutch society, although bound by many conventions, was very much more emancipated than any other in Europe at the period. Cuyp has used this simple winter activity of making holes in the ice to seek for fish into an excuse to depict a specific mood of calm in the cold air.

dramatic, forbidding and unreal. His many landscape drawings record with loving accuracy the watery scenery around Amsterdam. His landscape etchings are a delicate combination of these two extremes—the *Three Trees* being the best example.

Throughout this chapter emphasis has been put on the fact that patronage determined success. Present-day taste has rejected a very considerable number of successful 17th century artists. Carlo Dolci, Simon Vouet, Bartholemeus van der Helst, and many others have been relegated to academic text books. But these figures are an essential part of history even though their art is no longer esteemed. Conversely the 20th century has chosen to pick out a number of painters who were little known in their time—Vermeer, Georges de La Tour, for example—or whose careers had no establishment successes like Caravaggio. This is where taste and history have become confused. To take the point further a considerable amount of writing about art has survived from the 17th century, most of it in Italian or French and almost none of it in Dutch. What made Poussin deserve two full-length biographies in his lifetime or shortly after when Rembrandt was hardly mentioned by his contemporaries at all?

The answer to this paradox may be that those who chose to write about art in the 17th century looked at it in a way virtually incomprehensible today. Endless theories were propounded, most of them based on the assumption that there was a right and a wrong way to do things. Nature was still regarded as a subject requiring improvement. The real world was not for admiration. Even though philosophers were enquiring into broader concepts than man alone it seems that 17th century connoisseurs of painting were mostly old-fashioned even for their own time. They thus subscribed to the Renaissance ideal that man was the centre of the universe and that art must reflect that fact. Only the avant-garde in Italy collected landscape paintings. In the north this was not so simply because the good Dutch burghers were not in the habit of reading Italian theories of art.

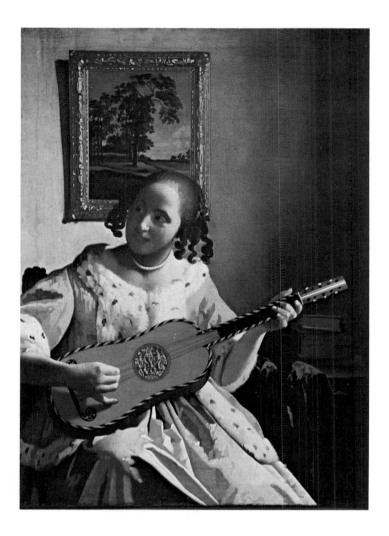

The Guitar Player, Johannes Vermeer (1632–75), signed: *JVMeer*, probably painted in the early 1670s. Canvas 53 × 46.3cm (21 × 18in). Iveagh Bequest, Kenwood, London, England. (*Left*)

Although painted towards the end of Vermeer's life and in a sense untypical of him, this picture has many qualities for which Vermeer has been esteemed for the last 100 years, even though in his lifetime and for 100 years afterwards he was forgotten. The way of laying on the paint in clear enamel-like patches and the clear lighting are unique to Vermeer. Every detail is highlighted without losing the tonal balance of the whole. The painting of the gold carving on the picture frame is especially brilliant.

The visit of the Stadholder to the Dutch Fleet at Dordrecht, 1646, Jan van de Cappelle (c.1624–79), signed, probably painted in the late 1640s. Panel 76 × 108cm (30 × 42½in). Private Collection, USA. (*Below*)

Most of van de Capelle's pictures are calm shipping scenes and do not depict particular events. This visit was painted by several different artists including Aelbert Cuyp and Simon de Vlieger. Unlike most seascape painters van de Capelle has virtually removed the anecdotal element from his picture and instead has produced a mood of exquisite calm, the equivalent in seascape of Vermeer in genre. The ships' sails form a carefully balanced pattern against the sky. There is none of the random quality of many seascape painters who sought to depict the turbulence of the water and man's struggle against it. It appears that, like many of his contemporaries, van de Capelle did not paint full time for a living.

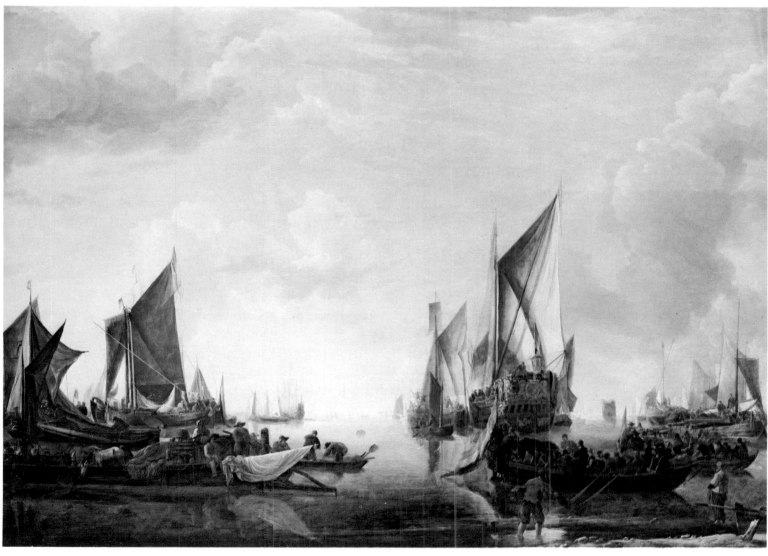

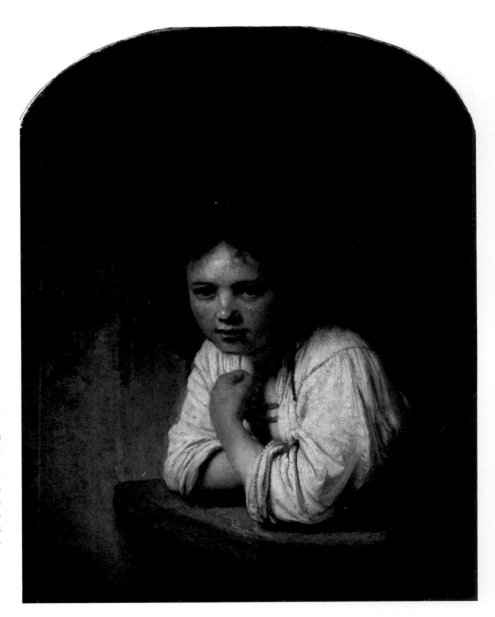

A girl at a window, Rembrandt van Rijn (1606–69), signed and dated: *Rembrandt f.1645*. Canvas 79 × 62cm (31 × 24½in). Dulwich College Picture Gallery, London. (*Right*) This is one of Rembrandt's most endearing pictures from his middle period. The sitter has not been identified. Rembrandt's preoccupation with surface texture is particularly obvious in this picture especially in the painting of the background as well as that of the girl's white dress. More than any other Dutch artist of his time, Rembrandt had the power of psychological penetration evident even in this simple face. The girl is shown in an introspective and pensive mood.

Portrait of a man aged 26 (The Laughing Cavalier), Frans Hals (1581/5–1666), dated 1624. Canvas 86 × 69cm (34 × 27in). Wallace Collection, London, England. (*Below*) This picture has been over-exposed for the wrong reasons. The sitter's eyes are supposed to be laughing, hence the popular title. Hals still had 40 years of painting career ahead of him when he produced this masterpiece of careful control. In the 1620s the free brushwork associated both with Hals and Rembrandt in their maturity had not been developed. The sitter has not yet been identified.

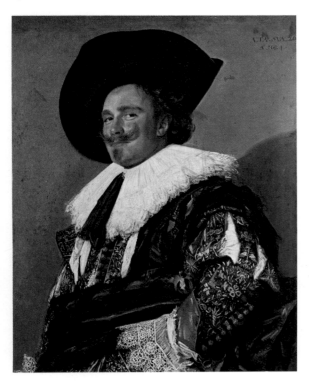

Instead, especially later in the century, the Dutch had their own theorists, in particular Gerard de Lairesse and Arnold Houbraken who, although they echoed Italian art theory, really preferred to concentrate on instructions on how to paint pictures. Elaborate laws governed composition, colour and expression but it seems that few painters took these instructions very seriously. Many biographies of artists were written at the end of the century and from these it is clear that many of the painters then so much esteemed, like Adrian van der Werff for example, are entirely forgotten today.

For the past three centuries attitudes towards 17th century painting have changed continuously. There is therefore no reason to suppose that these changes will not go on. As late as 1914 van Dyck was still considered by informed English people to be greater than Rubens and as late as 1972 the curator of a museum in an English town with a population of 300,000 people had not heard of Georges de La Tour even though under his jurisdiction was a masterpiece signed by that painter. Future generations may seek to place Teniers, the Flemish genre painter back on the pedestal he once enjoyed. The revival in interest in Italian Baroque art in the 1950s and 1960s shows signs of losing momentum. Taken over the whole field only three painters have been continuously esteemed, even though not always for the same aspects of their work. These are Velazquez, Rubens and Rembrandt and it is perhaps these three who represented such extremes in their time, who will still be considered great by the generations to come.

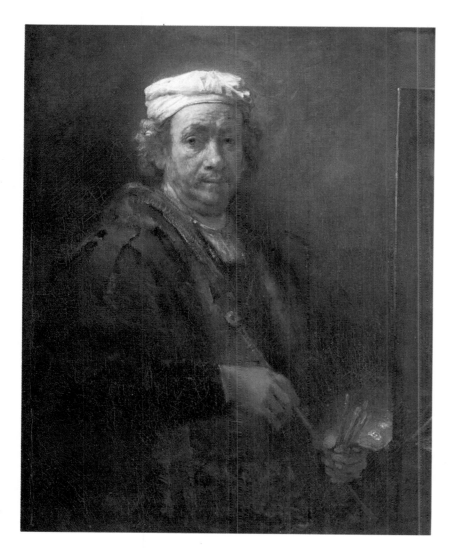

Self Portrait, Rembrandt van Rijn (1606–69), signed and dated: *Rembrandt F. 1660*. Canvas 111 × 85cm (44 × 33½in). Musée du Louvre, Paris, France. (*Left*)

In his last years Rembrandt painted a small group of memorable self portraits which show him at the height of his powers as a painter but in decline as a man. This combination of characteristics has made the last pictures of Rembrandt very much esteemed in the 20th century, where the emotional content of a picture has become very important to popular taste. It is unusual to see Rembrandt showing himself palette in hand, as in this particular example, as he often preferred to depict himself in fancy dress.

River scene with a ferry boat, Salomon van Ruysdael (*c.*1600–70), signed and dated: *S. van Ruysdael 1650*. Canvas 106 × 152cm (42 × 60in). Walker Art Gallery, Liverpool, England. (*Below*)

Painted at the end of his life Salomon van Ruysdael's river scenes occupy a key position in the development of Dutch landscape. They heralded the way for the great achievements of his nephew Jacob van Ruisdael and his pupil Hobbema. In these late pictures Ruysdael had mastered the art of composing his pictures—earlier in his career his relationships between sea and sky sometimes appear stilted. Here much emphasis is given to the trees on the river bank. Note for instance the cows on the ferry boat—this must have been a common sight as pastures were almost always separated by stretches of water.

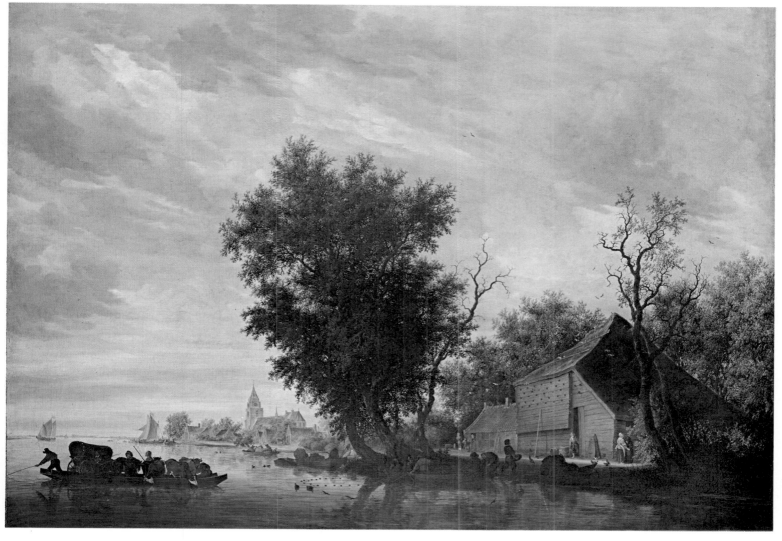

195

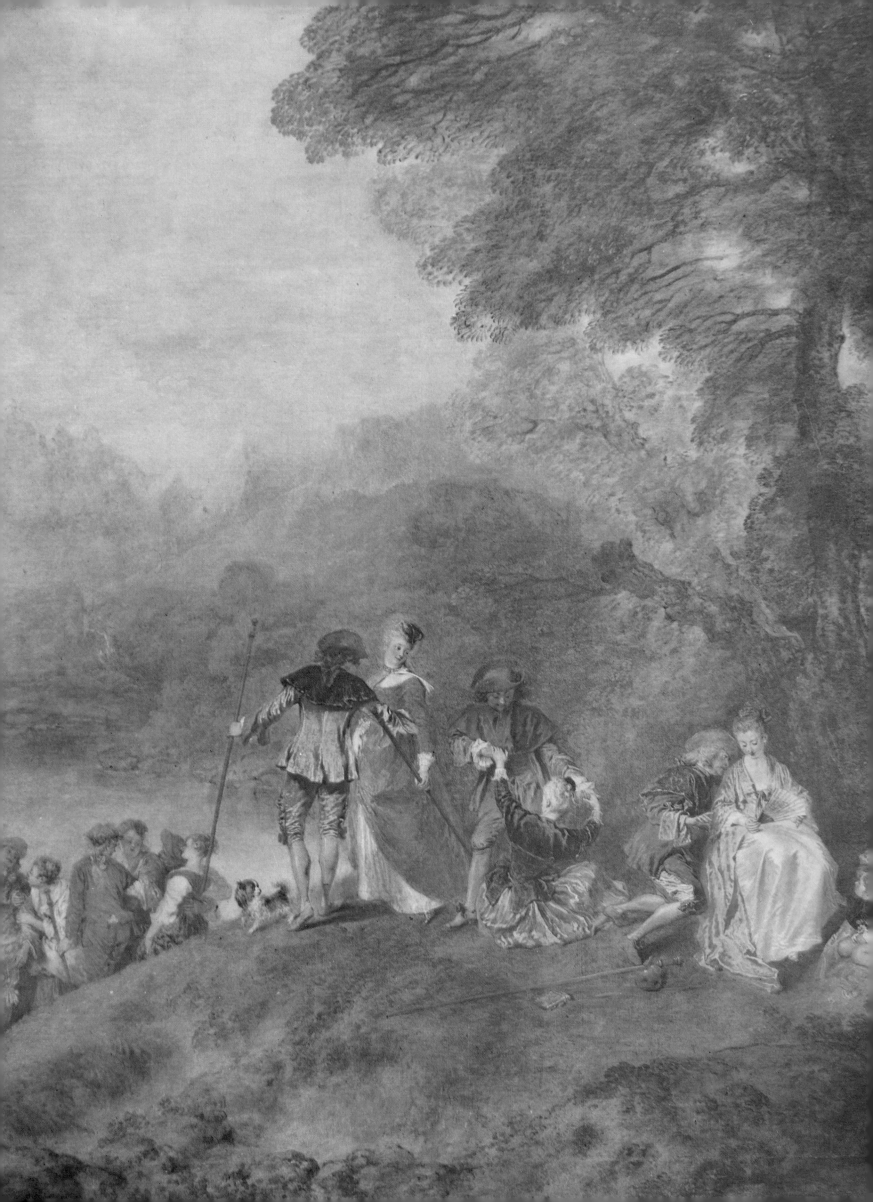

THE GRAND TRADITION
18th Century Art

The 18th century has been called 'the Age of Reason'. Critics of the term have been quick to point out that the period had its share of fanatics, charlatans and quacks, and that its civilized façade hid worlds of poverty, squalor and vice. Yet it *was* an Age of Reason in an important sense: it was an age when men increasingly refused to accept that customs and institutions were good because they were old or established by authority. Among the leading writers of the age were the French *philosophes*—'philosophers' like Voltaire, Diderot and Montesquieu, whom we should now be more inclined to call men of letters or social critics. One of their favourite devices was to describe Western customs as they might be seen by an imaginary Persian or Chinese: viewed without the usual preconceptions, the customs were revealed to be irrational and/or oppressive. Along with the exercise of reason went a humanitarian impulse, seen at its most impressive in Voltaire's one-man campaigns against injustice and religious persecution. The activities of the *philosophes* also influenced European opinion against practices such as the judicial use of torture, and persuaded Frederick the Great of Prussia and the Empress Catherine of Russia that they were—or at least ought to be—'enlightened despots'.

However, in the higher levels of European society it was not reason so much as 'reasonableness' that gave a new tone to 18th-century life. In northern Europe, at least, this society was increasingly wealthy, sophisticated, secular, leisured, sociable and cosmopolitan. Religious intolerance was disappearing, along with religious zeal; most people were still believing Christians, but they were cooler in expressing their beliefs and more openly concerned than in the past with the pleasures and rewards of the world. The social virtues were more highly valued; 'polite', 'genteel', 'civil' and 'agreeable' became frequently-used terms of praise, while in the first half of the century the word 'enthusiasm'— meaning fanatical conviction of any kind—was uttered in tones of deep disapproval. In France, fine manners and good conversation were cultivated in the salons where intelligent women presided over informal meetings of the great, the famous and the witty. English towns had a rougher masculine equivalent in their coffee houses and taverns; Doctor Johnson, the autocrat of English literature and conversation, opined that 'the tavern seat is the throne of human felicity'. With improved communications, gentlefolk who lived in the country were able to take part in the London 'season', and to go on long visits to fashionable spas

Interior of the abbey of Ottobeuren, Bavaria, D.F.R. Architect: Johann Michael Fischer (1692–1766). (*Above*) A superb example of the decorative style developed in south Germany and the Austrian Habsburg lands, and widely used for religious buildings. The style combined Baroque qualities—grandeur and dynamic sense of space—with the lightness of the newer Rococo style. In a religious context this achieved an effect at once joyful and overwhelming.

Portrait of Madame de Pompadour, Maurice Quentin de la Tour (1704–88), 1755. Pastel, 177.5 × 131 cm (69½ × 51½ in). Musée du Louvre, Paris, France. (*Below*) Apart from a brief and apparently very successful stay in London in the 1730s, La Tour pursued his career exclusively in Paris, where his ascendancy remained unchallenged in spite of his often eccentric behaviour. His immense technical skill gave a new status to the pastel, which had previously been considered a very limited and therefore minor art. Like other pastelists, La Tour concentrated on facial portraits, but he drew the occasional full-length to show off the potentialities of the medium. This charming, flattering study shows Louis XV's all-powerful mistress contemplating a music score.

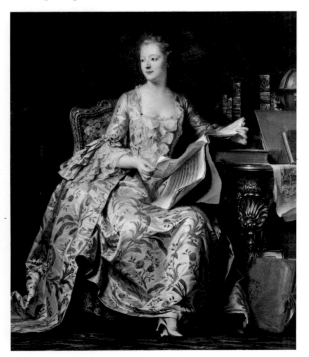

like Bath. Young men of good birth completed their education on the Grand Tour, polishing their French and sampling the arts and vices of Italy. Even European wars presented few obstacles to the gentleman on his travels, since the desperate religious and dynastic conflicts of the 17th century were replaced by more limited and formalized conflicts—passionless set-piece battles between professionals—which hardly impinged on non-combatants. In such circumstances, the upper class over much of Europe became a cosmopolitan body with a common language (since all educated men spoke French as well as their own tongue) as well as many common tastes.

This picture of a consciously civilized, urbane, cosmopolitan society is broadly accurate as far as the upper class is concerned; and in most countries it was the upper class alone that mattered. The most ambitious paintings and sculptures were commissioned by and for them, and canons of taste were formed by aristocratic patrons as much as by artists. However, the very different character of the middle class—industrious, sober, inclined to piety—was just beginning to make itself felt in western Europe, where economic growth was most in evidence; and the appearance of various forms of realistic, satirical and sentimental art in the course of the 18th century probably owes a good deal to the influence of middle-class taste.

In the arts, the 18th century was not an age of titans. Many of its finest works reflect the mood of society at large, and aim to please or record rather than to arouse intense emotion. The first great 18th-century style was the frivolous, pleasure-giving, highly decorative Rococo. Later, we find notes of feeling, sober moods, varieties of realism and satire; but they are generally most effective when executed on a small scale or in a minor key. When 18th-century artists attempted the 'Grand Manner' they frequently lapsed into empty rhetoric. With religion no longer at the centre of existence, and the heroic conception of kingship very much out of favour, there was simply not much to be 'grand' about. All the same, artists continued to attempt large-scale works on heroic, classical or allegorical subjects: it is as if the 18th century suspected itself of shallowness, and determined to show itself passionate and full of powerful convictions. But urbanity has its price: the passions and convictions, being assumed, ring false. In the second half of the century the image of classical antiquity was invoked yet again, in a new effort to create a serious, elevated style; but though the assumed republican austerity of Neo-classicism did find one great interpreter in Jacques-Louis David, it too was fundamentally artificial.

Lacking Renaissance hubris and Baroque ardour, the 18th century produced its finest art when it was most direct and least pretentious. Among its most valued achievements are works that contemporaries regarded as insignificant beside now-forgotten examples of the Grand Manner: portraits, genre scenes, view paintings, animal studies, still-lifes, light-hearted decorative pieces. Many crafts too, such as furniture making, reached a climax of skill and refinement that has never been surpassed. (These items, of course, are beyond the scope of this book.) In fact the majority of 18th-century treasures are just those that suggest its peculiar distinction as a reasonable age set between two ages of passion and striving.

Many of the best works of art from the early 18th century were what we should now call multi-media: decorative schemes in which paintings and sculptures were only elements in a larger overall design. There were plentiful opportunities for sumptuous interior designs in the town and country houses being built or enlarged in western Europe; at the same time, smaller versions of the royal palace at Versailles continued

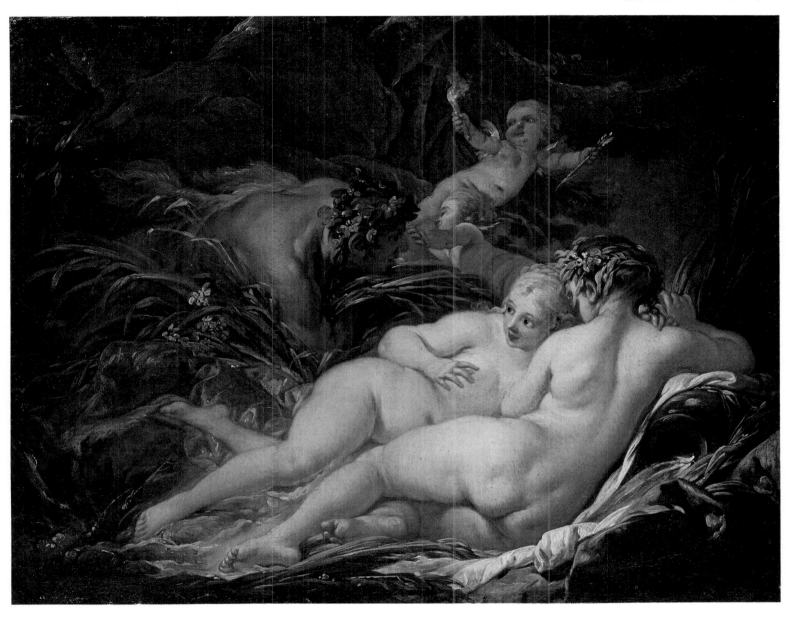

to be created in central Europe long after the French themselves had lost all taste for the grandiose. Wall and ceiling paintings, marble and wooden sculptures, elaborate wood carving, dazzling white plasterwork, and furniture were combined in a new decorative style—Rococo.

Rococo developed out of Baroque, but in direct revolt against its solemn, grandiose spirit. It made its first appearance as a distinct style in France, where the overpowering décor associated with the cult of Louis XIV began to lose popularity even before the king's death in 1715; its pretensions had probably begun to seem inflated as a series of military disasters in the War of the Spanish Succession (1701–14) dimmed the glory of the Sun King. When the pleasure-loving Duke Philip of Orléans became regent for the child Louis XV, pleasure-giving Rococo became established as the dominant style. Its cheerful charm and utter lack of pretension to seriousness made it the ideal post-war style. By contrast with Baroque, Rococo colours are light and bright, the sweeping curves are reduced to tight, capering S-bends, and the decorative schemes themselves are transferred from the immensities of churches and palaces to private rooms; intimacy, and a sprightly, frivolous charm, are the distinctive features of Rococo. It is above all a style of interior decoration, best seen in a setting such as the Hôtel Soubise in Paris; but a number of independently important painters and sculptors did work in a spirit that can legitimately be called Rococo.

At the very beginning of the century stands the figure of Antoine Watteau (1684–1721), one of the greatest of all French painters. Wat-

Pan and Syrinx, François Boucher (1703–70), painted 1759. Canvas, 32 × 41cm (12¾ × 16½in). National Gallery, London, England. (*Above*)
Boucher dominated French painting for most of the reign of Louis XV, delighting the court with endless variations on subjects from classical myth, which however provided little more than occasions for light-hearted erotica. Here the ostensible subject is the story of Syrinx, a nymph who fled from the advances of Pan and appealed to a river nymph to help her. As the lustful Pan clutched at her, she was transformed into a handful of reeds which emitted plaintive sounds as the wind blew through them; this, according to the myth, was the origin of the pan pipes.

The Embarkation from Cythera, Antoine Watteau (1684–1721), painted in 1717. Canvas, 127 × 191cm (50 × 75½in). Musée du Louvre, Paris, France. (*Previous pages*).
Cythera is the island of love, sacred to Aphrodite. The painting has traditionally been called *The Embarkation for Cythera*, but in recent times it has been recognized that the scene must be a leave taking, as is also suggested by the regretful afterglow radiating from the procession of lovers.

199

Bedlam, Scene 8 of *A Rake's Progress*, William Hogarth (1697–1764), dated 1733. Canvas, 61 × 74cm (24⅝ × 29⅝in). Sir John Soane's Museum, London, England. (*Right*)
Hogarth's 'modern moral subjects' gave him the chance to portray both the squalors and splendours of 18th-century British society in fascinating detail. *A Rake's Progress* follows its hero from the inheritance of a fortune, through vice and folly, to his ruin at the card table. In this final scene he is dying in the lunatic asylum, cared for only by a poor girl he has jilted. Like many another satirist, Hogarth reveals an evident relish for the abominations he warns us against.

The Greeting Harlequin, Johann Joachim Kaendler (1706–75), c.1740. Clandon Park, Surrey, England. (*Below*)
Porcelain, a uniquely hard, white and translucent ceramic, fascinated Europeans for centuries, and they imported it in quantities from China. But they failed to discover the secret of its manufacture until about 1710, when the first pieces were produced at Meissen, near Dresden in Saxony. The Meissen factory was effectively unchallenged for decades, and found in Kaendler a master-modeller of genius; the European vogue for displays of porcelain figures on tables and mantelpieces gave him the opportunity to model animals, pastoral and Commedia dell'Arte characters, allegorical figures, and many others. As technical information spread, porcelain factories sprang up over most of Europe; Kaendler's chief rival, Bustelli, worked at Nymphenburg in Bavaria.

teau's art has points of contact with Rococo, though it goes far beyond it in creating a timeless poetic world whose beauty is touched with the sadness of loss and separation.

The creator of this sophisticated beauty was a provincial born in Valenciennes, which had become French only six years before his birth; Watteau's contemporaries often referred to him as a Flemish rather than a French painter. His apprenticeship was long and difficult; he changed masters several times, and worked variously as a scene painter at the Paris Opera and on a production-line with other impoverished painters, putting in the figures on copies of Old Master works. Success came to Watteau suddenly and rather mysteriously after about 1710. Watteau's pre-eminence was recognized in this last decade of his life, and it was then that he painted most of the pictures for which he is remembered. In 1712 he was honoured with associate membership of the French Academy, but it was five years before he bothered to finish the presentation piece needed to secure full membership—a strikingly cavalier attitude towards the all-powerful governing body of French art. However, he made handsome amends in 1717 by presenting the Academy with *The Embarkation from Cythera*, which has always been the most celebrated of all his works.

Watteau's fresh, personal vision forms the greatest possible contrast to the public grandeur of royal and religious Baroque. There is no trace of either in Watteau's world of lovers and musicians in enchanted parkland. References to classical mythology are rare and perfunctory; even the statues tend to be expressive figures who look down on the scene like actors in disguise, and gesture or grimace as commentary on the action. There *is* action in these apparently tranquil scenes, though its exact nature remains elusive. Despite the all-suffusing misty light and the tenderly leafy landscapes, the theatre is never far away. The people, dressed in a kind of silvery fancy dress reminiscent of 16th-century costume, are enacting a masquerade, though their emotions may or may not be assumed. In some cases the painting itself may be seen as either stage illusion or reality, according to the spectator's inclination: the

'actors' appear in a columned courtyard with a landscape behind them, and columns and landscape may or may not be the wings and backcloth of a stage.

When Watteau's *Embarkation* was received by the Academy, he was put down in its records as a painter of *fêtes galantes*—a new term specially coined to describe Watteau's work. The *fête galante*—a painting of elegant lovers in a country setting—was a development of the *concert champêtre* (painting of open-air enjoyment) derived from the Venetian painter Giorgione. This mixture of the pastoral and the amorous perfectly represented the mood of cultivated French society, and the *fête galante* became enormously popular throughout the 18th century. Two painters of considerable ability, Jean-Baptiste Pater (1695–1736) and Nicolas Lancret (1690–1743), based their careers on imitating Watteau's style and mood very closely, with a few concessions to a taste for more overt erotic appeal.

A much more opulent sensuality—and also more vigour and originality—appeared in the paintings of François Boucher (1703–70). Although he began his career as an engraver of works by Watteau, Boucher was a more extroverted figure than the older master. He became the leading representative of the carefree Rococo spirit in French painting; and as that spirit pleased the French court through the Regency and into the long reign of Louis XV (1715–74), Boucher had a successful and prolific career as chief painter to the king, decorative artist, engraver and designer of tapestries for the famous workshops at Les Gobelins and Beauvais. In his characteristic paintings he created endless variations on stories from classical mythology; but like other Rococo artists, he was unable or unwilling to take the myths seriously, even as allegories. Boucher is supremely a painter of female flesh, and almost all his subjects are evidently chosen to show off his gifts in this direction. His goddesses, nymphs and heroines are simply girls, and all-too-human ones at that: interchangeable creamy-complexioned and rosy-bottomed girls, posed like extras with a touch of stage fright in a tableau. The men (or gods, or satyrs) provide nicely judged colour-contrasts. Love is virtually the only subject of Boucher's art, and even love is not taken very seriously: there is rarely a hint of passion or loss in all this rubicund dalliance, which is generally of the amorous-romp variety.

To the modern spectator, Boucher's world often looks mindless rather than merely light-hearted. Nonetheless his work possesses a cheerful vigour that accounts for his supremacy in the middle years of the century. The patronage of the court was lavish and discriminating at this time under the régime of Louis XV's chief mistress, Madame de Pompadour; and Boucher's career was made by the Pompadour just because he was able to create a decorative art that was playful, intimate and sufficiently varied. Other French Rococo painters, though technically accomplished, produced stereotyped and ultimately repetitious work. The chief exceptions were portraitists, notably Maurice Quentin de la Tour (1704–88) and Jean-Baptiste Perronneau (c.1715–83) Their best productions were in pastel, a medium that had a tremendous vogue in Paris after the triumphal appearance there of Rosalba Carriera (1675–1757), a woman pastellist from Venice. Quentin de la Tour had a knack of endowing his sitters with a flattering if slightly glib vivacity, and in his own day he outshone Perronneau; however, Perronneau's extraordinary glowing colours have since come to be highly appreciated.

The Rococo spirit lingered on in France down to the 1780s, though increasingly criticized as unserious or unfeeling. One of Boucher's pupils was Jean-Honoré Fragonard (1732–1806), who first made his name in 1765 with an ambitious quasi-historical painting. But he soon

An Allegory with Venus and Time, Giovanni Battista Tiepolo (1696–1770), painted *c*.1758. Canvas, 292 × 190cm (115 × 75in). National Gallery, London, England. (*Above*)
Tiepolo was the master-decorator of his age, working at incredible speed and on a vast scale. This splendid ceiling picture is typical of his dynamic style and brightly-lit, light-toned, airborne subjects. As in so many 18th-century works, the traditional myths and allegories are no longer taken very seriously; here, the very significance of the action is in doubt (can the wingless boy be new-born Cupid?). But by contrast with painters like Watteau and Boucher, Tiepolo does manifest the heroic energy appropriate to his subjects.

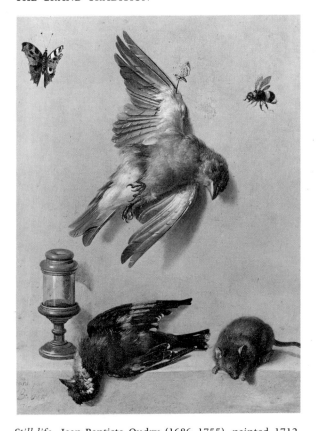

Still-life, Jean-Baptiste Oudry (1686–1755), painted 1712. Musée de Beaux Arts, Agen, France. (*Above*)
Oudry, the son of a Parisian picture-dealer, became a royal favourite through his skill as a painter of animals, and especially of dead game; this was an established genre, intensely interesting to the Bourbon kings of France, who were almost all passionate hunters. Oudry was also a designer of tapestries for the royal workshops at Beauvais and Gobelins; for Beauvais (of which he became director) he designed the *Hunts of Louis XV*, perhaps his finest work.

found more pleasure and profit in works of a rather arch eroticism, featuring lovers in gardens (as in *The Swing*) or clandestine affairs. In both types of picture the lovers are more knowing than Boucher's frolicking nymphs, though not necessarily more sensual: Fragonard's assignations and seductions often look like moves in a crafty social game rather than episodes of love or lust. But there are other sides to Fragonard; indeed he seems to have been a virtuoso artist capable of succeeding in many genres but committed to none. On occasion his warm, bright colours and freely handled paint bring to mind the Impressionists working in the following century. Fragonard's feeling for nature was strong too, and in many of his paintings—erotic pieces as well as *fêtes galantes* in the style of Watteau—the human figures seem about to be overwhelmed by the lush, swelling vegetation. Fragonard outlived his age and his own popularity: he witnessed the downfall of the Old Régime and its culture during the French Revolution, and survived to see the military adventurer Napoleon Bonaparte crown himself Emperor of the French.

Earlier in the century, Rococo spread over much of continental Europe, though it was often employed in a solemnly un-French spirit; an appreciation of intimacy could hardly be expected of princelings who were still in the process of ruining themselves by building imitations of Versailles. But the most striking and independent expressions of Rococo outside France were the mainly religious buildings of south Germany and the imperial Habsburg territories of Austria and Bohemia. These included Jacob Prandtauer's monastery of Melk, imposingly situated on a hill overlooking the Danube, Balthasar Neumann's Vierzehnheiligen pilgrimage church, and Dominikus Zimmermann's Wieskirche. Here, too, the interiors are integrated decorative schemes in which the individual contribution tends to seem insignificant. This style has been variously called Rococo and Baroque, because it is a curious hybrid of the two: the structural lightness, natural ornament and white-and-gold colour scheme of Rococo is combined with overwhelming, unmistakably Baroque manipulations of space, scale and decorative abundance.

The prevalence of such large-scale schemes could not prevent one decorative painter of genius from winning a European renown. The career of Giovanni Battista Tiepolo (1696–1770) heralded a revival in Venetian painting, though Tiepolo himself spent much of his working life away from his native city. His output was prodigious, and contemporaries remarked on the speed at which he worked. Although part of this was due to Tiepolo's use of assistants (including his two sons), he

Smoker's Case, Pipes and Drinking Vessels, Jean-Baptiste-Siméon Chardin (1699–1779), painted 1760–63. Canvas, 81 × 106cm (32 × 42in). Musée du Louvre, Paris, France. (*Right*)
Chardin brought a new dignity to the still life, showing that it could be a satisfying subject for easel painting without being buttressed by allegorical meanings or glamorized by the inclusion of splendid objects. As in his household scenes, the beauty of ordinariness acquires a kind of moral value. Both types of painting practised by Chardin were ranked very low by the French Academy—in spite of which, his household scenes became so popular in the 1730s that for some years he abandoned still life altogether.

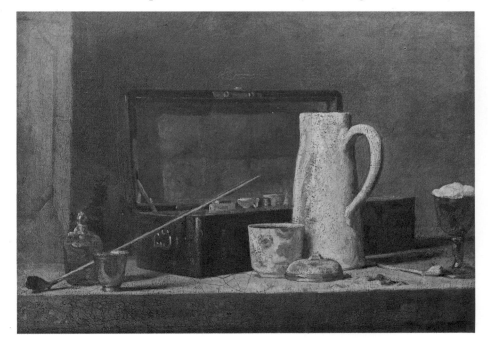

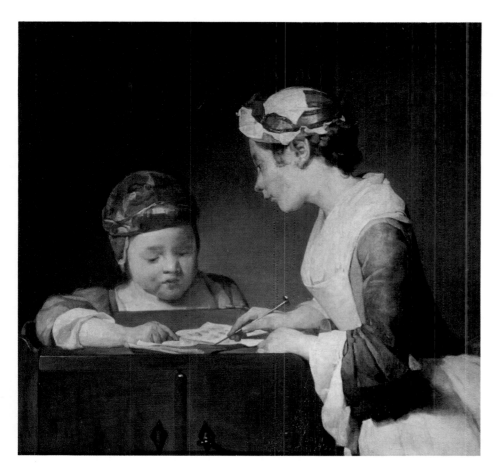

The Young Schoolmistress, Jean-Baptiste-Siméon Chardin (1699–1779), painted *c.*1740. Canvas, 62 × 67cm (24¼ × 26¼in). National Gallery, London, England.

In his domestic scenes as in his still-life studies, Chardin endows ordinary moments and everyday things with a grave beauty. He seems to have been the kind of artist who strives ceaselessly for perfection, sometimes taking months over a single painting and attacking the same subject again and again. *The Young Schoolmistress* (also known as *The Lesson*) exists in several versions, one of which was shown at the Paris Salon of 1740.

still showed astonishing facility and inventiveness in coping with the peculiarities and interrelationships of wall and ceiling surfaces. His most stunning effects of all were achieved on ceilings, apparently open to a dazzling blue sky, where dramatically foreshortened saints and heroes are borne up in apotheosis on luminous clouds, accompanied by a jubilant host of heavenly well-wishers.

The high point of Tiepolo's career came in 1750–53, when he decorated huge areas of the prince-bishop's palace (Residenz) at Würzburg. He also worked extensively in Italy, and the last eight years of his life were passed in Spain, where he painted the ceilings of the new royal palace. Significantly, his activities were confined to the Catholic south: heroic energy was not a quality much admired in Pompadour's France—in either painters or paintings. (Boucher had to pretend to be lazy, though he worked constantly.) Nor was it much in evidence elsewhere: in fact Tiepolo was the only major 18th-century painter before the 1780s to work in the Grand Manner and make it convincing.

However, if Tiepolo's art was too heroic for French taste, it was still thoroughly Rococo in a number of important respects. The colours are light and bright, enhancing the impression of weightlessness in even his most earthbound pictures. The heroism, too, is all blue skies and triumph—a wonderful, bubbling sense of happiness and health, with more vitality than French Rococo but a similar disinclination to encounter conflict or suffering or passion. (Working where and when he did, Tiepolo could not, of course, avoid subjects such as martyrdoms and the Passion; but he treats them with a certain lack of conviction.) He has a cavalier attitude towards allegory and antiquity that is also typically Rococo: turbaned Turks, negro pages and inquisitive hounds are liable to turn up among the crowds of Romans or early Christians. The heroism is not, after all, quite real—more like the mimic celebration of heroism in a masque, or a grand pageant under masterful direction.

The sense of theatre in Rococo—and in many other 18th-century works—has little in common with the spectacular efforts of Baroque illusionism. It is closer to the *Commedia dell'Arte*—the Italian theatre

An Experiment on a Bird in the Air Pump, Joseph Wright of Derby (1734–97), painted *c*.1767–68. Canvas, 213 × 243cm (72 × 96in). Tate Gallery, London, England.

Wright is perhaps most interesting as an early painter of scientific and industrial subjects, patronized by men like the inventor Richard Arkwright. However, Wright's taste for this kind of lighting was not merely scientific: he painted many moonlit landscapes in which similar effects are used to produce a rather eerie atmosphere. Here and elsewhere the details are less important than the emblematic significance of the scene as a 'march of science' tableau: the girls add a touch of sentiment, pointing up the fact that the bird is being sacrificed in the cause of knowledge.

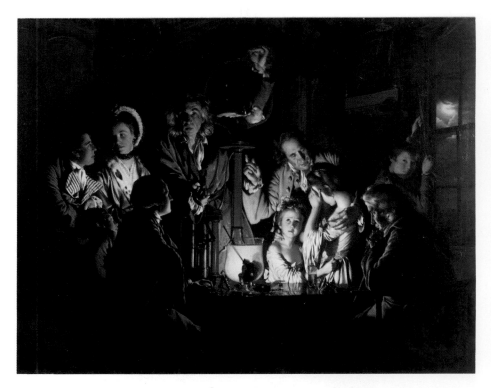

of burlesque improvisation in which chequered Harlequin endlessly woos Columbine, tricks foolish fathers and decrepit suitors, and brings about the union of young lovers before the final curtain. This minor but delightful art did in fact exercise a wide influence on writing and painting. In the 17th century the 'Italian Comedy' became established in Paris, where its plots were adapted by (among others) Molière for his own purposes. Its characters appear—transmuted into melancholy French pierrots—in the paintings of Watteau. And *Commedia* characters are the most popular models for the new minor art of porcelain modelling. After centuries of frustrated effort, Europeans at last discovered how to make porcelain, and in the ensuing craze not only tableware but also small figures were turned out in huge quantities from the factories which sprang up all over Europe. Under the hands of such masters as Franz Anton Bustelli (1723–63), these colourful little figures embody the sprightly Rococo better than any other European sculptures.

As might be expected, the south German Rococo produced the only really moving religious sculpture in this period; the outstanding examples are the painted wooden statues carved by the Bavarian artist Ignaz Günther (1725–75). Stone and bronze sculpture—especially in France—remained at an extremely high level of professional competence, though without equally powerful inspiration; here the 18th-century failure of conviction is particularly marked. With the important exception of tomb and portrait sculpture, 18th-century statuary is most effective as part of a larger setting such as garden design; its effectiveness in such a context might then be immense.

Artists who were not at ease with myth, allegory or religious imagery could hope to find replacements in the life of their own time. Contemporary realities provided a variety of opportunities for fresh subjects, insights or expressions of feeling; and as a mood of earnestness began to displace Rococo frivolity, various forms of realism and sentiment appeared in the arts.

An early and vigorous satirical realism was pioneered by William Hogarth (1697–1764). Its appearance in England was no doubt the result of two interrelated facts; that Rococo had never been adopted there, and that England was the only European country with a really substantial and influential middle class—notoriously the class with a taste for the factual and 'useful'. The most realistically down-to-earth of

all literary forms, the novel, appeared at about the same time as Hogarth's six-painting series *The Harlot's Progress* (1731), and appealed to the same market. *The Harlot's Progress*, followed by *A Rake's Progress* and *Marriage à la Mode*, made Hogarth's fortune; but most of the money came not from the paintings, but from the engravings that Hogarth made from them and sold by subscription to his large middle-class 'readership'. Hogarth claimed that his 'modern moral subjects' were something new in painting, and rightly so. In these action- and detail-packed pictures he creates an incomparable panorama of high and low life, human types and manners, conditions and habits, follies, crimes and vices. If his satire is part-prejudice (especially against high fashion and foreign art), he also lashes undeniable evils from cruelty to epidemic gin-drinking. Like other moralists, he titillates by displaying the seductive side of the vices he castigates; but he creates a harsh, unsentimental picture of their outcome in disease, insanity and ruin. Hogarth, himself trained as an engraver, initiated a great age of English engraving, both by his example and his practical activity in securing the first Copyright Act (1735) to protect artists' works from piracy. A satirical tradition also formed and flourished in England, its best-known representatives being James Gillray (1757–1815) and Thomas Rowlandson (1756–1827).

The realism is of a quite different kind in the paintings of Jean-Baptiste-Siméon Chardin (1699–1779). Chardin was an almost exact contemporary, as well as a fellow-countryman, of Boucher; but the two painters could hardly have been less alike in temperament and choice of subjects. Though trained in the Rococo tradition, Chardin worked in a style that has no point of contact with it except, perhaps, a taste for intimacy. His paintings are small, in spite of the fact that he was reportedly a slow worker who could spend months on a single picture—which doubtless accounts for the textural variety and subtlety he

Roman Ruins with Figures, Giovanni Paolo Panini (1691/2–1765), date unknown. Canvas, 49 × 63cm (19½ × 25in). National Gallery, London, England. (*Above*)
Paintings of ruins were extremely popular in the 18th century. Artists such as Panini (active in Rome from 1711) found a ready market for view paintings of the Forum and similar remains; but they also sold studies of purely imaginary ruins—often, however, incorporating some well-known monument that actually existed.

Venice: the Basin of San Marco on Ascension Day, Canaletto (1697–1768), probably painted during 1730s. Canvas, 121 × 182cm (48 × 72in). National Gallery, London. (*Below*)
Apart from a ten-year stay in England (1746–56), Canaletto's adult life was spent in Venice, where he devoted himself almost exclusively to painting views of the city. In this one the Doge and his attendants are approaching the state barge—the Bucintoro—for the traditional Ascension Day ceremony in which Venice 'married' the Adriatic Sea; this symbolized the naval and mercantile greatness of the city, which had largely disappeared by the 18th century. The arms of the Doge Alvise Pisani (1735–41) are shown on the Bucintoro and suggest an approximate date for the picture.

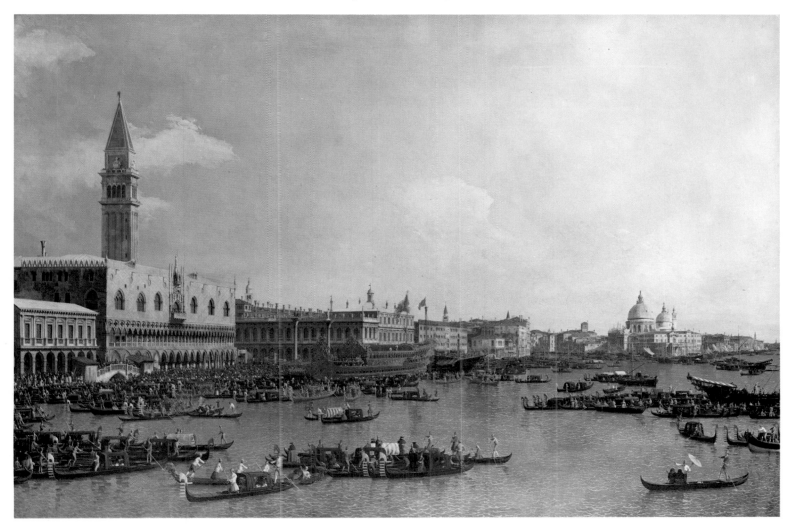

205

achieved, and which none of his contemporaries could match. In fact, Chardin's art is deceptively quiet and literal-seeming. He began as a painter of still life—in the 18th century placed right at the bottom of the Academic hierarchy—and later extended his range to take in scenes of ordinary domestic life (genre). The still lifes are almost always composed of very humble objects: pots and jugs, dead game and fruit, pipes and bottles. The genre paintings are equally undisturbed by the noise and bustle of life, capturing still moments in simple lives: a mother getting her child ready to go out, or a servant girl at work in the kitchen. By contrast with Hogarth's hectic accuracy, Chardin lifts his humble everyday realities into a timeless realm where their nobility stands revealed.

Yet another kind of reality was beginning to emerge in 18th-century England—a reality comprising invention and enterprise, machinery, workshops, factories, and busy, overcrowded industrial towns. One of the few artists to take any part of this reality as his subject was Joseph Wright of Derby (1734–97). Except for two years in Italy and a brief period in Bath in a futile bid to succeed Gainsborough as the reigning portraitist, Wright spent his entire working life in Derby, one of the English Midlands towns that was in the process of being transformed by the Industrial Revolution. Among his friends and patrons were scientists and businessmen-inventors such as Joseph Priestley, Richard Arkwright and Josiah Wedgwood. With their backing Wright painted *Experiment with an Air Pump* and other interesting pictures that combined the new technology and landscape with his own marked taste for dramatic candle-, furnace- and moonlit scenes.

One basic and by definition realistic function of the visual arts was to provide an accurate record of persons, places and events—in other words, to do the job now done by photography. The greater self-consciousness of 18th-century man made this function even more important than in the past, and a wealth of sharply individuated portraits and view paintings were produced.

View painting was most highly developed (as an art and also a trade) in Italy, which was still the climax of the Grand Tour and the goal of every aspiring student of art. Tourism was already an Italian industry. The ruins of ancient Rome provided subjects and a livelihood for artists such as the painter Giovanni Paolo Panini (c.1692–1765) and the engraver Giovanni Battista Piranesi (c.1720–78). Venetian painters found similar employment in recording the appearance of their famous and ancient republic-on-the-water. The prolific Canaletto (1697–1768) raised the most literal kind of view painting to the level of art, sober but never monotonous, by continually varying the viewpoint and distance from which his famous subjects—St Mark's, the Doge's Palace, the Grand Canal—are seen. Canaletto was unsurpassed in rendering the weathered yellow stones and green canals of Venice, but his younger and less successful rival, Francesco Guardi (1712–93), had a greater mastery of atmosphere. Guardi, sometimes working in collaboration with his brother Giovanni Antonio (1698–1760), painted with brighter colours and in a freer style than Canaletto, producing dazzling effects of light and a greater sense of movement in pictures of crowds at fêtes, balloon ascents and formal ceremonies.

Eighteenth-century portraits are legion. They are perhaps at their most attractive when they mirror the civilized ease characteristic of the Age of Reason; after the formal, posterity-conscious portraits of the 17th century, it comes as something of a relief to look at these genial, relaxed figures. The men are often shown in their morning gowns, with casual turbans covering their wigless heads, and before the century was

Bust of Voltaire, Jean-Antoine Houdon (1741–1828), dated 1781. Marble, height (including base) 48cm (19⅞in). Victoria and Albert Museum, London, England.
Houdon was the leading French sculptor from about 1770. Like many of his contemporaries, he was at his best in portraiture, which allowed greater scope for idiosyncrasy and characterization than other convention-ruled forms of sculpture. Houdon's mythical figures and even most of his full-length portraits (such as the *George Washington* in the Capitol at Richmond, Virginia, for which he was specially imported to the USA) suffer from a classicizing chilliness that is apparent by comparison with the liveliness of his busts. There are several versions of this one, which admirably conveys the great writer's tranquil cynicism, wit and humanity.

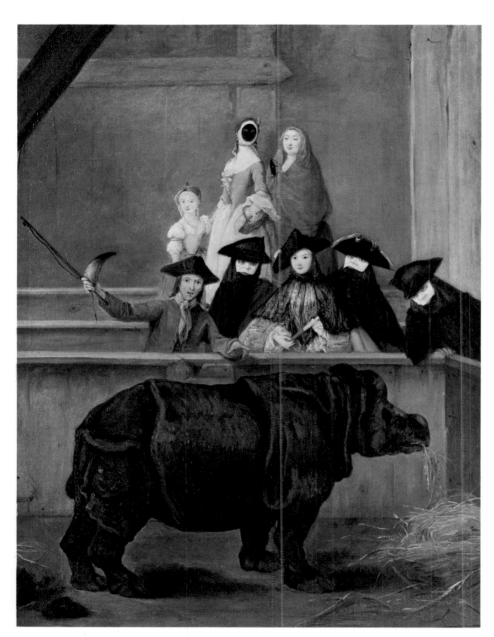

Exhibition of a Rhinoceros at Venice, Pietro Longhi (1702–85), painted *c*.1751. Canvas, 59.5 × 47cm (23¾ × 18½in). National Gallery, London, England. (*Left*)
Although not a great painter, Longhi was a reporter of genius. He had a sharp eye for the contemporary scene, and a wonderful subject in decadent, pleasure-loving Venice, with its fêtes and balls, its masked revellers and quarrelsome gondoliers, its plausible charlatans and obsessed gamblers. Longhi painted two versions of the rhinoceros, which is known to have been put on show at Venice in 1751.

over a Scottish portraitist, Sir Henry Raeburn, was to paint a charming picture of a clergyman skating.

Of course there was still a demand for more or less formal portraits. Many of Hogarth's are masterly within the limits of his self-chosen middle-class ambience; but he is at his best where, as in a group portrait of six of his servants, respect is touched with affection. And in the famous *Shrimp Girl* Hogarth breaks out of his own and his age's limitations in a wonderfully free and direct study of brimming, glowing vitality; by comparison, Quentin de la Tour's vivacity is seen to be highly artificial. However, fashionable and flattering portraits inevitably outlived the age of Madame de Pompadour. Two of the most accomplished practitioners of the art were women painters: Angelica Kauffmann (1741–1807) and Louise-Elisabeth Vigée-Lebrun (1755–1842). Both were typical 18th-century cosmopolitans. The Swiss-born Angelica Kauffmann painted the German art historian Winckelmann in Rome before making a great success in England and settling there for 15 years (1766–81). Vigée-Lebrun worked in her native France, where an idealized portrait of Queen Marie Antoinette made her famous; it was the Revolution that sent her on her travels. Both artists skilfully blended a Rococo lightness with the look of exquisite sensibility required in a society that was beginning to be ashamed of its own artificiality. But again, the limitations of charm become apparent when such paintings are compared with Chardin's late masterpieces—pastel portraits of himself and his wife, done in the 1770s after a career devoted to other genres.

George Frederick Handel, Louis-François Roubiliac (*c*.1705–1762), mid-18th century. Terracotta, 29.5cm (11½in). Fitzwilliam Museum, Cambridge, England.
Roubiliac, a Frenchman, was probably the most gifted sculptor working in 18th-century England. He was established in London by 1735, and made his reputation in 1738 with a statue of Handel for the pleasure gardens at Vauxhall, of which this is a copy; it constitutes an effective tribute from one immigrant to another.

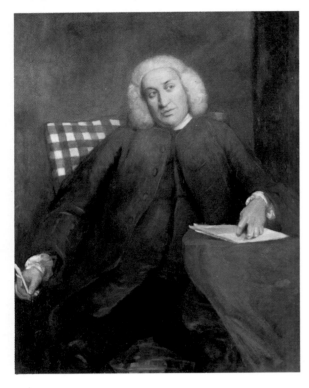

Portrait of Dr Samuel Johnson, Sir Joshua Reynolds (1723–92), painted 1756. Oil on canvas, 124.5 × 99cm (49 × 39in). National Portrait Gallery, London, England. (*Above*)
Reynolds had a great admiration for Johnson and learned much from him; Johnson, he said, 'qualified my mind to think justly', and the older man probably helped Reynolds acquire the social weight that eventually brought him a doctorate of civil laws and the presidency of the newly founded Royal Academy. Reynolds painted Johnson several times. In this relaxed but conventional early portrait the writer is still in his forties; with longer acquaintance Reynolds ventured greater realism and psychological insight. Johnson was such a well-known London figure that Reynolds's portraits were immediately engraved and sold as popular prints.
David Garrick, Thomas Gainsborough (1727–88), painted *c.*1770. Oil on canvas, 75.5 × 62.5cm (29¾ × 24⅞in). National Portrait Gallery, London, England. (*Below*)
Garrick was the greatest actor of his time and, according to Gainsborough, 'the greatest living creature'. The two men were friends, and often appeared together at the auction rooms in London run by James Christie, the proprietor of a business that is now internationally known. This is one of Gainsborough's more intimate portraits.

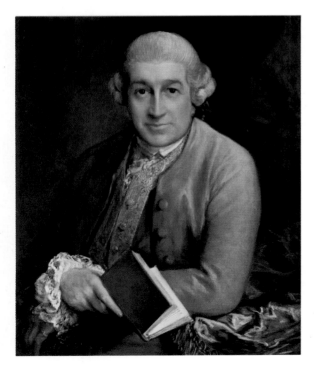

Portraiture, like other forms of sculpture, reached a high standard in France in the works of such artists as Lemoyne, Bouchardon, Pigalle, Pajou and Clodion. But only Jean-Antoine Houdon (1741–1829) achieved a notable authority and psychological penetration. The most famous men of his time sat for him: he portrayed Voltaire on several occasions, evidently fascinated by the combination of benevolence, experience and malice on the aged writer's face; and in the newly independent United States he carved a statue of George Washington and a bust of Benjamin Franklin.

English sculpture remained unmemorable except for the works of two immigrants who recorded the likenesses of most of their great contemporaries: the Fleming John Michael Rysbrack (1694–1770) and the Frenchman Louis-François Roubiliac (1705–62). Roubiliac's style was more fluent and individualized; he made busts or statues of, among others, Handel, Sir Isaac Newton and Alexander Pope, and an imposing monument to the Duke of Argyll in Westminster Abbey.

By contrast, English painters achieved a European eminence through their portrait works, which went beyond their immediate occasion and in effect hymned the special glories of contemporary English culture. Whereas Hogarth painted brawling London and its solid middle-class burgers, Sir Joshua Reynolds (1723–92) put on canvas the most powerful, famous and elegant representatives of the new imperial England; while Thomas Gainsborough (1727–88) made the portrait a medium for idealizing its landscape and country-house society.

Reynolds has a double importance, since he was an artistic phenomenon as well as an artist. When, as a teenager, he was apprenticed to the painter Thomas Hudson, artists—English artists, at any rate—were regarded as no more than skilled manual workers; even Hogarth failed miserably to establish himself as a 'serious' painter. Reynolds changed this state of affairs. He worked his way to Italy where, in approved fashion, he studied Raphael, Michelangelo and other Renaissance masters; then, impeccably qualified, he returned to London and quickly established his supremacy as a portraitist. Thanks to his social and intellectual qualities, Reynolds was able to meet the most powerful and distinguished men of his day on an equal footing. Almost single-handed, he made the artist respectable; and when the Royal Academy which he had advocated was established (1768), he was the inevitable choice for its first president. His accompanying knighthood set the seal on his own career and the English artist's new status.

Reynolds was immensely skilful as a painter, though his portraits are often too self-conscious or sentimental for modern tastes; however, *Georgiana, Countess Spencer, with Lady Georgiana Spencer* is masterly in its reserved tenderness, and Reynolds's penchant for grandeur found a completely suitable subject in Lord Heathfield, the governor of Gibraltar, posed with a massive key chained to his arm—symbolic of Heathfield's heroic three-year defence of the island ('the key to the Mediterranean') a few years before. Individual psychology is absent from Reynolds's work except in his portraits of close friends among the intelligentsia—such near-sighted scholars as Dr Johnson and Baretti, whose physical shortcomings are also recorded with affection.

As president of the Royal Academy, Reynolds delivered an annual discourse to the students at the prizegiving. Collected and published, the *Discourses* exercised an enduring influence, since they expressed many 18th-century ideas about art with a persuasively elegant authority. For Reynolds, the Renaissance masters 'should be considered . . . infallible guides' by the student who aspired to excel in the highest form of art. That highest form was the Biblical or mythological or ancient history

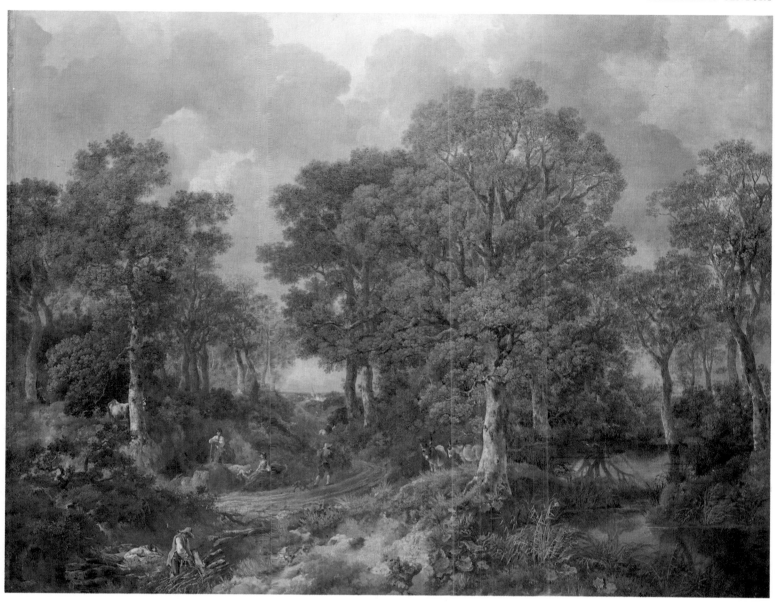

painting—the Grand Subject, so to speak which required to be treated in what Reynolds termed 'the Grand Style', based on the conviction that 'all the arts receive their perfection from an ideal beauty, superior to what is to be found in individual nature.' A preference for idealized or ennobled forms can be traced back to classical Greece, and is therefore not in itself absurd; but elevating general over specific and idiosyncratic appearances was, as we have already noted, a bad mistake in an age that approached Biblical and mythical subjects with little conviction. In this important sense, Reynolds's influence was unfortunate.

Ironically, Reynolds himself hardly ever practised the Grand Style: though he managed to educate the taste of his fellow-Englishmen up to a point, he failed to wean them from a prosaic preference for lifelike records of themselves, their animals and their estates. In retrospect, Reynolds was lucky: his public forced him in the right direction.

In Gainsborough's case this was far from certain. His splendid talent for landscape was tragically under-used, since he found that 'a Man may do great things and starve in a garret'—and chose to paint portraits instead. Apart from early works such as *Cornard Wood*, begun when he was still in his teens, Gainsborough's landscapes were executed on the margins of a busy career and often in the heart of the city (he arranged home-made table-top 'scenery' to work from); many are sketches or unfinished pieces, done for his own amusement.

Gainsborough was born in Sudbury, a little town in Suffolk, and lived there and in the county town of Ipswich for most of his early life. It was only in 1759, when he was already 32 years old, that he moved to

Gainsborough's Forest, Thomas Gainsborough (1727–88), probably painted 1748. Canvas, 121 × 154cm (48 × 61in). National Gallery, London, England.
This picture indicates Gainsborough's role in forming the English tradition of landscape painting, in which a warmly romantic feeling for nature is combined with close observation. The picture is sometimes also called *Cornard Wood*, though apparently on no solid evidence except the fact that the wood lay just outside Sudbury, Gainsborough's birthplace in Suffolk. The painter himself claimed to have begun the picture when he was still at school; but he also—and more plausibly—dated it to 1748, during his second residence in Sudbury.

Mare and Foals in a Landscape, George Stubbs (1724–1806). The National Trust, Rothschild Collection, England.
In England the aristocracy and gentry were supremely elegant in 18th-century urban fashion; but—far more than their French counterparts—they remained involved with the running of their estates and with country life in general. They commissioned artists to record their activities as sportsmen and breeders, and to paint portraits of favourite hounds and horses. Stubbs raised this documentary task to the level of great art; his series of paintings of mares and foals is done with a special tenderness, revealing the mother-child relationship without sentimentalizing it.

Thomas Jenkins and his niece, Angelica Kauffmann (1741–1807), painted 1790. Oil on canvas, 129.5 × 94cm (51 × 37¼in). National Portrait Gallery, London, England.
Angelica Kauffmann was a child prodigy who received commissions for paintings from the age of 11. After leaving her native Switzerland to tour Italy in the 1760s, she settled in London, where she became a friend of Reynolds and a founder-member of the Royal Academy. She graced the artistic scene in England until 1781, when she married the decorative painter Antonio Zucchi and returned to Italy. Her decorative paintings of mythical and allegorical subjects now seem rather insipid, and she is mainly remembered for her portraits and pastels.

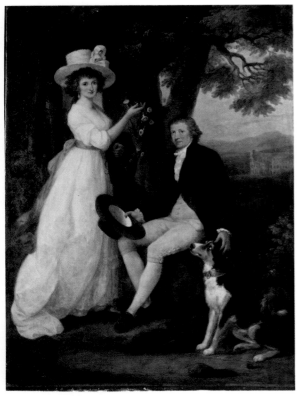

fashionable Bath and became an almost overnight success as a portraitist. It was another 15 years before he set up in London as Reynolds's chief rival; the capital proved large enough to hold both of them, and they seem to have remained on fairly amicable terms. After Gainsborough's death, Sir Joshua praised him to the Royal Academy students, but warned them that he was too original to be a good model for learners.

Gainsborough's art was not learnt in Italy and had few points of contact with the Grand Style as Reynolds understood it. His sitters are consistently more individualized than Reynolds's, but for us, at least, their individuality is less apparent than the Arcadian atmosphere that envelopes and romanticizes them. In his early Suffolk paintings such as *Mr and Mrs Andrews*, the landscape is as important as the sitters, emphasizing the rural order surrounding the couple. The same is true of *The Morning Walk*, painted late in Gainsborough's life, though the landscape around the newlywed squire and his wife is more lushly romantic. But even at the height of his London success, when he developed a glossy manner to depict fashionable beauties such as the Honourable Mrs Graham, swathed in flashing silks, Gainsborough chose to paint in a feathery, wildly beautiful landscape background; and the juxtaposition of sophistication and Arcadian sentiment is just what gives these pictures their curiously fascinating quality. Here, we feel, is high civilization, untroubled and untainted—even when the subject turns out to be a lady of long-lost reputation such as Mrs 'Perdita' Robinson or the dishonourable Honourable Frances Duncombe.

Landscape—as opposed to view and ruin painting—was not a flourishing art in the 18th century. But despite the lack of demand, the practice survived in England, and it was in this period that the distinctively English tradition of watercolour landscapes was founded by Alexander Cozens, Paul Sandby and others. In oils, Gainsborough's landscapes, with their romantic, sweeping masses, constituted a decisive precedent for Constable and the East Anglian landscapists of the generation after Gainsborough's death.

The country-house culture of England—sporting yet civilized—is recorded from a different angle by George Stubbs (1724–1806). As a lowly animal painter, Stubbs was expected to record his subjects with meticulous accuracy, and he was evidently a thoroughly reliable 'photographer'. But his rich, glowing portraits of horses and hounds, with seemingly incidental figures of jockeys and stable-boys and owners, go far beyond their immediate purpose, and embody the myth of a rural English 'Golden Age' before the industrial Age of Iron arrived.

A different side to Stubbs's sensibility is revealed by his paintings of wild beasts. In North Africa he saw a lion attack and devour a horse, and the subject occurs several times in his work. But he also executed less

bloodthirsty, beautifully observed paintings of leopards, tigers, zebras, lemurs and other animals; these too were made as records (for the pioneer scientist John Hunter) but are also unmistakably works of art.

The rural myth, casually implicit in Gainsborough's portraits and Stubbs's animal paintings, produced better art than the obtrusive mid-century cult of feeling. This achieved an early triumph in *The Father of the Family reading the Bible*, which created a sensation at the Paris Salon of 1755 and made the reputation of Jean-Baptiste Greuze (1725–1805). For some years after this, Greuze went from strength to strength as a modern moral artist. Like Hogarth, he constructed story-series with a powerfully-made moral point; but instead of Hogarth's raw, action-packed scenes, Greuze drenched each episode in an enfeebling sentimentality. *The Morning Prayer* and *A Father's Curse* foreshadow the academic paintings of the 19th century in their combination of anecdote, moral bias and sentimentality. Feeling, 'the heart' and sensibility were very much in the air from the 1750s, reinforced by the European vogue of Jean-Jacques Rousseau's novel *La Nouvelle Héloïse* (1761), which mingled sensibility, pathos and scenery. Rousseau's belief in the superiority of uncivilized man influenced all sorts of highly civilized people, including Marie Antoinette, who even had her own dairy at Rambouillet where she played at being a simple milkmaid. The general mood impinged on English artists (and also on such writers as Oliver Goldsmith); Reynolds's portraits are sugar-sentimental on occasion, and in later life Gainsborough produced a good many 'fancy pictures' (his own term) in which ragged but picturesque peasants decorate the landscape. A younger artist, George Romney (1734–1802), made numerous sentimental-classical paintings of a beautiful young woman who obsessed him—Emma Hart, who was later, as Lady Hamilton, to obsess Nelson.

It has already been suggested that mid-18th-century man suspected himself of shallowness and determined to make himself a 'man of feeling'. He also wanted to experience the thrill of heroism in his rather unheroic world. The contemporary or rational history picture found most of its early exponents among British-based artists—significantly so, for Britain (unlike France before the Revolution) was growing in pride and power, and producing real-life heroes such as General Wolfe, Clive of India and Lord Heathfield. Curiously enough, two of the most successful artists in this line were American-born painters who settled permanently in Britain. Benjamin West (1738–1820) actually pioneered the 'modern' historical picture with his *Death of Wolfe* (1771), and became such an established figure in British society that he eventually succeeded Reynolds as president of the Royal Academy. John Singleton Copley (1738–1815) arrived in Britain much later in life than West, but made his name there with *The Death of Chatham* (1780) and *The Death of Major Pierson* (1783). Both painters also tackled subjects from the more remote British past, often working from quantities of more or less accurate historical research. The results are hardly great art, but they undoubtedly broke fresh ground.

Sentimental village scenes and contemporary history paintings were indications of a new freedom for the artist to choose whatever subjects pleased him—or pleased his patron. But the supreme position of antiquity as a subject was never shaken; in fact, even as the new subjects were becoming established, a revived Classicism was sweeping Europe.

Neo-classicism (meaning 'New-classicism') was a more antiquarian and would-be-literal version of classical art than either the Renaissance or the Baroque styles had been. It began about 1750 and soon dominated the decorative arts even more completely than painting and sculpture: the elegant interiors of Robert Adam and the jasperware pottery of

The Father's Curse, Jean-Baptiste Greuze (1725–1805), undated. Oil, 103 × 106cm (40½ × 42in). Musée du Louvre, Paris, France.
Greuze won popular acclaim at the Paris Salon of 1755 with *A Grandfather reading the Bible to his Family*, which was skilfully timed to meet the developing taste for moral-sentimental subjects. This and subsequent pictures in the same vein (*Village Bride*, *Return of the Prodigal*, etc.) were praised by Diderot and bought by an appreciative public. The combination of well-observed detail and glossy unreality looks forward to the anecdotal 'academic' art of the Victorians.

Josiah Wedgwood, for example, were outstanding examples of Neo-classicism. In reaction against the frivolous Rococo, Neo-classical decoration was dignified to the point of severity. Its creators aspired to a new seriousness, also reflected in Neo-classical painting and sculpture.

Part of the impulse was provided by new finds at Pompeii and Herculaneum, the Roman cities buried under the lava of Vesuvius in AD 79. These made possible a larger view of Roman art, which the German critic Johann Joachim Winckelmann (1717–68) made the basis of his theories about ancient Greek art (at that time more prestigious but much less in evidence than Roman art). Winckelmann's celebrated (though only partly correct) description of Greek art, 'noble simplicity and calm grandeur', became the ideal of all Neo-classical artists. Appropriately enough, Neo-classicism was born in Rome, where Winckelmann took up residence in 1755. There he met and deeply influenced Anton Raffael Mengs (1728–79), a fellow-German painter who became the leading exponent of Neo-classicism in its first phase. A Scots painter, Gavin Hamilton (1723–98), was also a member of Winckelmann's circle in Rome, and painted some of the earliest Neo-classical pictures.

Neo-classical art—intellectually conceived, ambitious, trusting to draw strength from the grandeur of antiquity—was Reynolds's Grand Style *in excelsis*; but was also frozen to death. Pursued for their

The Sabines, Jacques-Louis David (1748–1825), painted 1799. Oil on canvas, 385 × 522cm (150 × 210in). Musée du Louvre, Paris, France.

A splendid set-piece demonstrating David's mastery of the dramatic

This is not the rape of the Sabine women – carried off by the Romans, who were short of women for their newly-founded city—but its sequel in the Sabine attack on Rome. The Sabine women, now mothers, intervened between their kin and their husbands, holding up their children to try and stop the fighting. In the foreground Romulus himself is prevented by his wife from killing her father, the Sabine king Tatius.

own sakes, noble simplicity and calm grandeur became synonymous with a lifeless dignity. Neo-classical sculpture is particularly frigid, doubtless because the Roman models were available to inhibit all trace of originality; whereas Roman painting was so little known that Neo-classical painters were at least forced to invent the 'rules' they were supposed to follow.

The British Neo-classical sculptor John Flaxman (1755–1826) had a European reputation until he was eclipsed towards the end of the century by the Italian Antonio Canova (1757–1822). In his day, Canova was regarded as a virtuoso comparable with Michelangelo and Bernini. Although posterity has not upheld this judgement, Canova, like some other Neo-classical artists, did later draw a certain vigour from contact with the real epic splendours and miseries of the Napoleonic era at the beginning of the 19th century.

Neo-classical painting took its subject matter from Greece and Rome; but its 'classical' style was suggested by ancient wall reliefs and (then-) modern notions of seriousness. Neo-classicists used clearly drawn outlines, dull colours and a flat relief-like treatment in an attempt to achieve severe, heroic effects. The contrast between Tiepolo's sunlit, heaven-ascending hosts and Mengs's rather dull, heavy 'eye-level' scenes is all the more piquant in that the two men were rivals in Spain during the

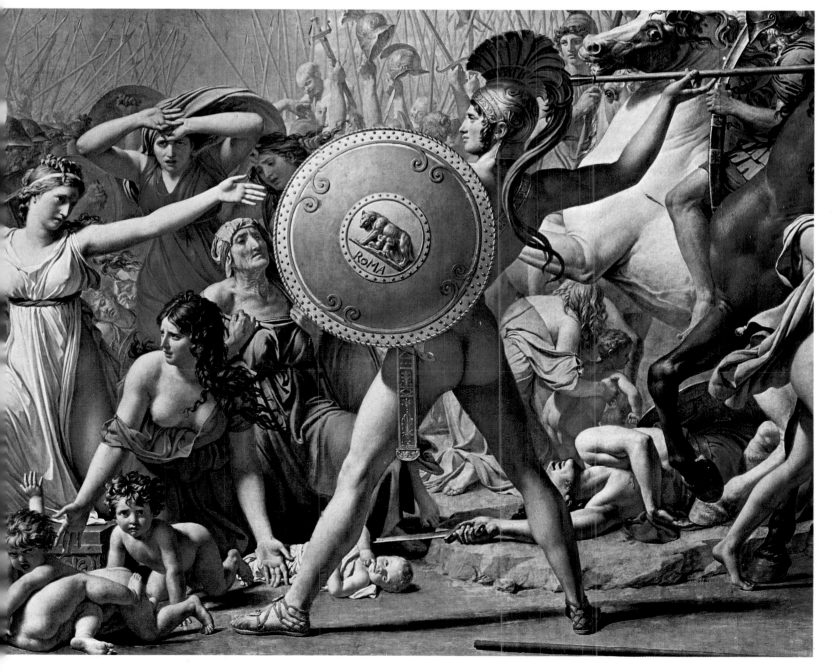

1760s, employed by the crown on projects of much the same kind.

Although Neo-classicism had a very long run—in a more or less debased form it lasted well into the second half of the 19th century—it produced only one artist of genius: Jacques-Louis David (1748–1825). David's teacher was another once-celebrated painter, Joseph Vien, who diluted his Neo-classicism with mildly sentimental-erotic touches. David himself was not converted to Neo-classicism until after he had won the French Academy's coveted Rome Prize (1774), which enabled him to study in the city. The Neo-classical style he developed in the 1780s reached a sudden climax of power and success in *The Oath of the Horatii* (1785), which was exhibited with enormous acclaim, first in Rome and later in Paris. *The Oath of the Horatii* shows the three brothers of Roman legend, dramatically lined up with right arms outstretched towards the three swords held up by their father; they are swearing to defend the Roman Republic although, as the spectator knows, this will involve a fight to the death with members of their own family. Its superb design, metal-cold colours and claustrophobic intensity made the picture a masterpiece; its republican conviction, exactly matching the austere mood and political unrest of the decade, ensured its popular success. For once, the Grand Style had been triumphantly vindicated by association with an equivalent grandeur of content and conviction.

The sincerity of the painter's convictions was soon to be put to the test by the French Revolution. Here, in contemporary reality, were the dramas of conflicting loyalties, sacrifice and republican virtue with which 18th-century man had previously tried to inspire himself at a distance of 1,800 years. David, at least, threw himself into the fray; he became the artistic champion of the Revolution, adapting his Neo-classical style to produce contemporary history paintings such as *The Assassination of Marat* (1793). After the fall of Robespierre, David was imprisoned for a time as one of the partisans of the 'sea-green Incorruptible'. Later still he became a worshipper of Napoleon and eventually first painter and artistic dictator of the Empire, recording the Napoleonic apotheosis of his famous *Coronation* painting. After the fall of the Empire, David lived in exile in Switzerland, though he exercised a continuing influence on the arts in France through his many pupils.

Despite its variety, 18th-century art hardly touched certain areas of experience. In an age of reason and reasonableness, there was no recognized place for either the sub- or the super-conscious. Social and sociable qualities were looked for in the arts as in life—a form of psychic repression that may have something to do with the surprisingly large number of breakdowns and suicides among 18th-century creative artists. Nineteenth-century Romanticism was to make a cult of nature, solitude, strangeness, excess and the exotic; all these are foreshadowed in the 18th century—but in a minor key, tamed into a merely fanciful taste for quaint Chinese-style ornaments and furniture (*chinoiseries*), carefully landscaped 'natural' gardens, spooky pseudo-medieval tales, and mock-Gothic buildings and follies.

One equivalent of this in painting was the taste for pictures of ruins. An artist like Panini catered simultaneously for this taste and for a pious tourist classicism when he painted the ruins of the Forum. Nor was classical disguise compulsory. There was a distinct demand for *capriccios*, fanciful paintings of purely imaginary remains, or of real ones in picturesque, fictitious groupings; even the sober Canaletto painted them. The engraver Piranesi turned from popular Roman views to create a fantastic architecture that went beyond polite imaginings: his vast prisons and gloomy vaulted places can only be glimpses of the oppressed mind itself.

Napoleon crossing the Alps, Jacques-Louis David (1748–1825), painted 1800. Oil on canvas, 207 × 203cm (81½ × 80in). Musée de Versailles, France.

The French Revolution turned David from classical to contemporary history subjects. He became an enthusiastic chronicler of the Revolution and later a worshipper of Napoleon, here shown as repeating the achievements of Hannibal and Charlemagne in bringing a large army intact over the Alps; the names of the three conquerors are carved in the rocks at the base of the picture. This is the ultimate in political romanticism of the bravura-totalitarian kind: cloak flaring and steed rearing, the Chief engrosses our attention at the expense of his toiling soldiers.

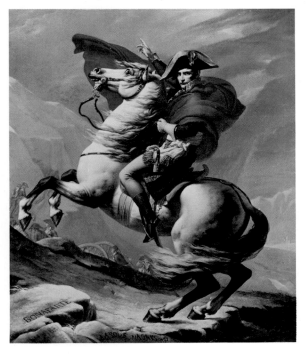

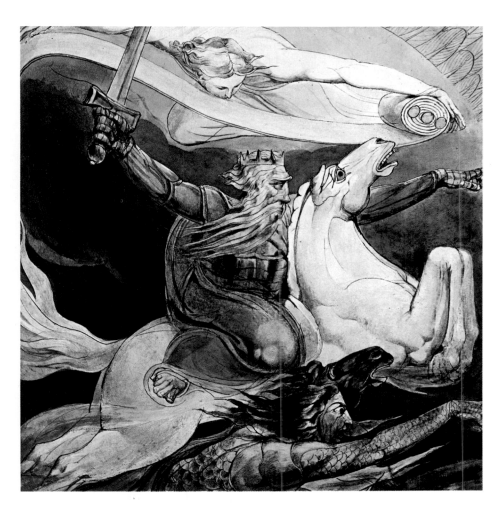

Death on a Pale Horse—The Fourth Horseman of the Apocalypse, William Blake (1757–1827). Fitzwilliam Museum, Cambridge, England.
The wild prophetic vigour of this picture is typical of Blake and indicative of his isolated position in the eighteenth century; it is unlike any other illustration in this chapter. Blake's work, both as artist and as poet, was the expression of his visionary philosophy, which peopled the universe with spirits and other unseen forces locked in titanic combat. To present this reality behind the physical world, he employed distorted forms and non-naturalistic colours; even technically he was an original, working in water-colours and tempera rather than prestigious media such as oils.

This dark side of the mind was most openly treated by the Swiss painter Heinrich Füssli (1741–1825), who settled in England under the name Henry Fuseli. Despite his years of study in Berlin and Rome, the style and subject matter of Fuseli's *The Nightmare* were deemed so extravagant that the painting caused a sensation when it was exhibited in 1782. Many of his later works were illustrations of Shakespeare and Milton; all the same, the unpleasant doll- and insect-like creatures in his *Midsummer Night's Dream* turn Shakespeare's enchanted wood into a place of sinister unease. Fuseli was by no means a great artist, but he is interesting as a figure apart in the English 18th century.

The same may be said of Fuseli's friend William Blake (1757–1827), a unique and eccentric visionary as both poet and artist. Blake ignored or denounced almost everything his own time admired—reason, sentiment, nature, antiquity, and Sir Joshua Reynolds ('This Man was Hired to Depress Art'). While earning his living as an engraver of other men's works, Blake wrote, engraved and illustrated his own poems and prophetic books, usually colouring the illustrations by hand in water-colours. In these works he created a mythology of his own; even his versions of Biblical scenes have heterocox meanings and an equivalently unusual mood and style. Realism is banished from Blake's strangely enclosed, seen-through-glass world. His extravagantly gesturing figures are apt to have the straining, distorted massiveness of Michelangelo (the artist Blake most passionately admired), or a sinuous weightlessness suggestive of medieval art. His forms and textures have a peculiarly lizard-skin or webbed quality, and his use of colour is as apparently arbitrary as revelation.

Isolated though he was, Blake was already a Romantic in spirit, believing in imagination and passion as the supreme artistic qualities ('the tigers of wrath are wiser than the horses of instruction'). With Blake, as with David, we quit the Age of Reason for an age of a very different temper.

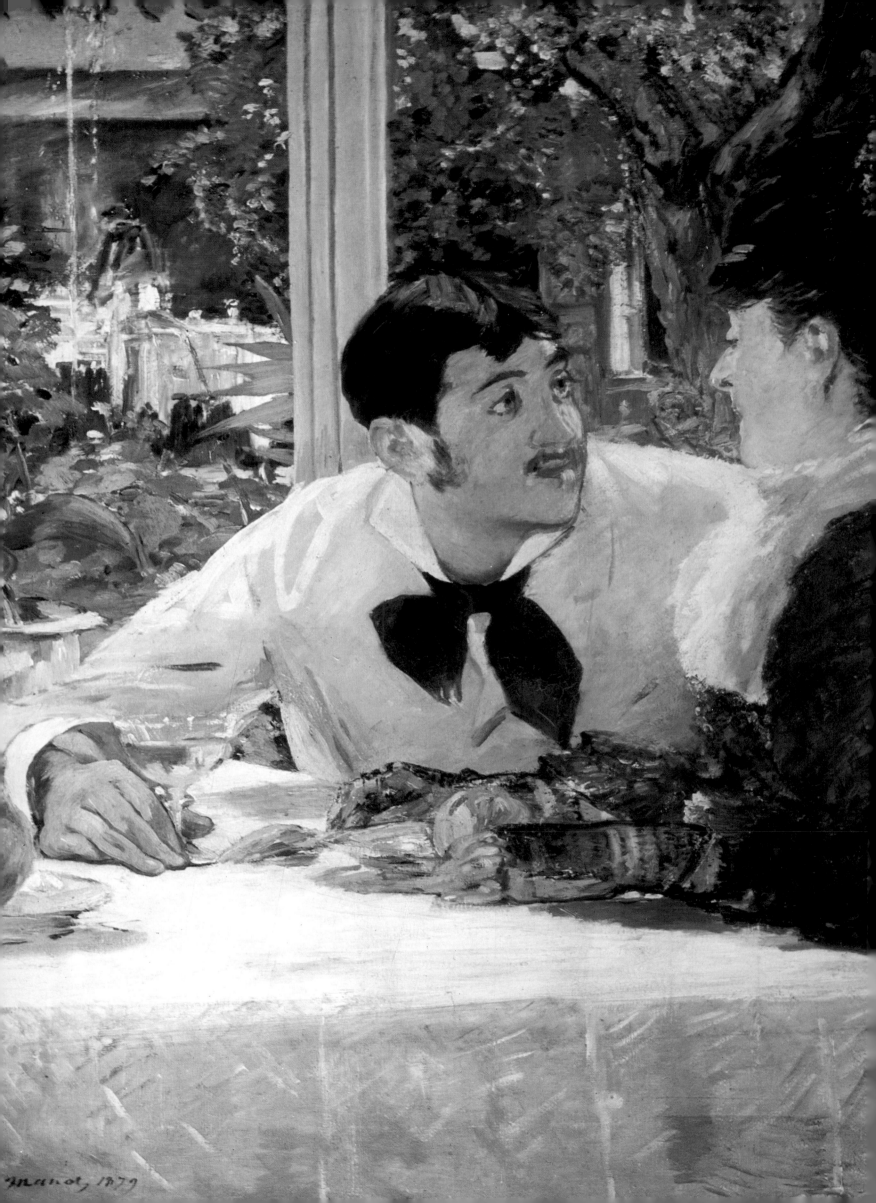

THE GRAND TRADITION
19th Century Art

During the period that now opens, European history is a story of revolutionary upheaval in political and social structure which was to transform western civilization. The roots lay in the previous century. The French Revolution dramatically upturned the conventions of aristocratic paternalism of the *ancien régime* in politics. The transformation of productive processes achieved in Britain, conveniently termed the Industrial Revolution, inaugurated the change from peasant to modern urban social structures whose most immediate impact in the realm of art was to be the rise of a new type of patron class. The wealthy industrialist was eager to invest in the trappings of culture and his taste for luxury and representational, moralizing art was a source of income to hundreds of minor talents throughout the century.

The artists themselves, stirred by the emphasis on personal sensitivity and feeling, already awakened by the 'sentimentalism' of certain mid-18th century writers and by the cult of simple humanity and the return to what was believed to have been the 'primitive' human experience inspired by the writings of Jean Jacques Rousseau, were turning to a mode of self-expressive art to be termed 'Romanticism'. The conventions of history painting were yielding to an interest in nature for itself which had its roots in early 18th century English landscape gardening and the nature poems of James Thomson; while the taste for the 'Gothick' and gloomy fantasy, already foreshadowed in the mid-18th-century *Night Thoughts* by Edward Young also contributed to the new mood. Above all, in literature, the passionate humanism of Shakespeare and Byron and the medievalizing novels of Sir Walter Scott, were to prove formative influences for artists in all fields.

At the beginning of the century John Constable (1776–1837) was a student at the schools of the Royal Academy, London. His first works were founded on Gainsborough and he learnt much from long study of Claude, Rubens and the Dutch 17th-century landscape painters. At the same time he was critical of the prevailing tradition. After return to his native Suffolk in 1802 he wrote to a friend, 'there is room enough for a natural painture'. In the years that followed he made hundreds of paintings and drawings in a systematic study of how to produce every effect of changing light and weather in the skies and the river meadows of the Stour valley. The almost scientific thoroughness of the programme was in keeping with his view that landscape painting was 'a branch of natural philosophy', what is called physics today. His father was a

Flatford Mill from a lock on the Stour, John Constable (1776–1837), painted c.1811. Oil on canvas, 24.8 × 29.8cm (9¾ × 11¾in). Victoria and Albert Museum, London, England. John's father, Golding Constable, was a prosperous mill owner; the watermills at Flatford and Dedham and the windmill at East Bergholt were favourite subjects for the painter. His oil sketches, of which this is one, are valued for the insight they give into his working methods. Here the composition is a little more careful than is usual in his sketches and the painting may have been worked up in the studio from pencil drawings.

At Père Lathuille's, Edouard Manet (1832–83), painted 1879. Oil on canvas, 92 × 112cm (36¼ × 44in). Musée des Beaux Arts, Tournai, France. (*Previous page*)
One of those rare masterpieces that seem to evoke to perfection a mood of contemporary life, this carefully posed painting was originally to have depicted a young officer and his belle. Instead, the young man who posed for Manet was the son of M. Gautier-Lathuille, proprietor of a popular cafe.

prosperous miller and John was apprenticed for a time; the work in the windmills, he said later, taught him to study 'the natural history of the skies'.

He developed a technique of revolutionary importance, but his attitudes to his profession remained traditional. Today, his brilliant sketches are as admired by artists as his large paintings but Constable considered the big set-piece works, exhibited year by year in the Academy, his real achievement. As his mastery matured they began to breathe the spontaneity of the sketches. Even so his reputation grew slowly. Academic artists expected landscape to follow conventions of composition, colour and tone and to portray elevated scenes on Italianate or Classical models, in a carefully graded pictorial world. Constable chose less elaborate subjects and worked to show the actual appearance of nature under his native skies.

The line of influence that can be traced between him and the French Impressionists later in the century, began with the showing of his picture the *Hay Wain* at the 1824 Paris Salon. It won Constable a gold medal and impressed many French artists, Delacroix in particular. Twenty years later his achievement was a major influence on the group known as the Barbizon school who, in turn, provided a model of open air immediacy in paint from which the Impressionists learnt.

Fuseli said that Constable made him reach for his coat and umbrella. The out-of-doors breath of light and movement, the almost tangible

sense of atmospheric vibration, was achieved by scattered highlights, touches of pure colour and subtle modulations of green tone. But Constable's pictures also have a dramatic unity of composition, new but unmistakable. Like his contemporary, the poet William Wordsworth, he was a deeply religious man. Of art he once said, 'painting is but another word for feeling'; of his subject matter 'willows, old rotten planks, slimy posts, and brickwork, I love such things' and of landscape painting, 'the sky is the chief organ of sentiment'.

John Constable was only the greatest of a distinguished group of English landscapists of this period. Most of them worked in watercolour which they transformed into a medium of high art. John Robert Cozens (1752–99), described by Constable as 'the greatest genius who ever touched landscape', was the senior artist. John Sell Cotman (1782–1842) produced broad wash landscapes in muted yellows, greens, browns and blues, highly prized by modern collectors. Thomas Girtin (1775–1802) worked with Turner for a time. Together they revolutionized watercolour technique by abandoning underpainting for a free style in which the colours are applied in transparent washes to a semi-absorbent paper.

Like Girtin, Richard Parkes Bonington (1802–28), who has been called the link between English and French Romanticism, died tragically young. Living and teaching in Calais, he too won a gold medal at the 1824 Paris salon. A fine painter in watercolour and oil he produced landscapes almost Impressionistic in style and influenced Delacroix who was a friend. Samuel Palmer (1805–81), probably the finest of these lesser English masters of this period, had no such continental connections.

In the year that Constable and Bonington were winning their gold medals he was pondering the impact of a visit he had made to William Blake. His sight of Blake's illustrations to the *Book of Job* had in fact determined the pattern of the next 10 years of his life. Between 1825 and 1835, Palmer and a group of friends calling themselves The Ancients, lived a simple reclusive life in the Shoreham Valley, Kent. There Palmer, working in ink and wash and occasionally in oils, painted landscapes and religious pastorals of visionary intensity. For the remainder of his long career he thrived as a successful society artist, his flagging inspiration and the promise of wealth tempting him away from his hermit like period of drop-out living. His early works were rediscovered in the 1930s when they inspired many young painters. Today they have received the accolade of the sale rooms, awarded by the Victorians to the brilliantly executed commonplaces of his middle and later years.

The Classical tradition remained strong in France. Jean-Auguste-Dominique Ingres (1780–1867), a pupil of David, saw himself as its champion and was so regarded by others. For the last 30 years of his life he was a celebrated public figure, for a time a Senator, and leader of the artistic establishment. Ingres once said: 'A thing well enough drawn is always well enough painted'. His belief that 'drawing is everything' and that colour is 'the animal in art', his attacks on Romanticism and his low regard for landscape, seem to guarantee his credentials as a Classicist in painting.

Purity of form was his watchword. But 'form' he conceived in exclusively artistic terms. He did not hesitate to distort anatomy or spatial relationships in the interests of the internal cohesion and expressiveness of the work of art itself. When he was a young man, his art was sometimes attacked as 'barbaric'; in old age he was considered a bastion of reaction. But his phenomenal mastery of drawing inspired Degas and was admired by Picasso, while his concern for the autonomy of the art object seems to pre-echo some of the attitudes of 20th-century

The Bather, Jean Auguste Dominique Ingres (1780–1867). Oil on canvas, 145 × 98cm (57 × 38⅝in). Musée du Louvre, Paris, France.
The monumental pose, simplicity of composition and the 'lost profile' of the turned figure breathe the classical inspiration which lay behind the work of Ingres. But despite the apparent restraint of treatment there is a smooth sensuality in the air. Such contradictions make it impossible to classify his work which may explain why, although admired by some of his greatest successors for his superb draughtsmanship, Ingres has never enjoyed great popularity with the public at large.

The Raft of the Medusa, Théodore Géricault (1791–1824), painted 1819. Oil on canvas, 495.3 × 685.8cm (193 × 282in). Musée du Louvre, Paris, France.
The wreck of the frigate *Medusa*, in 1815, caused a sensation in France. Géricault depicts the moment when the survivors first sighted rescue. He interviewed survivors, had a replica of the raft built in his studio and sketched corpses in the morgue. But the epic drama of this immense canvas transcends mere realistic reportage. His fascination with the extremes of human experience also led to psychologically penetrating portraits of asylum inmates.

modernism. Masterpieces such as *La Grande Baigneuse*, a weighty and sonorous composition dominated by the seated nude, her back to the spectator, are among the finest achievements of 19th-century art.

Partisans hailed Eugène Delacroix (1798–1863) as the champion of Romantic modernism. He disliked the role, considering himself in the Classical tradition. But the natural candidate for the part, Théodore Géricault (1791–1824), had died tragically young. Restless and passionate, he took inspiration from the Romantic literature of Scott and Byron. His most famous painting, *The Raft of the Medusa*, was exhibited when he was 28. Before the end of his short life, Géricault had revealed a remarkable range of interests and subject matter, from racing themes influenced by popular English sporting prints, to portraits of the insane of great psychological insight and power.

The apparent conflict between the Romanticism of Delacroix's work and his personal allegiance to Classicism was summed up by Baudelaire: 'Delacroix was passionately in love with passion, but coldly determined to express passion as clearly as possible.' The painter's themes certainly reflected contemporary Romantic concerns. The early masterpieces, *The Massacre of Scio* (1824) and *Greece Expiring on the Ruins of Missolonghi* (1827), echo Byron's commitment to the cause of Greek liberation; *Liberty Leading the People* was an evocation of the spirit of the Paris revolution of 1830; and the *Women of Algiers*, based on travel in Morocco expresses a characteristic Romantic fascination with the exotic.

For Delacroix, painting was a bridge between the artist and the spectator and colour was its chief constituent. He pioneered scientific study of colour relationships in painting and used the power of related as opposed to local colour. But his close attention to form and colour reveal him as a complete master of his art in the grand tradition and late in life he received several official commissions.

Delacroix's progression from *enfant terrible* to grand old man is parallelled in reverse by the career of Francisco José de Goya y Lucientes (1746–1828). After training and travel to Italy, he settled in Madrid aged 30, designing cartoons for the royal tapestry works. His official functions gave him access to the royal collections and there he engraved copies of paintings by Velazquez and saw mezzotints of portraits by Gainsborough and Reynolds. Goya now began to paint portraits himself. His reputation grew rapidly and he received important official commissions. He was appointed a painter to the king in 1786 and princi-

pal royal painter 13 years later. When Bonaparte ousted King Charles IV, Goya continued to do commissions for the court and, when the British liberated the peninsula, painted his famous portrait of the Duke of Wellington. However, his sympathies were liberal-republican as *The Execution of the Rebels on 3 May, 1808* makes heart-rendingly clear. With the reestablishment of the corrupt and tyrannical regime of King Ferdinand VII, the by now ageing painter went into voluntary exile in Bordeaux.

For much of his 82 years Goya enjoyed prestige and prosperity. Up to his mid 40s he painted with Rococo brio and elegance; then in 1792 an illness made him almost totally deaf His art began to diverge from the optimistic expertise expected of official art and portraits such as *Dr Peral* speak of a growing insight; it is remarkable, indeed, that he continued to be employed after the famous *Charles IV and His Family* which ruthlessly depicts the royal family as hard faced, vapid and selfish. There followed the satirical etchings *Los Caprichos*. The second series of etchings, *Disasters of War* (1808–15) are a burning and fearful record of the brutalities of the guerrilla war against the army of Bonaparte. Goya was the first great artist to comment on contemporary events. The third series of etchings, *Proverbios*, reveals the fantasy which, in the decorations of his own house, called while he was alive The House of the Deaf Man, produced some of the most horrific visions in the history of art. These 'black paintings' include *Saturn Devouring his Child* and *Two Giants Fighting in a Landscape*.

Algerian Women in their Apartments, Eugène Delacroix (1798–1863), painted 1834. Oil on canvas, 180×220cm ($70\frac{7}{8} \times 90\frac{1}{8}$in). Musée du Louvre, Paris, France.
Delacroix's father, who had been a minister in the Directory government, died when he was seven; an uncle funded his training as an artist. Géricault's 'Medusa' was one of his first great inspirations, Rubens was his other great enthusiasm. He considered the *Algerian Women*, painted after a visit to Morocco in 1832, one of his chief works. Lighted and shaded areas mutually intensify the powerful surface pattern of colour. Picasso was later to paint 'variations' on this picture.

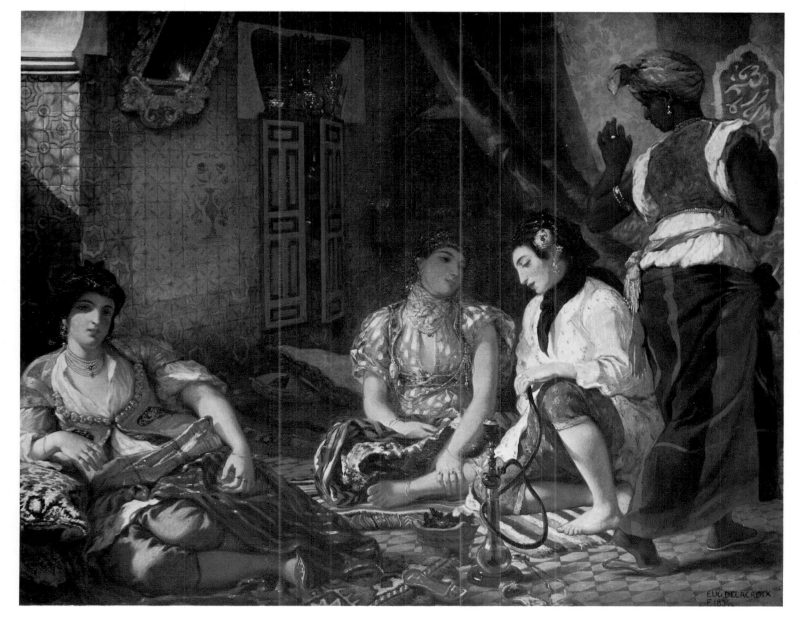

Goya's later paintings have an agitated, broken brushwork that looks forward to the Post Impressionists. His graphic art was eagerly studied by Delacroix, Degas and Daumier and, in the 20th century inspired the German graphic artist Kathe Kollwitz (1867–1945) and Picasso. Goya's transition from Rococo to macabre Romanticism is unique but his chief masterpieces stand outside classification like those of Michelangelo and Rembrandt.

Like Goya, one of the great unclassifiable originals of art, James Mallord William Turner (1775–1851) quickly won acclaim from the art establishment through phenomenal talent. When only 27 he was made a full member of London's Royal Academy and was the recognized master of architectural and topographical painting and of the techniques of the new watercolour style that he and Girtin had pioneered. He now embarked on an extensive study of former masters such as Claude and the 17th-century Dutch landscape masters and began sketching tours of Europe and Britain which yielded, over his long working life, a library of sketchbooks. A visit to Italy in 1819 inspired hundreds of works, among them Venetian scenes of breathtaking beauty and atmospheric sensitivity.

A reclusive and eccentric genius, loved by his close friends but remote from the public at large, Turner nevertheless filled a number of large-scale commissions for wealthy patrons. From the mid 1830s his devotion to the sun and the depiction of the effects of light became almost obsessive. He was the embodiment of the Romantic passion for the energies of nature and the 'feel' of the natural world. In his 60s he

Snowstorm: Hannibal and his Army crossing the Alps, Joseph Mallord William Turner (1775–1851), exhibited 1812. Oil on canvas, 144.8 × 236.2cm (57 × 93in). Tate Gallery, London, England.
Both subject matter and scale would seem to place this work in the academic tradition of history painting, but the swirling drama of the scene comes entirely from the turbulent genius of Turner. In it he drew on his journeys in the Alps, his observation of storm scenes in England and compositional techniques used in his sea pictures. During the production of this superb whirlpool of a picture, he was also working on pastoral English landscape scenes.

The Execution of the Rebels on 3rd May, 1808, Francisco de Goya y Lucientes (1746–1828), painted 1815. Oil on canvas, 266 × 345cm (104½ × 135½in). Prado, Madrid, Spain.
The rebellion had been against the regime imposed on Spain by Napoleon's marshal, Murat. The horrors of the guerrilla war which followed and the French repression profoundly affected Goya. This picture is on the scale of an academic history painting, but the mood is not in any way heroic. The desperate and helpless victims confront a firing squad of machine-like, and to the spectator faceless, agents of tyranny.

had himself lashed to the mast of a ship in a storm. It has been said his work 'looks beyond Impressionism and Expressionism in its vehemence and technical freedom'. He studied the science of optics as related to colour and unremittingly experimented with and expanded his mastery of paint. In works like *Snow Storm*, the subject on the canvas is lost in swirls of paint as the ship at sea was hidden by the storm. An exhibition of his work in 1870 influenced Monet and Pissarro, another at the Venice Biennale of 1948 impressed many young non-figurative artists of the post-war generation.

It was round about the middle of the 13th century that, in France and in England, there arose the belief that importance in art comes along with innovation, and that there is a struggle between the academic and the *avant-garde* which in the end is won by the innovators. In England, the paradigm of such a conflict between the progressive and the conservative, between the academic and a new spirit, was in the Pre-Raphaelite movement. The Pre-Raphaelite Brotherhood had been formed in 1848, three years before Turner's death; and the young artists who made up this little band, mostly students from the Royal Academy schools, had no interest in his art. Nature they revered: but landscape painting—'the old mistress' as they jeeringly called it—they found merely boring. They looked to the world of the present, in some respects: their art is one of social action and emotion, depicting modern life and its problems. But they had also a visionary side. While John Everett Millais (1829–96), William Holman Hunt (1827–1910) and Ford Madox Brown (1821–93) painted realistically, and prided themselves on doing so, Dante Gabriel Rossetti (1828–82) and his follower Edward Burne-Jones (1833–98) were attracted to the illustration of medieval subjects taking their inspiration from such sources as Dante and Arthurian legend.

Pre-Raphaelitism was not, therefore, a concerted or unified movement. But all its first adherents had the impulse to reject the authority of the Royal Academy and the weight of the old-master tradition. They painted outdoors, observing nature realistically rather than formulaically and used no studio props. They looked to poetry and romance and tried to imbue their pictures with a freshness of vision. Sometimes this determination to start anew could produce startling results. Millais, the most talented of the company, is a unique example of an artist whose precocity formed a style rather than imitated one. All artists, we know, work at first in borrowed styles. But if we look at the young Millais it is difficult to point to any previous artist that he admired. His first Pre-Raphaelite paintings, *Christ in the House of his Parents* and *Lorenzo and*

Ophelia, Sir John Everett Millais (1829–96), painted 1851–2. Oil on canvas, 76.2 × 101.6cm (30 × 40in). Tate Gallery, London, England. (*Right*)
Based on the description of the drowned, mad Ophelia in *Hamlet*, this painting was a startlingly original work in its unconventional subject matter, the necessarily graceless pose of the girl, and the vivid and detailed representation of the beauties of an English hedgerow.

Monna Vanna, Dante Gabriel Rossetti (1828–82), painted 1866. Oil on canvas, 88.9 × 86.4cm (35 × 34in). Tate Gallery, London, England. (*Opposite*)
Paintings like this one, bought by a banker, ensured Rossetti's reputation with London society. It has been estimated that during the 1860s and 1870s his annual income was more than £3,000, up to ten times that of a successful professional man.

The Last of England, Ford Madox Brown (1821–93), painted 1855. Oil on panel, 82.6 × 74.9cm (32½ × 29½in). City Museum and Art Gallery, Birmingham, England. (*Below*)
In the artist's words this painting, occasioned by the departure of Thomas Woolner, one of the Pre-Raphaelite Brotherhood, for Australia in 1852, 'treats of the great emigration movement, . . . culminating . . . in 1852.' 'To ensure the peculiar look of *light all around* . . . on a dull day at sea, it was painted . . . in the open air on dull days.' It epitomizes Brown's social concern and dedication to realism.

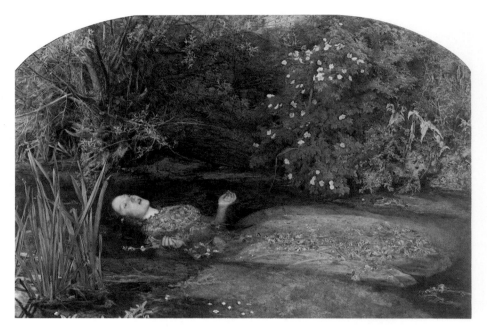

Isabella—naturalistic symbolism attached to a Biblical story and an illustration of Keats—must have reminded those who first saw them more of early Netherlandish art than of anything else. But that comparison is still rather remote. They were new and were made to look new. The paintings are compositionally lax or stilted but the virtuoso precision of the brushwork, the accumulation of detail, and above all the highly-pitched colour—Millais refused to work in an academic manner from darks towards lights—make them so bright and newly-minted, as to appear genuinely revolutionary.

One of Millais's early paintings is of great significance in the 19th-century evolution of naturalistic painting. This is *Ophelia* of 1850. It quite plainly has little to do with the illustration of *Hamlet*. One is scarcely reminded of the clammy atmosphere of Shakespeare's play but rather, struck by the singular inversion of its pictorial method. For here is the first English landscape painting—if it can truthfully be called a landscape—in which the horizon line has been eliminated. Millais has tilted the plane of his picture to make us look down on his subject. We cannot see the sky, although we are aware of it, since its blue is represented by reflections in the water at the lower part of the painting.

By taking out the horizon line Millais eliminated aerial perspective. Nearly all of his outdoor pictures are similarly enclosed. They are painted with almost fanatical reverence for natural fact, but sky is visible in them. He understood that his pictorial method would not allow him to paint atmospheric effects, or the picture would necessarily become vague just when he wished it to be always precise. His Pre-Raphaelite brother Holman Hunt also realized this. The consequence for his art was that his outdoor pictures are most often painted by night. The most famous example is his religious painting *The Light of the World*, in which Christ, carrying a lantern, emerges from darkness to knock at a door which we are to understand represents man's soul.

This may seem mawkish but the Pre-Raphaelites were not at all abashed to paint the simple problems of the soul. Indeed, Victorian taste called out for such subject matter. If the Pre-Raphaelite artists were at first rejected by the Royal Academy that had nurtured them, their popular success followed hard after. Their paintings sold for large sums of money and they had many followers. By the mid 1850s there was a standard representational style that owed much to their example. Practically all such paintings are now thought vulgar. In Victorian England the impulse to make high fine art—and this was certainly the

Bonjour, Monsieur Courbet!, Gustave Courbet (1819–77). Oil on canvas, 129 × 149cm (50¾ × 59⅝in). Musée Fabre, Montpellier, France.
Courbet depicts himself in the no-nonsense working clothes of an artist bent on exploring the world, being greeted by two fashionably dressed gentlemen. Both in subject and treatment it is a manifesto of a controversial artist who believed that painting should be 'the representation of real and existing things' and should 'interpret the manners, ideas and aspect of our own time'.

ambition of the young members of the Pre-Raphaelite Brotherhood— could very readily turn into its opposite, a willingness to supply the tastes of the bourgeoisie. This was Millais's comfortable fate. His decline as a painter was so obviously linked with his increasing public appeal that his career established another paradigm of modern art: that of the artist who betrays the integrity of his art for money. Ruskin did not hesitate to call Millais, once his friend, 'the Judas of the movement'.

By contrast, Rossetti typifies a truer kind of modern artist, faithful to his own vision in the face of every deprivation and humiliation. Rossetti was a bohemian and a private artist. The public face of Pre-Raphaelitism soon returned to the academic. What was shown at the Royal Academy was a neutral, moralizing realism with little inherent value as art. Rossetti never exhibited there and his art was known only to a select (but ever growing) number of friends and *cognoscenti*. Rossetti's quasi-mystical pursuit of the beautiful, symbolized in the form and features of dark, idolized women, brought him a reputation that was correspondingly arcane. In the end this was perhaps to his advantage.

Rossetti had one main disciple, Edward Burne-Jones who learnt much of what he knew of art from Rossetti. Yet he broadened Rossetti's vision, refined his drawing, lightened his palette and introduced motifs from the old masters. Burne-Jones led on to Aubrey Beardsley, and to much else, and so this non-realistic, poetic kind of art turned out to be the

dominant strain in Pre-Raphaelitism. Its reputation grew among artists both in England and in continental Europe for half a century after Rossetti first began to draw. It was a major influence on Symbolism, and its etiolated forms may be discerned in the arts and crafts movement, in Art Nouveau, and even in the progressive artistic milieu that produced, in Spain, the young Picasso.

In Germany there was a group of artists, the Nazarenes, whose aims were in some respects similar to those of the English Pre-Raphaelites. The Nazarene movement in fact anticipated Pre-Raphaelitism, for its leading members, Friedrich Overbeck (1789–1869) and Franz Pforr (1788–1812), turned for their inspiration to the Italian primitives (and Dürer) as early as 1809. Others joined them, for they had an attractive programme. They led a romantic search for purity in art, full of a desire to reanimate the soul of the German nation, and they felt that to be an artist was a religious mission. These admirable aspirations, however, could not guarantee the quality of the work they produced. The Nazarenes can hardly be said to have contributed much to the storehouse of earthly wonders but they have some significance in the history of 19th-century primitivizing. They inaugurated the idea that when there was something grand to be done the artist should look back to the simple, 'pure' founts of the early Italian Renaissance, when art was produced in happy concert with a society that had not yet been inflicted with rationalism, industrialism, and other modern ills. Such emotions may appear simple-minded but they were common enough, strongly felt, and they often had some kind of public acceptance. For that reason the Nazarenes attached much importance to fresco. Pre-Raphaelitism too was haunted by the vision of a revival of fresco painting. In France, the important painter Puvis de Chavannes (1824–98) based his career on an art that was often destined for such places as town halls; great fresco-like paintings that have national themes but whose pictorial inspiration is in early Italian art.

Large paintings that have a public-spirited purpose declined in number and importance as the 19th century progressed. The same is not true of sculpture and architecture. From the point of view of a lover of

Dardagny Morning, Jean Baptiste Camille Corot (1796–1875). Oil on canvas, 26 × 47cm (10¼ × 18½in). National Gallery, London, England.
Although in his old age the most renowned landscape artist in France, Corot took some years to become accepted. He visited the Paris Salon of 1824, where John Constable was exhibiting, and travelled in Italy. His paintings, often done direct in the open air, were admired by the Barbizon painters and Corot himself was a generous admirer and friend of the Impressionists.

Bystanders, Waiting at a Station, Honoré Daumier (1808–79), painted c.1858. Oil on canvas, unfinished, 59 × 115cm (23¼ × 43½in). Musée des Beaux Arts, Lyons, France.
It was once suggested that the scene showed a group watching some incident during the Revolution of 1848. Many of Daumier's paintings remained as sketches and others were unfinished. During much of his career a contract with the magazine *Charivari* demanded two lithographs a week from the artist. He generally worked on these graphic works at night to leave the daylight hours free for painting. The number of his paintings is uncertain; there were forgeries during his lifetime and in other cases his sketches were worked up and finished by other artists who sold them as original, complete Daumiers.

art, their importance is merely factitious. There is a forced grandeur in the art that celebrates, for instance, the founding of a new state such as Belgium. Belgian art—like official art in Spain, Italy or England—betrays provinciality, not national aspiration. The more that paintings insist on the latter the more they give evidence of the former. It took many years before this lesson was learnt. To only a very select few was it apparent that major art, in the mid 19th century, could not be made by following the formulae of previous major art. It was clear that the classical tradition had run dry and attempts to revivify it by reference to periods antecedent to the classical Renaissance were artificial. It was not the case that Italy was the *fons et origo* of all that was true in art. Increasingly, from the mid century onwards, France—or, rather, Paris—was the heart and centre of all that was genuinely achieved.

The ascendancy of Paris from the mid 19th century to the German occupation provides one of the most majestic sequences of innovation and mutual inspiration, of example and achievement, in all art. There was not, of course, one steady path through the early School of Paris. In a great artistic period there never is—the art will be too various and too lively for that. But in Paris we can see a complex tradition that links the Barbizon painters with the Impressionists, that connects Courbet and Manet to the old masters, that produces the overflowing genius of Renoir and Monet, that is considered and massively extended by Cézanne, developed by such as Gauguin and van Gogh, corrected by Seurat; and which was spread from Paris throughout Europe and to America by all who felt its authority.

It is perhaps Courbet (1819–77) who most exemplified the new French artist of the 19th century; a painter sure of himself and his mission, proud, resolute, not to be patronized, impossible to ignore. Gustave Courbet came to Paris from Ornans in 1839. His earliest paintings already showed his independence of spirit, for they were in a Spanish Baroque version of Romanticism. His obstinate career before the public eye really began in 1850, when he exhibited at the Salon, the one important rendezvous and showing place for all new painting, his *The Stone Breakers* and *The Burial at Ornans*. They were sensational, and his art was always to be controversial. For Courbet was not only a master painter who yet could often disregard the conventions of painting: he was also a man of the left. A contemporary wrote that he was 'the great subject of conversation in the artistic world . . . they make out that he was a joiner's or stonemason's assistant who, one fine day, was impelled by his genius to start painting and produced masterpieces straight off. Others say he is a frightful socialist and that you can tell from his pictures that he is a wild man and the chief of a band of conspirators'.

From that day to this, people have said much the same sort of thing

about original art. In Courbet's case, the aura of this quotation had some truth to it. He would have been happy to learn that there were bourgeois who considered his art to be a threat to society. He himself was plain about his artistic aims—he was a realist. What this meant, and what it means today, is a complex question. The meaning of the word is as flexible as the number of people who employ it but it points to a central concern of 19th-century art. If there was one leading trend in the art of the last century it was in the desire to make painting give a truthful representation of the natural world. Asked to paint angels, Courbet replied that he could not—'show me an angel and I will paint one'. The realist impulse was as strong in England as in France, and was there fortified by the immense authority of Ruskin. His advice to young painters was that they should 'go to nature, selecting nothing and rejecting nothing' and he went as far as to say that an artist could not paint well unless he loved nature more than that which mirrored it, art. Artists themselves were not so simple-minded. In 1855, at much the same time that Ford Madox Brown, in England, was producing such markedly realist—but also symbolic—works as *The Last of England* and *Work*, Courbet organized his own one-man exhibition. This was an innovation in France as it was in England where Madox Brown also organized a one-man exhibition. Courbet exhibited a painting which he

The Angelus, Jean François Millet (1814–75), painted 1855–7. Oil on canvas, 55.6 × 66cm (22 × 26in). Musée du Louvre, Paris, France.
This is only one of Millet's numerous studies of French peasant life. The realism of his observation has been thought to be marred by moralizing sentiment and his technical handling of oil paint was sometimes faulty. His considerable talents are more fully revealed in his drawings and etchings. This famous painting changed hands several times before being sold to an American in 1889. It was bought back for France by a wealthy merchant in 1909.

Arrangement in Grey and Black Number 2: Thomas Carlyle,
James Abbot McNeil Whistler (1834–1903), painted 1872–3.
Oil on canvas, 171 × 143.5cm (67½ × 56½in). Glasgow Art
Gallery, Glasgow, Scotland. (*Right*)
Massachusetts born, Whistler settled in London. A brilliant
and controversial figure, in 1878 he won libel 'damages' of
a farthing against John Ruskin for the critic's attack on his
Nocturne-Black and Gold, but the costs bankrupted him.
'Arrangement Number 1', companion to the 'Carlyle', was
the famous portrait of Whistler's mother. The butterfly was
his signature emblem.

Miss Lala at the Circus Fernando, Edgar Degas (1834–1917),
shown at the Impressionist Exhibition of 1879. Oil on
canvas, 117 × 78cm (46 × 30¾in). National Gallery, London,
England. (*Below*)
Degas himself spelt the artiste's name both 'Lala' and 'Lola'.
His admiration for the skills and fascination with the life of
circus performers was considerable. Shortly after this
picture was completed Edmond de Goncourt published his
novel *The Zanganno Brothers.* We are told that Degas sang
the book's praises 'to all his friends'.

regarded as something of a manifesto, *L'Atelier du Peintre,* which he
subtitled 'An Allegory of Realism'. However, although the painting
contains recognizable characters who represented Courbet's beliefs and
attitudes towards the world of the day, it is still enigmatic. It raises many
questions about Realism. If Realism was real enough what need had it of
allegory? Is not allegory in itself unrealistic? Neither Courbet's art, nor
any art that followed it, could in fact explain away that the nature of
reality and the nature of art are two different things.

Realism is not a constant in art, as Ruskin wished to believe. It was a
period style, plus an attitude of mind: and as a period style it was per-
haps more fragile than most. The attempt to transcribe contemporary
reality was not long a vehicle for art of the highest quality. Curiously,
some of the energy of Realism, some of its urgent desire to deal with
matters of the day, turned into caricature and cartooning. There was
much of caricature in Ford Madox Brown, even in a grave picture such
as *The Last of England,* and in France there was one artist, Honoré Daum-
ier (1808–79), who was at once a caricaturist, a jobbing lithographer,
and an artist of the first order. Something of Daumier's popular art was
thereafter absorbed in the traditions of fine art, but his was an excep-
tional case. It was becoming general for fine art, however much it may
have wished to be popular, or to reflect the popular, to separate itself
from the culture at large. An artist with populist themes was Jean-
François Millet (1814–75), born of a Norman peasant family and all his
life a painter of peasant subjects. By nature conservative, he painted
with little thought of political reform. His art was more at the service of
the constant reiteration of the sombre emotions aroused by the endless
cycle of sowing, tilling and reaping by peasants who lived on the soil in

which their forefathers were buried. Millet's most celebrated painting is *The Angelus*. It is a direct recollection of his grandmother's simple devotions in the fields at evening time, yet there is much in the picture that is indirect and is artistic. It brings Millet close, for instance, to that symbolist current in 19th century painting whose meaningfulness was intended to express all that is least easily grasped in our understanding of the world.

The very familiarity of *The Angelus*, so often reproduced in the context of cheap religious literature, makes us the less able to see the painting for what it is. Salvador Dali was fond of mocking at it—just as Marcel Duchamp mocked the *Mona Lisa*, which became the most famous painting in the world only during the late 19th century Symbolist period. But Millet should not be underrated. It is worth remembering the admiration that, in their different ways, Seurat and van Gogh had for him. This said, it must be admitted that to see Millet's art in quantity is to feel that Impressionism—diverse, energetic and secular—was badly needed. Again, the very familiarity of Impressionist painting makes us forget too easily what variety and wonderful surprises were now brought into art. Impressionism was not much heedful of the portentous aspects of Millet's painting and the too brusquely argumentative nature of Courbet's. For Impressionist painting is very purely *painting*, and is so in a way that had not been seen in art beforehand. It was not made at the behest of any social, political, or religious programme. It had, on the whole, singular freedom from any concerns other than the purely pictorial. And thus we find a corresponding freedom in ways of painting, in the very nerve-ends of painting, the way that paint is put down on the canvas. There are more ways of applying pigment in Impressionist art than there had been among any previous group of artists. Impressionist painting existed for delectation: sometimes, it seems, almost

Olympia, Edouard Manet (1832–83), painted in 1865. Oil on canvas, 130 × 190cm (51¼ × 74¾in). Musée de l'Impressionisme, Louvre, Paris, France.

In this picture, as in the famous *Déjeuner sur l'Herbe* Manet deliberately took a famous classic painting as his model; in this case it was Titian's Venus. Inevitably critics and public were outraged at the presumption of a modern taking liberties with the classics. But Manet did not consider himself a revolutionary and though much admired by the Impressionists never exhibited with them.

self-consciously entirely for its own delectation.

For that reason Impressionist art was especially annoying to the guardians of official culture, and the history of Impressionism is sadly bound up with official opposition, with the artists' poverty, with their struggles to have their work shown and to have it seen on its own terms. This history of Impressionism as a movement is complicated, for one must trace in it both the communal history of the group and the careers of individual artists. The first meetings were between Claude Monet (1840–1926), Pierre Auguste Renoir (1841–1919), Alfred Sisley (1839–99) and Fréderic Bazille (1841–71), who had all been students together. Apart from their friendship, they had in common an appreciation of the art of Edouard Manet (1832–83). His one-man exhibition of 1863 was exemplary to them. These painters formed friendships with Manet, and also with Camille Pissarro (1831–1903), Paul Cézanne (1839–1906) and Edgar Degas (1834–1917). Pissarro, Monet, Renoir, Cézanne and Sisley were rejected by the Salon in 1873. In the following year they determined to exhibit together, independent of the Salon. From the title of one of Monet's paintings in that show, *Impression: Soleil Levant*, they were dubbed with their collective title. There were seven **more** Impressionist exhibitions thereafter, the last of them held in 1886.

Just as Manet's art was the first example to these painters, **so does he** (with Cézanne, the other of the two greatest painters of early **modernism)** stand somewhat apart from them. In part this was due to his seniority; in part it was a difference in personality, for Manet was a dandy rather than a bohemian. He did not exhibit with the Impressionists but persisted, with unequal success, to look for a home for his art in the Salon. Manet was more convinced than any Impressionist that his art was equal not only to that of the Salon artists but to the old masters as well.

Montagne Ste Victoire, Paul Cézanne (1839–1906).
This landscape, which Cézanne painted no fewer than sixty times, inspired him to his profoundest insights into the nature of geological structures and their effect on surface appearances and into the significant objectives of the landscape painter. As the series of paintings advanced the forms recorded on his canvases become increasingly simplified and the underlying structures of the scene more fully revealed.

La Vieille au Chapelet, Paul Cézanne. Oil on canvas, 81 × 65.6cm (31 × 24½in). National Gallery, London, England. (*Left*)
Often billed as the father of modern abstract art, Cézanne was not only one of the most painterly of painters, but also a man with deep insight into the human condition. This picture, one of his masterpieces, is a record of his mastery in the struggle with his medium to reveal living human experience.

Gabrielle with a Big Hat, Pierre-Auguste Renoir (1841–1919). Oil on canvas.
Renoir, who once said 'If I did not enjoy painting I should certainly not do it', was little given to introspection and happily devoted to the simple pleasures of living. Although closely connected with Impressionism he also made a considerable reputation at the Salons from his middle thirties on with a number of fashionable portraits. The painterly style of his later years is well shown in this portrait of Gabrielle, the family servant.

He was a 'Louvre artist', and in his painting we see all the signs of a sensibility that was extraordinarily acute to his great predecessors. It is noticeable that these revered old masters were both Spanish and Italian: Manet had a particular love of Velazquez. However, the paintings that caused the greatest furore when he exhibited them in 1863 and 1865 were more directly linked to Italian art. *Olympia* is in the tradition of the reclining nude first perfected by Titian, and the *Déjeuner sur L'Herbe* takes it composition from Giorgione as well as a motif from Raphael. There is an element of competition in such obvious connections; there is also an element of respect; but beyond that, and more important, was Manet's desire to give his own superb painterly equipment the same formal area that had been occupied by classic art. It is the essence of Manet's art that in so doing the substantive elements of his painting took command. The paintings are in the first place *paintings*. In the facts of their pigment, their colour, their application we find the absolute assurance that bespeaks mastery rather than imitation.

Manet was not really an Impressionist in his paintings of the early 1860s and if he was a realist at all he was an utterly isolated one. By the 1870s, however, there are elements in his style which ally him to painters such as Monet. He worked out of doors, there are occasional off-centred compositional effects whose origin is in Impressionism and his palette was in general lightened. Nevertheless, it would not be true to say that he was converted to the Impressionism of younger men. From his early days to his last great work, the *Bar at the Folies Bergère* he

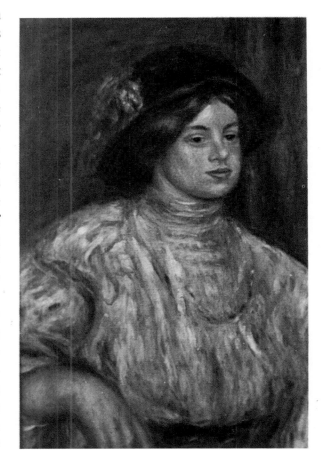

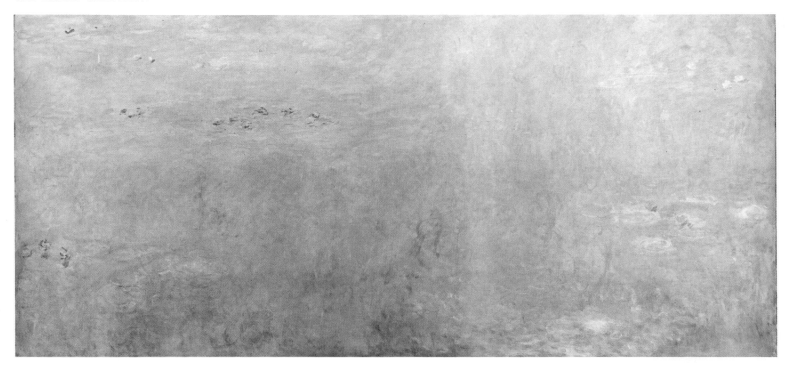

Waterlilies, Claude Monet (1840-1923). Oil on canvas, 200 × 426cm (79 × 168in). National Gallery, London, England.

When he was fifty, Monet bought the property at Giverny which was to be his home for the rest of his life and which, through a massive series of paintings, is perhaps the best known residence in the history of art. The water gardens, which Monet himself had constructed and which he called his 'outside studio', were his favourite theme. Between 1914 and 1916 he began to plan a large-scale mural of water-lily paintings, building a massive new studio for the work and, with the encouragement of President Clemenceau, offering two to the state to commemorate the Armistice of 1918. The paintings continued until Monet's eyesight finally failed. The aura of peace that pervades them is almost mystical, their vast scale and painterly qualities have been of influence on recent American and European artists.

remained so acute to any kind of painting culture that he could make very many kinds of art into his own. It is only of an artist of great stature that we can say this, and maybe only of Manet, whose position is pivotal between post-Renaissance and *avant-garde* cultures.

It was unfortunate, perhaps, for Degas, the painter of the day whose temperament was most akin to Manet's, that his reputation should be so much overshadowed by him. For he too was a major artist. It was Manet who made his ambitions more stylish (in the best sense) and more contemporary when they met by chance in the Louvre in 1861. Before that date Degas's guiding light had been Ingres, not that he ever lost sight of the classical master, as his drawing indicates. But Manet—and perhaps some of the writers who gathered around the Impressionist painters—shifted his attention from classical subjects to the original observation of the contemporary world. Degas developed thereafter his repertoire of laundresses, ballet dancers, circuses and race meetings. These were in the interests of literary reportage or social description, but were a vehicle for his pictorial sensibility. 'No art was ever less spontaneous than mine' he claimed. His seemingly casual composition was in fact as superbly judged as Manet's. It was to some extent influenced by the current enthusiasm for Japanese prints and by the invention of photography but that does not explain his composition. In the end the niceties of judgement were formed by the Impressionist apprehension that the too obviously symmetrical composition of traditional art might be replaced by a structure determined by the *peinture claire* of a high-keyed picture in which light and space were as evidently made by pigment as was depicted volume.

Light and space are for many lovers of Impressionism its whole life: certainly the painting of atmosphere occupied very many of its adherents, Monet and Renoir in particular. Of all the friendships and partnerships in early modern art—later to be tragic with Gauguin and van Gogh, haughty and abstracted with Picasso and Braque—none is more touching than that between Monet and Renoir, penniless young men painting together, side by side, easel to easel, at the little riverside village of La Grenouillère in the summer of 1869. It is one of the key moments in the history of Impressionism. Monet had studied first with the delectable *petit-maître* Boudin (1824-98), who taught him to paint out of doors, and with Courbet, while Renoir had been employed in porcelain decoration. This perhaps explains the difference in approach

of the young painters as they explored the same problems of *plein-air* painting, Monet the more aggressive, Renoir the more graceful and attendant to nuance. In his novitiate Monet had been more taken with Manet than had Renoir. His early masterpiece, *Women in a Garden* of 1867, is evidently so much indebted to Manet that it could not have been painted without him. Yet even in that picture there is something about the play of light, in patches, dabs, movements and rhythms, that announces that Monet was always to be a painter of landscape, and of quietly moving things in a landscape: clouds, rain, sunshine, water. So he was, until long after the end of the century, for Monet did not die until 1926. This gave him a longer career than Sisley, or Pissarro, or indeed any of his contemporaries, and it has seemed to give him a firmer link with the painting of our own day. For the huge canvases that he was to make, late in life, of the gardens and lily ponds at his home in Giverny have been seen as the French predecessors of American Abstract Expressionist painting of the 1950s.

Monet's latest pictures of this sort were perhaps not fully appreciated until the American art movement showed them up, made them (as it were) visible from a different point of view. The artistic movements of the late 19th and early 20th centuries are indissolubly linked, and it is often the case that the insights of the later period give us the opportunity to adjust our feelings about the earlier It is not merely the painting of Cézanne himself, for instance, that makes one so much honour him: it is the knowledge that there was so much in Cézanne that nourished the early stages of modern art. His reputation high only among artists when he was given memorial exhibitions in 1906, has widened, and not diminished, since then, yet he was little appreciated in his lifetime. Like a number of 19th-century artists of great sophistication Cézanne began his career with paintings that were deliberately rough, in a vein of wilful offensiveness not only to the Salon judges, who of course rejected them, but also to the suave and poised Manet. A more deliberate and thoughtful art followed, and was wisely supported by the benign, kindly Camille Pissarro. Cézanne's association with Pissarro was a long one, and he also respected Monet, but his feeling was that he had to disassociate himself from this nucleus of the Impressionist group. He exhibited with them only twice, in 1874 and in 1877, preferring to retire to his native Aix to continue what he called his 'researches'. The infinitely patient years of pictorial exploration cannot easily be described in simple words, and some of Cézanne's most famous *dicta*, that he wished to 'do Poussin over again from nature' and that nature might be understood in terms of 'the cylinder, the sphere, the cone, everything in proper perspective' have given the impression that his intelligence was formulaic. This was not so. He was the most sensitive of painters and the most attentive to the way that one single stroke of the brush could alter the complexion of an entire picture. Everyone who knew him felt that one single brushstroke could have all of Cézanne in it. Renoir said 'all Cézanne has to do is to put a touch of colour on a canvas and it becomes interesting; it's nothing and yet it is beautiful'. Renoir was trying to express how wholly a painter Cézanne was. The Master of Aix's intelligence, Renoir knew, was so utterly and profoundly pictorial that only the most dedicated of painters could comprehend him. Honour in fact came late; the dealer Vollard gave Cézanne an exhibition in 1895, but his real fame arose only after his death.

The 19th century provides many examples of artists who did without fame, who shunned it, or who revelled in it and yet were undeserving. Sometimes, merely to be an artist, or to behave in a way that was regarded as artistic, could sustain a meagre talent and propel a whole

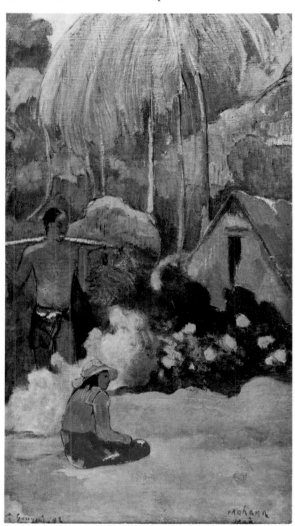

Tahiti Landscape, Paul Gauguin (1848–1903). Oil. Athenaeum Museum, Helsinki, Finland.
Gaugin's departure for Tahiti in 1891 was inaugurated at a banquet presided over by the symbolist poet Mallarme. The painter, who was to spend many years in the islands, hoped to find there a life of primitive human innocence. His canvases of this period are among the most powerful statements of the age-old myth of the noble savage, but in fact he was disillusioned by the extent to which European influence had already affected Tahitian life styles and his paintings and writings are, to an extent, fantasy reconstructions of the life he had expected.

public career. It would not be generous to say that an artist such as Whistler (1834–1903) was undeserving. Yet his success as an artist and his notoriety as an artist became intertwined, to the confusion of his audience and, ultimately, the misjudgement of art other than his own. He came from America and first introduced the Parisian *avant-garde* to London, and his early pictures have an odd air of owing something to Millais and Rossetti as well as Courbet and Manet. His figure paintings, however, the portraits of Carlyle and of his mother, are excellent. In 1878, one of his *Nocturnes*, Impressionistic paintings of the River Thames, was violently attacked by Ruskin. Whistler replied with a libel action. Nothing was settled in court about their respective artistic principles, but Whistler's wit, elegance and dandyism helped to shift public attention from works of art, which are hard to understand, to the idea of the artist, which was quite easy to talk about. English aestheticism had begun. It was a phase of cultural life that produced very little art but much attention to vague notions about art. While literary high society spoke of art, others worried about the responsibilities of art to society in general. This too was an evasion of the issue. William Morris (1834–96), a designer and writer, was the main inspiration of the Arts and Crafts movement, and its wish to combine all sorts of creative and semi-creative work into one utopian melange. In the last years of the century such feelings spread throughout Europe and were combined with the common Art Nouveau style. This was provincialism made international; and it appeared that the more that the Arts and Crafts movement flourished, (i.e. the more people were enlisted under its

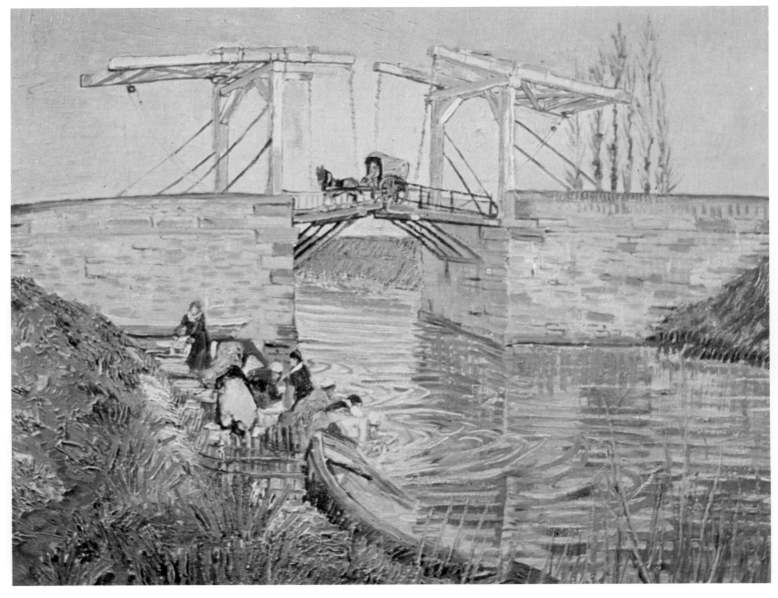

The Drawbridge at Arles, Vincent van Gogh (1853–90), painted 1888. Oil on canvas, 54 × 64.7cm (21¼ × 25½in). Rijksmuseum, Amsterdam, Netherlands.
One of the artist's best loved pictures, it dates from the brief stay at Arles in the south of France which seemed to liberate his dazzling sense of colour.

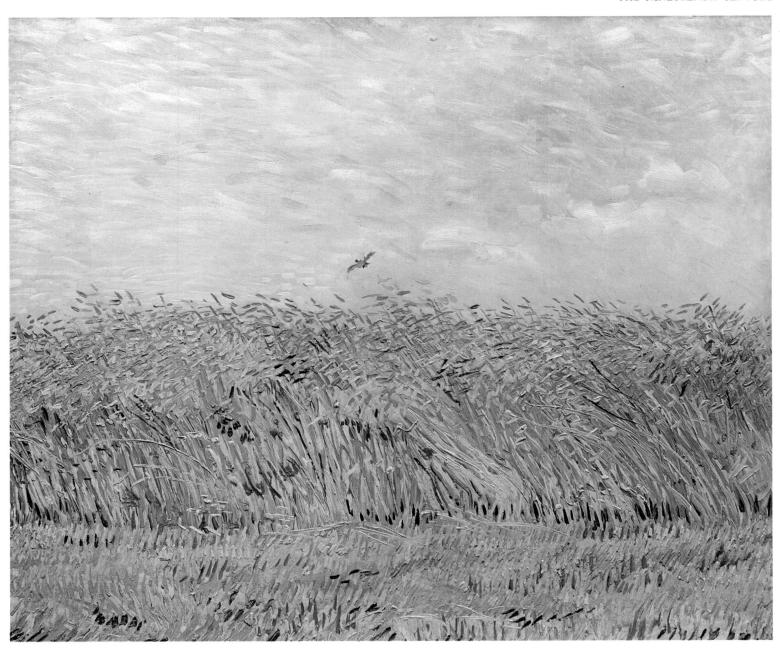

hand-woven banner) the less it was able to produce fine art.

This is not to maintain that an artist of genius could not make something quite especial out of handicrafts. Paul Gauguin (1848–1903) was one such, when he ran out of paint. His decorative wood carvings are the product of a fine artist's sensibility. Gauguin provides another example of the malign influence of artistic fame. The story of his life is so well known that it has usually diverted attention from his considerable contribution to art. One might draw attention, therefore, not to the abandonment of his life in business, but to the fact that he was the first painter to be brought up wholly within the *avant-garde* tradition, that is he had no academic training at all. He was introduced to painting by Pissarro in 1874, and Pissarro was by then an Impressionist of long standing. Gauguin showed a work (*Cézannesque*) at the fifth Impressionist exhibition of 1880 and exhibited in the three subsequent ones. After this he settled in Brittany, at Pont-Aven, where he gathered around his forceful personality a group of artists who were, by and large, the most talented of those who grew up in the wake of Impressionism. After a disastrous attempt to set up an artistic household with van Gogh in Arles, Gauguin departed for the South Seas. There he began those paintings and designs for which he will always be best known. This was a new, more radical aspect of the 19th century's search for the primitive. Rather than look to the early Italians, Gauguin, denouncing 'the disease

Wheatfield with Lark, Vincent van Gogh (1853–90). Staedlijke Museum, Amsterdam, Netherlands.
The feeling of light airiness in this picture is the measure of van Gogh's growing versatility as a landscape painter towards the end of his tragically short life. It is a far remove from the turbulent, sometimes tortured forms and swirling brushstrokes of other works in his last years.

Study for the Burghers of Calais, Auguste Rodin (1840–1917). Bronze, height 208.5cm (82in). Musée Rodin, Paris, France. (*Below*)

Rodin's famous group *The Burghers of Calais* was created for a commission by the Calais city council. It was to commemorate the heroism of a group of leading citizens who, when King Edward III of England captured the town in 1346, offered to forfeit their goods and their lives if he would spare the rest of the population. Rodin's psychologically powerful, but far from heroic, study so offended the city fathers that they refused to erect it according to his design.

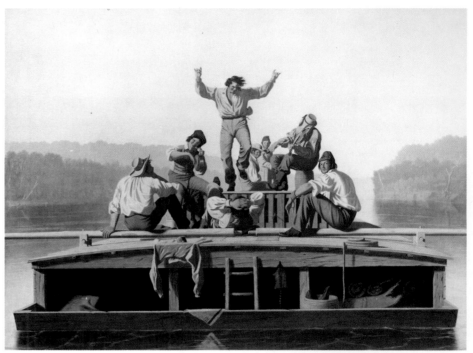

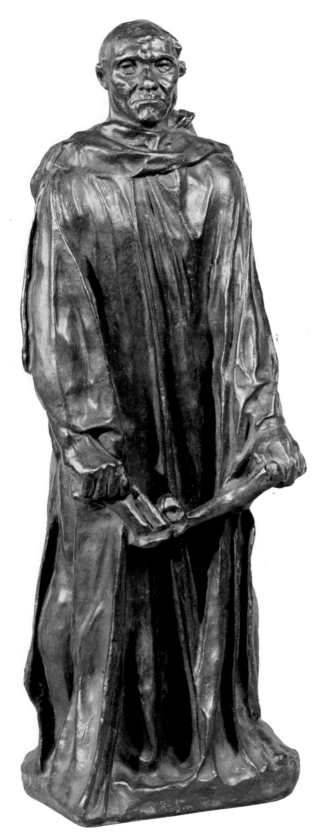

of civilization', preferred to leave Europe altogether for a life in a culture which he believed to be savage. Was this wise and if so, in what sense wise? It produced marvellous art and it killed Gauguin. Perhaps we ought to think of the paradox of primitivism in modern art. It is this: such primitivism is in fact a wild kind of sophistication, and its results must take their place in western civilization.

The life of Vincent van Gogh (1853–90) became a legend that came near to diminishing his stature as an artist. The son of a Dutch parson, he worked for a time with a firm of art dealers in The Hague, London and Paris; he worked briefly as a school teacher in London; and was a lay pastor for a time in Belgium. In 1880 he turned wholly to art, being virtually self taught. While living in Paris from 1886 he met Gauguin and proposed they found an artists' colony in Arles. They quarrelled violently late in 1888 precipitating the first of van Gogh's attacks of madness when he cut off part of his right ear. Two years later he shot himself at Auvers-sur-Oise.

But van Gogh was one of the most expert and conscientious of painters and his letters are among the greatest literary monuments in the history of art. After his arrival in Paris colour was the focus of his studies. The masterpieces which flowed from his brush after the move to Arles embody his perception of colour as a divine relation and his humble respect for nature. The brilliant, heightened colour, the simplification of form, the frenzied brushwork and thickly applied paint, produced canvases of great expressive power. During his life, the Dutch master sold only one painting. Ten years after his death his works were beginning to exert their profound influence on the artists of the early 20th century.

An almost exact contemporary of van Gogh, Georges Seurat (1859–91) played like him a decisive role in the liberation of pure colour. The preparations in sketches and colour studies for his major paintings were entirely conventional; the results were revolutionary. Basing his researches on the writings of painters like Delacroix and the work of scientists, Seurat analysed colour in nature into its constituent parts and then set these down on the canvas in dabs of primary and secondary colours. Viewed from the correct distance, these are intended to merge by a process which he termed 'optical mixture' to produce in the eye of

the spectator a vibrant reconstruction of the original colour effect. The technique was termed '*pointillisme*' or 'civisionism' and Seurat and his followers were dubbed 'Neo-impressionists.'

Like the Impressionists, he aimed at a true rendering of natural appearances but unlike theirs, Seurat's work has real monumental presence governed by his concern with composition. His death at 32 cut short developments towards still greater compositional complexity. His meticulous application of colour, determined by rigorous theory, opened to other artists new vistas of the decorative, dramatic and expressive possibilities of pure colour. His work influenced many of the group known as the Fauves.

Apart from the Neo-classical figures of the Dane, Bertel Thorwaldsen (1770–1844), greatly admired in their day, much of the most interesting sculpture of the 19th century was done by men such as Daumier and Degas, better known as painters. But at the close of the century the field was dominated by the heroic achievement of Auguste Rodin (1840–1917).

Until his 40s, Rodin was employed as a craftsman in porcelain factories and workshops but in 1877 he made a sensation with *The Age of Bronze*. The lifelike vitality of this youthful male figure was such that he was accused in some quarters of using lifecasts. But the realistic effect was achieved not by photographic representational accuracy, but by his fidelity to the feeling for the subject. Rodin was true to his material and first and foremost a sculptor. He restored to the art a respect for volume, mass and presence in space and, in the words of Sir Herbert Read, 'the rhythmical articulation of planes and contours'. Later works, like the monument to Balzac, in which the figure emerges from the stone, as if half complete in a Michelangelesque fashion, achieved a monumental union of symbolism and realism.

The Jolly Flat Boatmen, George Caleb Bingham (1811–79). Oil on canvas. National Gallery of Art, Washington, USA. (*Opposite*)

Brought up in frontier Missouri, Bingham, like many other 19th-century American artists, tried his hand at a number of jobs before taking up painting. He studied briefly in Philadelphia and worked for a time in Washington before returning to Missouri where he painted a series of carefully observed scenes of local life.

The Bathers, Asnières, Georges Seurat (1859–91), painted 1883–4. Oil on canvas, 201 × 301.5cm (79 × 118½in). National Gallery, London, England.

This painting, Seurat's first major work, has many impressionistic characteristics: concern with the surface play of light, vivid visual impact and a commonplace subject. Equally it makes clear why Seurat's work is sometimes dubbed 'neo' or 'post' Impressionist. His application of dots of pure colour derived from his scientific interest in optics and the painting has a solidity of form and composition not aimed for by the Impressionists.

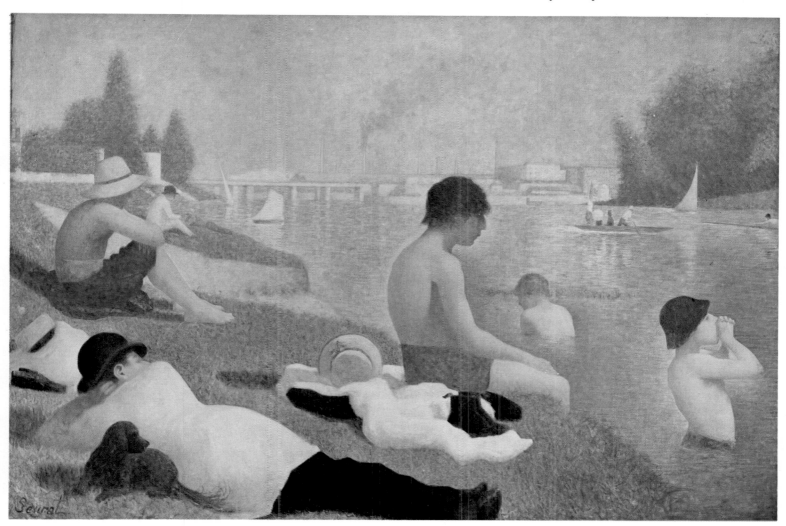

ETHNOGRAPHIC
North American Indian and Eskimo Art

The material culture of the indigenous population of North America is often regarded as synonymous with its 'art'. Art must, however, be distinguished from the crafts produced by the same people and even the same individuals, and these individuals must be identified. Their role—and the role of their art—in Indian and Eskimo society must be explained if we are to understand anything of the extraordinary florescence of Indian culture, particularly during the 19th century. Finally the materials, and most importantly the techniques employed by Indian craftsmen must be explained, both in terms of regional and cultural variation, and in terms of evolution through time.

Indian and Eskimo artists were mastercraftsmen, who excelled in the making of what were usually everyday articles, such as clothing or pottery, or else ceremonial and religious artefacts, such as masks and other items of paraphernalia. Every family and domestic group contained the craftsmen necessary to produce clothing and domestic utensils, weapons, dwellings, watercraft and many other essential items. These craftsmen differed in prestige, and their prestige depended particularly on two criteria: technical proficiency and productivity. A Sioux woman who excelled in beadwork would be well known, not only within her own domestic circle, but outside it amongst the people with whom her work was traded. In contrast to contemporary art originality in design and colour were not necessarily matters of great importance. This was firstly because, before the arrival of Europeans, technical innovation and the acquisition of new materials were things which occurred extremely gradually. Secondly within a tribal setting strict codes governed technique and colour allowing for little variation between one object and the following one. This means that it is relatively easy to distinguish different forms and decorative style of moccasins from the Plains, even though during the 19th century those produced by a single woman may have been varied to incorporate new materials as they became available. Equally it is simple to distinguish pottery styles from different Pueblos in the south west because of traditionalism. In one sense there was no need for inventiveness because everyone in Indian society could distinguish a masterworker from his or her fellow craftsmen; but there was also, particularly after the arrival of Europeans, the desire to make objects appear attractive which encouraged gradual change through the use of new pigments, paints and decorative materials.

*Navajo 'eye dazzler' rug, c.*1880, South-West United States. Wool and cotton, width 132cm (4ft 4in). Museum of Mankind, London, England. (*Previous page*)
Until the 1880s the Navajo made textiles primarily for their own use; with the arrival of the railroads, manufactured yarns and textiles appeared in the South West, so that Navajo textiles changed in both quality and design. Rugs such as this one were woven for white homes out of wool from Germantown, now part of Philadelphia, using a cotton warp. The extremely elaborate design is derived from Mexican serapes or cloaks, and employs a large variety of wools, some of which are variegated. The design is termed 'eye dazzler' because of the effect of the experimentation with bright new colours—characteristic of this period.

Every family and every tribal group was of necessity self sufficient in a high proportion of crafts; equally most objects made were entirely utilitarian. A pair of soft sole moccasins or a cedar bark blanket on the northwest coast was made for daily life and did not last long. While the form of an object was almost always primarily concerned with its function, there was imperceptible gradation away from entirely utilitarian objects. A pair of soft sole moccasins might be plain or decorated with a few strands of dyed horse hair, or, at the other end of the scale it could be beaded all over—including the soles—for use on a specific occasion. Likewise the vast majority of northwest coast cloaks were made of cedar bark without any decoration except perhaps a strip of sea otter or mink around the neck. However, other blankets, particularly those known as Chilkat blankets made by a Tlingit group in Alaska, were intricately woven from mountain goat wool with only minimal amounts of cedar bark; these were exclusively used by chiefs on ceremonial occasions. While one aspect of decoration was prestige—the Plains woman wishing to decorate her husband's clothing, or the northwest coast chief demonstrating his nobility—another was religious and mythological symbolism; this, in providing a wealth of motifs, creatures and figures, gave craftsmen the opportunity to excel in the service of higher ideals. Because of this it is very often the paraphernalia of religion, and of shamans, which is the most artistically interesting.

The range of technology open to craftsmen was limited, and it is usually the degree and excellence of decoration and craftsmanship which distinguishes individual Indian and Eskimo objects. The northwest coast carver making a mask for a chief would use the same type of adze and knife as one carving a commemorative pole or a food bowl. The food bowl would, however, be undecorated if it were for use by a commoner, but if for a chief might be carved with delicate fluting or an inherited crest in the form of an animal. The excellence of Eskimo carving was employed equally in the production of utilitarian objects such as harpoons and in those which would be ritually useful. Amongst the Eskimo of southern Alaska a small walrus ivory carving of a sea otter was often attached to a kayak as an amulet to help in the hunting of the same animal. Likewise the throwing stick, from which the dart was launched at the sea otter, was often carved with a very abstract form of the sea otter. It is this decoration of objects which distinguishes them as art from their plain counterparts. On the other hand there were always large categories of objects whose religious use precluded the existence of secular equivalents. These included masks and amulets, used for instance by shamans in curing, which might be decorated with the images of the shaman's spirit helpers. Amongst the Iroquois of northeastern Canada and New York State people who dreamt of a False Face were permitted to join the Medicine Society and to wear masks while participating in curing ceremonies. Although these masks varied considerably, they were carved within a set form limited by tradition and the dream of the individual. There were no masks for purely secular use, of course, and unlike those of the northwest coast were not part of a carving tradition which embraced every aspect of life.

The materials used by Indians and Eskimos were naturally limited to those easily available. Among the Eskimo, and on the Plains, these largely derived from animals. The caribou and bison (as the buffalo is more correctly called) provided a huge range of materials for use in every form of artefact. On the northwest coast, in Washington, British Columbia and Alaska, forest resources were, as already mentioned, of paramount importance. This is also true of the sub-Arctic areas, and of eastern North America, although carved wooden objects were substan-

Painted Mimbres bowl, c.1000–1400, New Mexico, USA. Pottery, diameter 23cm (9in). Peabody Museum, Harvard University.

Although not notably well made, the extraordinary liveliness and accuracy of the painting on this type of vessel make them one of the most important sources of information about the prehistoric South West. The design elements of Mimbres bowls centre on a white field, which may be left empty or filled with a representational design, such as the warrior with shield on this example. The border is usually in the form of a geometric design, of varying complexity, in this case being rather simple. This type of pottery is almost only known from burials.

tially augmented by bark for the making of bowls and for the covering of wigwams and canoes. In the south west and California pottery and basketry objects were, respectively, particularly important. In the last 200 years stone was relatively little used for objects that we might consider art; the most important exception to this is the carving of pipe bowls of clay stone, the most famous of which is known as Catlinite after the important 19th century painter of Indians, George Catlin. Among the Eskimo soapstone was used for making lamps—burning mammal oil—and in the last 30 years has developed into a highly original tradition of carving representative figures.

The painting of artefacts was particularly significant on the Plains where there was a figurative and a geometric tradition, in the south west where it was important in the decoration and design of pottery and dance paraphernalia, and on the northwest coast where it was used to great effect in decorating wood sculpture. In the north east and on the Plains there were three important decorative traditions. The least widespread of these was that of moosehair embroidery for buckskin and other artefacts; the Huron, traditional allies of the French in Canada adapted this aboriginal technique to include French floral motifs. The most widespread of aboriginal traditions was that of embroidery with porcupine quills; a wide range of artefacts, from birchbark dishes to clothing and pipe stems were decorated with geometric, and less frequently figurative designs in several techniques. After the arrival of Europeans beadwork employing glass beads especially from Venice supplanted porcupine quillwork as the predominant decorative technique. Beadwork was used on every conceivable type of object, even in California as a means of decorating baskets. To some extent, however, glass beads supplanted aboriginal shell beads. Metal was little known before the arrival of the white man, although there were sources of native copper in the Arctic and Great Lakes area which were widely traded. The aboriginal trade routes were an important aspect of raw materials, but only for scarce or luxury items. The best known of these is Catlinite, the red pipe stone widely traded by the Sioux; two other important articles of trade were abalone and dentalium shells which were traded far inland for decorative purposes. The shells were also used as a currency. After the arrival of Europeans metal and glass beads were two of the important articles

Shell gorget with a quilled back ornament, Eastern Woodlands, c.1760–1800. Shells, quills and glass, length 125cm (49in). British Museum (Museum of Mankind), London, England.
Indian chiefs of the Eastern Woodlands wore flat shell discs as pectoral ornaments. This example is attached, with two straps of cylindrical glass beads, to two back ornaments each consisting of webbed orange porcupine quillwork decorated with the design of thunderbirds in black. The shell would have been imported from the coast and laboriously ground into shape with stone tools.

incorporated into aboriginal trade patterns.

The first inhabitants of North America arrived in Alaska across the Bering Land bridge, which was brought about by the lowering of the sea level during successive ice ages. Between about 40,000 and 2,000 years ago a series of different peoples arrived in Alaska and spread across both North and South America. The last of these were the Eskimos who only reached the eastern areas of the Arctic, particularly Greenland, in the last 1,000 years. The aboriginal population of North America was not therefore in any way static; and after the arrival of Europeans movements intensified as different peoples prospered or were destroyed as a result of new influences such as firearms, alcohol and the horse. Until approximately 2,500 years ago the population of North America depended entirely on hunting animals, fishing and the gathering of vegetable foods and shell fish. After that time agriculture spread slowly up from Mexico to the south.west of the United States, and to the Mississippi-Missouri and Ohio river systems. It was these agricultural peoples who created much of the interesting prehistoric art.

Painting, as one would expect, survives principally on pottery which was produced in huge quantities by a large number of cultures in the south, south east and south west. The best known is that produced in the south west, particularly the geometric styles which were created by the Anasazi peoples, and the figurative pots made by the Mogllon, the best known of which are those of the Mimbres culture. Pottery vessels were sometimes sculpted, both in the south west and south, into shapes of animals and humans. More superb are the very limited categories of stone figurative sculpture. The finest of these are the small Hopewell pipes carved in the form of animals. The Hopewell of Ohio, dating between 200 BC–500 AD, were agriculturalists using copper tools who buried lavish offerings of copper artefacts, stone pipes and cut out mica figures of snakes, claws and heads, with important personages. In the south east a number of large alabaster figures have been excavated, for instance from a grave in the temple mound at Etowah, Georgia, which were part of an important general sculptural tradition which flourished in the 500 years before the arrival of Europeans. In other parts of North America sculptural traditions are also known from artefacts which survived burial. Prominent amongst these are the Eskimo traditions of Alaska, the old Wakashan style which was the prototype for the later art of the northwest coast, and individual traditions such as that of the Chumash of southern California in zoomorphic soapstone figures. In some areas these traditions survived into the historical period and emerged as small parts of much more extensive systems of material culture. This is true of the Eskimo area and of the south west of the United States where pottery styles can be traced back 2,000 years.

This huge area of the Eastern Woodlands, comprising the interior of Canada and Alaska, and the whole of the United States east of the Mississippi can be considered one culture area with a series of overlapping art styles and craft traditions. In the north, among the sub-Arctic groups of the Athapascan and Algonquian language groups, subsistence depended on hunting animals for food: after the arrival of the white man the pattern of hunting was radically changed by the fur trade, in which fur bearing animals were hunted and their pelts exchanged for many of the necessities of life. Around the Great Lakes and in northeastern Canada and the United States subsistence also depended to a large extent on hunting, and on gathering wild foods such as wild rice, but, among the Iroquois for instance, farming was a significant and important activity. By contrast in the south east, in the area between the south Atlantic and Gulf of Mexico coasts, the Five Civilized Tribes (the

Chickasaw, Creek, Cherokee, Choctaw and Seminole) were highly organized agricultural peoples who quickly adapted white technology and institutions to their own purposes. It was this success which led to their removal—mostly during the 1830s—into what is now Oklahoma, so that their lands could be colonized by white settlers. As a result relatively little remains of their art.

In the north and central areas the most significant art form was that of porcupine quillwork embroidery, for buckskin garments and a multitude of accessories. Of all the crafts pursued by Indian artists it is this which is most characteristically North American. The wide variety of techniques included wrapping the quills around a piece of birchbark or hide and attaching the strip to the garment; creating a net or web like effect by bunching leather strips alternately with quills; edging artefacts with a variety of different stitches; creating a band like effect by passing quills around two parallel sinew threads; by plaiting wide strips of quillwork; and by weaving quill strips in bow looms and attaching the finished strip to the garment afterwards. Quills were dyed in orange, black and blue, and were used with the natural white colour to create geometric designs. In the Great Lakes area they were also used to create motifs, for instance the Underwater Panther and Thunderbird, two of the most important mythological beings. On the eastern Plains and amongst the Iroquois and Algonquian peoples the Thunderbird was an enormous creature who flashed lightning with its eyes and thunder with its wings; one of the benefits it brought was success in war. Its counterpart was the Underwater Panther, a creature with the attributes of the lynx, bison and snake and one of whose activities was the provision of knowledge about medicine. Both these creatures appear in quillwork on pipe bags, pouches, quilled pipe stems and clothing, as well as in other media.

Another important decorative technique, but only used in the north east, was that of moosehair embroidery. Best known for their moosehair

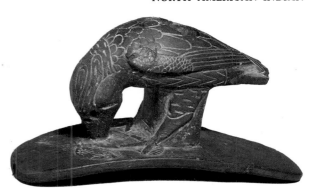

Hopewell pipe in the form of a bird of prey devouring a bird, c.200–400, Ohio. Claystone, 10.5cm (4½in). British Museum (Museum of Mankind), London, England. (*Above*) This type of pipe is known as a 'platform' pipe from the flat base, which dispelled heat from the smoke through its large surface area. It is one of 200 pipes excavated in the 1840s from a single mound in Mound City. Most of them show, extremely realistically, animals, birds and reptiles; all are made from a soft claystone and many have been discoloured and broken by fire. The Hopewell tradition of carving pipes of this kind is the most sophisticated prehistoric sculptural tradition from which artefacts have survived.

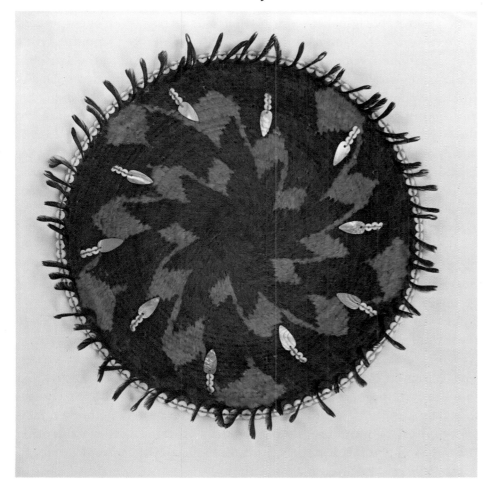

Pomo gift basket, between 1880 and 1920, California. Willow, feather and shell, diameter 25cm (10in). Denver Art Museum, USA. (*Left*) Although the Pomo are best known for their feathered baskets, given as presents on ceremonial occasions, this was only one aspect of their basketry which incorporated more weaving techniques than any other Indian group in California. Most Pomo baskets are formed with willow stems as a base and a variety of different materials for wrapping the coils. The feathers of a large number of different birds were used in decoration, including robins, thrushes, blackbirds, orioles, duck, quail and woodpeckers. The beads are made from clam shell, while the iridescent pendants are of abalone.

embroidery are the Huron who were encouraged in the 18th century by their French allies to copy French floral designs, particularly on to moccasins. The most striking purely aboriginal artefacts decorated with moosehair are the burden straps, used for carrying heavy loads, which were decorated with false embroidered geometric designs on a woven base of elm or cedar bark, or nettle fibre. In the 19th century silk thread largely replaced moosehair and was widely used in the north east and sub-Arctic for decorating clothing with floral designs.

Beads, either of whole shells or made from shell, were used in limited quantities before European contact. In the 17th century with the advent of metal tools large numbers of white and purple shell wampum beads were produced, both for the creation of wampum belts with figurative and geometric designs which recorded treaties and to a much lesser extent, for inlay and appliqué work. At the same time increasing numbers of glass beads were introduced and used with quillwork. Eventually beadwork supplanted quillwork altogether. In the eastern woodlands the most intricate patterns—either geometric or floral—were used in the Great Lakes area, particularly by the Ojibwa, to decorate bandolier bags, and to make broad woven sashes consisting entirely of beadwork threaded on cotton. Another use for beads was in the decoration of bags, sashes and garters made of wool—either commercial yarn, or in the areas towards the Plains, bison wool. These were fingerwoven or plaited, often in many colours with the beads incorporated into the designs; among the Prairie tribes these were also resist dyed—that is decorated with areas left undyed after being coated with a substance to repel the dye. In the south east, among the Five Civilized Tribes extremely fine bags and sashes were made from woollen materials, often with beads in geometric designs spaced throughout the fabric. Another characteristic southeastern artefact is a sash with appliqué beadwork incorporating scroll designs.

The vast majority of artefacts which survive from the Eastern Woodlands are items of clothing and accessories decorated in these techniques which were aboriginal in concept, although they often incorporated western materials. One technique was entirely derived from the white man: appliqué ribbon work. On the Prairies and around the southern Great Lakes imported woollen cloth garments were decorated with silk ribbon work along the edges; using several different colours, and by cutting out geometric patterns, broad bands of design were added to the edges of women's skirts, breech clouts and leggings. These designs may, however, relate to the painted designs with which coats and other caribou skin articles were decorated in the north east. Naskapi hunting coats for instance, were decorated at the edges with impressed geometric designs which relate to the appliqué work from further south. As a central motif for the interior of the jackets these coats used a design known as the double curve motif, which consists of two or more incomplete circles joined together. This was used particularly in the maritime provinces of Canada and northern New England, especially by the Micmac, in articles of beadwork on clothing made from trade cloth.

As mentioned earlier the most important masked ceremonies were those of the Iroquois False Face society. In this masks, carved from living trees, were used to recreate characters from dreams to help in curing. The features of the faces, particularly the lips, were heavily exaggerated into unrealistic forms from which individual masks took their characteristics. Additionally the masks were usually carved with deep incisions indicating wrinkles or folds of skin, decorated with metal around the eyes and given hair in the appropriate place. Other peoples, such as the Delaware, also used masks, although their traditional use has dis-

Naskapi hunting coat, c.1780, North-Eastern Canada. Painted caribou skin, back length 121cm (48in). Pitt-Rivers Museum, Oxford, England.
Naskapi coats were usually painted with geometric designs confined to the borders, but in this case they extend over most of the coat. The patterns were applied with bone stamps or brushes, and as in Plains painting, the colours were sized with glue made from fish roe. The design on the coat is related to the hunt, particularly the pursuit of the caribou, which was the most important animal both economically and mythologically. Originally the Naskapi may have worn blankets or sheets of caribou skin painted with such designs; under European, perhaps French, influence, they may have changed this to tailored coats similar to those worn by early colonists.

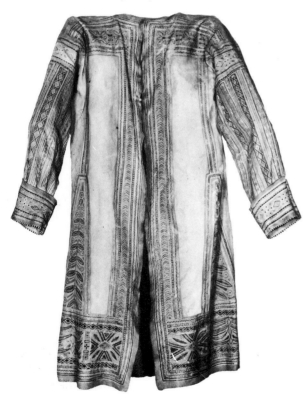

appeared. Besides masks a variety of tools and ritually important artefacts were carved from wood. The most common examples of fine wood carvings are the ball headed clubs which were widely used around the Great Lakes and in the north east. These were often carved from maple burls, and might include carvings of animals around the ball. Bowls were also made from burls, and were similarly carved with images of mythologically important animals. All over the north a great variety of decorated artefacts were made from birchbark. Apart from wigwams, other dwellings and canoes, small containers were produced in large quantities for everyday use. Sometimes these were decorated, the most typical form of decoration being porcupine quillwork. In addition to this in New England baskets were made of wood splints, while in the south east they were also made of split cane.

The supposedly 'typical' Indian is that of the Plains, with his horse, bison hunting, and feather bonnet. The territory of the Plains Indian extended from the Mississippi Valley in the east to the Rocky Mountains in the west, and from Oklahoma and Texas in the south across the Canadian border into Alberta in the north. The defining characteristic of Plains culture is, of course, the hunting of the bison, although some groups hunted it only seasonally, and farmed or hunted elk and other animals as well. Plains culture as it existed in the 19th century was made possible by the introduction of the horse by the Spaniards in the 17th century, and only emerged as we know it in the 18th century. While bison were, of course, hunted long before the introduction of the horse, it was the horse which made possible large scale hunting.

This mobility defined the types of artefacts which were made and the extent of possessions: they had to be strictly limited to essentials such as clothing, tepees, weapons and a very limited amount of ritual paraphernalia much of which was associated, directly or indirectly, with the great Plains ceremony complex, the Sun Dance, in which the people of the Plains participated each year. This strictly limited material culture was to a large extent derived from the bison, which as well as providing food, produced the raw material for sinew cord, clothing, horn spoons, and raw hide containers and shields. The rapid changes of the 18th century both left behind, and also introduced, influences from the Eastern Woodlands. Firstly some farming societies survived; for instance the Mandan, Hidatsa and Arikara of the Upper Missouri lived in earth lodges—that is hemispherical earth covered dwellings—rather than tepees, and only hunted bison seasonally. Also the increased ability to hunt the bison provided by the horse drew into the Plains people from surrounding areas, and with them, particularly from the east, came traits associated with Eastern Woodlands culture. Therefore the Eastern Plains peoples used substantial Eastern Woodlands derived traditions such as porcupine quillwork and wood carving.

Whereas artefacts from the Eastern Woodlands have survived from the 17th century onwards, almost nothing is known of Plains art before the beginning of the 19th century because the area was little known to the European. Moreover there are only a few collections of Plains art from the first half of the 19th century—between six and twelve groups of material acquired by early explorers and traders. So most of what we know of Plains art derived from artefacts collected after 1850, and before 1900 by which time defeated Indian groups had been forcibly confined to reservations for at least 10 years. Because most Plains art is relatively late, and because as we have mentioned possessions were few, most surviving artefacts are articles of clothing and accessories decorated with beadwork. Only in the north and east, and particularly from the Santee Sioux, is quillwork known; on the Plains bird quills as well as

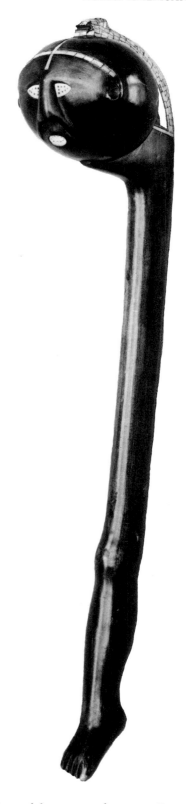

Ball headed war club, seventeenth century, Eastern Woodlands. Wood, length 66cm (26in). National Museum, Copenhagen, Denmark.
The ball of such a club was sometimes formed from the burl of a tree and carved, as here, with the representation of an animal spirit important to the owner. Occasionally they were decorated with wampum, shell inlay and shell beads, which were also formed into belts with designs symbolizing alliances and treaties. In the eighteenth and nineteenth centuries this type of club was replaced first of all by metal tomahawks, made in Europe, and then by firearms. At this time clubs were still made, but only used for ceremonial purposes.

porcupine quills and maidenhair fern were used. Beads were traded to every group, and beadwork styles in the middle of the 19th century were relatively stable, and have remained so in some areas. Initially traders brought quite large beads, termed 'pony' beads, but after the middle of the century they introduced an ever increasing quantity of forms and colours of the small beads termed 'seed' beads. As with quillwork the vast majority of beadwork designs are geometric; occasionally, particularly amongst the Sioux, late artefacts such as pipe bags incorporated figurative designs derived from paintings, or such motifs as the United States flag. The most obvious distinction in beaded designs is that between northern Plains designs, such as those of the Crow, Sioux and Blackfoot, who favoured strong simple geometric designs covering large areas; in this, while the Crow used beads of many different colours, the Blackfoot used a maximum of five or six different colours. On the other hand in the south the Kiowa and Comache for instance used beads largely as trim for garments—thin lines of appliqué beadwork, again in geometric designs, were used on moccasins or shirts in conjunction with fringes. Sculpture on the Plains was confined to the carving of pipe bowls usually made of Catlinite claystone, and dance sticks. However those groups of the north east carved finely decorated war clubs, and others such as the Pawnee carved finely executed details to the heads of cradleboards. The finest of Plains art is, however, the painting; figurative designs, particularly illustrating the exploits of the owner of the bison robe or shirt were used in abundance on traditional artefacts; after confinement to reservations this art continued for a time using paper and cotton cloth rather than buckskin. Shields of rawhide were often painted with figures, perhaps an animal derived from a vision. A significant Plains art was that of the multicoloured painting of raw hide containers, *parfleche*, which were decorated with distinctive designs by women. In contrast figurative designs were executed by men.

The south west of the United States, the states of Arizona and New Mexico, is a very diverse area of pine covered mountains and arid desert. The most important aboriginal culture group is that of the Pueblos. In raised flat topped mountain areas, called *mesas*, these very traditional agriculturalists live in much the same way as their ancestors have done for well over 1,000 years. Besides these people the south west contains small groups of hunters and gatherers such as the Pima and Papago who are well known for their coiled basketry; the Apache, a nomadic people culturally intermediate between the Plains and south west, and the Navajo, the largest native group in the United States. The Navajo traditionally depended on sheep rearing introduced by the Spaniards: they are justly famous for the fine woven blankets, rugs and other articles which are still made from wool. The second art form for which the Navajo are well known is their jewellery of silver and turquoise; this too was the result of Spanish influence, and initially they used silver coins as raw material.

Among the Pueblo peoples the agricultural cycle, particularly the growing of maize and the need for rain in a dry environment, were the two dominant factors. The extraordinary level of ceremonial surrounding agriculture still exists today, and is dominated by *kachinas*, or gods called upon and propitiated throughout the agricultural year. The Pueblo peoples still create a wider range of artefacts than any other group in North America. As well as the ceremonial paraphernalia, including painted hide masks and costumes, pottery, textiles and basketry are important. The Hopi are noted for their textiles, in plain and twilled weave, made from sheep's wool but decorated traditionally in cotton, for the basketry, which had ceremonial use, and for their pottery. All

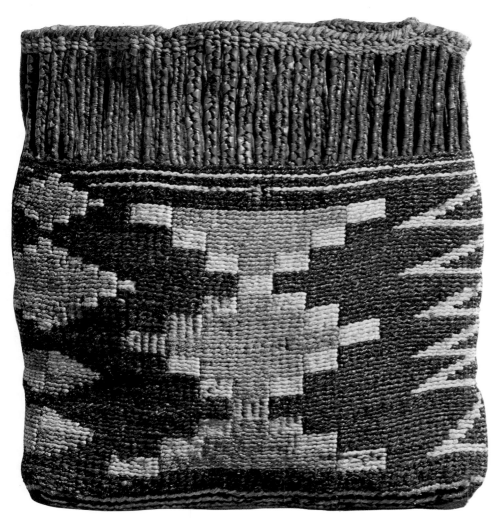

Huron false embroidered pouch, c.1725, North-Eastern Canada. Moosehair and hemp, 12 × 12cm (5 × 5in). British Museum (Museum of Mankind), London, England.
The moosehair was obtained from the rump, cheeks, mane and dewlap of the animal, and dyed by boiling with appropriate mixtures of animal and vegetable substances. The geometric design was achieved by wrapping the weft with a moosehair as it was brought out to pass round the warp thread on the exterior. The twined base of the pouch is made of Indian hemp, which was commonly used for a wide variety of utilitarian objects including ropes and burden straps. The French, because of the expense of obtaining European thread, were encouraged to take up and adapt moosehair embroidery to European designs.

Pueblo groups used pottery, none of which was glazed, each Pueblo making pottery in a highly distinctive style. The Zuñi, as well as producing perhaps the finest pottery, are well known for their animal fetishes of turquoise and other materials.

The state of California is effectively cut off from the east by the Nevada Desert, and its culture is therefore characterized by distinctive traits. Most important the primary food source for the dense population was the acorn, although deer in the interior and shell and seafood along the coast supplemented this. The level of technology appeared simple but the requirements of the preparation of acorns. particularly containers for collecting, sorting and cooking, led to a highly developed basket industry; it is the baskets, which were also made for a variety of ceremonial purposes, for which Californian Indians are particularly noted. In the late 19th and early 20th centuries the work of the few remaining basket makers was much in demand by white collectors for the excellence of their coiled technique. The colours used were mostly natural browns, blacks and yellows, and most decoration employed geometric designs, although in some areas, for instance amongst the Yokuts, figurative designs were also used.

The first significant colonization of California occurred along the coast in the form of a few Spanish missions; when large numbers of white people entered the state with the 1849 gold rush the fragile aboriginal way of life disintegrated in a remarkably short time. As a result relatively little survives of Californian art apart from the basketry. However many traditions are known from relatively few artefacts. The most important of these is the sculptural tradition of northern California, for instance Yurok, Karok and Hupa elkhorn sculpture. Small spoons, for use by men, and small 'purses' for carrying dentalium shell currency were carved from elk horn and incised with simple geometric designs. Else-

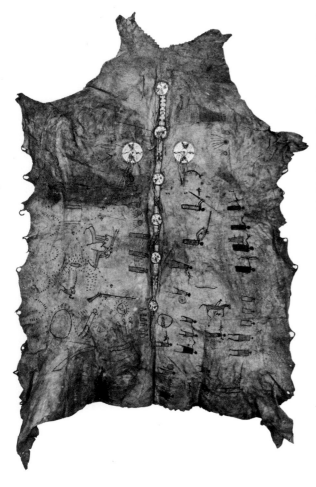

Painted robe, *c*.1850, Plains. Bison skin, length 205cm (81in). National Museum, Copenhagen, Denmark.
Robes were painted by Plains Indians with visions, personal records of exploits or calendars; this represents one of the former types of design though it is not clear which since imaginary events were not always distinguished from real ones. A robe might take a single artist a fortnight to paint, or it might be painted by more than one person, perhaps with a narrator standing over the painter telling the story which the robe was destined to depict. The paints used were made from a variety of different coloured clays and vegetable materials, and were applied with various types of 'brush' including the porous centre of a bison's leg bone. This robe is also decorated with a porcupine quill strip and two rosettes.

where along the coast, for instance amongst the Chumash, naturalistic stone effigies were made from soapstone. Of the purely decorative traditions feather work is the most important. The Pomo for instance made huge hemispherical headdresses, while the peoples of northern California wore horizontal headdresses formed from feathers laid next to each other on a piece of backing. Feathers were also used in the decorating of baskets, particularly by the Pomo for their 'gift' baskets, as were shell beads; the latter were also used for necklaces and other decorative ornaments. Although so much of this disappeared after the colonization of California, the stone age technology survived in isolated mountain areas until the beginning of this century.

The peoples of the northwest coast, in Washington, British Columbia and southeastern Alaska were richly supplied with food in the form of superabundant quantities of salmon, herring, cod, halibut and other fish, and with timber from the huge forests which clothed the shore. This wealth enabled them to live an almost sedentary life, local movement (apart from trade and warfare) being confined to the changing of fishing camps with the seasons; considerable leisure was brought about by this economic surplus. Society was organized hierarchically, with chiefs, commoners and slaves; the chiefs used their wealth—for they owned most of the economic resources—in elaborate forms of display which engendered the most fantastic and elaborate, as well as the most subtle art style of North America.

The most important component of northwest coast art is that of sculpture using metal tools, even to some extent before the arrival of Europeans; second to carving was painting, usually an integral part of the sculptural artefacts, but also an end in itself on clothing and flat wood surfaces such as box sides and house fronts. Less important were textiles, made of cedar bark for every day use and either decorated with or made entirely from goat's wool for ceremonial use. Twined basketry objects, both for utilitarian purposes and for ceremonial uses, were made in large quantities from spruce roots; the latter were either painted, or decorated with false embroidered designs in grass. Lastly stone objects, particularly ceremonial weapons, were superbly made of basaltic rocks in prehistoric times.

All these things involved a sense of design and style of workmanship which was common to the whole area, but which was more sophisticated and more rigidly employed among the tribes of the northern part of the area, the Tlingit, Tsimshian and Haida. The art style aimed to depict crests and supernatural beings, (whether they were human, or entirely mythological) on objects and artefacts for ceremonial use. Thus the decoration of a chief's bowl or a totem pole is adapted to the function of the object which exists separately from the decoration. The second aspect of the style is that the characters shown on the sculpture or painting are always conventionalized, in a semi-realistic manner, and are almost always symmetrical. An animal, for instance the beaver or killer whale which are clan crests, would be identifiable by a specific symbol. A feast bowl in the form of a beaver will always be identifiable because the beaver is shown with a tail filled with cross hatching and jaws with large incisors holding a stick; the killer whale is always shown with a dorsal fin, whether in a three-dimensional clan helmet or in a highly conventionalized Chilkat blanket. Part of this stylization was carried out using a system of decoration, either in two-dimensional or low relief, employing form lines, broad swelling and tapering lines which mark out ovoid shapes outlining the stylized being. These were normally painted in black, red and blue, in descending order of importance. The northwest coast artist liked to fill every available space with

decorative design of this kind, which was a factor contributing to the appearance of movement which many artefacts have. The last characteristic of this style was that an animal or superhuman creature would be depicted in all its parts: in a flat design it would be split down its axis and spread out, two-dimensionally, so that every limb could be seen.

Rank and prestige required that chiefs used and produced a multitude of objects decorated in the ways described; the most important occasions included celebrating events in the life cycle such as the birth of an heir or the death of a chief. On these occasions, which lasted many days during the winter when food gathering activities were minimal, a pole might be raised at the front of a chief's house, in honour of a past chief, celebrating the clan's crests, rights and nobility. A feast would be given at which chiefs and dancers would wear elaborate apparel illustrating mythological characters and their history. The dances, which included highly theatrical productions, were at their most elaborate amongst the Kwakiutl of southern British Columbia. The central theme of the Kwakiutl celebrations was the seizure of novices by cannibal spirits who endowed the novices with significant tribal qualities. One of these spirits, Bakbakwalanooksiwae which means Cannibal-at-the-north-end-of-the-world, inspired helpers who were huge cannibal birds with vast painted wood masks—the beaks of which were up to 2.4m (8ft) long. Although highly conventionalized, the Kwakiutl style of decoration in both painting and sculpture differed from that of the northern north-west coast in employing painted designs, of the same general form but following the line of carving, and specifically in the use of white paint.

The Arctic is inhabited by the Aleut, on the Aleutian Islands in Alaska, and the Eskimo, the most recently arrived aboriginal inhabitants of North America. Living at the edge of the inhabited, and habitable, world their life style is closely related to the environment with life depending on the day to day, as well as seasonal observation of the weather, and the movement of ice and animals. In the summer seasonal migrations were made for hunting large animals such as caribou and musk ox, and for fishing, while in winter seal and walrus were hunted. In parts of Alaska whales were (and still are) hunted from skin covered open boats called umiaks.

Material culture, and therefore art, is closely related to this continual

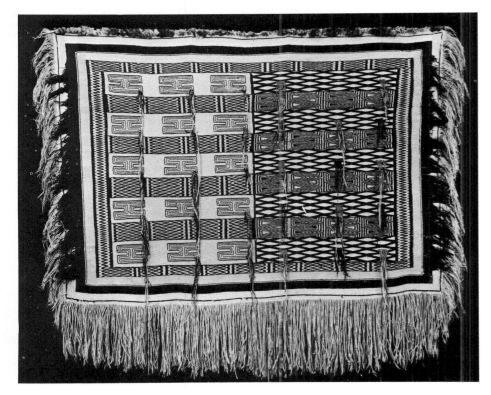

Tlingit blanket or cloak, c.1800, British Columbia. Wool, 128 × 179cm (50½ × 70½in). Peabody Museum, Harvard University, USA.
This type of robe was woven of mountain goat wool using many complex techniques. The black colour was achieved with a solution of hemlock bark and urine. This is an example of the prototype of a much more common type of robe, known as the Chilkat blanket, which was made by the Chilkat Tlingit in Alaska during the nineteenth century and used by chiefs almost everywhere on the North-West Coast. Using the same techniques, and yellow cedar bark as the foundation for the wrap, the Chilkat Tlingit created numerous cloaks, tunics, hats and leggings with figurative designs incorporating the crests belonging to the wearer.

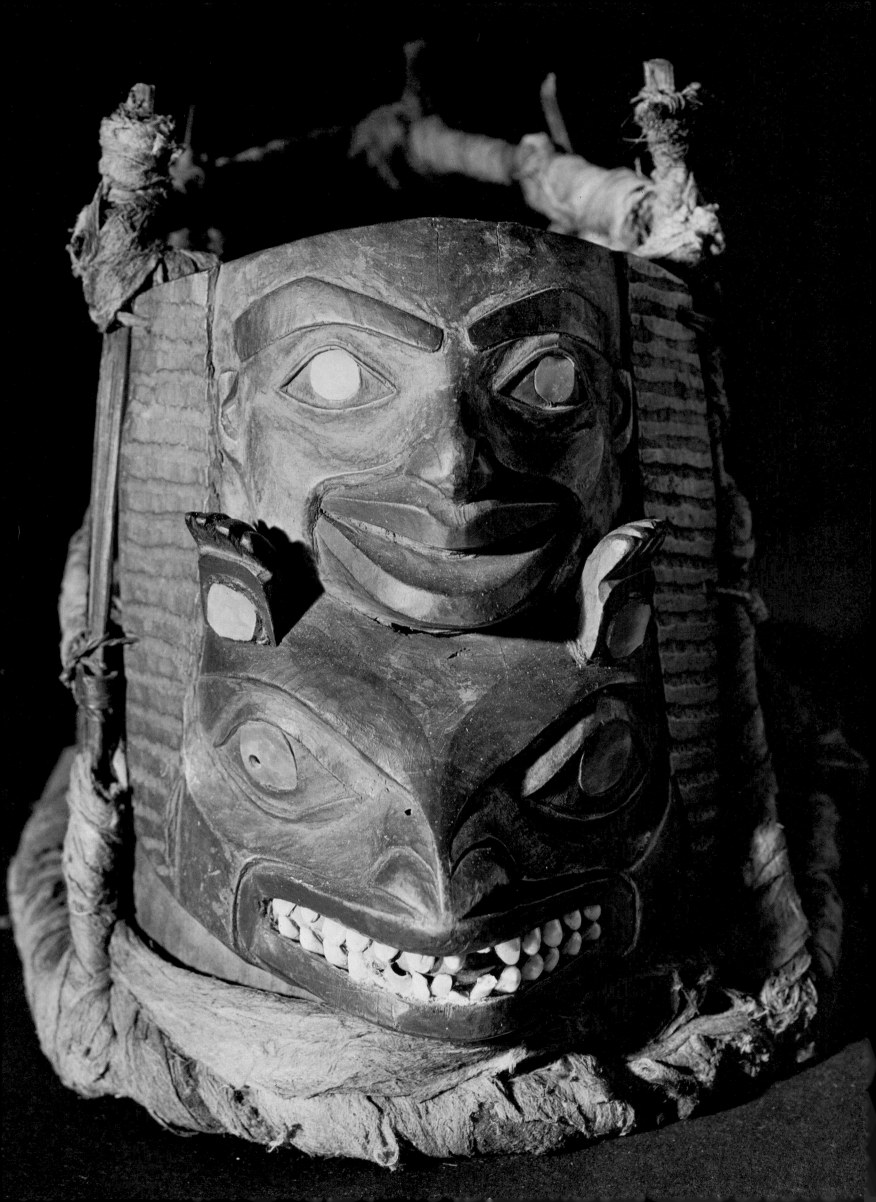

struggle for survival. Many of the finest and most beautiful Eskimo arte-facts, particularly from the prehistoric cultures of Alaska such as the Old Bering Sea Culture, are decorated harpoon toggle heads, harpoon weights and a multitude of small ivory artefacts related to the hunt. During the winter months, when the pursuit of food was impossible, men carved these extraordinary objects. In the prehistoric period the predominant style used incised curvilinear and geometric designs. In historical times the number of sculptural objects increased with the greater availability of metal; in the 19th century these were very often animals carved as amulets, but after 1890 they were increasingly souv-enir objects made specifically for sale. In Alaska in the 19th century bowdrills and other artefacts were incised with figurative designs, particularly showing scenes of hunting. Wood was a major resource only in some parts of Alaska; on the Aleutian Islands superb bentwood hunting helmets were made and painted with subtle multicolour linear and geometric designs; on the mainland the Eskimo groups of south-eastern Alaska used highly original wood masks of imaginary beings who were important to shamans in the honouring of dead animals and in the propitiation of those still alive. While the men hunted and carved with chert and metal tools the women sewed and embroidered clothes from furs, skins and guts, the latter being taken from whales and other sea mammals, split down the middle and sewn together to form highly effective waterproof garments. On the Aleutian Islands women made perhaps the finest twined basketry of North America from wild barley straw.

Indian and Eskimo art derives its stimulus—and interest—from a wide range of sources, not all of which are traditional. In some areas, as already mentioned, pottery is produced as it has always been, and in the same forms and styles as in the 19th century and earlier. This is true for instance of the Hopi; but at the same time other south western pottery traditions are experimenting with new techniques, such as carving and inlay, and also with new forms. In many areas of the United States and Canada entirely non-Indian art forms have been taken up by Indian artists; prominent in this is painting, drawing and printmaking of traditional subjects. In between these two extremes are traditions which have been adapted and changed by contact with western art and the art market; the most successful of these is the Canadian Eskimo soapstone sculpture. Aboriginal lamps were carved of soapstone; after World War II this tradition blended with another of small scale sculp-ture of artefacts in bone and ivory in the production of imaginative figurative sculpture showing Eskimo scenes, life and mythological sub-jects; today it is known the world over. On the northwest coast there has been a tremendous revival in carving during the last 20 years; some objects produced, masks, carved house poles and commemorative poles are used by the carvers and their relations, while others are made for sale to non-Indians. One aspect of this is that non-northwest coast art-ists, working traditionally, are producing remarkable objects. Apart from painting and sculpture other crafts survive in many areas; on the northwest coast and in the south east there are a few basketmakers still working, while around the Great Lakes there are artists making con-tainers of birchbark decorated with porcupine quillwork. The most thriving aspect of Indian art is however costume for Indian events and ceremonies. To some extent individual tribal styles have merged to form a single modern tradition of craftsmanship which extends across North America. Thus it is normal to find eagle feather headdresses, similar to those traditionally used by Plains warriors, being worn at pow-wows everywhere between Oregon and Maine.

Tlingit chief's frontlet, c.1800–1850, Alaska. Wood, whale-bone and shells, height 18cm (7in). British Museum (Museum of Mankind), London, England.
Frontlets like this were incorporated in head-dresses. This one is on a baleen frame, which would have been decorated with ermine and worn by chiefs at feasts. The painted wood carving, inlaid with abalone shell, incorporates two mythological creatures probably ancestral to the original owner; unfortunately it is not possible to identify them, since the collector, probably an explorer on the North-West Coast, would not have been interested in collecting what would have seemed to him trivial details.

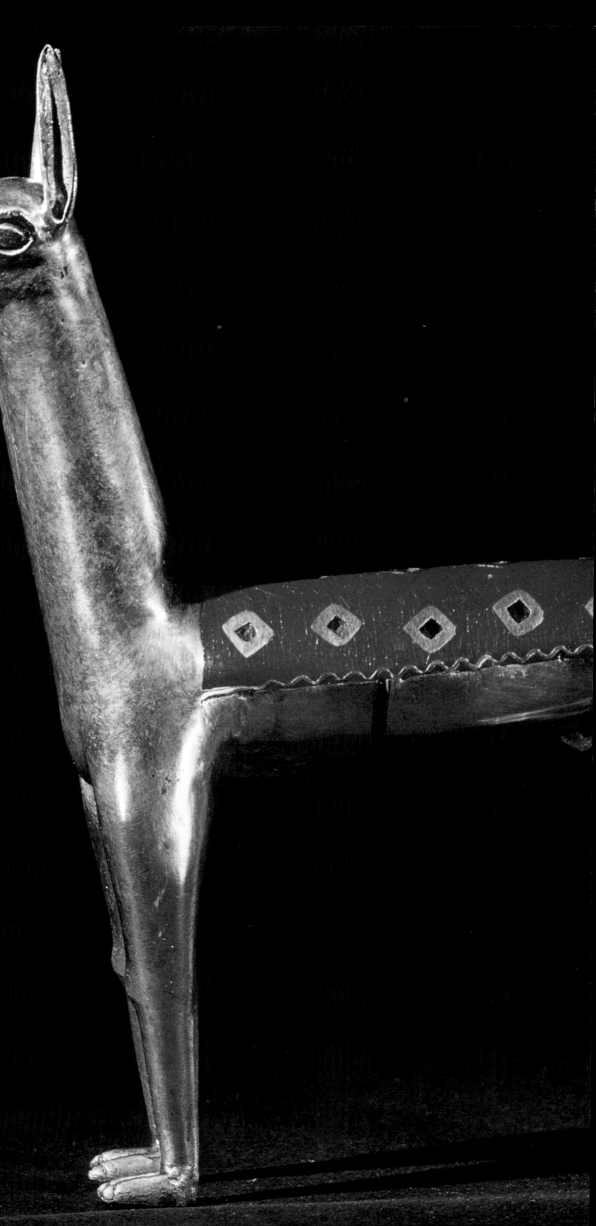

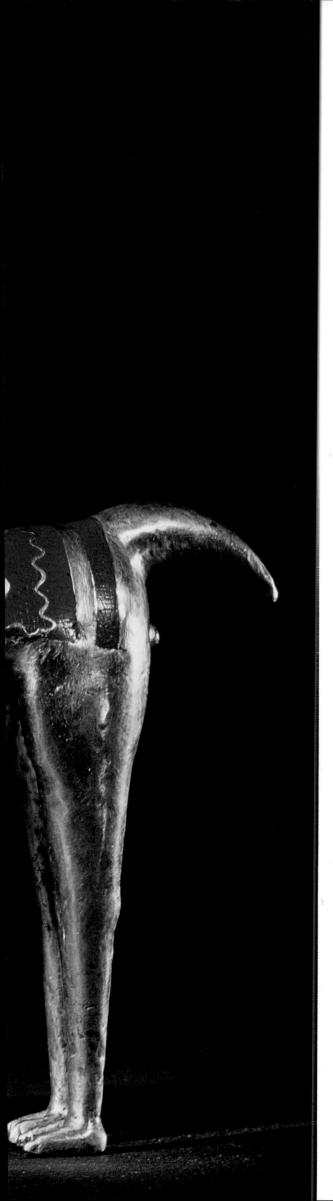

ETHNOGRAPHIC
Pre-Columbian Art

When Francisco Pizarro and his band of Spanish adventurers conquered the western coast and highlands of South America in the 1530s they expected to find gold and silver and their hopes were fulfilled; what they did not expect was to find themselves pitched against a sophisticated empire such as that of the Incas. The Incas were relative newcomers but their culture rested firmly on ancient foundations going back to the Chavin 'horizon' in the 9th century BC. Like that of Mesoamerica, the population of South America was composed of Indians, but the arts flourished only in a fraction of the sub-continent, the northern half of the zone extending from the Andes to the Pacific coast and occupied now by Ecuador, Peru, and part of Bolivia. The staple food was maize. Textiles came from cotton and the wool of the vast herds of llamas, alpacas and vicuñas supported by the *altiplano*. In contrast with Mesoamerica metal had been mined, collected and processed from the start, in the form of gold, silver, copper and diverse alloys. One of the salient features of religion was the jaguar (puma) cult. Slavery was not common and human sacrifice was practised only in a limited way.

The Chavin culture asserted itself in the central zone of the Peruvian Andes and coastal strip. It lasted from about 900 to 300 BC and is named after its foremost surviving site, Chavin de Huantar, situated at an altitude of 3050m (10,000ft). Massive stone buildings were erected on platforms and faced with regular courses of stone slabs. Friezes, stelae and obelisks have survived here and there. The leit-motiv of their decoration was the jaguar, to which were added birds of prey, alligators with feline heads or fangs, human figures with jaguar faces and hair turned into snakes. The prototypes of South American art existed therefore in Chavin. The sculpture spread along the valleys down to the coast but the buildings at that level were made of sun-baked bricks and have crumbled away. Only small carvings in the round have survived, as well as some goldwork and monochrome pottery displaying the stirrup-spout which became characteristic of Andean ceramics.

The remarkable remnants of an ancient culture were unearthed in 1929 on the peninsula of Paracas, south of Lima. The coastal strip is a rainless, desert zone that preserves for ever anything buried under its surface. A number of the dome-shaped tombs cut in the rock contained textiles and pottery of rare quality, produced between 300 BC and 200 AD. More than 400 mummies were found; they were dressed in gorgeous robes that had retained their brilliant colours, including indigo.

Jade celt or votive axe, Olmec culture, La Venta, Mexico, 3rd century BC. Jade, height 27.9cm (11in). British Museum (Museum of Mankind), London, England.
This was part of a group of figures called were-jaguars, partly man, or rather child, and partly jaguar. Many of them are shown, like this one, with cleft skulls, and look like crying babies. They may represent rain spirits.

Llama, Inca, fifteenth century. Silver. American Museum of Natural History, New York, USA. (*Previous page*)
Gold and silver models of plants and animals, like this llama, were placed in the gardens of Inca temples. Although not strictly sacred animals, all llamas, vicunas and alpacas belonged to the emperor, who thus controlled the immensely valuable wool supply.

A variety of techniques were in use: brocade, embroidery, gauze, double cloth. The materials employed were cotton and alpaca wool. The decoration was stylized, using a range of fantastic monsters, hybrids, animals and mythological scenes. The embroidery is amongst the finest ever created. Paracas pottery displays the same sense of colour and fantasy and its decoration is also artfully stylized; painting was applied within an incised outline. The colours were mixed with a resinous substance and were painted on after firing. They included orange, dark blue and green. Among the motifs were feline faces, severed hands, demons, plus a variety of birds and also geometrical patterns.

Nazca was further south and also became famous for its textiles but even more so for its polychrome pottery which goes back to the beginning of our era and retained its quality and inventiveness until about 500 AD. In contrast to Paracas the colours were non-resinous and were applied on slip (semi-fluid clay) before firing. There were up to eight colours, including greys and violet. The decoration was similar to that of Paracas. In both areas the vessels were often surmounted by a spout and sometimes two spouts connected by a bridge. The potting was very fine. No architecture and sculpture of these cultures remains.

In the north the Mochica culture flourished in the Moche, Chicama and Virú valleys during the Classic period (300–900 AD). Some vestiges of monumental building survive but they are not of great interest, except for remains of murals showing prisoners being led to what was probably the sacrificial block (Pañamarca); another painting illustrates a battle between men and weapons, won by the weapons. The theme of human sacrifice, particularly of prisoners of war is frequently depicted on Mochica pottery of which a considerable quantity has survived. It had nothing of the finesse and fantasy of Paracas and Nazca. It displayed a new outlook which we could call naturalistic, with strong emphasis on salient features, head, eyes, nose and penis. Many jars are effigy-vessels. The human figure or at least the head played an important role to the extent that a number of pots seem to be portraits or at least types. Many other subjects were modelled in the round, such as animals and plants, and a variety of scenes including erotic postures where human beings or animals and even man and beast indulge in sexual display, often of a sodomitical character. These were probably connected with fertility magic or other rituals. Other scenes depict diseases. Their artistic quality is uneven, and some do not rise much above the level of garden gnomes. Many came out of moulds and could therefore be mass-produced. The colours were generally white and dull red. Another variety of wares was modelled in low or pressed relief instead of in the round. A third group displayed painted scenes, showing fanged gods, fabulous episodes and sacrifices. The stirrup spout was common. Mochica pottery was made for funerary purposes. Metalwork also flourished, using copper, gold and silver and alloys. One famous example is a puma skin of sheet gold with a head modelled in the round.

Contemporary with Mochica another important and aggressive new society with the name of Tiahuanaco took command of southern and central Peru. It originated on the Bolivian side of Lake Titicaca and was the immediate predecessor in that area of the Inca empire. During the Classic and early Post-Classic periods Tiahuanaco was predominantly a religious society governed by the priesthood. Around 700 AD the control passed into secular hands at Huari, a city in central Peru which was dominated by a warrior-caste. The empire expanded vigorously in every direction; in the north it reached the border of the Mochica territory and it penetrated the Nazca area in the south-west. Not much remains of Tiahuanaco and Huari architecture: some large blocks of

stone, cut with precision; monolithic doorways; friezes with condor and jaguar motifs. The art of sculpture is represented by a few pillar-shaped statues of a massive kind, next to figures in a kneeling position. They are stiff, heavy and rigid. The pottery is polychrome, painted over red slip. The subjects are the usual cats and birds of prey, with some geometrical patterns. Tall beakers called *kero* are elegant and finely potted. The Tiahuanaco culture collapsed around 1100 AD and was succeeded in southern Peru by several petty contending states before the rise of the Incas in the 1430s. In the north the Mochica culture gave way to newcomers called the Chimu.

The Chimu kingdom established its hegemony over the Moche-Chicama areas in the 14th and 15th centuries. Its capital was built at Chan-Chan on the coast and consisted of 9 or 10 compounds surrounded by walls of mud-brick. It was linked to the regional cities by a network of roads. The king was venerated as a demi-god.

Chimu pottery was predominantly black and burnished and stirrup-spouted. Panels in relief were pressed on the globular variety of bowls. Wares were mass-produced, as were the textiles which appear in the form of brocade, gauze and double-cloth, tapestry being rare.

Stirrup-spouted vase, Mochica, Moche or Chicama valley, Peru, made between 6th and 8th centuries AD. Pottery, height 24cm (9½in). British Museum (Museum of Mankind), London, England.
This type of funerary pottery is characterized by its red and white colours, its stirrup spouts and its naturalism. Some of the faces look remarkably as if they were portraits. Many of the vases were made from moulds.

Lintel from Yaxchalan, Chiapas, Mexico, late classical Maya culture, *c.*AD 730. Limestone, height 129.5cm (51in). British Museum (Museum of Mankind), London, England. The lintel is carved to represent a richly bejewelled woman making an offering. In front of her rises a snake from whose mouth emerges a threatening warrior with a spear. The Maya culture produced a great number of reliefs in stone or stucco decorating temples and stelae.

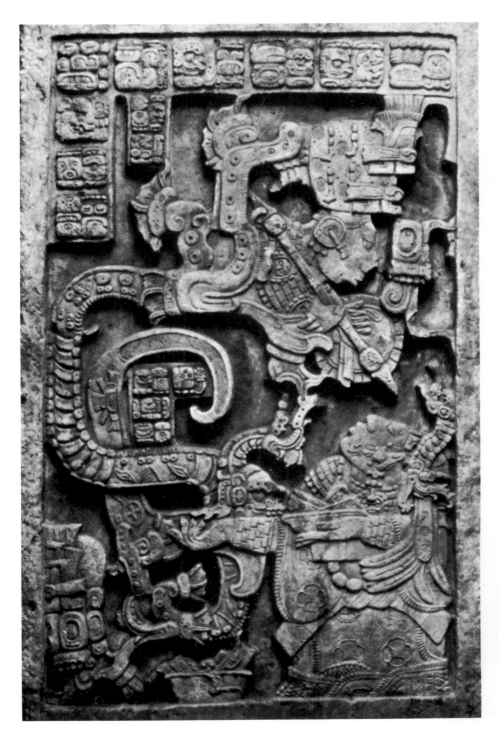

Animals were a favourite subject; they were stereotyped. Featherwork was widespread. So was metalwork, consisting in gold masks and beakers (*kero*), body-decoration, sceptres and knives in gold, silver and copper or alloys. The Chimu nation fell to the Incas in the second half of the 15th century.

The Inca civilization started in a petty highland state near Lake Titicaca. They are believed to have settled at Cuzco around 1200 AD. It was to be their capital. In 1437 they embarked on an expansionist policy. Less than 100 years later, when the Spaniards attacked them (1532–1534), they were the masters of an empire 3,200km (2,000 miles) long and 490km (300 miles) wide, extending from Ecuador to central Chile and from Brazil and Bolivia to the Pacific coast. The Incas left no written record of their history. It was transmitted through oral tradition and written down by the Spaniards in the 16th century.

The Incas built their empire on the foundations laid partly by Tiahuanaco-Huari and particularly by the Chimu state which was allowed to retain much of its structure and its administrative traditions from which the Incas borrowed. The Incas were excellent and disci-

plined soldiers but they were even better administrators. Their empire was a highly centralized organization, governed from Cuzco by an emperor revered as a god and obeyed as an absolute monarch. The administration was run by the royal Incas (the emperor's kinsmen) but also by so-called 'Incas-by-privilege' or meritocrats and finally by the *curacas* or native princes in conquered territories. The social unit or cell was the *ayllu* or the clan. The empire was divided into provinces themselves subdivided into smaller units. An efficient system of tax collection gathered the expected income (mainly in goods) for the state. Labour service was drafted for public works. There was no slavery. Military recruitment was equally well organized. Everything was managed ultimately from Cuzco and this was made easier by a superb network of roads, stages, storehouses and messengers. The Incas believed in a creator god, but he was remote and their religious fervour concentrated on divine intermediaries such as the heavenly bodies, ruled by the sun who was their ancestor. All land, mines, flocks of llamas, belonged to the Sun, therefore to the Inca emperor, and they were distributed by him to his people, according to their status and their needs. The priestly class was recruited from the royal family. Human sacrifice was not a common practice. The Inca government can be considered as a form of enlightened despotism.

Not much Inca sculpture has survived and that is chiefly in a small format. Pottery was neither original nor refined. The same can be said of the textile production and the metalwork. The Incas were technicians rather than artists, like the Romans. The walls of the shrines and palaces were coated with gold sheets, which were later stripped off by the Spaniards. In South America as a whole gold and silver were not considered as currencies and objects of greed as they were in Europe. They were essentially materials for decoration and prestige.

Mesoamerica is the name given to those regions of Central America where the arts flourished before the Spanish arrival in 1519. They include what are now central and southern Mexico, Guatemala and Honduras. The earliest culture of Mesoamerica went by the name of Olmec (meaning rubber) and can be traced back to the 12th century BC. It reached its climax between 900 and 300 BC. The Olmecs laid the foundations of Mesoamerican culture and were followed by the Mayas in Yucatán (east Mexico), Guatemala and Honduras, who flourished between 300 and 900 AD (the Classic period), at more or less the same time as the Teotihuacan culture in central Mexico. The savage Toltecs built their great centre of Tula, also in Mexico, around 1300 AD while the Mixtecs held sway in the south (Oaxaca). They were succeeded in the 15th century by the even fiercer Aztecs who succumbed to Cortes and the Spaniards in 1521. The population of Mesoamerica is reckoned to have been about 10 million at the time of the conquest. They were all of Indian stock stemming from north-east Asia at the dawn of history. It was an agrarian society and their staple diet was maize, followed by beans, squash and cacao. They grew tobacco and cotton and collected rubber. They made no use of metals before the 10th century. Their symbols were the jaguar (Olmec) and the serpent (Mexico).

The main Olmec centres were ceremonial shrines, outside the stone-built residential areas. The two most important, as far as we know, were San Lorenzo, built between 1100 and 900 BC and La Venta, built between 800 and 300 BC. Both consist of pyramids on platforms within courtyards. One of the pyramids at La Venta is 128m by 73m (420ft by 240ft) and 30m (100ft) high. The builders were more concerned with the external layout than with the interior which was dark and cramped. This was to be a common feature of Mesoamerican architecture. The

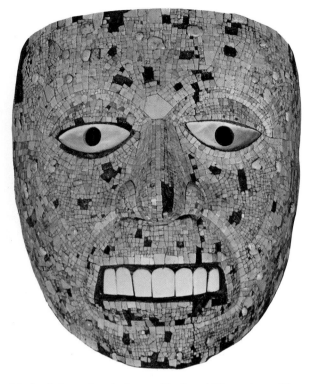

Mask of Quetzalcoatl, Aztec, Mexico, 15th century AD. Turquoise and shell, height 16.7cm (6¾in). British Museum (Museum of Mankind), London, England.
The serpent god played a dominant role in Toltec and Aztec mythology. He was connected with wind and rain, and also with learning and healing.

Olmecs were the first Mesoamericans to handle large masses of stone and build colossal statues. The most famous of these are the heads from San Lorenzo, La Venta and Tres Zapotes. They were carved out of basalt and are characterized by thick lips, puffy faces, heavy features and German-style helmets. Some were coated with plaster and painted. Olmec sculpture was usually stylized, but sometimes naturalistic, as in the case of the wrestler of Antonio Plaza. It displays strength, simplicity, forcefulness, not to say severity. It was to remain unsurpassed in Mesoamerica. Some of the finest carvings are made of jade, either celts, figurines or masks. These are still turning up from excavations in Guatemala and Honduras. The most intriguing are the baby-faced jaguars (or jaguar-faced babies) in jade or serpentine, called *were-jaguars*, said to be the offspring of intercourse between woman and jaguar. They were probably the ancestors of the rain-gods of later cultures. The jaguar was common to the mythologies of South America and may have originated there. In the land of the Olmecs it played the role to be played later in Mexico by the plumed serpent. Another form of sculpture was the low relief on a stele. This was to become a common feature of the Maya culture. The Olmecs also produced some interesting pottery, but the potter's wheel was unknown to them as was indeed any other form of wheel; this applied to the whole of Mesoamerica until the Spanish conquest. Metal was equally unknown, including gold and silver. The Olmecs used glyphs as religious and calendar symbols and they practised the ball-game adopted by all Mesoamericans. Their artistic influence extended far out into Mexico and into the South.

The Maya civilization flourished between 300 and 900 AD, but it was already in existence around 500 BC and its so-called Formative period goes back to 2,000 BC. It was located chiefly on the limestone plateau of Yucatán and amidst the rain-forests, swamps and savannahs of El Petén in Mexico and Guatemala. The Mayas did not constitute an empire but a confederacy of city-states with a common language and culture, not unlike the Greek world of classical times. They numbered between two and three million and formed a hierarchical and theocratic society, dominated by an aristocracy composed of warriors and priests who lorded it over commoners, mostly farmers and merchants. At the bottom of the scale were the slaves, who were mainly prisoners-of-war and formed an important article of trade. At the head of each state was a hereditary chief, with full powers. With his elongated skull, tattooed face and remodelled nose, he was treated as a demi-god; he was dressed like an idol. He was controlled by a council composed of kinsmen.

The Mayas were a clannish society. The priests acted as intermediaries between man and his gods; one of their chief functions was to keep calendars and to determine, by a combination of astronomy and astrology, the proper dates for harvesting and for other vital decisions. The Maya religion was founded on a belief in cycles when the world was re-created periodically and its catastrophic end avoided through ritual and sacrifice. During the Classic period animals were sacrificed rather than men, without excluding the latter. But with the advent of the Toltecs in Yucatán and the spread of Mexican beliefs in Post-Classic days the custom of immolating men to propitiate the gods was adopted by the Mayas. People were thrown into wells, as at Chichen Itza, or their still-throbbing hearts were cut out of their chests as offerings to the divinity. A pantheon of gods was held to exist, of whom the most important were Itsmaya the food-giver, who presided also over medicine and glyph writing, Yum Kax the corn-grower and provider of the all-important maize; Chac, the rain-god; and Ah Puch the god of death. The Mayas showed an acute interest in chronology. To ensure that the agrarian

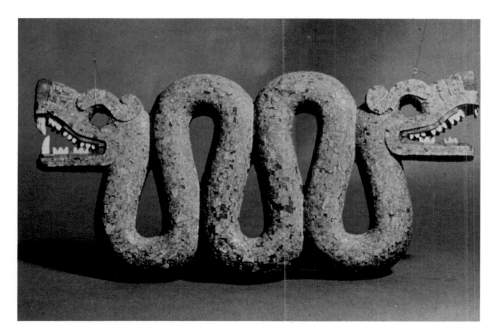

Double-headed serpent, Mixtec, Mexico, late classical period, c.1500. Turquoise and shell over wood, length 43cm (17in). British Museum (Museum of Mankind), London, England. The snake-cult played as important a role in Mexico as the jaguar-cult did in South America and among the Olmecs. It was connected with the God Quetzalcoatl who was represented as a plumed serpent.

liturgical year was observed they evolved precise calendars covering the natural year (360 days plus 5), the ceremonial year and the cosmic cycle. Their mathematics were based on a vigesimal system. To commemorate religious events as well as other important dates, and to record genealogies they used an ideogrammatic system of glyphs or symbols developed from the Olmecs.

One of the supreme achievements of the Mayas artistically speaking was in the realm of architectural sculpture. Maya stone sculpture was generally part of the architectural decoration and took the form of friezes, corbels and finials. They erected stelae, i.e. stone slabs on which the portraits of rulers and high priests were carved in profile and in relief, with elaborate garments and headgear, noble and disdainful profiles and artificially elongated skulls (the Mayas were brachycephalic). They displayed power, dignity and distinction. The decorative motifs make constant use of the symbolism of the jaguar or its fangs which were considered a divine attribute. The shrines were also adorned with stucco reliefs. Pottery was done by coiling, in the absence of the potter's wheel. It was fired in open kilns at 230°C (450°F) and designs were often done by moulding. It was painted in red, yellow, brown colours; sometimes blue was used. Terracotta figures of great elegance and liveliness were to be found all over the country. Some of the finest are funerary figures excavated from the cemeteries of the island of Jaina in the gulf of Mexico. They illustrate Mayan society vividly. The Mayas inherited the ball-game from the Olmecs. It possessed a ritual significance and in the Post-Classic period it ended with the sacrifice (through extraction of the heart) of one or several of the players. The Maya civilization disintegrated in the 10th century AD for reasons difficult to determine. Some climatic change or other natural catastrophes may have occurred. Or, more probably, it did not survive the invasions like those of the Toltecs and the Itzas, made possible by internal dissensions. Our information is scanty. The Spaniards arrived in Yucatán as late as 1542, but the Mayas were finally reduced only in the 17th century, and the race is still with us. Throughout their history they produced a number of illustrated books, written and painted on bark fibre. These invaluable documents were unfortunately destroyed by the Spanish clergy.

The Formative period of the Mexican culture extended from about 1500 BC to 500 BC, the earliest examples of art being the circular platform of Cuicuilco (6th century BC) and the pottery of Tlatilco. The Mexican plateau lies at an altitude of nearly 2,000m (6,500ft) and it is about 160km (100 miles) in diameter. The first important culture to

Mixtec illuminated manuscript (Codex Zouche-Nuttall), Mexico, 14th or 15th century. Deerskin and gesso. British Museum (Museum of Mankind), London, England. (*Below*) The Mixtec culture flourished in south-west Mexico and produced the only manuscripts that have survived from pre-Conquest days. They are concerned mainly with genealogies, conquests and important episodes of past history. These were depicted in a form similar to our strip-cartoons, and painted on strips of gesso-coated deerskin bound in wooden covers.

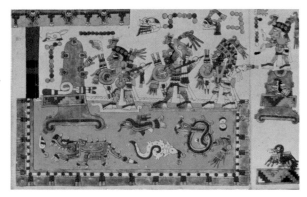

emerge was that of Teotihuacan (300 BC to 750 AD), which is nearly contemporary with that of the Mayas in the south-east.

The earliest and most famous Teotihuacan piece of sculpture is a colossal water-goddess carved out of basalt; equally famous are alabaster vessels made in the form of felines. Surviving stucco reliefs display rattlesnakes, feathered serpents and sea shells. Funerary masks in pottery or semi-precious stones were found hung on mummies. Elegant terracotta figures were modelled by hand in the early period but replaced later by moulded types. As for painting the little that is left includes a landscape mural and some processional scenes. The Teotihuacan civilization seems to have been dominated by the priesthood. It collapsed suddenly in 750 AD under the impact of northern 'Chichimecs' (barbarians) probably the Toltecs, who were above all a warrior race.

The Toltecs adopted religious beliefs centred on human sacrifice to which they gave an increasing importance. They were resolutely aggressive, helped no doubt by their adoption of metal weapons. Metallurgy thus appeared for the first time in Mesoamerica, imported probably from the Andean cultures of South America. The chief centre of the Toltecs was Tula, about 60km (40 miles) from Teotihuacan. Founded around the year 1,000 it survived until the late 12th century, an unfortified shrine modelled on its predecessors. The surviving sculpture of the Toltecs is harsh and graceless, obsessed with violence and death. The fall of Tula coincided with another invasion of 'Chichimecs' involving probably this time the Aztecs.

The Aztecs settled in the valley of Mexico around 1250 AD as the vassals of a local overlord. Eventually, in order to escape his attentions. they moved to an island in the middle of the immense lake that then occupied the centre of the Mexican plateau. They called it Tenochtitlan. This was in 1350. They grew floating gardens, built causeways and

Jaguar, Teotihuacan IIA Classical period between AD250 and 550. Alabaster, length 33cm (13in). British Museum (Museum of Mankind), London, England.
The jaguar cult played a very important part in the civilizations of South and Central America, particularly in Peru and among the Olmecs from whom it spread to Mexico.

enlarged the city to such an extent that it harboured a population of 75,000 at the time of the Spanish occupation. The king himself was elected by a council from among the brothers or nephews of his predecessor. He was a demi-god and had absolute powers but consulted his council. There were about 5,000 priests in Tenochtitlan, led by two high priests. The principal god was Huitzilopochtli, the sun.

Around 1430 the Aztecs embarked on an aggressive policy of conquest, in alliance with two neighbouring tribes whom they eventually reduced. This aggressiveness seems to have been directly linked with the custom of widespread human sacrifice which they inherited from their predecessors in Mexico, the Toltecs. For the Aztecs it became an obsession. According to their millenarist creed the present age was preceded by four periods each of which had ended in disaster (including a flood). It was heralded by an act of self-immolation by two gods who threw themselves into the fire and emerged as the sun and the moon as the result of self-immolation by a number of other gods. In order to ensure the renewal of the annual cycle of fertility on earth and the daily return of the sun to the sky, and to maintain thereby the continuity of life, the gods required human sacrifice on a massive scale and particularly the offering of live hearts; these were carved out of the chests with a stone-bladed knife by priests operating on the platform of the ceremonial pyramids which were concentrated in a fortified compound at the centre of Tenochtitlan. The Aztecs were careful in their wars not to annihilate the tribes they set upon; they wanted to keep a reserve of victims in order to be in a position to pay their yearly tribute to their bloodthirsty gods. At the time of the Spanish landing they were expecting with trepidation the return of Quetzalcoatl, a mythical hero of Toltec origin, with a white complexion and a beard, associated with the plumed serpent. They accelerated the rhythm of human sacrifices to the rate of 10,000 or more in a year. When they heard of the landing of white men with beards riding horses (an animal unknown in Mesoamerica) they went berserk. When the Spaniards reached Tenochtitlan after months of fierce fighting they saw the pyramids and the priests soaked in blood and bodies strewn all over the ground. Human sacrifice and the extraction of hearts existed, as we saw, before the Aztecs but the latter took this ghastly and wasteful tradition to extremes.

On the whole the Aztecs were a cruel and unimaginative, not to say stupid people, brave on the battlefield and contemptuous of death, but profoundly insecure and they got caught into the most vicious of spirals. Their art illustrates their ferocity; it revels in blood-curdling themes and Toltec symbols such as eagles devouring hearts, skirts made of hearts and severed hands within a context of meandering snakes. The expression on the faces they painted or sculpted is universally fierce, cruel, glum or charged with hatred. They made fine jade masks to be appended to mummies; these represented victims who had been flayed and whose skin had been donned by ritual dancers. Technically speaking Aztec art is competent and undeniably powerful, but it is derivative and seems crude when compared with that of the Olmecs and the Mayas. Among their most memorable creations are mosaics of turquoise and other stones, glass and feather work. They also made gold objects. Typically enough their shrines were fortified. The unit of Aztec society was the clan. Each clan elected its leader.

Other Mesoamerican cultures which played a role and left artistic vestiges are those of south Mexico, the Mixtecs (contemporary with the Toltecs). They built the great shrine of Mitla and left important ritual books as well as pottery. Next to them were the Zapotecs who left their mark on the architecture and sculpture of Monte Albán.

ETHNOGRAPHIC
African Art

Sculpture is what most people understand by African art. In European cultures the different arts, such as architecture, painting, sculpture, the decorative arts and music and dancing, tend to be thought of as separate subjects. African art, on the other hand, will combine a carved mask, the dancer's costume, the appropriate music and dance, the participation of perhaps other masked dancers and an audience into one artistic whole. A figure-carving too, may be only one element in a ritual, itself the work of art, which is concerned with the well-being of the past, present and future members of the community.

It is often difficult for us to enjoy African art. As with other arts, appreciation comes with knowledge and understanding of the subject. The geographical area covered is so large and there is such a diversity of peoples and cultures, that while generalization is unavoidable in a short review, exceptions and omissions will be numerous. Until about 100 years ago, Africa was the 'Dark Continent', and only a handful of explorers, missionaries and traders knew anything much about it. The general 19th-century European attitude was that Africans needed all the help they could get, whether through missionary enterprise or colonial administration. Interest in African culture tended to come after conversion or colonization, and often by then the original culture had been partially or even totally destroyed.

The main sculpture-producing areas of Black Africa (south of the Sahara) are west Africa from Guinea across to Cameroon and Chad, and the Congolese culture area including Gabon and Angola. Over this part of Africa, a settled agricultural way of life is general, and visual arts such as sculpture and architecture flourish. Pastoral and hunting groups usually find their major artistic outlets in the decorative arts, music, dancing and story-telling.

Within the sculpture-producing area, African kingdoms such as those of the Ashanti of Ghana, Benin in southern Nigeria, Kongo at the mouth of the river Zaire, and the BaKuba of central Zaire have all been important centres of sculpture and other arts. Art produced in the context of a court nicely exemplifies the difficulty of classifying African art into religious or secular categories. An African king is rarely a divine king in the sense of one ritually killed and replaced at intervals. He is not actually a god, but he may have divine attributes and represent the gods, and enjoy absolute power. While not always a priest-king, an African king or chief often carries out a good many priestly functions on

behalf of his people at festivals and on occasions such as preparing the ground for the next season's crop, mustering for a war, or at time of natural disaster. Continuity is very important over most of Africa: the cult of ancestors, whether tribal and semi-mythical, royalty of a generation or more ago, or personal family, forms a major part of religious expression, as the fortunes of present and future generations are bound up with past generations and so much depends on the correct rituals and offerings.

Ancestor-figures of deceased royalty are found in all the kingdoms mentioned above except that of the Ashanti of Ghana, and it is almost certain that the famous 13th- and 14th-century bronzes and terracottas of Ife, near Benin in southern Nigeria represent royal ancestors. The terracotta heads and limb fragments from Nok in northern Nigeria, the earliest large sculptures known in Africa and dated to the second half of the first millennium BC, may have had a similar purpose. Such ancestor-figures were used to represent the deceased king during the funeral ceremonies, which might last for a year or more; his successor would make offerings before them to ensure the continuing welfare of the kingdom.

In Ghana, on the other hand, a man's spirit was believed to live in his stool. There were numerous chieftaincies among the A'shanti and the neighbouring and related Baule of the Ivory Coast. The stools of dead chiefs, sometimes plated with gold, or if belonging to a Queen Mother, with silver, were kept in stool houses and had blood offerings and sacrifices made before them to keep their power vital. The Golden Stool of the Ashanti people, which, according to legend, descended from heaven during the 17th century into the lap of the first Asantehene, or leader of the Ashanti federation, was believed to contain the soul of the Ashanti people, and if lost or destroyed, the nation would sicken and die. This in fact happened between 1900 and 1920, when the Golden Stool was lost for a while.

Members of the gold-workers' guild had a monopoly of craftsmanship in gold, the main wealth and currency of Ghana (formerly known as the Gold Coast). They lived and worked at the royal courts and made gold or gold-covered regalia, insignia and ornaments for the king and his officials. Gold-dust, the currency in pre-colonial days, was reckoned by the use of brass goldweights, also made by the goldsmiths. These, made by the lost-wax process, are miniatures, averaging 5–8cm (2–3in) in size, and either have abstract geometric motifs or represent people, animals or everyday objects, often illustrating a proverb or symbolizing some aspect of divine power. Trans-Saharan trade in Ghanaian gold may explain the presence of a 14th-century English bronze ewer in the royal treasury at Kumasi, and the Islamic forms of many types of Ashanti brass vessels.

In Europe, the embellishment of churches and cathedrals to the greater glory of God counts as religious art. Given the partially religious nature and function of African kingship, the work of such court craftsmen as the guilds of goldsmiths, brasscasters and carvers of wood and ivory, together with musicians, dancers and singers who might sing the king's praises and recount past history and lineages can be described as combining worldly pomp and circumstance with display of a religious or ritual nature. The finest skills of African architectural adornment have been lavished on the palaces of kings or chiefs. European travellers of the 17th and 18th centuries spoke admiringly of the cities and palaces of Ashanti in Ghana and Benin in south Nigeria. When the British came to sack Benin city in 1897, large numbers of heavy rectangular bronze relief plaques, averaging 45cm (18in) across, were

found in the palace. These portrayed the Oba, or King of Benin, in different situations, a variety of court characters and activities, and even Portuguese soldiers. About 1,000 of these plaques, which are attributed to the period of about AD 1550–1650, are known; they were used to cover the wooden pillars supporting the Oba's reception courts. Large bronze snakes, cast in sections, were attached to the roofs of towers within the palace; they may well have symbolized the power of the king.

Among the Yoruba of southern Nigeria palaces were adorned with elaborately carved solid wooden doors; posts supporting verandahs were carved in the forms of standing figures, women with children or horsemen; in the latter case, the size of the tree trunk generally resulted in a large man riding a disproportionately small horse. Chiefs' houses in Cameroon had elaborately carved door frames and verandah posts, while a chief's stool, bed and food vessels were all finely carved and were sometimes covered with beadwork. Further east, in Zaire and the Great Lakes district, kings' houses were furnished with walls and screens of canework finely and intricately patterned in black and pale gold. Whether rectangular, as in the Congolese culture area, or circular and domed, as in the Lake Victoria region, the reed dwelling can be made into palaces and relic-houses worthy of royalty. Where suitable stone occurs, as in Zimbabwe, the reed-and-thatch-built king's palace layout may be translated into stone.

African religion can be broadly defined as a dynamic, pagan animism, which often survives under an overlying religion such as Islam or Christianity. While a paramount God may be named, He is generally reckoned benevolent and not overmuch concerned with men's affairs. A host of lesser gods, spirits and natural forces such as thunder and lightning must be appeased with offerings and ceremonies to avert misfortune. Everything that happens is the result of some spirit activity; if good, it is because the right rituals have been observed; if bad, it may be that some spirit is neglected or that some ill-wisher has turned a spirit against one. These spirits and lesser gods live in carved figures. in a particular place such as a rock or large tree, or in a shrine, whether elaborate and containing figures, or a small 'spirit-house' containing a snailshell and other significant objects. The principle of dynamic growth is of widespread importance, and the growing spiral of a real or carved snailshell or an animal's horn is often used to symbolize this. The widespread belief that life is a single repeating cycle made up of the dead, the living and the unborn explains the importance of ancestor cults and also of *rites de passage*, or ceremonies marking the transition of members of the community, often in a group, from one stage of life to another. Circumcision or initiation ceremonies for boys and youths, and ceremonies for girls entering on womanhood are typical *rites de passage*; other important stages came at the end of funerals, marriages, and the birth and naming of a woman's first child.

Masked dances to mark the finish of young men's initiation are widespread; they may also take place at certain stages in the agricultural cycle. A good example of the latter is found among the Bambara of Mali where their antelope mask represents the spirit of Tyiwara, who introduced agriculture. His dance now honours the most energetic farmer and encourages the others, but it was originally meant to promote the fertility of the crops. The masks, which are worn attached to small basketwork caps, may portray male or female antelopes; the female often carries her fawn on her back. Portrayal is either naturalistic or is an abstract interpretation of the animal's horned head.

The Sande society of Sierra Leone is the only women's society in

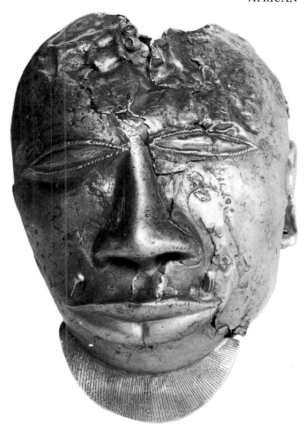

Head, Ashanti tribes, Ghana, probably mid-19th century. Gold, height 18cm (7in). Wallace Collection, London, England.
This head, sometimes described as a mask, was in the rich treasure of King Kofi Kakari of the Ashanti, and was brought to England as part of the indemnity after the First Ashanti War (1873–4). It would have formed part of an effigy of a deceased King (Asantehene) and would be used in the ceremonies attendant upon his 'second burial'. The head, weighing 1.5kg (3lb 6oz), is hollow, cast by the cire perdue or lost-wax process. The casting is about 4mm ($\frac{1}{8}$in) thick and somewhat carelessly finished, though most impressive in right profile.

Head, Nok culture (c.500 BC–AD200). Nok, southern Zaria province, northern Nigeria. Terracotta, height 35cm (13$\frac{3}{4}$in). Federal Department of Antiquities of Nigeria. (Pages 264-65)
Nok terracottas have been found in the course of open-cast tin-mining in the alluvial gravels of north and north-western Nigeria. The heads seem to come from whole figures, some life-size, while other heads and fragments are small and delicately modelled. They may have been made as shrine furniture, funerary effigies, or even for domestic use. Many, such as this head, can be linked with the present-day population by affinities in hairstyles and in art, by similar ways of treating facial features and body proportions.

Head and tusk. Benin City, Nigeria. Head, probably mid-19th century; tusk, probably 19th century. Head, bronze alloy; tusk, elephant ivory. Height of head, 51.5cm (20.3in); length of tusk 188cm (74in). Museum of Mankind, London. (*Opposite*)
Heads and supporting tusks were used on altars for the cult of the Oba's ancestors, and this cult dates back to 1700 or earlier. They were not necessarily made as pairs. The head is that of an Oba (King) of Benin wearing a coral-bead choker and a headdress of a style introduced after 1816. The tusk is carved with representations of court officials in coral-bead tunics, wearing belt-mask insignia, musicians, leopards (an emblem of royalty) and other motifs pertaining to royalty.

Africa known to use masks when initiating girls into womanhood and wifely duties. As all woodcarving in Africa is done by men, the masks are anonymously carved and are 'found' by a stream. This is not to say that the Sande is the only women's society; they exist over all Africa as a means whereby the older women train the young girls into the proper way of doing things. Similarly the older men in Sierra Leone, who are all members of the Poro society, train youths into their responsibilities to the tribe at the start of manhood. The Poro society takes many different forms as it has absorbed other societies, and covers a wide area from Sierra Leone to the Ivory Coast, and has a large variety of masks. Such a society may concern itself with the later stages in a man's life up to his death and funeral, with maintaining social law and order, supervising group hunting and agricultural activities, and providing entertainment. The mask includes the anonymous dancer's costume, which can be made of cloth, netted string or raffia fibre and covers him completely. Without the dance and music, the mask has less power, and if a mask is destroyed another is made and consecrated in the prescribed way, with proper ceremonies. The Great Mask of the Dogon of Mali is never worn. This mask represents the first ancestor of the tribe, and a new one is made every 60 years.

Offerings are made to a mask of that type or an ancestor figure, often by cutting a chicken's throat and smearing the blood and feathers over its surface. Dogon sculpture, which is closely linked with ancestor worship, often has a very distinctive crust of dried eggs and blood. In Nigeria, Cameroon and Gabon palm oil is used to make an offering. Typically the wooden effigies carved by the Fang of Gabon to guard baskets containing the bones of the deceased are dark and sticky with repeated applications of palm oil, just as among the living, palm oil is a cosmetic used to make the skin shining and supple. Another cosmetic is the red powder made from grinding camwood; this, mixed with palm oil, is used when tending *ibeji* figures in Yorubaland, south Nigeria. These figures are carved for a woman who gives birth to twins, one or both of which dies. The mother tends the doll which is usually about 20–30cm (9–12in) high, oils it, rubs it with camwood, and dresses it with strings of beads. This both comforts the mother for the loss of her baby, and is also necessary to prevent a similar misfortune occurring in a later pregnancy. The surviving twin continues to care for the *ibeji* if need be.

An art-form peculiar to the Congolese art area is the fetish. In the coastal region, this takes the form of a man, or less often an animal, which is bristling with nails, arrowheads and knife-blades. Each piece of iron represents an offering to the fetish and an appeal to the spirit inside it. Other fetishes are human figures with a cavity in the back, belly, or crown of the head; this hole is filled with a magical compound including things like blood, hair, beeswax, nail parings, latex and feathers which invest the fetish with magical power. A piece of mirror, china or a cowrie shell may be used to 'seal' the magic in. Such fetishes are made by the BaKongo, MaYombe, BaTeke and BaSongye of Zaire. Among the BaSongye, an antelope horn containing 'medicine' is stuck into the crown of the head; while among the BaTeke the fetish may be a cloth-covered bundle with a carved male head sticking out of the top. Some fetishes are benevolent and have offerings made to them; others are hostile and must be appeased; yet others are protective. Not all fetishes are in sculptural form; most are animal horns, snail shells, calabashes or other hollow objects suitable for containing the 'medicine'. Central Zaire is reckoned to be one of the finest art-producing areas of Africa, although it was hardly known to Europeans 100 years ago. The

Headdress mask, Bacham chiefdom, West Bamileke tribes, Bangwa-Dschang region, Cameroon. Probably late 19th-early 20th centuries. Wood, height 67cm (26⅜in). Rietberg Museum, Zurich, Switzerland.
The carvings of a good Cameroon Grasslands sculptor may be dispersed over a wide area. There are only a very few masks of this type extant, and the recorded provenances do not really indicate where they were made. This mask was made to be worn on top of the head, like a crown, and combines remarkable three-dimensional cubism with extraordinary breadth of treatment. Masks such as this were carried in front of kings and members of the secret society on important occasions.

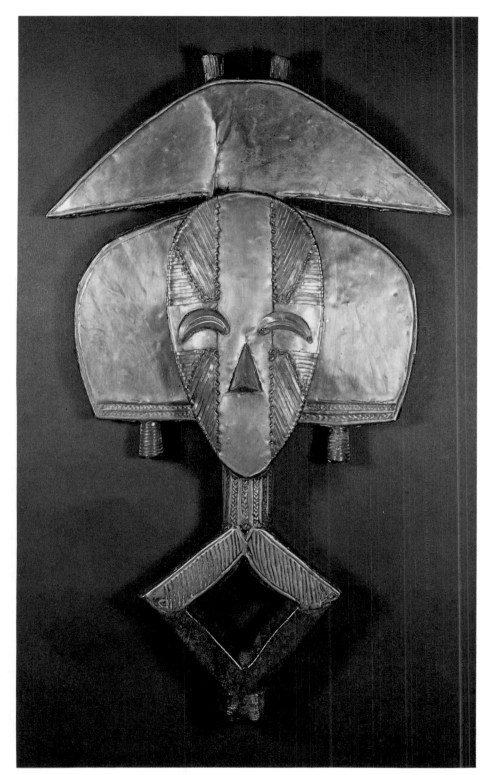

Stylized human figure, BaKota tribe, Gabon. Probably late 19th century. Wood, covered with sheet brass and copper strips on the front of head and 'shoulders', height 65.6cm (25¾in). British Museum (Museum of Mankind), London, England.

These *mbulu ngulu* figures are placed in baskets containing the bones of ancestors, and kept in the family shrine. They are not actual representations, although differentiated into 'male' types with convex faces and 'female' (like this) with concave faces, large crest and broad side pieces. They were probably made to enlist the help of family ancestors in protecting present and future generations from illness and misfortune.

kingdom of Kongo, on the coast, had trading relations with the Portuguese from the early 16th century onwards, but the rapids on the River Congo (now Zaire) and the dense forest proved an insuperable barrier for centuries. In the Kasai basin, the people who call themselves BuShongo (People of the Throwing-Knife) and are called by others BaKuba (People of Lightning) have a history as important in the Congolese area as that of Ife or Benin in Nigeria. Their oral tradition lists over 120 kings, the earlier ones mythical, but the 93rd king can be dated to about AD 1600 by a total eclipse of the sun during his reign. This king, Shamba Bolongongo, was the first ruler to have his portrait carved; he is also said to have introduced weaving and embroidery in raffia. Several portrait-statues of BaKuba kings survive. Very characteristic of BaKuba art is geometric interlacing ornament, whether engraved on the surfaces of drums, boxes, seats, spoon-handles or cups, or in the patterns of raffia-pile cloth where a velvet-like effect is achieved by embroidering with needle and thread often in black, purplish-red and the natural

pale gold, and trimming the pile with a sharp knife. Each design had a name, which might refer to a proverb or historical character, and one cloth might combine as many as three or four designs.

South-east of the BaKuba, the BaLuba group includes several other notable art-producing tribes, and their sphere of influence extends into Angola and Zambia. Much BaLuba art strikes us as being serene and harmonious: but the BaLuba and the Fang of Gabon who also produced very 'serene' carvings were actually warlike and violent. In BaLuba art, stools, offering bowls and neckrests supported by female figures were common. These figures have distinctive hairstyles and body cicatrization. African skin, if tattooed in a certain way, heals in keloids, or raised lumps, and women especially might have most of their bodies tattooed in this way. As well as having aesthetic appeal, such markings served to identify members of a tribal sub-group or clan. Body decoration was an art-form in itself, whether body-painting as practised by the Fulani of Niger or the Ibo of Nigeria, or the elaborate cicatrization of Zaire or the MaKonde of Mozambique.

Masks occur in great variety in Zaire: the dramatic large boldly striped masks of the BaSongye; the baroque BaKuba combinations of painted wood, beads, cowries, raffia cloth and fur; the geometric abstracts of the BaTeke; and the delicate BaPende masks, with finely carved triangular mouths and eyelids. Small objects, such as combs, boxes, and whistles, are no less artistically carved. Among the BaPende of south Zaire and the neighbouring BaJokwe of Angola, the European upright wooden chair has been transformed by the addition of many tiny figures to the cross-bars of back and base; such chairs might have been valued trade goods in the beginning and were copied and Africanized as chiefs' chairs later on.

Fang ancestor-figures of Gabon, guarding baskets of bones have already been mentioned. In the same country, the BaKota group of tribes have similar guardian figures, but while those of the Fang are representational and recall the proportions of a new-born infant, those of the BaKota are semi-abstract, a human face with crested headdress, covered with strip or sheet brass or copper on a hollow diamond-shaped 'body'. Masks carved by the BaKota have no resemblance to their ancestor-figures.

North of Gabon, the Cameroon Grasslands area produces masks, houseposts, doorways, figures and stools which are among the most vigorously carved of African sculptures. While most African statuary is static, some Cameroon pieces, notably from the Bangwa, really seem to move.

Far fewer pieces of eastern African art survive. While it is true that pastoral groups do not produce sculpture, the greater part of the population in Uganda, Kenya, Tanzania and Zambia is agricultural, leading an adequately settled life, although they may have had to move their villages every few years as the houses fall down or become tick-infested, and the surrounding land gets exhausted. Yet the situation in Mali or Niger, where the Dogon and Bambara have to work hard to get a good crop, and are subject to the influence of Islam, with its hostility to the representational arts, is not so different from that over much of east Africa, where, along the Swahili coast, Islamic influence is clear. Both areas have been subjected to extensive tribal movement and conquest.

In fact, a small handful of high quality sculpture survives, for example from the WaZaramo and WaNyamwezi of Tanzania, and especially the MaKonde and related groups living in the area where Mozambique, Tanzania and Malawi meet. Allusions in early travellers' writings, together with the existence of some pieces, mostly badly

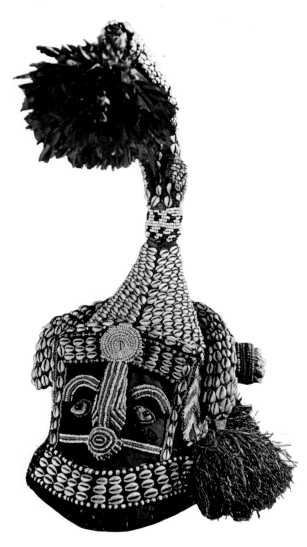

Mask, BaKuba tribe, Zaire. Probably late 19th century. Cane, wood, beads, cowrie shells, raffia cloth and fringe, trade cotton cloth, total height 60cm (23⅝in). Musee Royal de l'Afrique Centrale, Tervuren, Belgium.
The BaKuba have about ten mask styles. This one is the *Mwaash a mbooy* (*mashamboy*), and symbolizes Woot, the primal ancestor of the BaKuba people, who founded their royal line, political system and culture. The top of the mask shows the trunk and tusks of an elephant (a symbol of royalty). The mask is used at initiations and royal dances, and may only be worn by men of royal descent.

documented, collected around the turn of the century, suggest that there may once have been many more fine carvings which have perished due to the combined effects of time and decay. Arab slave-raiding together with their ivory trade penetrated far into the interior and at its worst destroyed tribal life, and the work of the European missionaries who were generally hostile to 'idols', 'devil dances' and other such aspects of African life also contributed to the disappearance of the indigenous art forms.

In the north-eastern part of this area, the Sudan and the Horn of Africa, ancestor-figures, whether small ones for keeping inside the hut, or large ones for grave markers, are the typical form of sculpture. The Konso and related tribes in Ethiopia carve heads with crested head-dresses on the ends of their grave-posts; the Bongo and Bellanda of the Sudan carve posts in the form of men or, occasionally, women to mark the graves of important people. The Bari of the Sudan carve small human figures. While a great deal of African carving reflects in its proportions the limitations imposed by the shape and girth of the original tree trunk, this characteristic is so marked in this part of Africa that it is described as 'pole sculpture'.

The sculpture of the MaKonde of south Tanzania and northern Mozambique has been labelled an outlier of the BaLuba sphere of influence. This is largely because of a typical form of MaKonde mask. Almost without exception, east African masks are 'face' masks covering the face only; 'helmet masks', which cover the head and face, and which occur throughout west Africa and the Congolese culture area, are common among the southern MaKonde of Mozambique. The masks are now used in dances which entertain and which satirize errant members of the group, but the northern MaKonde of Tanzania usually make face masks. Earlier masks include female torsos with characteristic MaKonde body cicatrization, and were probably used originally for initiation and agricultural ceremonies. Facial tatooing is a characteristic of MaKonde masks and figures. In the earlier pieces this is rendered by applied strips of black beeswax; later on by incised lines. Hair was shown by actual human hair anchored by tiny impressed cuts into the scalp; beards might be made of animal hair. The MaKonde today have a thriving art industry for the European market, with the carving mostly in ebony or hippo ivory.

This is only a short survey of African art, which does not try to do more than pick out some outstanding points. Hardly anything has yet been said of ivory-carving, both in elephant and hippo ivory, yet salt-cellars and spoons, some with the Portuguese coat-of-arms and carved for the European market in the 16th century, 16th-century ivory belt-masks worn by the Oba of Benin, and bracelets from the Yoruba town of Owo, Nigeria, rank among the finest pieces of African art. Elephant ivory, because of its beauty and rarity, was often a royal perquisite, and the elephant a symbol of royalty.

As well as wood, ivory and terracotta, stone, usually soft soapstone, was a sculptural medium. In Sierra Leone, *nomoli* figures, thought to belong to the 16th century or earlier, have been dug up when preparing the fields, and are set up by the present inhabitants as guardian figures to watch over the rice crops. Ancestor figures in soapstone are found at Esie in Nigeria, and others found near the mouth of the river Zaire have been made by the BaKongo to guard the graves of their ancestors from as far back as the 17th century. Yet the African carver did not restrict himself to soft stone, but was prepared to tackle granite and vein quartz, as the stools and sculptures recovered from ancient Ife in Nigeria clearly show.

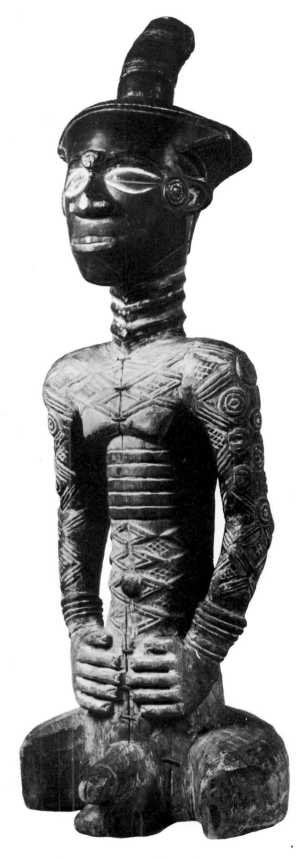

Ancestor figure, Ndengese tribe, Lukenye River, central Zaire. Probably late 19th-early 20th centuries. Painted wood, height 68cm (26¾in). Sammlung fur Völkerkunde der Universität Zürich, Zürich, Switzerland.
The hair-style, treatment of face and scarification patterns put this carving into the BaKuba art area, although the Ndengese, living north of the BaKuba, belong to the Mongo tribal group which is not noted for its plastic art. These distinctive effigies, and a type of slit gong, are the only carvings that are certainly attributable to the Ndengese, among whom the Totshi society occupies a politically important place.

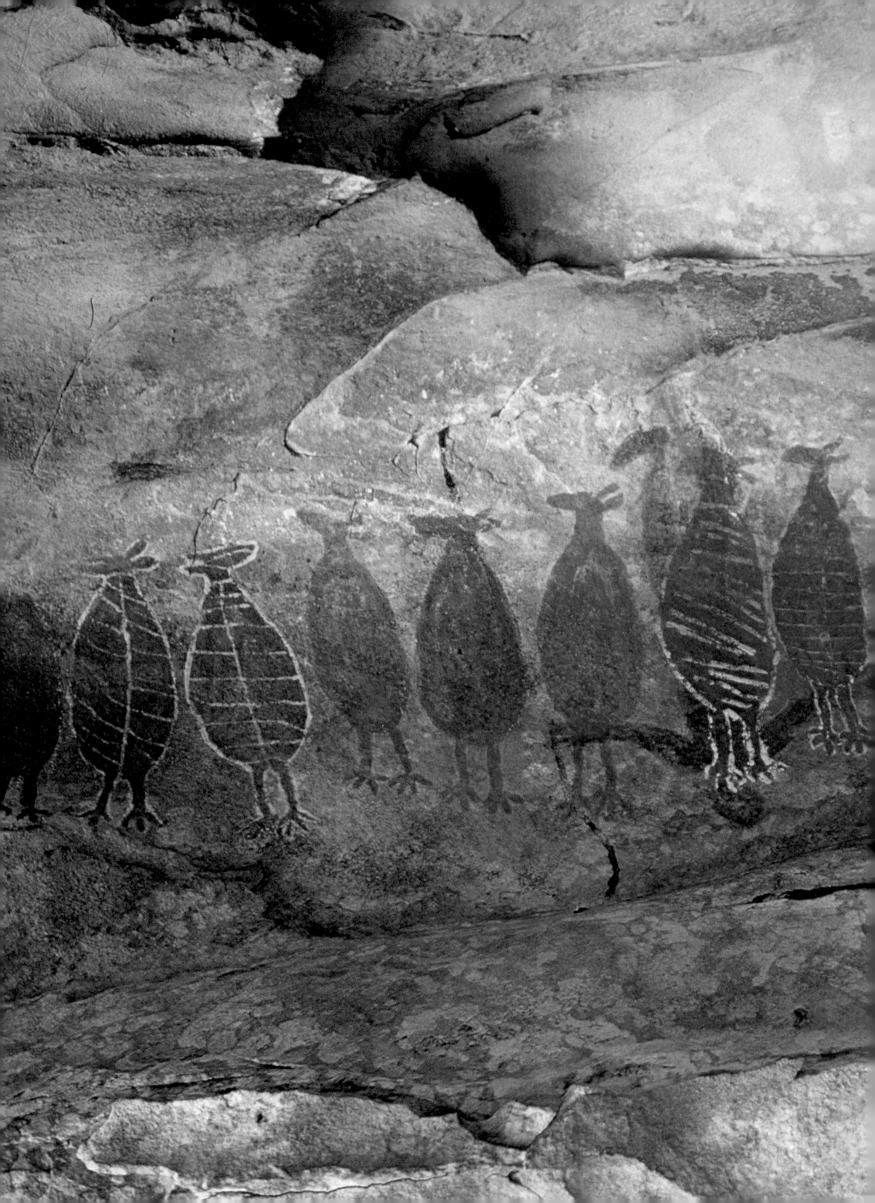

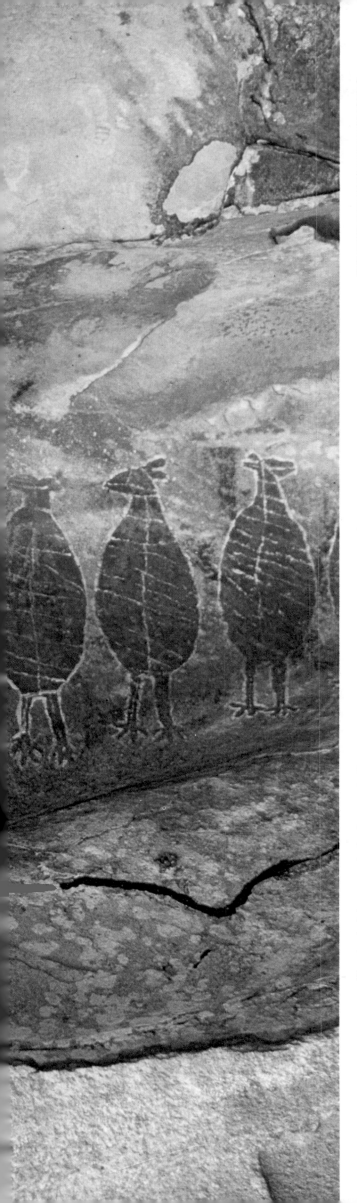

ETHNOGRAPHIC
Aboriginal and Oceanic Art

The people we now call the Aborigines occupied the Australian continent in the 5th millennium BC. Like all Oceanic populations they came originally from the Asian mainland. They were of dark stock, small, with fuzzy hair. They were, and remained, a semi-nomadic society. They had to adjust themselves to desert conditions which discouraged agricultural activities. They never emerged from their condition of neolithic hunters and food-gatherers, roaming over the vast spaces of Australia, in search of food and water, carrying the minimum equipment: light weapons (spears, boomerangs) and wooden dishes—they had no pottery. The art they produced was light and fragile. It consists essentially of paintings and incisions. Rock-paintings represented hunting scenes and had a magical purpose like their counterparts in southern Europe and Africa; or they illustrated myths concerning the origin of the world and of the surrounding landscape features. These mythological paintings referring to the 'dream time' display great powers of imagination. They describe tribal ancestors and spirits such as the moon-faced *Wandjinas* and the dashing *Mimis*, who look like stick-insects. The colours were simple: red or yellow from ground ochre stones, white from pipe-clay or crushed shell, black from carbon. They were painted with burred twigs, palm fibres or simply the fingers. Painting was done not only on stone but also on the bark of the eucalyptus tree and on wooden shields. In this case it could be either figurative (of man and animal) or beautifully abstract in a most sophisticated way. A remarkable feature of aboriginal painting is the so-called 'X-ray' representation of the internal organs and bone structure of man or beast, the stomach, liver, intestines, spine and ribs. There was very little sculpture in the round and this was limited to the northern regions which came under the influence of Melanesian New Guinea. But all over the continent are to be found abstract and geometrical symbols engraved on rocks, next to stencilled imprints of hands and feet.

The term 'Melanesia' means the 'black islands' in reference to the dark skin of the inhabitants of New Guinea and of the clusters of islands stretching for 2,000 miles north to south far off the north-east coast of Australia. Artistically speaking Melanesia was put on the map in the 1920s by the Surrealists who were fascinated by the imaginative powers it displayed and by its obsession with death, head-hunting, cannibalism and sex. They saw in it a fantastic expression of the world of the subconscious brought recently to their knowledge by Freud. They admired

equally the boldness of the forms and the variety of the materials borrowed from nature for the decoration of objects and of people.

New Guinea is the largest area of the Melanesian world, a huge island, settled since 3,000 BC by successive waves of immigrants from south-east Asia. The population, of about three million represents a mixed lot of early refugees, speaking more than 700 different languages, scattered in small villages among the mountains which rise up to 4,900m (16,000ft)—and the mosquito-ridden valleys and coastal swamps. They constitute a democratic society of gardening and fishing communities each governed by a body of elders under the guidance of an elected chieftain. Until recently they belonged to the Stone Age. Their religious beliefs were elementary, founded on animism and ancestor-worship and centred on a community house reserved for men, where divination and initiation ceremonies took place. Cannibalism was rife in the Melanesian world and the people of New Guinea indulged constantly in petty wars often connected with head-hunting. They considered the head the centre of power and collecting enemies' heads was deemed necessary for the survival of the group, and for the success of various enterprises, especially among the Papuan tribes of the south and the west.

The northern half of New Guinea is irrigated by the Sepik river. This is about 1,300 km (800 miles) long, and has many tributaries. This vast catchment area produced art on a lavish scale, particularly woodcarvings, small ancestor figures or charms and colossal statues, masks for the dance and the initiation ceremonies, house and canoe decoration, shields and boards, ornamented utensils, tools and weapons. The style varied from one valley to another along the great river, but the spirit remained unmistakably Sepik with the curvilinear patterns, the concentric circles and spirals, the constant metamorphosis of man into animal or plant and vice-versa, and above all the emphasis on the human face or head, with the long, hooked nose with splayed nostrils.

The overriding theme was the representation of the spirits. These were either the supernatural forces at work behind the natural phenomena or the ancestor-spirits—the spirits of the clan and the family, the expressions of continuity and identity in a hostile, insecure world. The oldest of these carvings were sculpted with stone tools (adzes), the finer details being carved with hard shells and animal teeth. A small number survive in museums and go back beyond World War I, but very few of the objects are more than a century old, owing to the damage inflicted by the insects and a hot climate with the highest rainfall in the world. Melanesian sculpture was nearly always painted in bright colours and adorned in a most imaginative way with feathers, fibre, foliage, fruit and fur. The masks were inserted in the most gorgeously plumed headgear and completed by multicoloured leaf and grass skirts. They also represented spirits and they were used in dances or ceremonies where the dancer became the spirit he impersonated. Besides masks and statues every house contained a number of skulls, either those of enemies killed in battle or those of defunct relations which were overmodelled in clay and painted as portraits. Shields and boards of every description were used as easels for painting. Bark and pandanus leaves served the same purpose, but the finest shields were perhaps those made out of feathers. The Sepik people, or at least some of them, made coiled up pottery; they did not know the wheel. The architecture and decoration of their great assembly houses, reaching a height of 30 or 40m (100–130ft) is impressive. The only cloth the Melanesians knew was the *tapa*-cloth made of the inner bark of the mulberry tree, beaten into a sort of felt which was then painted. Very few stone sculptures have been found but they seem

Kangaroos, cave painting, Northern Australia. (*Previous page*)
Animals were often depicted in the caves in connection with hunting. It is believed that the painting had a magical purpose. Their date is difficult to determine, as the style of painting shows little alteration apparently over many centuries.

Rock painting, Arnhem land, Australia.
These paintings depict myths of origin and often also hunting scenes. They are to be found in shallow caves and rock shelters. They are renovated at intervals by visiting aboriginal groups.

to be very ancient.

South of the Sepik valley stretched the vast jungles and swamps surrounding the Gulf of Papua and the Asmat and Mimika areas. This was the heart of the head-hunting and cannibalistic Melanesia. The style of the Papuan Gulf is different from that of the Sepik world. Spirals, hooks and concentric circles are replaced by meanders, triangles and chevrons decorating painted boards representing ancestors (*gope*) or open-work carvings called *agiba* surmounted by a large flat face under which were hung skull trophies. The Asmat and Mimika tribes used the wood of the *sago* tree as their material; they cut out grooves and dyed them ochre red according to patterns evoking the flying-fox and particularly the praying mantis. They were the symbols of head-hunting and were combined with phallic representations. To portray and honour their deceased parents they sculpted whole trunks, 8 to 10m (26–32ft) high, with painted grooves. They then laid the

Decoration from the front of a ceremonial house, Abelam (Maprik), New Guinea. Pandanus leaves sewn together and painted, height 153cm (61⅞in). Museum für Völkerkunde, Basel, Switzerland.
The ceremonial house dominated the village. It could reach a height of 27.5 metres (90 feet). It was reserved for the initiated men.

trunks on trestles outside their houses. Their shields with motifs carved in relief are equally remarkable.

The Abelam lived north of the Sepik, between the river and sea in fertile, healthy highlands. Their sculpture was characterized by bright colours; red, yellow, black and white. They preferred long vertical points looking like stalactites and stalagmites to the hook-motif. Their favourite animal-motif was the hornbill, while the Sepik people adopted the crocodile, the eagle, the catfish, the cockerel.

The northern coast around the Geelvink bay produced interesting ancestor shrines, called *korwars*, consisting of a skull, sometimes

dressed like a doll, resting on a lattice-shaped altar. Further east by the coast was the Lake Sentani. The settlers built themselves houses resting on piles sunk into the lake bottom and made of a very hard wood which they carved with the appropriate stone tools. These piles consisted of trunks planted upside down, with their roots supporting the ridge pole of the house. The sculptor transformed these roots into lizard or bird forms. House and canoe decoration would also take the form of heron-like birds of great size and beauty. Standing figures were found around the chieftains' houses, representing ancestors with pointed chins and no necks, or mother and child groups, impressively simple and smooth, with fluid lines unique in Melanesia. The big Sentani hour-glass drums in hard wood and the wooden dishes with their sophisticated, Celtic-like patterns are also noteworthy.

At the south-eastern tip of New Guinea, beyond the Huon Gulf lie the Massim promontory and the Trobriand Islands. They were inhabited by a population of sailors and traders, with some Polynesian blood, famous for the *kula* trade and for their uninhibited love life, as described by Malinowski. They carved only small objects, mainly lime spatulae, thus adding chalk to the betel or areca nut they chewed as a stimulant. These spatulae, made of polished ebony-like wood, were usually surmounted by a human or animal figure, carved with exquisite care and precision; the incised patterns in the wood were filled with lime to bring out the design.

The Melanesian culture included the islands of New Britain, next to New Guinea, with fantastical multi-coloured masks made out of *tapa*, fibre and bamboo for fertility festivals, and New Ireland where the quinquennial festivals required the carving of *malanggan* or open-work sculptures where an outer mesh of snakes, flying fish and lyre-bird feathers in light wood surrounded an inner core figuring a pig, a man or some hybrid monster. Most awesome are the sacred *uli* ancestor statues, which were kept in a sacred enclosure.

Further south the New Hebrides are famous for their sculptures carved out of the giant fern's root and also for the 2m (7ft) tall *ramba-ramb* figures made of sticks, bark cloth and bones, surmounted by an overmodelled skull wrapped in cobwebs, fibre and *tapa* cloth and holding a stuffed dog on a lead. With the Solomon islands the Melanesian style changes radically. Figures are carved in the round out of hard wood painted only in black, burnished and inlaid with mother-of-pearl. Some, like wrestlers are naturalistic. They represent mostly ancestors and other spirits and animals such as the shark and the bonito fish. Finally there is New Caledonia which produced dance masks with huge hooked noses impersonating a water-spirit, and colossal anthropomorphic house posts. For human sacrifices they used disc-shaped axes made out of greenstone.

This great variety of styles, which makes Melanesian art so fascinating illustrates a culture with specific features common to all Melanesians and setting them apart from other primitive societies particularly the Polynesian world of the South Pacific.

Polynesia, like Melanesia, is a word coined in the 18th century and means 'many islands'. It refers to the galaxy of archipelagos included in a triangle of the South Pacific the sides of which measure about 8,000km (5,000 miles) each, with the apex on Hawaii and the base stretching from New Zealand (the land of the Maoris) to Easter Island. This triangle was explored and charted in the late 18th century, chiefly by Captain James Cook in the course of three voyages when he discovered that the Poly-nesian culture was homogeneous. The same language was spoken all over the vast area and the social structure as well as the customs and the

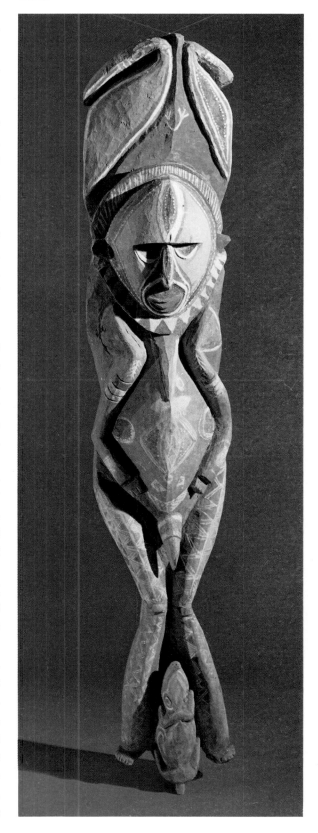

Ancestor figure, Abelam (Maprik), New Guinea. Painted wood. Museum für Völkerkunde, Basle, Switzerland.
The spirits of ancestors played a large part in the cults of the peoples of New Guinea and, consequently, in their carving. Decorated ancestor figures, like this one surmounted by two birds, stood by the houses of the village chiefs.

myths of origin were similar, if not identical.

The Polynesians left the Asian mainland much later than the Melanesians, and, according to one system of reckoning; colonized the Fiji islands around 1000 BC, occupied the Friendly Islands (Tonga), and Samoa between 500 and 300 BC, the Society Islands (Tahiti and the Marquesas) after 300 AD, Hawaii around 700 AD and New Zealand around 900 and 1300 AD. They were amongst the greatest seafarers the world has known, on a par with the Vikings. They designed ocean-going double-hull canoes which could contain 60 to 80 men and they mastered the art of navigation and star-reading.

The Polynesian society was aristocratic and theocratic, very different in this respect from the Melanesians. It was composed of three separate strata; the noblemen and priests, the commoners who farmed and fought for them and the slaves who were recruited among prisoners of war, criminals and taboo-breakers whose lives counted for nothing. The Polynesians believed in two main forces, one positive, called *mana* a form of vital energy derived from the gods and the other negative, called *tapu* (taboo), an inhibiting power that put men and things under interdict. The Polynesians projected their aristocratic outlook into their religion. They believed in a supreme god who created the world and man, with the help of four divine intermediaries from whom all noblemen descended via culture heroes. The function of the priestly caste (*tahuna*) was to interpret the will of the gods and formulate the *tapus*. Elaborate ceremonies were staged on elevated earth and stone platforms. The artists were held in high esteem; they were part of the priesthood and therefore of the aristocracy. They had the monopoly of religious sculpture and of any other important work such as canoe building. They went about their work with intense professionalism and care, after a rigorous initiation and with the help of prayers and incantations.

Most Polynesian art was destroyed by the islanders themselves when they came under Western and particularly missionary influence. What is left shows a remarkable sense of quality. Like those other boat-builders, the Vikings, they were amongst the greatest woodcarvers of all time. They also worked in stone (the Marquesas), nephrite or jade (the Maoris), walrus ivory, whalebone and shell and they produced, particularly in Samoa and Hawaii, *tapa* or barkcloth painted with abstract patterns of breathtaking distinction and quality.

The aristocratic outlook of the Polynesians was reflected in the restraint and sophistication of their carving which keeps to the essential and displays an acute understanding of the particular material employed, such as the various types of wood. Their work consisted mainly in representations of the gods (as in Hawaii, the Austral Islands, Maori land, Easter Island) and spirits (the *tikis* of the Marquesas, Tonga, the Maoris), the making of war clubs (Fiji, Tonga) war canoes (Fiji) head-rests, dishes and bowls, stools, flywhisks (Tahiti, Tonga, Fiji, Hawaii). The styles differed from island to island and are immediately recognizable but the Polynesian outlook is the same everywhere. The houses were built with a strong feeling for proportion, elegance and functional economy; so is the furniture.

We only find architecture in the full sense of the word among the Maoris of New Zealand who had to cope with cold weather and spent more time indoors. For the same reason they wore linen clothes in place of *tapa* or grass skirts. The Maoris, who came originally from the Marquesas in two successive invasions, practised tattooing, like their forbears. Their sculpture which is often part of the architectural ornamentation presents the same spiral motifs and other signs that are to be

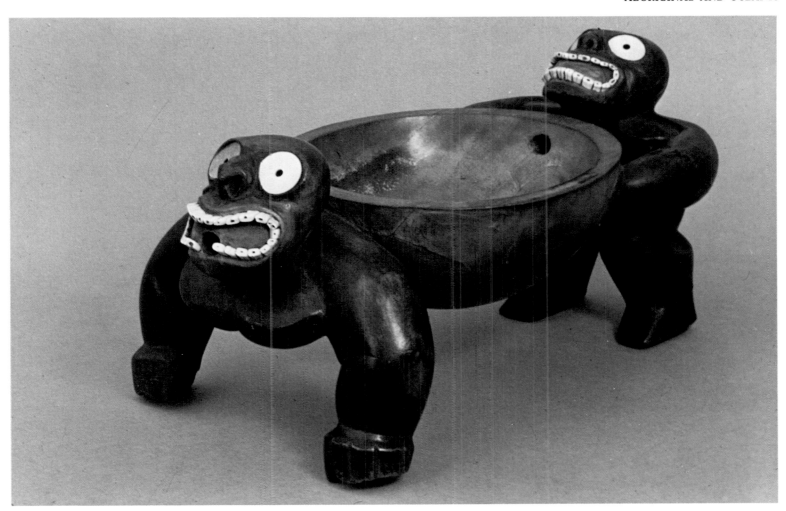

found on the body decoration. Among the recurrent themes of Maori carving are a mythical owl-like bird, called the *manaia*, sea-monsters and lizards. The canoes were as impressive as those of the Fijians, with their great prows carved in open-work.

The Hawaiian noblemen had superb cloaks and helmets made for themselves out of small red and yellow feathers stuck on to basketry-work. The representations of Pele, the goddess of volcanoes which they used as a war-standard were similarly made. We have also preserved regal and ceremonial garb from Tonga and Marquesas, adorned with feathers and large shells, as well as admirable Marquesan crowns of mother-of-pearl and tortoiseshell.

The Polynesians were taller than the Melanesians, and lighter complexioned, with straight or aquiline noses and flat or curly hair. Their good looks and proud bearing combined with their charm, good manners and the easy-going receptiveness of their bare-breasted ladies appealed enormously to the Europeans. But they had no sense of property, could be cruel and they practised human sacrifices. Some islands (Fiji, Marquesas, Maoris) were cannibalistic.

Easter Island was a world apart, a tiny dot in the south-eastern Pacific 3,000km (2,000 miles) from the Chilean coast and its nearest neighbours on the other side. It is famous for its colossal statues (probably of ancestors), built of volcanic stone and erected on platforms along the coast. Its sculptors also produced powerful as well as refined little carvings of very hard wood, representing the 'hungry man' and lizards or the sooty tern in connection with the annual bird cult. At the other end of the Ocean on the north-west side lies a galaxy of tiny islands known as Micronesia. Among them are the Caroline islands, settled by Polynesians and the homes of superb carvings up to 1.5m (5ft) tall, representing stylized human figures in a Brancusi-like style. White, stylized, Japanese-like masks also came from there.

Bowl, Polynesia, Hawaii. Wood, the eyes of the figures mother of pearl, the teeth of bone, height 25cm (9⅞in), length 47cm (18in). British Museum, London, England. Probably used to drink Kava (or awa), a fermented beverage. The two supporting figures are spirits (*Menehune*) or hobgoblins. They are often represented in connection with household implements, tools and instruments.

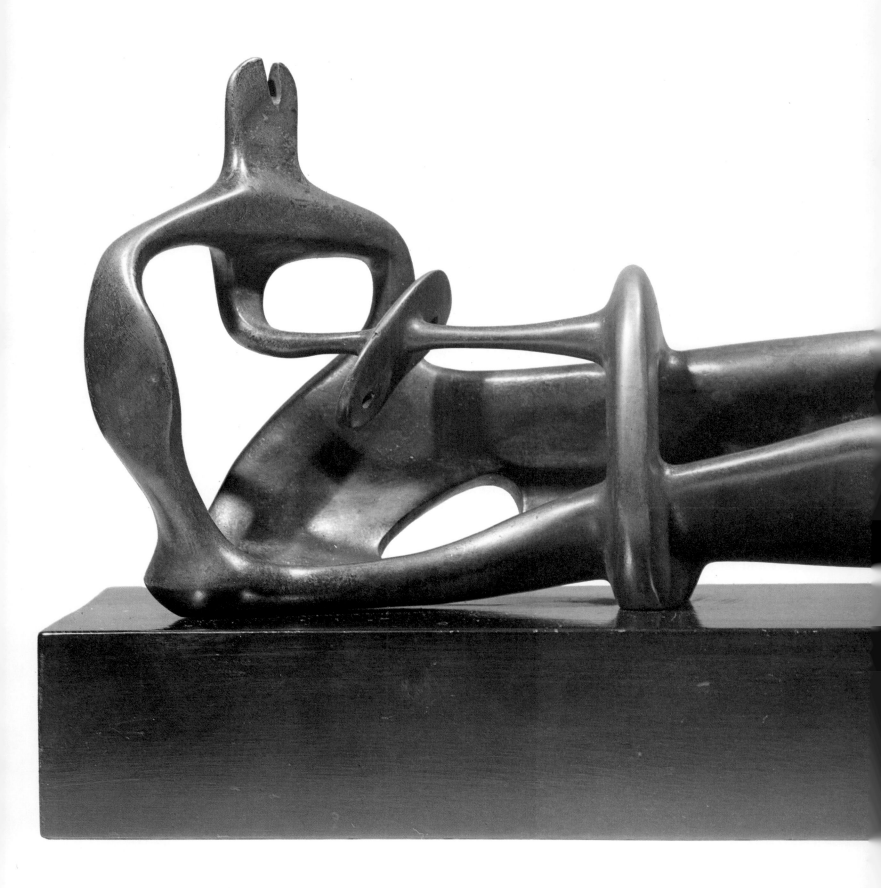

20th CENTURY ART

Soon after the year 1900 western art changed gear. At the time enthusiasts believed it had gone into overdrive. Some would say, with almost literal justification in the case of surrealism, that it has gone over from manual to automatic transmission; others, that we have a whole new fleet of vehicles; and others (enthusiastic artists among them as we shall see) that we have now reached the scrap yard.

Just over 70 years ago a group of artists in Paris, Picasso the most famous among them, proclaimed the revolution. They announced that their work brought to an end the worn-out tradition of representation in art begun by the Renaissance or, even, classical Greek art. When it had started hardly mattered. Now it was dead and a good thing too. Between 1907 and 1917 a cluster of *avant-garde* painters and sculptors claimed for art the right, even duty, to build its own reality with its own materials. The pained cry of 'What is it supposed to be?', raised by generations of laymen ever since was out of date for these frontiersmen by 1914 at the latest. Art historians have cited Cézanne and Van Gogh as the immediate forerunners of the new attitude and archaic styles from the non-European traditions or from the prehistoric European period are given as its remote ancestors. But for us, the revolution is more important than the antecedents. It gave birth to an art which demands a new way of looking.

Throughout this book we have paid special attention to the techniques used by artists of different periods and traditions. This is an age of technology and an interest in the technology of art is natural to it. Moreover, experimentation with the materials and methods of working has proved one of the most absorbing activities among artists themselves. Sometimes it has meant disposing with technique, discipline and craftsmanship altogether.

'Originality' and 'spontaneity' are watchwords of our generation and the German Wolf Vostell, believing that destruction is a vehicle of spontaneity, has been doing destructive things such as singeing and charring posters and pictures since his mid-20s. Others have made exhibitions of themselves, mutilating and scarring their bodies in public, a display which in one case reached the logical conclusion of the artist's death. In the late 1950s the young French pioneer, Yves Klein (1928–62), presented a Painting Ceremony in Paris in which naked young women, attractive for the most part, smeared with paint, rolled and dragged one another about, under the artist's direction, on a large

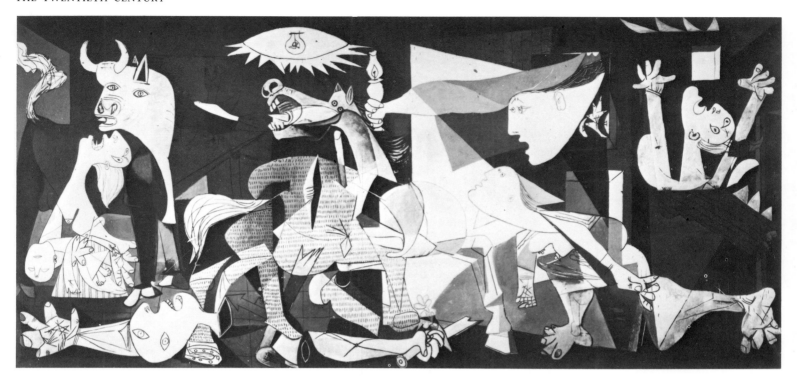

Guernica, Pablo Picasso (1881–1973), painted 1937. Oil on canvas, 350 × 782cm (138 × 308½in). Museum of Modern Art, New York, USA. (*Above*)
This famous picture was painted as a passionate protest against the bombing of the Basque town of Guernica by German warplanes, supporting the Francoist forces in the Spanish Civil War. Its impact is made even greater by the muted, almost monochrome colour scheme Picasso used.

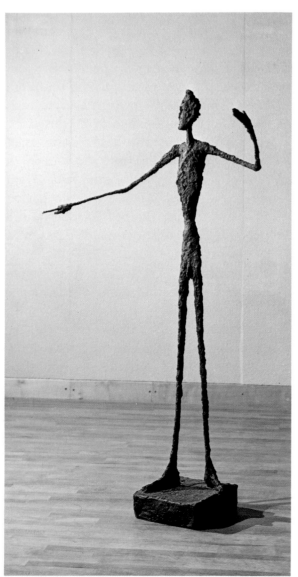

canvas. The ceremony was accompanied by 20 musicians playing Klein's *Monotone Symphonie*—a single note sustained for ten minutes, followed by ten minutes silence.

An early attempt to get away from the idea of art boomeranged rather unfortunately. In 1914, Marcel Duchamp had presented a urinal and the bottle rack from a French restaurant kitchen as 'ready-mades'. The bottle rack is still to be found in the sacred precincts of the Philadelphia Museum of Art and reproduced in the pages of art books. In a letter to Hans Richter, a founder of dadaism, Duchamp wrote in 1962: 'When I discovered ready-mades I thought to discourage aesthetics. . . . I threw the bottle rack and the urinal in their faces as a challenge and now they admire them for their aesthetic beauty.'

The 1970s' 'conceptual art' posed once again the long-standing 20th century question about the whole idea of art. It proposed that physical manifestations of the artist's conception are unnecessary and that the idea itself is the work. One group of Conceptualists began presenting its concepts in the journal *Art and Language*, on tape, microfilm and posters. The British conceptualist Keith Arnatt (*b*.1930), once wittily posed for the camera wearing a sandwich board with the words **'I'm a Real Artist'** elegantly printed on it. Other artists are working on a more than monumental scale. In 1970 the American Robert Smithson (1938–73) used earthmoving equipment to shift stones and boulders on the Great Salt Lake, Utah into a construction over 450 metres (1,476ft) long, which he entitled *Spiral Jetty*. Other 'earth' or 'land' artists have made similar transformations, or scored designs on the earth's surface so immense that they can only properly be viewed from the air.

Gallery art has to rely on less sensational effects. The Welsh sculptor Barry Flanagan (*b*.1941) has made use of polystyrene granules, lengths of rope and mounds of sand to dispose in patterns on gallery floors. In the aptly named 'junk' sculpture the American John Chamberlain (*b*.1927) and the French-born César (*b*.1921) have deployed the massive presses of the scrap yard to produce cubes of crushed cars, sewing machines or bicycles. The Bulgarian-born Christo (*b*.1935) has made his art not by packaging junk, but by literally packaging buildings and landscapes, even wrapping a mile of Australian coastline in polythene.

A logical conclusion of the contemporary fascination with technique was approached in the movement known as 'process art'. Materials such

as fat, yeast, felt and coal have been used in stacking, smearing, or draping seemingly organic and amorphous forms—the process itself being the main focus of attention. Since the Dadaism of the 1910s artists have from time to time abandoned materials altogether for performances or public displays in which the gestures and actions are essentially 'absurd', that is to say, gratuitous and in themselves purposeless. The English performance artists Gilbert and George, who appeared with gilded hands and faces on a plinth miming to a recording of a music hall song, claimed themselves as 'living sculpture'. Whether they should also be considered treasures of world art is not clear.

They represented one aspect of the movement for 'happenings' which flourished in America, Europe and Japan during the 1960s and early 1970s—'revolutionary' art often funded by official government councils and ministries of arts.

In 1901 the Paris gallery Bernheim-Jeune held a retrospective exhibition of the works of Van Gogh. The vivid canvases had a strong impact on many young painters who were to win the ultimate accolade of critical abuse four years later with the title of the 'wild beasts'. Their exhibition was at the Salon d'Automne opened in 1903 to present the works of major modern artists still denied full recognition by the art establishment, as well as of young innovators. At the Salon of 1905 one room in particular caught the eye of the critic Louis Vauxcelles. At the centre was a sculpture in classical style; the walls surrounding it were aflame with canvases of pure flat colours. In his review Vauxcelles scornfully described the scene as *Donatello parmi les fauves*, that is 'Donatello among the wild beasts.'

The Fauves had been canonized. They were neither a school nor a movement, but a group of painters entranced by the effects from placing flat areas of pure colour down on canvas. Among them was André Derain (1880–1954), the Dutch-born Kees van Dongen (1877–1968), who later enjoyed success as a fashionable portrait painter and the Fleming Maurice de Vlaminck (1876–1958). Untrained, Vlaminck boasted that he had never even been in the Louvre and acknowledged only van Gogh as an influence. His works had a truly savage intensity at this time and though, possibly under the influence of Cézanne, his colours soon became more subdued he always believed that 'instinct is the foundation of art'. 'I try' he said, 'to paint with my heart and my loins.'

The 'king of the beasts' in that historic year of 1905 was Henri Matisse. Born in 1869, he was the doyen of the Parisian *avant-garde*, having abandoned a job in a lawyer's office in his early 20s to devote himself to art. As a student he met Georges Rouault and the painter and sculptor Albert Marquet (1875–1947), who became a close friend. At first inspired by the bright palettes of the Impressionists and the Neo-impressionists, Matisse turned to the works of Cézanne about 1899 and plundered his meagre savings to buy the small Cézanne *Bathers* from the dealer Vollard. The painting, he wrote later, 'sustained me spiritually in the critical moments of my career as an artist'. Like Cézanne, he brought a powerful sense of structure to both his painting and sculpture.

Matisse and the Fauves freed artists from all inhibitions and conventions in the use of colour just as Cubism was to release them from considering representation in their approach to form. By 1904, the first experimental stage of his development was complete and Matisse returned to a brilliant, Neo-impressionistic palette. Like the German Expressionists, whom he in part influenced, he had a serious expressive purpose and drew on primitive forms. In 1908 he wrote 'What I look for above all else is expression.' But Matisse lacks the Germans' violence of mood. It was a special irony that he should have been dubbed a 'wild

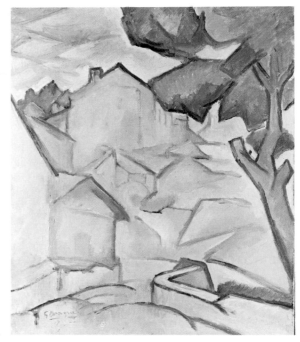

Houses at L'Estaque, Georges Braque (1882–1963), painted 1908. Oil on canvas, 59.5 × 73.0cm (28½ × 23½in). Kunstmuseum, Berne, Switzerland. (*Above and 284 bottom*)
Reclining Figure, Henry Moore (b.1898). Bronze, length 33cm (13in). Private collection, England. (*Previous page*) More than half of Moore's sculptures of full length figures are reclining, a form which suits his concern with the characteristics shared by human properties and natural landscapes.
Man Pointing, Alberto Giacometti (1901–66), 1947. Bronze, height 178cm (70½in). Tate Gallery, London. (*Opposite*) Giacometti's characteristic 'matchstick' emaciated figures are disturbing statements of an anxiety-ridden age.
The Back I, Henri Matisse (1869–1954), c.1909. Bronze, height 188cm (74½ in). Tate Gallery, London. (*See p. 284*) Sculpture played a major role in the creative life of Matisse. *The Back* was a series of four sculptures over twenty years in which the forms were successively simplified into a bold abstract design.

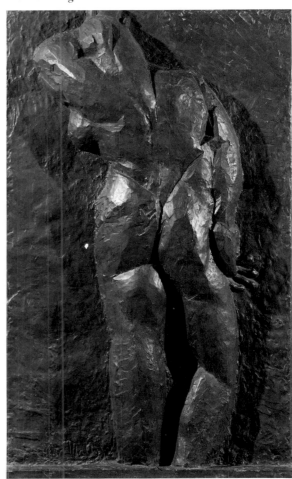

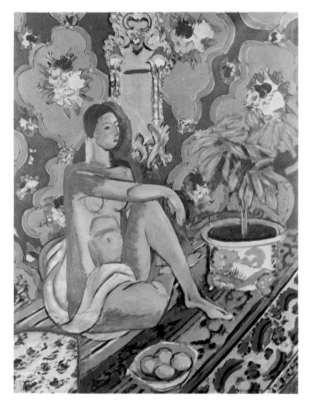

Decorative Figure on an Ornamental Background, Henri Matisse (1869–1954), painted *c*.1927. Oil on canvas. Musée d'Art Moderne, Paris, France. (*Above*)
This picture, which reflects the artist's fascination with eastern fabric and designs, exemplifies his belief that decorative expression was one of the functions of art. Inevitably this conviction earned him abuse as 'bourgeois' and 'decadent' by some members of the *avant-garde*. Matisse himself said, 'I am concerned with arabesque like the Renaissance artists.' The remark is revealing for the arabesque, Oriental in origin, is an essentially linear and decorative concept. It contrasts markedly with the bold, almost abstract design of *The Back* (p. 283).

beast' for, as he later wrote, he dreamed of an art 'of balance, purity and serenity', free of 'depressing subject matter' which should be like 'a good armchair in which to rest from physical fatigue'. It would, perhaps, be difficult to construe a series of observations more at odds with the spirit of innovative art in this century.

Twenty-five years after his death the reputation of Matisse remains undimmed. In his old age he made a departure more radical than his work with the Fauves. In 1941 he emerged from a course of surgery a permanent invalid. A series of interiors painted at the end of the decade irradiated with light and colour showed that the great man's perceptions were as individual and keen as ever and the areas of colour seemed to have a life of their own. In the last four years of life, unable any longer to wield a brush, he devised a type of collage technique that would enable him to continue his exploration of the world of colour relationships. Paper coloured to his specifications was cut by himself or assistants and laid out on immense backings in designs of throbbing vitality.

In 1907, two painters working in Montmartre, Pablo Picasso (1881–1973) and Georges Braque (1882–1963) began painting the pictures that launched a visual revolution. The curtain was raised by Picasso's large canvas *Les Demoiselles d'Avignon*. This picture, based on a brothel scene, was named from the Carrer d'Avinyo in Barcelona's red light district. Its ugliness and distortions shocked even Picasso's friends. But the five figures have haunted western art ever since. The canvas throbs with vigour. The two figures to the right show the impact of African tribal sculpture, a premonition of the importance alien 'primitive' art was to have on many other artists; the figure on the left seems to derive from Egyptian sculpture, while the two in the centre strike poses familiar in the conventional repertoire of European art. The geometric forms that make up the figures were to prove prophetic of a very near future.

Overcoming an initial revulsion from the aggressive ugliness of the

Les Demoiselles d'Avignon, Pablo Picasso (1881–1973), painted 1907. Oil on canvas, 244 × 234cm (96 × 92in). Museum of Modern Art, New York, USA. (*Right*)
Perhaps the most influential single painting of the 20th century, Picasso's *Demoiselles* shocked even his friends and admirers when they first saw it. However, the revolutionary implications of its style were very quickly appreciated by Braque (page 283 top), Picasso's partner in those days and, with rather less earnestness and high purpose than critics attributed to them, the two created the style soon dubbed Cubism.

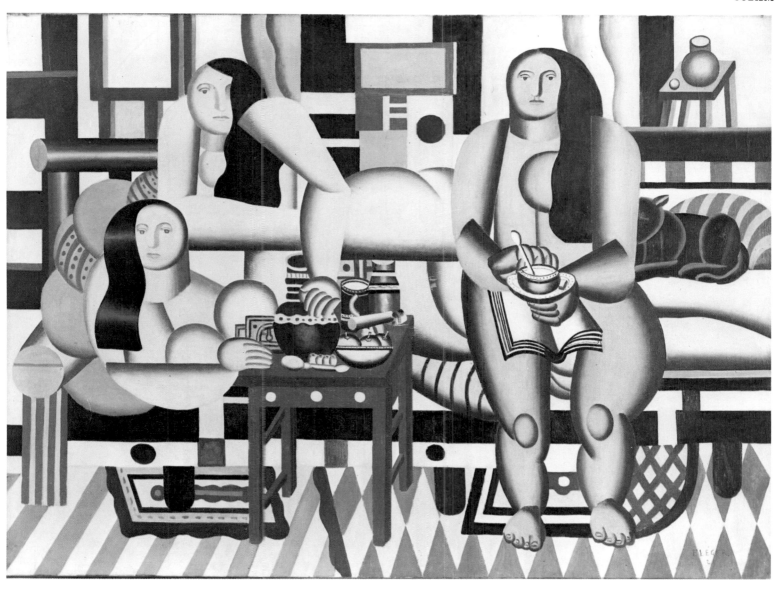

images, Braque, reflecting on the formal implications of the *Demoiselles*, began to modify his own work. A recent critic credits him with the first truly 'Cubist' painting. Over the next seven years, he and Picasso, 'roped together like two mountaineers', developed the style, christened by a critic from a remark of Matisse about 'Braque's little cubes'. They exhibited little and were surrounded by imitators and theorists ready with explanations of the meaning of the new style. The two originators and their close circle passed their time in work, jokes and banter with Picasso and Braque indulging in almost music hall double acts. They said little of their intentions though Braque let fall the important comment 'There is no certainty except in what the mind conceives'. This suggests an attitude of mind far removed from the analysis of the ultimate truth of reality which many theorists proposed to be their concern.

The first variant of the style, termed analytical Cubism by some critics, lasted up to about 1912. It was recalled that in a letter to his friend the painter and critic Emile Bernard Cézanne had advised that the artist should 'deal with nature by means of the cylinder, the sphere and the cone'. This famous quotation became the text on which many critiques of Cubist canvases rested. Many works by Fernand Léger (1881–1955) exhibit their cylinders and cones quite clearly but the canvases of Braque and Picasso, during the years of true Cubism, are a pattern rather of facetted shapes, apparently set at angles to the canvas.

Lurking behind and among them, so to speak, the spectator can detect indications of the familiar objects the painter has used as his subject. But the object of attention is the patterned surface of the canvas and its pictorial qualities, not the objects themselves. As this facetting tech-

Le Grand Déjeuner, 'Three Women', Fernand Léger (1881–1955), painted 1921. Oil on canvas, 183 × 252cm (72 × 99in). Museum of Modern Art, New York, USA.
Born in Normandy, the son of a farmer, Léger trained as an architect before turning to painting. From 1909 he was associated with the Cubists, a member of the *Section d'Or* in the early 1910s and was later involved with the abstract movements *de Stijl* and Purism. The *Grand Déjeuner* was one of a group of monumental figure paintings and still lifes influenced by this association, which presented the incidents of everyday life in an almost heroic convention.

Jacques Lipchitz and his wife, Amedeo Modigliani (1884–1920). Oil on canvas. Art Institute, Chicago, USA.
Painter, sculptor and draughtsman, Modigliani trained in Venice and Florence before settling in Paris in 1906. He allied with no movement, but a meeting with the sculptor Brancusi was decisively important in the development of his work. His wild and Bohemian life in Montparnasse became a legend cultivated by his literary friends; it obscured his professional concentration on painting in his later years. This portrait of his friend the sculptor Lipchitz shows the curved lines and elongation of the nose ridge that characterize much of his work.

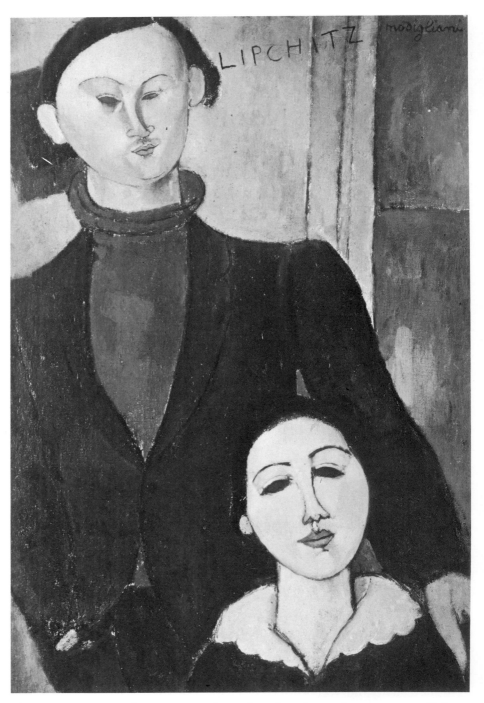

nique was pursued to greater lengths the object becomes so disintegrated as to be almost indecipherable. At the same time the colours have been drained, with tonal variety confined to greys, olive greens, muddy blues and browns. The trellis of the picture surface between the spectator and the object has become so close meshed that the nature of the object itself is an almost insoluble enigma. When this stage, known as 'hermetic' (i.e. 'secret') Cubism had been reached, Picasso and Braque were already veering on to a new tack.

In 1912, playing with the distinction between the real and the imitation and fascinated, like Braque, by fake materials, Picasso stuck a piece of manufacturer's imitation cane-work material on to the oval canvas of his painting *Still life with chair caning*. The shaped canvas was something of a novelty; the applied material represented a first step in a new technique. Soon Cubists were cutting shapes of objects out of newspapers or any handy material, sticking these on to canvases as part of their still life compositions. The paradox between the 'real life' function of the newspaper and its pictorial function as the representation of something quite different was an amusing and thought provoking game, challenging the notion that reality could be represented in paintings at all. 'Collage', as the new technique was termed, fractured the plane of

the painting and the idea of painting as a two-dimensional surface art came into question. The new technique was used with even more disruptive effect by the Dadaists.

Of the numerous painters who followed Braque and Picasso, sometimes seeming to adopt Cubism as their own, the most important were Fernand Léger and Juan Gris (1887–1927) who was considered by some to be the third great Cubist. Others, like Roger de la Fresnaye (1885–1925) and Albert Gleizes (1881–1953), adapted the geometrical conventions of the Cubist vocabulary to paintings in a more conventionally representational style. The movement spawned other groups, notably the Section d'Or with Raymond Duchamp Villon and Marcel Duchamp as leading figures. Through them the English Vorticists developed certain Cubist traits. Cubism also affected the Russian Constructivist and Suprematist movements and the post-war movement of *de stijl* in the Netherlands.

In the 1920s the clean-edged geometrical shapes were being introduced into the vocabulary even of commercial design, while in America, William Sheeler (1883–1965) and Charles Demuth (1883–1935) turned out smart and stylish canvases of architectural subjects, emphasizing the geometrical aspects of their surfaces. Some called the style Cubist-realism, others called it Precisionism.

By 1914 the two original pioneers were drawing apart. Braque enlisted in the French army and in 1915 he was seriously injured. After his convalescence he returned to Paris where he was to live for the rest of his life. *La Guitariete* (1917) continues some of the ideas of the last stage—'synthetic' Cubism—but the colours are now stronger. Cubism continued the language of Braque's subtle colour sense and fluent painterly technique and the still life remained his principle preoccupation until in the great Atelier series of the early 1950s, it came to embrace the studio, the artist, his model and even the painting itself. In many of his later works the image of a bird in flight evokes a sense of mystery that deepens the mood of harmony and peace in his work.

Picasso was born in Malaga, though the family moved to Barcelona when he was a boy and it was there that he trained. Almost from childhood he showed a prodigious talent for art. He rapidly mastered the traditional skills; in his mature works the *Vollard Suite* reveals his breath-taking mastery of classical draughtsmanship.

The paintings of Picasso's first Blue Period are austerely representational studies of the poor, infused by a deep melancholy. They were followed by the more optimistic, warmer Rose Period. These were only the first two of a succession of styles, each marked from the preceding one by a sharp break and change of direction, in which, with effortless virtuosity of technique, the artist appeared to exhaust the possibilities of each theme before turning to a new one. The pattern has been followed by many men of lesser talent and with less justification.

In the early 1900s Picasso remained solvent largely thanks to the generous purchase of his pictures by Gertrude Stein. Then came the revolutionary *Demoiselles*, to later generations 'the vital step in freeing the artist from his traditional obligation to natural appearances'. Picasso's exploration of the various phases of Cubism may be said to have culminated with the monumental *Three Musicians* of 1921 but in 1917 he had begun a seven year association with Diaghilev's ballet company. With them he visited Rome, Naples, Florence and Barcelona producing many theatre designs of which the most renowned is the drop-curtain for Satie's ballet, *Parade*.

The visits to Italy may have prompted the strongly classical flavour of his figure drawings in the early 1920s, though the style conformed

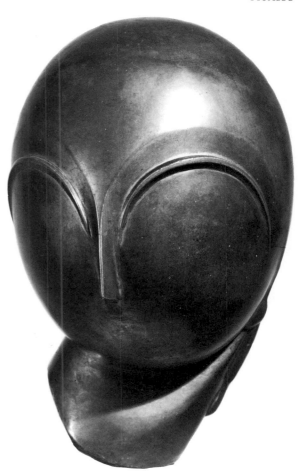

Mademoiselle Pogany, Constantin Brancusi (1876–1957), 1913. Bronze, height 27cm (10½in). Musée National d'Art Moderne, Paris, France. (*Above*)
Brancusi settled in Paris in 1904. The current interest in African art and the influence of African sculpture are clearly apparent in the dynamic curves of this portrait head which also reveals something of the elegance of *art nouveau* styles of the early 20th century.

Figure, Jacques Lipchitz (1891–1973), completed 1930. Bronze. Hirshhorn Museum, Smithsonian Institute, Washington, USA. (*Below*)
The Lithuanian-born Lipchitz settled in Paris in 1909. Friendship with Picasso, Juan Gris and others, led him to work in a basically Cubist style from about 1915 to 1925. Then he turned towards a freer, more evocative use of natural forms as in this sinister and surrealistic sculpture.

Three Dancers, Pablo Picasso (1881–1973), painted 1925.
Oil on canvas, 221 × 142cm (85 × 56in). Tate Gallery,
London, England.
With the frenzied gestures of this work, Picasso moved
away from the almost classical abstraction of his earlier
Cubist works which had reached monumental expression
in the *Three Musicians* of 1921. Albert Gleizes and Jean
Metzinger, theorists of Cubism, wrote: 'For the partial
liberties conquered by Courbet, Manet, Cézanne and the
Impressionists, Cubism substitutes an indefinite liberty.'
The *Three Dancers*, called Picasso's 'last great Cubist work',
is also a characteristic interpretation of Surrealism by the
versatile master.

with the Neo-classical idiom abroad in music and the arts at this time.
Gradually grotesqueries began to break in on the monumental figures
producing strange, dislocated anatomies until the frenzies of the *Three
Dancers* (1925) confirmed a period of ambiguity and distortion of
organic form which accompanied his involvement with Surrealism. In
the 1930s, the politics of his troubled homeland called forth some of his
most passionately committed works. The etchings *The Dream and Lie of
Franco* (1937) and the impassioned rhetoric of *Guernica* declaimed his
hatred for Fascism and dictatorship. He had returned to Spain for a time
during the brief republican interlude but left again in 1937, determined
not to return during the rule of Franco.

During the war, Picasso lived in Paris under the German occupation
then, in 1946, he moved to the south of France living at Antibes with
Francoise Gilot, by whom he had a son Claude and a daughter Paloma.
Picasso had married the ballerina Olga Koklova in 1918 and in 1961 he
married Jacqueline Roque. Three years after the move to Antibes, he
opened a ceramic workshop at Vallauris where he produced a number
of important works in this new field of endeavour. In 1958 he did the
mural for the UNESCO building in Paris, while work of all kind con-
tinued to pour from his studio. Among the most influential works of
the post-war period were his variations derived from the famous works
of the past such as *Las Meniñas* by Velazquez and the *Woman of Algiers*
by Delacroix. Then, in 1966, exhibitions in London, Paris, New York
revealed to the world his sizeable oeuvre of sculpture which stretched
back to the 1910s but had remained relatively unknown.

The opposite, mechanistic pole of 20th century artistic impulse was
most powerfully represented in the relatively short-lived but deeply
influential Constructivist movement which had its origins in the 'relief
constructions' of Vladimir Tatlin (1885–1953). Trained as a painter, he
began to make these constructions in the early 1910s; before the end of
the decade he had evolved 'Corner Constructions', free hanging forms
designed to modify the space they occupied and enclosed. These near
abstract structures, from glass, iron and wood were abandoned for the
practical concerns of the artist-engineer as Tatlin saw his role with the
coming of the Bolshevik Revolution. At the head of the Moscow Depart-
ment of Fine Arts, he plunged into what he termed the 'culture of
materials', designing workers clothes, stoves, and other practical pro-
jects. Through El Lissitsky Constructivist concepts spilled over into the
field of typography and through Kandinsky and László Moholy-Nagy
(1895–1946) they reached the Bauhaus and so influenced much design
thinking in western Europe. But whereas the Constructivists could come
to terms with the revolution the pure abstract tradition represented by
the painter Kasimir Malevich (1878–1935) eventually died under it.
Malevich, the founder of what he termed 'Suprematism' in art, is chiefly
now remembered for a series of paintings, such as *White on White*,
literally a white square on a white ground, which pushed the concept
of paint on canvas to the limit and posed, by implication, questions still
being pondered by the so-called 'Minimalist' school of the 1960s. The
rigorous passion of the Russian artistic revolutionaries made Moscow
one of the major centres of experimentation in the 1910s.

From the 1910s on, Malevich bulked almost as large in the history of
sculpture as in painting. His *Head of a Woman* was one of the few great
examples of Cubist sculpture, the others being by Henri Gaudier-
Brzeska (1891–1915) and certain works by Alexander Archipenko
(1887–1964). More prophetic of the future developments were his
assemblage pieces, made up from odd pieces of metal and scrap to pro-
duce sometimes powerful, often witty animal-mimicking forms. How-

ever, here Archipenko was also a pioneer, introducing the principal of the collage into sculpture in the 1910s. Between the wars, Picasso's sculpture was parallelled by the work of his great compatriot Julio Gonzales (1871–1952). Living in Paris from 1900, he had begun his career as a painter, but turned to sculpture in iron. Although he used industrial processes and aimed always to produce forms that observed, rather than broke the limitations of his material, nature was always the source of his inspiration.

Perhaps the greatest sculptor working at this time was the Rumanian Constantin Brancusi (1876–1957). Of peasant origins and trained originally as a stonemason he turned to sculpture aged 22 and never lost the craftsman's love and respect for material nor the peasant's intuitive sense of traditional symbolism in carving. In 1904 he settled in Paris for life. Primitive alien cultures and the art of the east fed his inspiration. Though revolutionizing 20th-century attitudes to sculpture, works like *Le Baiser* (1908) embodied a mystic, contemplative mood which was never to leave his work. Simplicity and symbolism of form, so at odds with much that was mechanic in the new art, were in the works of Brancusi enduring influences on some of his greatest successors.

Futurism, dedicated to the cult of speed, motion and the machine, burst on the world in February 1909. In Paris the *Figaro* newspaper carried the 11-point 'First Foundation Manifesto', written by the dramatist and poet Filippo Tommaso Marinetti (1876–1944). Futurist publicity, a dozen manifestoes, leaflets, exhibitions and demonstrations continued until the outbreak of war. Marinetti and two others of the movement Umberto Boccioni (1882–1916) and Luigi Rossolo joined the colours immediately. It was consistent. Point nine of their first manifesto had proclaimed the glorification of war 'the world's only hygiene'. Point 10 had demanded the destruction of museums, the cemeteries of the past.

The Futurists were the apostles of 20th century industrialism as the environment and subject of the artist. A racing car, so went the thesis, was more beautiful than the *Victory of Samothrace*. The comparison is very apt. The Greek statue had been designed as a memorial to a great naval victory. It represents Nike, goddess of Victory, alighting on the prow of a warship. Her upstretched wings and wind-blown robes evoke an almost kinetic sense of movement, despite the massy weight of the stone. The sculptor relied on the feelings of the spectator about the idea of movement. The Futurists represented motion in terms of high-speed photography—depending not on how it feels to be in motion but how science reveals motion actually to be.

The best known Futurist works, Giacomo Balla's *Dog on a Leash* and Umberto Boccioni's sculpture *Unique Forms of Continuity in Space* are both expressions of motion and both attractive works of art. But the most famous work to embody the principles of the movement was painted not by an Italian but by the French artist Marcel Duchamp (1887–1968). His *Nude Descending a Staircase* when displayed at the American Armory Show in 1913 caused the sensation of the show. It also reveals the debt that, unwilling though they were to admit it, the Futurists owed to Cubism.

Duchamp, born in 1887, is one of the legendary figures of modern art. The year following the Armory Show he met Francis Picabia. Their writings were to be formative in the movement known as Dada—the anti-art movement which broke out in Zurich and New York in 1915, 1916. In 1915 Duchamp left Europe for America where he had a considerable influence over Alfred Stieglitz whose anti-art movement parallelled Dada. It is strictly speaking a betrayal of Dada to mention it in such a book as this since more violently, more consistently and also

Nude Descending a Staircase, No 3, Marcel Duchamp (1887–1968), painted 1912. Oil on canvas, 152 × 89cm (58 × 35in). Philadelphia Museum of Art, USA. (*Above*)
Despite his original and individual genius, Duchamp was associated with Futurism in its early phase. This picture, like contemporary Futurist works, was inspired by chronophotography in its attempt to create an equivalent on canvas of the moving figure. The picture, rejected from a Cubist exhibition, won instant notoriety at the Armory Show of modern art in New York in 1912.

Dynamism of a Dog on a Leash, Giacomo Balla (1871–1958), painted 1912. Oil on canvas, 91 × 110cm (35 × 43in). Albright-Knox Art Gallery, Buffalo, NY, USA. (*Below*)
This picture is one of a series, which Balla painted in a little over twelve months, of studies of movement. The artist made use of chronophotography (multiple exposure time lapse photography) to create the visual equivalent of movement in a static medium. In muted, almost monotone blues and blacks against a grey-green ground, Balla produced an easily accessible and attractive work within the theoretical context of Futurism, one of the most revolutionary of contemporary art movements.

more effectively it made war on all the received notions of gallery art, established ideas of meaning and the bourgeois-rationalist concepts of significance and value. But many of the Dadaists proved themselves products of the world they contested. They were serious minded young men who made even their laughter for a purpose. Indeed, so seriously did they take themselves that when they too became part of the history of art, one of their founder members, Hans Richter (1888–1976), published a thoughtful book on Dada.

The deadly earnest intention of Dada was to cleanse and revive art, if necessary by cauterization. 'Art falls asleep. Art needs an operation. Art is pretension, hysteria born in the studio.' The surgery prescribed was not only absurd and shocking public exhibitions by the artists themselves, but also the use of chance as a stimulus to artistic creation. The concept of chance was taken up by the Surrealists and was to become central not only in modern art but also in music, notably in the theories of the American John Cage, which also have deeply influenced many artists of recent years.

To clean the eyes and shock the system of the spectator into fresh, lively response, Dadaists in their art made use of any material to hand. The most famous results were that Kurt Schwitters called his *Merzbau*, collages and constructions built up from fragments and rubbish of every kind. It was also at this time that the technique known as photomontage was born. The Austrian Dadaist Raul Haussmann (1886–1971) claimed to have invented it, but its most famous practitioner was undoubtedly John Heartfield (1891–1968), a founder of Berlin Dada. In his violent and satirical montages against the evils of Nazism, capitalism and war, he deployed all the techniques of the medium such as the pasting together of cut-out sections of different photographs, or the making of multiple exposures on a single negative.

The Uncertainty of the Poet, Giorgio de Chirico (1888–1978), painted 1913. Oil on canvas, 105 × 94cm (41½ × 35½in). Collection Sir Roland Penrose, London, England.
The juxtaposition of the apparently sculpted torso and the bunches of bananas before the stylized arcading compose an image typical of de Chirico's mysterious paintings during his Metaphysical period. Later he abandoned his idiosyncratic style for a more conventionally realistic manner, to the anger of his one-time friends among the Surrealists.

Venus Asleep, Paul Delvaux (*b*.1897). Oil on canvas. Tate Gallery, London, England.
The Belgian painter Paul Delvaux embarked on his career as an essentially classical artist. His development is a good example of the influence of 20th century movements on artists of the second rank. Impressed by the work of his compatriot, Magritte, he was still more deeply affected by de Chirico. The combination of Surrealism, Metaphysical art and Delvaux's personal experiences and interests, produced the fantasy world of his paintings where eroticism, classical themes and contemporary motifs populate often nocturnal scenes.

At almost the same time as the Futurist explosion, other Italian painters, principally Giorgio de Chirico (1888–1978), were evolving a radically different idiom to be known as 'Metaphysical' painting. Machinery and motion are frozen out of his dream-like pictures where languid sculptures set in starkly lit classical-type sculpture and town squares evoke an eerie mood of pensive melancholy. Between 1911 and 1915 he was working in Paris, on close terms with *avant-garde* artists. His metaphysical art had little in common with theirs but did pre-echo and encourage their interest in the subconscious and the mystical irrational. Carlo Carra (1881–1966), who had signed the 1910 Futurist manifesto of painters, turned to Metaphysicalism, though he did not acknowledge his debt to de Chirico.

De Chirico's Metaphysical paintings foreshadowed the dream-like quality of Surrealism, the movement that was to dominate much of the 1920s and 1930s. The word seems to have been coined by Apollinaire in 1917 to describe the work of a group of artists who included Marc Chagall. One of the most prominent figures of the early-century Paris *avant-garde*, Apollinaire died in 1918 and it was partly in homage to him that André Breton (1896–1966) adopted the term for his Surrealist Manifesto of 1924. While Surrealism as a movement can be conveniently dated from this year, its philosophical origins were deep and complex.

Many of the ideas brought together in the manifesto are to be found scattered through the writings of German and French romantic writers from Novalis to Mallarmé, while the English poet Samuel Taylor Coleridge had written his magical fragment *Kublai Khan* as the transcription of a dream. Like the representatives of the modern alternative culture, he and his friend de Quincey had explored trance states under the influence of drugs. Drugs did not form part of the apparatus of the Surrealists; their researches into the unconscious, fundamental to their whole 'way of knowing', drew on the theories of Freud. 'I believe,' wrote Breton, 'in the future resolution of these two states—dream and reality—into a kind of absolute reality, or *surreality*, if one may call it so.'

The movement gestated in Paris between the years 1919 and 1924 within a group of young writers who ran the review *Littérature*. They

Bella with Flowers, Marc Chagall (*b*.1889), picture dated 1941. Gouache, 65 × 49.5cm (25¾ × 19½in). O'Hana Gallary, London, England.
Born of a poor Russian-Jewish family in Vitebsk, Chagall studied for a time under Leon Bakst and lived in Paris in the early 1910s. Returning to Russia he became director of the Vitebsk art school after the Revolution but finally left Russia in 1922. The folk traditions and legends of his home town remained a constant source of inspiration being transmuted into a language of universal symbolism. Later works included large official commissions in stained glass and mural paintings for, among other places, the Paris Opera and the new Metropolitan Opera, New York.

were joined by the Dadaist Tristan Tzara. The demonstrations of the Paris Dadaists struck them as laudable guerilla actions against the bourgeoisie, but the *Littérature* group aspired to find a new road to the truth about the human condition. In 1922 Breton and the poet Philippe Soupault produced *The Magnetic Fields*, pioneer poems of what was to be called 'automatism' in writing. The authors wrote 'at the dictation of the unconscious', regarding themselves as mediums between the hidden realm of the unconscious and the world of conscious awareness. Aiming to tap the true source of inspiration, unsullied by preconceptions, the group held seances at which one of them entered a trance and his utterances were recorded as the true poetry of the soul. In 1922, Breton took over the direction of *Littérature*. The negative and destructive tendencies of Dada received less space and Man Ray (*b*.1890) from New York, Marcel Duchamp (1887–1968), Max Ernst (1891–1976) and Francis Picabia (1878–1953) were added to the group.

In the manifesto Breton magisterially defined Surrealism as 'pure psychic automatism by which is intended to express, either verbally or in writing, the true function of thought'. It was based on 'the belief of the superior reality of certain forms of association heretofore neglected, in the omnipotence of the dream, and in the disinterested play of thought'. A later authority described its aim as 'to express pure thought, freed of all controls imposed by reason and by moral and social prejudices'. The Surrealists saw their new principle as a way of life and the 'sole psychic mechanism . . . for . . . the solution of the principal problems of life'.

The literary origins of Surrealism are essential to an understanding of the work of the artists who adopted allegiance to the movement. Its antecedents in 19th century Romanticism were developed not only by Breton but also by the poet Louis Aragon, a co-editor of *Littérature*, whose *Treatise on Style* (1928) amplified the theories of Surrealist literature, and by the poet Paul Eluard. Breton himself published two more manifestos (1930 and 1934) and founded surrealist research laboratories which used techniques derived from Freudian psycho-analysis to study the subconscious.

The movement was in tune with the intellectual climate. Rationalism had been ruptured by Freud himself, the shocking gestures of Dada and the mindless turmoil of World War I. Spiritualism too was in vogue. Sir Arthur Conan Doyle, famous as the creator of Sherlock Homes, published his *History of Spiritualism* in 1926. Even in the austere halls of science spiritualism had its devotees. The British physicist Sir Oliver Lodge, world renowned for his work on the electron, published numerous books on the subject. Today, we can see Surrealism as a major influence shaping the development towards popular occultism that is today widespread. Rejecting the spiritual heritage of Christianity and the dualistic philosophy of Descartes (whose separation of mind and matter it considered had paralyzed western thought) it aimed to return to human concerns, rehabilitating superstition and magic.

The artists who adopted allegiance to the movement aimed to create a new reality using dreams, chance effects and automatism, steadfastly ignoring any aesthetic or moral considerations. André Masson (*b*.1896) had his art studies broken by call up to the French army. He came out of the war severely wounded and deeply affected by the fearful experiences of life in the trenches. In Paris from 1922 he met Joan Miró and then André Breton. He soon engrossed himself in the adaptation of Breton's theories of literary automatism to painting. With Miró he produced 'automatic' drawings from the free movement of pen on paper. To achieve the same degree of freedom on canvas, he 'drew' continuous

The Reckless Sleeper, René Magritte (1898-1967). Oil on canvas. Tate Gallery, London, England.
The image of the resting bourgeois, pondering as it were, upon the commonplace images of his dream world, seems to epitomize the art of Magritte. But behind the wit lies a deeper vision in which, according to one critic, 'the viewer rediscovers his isolation and hears the silence of the world'. Employed for a time as a designer in a wallpaper factory, Magritte turned decisively to Surrealist art in the mid 1920s, rapidly becoming one of the most influential members of the movement. He is one of the rare major 20th-century artists to have disregarded technical innovations, but his art exerted a considerable influence on Pop Artists and other members of the 1960s *avant-garde*.

lines of glue which he then fixed with coloured sands, an intriguing parallel with American Indian sand painting. In 1940 Masson went to the United States where he was to be one of the most influential of the exiled Surrealists there.

Like Baudelaire, the Surrealists believed that 'the beautiful is what is bizarre'. They sought a 'convulsive beauty' through surprise, rejecting all art that aimed at rationality or logic. Like the Futurists they found no beauty in the Parthenon, they rejected the works of Michelangelo and, most startling of all for a 20th century movement, that of Cézanne. Rather they looked to archaic art—Cretan and Mycenaean for example —whose rationality and logic had long since been forgotten with the disappearance of the civilizations which produced them. They took inspiration from the arts of the American Indian, Oceania and Black Africa. Few experts today would suppose that an African sculptor carving a ritual dance mask in a tradition that stretched back centuries was aiming to achieve beauty through surprise. But the Surrealists were seeking inspiration in what seemed bizarre by the conventions of their own day and age. It has been said that the most committed among them 'would cheerfully have sacrificed all Romanesque art and the cathedrals of medieval Europe in favour of the statues on Easter Island'.

Of all contemporary artists who achieved beauty by surprise, Pablo Picasso received Breton's highest praise. But de Chirico's Metaphysical paintings were perhaps still more important to the movement. Breton quoted with approval his words, 'the profound work will be drawn up by the artist from the furthest depths of his being'. About 1930 de Chirico turned away from Modernism to paint in what his erstwhile friends considered to be a style of mannered, outworn naturalism. They were furious at his betrayal of the cause. Their objective was to inspire an avowedly revolutionary movement to change life and, in words taken from Karl Marx, 'transform the world'. As the 1930s advanced, the political commitment of the movement clearly expressed in its organ *La Révolution Surréaliste*, moved into conformity with the Communist Party line. The difficulties of yoking the mercurial and intuitive vigour of the movement to Marxist orthodoxies, whether Stalinist or Trotskyist, inevitably caused violent and bitter dissensions among the Surrealists; these persisted even after World War II.

Two types of Surrealist art can be distinguished. In the first images and distortions, recognizably figurative in manner, are used to depict, as it were, visions of an alternative reality. Salvador Dali was to call them 'hand-painted dream objects' and those who sought an ancestry for the movement in past tradition were to draw parallels with the strange pictures of Hieronymous Bosch and the composite fantasy heads of the early 17th century artist Arcimboldo.

The first major works in this figurative style of Surrealism were by the German-born Max Ernst (1891-1976). At 20 he was in contact with the Blaue Reiter group and visited Paris in 1913. In the German army during the war he wrote afterwards: 'How to overcome the disgust and fatal boredom that military life and the horrors of war. Create? Howl? Blaspheme? Vomit?' In 1919 he founded the Cologne Dada group and his one-man exhibition in Paris was acclaimed by artists who were already working their way towards Surrealism. Then, in 1922, Ernst painted *Les Hommes n'en sauront rien* which he dedicated to Breton and which is considered the first early masterpiece of Surrealism. The same dreamlike atmosphere and eerie juxtaposition of apparently unrelated images is to be seen in the organic-mechanic form of the *Elephant Celebes* (1921). In the mid 1920s Ernst 'at random dropped pieces of paper on the floor and then rubbed them with black lead'. This new technique he called

frottage (from the French, 'to rub'). In 1925 he published a series of *frottage* drawings, combining the random images and textures. Soon after he was active on the collage technique. But he broke with Breton and three years later went to America and settled in New York.

The other important Surrealists in this style included the Belgians Paul Delvaux (*b*.1897) and René Magritte (1898–1967) and probably the most controversial figure of all, the Catalan artist Salvador Dali (*b*.1904). Willingly allowed notoriety by the bourgeoisie for his waxed moustache, his extravagant gestures which he continued long after other Surrealists had abandoned such things, his unswerving admiration for himself is recorded in the autobiographical *Diary of a Genius* and the *Unspeakable Confessions of Salvador Dali*. Since the war he has distinguished himself as a designer of jewellery and, somewhat unexpectedly, produced a series of illustrations for Lewis Carroll's *Alice's Adventures in Wonderland*. In a way, the fantasy world of Carroll's nonsense masterpiece suits well with the ideas of Surrealism. But it is a world away from the ghoulish and sensual imagery of the Surrealist films *Un Chien Andalou* (1929) and *L'Age d'Or* (1930) on which Dali collaborated with the Spanish director Luis Buñuel. Dali's pictures, such as the *Persistence of Memory*, are probably the most widely known of the whole movement.

The second style of Surrealism was one of abstract fantasy, evolved by Picasso and Joan Miró (*b*.1893). A Catalan, like Dali, Miró had great admiration for the folk art of his country which remained a constant inspiration of his work. Fauvism, Cézanne and Cubism all provided him with material in the development of his first, highly original style of primitive 'detailed' landscapes. From 1920 he was a central figure of the

Painting, Joan Miró (*b*.1893), painted 1927. Oil on canvas. Tate Gallery, London, England.
Closely associated with the Surrealists in the 1920s and 1930s, the Catalan-born Miró was described by André Breton, arch-theorist of Surrealism, as 'the most Surrealist of us all'. He settled in Paris in 1920 but lived in Spain between 1940 and 1948. His art embraces sculpture, pottery and ceramic wall design as well as painting, while in 1954 he won the Grand Prix for graphic art at the Venice Biennale. Perhaps his most important influence has been on the work of American artists such as Alexander Calder.

To Oskar Panizza, George Grosz (1893–1959), painted 1917. Oil on canvas. Staatsgalerie, Stuttgart, FDR. (*Above*)
Called up in World War I, Grosz was discharged into a military asylum for a time. This picture's frenzied tumult proclaims his disillusion and despair at the European holocaust; its dynamic diagonals reflect his study of work by Robert Delaunay and the Futurists. In the 1920s Grosz produced cartoon-like drawings, purposely crude in technique but harsh indictments of the ugly profiteering in post-war Germany. Grosz was prominent in the mid 1920s *Neue Sachlichkeit*, 'New Objectivity', movement.

The Cry, Edvard Munch (1863–1944), painted 1893. Oil on canvas. National Gallery, Oslo, Norway. (*Below*)
Munch trained in Oslo (then, Christiania) and began painting in a style of social realism. With paintings like this famous one, an almost neurotic intensity of expression entered in his work. He became a celebrated model for the German Expressionists, living in Germany for many years up to 1908. The following year he returned to Norway, after recovering from a nervous breakdown.

Paris *avant-garde* and contributed to all the Surrealist exhibitions. His highly inventive canvases of brightly coloured forms and calligraphic line of the mid 1920s led Breton to remark 'he is the most Surrealist of us all.' Towards the end of the decade, partly as a result of a visit to Holland, his canvases simplified in their composition and developed greater symbolic power both in colour and imagery. Their influence can be seen in the work of Kandinsky. In the 1940s he produced an important series in gouache which he called *Constellations*. At the same time his work in graphic media produced the masterly *Barcelona* series. After World War II Miró was one of the most influential of the original Surrealists.

The figurative Surrealists made a wider impact outside the professional art world, violent and unsettling as their imagery often was. Almost in the manner of the narrative paintings of the 19th century salon artists, they gave their paintings titles which often seemed to point a moral or suggest a philosophic statement. Like Dada and Cubism, the Surrealists were creating their own reality but for these reasons it has proved a reality that lay people have felt they may find entry into. The revived vogue for the Belgian Surrealist René Magritte (1898–1967) gives a clue to the continuing popularity of the movement.

Magritte admitted the influence of de Chirico who, he said, showed him that 'the most important thing was to know what to paint'. Magritte showed scant interest in technical innovations and, over 40 years, retained an essentially unchanged style so as to 'concentrate on the representation of ideas which reflect the visible world.'

He was also an artist with a keen sense of humour. Although a late work, *The Great War* (1964) is one of the truly witty jokes by the artist at the expense of the bourgeoisie. A demurely dressed and bowler-hatted gent rises, three-quarter length, against a lightly clouded sky, his face obscured by a large apple floating before it. The echoes of the William Tell legend are irresistible. In front of the canvas, we can assume, armed with the crossbow of war which the prosperous but unperceptive bourgeois has primed with his neuroses and his taxes, stands the warrior aiming as instructed at the target—which however is not on the head, but which he will hit.

Expressionism, a term which has reverberated through the history of modern art, can be said to have had its beginnings as a movement early in the 1900s in Germany and more precisely in the city of Dresden. In a general sense, the word can be used of any art in which the artist distorts reality so as to express his inner emotions and personal vision. In France the Fauves and the Cubists were breaking the western tradition of representation to construct a new, autonomous system of form and colour independent of natural reality with which they could build the alternative reality of art. The Germans were seeking an elemental language of primitive power in which to express the deep seated emotions of humanity and themselves.

Distortion has been a recurring device in the history of art, but usually in the interests of narrative of doctrine. The distortions of the medieval painting were rarely Expressionistic in the modern sense. Nevertheless, some German Gothic crucifixes are so emotionally violent that the modern use is apt and many critics see the works of Grünewald as instances of true Expressionism. At the end of the 19th century the paintings of the Dutchman Van Gogh and of the Norwegian Edvard Munch established Expressionism at the forefront of north European art.

The group which constituted itself in Dresden in 1905 under the name *Die Brücke* ('The Bridge') was especially impressed by Munch. The leader of the group was Ludwig Kirchner (1880–1938) and the chief members were Emile Nolde (1867–1956), Karl Schmidt-Rottluf (*b.*1884)

and Otto Mueller (1874–1930). They took up residence in a large common studio and encouraged support from the public with a system of associated lay membership. They thought of themselves as a kind of medieval guild and their name reflected Kirchner's aim which was to 'draw all revolutionary and fermenting elements to itself'. Their sources of inspiration came from the art of medieval Germany, the woodcuts of the 15th and 16th centuries and the tribal art of Africa and Oceania which imperial adventures and the work of anthropologists had brought to the attention of Europe. Their use of the woodcut as a medium of serious art was something of a technical innovation in Europe. From 1908 members began to leave Dresden for Berlin but during their first three years the work of the various members showed such strong similarities that it was often difficult to identify one from the other. It was a style of flat, linear designs and strong contrasting colours. It was ideally suited to the expression of their hyper-sensitive and restless natures, obsessed by political, religious or sexual concerns.

The life of Kirchner was a parable of his times. Violent art like his, seemingly so out of tune with the comfortable pride of Wilhelmian Germany, refracted a violence not far below the surface. The jarring

Berghener, Ernst Ludwig Kirchner (1880–1938). Oil on canvas, 90 × 100cm (35½ × 39½in). Christie & Co., London, England.

Perhaps the most gifted, certainly the most sensitive of the artists of the *Brücke* group of German Expressionists, Kirchner was especially vulnerable to the pressures of wartime and of post-war Germany. He took drugs and, as a result of a period in the army in the first year of World War I, was subject to recurring mental and emotional disturbance. Underlying his depressive condition was the ultimate dichotomy in Expressionist aims between formal structure and deep self expression. This tension is seldom absent from Kirchner's work.

297

colours of his paintings, the harsh outlines of his woodcuts, his admiration for primitive German and alien art, and his increasingly stark images of contemporary city life grated the complacency of the times. As an enlisted man in the war he suffered a nervous breakdown. After the war his work took a somewhat more even temper. But he continued at the frontier of experimentation and with the advent of the Nazi regime found himself disgraced and his works displayed in the Exhibition of so-called Degenerate Art. Failing in health and broken in spirit he committed suicide.

Emile Nolde, perhaps the most important artist of the group, later associated himself with the *Blaue Reiter* painters. But throughout his life his work remained that of an essentially solitary figure. Folk art was an important source of inspiration in addition to Van Gogh, Munch and the pioneer Anglo-Belgian Expressionist painter James Ensor (1860–1949). The macabre, carnival masked figures in such works as Ensor's *Christ's Entry into Brussels* (1889) or *Death and Masks* seem to hover behind the canvas of a work like Nolde's *Young Woman with Men*. Between 1909 and 1915 Nolde painted a number of important religious pictures, such as *The Legend of Maria Aegiptiaca* (1912) and other works with an emotional violence of colour and paint which make them among the most powerful manifestations of the whole Expressionist movement. Nolde, who travelled both in the Far East and the South Seas in due course found himself also condemned as a 'degenerate'. His reaction was robust. In 1941 he was forbidden even to paint and proceeded to produce hundreds of watercolour studies of subjective primitive and clearly 'degenerate' images which he called his *Ungemalte Bilder* ('unpainted pictures').

The violence of the *Brücke* artists forced attention. Their great contemporary, Paula Modersohn-Becker would, perhaps have been out of place in their somewhat frenetic debates, but her pictures, though seemingly calm are equally moving expressions of the human spirit. Born in 1876 of a cultured Dresden family she went to Berlin at the age of 20 to be an artist and the following year joined an artists' colony where she was taught for a time by a local peasant painter. She married in 1901, having visited Paris the year before, returning with confused impressions but a firmer commitment than ever to her art. The tension between her domestic and professional lives caused her increasing distress. She made three further visits to Paris before her death in 1907 and the impact of Van Gogh and Gauguin is apparent in her works.

The moving spirit behind the second grouping of Expressionists was the Russian-born Wassily Kandinsky (1866–1944). Abandoning a career in law he quickly made a reputation as an artist after arriving in Germany in 1896. The chief sources of his art were Russian peasant symbolist art and contemporary *avant-garde* German paintings. He studied in Munich where he set up as a teacher in 1901. Between 1903 and 1908 he travelled widely in Italy, Holland and Tunis; a stay in Paris gave him the opportunity to see the work of the Fauves. In 1809, with his compatriot Alexei von Jawlensky (1864–1941) he launched the New Artists' Federation for the exhibition of works of *avant-garde* artists. They were joined by Franz Marc (1880–1916) among many other artists and they held their first exhibition over the winter of 1909–10 in Munich. In the latter year Kandinsky was working on his important treatise *On the Spiritual in Art* (to be published in 1912) and also painted a watercolour which is considered the first true abstract work of modern art.

At this time also Kandinsky became closely associated with Marc and Auguste Macke (1887–1914). But divisions were opening up in the Federation which broke it apart in 1911. Kandinsky's increasing move

Battle, Wassily Kandinsky (1866–1944). Oil on canvas. Tate Gallery, London, England.
Sometimes considered the pioneer of 20th-century abstract art, Kandinsky was influential in German art circles in the early years of the century, held a teaching appointment for a time under the Russian Revolutionary regime and then, in 1922, joined the Bauhaus. His evolution towards abstract art was gradual. By 1909, when Kandinsky was in his mid forties, he was painting landscapes which he termed *Improvisations* and which showed a progressive detachment from nature. What is generally considered to be his first purely abstract painting came the following year.

towards Abstraction may have been at the root of the trouble, at any rate he and his friends seceded from the Federation and Marc planned a counter-exhibition for December that year. It was billed as the First Exhibition of the Editorial Board of the Blue Rider. It lasted until January 1912. In addition to Kandinsky, Marc and Macke, the exhibitors included Delaunay, the composer Arnold Schoenberg and others. At a subsequent show that year they were supported by Klee, Malevich, Nolde, Picasso and Vlaminck. That year also saw the publication of the *Blaue Reiter Almanak* containing important essays by Marc and Kandinsky, the chief theorist of the group. They had no unity of style or organization but they did have a kind of programme. It rested on the intuitive inspirations of child and primitive art, the power of abstract forms and the symbolic and the psychological potential of line and colour. The group dispersed on the outbreak of war in 1914, Macke and Marc were killed at the front. After the war Kandinsky and Klee joined the Bauhaus.

Born in Switzerland in 1879, Paul Klee made his career in Germany until the coming of the Nazis in 1933. Working in Munich in the early years of the century, it was almost inevitable that he should have joined the *Blaue Reiter* artists. But Klee was too great an individualist to conform with any group programme. Contacts with Delaunay in Paris and the *Blaue Reiter* and a journey to Tunis in 1914, converted him from the monochromatic work in graphic media with which he had begun his career to a new interest in colour. In 1925, he recorded his belief that 'nothing can replace intuition'.

In his *Pedagogical Sketchbook*, published as a *Bauhausbuch* in 1925, Klee likens the artistic activity to the growth of a tree. The artist is likened to the trunk, the roots feeding him forms and ideas from the pattern of nature, the branches and blossoms, the final flowering, being the work of art in which nature has been transmuted through the life processes of the tree—that is, through the creative imagination and experience of the artist. Klee's middle and late works show his subtle

Blue Horses, Franz Marc (1880–1916), painted *c*.1911. Oil on canvas. Walker Art Center, Minneapolis, USA.
One of Marc's most famous pictures, *Blue Horses* embodied the artist's love of animals and might be considered the title picture of the *Blaue Reiter* ('Blue Rider') group formed in 1911, of which Marc and his friend Kandinsky were the chief members. In fact, the title had already been used by Kandinsky for a painting of 1903 and his influence directed Marc to an increasingly abstract style.

Fish Magic, Paul Klee (1879–1940). Oil on canvas. Museum of Art, Philadelphia, USA. (*Right*)
Influenced by the leading movements of his time, Expressionism, Cubism and Surrealism, Klee nevertheless evolved one of the most original and individual styles in the history of painting. He once wrote that his aim was to 'make memories abstract' and later that his method of art was 'taking a line for a walk'. The result is a fanciful, dream-like world of wit and imagination which sometimes seems reminiscent of child art and is clearly influenced by the images of primitive art but which demands from the spectator a sophisticated awareness of colour relationships and abstract design.

Menhirs, Barbara Hepworth (1903–75). Tate Gallery, London, England. (*Below*)
In 1932, with Ben Nicholson, her second husband, Barbara Hepworth visited the Romanian sculptor Brancusi in his Paris studio. She took with her photographs of her sculpture *Pierced Form* (1931). She wrote of it 'I had felt the most intense pleasure in piercing the stone in order to make an abstract form.' In Brancusi's studio she discovered the 'joy of spontaneous, active, and elemental forms of sculpture'. The inspiration remained with her as did the concept of activating the space occupied by a sculpture by opening it out.

sense of colour, a fluid and precise control of line, fantasy and often an impish sense of wit.

Although his life was cut tragically short at the battle of Verdun in 1916, Franz Marc, known for his paintings of animals, had already moved towards the boundaries of what a later age would call Abstract Expressionism. He had begun his career as a student of philosophy and theology at Munich University but then took up painting at the academy. The evolution of his style was indebted in part to the influence of Delaunay's paintings seen in Paris in 1912. Association with Kandinsky deepened his preoccupation with the expressive possibilities of colour. His aim was to find a visual language to express spiritual reality, and in animals he found a tenderness and nobility lacking in humanity. In later works, forms begin to penetrate one another, colours become brighter and less opaque. With *Fighting Forms* in 1914 the progress towards the abstract is well advanced.

With the outbreak of the war in 1914 Kandinsky made his way back to Russia. After the Revolution he helped reorganize the museums and to devise a programme of art training though its Symbolist philosophy was rejected by the Constructivists. By 1921 it was clear that the political revolution was going to crush the artistic revolution and he accepted an appointment at the Bauhaus. He remained with the Bauhaus until it was closed in 1933, publishing there his influential work *Point and Line to Plane*. From 1920 his paintings became rigidly abstract, introducing geometrical forms which looked back to the suprematist paintings of the 1910s. After 1933 he moved to France and his paintings became the influence of Miró, developing certain Surrealist features.

Kandinsky did not finally excise all representational aspects from his art until about a decade later. Underlying Abstract art is the artist's belief that the raw materials of his trade, form and colour, can in themselves stir response and excite imaginative experience in the spectator. In this sense Abstract art was the ultimate break with the tradition of representation. It had an ancestry. The later paintings of J. M. W. Turner had pursued the artist's interests in atmospherics and design to a point where the natural phenomena were obscured in a swirl of paint and brushwork. Anglo-Saxon and Celts, we have seen, had produced abstract designs and there are examples from still earlier periods. But

King and Queen, Henry Moore (*b*.1898), 1952–3. Bronze, height 164cm (64½in). Tate Gallery, London, England. (*Left*) Moore has always kept a careful photographic record of his work. One of his photographs of this epic work shows the two figures, emblematic of legend and deep human motivations, seated starkly on their wild Scottish moorland against a lowering sky of grey clouds. Much of his sculpture is designed for open air sites, few pieces achieve the numinous power of this.

Ecce Homo, Sir Jacob Epstein (1880–1959), completed 1935. Convent of the Holy Child Jesus, London, England. (*Below*) American born, Jacob Epstein settled in London in 1905 and quickly won a controversial reputation with the modernistic semi-relief carvings he did to commission for the British Medical Association Building in The Strand. In subsequent monumental sculptures, such as the *Ecce Homo*, the influence of archaic and primitive tribal art is apparent. The result, as in this study of the bound Christ, can be disturbingly powerful. Epstein had a second, fashionable reputation as a portraitist, producing impressionistic bronze portrait heads of the famous.

since the intentions of these remote artists can hardly be known, and since their ultimate inspiration by natural form is usually clear, we cannot claim them as meaningful precursors of the 20th century's pursuit of abstraction as a major concern for the true artist.

The impulses towards abstraction are powerful in much art of this century, whether in the mechanistic sense of the Constructivists or in the organic formed structures of Brancusi. His student, Isamu Noguchi (*b*.1904) evolved his own high personal sculpture from a synthesizing of his inspiration, that of oriental art, of Constructivism and Surrealism. The older sculptor Julio Gonzalez always revealed the organic inspiration of his work. Henry Moore continued the combination of abstraction and natural forms.

Born in 1898, the son of a Yorkshire miner he studied art in Leeds and London, visited Italy and then taught in London. In 1940–42 he was an official government war artist, producing a famous series of almost sculptural drawings of Londoners during the Blitz. His international standing was confirmed in 1946 by a retrospective exhibition in New York and, in 1948, with the major prize at the Venice Biennale. He enjoys the prestige of the elder statesman and, consequently, is considered old fashioned by some of the *avant-garde*.

His sculptures are concerned with form and space; their shapes are derived from human and natural forms; and their creator is concerned with making significant observations about the world outside the realm of art itself. Certain themes, like the reclining female figure, mother and child, the family, have preoccupied him throughout his

Somerset Maugham, Graham Sutherland (*b*.1903), 1949. Oil on canvas, 137 × 63.5cm (54 × 25in). Tate Gallery, London, England. (*Opposite top*)
Sutherland contributed to the London Surrealist exhibition of 1936 but, in the later 1940s, evolved a characteristic style of spiky, expressive abstract forms. He also established a considerable reputation as a portraitist.

Figure Writing Reflected in Mirror, 8796, Francis Bacon (*b*.1909). Oil on canvas, 198 × 148cm (78 × 58in). Private collection, France. (*Opposite below*)
The Dublin born painter Francis Bacon did not, on his own assessment, truly 'begin' as an artist until the age of thirty-five, although his work had enjoyed some critical acclaim for some ten years before that. His deeply disturbing art is based on a pessimistic philosophy: 'Man now realizes that he is an accident, a completely futile being . . .'. His characteristic image is the human being in a state of claustrophobic anxiety and fear.

White Relief, Ben Nicholson (*b*.1894), 1935. Painted wood, 102 × 166cm (40 × 65½in). Tate Gallery, London, England. (*Above*)
Britain's major abstract artist of the 1930s and 1940s, Nicholson evolved a style of cool austerity in which pure form and colour relationships achieve an elegant lyricism of sensitivity and power. In *Notes on Abstract Art*, published in 1941, he compared the formal relationships of his art with musical harmonies.

career. In his hands, inspired by an instinctive feel for the scale, texture and mass of physical reality he has made sculpture a language of deep human communication.

His first influences were English medieval sculpture and non-European, archaic art, notably the carving of the Mexican Aztecs. He made several visits to Paris in the 1920s meeting Picasso and Brancusi and in Italy he was to discover the monumentality of Masaccio. The sculpture of Michelangelo was a foundation influence.

Moore's standing as one of the century's greatest sculptors derives from his vision and from the way in which he has synthesized the achievements and insights of others in a new and expressive monumental art. Like Brancusi, from whom he learnt much, he engaged in a dialogue with his material, knowing the value of allowing it to shape the character of the work. Surrealism and the sculpture of Jean Arp revealed to him the ambiguity and variety and meanings of familiar forms. Moore's achievement as a sculptor is the more surprising since he came from a country with no significant tradition in the art since the Middle Ages. His example and that of the Yorkshire-born Dame Barbara Hepworth seemed to liberate a dammed flood of natural talent for today, British sculptors are among the world's foremost.

Barbara Hepworth (1903–75) developed along a course parallel to Moore's until the 1930s with her interest in the opening out of forms led to characteristic pierced shapes in wood and stone, in both of which materials she was a superlative craftswoman. The purity and abstraction of form she achieved shows a debt to Brancusi and Arp. From the start her work showed a feeling of monumental power in repose, combined with an elegant abstraction allied in spirit to the painting of Ben Nicholson, for a time her husband. She won international recognition after World War II and her style developed, both in experimentation with new materials, such as sheet-metal, wire and bronze, and in increased power. But it never lost the original nobility and subtlety in the handling of surfaces.

The next generation of British sculptors produced such masters as Lynn Chadwick (*b*.1914), Kenneth Armitage (*b*.1916), William Turnbull (*b*.1922), Edward Paolozzi (*b*.1924) and Anthony Caro (*b*.1924). Chadwick, trained as an architect, turned to sculpture in his early thirties making mobiles. In the 1950s he was the chief of a group of sculptors producing linear constructions in contrast to Moore's monumentalism. Chadwick's later organic forms scaled with angular forms have a disturbing Surrealist quality. Yorkshire-born Armitage achieved his first major output working from plaster cast to bronze achieving remarkable vitality. Among his best-known works, *Figure lying on its side* (1958–9) showed the trend towards abstraction to be seen in later work. Paolozzi, who worked for a time in Paris, developed a highly personal and powerful style owing something to the revival of Dadaism and to the art of Dubuffet, in which tiny cog wheels and small machine parts were metamorphosed as the skin of strange quasi-organic forms that breathed a sinister, almost menacing identity. Later these 'ready-made' constituents were built into powerful robot-like figures, whose surfaces were modified in subsequent works to smoother, plated and fluted 'skins'. Turnbull's work presented a contrast of lithe but austere sculpture of smooth metal abstraction.

The most important English sculptor of the second generation Anthony Caro was, like many others, an assistant of Moore's. But the influence he acknowledged was that of the American David Smith. Like Smith, Caro made use of mass-produced steel parts and other ready-made material. In his 40s he was concerned with extent, it was said that

each piece 'took possession of a certain territory', modifying the space in which it was placed. But although Caro's work seems a blatant rejection of Moore its sprawling lines do show a skeletal resemblance to the reclining figures of the older master.

David Smith (1906–65) made sculpture possible only in a technological civilization. The source of his ideas flowed from his experiences as a worker in heavy industry as much as his appreciation of the work of Julio Gonzalez and the theories of Kandinsky, Mondrian and Cubism. He was using 'found' steel parts as early as the 1930s. Thirty years later, his reputation established, he was producing series of large-scale works taking a single idea through a number of permutations. But despite their size these works are not monumental in the sense that Henry Moore's work is and do not have, or look for, the association of ideas with the natural world which are the furniture of a Moore work. The impersonal, neutral aura of his sculptures put Smith in line with the younger painters of the post-painterly abstraction New York school.

Moore's great contemporary in painting, Ben Nicholson (b.1894), was the son of the distinguished artist Sir William Nicholson and embarked on his artistic career at the age of 17, travelling widely. In the 1920s he began working in an experimental style, showing the influence of Cubism and the English primitive painter Alfred Wallis. He emerged as the principal English Abstract painter in the 1930s with a series of unemotional and searchingly analytical still lifes. His work showed considerable textural sensitivity and an art of pure formal and colour relationships. A meeting with Mondrian was critical. Soon after he began the first of his Abstract reliefs. He lived at St Ives, Cornwall from 1940 to 1956, at first with his wife Barbara Hepworth. The place became an important artistic colony. Younger artists, such as Peter Lanyon (1918–64) and Patrick Heron (b.1924) evolved into what became virtually a school of Abstract landscape painting. From 1956 members of the school held important one-man exhibitions in New York.

Of Nicholson's near contemporaries, only Victor Pasmore (b.1908) painted abstracts, and then comparatively late in life. In 1938, with artists such as William Coldstream (b.1908) he was a co-founder of the Euston Road School, where the artists, working alongside their students, taught representational techniques. Then in 1952, after a period of contact with Nicholson, he began working in abstracts and especially in relief constructions.

The other principal mainstream artist of this generation was the Welsh-born Ceri Richards (1903–71). Influenced by Surrealism after early experimentation with collage, he later turned to a style of lyrical informal abstraction, using themes from Dylan Thomas's poetry for some of his works. The first half of the century saw a number of individual, reclusive and even eccentric painters at work remote from the world of the galleries. Chief among these in present popular and critical estimation, is no doubt L. S. Lowry (1887–1976) of Salford, whose stick-figured industrial landscapes have almost reached the standing of popular icons. The strange, shiny, night-life world of Edward Burra's paintings present an equally idiosyncratic and fascinating artistic personality while the impassioned and eccentric religiosity of Sir Stanley Spencer (1891–1959) did sometimes reach to the skies of mystical inspiration.

A still stranger, indeed almost sinister figure, the Irish-born Francis Bacon (b.1909), became the second British painter after Nicholson to win world recognition as an artist of the first rank. His obsessive images of distortion and terror include some of the unforgettable images of our time. From the tortured canvases of Bacon, to the brash, aggressive sym-

bols of Pop Art is about as extreme a journey as could be made in a single tradition, but it was in London, during the mid 1950s that the most explosive post-war movement of modern art was to begin.

The impetus came from discussions among a group of architects, painters and sculptors—Alison and Peter Smithson, Richard Hamilton (b.1922), Edward Paolozzi and the critic Lawrence Alloway. Facing the lack of a common culture in an age of specialization and yet information transfer, they looked at the one shared experience—that of the urban industrial environment and postulated it as the proper concern of the artist. Films, advertising, packaging, science fiction, pop music, and especially all the products of American consumer culture and the ethic of commercial obsolescence, were to be built into the subject matter and aesthetic of the new Pop Art.

Hamilton, an engineering draughtsman before he was an artist, and a friend of Marcel Duchamp, produced the first icon of the new style in his *Just What is it that Makes Today's Homes so Different, so Appealing?* (1956). A body-building muscle man, holding a lollypop with the word 'pop' emblazoned on it and a naked beauty queen are seen sitting and standing in a domestic interior packed with comfy furniture and domestic appliances.

The movement took off stratospherically and almost instantaneously was accompanied by a parallel movement in America. Among the principal British artists to make their names during the Pop period were the sculptor Joe Tilson (b.1928) with his huge painted reliefs of commonplace objects; Peter Philips (b.1939) with pictures like *For Men Only Starring MM and BB* (1961), one of the early exploitations of Marilyn Monroe as a pop Art image; Peter Blake (b.1932) and Derek Boshier (b.1937). It was also then that the meteoric rise of David Hockney (b.1937) began. Another Yorkshire man, he studied at Bradford, then came south and made himself an over night celebrity with dyed blond hair, gold lamé jacket and other gimmicks. He had, however, both stylishness and stunning technical virtuosity; qualities still predominant in his elegant cool and pensive scenes.

The group of artists associated with Pop Art in America included Mel Ramos (b.1935), who chose comic strips and then increasingly erotic pin-up girls as his subject matter; Edward Ruscha (b. 1937), who produced a series of pictures of filling stations in strong colours and strong perspective; Jasper Johns (b.1930), who took advantage of the banality of Pop Art imagery such as the American flag and target symbols, to

Whaam!, Roy Lichtenstein (b.1923), painted 1963. Oil on canvas, 173×406cm (68×160in). Tate Gallery, London, England.

Up to his mid thirties Lichtenstein worked in the mainstream of American Abstract Expressionism. However, in the late 1950s he began to experiment with the use of commercial cartoon images found, for example, on bubble gum wrappers or in pulp magazines. He mimicked these images in massive blow ups, as here, reproducing them apparently faithfully, down to the dots of the printing screen. He practised the cult of the banal with an elegance that made him a leading figure of American Pop Art.

explore the qualities and textures of paint on a surface; Robert Rausch-enberg (b.1925) who moved to Pop after a period of 'minimalist' painting and used the imagery to make the spectator more aware of self and environment; Roy Lichtenstein (b. 1923), who did blow-up style pictures of comic strip cartoons; and Andy Warhol (b. 1928).

With the same flair for showmanship as Hockney, Warhol made him-self notorious with the painting of seemingly exact replicas of Camp-bell's Soup cans and many other similar repetitive images. He also made films of almost interminably repeated images or of totally uneventful subjects. Boredom was the object of these exercises and an aesthetic of boredom was constructed to accompany the new manifestation of art.

The American art scene of the early 1900s faithfully reflected the situation in Europe during the previous half century. The approved conventions were upheld by the establishment, with the National Academy at its head. Beyond the pale were scattered groups of painters in rebellion. Prominent among these were the Philadelphia Realists. In 1908, together with three other anti-establishment artists, they mounted an exhibition.

The Eight, as they called themselves, had little in common save exasperation with the oppressive conformism of 'official' art, nor were they, in European terms, particularly *avant-garde*. Impressionism, Post-impressionism and Realism were all represented; their subjects included landscapes as well as urban themes that the academician would consider squalid. But the Eight proved influential, particular Robert Henri (1865–1929), a teacher of standing who encouraged his pupils to concentrate on urban subjects. Among the most successful of these was George Bellows (1882–1925), who soon made a reputation with his 1909

Mr and Mrs Ossie Clark and Percy, David Hockney (b.1937), painted 1970–71. Oil on canvas, 214 × 305cm (84 × 120in). Tate Gallery, London, England.
David Hockney's stylish and elegant work rapidly won him fame; his early awards included a prize in the Graphics Section of the Paris Biennale in 1963, while the Whitechapel Art Gallery held a retrospective exhibition of his works in 1970. Prominent in the second period of British Pop Art he moved on towards a less rhetorically naturalistic style. However, his strong sense of pattern emerges in all his work and here is accompanied by strong colour and flat textures to turn what appears a placid domestic scene into one of somewhat Surrealist mystery.

Liz, Andy Warhol (*b*.1930). Mayor Gallery, London, England.

In the 1950s, Andy Warhol worked as an illustrator in the world of advertising. By the beginning of the 1960s he was becoming one of the leading figures of American Pop Art. Early works such as *Dollar Bills* and *Campbell's Soup* consisted of repeated stereotyped images of the commonplace objects of their titles. He soon moved to the manufacture of art as an industrial process, calling his studio the Factory, and teasing the bourgeoisie with comments like 'I'm painting this way because I want to be a machine', and 'I think it would be terrific if everybody was alike'. Liz Taylor and Marilyn Monroe, icons of popular culture, were natural subjects for Pop Artists whose aim was not portraiture but an exploded statement of the commonplace.

series of prize fight paintings. Bellows, who later subjected his naturally dashing and painterly style to a theory he termed 'dynamic symmetry' in the interests of greater formal balance, also became a successful cartoonist and lithographer. He and the four urban realist members of the Eight—Henri, Ernest Lawson, George Luks and John Sloan—came to be recognized, derisively, as the Ashcan school.

The work of the Eight has an honourable place in the development of modern American art. However, more important, was their part in organizing the famous Armory Show of 1913. The great exhibition, showing more than 1,000 works by *avant-garde* European artists, opened in February at the armoury of the 69th Regiment, in New York— because no gallery could be found to hold it. To the outrage of most of the public and many of the critics, Cubists, Fauves and Expressionists had their first public showing in the United States. Probably the worst furore was provoked by Marcel Duchamp's futurist work, *Nude Descending a Staircase No. 2*. But many artists and a number of adventurous collectors were deeply impressed and, when the hubbub had subsided, it was clear that modernism had become an established part of the American art scene.

A little before the artists of the Eight embarked on their crusade, Alfred Stieglitz (1864–1946) had launched his revolution in photography. His series of studies in the daily life of New York was to stretch over 40 years and in 1902 he and his young protégé Edward Steichen (1879–1973) opened their Photo-Secession Gallery. Intended as an outlet for young photographers, it was also important in publicizing modern painters. Among the works that the gallery popularized were watercolours and engravings of European buildings and of New York skyscrapers done by John Marin (1870–1953). Marin, who first trained as an architect, was to become the leading watercolourist in the United States, developing a style reminiscent of Kandinsky's pelucid abstracts.

Soon after the outbreak of World War II, the leading Surrealists went to America. In 1942 the wealthy Peggy Guggenheim, married to Max Ernst, opened the Art of This Century Gallery in New York. It was to be a centre of influence on young American artists. Important European artists like the German-born Hans Hoffman and the Armenian-born Arshile Gorky were already settled and teaching in the United States but the opening of American art to Europe, begun by Stieglitz and the Armory Show, had faltered in the years of Depression in the 1930s. At this time, as part of its programme of public works for the relief of unemployment, the government's Works Progress Administration had funded a series of Federal Arts Projects such as murals on public buildings. Since officialdom did not discriminate between abstract and representational artists, the modernists began to win acceptability of a kind and developed a sense of *esprit de corps* with their colleagues. The conditions were shaping for the post-war invasion of Europe by the nationalist school of American art.

The coming of the Surrealists was decisive though Gorky, in America since 1920, was already influential with some young artists. By the late 1930s he was also moving towards Surrealism in the style of Joan Miró. In 1947, he gave a press interview in which he said: 'When something is finished, that means it's dead, doesn't it? . . . I never finish a painting. The thing to do is always to keep starting to paint, never finish painting.' This doctrine of the vitality of the incomplete or, as some critics have called it, of 'continuous dynamic', almost prophetic of the way art was later to go in the consumer age of built-in obsolescence, was soon expanded by Jackson Pollock (1912–56) 'When I am in the painting,' he said, 'I'm not aware of what I'm doing . . . the painting has a life of its

own. I try to let it come through. It is only when I lose contact with the painting that the result is a mess.'

After a conventional training, Pollock had turned to Surrealism in the later 1930s and contributed to the International Surrealist Exhibition in New York in 1942. He had been influenced by André Masson's theory of automatism. In the next five years he evolved towards the style that was to make him famous—'action painting', as it was generally known. Tacking an untreated canvas to the floor of his studio, Pollock walked round it dripping paint on it from brush or can with gestures dictated by intuition. As the convoluted patterns built up the painter lost himself in them and responded to chance and accidental effects. The resulting swirling sinuosity of line, punctuated with lakes and blots of solid colour, has its own feeling of shallow depth through the overlay of the successive layers of paint.

Pollock's violent, raw gestures heralded a new American style to be known as 'Abstract Expressionism.' But a major figure in the emerging New York School was Hans Hofmann. The friend of Matisse, Delaunay and Picasso in Paris, he had founded a school in Munich in 1915 and settled in the United States in the early 1930s. About 1940 his representational pictures in an Expressionist style gave place to a vigorous Abstract style. The third foundation figure of the New York School was Robert Motherwell (b.1915). He began his career as a student of philosophy and was to become a prominent critic and largely self-taught painter. He is best known for monumental canvases dominated by massive banners and rough geometrical shapes, often in black and his best known paintings are probably the series *Elegies to the Spanish Republic* of the late 1950s.

Abstract Expressionism had two main streams. There was the violent gestural style of Pollock and the Dutch-born Willem de Kooning (b.1904). Coming to the States in 1926 he was influenced by Gorky, but made his name with the large, violent canvases of the series *Women* (1952). He returned to the theme in the early 1960s painting them in a flamboyant, almost satiric style. Franz Kline (1910–62) was the third major figure of this stream.

The second stream was more purely Abstract and, in the words of one critic, 'mystic'. The principal artist was Mark Rothko (1903–70). Born in Russia, he came to the United States as a boy. In the 1930s he was associated with the Expressionist Group of Ten, worked on Federal Art Projects and became a leader of the 1940s New York school which he founded with Motherwell, William Baziotes (1912–63) and Barnett Newman (1905–70). His paintings did not lose all figurative associations until about 1950 but then he developed the style for which he became world famous. Subtle colour relations are central to it. Rectangles of coloured space, with ill-defined edges are placed on a coloured ground; like many other American artists of widely different style, Rothko's pictures tend to present a strong central image.

While Abstract Expressionism was at the height of its success, Barnett Newman (1905–70), in his mid-40s, was evolving a style contrary to it in spirit. The canvas was saturated with one virtually undifferentiated colour and 'activated' either horizontally or vertically by a band or bands of different colour.

At about the same time, the New York artist Helen Frankenthaler (b.1928) evolved her own individual style of lyrical abstraction. Her medium was thin washed pigments on unprepared canvas which yielded misty, diaphanous textures. Her *Mountains and Sea* impressed the Washington artists Kenneth Noland (b.1924) and Morris (1912–62). Louis developed the technique of stain painting, using thinned acrylic

Supernovae, Victor Vasarely (b.1908), painted 1961. Oil. Tate Gallery, London, England. (*Above*)
Vasarely studied under Laszlo Moholy-Nagy, who introduced him to the work of Kandinsky and Mondrian among others. In 1947 he committed himself to the geometrical idiom that is his characteristic contribution to 20th-century art. The ambiguous play of colour and shapes in his paintings was to be deeply influential on the Op Artists of the 1960s. But both in painting and sculpture, Vasarely aims to relate his abstract art forms to the 'highly developed techniques of urban construction' and industrialized, scientific society.

Antennae with Red and Blue Dots, Alexander Calder (1898–1976). Painted metal, height 110cm (43¾in). Tate Gallery, London, England. (*Below*)
Trained as an engineer, Calder turned to art in the 1920s, visiting Paris where he met Miro, one of the most important influences on his own work. At this time he evolved his highly individual structures, purely abstract forms of wood, iron, wire or aluminium, which he termed 'stabiles'. Early in the 1930s he devised the 'mobile' for which he is best known. Calder's mobiles are carefully balanced constructions of wire and plates suspended in space which swing under their own momentum or are activated by the surrounding air currents.

pigments which he spilled and scrubbed into unprimed canvas so that its weave became part of the image. Later, in pictures termed 'unfurleds' the centre of the canvas is left blank with flowing ribbons of strong colours sloping inwards down either side. His last works were brilliantly painted chromatic stripe paintings.

These, and the later works of Noland, are grouped with the 'hard-edge' style, prefigured by Josef Albers (1888–1976) in his *Homage to the Square* series, which he called the 'dish' in which he 'served his own colour interactions.' The principal hard-edge painters were Al Held (*b*.1928) and Ellsworth Kelly (*b*.1923) whose work employed canvas panels and shaped canvases painted in bold, monotonal areas.

Noland followed his stain paintings with target-like images of chromatic brilliance, set in bare canvas. These were in turn followed by chevron motifs, later applied on diamond-shaped canvases; long narrow canvases covered in brilliant, horizontal stripes; and, in the early 1970s, colourful Mondrian-like abstractions. Other artists in the style covered the canvas with narrow vertical stripes or, like Larry Poons (*b*.1937), presented small discs or ovals on a coloured ground.

By the late 1960s, geometrical art of one kind or another dominated the American *avant-garde*. It was, in large measure, a reaction to the flamboyance of Pop Art and the romanticism of Abstract Expressionism. In the words of the critic Lucy R. Lippard it aimed to 'go beyond Cubism, to present an art without reference to outside events, or personal content.' The 'primary structurists' made spatial relationships their chief concern. Donald Judd (*b*.1928), the movement's most articulate apologist, produced large, straight-sided 'object structures' placed square on the floor, rising to eye level. Don Flavin (*b*.1933), used white and coloured light fittings vertically on walls or in free standing barrier-like structures and across corners to reshape the space. Larry Bell (*b*.1939) worked with glass vacuum coated with metallic compounds to produce semi-transparent, tinted panels and cubes or maze-like structures which irradiate the environment with colour continuums and reflections. Sol LeWitt (*b*.1933), became known for large modular grids of painted metal while Carl André (*b*.1935), who gained notoriety with a display of fire bricks, included among his 'primary structures' and 'scatter pieces', layouts of styrofoam bars, magnesium sheets and on one occasion bales of hay in a field. He proposed the site itself could be considered sculpture. Journalistic critics dubbed this kind of work 'Minimal art'.

Among artists who produced work classified under this title were Frank Stella (*b*.1936), Robert Mangold (*b*.1937), Robert Ryman (*b*.1930) and Agnes Martin (*b*.1908). Martin had won much critical acclaim in the early 1960s with all-over grid compositions, pencilled on monochrome oil or acrylic grounds. Illusion, texture, delicacy and strength characterize her work which, with *Tundra* (1967), a canvas divided into six tall rectangles, opened new directions. Ryman's interest in materials and textures led him to the use of matt paint on rolled steel, unstretched linen or plastic. His works exploited the whole visual field—the edges of a stretched canvas being a vital part of the effect. Like other contemporaries he produced 'multiples', such as *Standard*, a 12-part series of paintings to be seen as one work. Mangold's paintings are introspective works in which he aims at 'a simple, direct statement which should affect the viewer quietly but forcefully'. Frank Stella made his reputation with a series of all black canvases broken by lines about 10cm (4in) apart. Later he produced works in asymmetrical shaped curved canvases painted in bright flat colours. The monochrome canvases of other Minimalists are clearly foreshadowed by the paintings of the Russian

Yellow Island, Jackson Pollock (1912–1956). Tate Gallery, London, England.
Up to his mid thirties, Pollock experimented along what were to appear subsequently as comparatively orthodox lines in the traditions of modern art. Then, in 1947 he evolved the gestural style of drip painting soon termed 'action painting' with which his name has since been identified. Although championed by some art critics, his revolutionary working method was attacked, as no doubt it was supposed to be, by the lay public as well as members of the art establishment.

Malevich in the 1910s and the late 1950s 'identical', black paintings of Ad Reinhardt (1913–67).

Some artists believe that with works like these painting may have reached the end of the road. The death of art has been frequently announced before, but this time it is intriguing to find that the sculptors, with the mid-'70s style of 'Super-realism' are once again painting their figures. The effects, we may note in passing, are often startlingly effective social commentaries—the exact representation of a person at a certain emotional moment, gives the chance to study him or her and reflect on the personality portrayed. Were Super-realism to find itself any more enduring than the scores of other movements since the war, painters might find themselves back in the Middle Ages, condemned merely to paint the sculptures of other men.

It is a speculation we can safely dismiss. Painting inevitably finds new directions, and for those artists who do believe those directions will prove blind alleys, the great technological age of art beckons. As early as the 1920s, Naum Gabo had produced an example of kinetic art with a single vibrating metal rod which, when oscillated by an electric current, produced the illusion of a standing wave. Moholy-Nagy and other pioneers developed the concepts of this type of art and in the 1940s the Hungarian-born Nicolas Shöffer (b. 1912) was building 'spatio-dynamic' towers. With laser holography artists can now look to ever more elaborate and flexible technology. But even in this age the man with the paint and brush may still be able to match them. In the 1960s the illusionistic paintings of the Optical artists produced visual sensations which were so vigorous and strobic in effect that they were sometimes referred to as a branch of kinetic art. Deploying an expert's knowledge of colour and optics Victor Vasarely (b.1908) was able almost literally to illuminate the canvas with paint alone.

In the middle of the 18th century, William Hogarth attacked the art establishment of his day for praising anything from Italy and the undiscriminating public for accepting the judgement of the establishment. There are critics today, even some artists, uneasy about what the American Harold Rosenberg has called, 'the "What next?" steeple chase.' There is big money to be made in this race. When Mark Rothko died in 1970 a legal struggle followed for control of his large stock of paintings. It exposed much of the commercialism behind the new art—contrived promotion by galleries, agents, auctioneers, sometimes critics and even artists. Manipulation of the art market is, of course, not new. However the rapid succession of styles and schools has given it a new dynamic. In the words of the critic Edward Lucie Smith: 'Picasso's example [of abrupt changes of style] allied to purely commercial considerations, has encouraged the contemporary artist to standardize his product, and to move forward, when he needs to, only by dramatic leaps.'

Some artists have been shocked, others astonished at the ease with which 'anyone can assume the title of artist, or even genius'. In 1950, the 42-year-old Victor Vasarely wrote, 'Any spot of colour, sketch or outline is readily proclaimed a work, in the name of sacrosanct subjectivity'. At the time of the Pop Art fashion Roy Lichtenstein is reported to have said: 'It was hard to get a painting which was despicable enough so no one could hang it—everyone was hanging everything'. In such a world the layman could do worse than cling to the old, much derided dictum: 'I don't know much about art, but I know what I like'. This way he will often find himself a step ahead of the critics and will always be able to derive pleasure and interest from his visits to exhibitions of contemporary art.

Sky, Morris Louis (1912–62). Acrylic paint on unprimed canvas, 290 × 143cm (90½ × 56in). Private Collection, USA. Associated with the group named the Washington Color Painters from an exhibition held in 1965, Louis continued to experiment with technique throughout his career, but his concern was always with the power and effect of colour relationships. In his later works the pre-occupation reached a logical conclusion with stripes of colour laid down in parallel groups on untreated, that is unprimed, canvas. With paintings like these Louis expressed one of the consistent themes of 20th-century art—the artist's obsession with the materials of his trade.

Analytical Techniques and Frauds

Historical and critical evaluation of works of art in order to establish either provenance or authenticity is founded on two approaches—the intuitive judgement of the critic and the use of scientific techniques.

Of these two approaches it is the judgement of the expert or critic which is probably the most important, the scientific techniques only providing the proof. This intuition comes with years of experience, but one example of this approach is the value of possessing a knowledge of the fashions and styles, both of dress and interior decoration, of the period in which the work under examination was supposed to have been executed. The artefacts in a painting are often datable to within a few years. Frequently, forgers have lacked knowledge or experience of many of the details they have chosen to paint. For example a Ch'ien Lung vase in a 17th century painting points to a forgery.

A notable example of the incorrect styling of ceramics in a painting occurs in *Christ and his Disciples at Emmaus*, attributed to Hans Van Meegeren (1889–1947) in the style of Vermeer. The painting has a Dutch or German faience jug which could not have been painted in the 17th century when such jugs were common, for not only is the shape slightly wrong but the handle is incorrect when seen in profile.

Any analysis of a piece of art will begin with a simple typological classification, a description and photographic documentation. This can be supplemented by a study of the technique of execution and the internal, microscopic structure of the piece.

The simplest type of microscopic analysis requires the use of a binocular microscope to examine the surface of the work under various lighting conditions to highlight relief variations. With paintings, microscopic analysis is particularly useful for identifying pigments, since most natural pigments and some commercial products have well-established optical properties. The history of pigment use is well-documented and unless the forger's knowledge of pigment use is almost perfect and he has a supply of the genuine pigment, microscopic analysis can frequently reveal the fake.

In order to perform the analysis a cross-section sample from the work is obtained either by cutting with a scalpel at the edge of a crackle line or area of paint loss, or by taking a cylindrical section using a hypodermic needle. The sample is then mounted in a cold-setting polyester plastic and polished before being viewed under the microscope. Pigments easily identified by this method are those manufactured by a precipitation process which produces regularly-shaped particles.

Microchemistry can be used to identify the chemical structure of pigments. For instance, lead white when treated with nitric acid and the solution evaporated, leaves crystals of lead nitrate which can be identified under the microscope.

The final identification of a pigment often involves the use of another standard analytical technique called X-ray diffraction. The method is based on the fact that each mineral in a pigment has its atoms arranged in planes, the spacings between which are particular to each mineral. An X-ray beam is passed through a crystal of pigment and the rows of atoms diffract the X-ray by specific amounts; the emerging beam is directed on to a photographic plate which gives a film showing a series of lines, the spacings and intensities of which identify the mineral.

An example of the use of microchemistry and X-ray diffraction complementing each other is to distinguish between a 20th century-manufactured lead white and lead white of classical origin. The commercial lead white has a slightly different chemical composition from that of early lead white. Treatment of both with nitric acid will yield lead nitrate thus broadly identifying the pigment. X-ray diffraction shows

the two forms of the pigment have different crystalline structures.

The use of these techniques to identify (or refute) works of art is only useful when used in conjunction with a knowledge of pigment development over the centuries. Two things that the analyst will need to know when he begins his work is what is the likely chemical composition of given pigments on the work in relation to its possible provenance, and were the pigments available at the time the painting was apparently completed. The chemical composition of pigments varies according to source and/or method of preparation.

An example of the history of use of certain pigments is that of blue pigments between the 14th and 19th centuries. Over these years Prussian blue was introduced with the result that azurite use declined sharply; new sources of ultramarine (from lapis lazuli) were found in Russia and the pigment was chemically synthesized by Guimet in 1826. The introduction of cobalt blue led to a decline in the use of ultramarine however. After 1936, monastral blue, a copper phthalocyanine dye, superseded all other blue pigments.

One fake exposed on such evidence was a *Merry Cavalier* attributed to Frans Hals (1580–1666) in which the cavalier's coat was painted in synthetic ultramarine, the collar in zinc white and the background in cobalt blue, all of which post-date Hals' death by as much as 120 years.

The analytical methods so far discussed suffer from the disadvantage that many paintings have been retouched at some time in their history and pigment anachronisms do not necessarily point to the work being a fake. A recent, more subtle analytical technique is neutron activation analysis which allows the study of trace mineral impurities in a pigment. The basic theory behind the technique is simple: the atoms of all elements (iron, lead, calcium etc.) are partly composed of a nucleus which contains neutrons and protons, and which, in non-radioactive elements, are bound together in stable proportions. When a nucleus absorbs an additional neutron it becomes unstable and compensates by emitting radioactivity in the form of gamma rays. Every element has its own characteristic gamma ray emission whereby it can be identified.

A fuller documentation of the history of lead white, among other pigments, has benefited from this technique. Until the 18th century the method of making lead white remained unaltered. Galena ore (lead sulphide) was heated to produce litharge (lead oxide) from which lead was obtained by a smelting process. The lead metal was then hung in strips across vats containing acetic acid and the whole placed in a dung-bed. The carbon dioxide from the dung fermentation and the vapour from the acid solution caused lead white to be formed on the surface of the strips. In the 18th century waste tanner's bark was used instead of dung, which improved the yield of lead white. In the second half of the 18th century the strips were rolled through brass rollers to remove the pigment. Cremnitz white, a purer lead white, was also used from the beginning of the 19th century and the use of zinc white (zinc oxide) also began around this time. All of these variations can be detected using neutron activation analysis.

For example, Dutch paintings from the 16th to the 19th century can be analyzed according to the silver and zinc impurities in lead white. From around 1850, silver impurities in the pigment fell by a factor of five and while zinc impurities in Old Masters are negligible, post-1850 lead white shows much variation in the concentrations of this element.

A further technique used for analysis of the main elements in a pigment is mass spectroscopy, which is particularly useful for studying those pigment elements such as sulphur, lead, carbon and oxygen, which have isotopes. An isotope is one of two or more forms of an ele-

Portrait group. Panel, 40 × 37cm (16 × 14¾in). National Gallery, London, England.
Detailed stylistic analysis showed this panel up for what it is—a Victorian pastiche of an Italian Renaissance painting.

ment, which are different from the parent isotope in the structure of their nuclei but which have the same chemical reactions. Sulphur for instance, is composed of three isotopes and in a typical sample the major isotope will constitute 95 per cent of the sample, the remainder being made up of the other two isotopes in concentrations of 4.22 and 0.76 per cent. The relative amounts of the isotopes in a given element depends on the sample's origin. The relative distribution of sulphur isotopes in lapis lazuli from Afghanistan for instance, is different from that in a sample from Chile. The isotopic distribution of sulphur in cinnabar (mercuric sulphide) used in European paintings varied in the years 1750–1800 as the Dutch cinnabar was gradually replaced by Chinese ore. Lead white used in European paintings before 1800 shows little change in the distribution of lead isotopes regardless of where the samples came from. With the advent of supplies of the ore from the US, Canada and Australia the isotope distribution can be seen to change. The distribution of the lead isotopes found on Van Meegeren's *Christ and his Disciples* allowed that work finally to be declared a forgery.

X-ray photography or radiography provides a method of looking beneath the layers of paint to the canvas and the panels. The tendency of some artists to paint over a previous canvas is well-known, and radiography is capable of revealing the subject-matter of the earlier work. An example of underpainting was revealed by a study of William Hogarth's *Tavern scene: an Evening at The Rose*, which is now in the Soane Museum, London. When a radiograph was taken by placing a photographic film against the surface of the painting and passing X-rays through both from behind, a man's portrait showed on the developed film.

The technique is also useful for identifying characteristics of the panel mounting that are not visible by ordinary means. Using the technique for analysis of Campin's *Madonna and Child* showed that part of the panel mounting is an inferior replacement. X-radiography is also used to examine the preparatory undersketching of a painting and is at its most useful when examining works that have been sketched with a needle; when the first layer of lead white is applied to the canvas, the grooves fill up and become more opaque to X-rays than the rest of the canvas.

On paintings that have been sketched with charcoal however another technique has to be employed since charcoal has little effect on X-rays; the technique is called infrared reflectography. The use of infrared radiation can reveal characteristics at depths up to four times greater than detectable visually. The method can only be used with complete success when the primary coat of the painting 'contrasts' with the underlying sketch. For instance, the Florentine schools in 15th-century Italy used a light ground that was gypsum-based and with the sketch in charcoal; in the 16th and 17th centuries however darker grounds were used, probably with chalk sketching, although this is not certain since chalk does not 'contrast' well with the painting oil used.

One further technique that has found a place in painting analysis is the use of dendrochronology, or tree-ring dating, on panel supports. The ring-width in wood samples varies characteristically from year to year, mainly due to weather changes and so the rings on a piece of panel will be similar to panels of the same age. The match is rarely perfect but can be analyzed statistically. In addition, by comparing wood from various periods complete ring sequences can be established stretching back many centuries, so allowing the panel to be dated fairly accurately. One drawback to the technique is that allowances have to be made for the interval between the felling of the tree from which the panel was cut and its final use by the painter.

Madonna and Child, Robert Campin, 1378–1444. Panel, 63.5 × 54cm (25 × 19½in). National Gallery, London, England.
Detail of the X-ray of the picture opposite, showing where the more recent panel was added to the original. The difference between the two parts is very obvious on the X-ray.

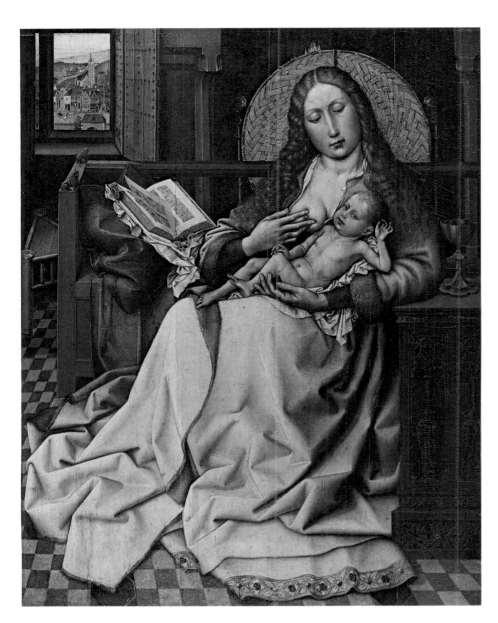

Madonna and Child, Robert Campin. National Gallery. The complete painting from which the detail opposite was taken. This shows just how difficult it can be to spot additions to a picture when they have been made skilfully and with care.

The establishment of authenticity for sculpture can often present special problems, principally because over the centuries Greek and Roman works, as well as Gothic, Renaissance and Baroque pieces have been copied or imitated. Since the stonemason used materials which had a range of hardnesses, so too did his tools vary; the expert with his knowledge of the history of technical methods and period style can date a work very closely. It is not so easy however, to attribute works to particular sculptors.

Particularly difficult to establish are later imitations or reproductions of classical Greek and Roman sculptures. The Renaissance period is notorious for its copies of classical sculpture. The nobility who commissioned works of art were very fond of classical forms and motifs and out of their desire for perfection had damaged antique works restored and many copies made.

A good forger will not only use the tools appropriate to the period of his piece, he will also often bury the finished sculpture in acidic earth to provide it with an aged appearance. Forced ageing on marble can usually be identified by microscopic examination of the surface; the crystals of calcium carbonate are naturally rhomboid-shaped with pointed corners. On old marble the crystals are blunted or even completely dissolved, whereas a forged work may have been left in the soil for too short a time for this 'weathering' to have been completed. Chemical treatment by the forger with strong acid is detectable by chemical analysis. Alabaster works can be analyzed in a similar manner. But again, the intuition of the expert is invaluable.

Glossary

Abstract Art In general any art which does not represent forms from the physical world; specifically the art of various 20th century movements which derives from the premise that colour and form have their own emotive, aesthetic or dynamic qualities independent of representational values. In some styles of abstract art, for example CUBISM, the 'subject' of the painting can be deciphered, in others the canvas or sculpture presents a self-contained world of geometric or organic-seeming shapes which together build the art object which has no reference to physical experience.

Abstract Expressionism The dominant style in American painting in the 1940s and 1950s. It ranged from the convoluted and vigorous ACTION PAINTING of Jackson Pollock to the brooding rhetorical images of Mark Rothko and Adolf Gottlieb. The Abstract Expressionists exploited the tactile qualities of paint and the emotional effects of colour to produce frequently dramatic and evocative canvases. The style was followed by quieter, less gestural painting known as post-painterly abstraction and by the banal realism of POP ART.

Abstraction Creation A style of non-figurative art developed in the 1930s by Antoine Pevsner and Naum Gabo; it combined some of the techniques of painting and sculpture.

Academic Term used particularly of the figurative art fostered by the official academies of the 19th century, which demanded technical polish and obedience to formal laws of composition and drawing. The word is used pejoratively of any well-established style which appears to have degenerated into arid repetition of formulas.

Action Painting The colloquial name for the style of ABSTRACT EXPRESSIONISM evolved in the late 1940s by the American painter Jackson Pollock. Paint was dropped and swirled on to the canvas from brush or can with unpremeditated gestures of the arm and hand, the artist looking only to exploit and develop chance patterns and occurrences thrown up in the undirected, almost subconscious flow of his actions.

Art Nouveau The style of the 1890s and early 1900s primarily associated with architecture and the applied arts. Its hallmark was the sinuous, tendril-like line and 'flame' curve. In the pictorial arts the most famous exponent of this expressive linear style was Aubrey Beardsley. The German variant known as *Jugendstil* was represented in the paintings of the Swiss, Ferdinand Hodler and the Austrian, Gustav Klimt.

Barbizon School A group of French Romantic landscape painters working at the village of Barbizon, in the Fontainebleau Forest in the mid 19th century. Their most important innovation was to paint direct from nature in the open air, instead of working up sketches in the studio. Chief among the group was C. F. Daubigny.

Baroque This term, applied to European painting, sculpture and architecture of the 17th and early 18th century, was coined, it is thought, from the Portuguese word *barroco* for a type of misshapen pearl. Baroque architects designed buildings around carefully inter-related geometric spaces which provided a dramatic stage setting for elaborate and vigorous schemes of painting and sculpture. At its glorious best the style produced totally integrated scenarios in which architecture, sculpture and painting, combined to great theatrical and emotive effect. By the early 1700s, however, this effect was more often heavy and sombre and the lighter, elegant style known as ROCOCO began to evolve.

Bateau-Lavoir Group The name for the small group of painters and writers associated with the young Picasso in 1908. The chief members were Braque, Gertrude Stein, Apollinaire and Juan Gris; they were called after the filthy tenement in Montmartre were Picasso lived.

Bauhaus Movement An aesthetic of functionalism in architecture and the applied arts which influenced most aspects of art in the western world during the 1920s and 1930s. The Bauhaus itself was a teaching institution founded at Weimar in 1919 by the architect Walter Gropius; it moved to Dessau in 1925. Its programme was the integration of all artistic disciplines, the application of the visual and applied arts and architecture as related activities, and the adaptation of all to the techniques of industrial construction. Among the diverse sources of inspiration was Russian CONSTRUCTIVISM; among the legion of major artists who taught at the Bauhaus were Wassily Kandinsky, Paul Klee, Lyonel Feininger, Mies van der Rohe the architect and Lázló Moholy Nagy who, in 1937, established a Bauhaus at Chicago.

Blaue Reiter, Der (German, 'The Blue Rider') Group of Expressionist painters working in Munich in the early 1910s. The name, also given to their publication *Der Blaue Reiter Almanak*, embodies the concern with horses and the almost mystical respect for the colour blue that characterized the paintings of Franz Marc and Wassily Kandinsky, respectively. The artists shared common interests in primitive and child art, abstract forms and the psychological associations of colour. They held two important exhibitions in 1912 and 1913.

Brücke, Die (German, 'The Bridge') A group of German Expressionist painters, active (1905–c. 13) in Dresden and later Berlin. The sources of their inspiration included the paintings of Munch and Van Gogh, certain aspects of medieval art, African and Oceanic tribal art, and the power of pure colour. The chief members were Emile Nolde, E. L. Kirchner and Karl Schmidt-Rottluff.

Camden Town Group A group of English painters, inspired by Walter Sickert, who came together in the early 1910s to produce works in the style of POST-IMPRESSIONISM.

Classicism and Classical Terms used in two quite distinct senses. First, to describe the art of ancient Greece of the 5th and 4th centuries BC. In this sense classical is also used as elements of later art such as Roman or RENAISSANCE which derive from the Greek example. Secondly, Classicism is used in a more general sense in contrast to ROMANTICISM. The Classical qualities being objectivity, formal logic and clarity, they are seen as opposed to Romantic subjective

Cloissonnism Derived from the French term *cloissonné*, a type of enamel work in which cells of colour are divided by metal ridges, this term is sometimes used of paintings by Gauguin and Emile Bernard in which areas of flat colour are divided by heavy outlines. The heavy boundary lines in works by Georges Roualt produce an allied effect but his colour is generally less brilliant.

Concrete Art A term coined in the 1930s by the DE STIJL artist Theo van Doesburg as a more apt description of a manner of ABSTRACT ART which, according to another advocate, created works 'that have developed through their own, innate means and laws'.

Constructivism A revolutionary art movement in Moscow in the 1910s and the early 1920s. The pioneer works were the 'relief constructions' of Vladimir Tatlin. A basic principle was that artists should integrate with society. Sources of inspiration were the collage technique, CUBISM and FUTURISM, with its emphasis on movement. The principal Constructivist contributions were in the fields of sculpture (Naum Gabo and Antoine Pevsner), architecture, industrial design (Tatlin and Alexander Rodchenko), film and typography (El Lissitzky). In all these areas Constructivism was widely influential.

Cubism The style initiated by Picasso and Braque about 1908–8. In the early, 'analytical' phase, they painted canvases, mostly still-lifes, which presented observed reality broken down in a field of facetted surfaces. Their radical approach made painting effectively independent of external reality and the surface of the canvas itself a principal concern of artists. The further fracturing of the image produced a surface so difficult to interpret that some critics introduced the term 'hermetic' (i.e. secret) Cubism. Later, colour played a larger part than before and non-painterly materials were stuck to the canvas; forms

also became more open. This last phase is often termed 'synthetic Cubism. Picasso, Duchamp-Villon and Archipenko produced important Cubist sculpture.

Cubist Realism An American style of the 1920s, sometimes also called Precisionism, which adapted the geometrical aspects of CUBISM to a stylized realism.

Dada Anti-art movement originating about 1917 in Zurich and other European centres and New York, leading figures included Tristan Zara, Hans Arp and Hans Richter; in America Marcel Duchamp was to prove of long-term influence. The Dadaists were dedicated to clearing the dead weight of past tradition in the practice of and respect for art. Their means were outrageous public gestures and the creation of 'art' from deliberately non-art materials, such as the *Merzbauen* or 'rubbish structures' created by Kurt Schwitters who founded a Dada group at Hanover.

Danube School A group of 16th-century painters working in the Danube region, chief among them Albrecht Altdorfer and the young Lucas Cranach. Their landscapes, realistic but romantic in mood were important, very early, examples of the genre.

De Stijl Dutch word, meaning 'the style', for a group of Abstract artists, most famous among them Piet Mondrian, and also the title of a magazine published from 1917 by Theo van Doesburg. In Mondrian's painting the style was characterized by austere, rectangular geometric abstraction; but his work was inspired by mystical concepts deriving ultimately from the neo-Platonism of the early Christian era. In his essay entitled *Neo-Plasticism* (1920), he argued that De Stijl type abstraction was the best vehicle for the expression of spiritual values. The movement inspired architects and designers such as Gerrit van Rietveld, won the respect of the sculptor Brancusi and continued to influence design, notably through the BAUHAUS, and ABSTRACT ART during the 1930s.

Divisionism Technique developed in the 1880s by Georges Seurat, sometimes called Pointillism. The aim was an exact re-presentation of the colour values observed in nature by laying down a field of dots of pure colour which, at a calculated distance from the painting, appeared to fuse into a realistic pattern of tones.

Euston Road School Group of British realist artists active in the late 1930s, chief among them William Coldstream and Victor Pasmore. In the late 1940s Pasmore was to adopt a highly abstract style.

Expressionism In general terms, this word is used to describe works of art in which the artist has distorted appearances to express his emotions or his vision. Specifically 'Expressionism' denotes movements in 20th-century art, foreshadowed in works by van Gogh and Munch, of which the first were DIE BRÜCKE and DER BLAUE REITER in Germany. Constant Permeke, Gustave de Smet and Fritz van der Berghe, working at Laethem-Saint-Martin in the Netherlands formed a later and important group. Major independent masters of Expressionism include the painter Oskar Kokoschka and the sculptors Ossip Zadkine and Ernst Barlach.

Fauvism Name (from the French word meaning 'wild beasts'), given by a critic to a group of painters exhibiting at the Salon d'Automne in Paris in 1905. The chief figure was Henri Matisse and the major Fauvist contribution to 20th-century art was the bold handling of pure colour. Some Fauves were influenced by the DIVISIONISM of Seurat, but the characteristic style applied colour in flat patterns.

Futurism Italian movement in art and literature launched in 1909 with a manifesto by the writer Filippo Tommaso Marinetti and influential throughout the 1910s. Rejecting the art of the past, the Futurists propagandized an artistic principle based on the machine, on movement and on speed. They glorified war and urged the destruction of all museums. The principal figures in the movement were Giacomo Balla, Umberto Boccioni, Luigi Russolo and the architect Antonio Sant'Elia.

Impressionism French art movement which flourished from the 1860s to the 1880s. Its subject was generally landscape and its aim was to capture the fleeting visual impressions of a scene rather than to report it with clean edged, photographic realism. The movement was named from a painting by Claude Monet which he entitled *Impression Sunrise*. Monet described an Impressionistic picture as a 'spontaneous work, not a calculated one'. The leading Impressionist painters, Monet, Sisley, Renoir and Pissarro deeply admired the work of Edouard Manet, though he did not exhibit with them. Also classed with the Impressionists was Edgar Degas. Their brilliant and light-flooded pictures inspired a generation of painters throughout Europe but the style had to fight hard for official recognition. Later outstanding artists in the style included the American-born Mary Cassat and Berthe Morisot.

International Gothic 14th to 15th-century style in art and sculpture. The elegant, elongated figures explain the style's fashionable popularity and the jewel-like detail of the paintings show a debt to manuscript illumination. France and the Netherlands were the chief centres of the style but outstanding examples were produced in England, Bohemia, northern Italy and Germany.

Kinetic Art Art, generally sculpture, involving movement. A 'dynamic-constructive art form' had been proposed in the 1920s and László Moholy Nagy produced an early example. True kinetic sculpture is mechanically, or electrically motivated. In the 1950s Nicholas Schoeffer produced moving sculptures involving illuminations. The optical sensation of movement can be produced in painting by exploiting illusions; such OPTICAL ART may be considered a branch of Kinetic Art.

London Group An English exhibition society founded in 1913. Among its principal artists were members of the CAMDEN TOWN and VORTICIST groups, Roger Fry, Duncan Grant and David Bomberg.

Mannerism Specifically, the artistic style which originated in Italy in the mid 16th century. The search for novelty in reaction to the conventions of the high RENAISSANCE led to exaggerated proportions for the human figure, complicated postures and asymmetrical composition. The sculptor Benvenuto Cellini and the painter Il Bronzino worked in the style but the most famous artist whose works may be classed as Mannerist was El Greco.

Metaphysical Painting The term given to the strange, dream-like pictures of Giorgio de Chirico. His canvases of the 1910s anticipated aspects of SURREALISM; they paralleled in the work of another Italian, Carlo Carra.

Nabis, the A group of painters, taking their name from the Hebrew work meaning 'prophets', who exhibited together during the 1890s. Chief among them were Pierre Bonnard, Edouard Vuillard and Maurice Denis who were inspired by patterns of flat colour in some of Gauguin's work.

Nazarenes A group of German Romantic painters of the early 19th century who aimed to revive religious art after the models of earlier artists such as Durer and Raphael.

Neo-impressionism Sometimes used as an alternative term for DIVISIONISM but also for modified versions of it. Seurat and Paul Signac worked to make DIVISIONISM a scientific system for the application of colour to achieve optimum optical realism, studying scientific theorists like Eugène Chevreul. The Neo-impressionism practised by van Gogh, Pissarro and Matisse in some of their works used the application of pure colour in dots and dashes to great painterly effect but without scientific rigour.

New Objectivity (in German, *Die Neue Sachlichkeit*) The term describes the work of the German painters and graphic artists, George Grosz, Otto Dix and Max Beckmann during the 1920s. Rejecting the emotional distortions of later EXPRESSIONISM they produced drawings and paintings of contemporary German society with a satirical edge.

Op Art or **Optical Art** A style of 1960s ABSTRACT ART which exploited the purely visual sensations of colour and pattern to produce illusionistic paintings of apparently flickering movement and shifting emphasis. Principal artists in the style, which can be considered a branch of KINETIC ART, were Victor Vasarely and Bridget Riley.

Orphism The name usually applied to the style of paintings done by Robert Delaunay in the 1910s in which 'the breaking up of form by light creates coloured planes'. Delaunay himself also used the word 'simultaneism' to describe the effect of his canvases of coloured rings and circle segments.

Pointillism A term sometimes used synonymously with DIVISIONISM.

Pop Art A movement of the late 1950s and 1960s originating in London but practised soon afterwards in the US. Pop artists took the banal images of popular consumer culture for their material. Important practitioners were Richard Hamilton and Peter Blake in England and Jasper Johns, Richard Rauschenburg, Roy Lichtenstein and Andy Warhol in the US.

Post-impressionism This term was coined in 1910 as a portmanteau description for the work of a number of artists, among them Cézanne, Gauguin, van Gogh and Rouault, who, despite their diverse styles, jettisoned the Impressionists' preoccupation with purely visual appearances.

Poussinism A view of art by 17th-century French academic painters which held that the 'classical' elements of drawing and design were fundamental and colour was decorative and secondary. Their model was Poussin and they were opposed by the Rubenists.

Pre-Raphaelites A group of English painters who came together in 1848. For a time paintings appeared signed with the mysterious initials P.R.B. for Pre-Raphaelite Brotherhood; it summed up their ideal of restoring painting to what they regarded as its purity and clarity before the time of Raphael, in other words before the inauguration of the high traditions of ACADEMIC ART. Their works, often on Biblical or narrative themes, were extremely detailed and in strong colours. The principal members of the group were D. G. Rossetti, John Everet Millais and Holman Hunt; they remained together for only a few years but influenced a number of other English painters, notably Ford Madox Brown.

Renaissance The period of European history and art history conventionally dated from the early 15th to the early 16th century. During this century, starting in Italy, a revolution took place in the style of the arts in Europe which, by the end of the period, put the human experience and the human scale at the centre of artists' concerns. Various styles and schools flourished in Europe during the Renaissance period which had its antecedents in the early 14th and which faded only in the mid-16th centuries.

Rococo 18th-century style in the arts which evolved at the French court in reaction to the heaviness of the later BAROQUE. The word probably derives from the French for shellwork, 'rocaille', and the style, first adopted in interior decoration was one of soft colours and gentle, elegant curves. Lightness and gaiety of mood marked the painting of the period in the work of such artists as Boucher and Fragonard. The genius of Watteau, though at home in the atmosphere of Rococo, was of a nobler and more intense quality.

Romanticism The generic term for a revolution in European sensibility and apprehension of the world, at its height from the 1790s to the 1830s. Its principal themes were a heightened feeling for nature; personal and subjective emotion; and a fascination with the exotic, whether from non-European cultures or from the medieval European past. All these themes had antecedents in the 18th century; flowing together they produced a new respect for the individual experience of the world, a new awareness of mankind's alien role in the natural environment, and an ideological rejection of societal bonds and values.

Literature led the way—the English Romantic poets, Walter Scott's historical fiction, revived and Europe-wide admiration for the works of Shakespeare, German writers such as Herder, Goethe and Schiller. Landscape and historical melodrama absorbed the leading Romantic painters such as Constable, Turner, Delacroix, Gericault and Caspar David Friedrich. The prophetic vision of William Blake stood outside the movement and the genius of Goya towered above it. The painter's approach to colour, form and subject matter were all profoundly modified by the age of Romanticism.

Rubenism The school of thought in French 17th century art opposed to POUSSINISM. Where the Poussinists stressed form and design the Rubenists held that colour was the most important factor in painting. Rubens and Titian were their models.

Seven and Five Society, later the '7 and 5' Abstract Group British group of artists in the 1920s and 1930s, of whom Ben Nicholson, Henry Moore and Barbara Hepworth were principal members, which in 1935 mounted Britain's first all-ABSTRACT ART exhibition.

Suprematism Style and movement originating in the 1910s in the work of the Russian Abstract painter Kasimir Malevich. His first example, a black square on a white ground, established the geometric concerns of the style. It was followed by the White on White series of 1918 and a development of the style in which amorphous forms combined with the geometric.

Surrealism The dominant style in European arts during the 1920s and 1930s. It had antecedents in DADA and the METAPHYSICAL PAINTING of de Chirico and derived immediately from experiments in poetry. Its priest and pioneer was André Breton who established the release of the images and energy of the subconscious as the chief concern of the movement. There were two main streams, figurative and abstract but both used chance effects and automatism and ignored conventions of morality and aesthetics, aiming at a new, autonomous reality. Among the most famous exponents were Picasso, Max Ernst, Joan Miro and Salvador Dali and among the most controversial works the Surrealist films of Luis Bunuel.

Synthetism Style evolved by Gauguin and Emile Bernard at Pont Aven in Brittany in the late 1880s using local colour within the painting to symbolic effect. Gauguin's work at this period is sometimes called symbolist and the style CLOISSONNISM.

Tachisme French movement of the 1950s related to ACTION PAINTING. Georges Mathieu was one of the leading figures.

Unit One A group formed in 1933 in Britain by Henry Moore, Benn Nicholson, Barbara Hepworth and Paul Nash with the poet Herbert Read. The members proselytized the cause of European art in Britain and organized the International Surrealist Exhibition of 1936.

Utrecht School Name sometimes used of the group of 17th century Dutch artists, among them Gerard Honthorst, who were inspired by the realism of Caravaggio.

Vorticism British art movement of the 1910s, inspired in part by CUBISM and FUTURISM. Its leaders included Wyndham Lewis, who edited the group's magazine *BLAST*, William Roberts and the sculptor Gaudier-Brzeska.

Wanderers, The A group of Russian artists of the 1860s and 1870s. Rebelling against the orthodoxies of the St Petersburg Academy they worked to bring art to the people, travelling the countryside organizing exhibitions and painting narrative and didactic pictures drawn from peasant themes.

World of Art Russian art movement of the 1890s rejecting what it considered the Russian provincialism of the Wanderers and, in its exhibitions and its magazine, *Novi Mir*, propagandizing Western *avant-garde* styles and the cult of art for art's sake. It embraced poets and musicians as well as artists and was the cradle of Diaghilev's *Ballets Russes*.

Galleries and Collections

The following is a list of art galleries and collections open to the public, listed alphabetically by city. When a collection is specific rather than general, either the name of the gallery indicates the speciality, e.g. **Breughel Museum,** or information is included within the individual entry. It is advisable to check the times when the galleries are open.

AUSTRALIA
Art Gallery of South Australia
North Terrace, Adelaide, South Australia 5000.
19th and 20th century paintings, drawings and prints by Australian artists; European works from the 15th century.
Western Australian Art Gallery
Beaufort Street, Perth, Western Australia 6000.
Australian, aboriginal, English and European art from the 18th century.
Art Gallery of New South Wales
Art Gallery Road, Domain, Sydney, New South Wales 2000.
European art from the 18th century; special emphasis on 19th century British artists.

AUSTRIA
Albertini Graphics Collection
Augustinerstrasse 1, 1010 Vienna 1.
European drawings of the 15th–20th century including Dürer, Michelangelo, Hogarth.
Austrian Baroque Museum
Unteres Belvedere, Rennweg 6, 1030 Vienna 3.
Paintings and sculpture by Austrian Baroque artists and 18th century portraits of the Imperial family.
Austrian Gallery of the 19th and 20th Centuries
Oberes Belvedere, Prinz Eugen Strasse 27, 1030 Vienna 3.
Collection includes Romako, Frankl and Kokoschka.
Gallery of Paintings of the Academy of Fine Arts
Schillerplatz 3, 1010 Vienna 1.
Includes 14th–18th century Italian painting and 18th–19th century French work.
Museum of the History of Art: Gallery of Paintings
Burgring 5, 1010 Vienna 1.
15th–19th century European paintings including Rubens, Rembrandt and Canaletto.
Museum of the 20th Century
Schweizergarten, 1010 Vienna 3.
Includes painting and sculpture by Munch, Picasso, Moore and Mondrian.
New Gallery of the Museum of the History of Art
Stallburg, Reitschulgasse 2, 1010 Vienna 1.
19th–20th century paintings including Millet, Rodin and Böcklin.

BELGIUM
Breughel Museum
Rue Haute 132, 1000 Brussels.
Museum of Art
Rue de Brederode 21, 1000 Brussels.
15th–18th century paintings and drawings including Rubens and Van Dyck. Sculpture.
Museum of Modern Art
Place Royale 1, 1000 Brussels.
Fine Arts Museum
Citadelpark, Ghent.
Includes Hals, Tintoretto, Reynolds, Hogarth. Sculpture includes Rodin, Renoir.

CANADA
Montreal Museum of Fine Art
1379 Sherbrooke Street W., Montreal 109, Quebec.
13th–20th century European painting, sculpture and drawings.
National Gallery of Canada
Lorne Building, Elgin Street, Ottawa 4, Ontario.
16th–20th century European paintings.
18th–20th century Canadian paintings.
Art Gallery of Ontario
317 Dundas Street W., Toronto 133, Ontario.
Includes 15th–18th century Italian paintings; 19th–20th century Canadian and American paintings and sculpture.
The Vancouver Art Gallery
1145 W. Georgia Street, Vancouver 5, British Columbia.
18th–20th century European, especially British paintings.

DENMARK
Royal Museum of Fine Arts
1307 Solvgade, Copenhagen.
Danish 18th–20th century paintings.
European painting 18th–20th century.

FINLAND
Ateneum Art Gallery
Kaivokatu 2–4, Helsinki 10.
16th–20th century European paintings and drawings. 19th–20th century Finnish artists.

FRANCE
New Museum
25 rue Richelieu, 62100 Calais, Pas-de-Calais.
Includes 16th–18th century Dutch and Flemish painters.
Chateau Museum
76200 Dieppe, Seine-Maritime.
Includes works by Boudin, Pissarro and Dufy.
City of Paris Museum of Modern Art
11 avenue du Président-Wilson, 75016 Paris 16e.
Includes Picasso, Léger, Dufy, Braque.
Cognacq Jay Museum
25 boulevard des Capucines, 75002 Paris 2e.
Includes early Rembrandts.
The Louvre
Palais du Louvre, Paris 3e.
Museum of Impressionism
Place de la Concorde, 75001 Paris 1er.
National Museum of Modern Art
13 avenue du Président-Wilson, 75016 Paris 16e.
Includes Matisse, Bonnard and Juan Gris.
Rodin Museum
Hôtel Biron, 77 rue de Varenne, 75007 Paris 7e.
Museum of Fine Art
Chateau des Rohans, 67000 Strasbourg, Bas-Rhin.
Includes Tintoretto, Corregio, Greco, Goya, Rubens, Van Dyck and Watteau.
Museum of Fine Art
18 place François-Sicard, 37000 Tours, Indre-et-Loire.
Includes Vignon, Bosse, Rodin and Houdon.
Museum of History
Versailles, Seine-et-Oise.
Includes Cranach, Clouet, Le Brun. Delacroix and Winterhalter; sculpture by Coustou, Girardon, Pigalle etc.

GERMAN DEMOCRATIC REPUBLIC
Bode Museum: Collection of Paintings
Bodestrasse 1–3, Museuminsel, Berlin 102.
14th–18th century European painters

including Cranach, Poussin and Gainsborough. Also Bode Museum: Sculpture Collection.

FEDERAL REPUBLIC OF GERMANY
Charlottenburg Palace
19 Luisenplatz, 1000 Berlin.
Houses Frederick the Great's picture collection.
Department of Sculpture
Arnimallee 23–27, 1000 Berlin 33.
Includes 3rd–18th century Western and Byzantine religious sculpture.
Gallery of Painting
Arnimallee 23–27, 1000 Berlin 33.
Medieval to 19th century European painting.
National Gallery
Potsdamer Strasse 50, 1000 Berlin 90.
19th–20th century European paintings, drawings and sculpture.
City Museum of Art
Ehrenhof 5 und Schulstrasse 5, 4000 Düsseldorf, Nordheim-Westfalen.
16th–20th century German paintings. Medieval and Baroque sculpture.
Art Collection of the University of Göttingen
Kurze Geismarstrasse 40, 3400 Göttingen, Hessen.
14th–18th century Italian painting and sculpture; 16th–17th century Dutch and Flemish works and 15th–20th century German.

GREAT BRITAIN
Birmingham City Museum and Art Gallery
Congreve Street, Birmingham 3.
Gulbenkian Museum of Oriental Art and Archeology
Elvet Hill, Durham, County Durham.
Fitzwilliam Museum
Trumpington Street, Cambridge, Cambridgeshire.
15th–20th century paintings.
Sudley Art Gallery and Museum
Mossley Hill Road, Liverpool, Lancashire.
18th and 19th century English paintings including Turner, Gainsborough and Holman Hunt.
Walker Art Gallery
William Brown Street, Liverpool, Lancashire.
Includes early Italian and Flemish painting.
The British Museum
Great Russell Street, London, WC1
The Queen's Gallery
Buckingham Palace, Buckingham Palace Road, London SW1.
Courtauld Institute Gallery
Woburn Square, London WC1.
Includes Impressionists and post-Impressionists.
Dulwich College Picture Gallery
College Road, London SE21.
Includes Rembrandt, Rubens and Gainsborough.
The National Gallery
Trafalgar Square, London WC2.
The National Portrait Gallery
St Martin's Lane, London WC2.
The Tate Gallery
Millbank, London SW1.
The Victoria and Albert Museum
Cromwell Road, South Kensington, London SW7.
The Wallace Collection
Hertford House, Manchester Square, London W1.
Ashmolean Museum of Art and Archaeology
Beaumont Street, Oxford, Oxfordshire.
Includes Old Masters, European painting, sculpture and bronze.

HOLLAND
Rijksmuseum: Department of Paintings
Stadhouderskade 42, Amsterdam.
Royal Gallery of Paintings: Mauritshuis
Plein 29, 'sGravenhage.
Includes 15th–17th century Flemish paintings; special Holbein and Cranach collections.
Boymans and Van Beuningen Museum
Mathenesserlaan 18–20, Rotterdam.

ITALY
Uffizi Gallery
Loggiato degli Uffizi 6, Florence.
Includes classical Greek sculpture, European painting 15th–19th century.
Museum of Ancient Art
Castello Sforzesco, Piazza Castello, Milan.
Sculptures include Michelangelo; paintings include Bellini, Lotto and Foppa.
Museum of the Palazzo dei Conservatori
Piazza Senatori, Rome.
National Gallery of Ancient Art
Barberini Palace, Via Quattro Fontaine 13, Rome.
Renaissance and Baroque paintings, also Raphael, Holbein, El Greco, Rubens.
National Gallery of Modern Art
Viale delle Belle Arti 131, Rome.
Picture Gallery (Vatican Museum)
Vatican City, Rome.
Includes a copy of da Vinci's 'Last Supper'.

SPAIN
Museum of Modern Art
Parque de la Cuidadela, Barcelona.
National Museum of Painting and Sculpture
Museo del Prado, Paseo del Prado, Madrid.
Provincial Museum of Fine Art
Plaza Museo 8, Seville.
Spain's second most important gallery.

USSR
Hermitage Museum
M. Dvortsovaya naberezhnaya 34, Leningrad.
State Pushkin Museum of the Fine Arts
Vl. Volkhonka 12, Moscow.

UNITED STATES
Museum of Fine Arts
Huntington Avenue, Boston, Massachusetts 02115.
Includes 14th–20th century paintings; Impressionist collection.
Art Institute of Chicago
Michigan Avenue at Adams Street, Chicago, Illinois 60603.
15th–20th century painting especially French.
Indianapolis Museum of Art
1200 W. 38 Street, Indianapolis, Indiana 46208.
Los Angeles County Museum of Art
5905 Wilshire Boulevard, Los Angeles, California 90036.
New Orleans Museum of Art
Lelong Avenue, City Park, New Orleans, Louisiana 70119.
European painting 15th–18th century; 19th and 20th century American works.
Solomon R. Guggenheim Museum
5th Anveue between 88th and 89th Street, New York, New York 10000.
Includes Picasso, Chagall and Klee.
Metropolitan Museum of Art
5th Avenue and 82nd Street, New York, New York 10028.
M. H. de Young Memorial Museum
Golden Gate Park, San Francisco, California 94118.

Index

Numbers in italics refer to the pages on which illustrations appear.

Acknowledgements

The publisher would like to thank the following individuals and organisations for help and permission to reproduce the photographs in this book.